Readings on Color
Volume 2: The Science of Color

Readings on Color
Volume 2: The Science of Color

edited by Alex Byrne and David R. Hilbert

A Bradford Book
The MIT Press
Cambridge, Massachusetts
London, England

This book was set in Times Roman on the Monotype "Prism Plus" PostScript Imagesetter by Asco Trade Typesetting Ltd., Hong Kong and was printed and bound in the United States of America.

Library of Congress Cataloging-in-Publication Data

Readings on color / edited by Alex Byrne and David R. Hilbert.
 p. cm.
Includes bibliographical references and index.
Contents: v. 1. The philosophy of color — v. 2. The science of color.
ISBN 0-262-02424-1 (v. 1 : hardcover : alk. paper). — ISBN 0-262-52230-6 (v. 1 : pbk. : alk. paper). — ISBN 0-262-02425-X (v. 2 : hardcover : alk. paper) — ISBN 0-262-52231-4 (v. 2 : pbk. : alk. paper)
1. Color. 2. Color—Philosophy. I. Byrne, Alexander.
II. Hilbert, David R., 1959– .
QC495.R32 1997
152.14'5—dc21 96-44539
 CIP

Contents

Acknowledgments

Austen Clark, Larry Hardin, and Steven Palmer gave us good advice on selecting papers for this volume. We are also grateful to Larry, Steven, and to John Allman, Fiona Cowie, Katie Hilbert, Kim Sterelny, and Jim Woodward for comments on the editorial material. Joe Levine helped with the early stages of the project. Doreen Domb and Gina Morea gave invaluable assistance with obtaining the permissions. Betty Stanton, Jerry Weinstein, and Katherine Arnoldi at The MIT Press were, as usual, indispensable. Finally, Ned Block deserves special thanks for his enthusiastic support.

Sources

1 Kurt Nassau, The Causes of Color, *Scientific American* 243 (October), pp. 124–54. Reprinted with permission. Copyright © (1980) by Scientific American, Inc. All rights reserved.

2 D. L. MacAdam, The Physical Basis of Color Specification. Reprinted with permission from D. L. MacAdam, *Color Measurement: Theme and Variations*, Springer-Verlag (1985), pp. 1–25.

3 Leo M. Hurvich, Chromatic and Achromatic Response Functions. Reprinted with permission from L. M. Hurvich, *Color Vision*, Sinauer Associates Inc. (1982), pp. 52–76.

4 Russell L. De Valois and Karen K. De Valois, Neural Coding of Color. Reprinted with permission from E. C. Carterette and M. P. Friedman, eds., *Handbook of Perception, Vol. 5: Seeing*, Academic Press (1975), pp. 117–66.

5 Edwin H. Land, Recent Advances in Retinex Theory. Reprinted with permission from *Vision Research* 26 (1986), pp. 7–21, Elsevier Science Ltd., Oxford, England.

6 Brian A. Wandell, Color Constancy and the Natural Image. Reprinted from *Physica Scripta* 39 (1989), pp. 187–92, by permission of the Royal Swedish Academy of Science.

7 Dorothea Jameson and Leo M. Hurvich, Essay Concerning Color Constancy. Reproduced, with permission, from the *Annual Review of Psychology* 40, pp. 1–22, © 1989, by Annual Reviews Inc.

8 Yun Hsia and C. H. Graham, Color Blindness. Reproduced from *Vision and Visual Perception*, ed. C. H. Graham, pp. 395–413, © 1965, John Wiley & Sons, Inc. Reprinted by permission of John Wiley & Sons, Inc.

9 M. Alpern, K. Kitahara, and D. H. Krantz, Perception of Colour in Unilateral Tritanopia. Reprinted with permission from *Journal of Physiology* 335 (1983), pp. 683–97.

10 Jeremy Nathans, The Genes for Color Vision, *Scientific American* 260 (February), pp. 42–9. Reprinted with permission. Copyright © (1989) by Scientific American, Inc. All rights reserved. Illustrations © George V. Kelvin/Scientific American.

11 Norman Geschwind and Michael Fusillo, Color-Naming Defects in Association with Alexia. Reproduced from *Archives of Neurology* 15 (1966), pp. 137–46.

12 Matthew Rizzo, Vivianne Smith, Joel Pokorny, and Anthony R. Damasio, Color Perception Profiles in Central Achromatopsia. Reprinted from *Neurology* 43 (1993), pp. 995–1001, by permission of Little, Brown and Company (Inc.).

13 Charles A. Heywood, Alan Cowey, and Freda Newcombe, On the Role of Parvocellular (P) and Magnocellular (M) Pathways in Cerebral Achromatopsia. Reprinted from *Brain* 117 (1994), pp. 245–54, by permission of Oxford University Press.

14 Roger N. Shepard, The Perceptual Organization of Colors: An Adaptation to Regularities of the Terrestrial World? Reprinted from *The Adapted Mind* by J. Barkow, L. Cosmides, and J. Tooby, eds., pp. 495–532. Copyright © 1992. Reprinted with permission of Oxford University Press, Inc.

15 J. N. Lythgoe and J. C. Partridge, Visual Pigments and the Acquisition of Visual Information. Reproduced, with permission, from *Journal of Experimental Biology* 146 (1989), pp. 1–20, by Company of Biologists Ltd.

16 J. D. Mollon, "Tho' She Kneel'd in That Place Where They Grew … ": The Uses and Origins of Primate Colour Vision. Reproduced, with permission, from *Journal of Experimental Biology* 146 (1989), pp. 21–38, by Company of Biologists Ltd.

17 Paul Kay and Chad K. McDaniel, The Linguistic Significance of the Meanings of Basic Color Terms. Reprinted from *Language* 54 (1978), pp. 610–46, by permission of the Linguistic Society of America.

Introduction

The readings collected here provide an overview of contemporary empirical work on color and color vision; this volume also contains a glossary and suggestions for further reading. Its companion volume (*Readings on Color, vol. 1: The Philosophy of Color*) comprises a selection of recent philosophical papers on color.

It is impossible to give a comprehensive survey of color science in a single volume. The selections have been chosen with an eye to their philosophical relevance, but we have also tried to cover the issues central to the contemporary scientific study of color, thus meeting the needs of non-philosophers who require some entry point into the large empirical literature.

The readings range from physics to linguistics, and as a consequence they contain a large technical vocabulary. The most important terms will be clarified in this introduction, but the reader is encouraged to make full use of the glossary.

The readings have been arranged so that the later chapters only presuppose material covered earlier. Thus someone with no knowledge of color science should read the selections in roughly their order in the text. The first chapter, on the physics of color, is an exception: the material it covers is not strictly necessary to an understanding of anything later, although it does lurk in the background of many of the other chapters.

The following sections summarize the selections, highlight the significant contributions science has made to understanding the nature of color and color vision, and indicate the status of current controversies. Along the way, we also sketch the necessary background for those new to color science.

1 The Physics of Color

The various colors that objects appear to have arise from the interaction between light and matter. If we fix the viewing conditions and the subject's perceptual apparatus, the difference between an object that appears green and an object that appears red is due to the different ways that those objects interact with light. Nassau (chapter 1) is not concerned with the mechanisms of color perception but rather with explaining how an object in the field of view affects the character of the light reaching the eye. What is it about emeralds that typically results in their appearing green and what is it about rubies that typically results in their appearing red? As Nassau illustrates, the answers to such questions are neither simple nor uniform.

Light is composed of wave- and particle-like entities called *photons*, each of which has a wavelength (usually measured in *nanometers*: billionths of a meter). The energy of a photon (usually measured in *electron-volts*) is inversely proportional to its wavelength. The *intensity* or *power* of a light source at a given wavelength is the total

amount of energy of photons of that wavelength emitted per second.[1] The *spectral power distribution* (SPD) of a light specifies its intensity at each wavelength in the visible spectrum (see Nassau, figure 1.1). As far as color is concerned, we can think of the SPD of a light as completely characterizing its physical properties.[2]

The visible spectrum, from violet to red, runs from about 400 nm to 700 nm. The ratio of the intensities of the illumination provided by direct summer sunlight to that available on a moonless night is about 10^9 to 1. Normal indoor lighting typically lies somewhere near the center of this range.

When an object is illuminated it will reflect some proportion of the incident light, absorb some proportion, and transmit any remainder. Different wavelengths will be differentially absorbed, reflected, and transmitted by a given object. Two objects that differ in the way they absorb, reflect, or transmit light will, under certain illuminants, differ in the light that they send to the eye. In such a situation, and ignoring the effects of overall scene composition (see section 4 below), any difference in perceived color will be due to differences in reflection, absorption, or transmission of light by the objects.

Although the most common form of interaction between light and matter relevant to color is between light and electrons, Nassau explains that such interactions are quite diverse, and that other mechanisms such as scattering and interference often come into play. One lesson philosophers may take from his discussion is that, from the standpoint of fundamental physics, color categories put together objects with very different properties. (See Smart 1975, 1987 [chapters 1 and 4, *Readings on Color, vol. 1*] and Armstrong 1987 [chapter 3, *vol. 1*].)

2 The Measurement of Color

Colorimetry, or color measurement, is a fundamental tool of color science. Its aim is the development and application of practical and objective methods for describing objects in a way that will allow reliable predictions of their perceived color. Although this is the ostensible goal of colorimetry, most colorimetric systems and methods only allow predictions of perceptual matches rather than perceived color. Since two stimuli may change substantially in their color appearance while remaining matched, this constitutes a significant limitation. This caveat applies in particular to the most commonly used colorimetric system—the *CIE*[3] *standard observer*—described below. Accurate color appearance models would constitute a significant extension of colorimetry, and the development of these is an area of active research. In spite of its limitations classical colorimetry is very useful, not only in research but

also in industrial and commercial applications. MacAdam (chapter 2) provides an introduction to classical colorimetric practice.

The *reflectance* of an object (or surface) at a given wavelength is the ratio of the light (number of photons per unit area per unit time) it reflects at that wavelength to the incident light at that wavelength. The *surface spectral reflectance* (SSR) of an object is the reflectance of the object at each wavelength (in practice, narrow bands of wavelengths) in the visible spectrum. Thus we may view Nassau (chapter 1) as explaining why objects have particular SSRs. Displaying an object's SSR graphically results in its *spectral reflectance curve* (MacAdam, figures 2.2–2.6). In order to achieve a widespread system of color measurement the illuminants need to be standardized. The most important of these is *CIE illuminant C*—an approximation to average daylight that has the virtue of being reproducible in the laboratory using a standard light source and filter.

The visible light reaching the eye from an object is the joint product of its SSR and the SPD of the incident light.[4] Ignoring the effects of scene composition, these exhaust the physical characteristics of objects and light relevant to predicting color appearance.[5] But the relation between the physical stimulus and color appearance is not straightforward. First, not all differences in the SSR of the object or the SPD of the illuminant are perceptually detectable. Second, and more important, a pair of spectral reflectance curves is little help by itself as to whether the corresponding two objects will appear to match in color when viewed in a given illuminant.

The color of an object varies along three perceptually evident dimensions: *hue*, *saturation*, and *lightness* (or *brightness* for lights). The hues are the reds, greens, yellows, and blues, and the perceptual mixtures of these: the oranges (red-yellows), turquoises (blue-greens), and so on. Saturation is the proportion of a given hue: highly saturated colors are those that are more vivid, or less washed out (thus pastels are desaturated). Lightness is variation along the black-through-gray-to-white continuum: the closer to white, the more lightness (the more dazzling a light, the more brightness).[6]

For physiological reasons (see section 3 below) three suitably chosen lights can be combined to match the apparent color of any light.[7] This fact, the *trichromacy* of human color vision, provides the basis for the practice of *tristimulus colorimetry*.

Tristimulus colorimetry works by perceptually matching stimuli with mixtures of three lights (*primaries*). A sample light is introduced into one half of the field of view and the three lights chosen as primaries are mixed in the other half. The amounts of the three primaries are adjusted until the two halves appear exactly the same in color. The amounts of the three primaries required to match the sample are the *tristimulus values* of the sample for those primaries and that observer. There will be

variations in the tristimulus values from observer to observer even if we restrict our-
selves to observers with normal color vision. In order to allow for standardization
in color measurement the CIE has averaged the tristimulus values obtained from
a large and representative body of observers with normal color vision on samples
throughout the visible spectrum. This set of tristimulus values for *spectral lights*[8]
defines the *1931 CIE standard observer*. The CIE standard observer provides an
objective and reproducible way of sorting lights into classes of equivalent stimuli.
Rather than specifying color appearance the standard observer describes which lights
are perceptually equivalent. Since, given the SPD of an illuminant, it is possible to
calculate the light stimulus produced by an object with any given SSR, the standard
observer can also be applied to surfaces.

It is important to keep in mind that the CIE standard observer provides a system
for predicting one aspect of the visual response to physically characterized lights, and
not a physical description of the composition of those lights. A light with a particu-
lar tristimulus specification need not contain any light with the wavelengths of the
relevant primaries. In fact, the primaries used by the CIE are "imaginary"—not
physically realizable—and were chosen primarily for computational convenience
(although the data on which the standard is based were, of course, collected using
real primaries!). A simple mathematical transformation allows tristimulus values
given with respect to one set of primaries to be reexpressed in terms of a different
set.[9] In this respect colorimetric primaries differ from the primaries often referred to
in discussions of painting or printing. In those cases the primaries are often genuine
components of the physical mixtures they are used to describe.[10]

It is also important to understand that any colorimetric specification is only valid
for very restricted viewing conditions. Colorimetry is done using small spots of light
on a homogeneous neutral background. Although colorimetric specification is a reli-
able predictor of perceived color matches in many viewing conditions, the color of
the background, which is rarely in real life either homogeneous or neutral, can have a
powerful influence on the perceived color of a surface (see section 4 below). Another
indication of the sensitivity of tristimulus specification to viewing conditions is that
the CIE has separate standard observers for samples that subtend, respectively, more
and less than 4 degrees of visual angle.[11]

3 Psychophysics and Physiology

The contemporary understanding of color vision has its roots in the nineteenth cen-
tury and some aspects of human color vision are as well understood as any topic
in human perceptual psychology and physiology. Hurvich (chapter 3) and De Valois

and De Valois (chapter 4) summarize what is known about the basic response characteristics of the human color vision system and the physiology underlying them.

The human *retina* contains two morphologically and physiologically distinct classes of *photoreceptors*. Because of their characteristic shapes they are known as *rods* and *cones*. Rods are more sensitive than cones and thus are important in conditions of low light. Rods are all of one type, and they play little role in color vision.[12] The cones are subdivided into three types on the basis of their differential sensitivity to different wavelengths of light. The three cone types are morphologically indistinguishable, and although their existence was inferred in the nineteenth century in order to explain the trichromacy of human color vision, it is only recently that direct measurements of their *spectral sensitivities* have been made, and very recently that the *photopigments* they contain have been isolated (see Merbs and Nathans 1992).

All human photoreceptors, and most photoreceptors of any kind, share one basic characteristic: they provide the same response to an absorbed photon of light, no matter what its wavelength. This fact, sometimes called the *principle of univariance*, implies that a single photoreceptor type cannot by itself provide the information for any color distinctions beyond light and dark. Although photons of different wavelengths have different probabilities of being absorbed by a single photoreceptor, that photoreceptor's response contains no information about the wavelength of the incident light. The photoreceptor's response may have been produced by a dim light at a wavelength to which it is relatively sensitive or, on the other hand, a bright light at a wavelength to which it is relatively insensitive. Color vision, strictly speaking, requires at least two photoreceptors with different response characteristics. In the human eye, all the information about the color of the stimulus is contained in the relations between the response levels of the three types of cones.

Given these facts, it is tempting to label the three types of cone photoreceptors with color names corresponding to the predominant color of the part of the spectrum in which their peak sensitivity falls. Thus the short wavelength receptors (*S-cones*) become the *blue* cones; the middle wavelength receptors (*M-cones*), the *green* cones; and the long wavelength receptors (*L-cones*), the *red* cones.[13] It is natural to postulate that perceived color corresponds to the additive mixture of these three colors in proportion to the degree of excitation of the relevant photoreceptor type. Although more sophisticated versions of this theory were popular among some nineteenth-century color scientists, it has become clear that it is inadequate. First, although some of the theory's implications for the generation of hues other than the three primary ones are plausible—purple does appear to be a reddish blue—there are obvious problem cases. Yellow does not appear to be a perceptual mixture and it certainly does not appear to be a mixture of red and green. Moreover, *nothing*

appears to be a mixture of red and green. (Of course, these claims are about perceptual appearances and do not limit physical mixtures: an illuminant may be a mixture of spectral green and red light, for example.) Second, data about the actual shape of the cone spectral sensitivity curves show that any light that excites the M-cones also produces substantial excitation in either the S- or L-cones. This raises a difficulty as to how it is possible, as it undeniably is, to perceive some stimuli as green without any hint of redness or blueness. These and other considerations have led to the rejection of theories of this type, in which each kind of photoreceptor is associated with a basic color sensation, and their replacement by a different class of theories in which color appearances are to be explained instead by appeal to *opponent processes*. Opponent-process theory is the organizing theme of both chapters 3 and 4.

The fundamental idea of opponent-process theory is that all (human) color appearances are generated by the operation of three independent neural processes: red-green, blue-yellow, and white-black. Focusing on the two chromatic processes (red-green and blue-yellow), they are *opponent* in two important senses. First, as mentioned above, no color appears to be a mixture of both members of any opponent pair (e.g., red-green). Second, adding one member of an opponent pair to the other results in a (partial) cancellation of the two hues. Each member of an opponent pair, we might say, inhibits the other. So, if to a stimulus perceived as greenish we add a stimulus perceived as reddish the result will be a perception of a color that is neither as red or as green as either of the stimuli we are adding. If the proportions are just right the result will be a hue that is neither reddish nor greenish.[14]

In making the theory quantitative it is convenient to associate each member of an opponent pair with, respectively, negative and positive numbers. If (as is the usual convention) green is taken to be negative, and red positive, then we can predict whether red or green is perceived in a mixture of red and green stimuli by subtracting the green value from the red value. If the result is negative the perceived hue is greenish, if positive the perceived hue is reddish, and if zero the perceived hue is neither reddish nor greenish. Similarly we can associate blue with negative values of the yellow-blue process and yellow with positive values. If both the red-green and yellow-blue processes are in balance the result is a neutral hue, one with no chromatic content. If the red-green process is in balance and the yellow-blue process is positive the result will be the perception of a *unique* yellow—one that is neither reddish nor greenish. The unique hues (red, green, blue, yellow) are the ones that are perceptually unmixed, and according to opponent-process theory they are the result of zeroing one of the two chromatic processes while leaving the other unbalanced. All other hues (e.g., purple, orange) are referred to as *binary* because they appear to be mixtures of two of the four unique hues.

As Hurvich (chapter 3) describes, the numerical values that have been assigned to the opponent processes may, for each process, be plotted as a function of wavelength.[15] The basic technique used in determining these *chromatic response functions* is to identify the amounts of different spectral lights required to put one of the opponent processes into balance. Although the experiments explained by Hurvich assume the truth of opponent-process theory, and serve merely to fix the value of important parameters (the chromatic response functions), the theory has a great deal of support drawn from several different areas of color science.[16] Opponent-process theory and the claims about the color appearances it supports have been of considerable interest to philosophers. For example, it has been argued that no physical account of color can be correct, on the grounds that the unique/binary distinction will not apply to any physical properties that are candidates for being the hues.[17]

Opponent-process theory as characterized here and by Hurvich is a functional account of color vision at the psychophysical level. That is, the theory relates physical stimuli to color appearances without giving any detailed account of the realizing neural mechanisms. De Valois and De Valois (chapter 4) describe some of the basic neural features presumed to underlie various psychophysically characterized features of color vision, including opponency. As discussed above, the first step in the physiological pathway underlying color vision is the response of the various classes of cone photoreceptors. Importantly, the cone responses are not passed unmodified via the optic nerve to the brain. Significant visual processing occurs in the retina itself, with the cones sending their outputs, via the *bipolar cells*, to retinal neurons called *ganglion cells*.

One striking feature of ganglion cell responses is the degree of opponent organization they display. Ganglion cells, like many other neurons, generate outputs even when they are receiving no inputs. Consequently, they respond to inputs by either raising or lowering their output level. In this respect their behavior is analogous to the neural processes hypothesized by opponent-process theory. Indeed, many retinal ganglion cells, as well as many cells later in the visual pathways, are *spectrally opponent*. That is, they are excited by one cone type and inhibited by another.[18] For example, some ganglion cells increase their firing rate in response to inputs from L-cones and decrease it in response to inputs from M-cones. There are also ganglion cells with the opposite response characteristics: they are inhibited by L-cones and excited by M-cones. These neurons, known respectively as *L-M* and *M-L cells*, bear an interesting similarity to the psychophysically measured red-green opponent process. Similarly, there are also cells that respond to the differences between the outputs from the S-cones and the combined responses of the M- and L-cones, which may be related to the yellow-blue opponent process.

It is now clear that information about the wavelength, and presumably the color, of the stimulus is recoded in the retina and reaches the brain via channels using opponent coding. What is less clear is the relation between the physiologically determined opponent channels and the psychophysically measured opponent processes. The retinal ganglion cell population does not appear to have the right characteristics to explain completely the psychophysical response mechanisms, and the cortical processing of color information is still poorly understood.[19] For example, retinal ganglion cell outputs typically confound wavelength and intensity in ways that are not characteristic of our perceptual responses. No doubt somewhere in the brain these different components of color information are disentangled, but a precise understanding of the physiological underpinnings of the mechanisms of color vision is still not available.[20]

4 Color Constancy

For the purposes of the scientific work described so far, it is largely harmless to assume that the perceived color of an object is solely determined by the SPD of the light the object sends to the eye. But it has been known for some time that this assumption is a significant simplification. Well-known visual effects like *simultaneous contrast*,[21] in which the perceived color of an object is influenced by the color of its surround, definitively establish that the relation between stimuli and perceived color cannot be fully understood by taking each point in the scene before the eyes in isolation. As Land puts it, "The composition of the light from an area in an image does not specify the color of that area" (chapter 5, p. 144). Holding the subject's perceptual apparatus constant, the perceived color of an object is determined by the character of the light produced by the entire scene before the eyes.

Interestingly, one result of these nonlocal influences is that human color vision, and that of at least some other organisms, displays *color constancy*. Recall that the light reaching the eye from an area of a surface is the joint product of the SPD of the illuminant and the SSR of the surface. As the illuminant varies, so does the SPD of the light reaching the eye. In spite of this variation in the local visual stimulus, under many conditions the perceived color of an object will not appreciably change. Color constancy is this stability of perceived color across alterations in the character of the illuminant. However, it is an important fact that human color vision is only approximately color constant. It is easy to devise scenes and viewing conditions for which constancy effects are minimal or nonexistent and, as it happens, these kinds of viewing conditions are favored for colorimetric and many experimental tasks. An interesting but virtually intractable question is how much color constancy human

color vision displays under natural conditions. The difficulty is partly conceptual: is it constancy in color phenomenology or color judgment that we are attempting to measure?[22] It is also partly technical: how can we construct a representative sample of natural viewing conditions and scenes in order to make laboratory measurements?[23] In spite of these problems there has been a great deal of both experimental and theoretical work done on the nature of the constancy mechanisms, and chapters 5, 6, and 7 survey some of the more influential approaches to this topic.

In a series of spectacular demonstrations Edwin Land brought color constancy to the attention of many outside the community of color scientists. His proposal for explaining these results, the "retinex" theory, achieved some notoriety among specialists for the way in which it ignored many of the established traditions of the field. In chapter 5 Land presents a version of his retinex algorithm for computing perceived color, and some of the kinds of experiments that support it. Land's basic approach to color constancy is fairly simple. He divides the visible spectrum into three relatively broad bands: short, midspectral, and long. To determine the perceived color of a particular area of a scene, the amount of light reflected by that area is measured in one of the three wavebands. The ratio between this measurement and the average of the amount of light reflected in that waveband for all other areas of the scene is then computed.[24] This procedure is then repeated for the other two wavebands. The result is a triplet of numbers that Land claims can be used to predict the perceived color of the target area. Since changing the amount of light within one of the wavebands will result in roughly proportional changes in the amount of light reflected from the target area and the overall scene average for that waveband, Land's triplets are relatively insensitive to changes in the illuminant. There are interesting questions—some of which Land addresses—about the degree to which this algorithm provides an accurate model of human color vision, and whether or not it is consistent with what is known at the physiological level.

Wandell (chapter 6) takes a more analytic approach to color constancy, and provides a representative sample of the computational approach to color vision. He starts by formulating an abstract description of the problem: estimate the SSRs of the areas in a scene given only the SPDs of the light reflected from those areas. Wandell's goal is not to model the performance of any biological color vision system, but rather to provide an algorithm for solving an optical engineering problem. In order to compute reflectance correctly the algorithm must separate out the respective contributions of the illuminant and the reflectance to the reflected light. As Wandell sets up the problem, the algorithm must operate without built-in information about the precise character of the illuminant or the scene composition.

The next step is to represent the relevant physical magnitudes—SPDs and SSRs—on which the algorithm will operate. Wandell approximates the SPD of the illuminant using a linear model in which SPDs are represented as a weighted sum of a fixed number of basis SPDs. A similar linear model is also used for SSRs. It turns out, largely because both naturally occurring surfaces and lights have SPDs and SSRs that typically vary slowly across the spectrum, that these linear models provide good approximations with relatively small numbers of basis functions. It appears that three basis functions are required for the representation of naturally occurring lights, and six or seven basis functions for the representation of reflectance (Maloney 1986).

The end result is an equation expressing the receptor outputs as a function of the SPD weights of the illuminant, the SSR weights of the target area, and receptor spectral sensitivities. In order to work out the SSR of the area, the equation must be solved for the SSR weights. The equation is only solvable if there is at least one more photoreceptor type than there are degrees of freedom in the linear model of SSRs. That is, if the number of receptor types is less than or equal to the required number of reflectance basis functions, then the equation cannot be used to compute the SSR of the target area. Wandell's model thus generates an interesting constraint on the possibility of achieving perfect recovery of surface spectral reflectances. It is a constraint, however, that does not appear to be met by human color vision. Since the human eye has three photoreceptor types, perfect recovery of SSRs in a scene would require the SSRs of naturally occurring objects to be representable using only two basis functions and, as just mentioned, the required number appears to be approximately six or seven.

Jameson and Hurvich (chapter 7) present an overview of color constancy from the point of view of mainstream color science. They approach the subject at a more concrete level and make greater use of psychophysics and physiology. Jameson and Hurvich are somewhat skeptical of the more abstract and analytic approaches taken by both Land and Wandell, and are more concerned with the precise characterization of color constancy, and the degree to which it is exhibited in human color vision. Although the existence of some degree of constancy in human color vision is undeniable, the importance of constancy phenomena, and the best approach to understanding the mechanisms that produce them, remain subjects of continuing debate.

5 Color Defects and Genetics

Color vision, like any other biological characteristic, varies from individual to individual. A familiar and extreme example of such variation is that a non-negligible proportion of human beings are color "blind," most of them being specifically

insensitive to the difference between red and green. Given the salience of color and, in particular, the striking difference between red and green for those of us with normal color vision, it is a surprising fact that color blindness was first clearly characterized not much more than a century ago. Thus color blindness does not appear to be a functionally significant problem in most practical contexts.

Color blindness is of great theoretical interest. Hsia and Graham (chapter 8) provide a comprehensive review of the various defects of color vision due to receptoral abnormalities.[25] Study of such defects has proved very illuminating in understanding normal color vision and also raises some interesting questions about the contribution of the photoreceptors to the character of color experience. Most color-blind persons are not, in fact, color blind in any strict sense of the phrase. Rather, their color vision differs from that of color-normal persons in several well-defined respects, none of which amount to a complete loss of color vision. The most common form of color blindness is *dichromacy*. Dichromats require only two primaries in matching experiments, and lack the ability to discriminate some stimuli that are readily discriminable by normal (trichromatic) subjects. For example, all dichromats will accept a match between some monochromatic lights and a white light. Dichromacy results from a loss of function of one of the three cone photoreceptor types, and comes in three corresponding forms.[26]

What is commonly called red-green color blindness actually consists of two different defects depending on whether it is the long- or middle-wavelength receptor whose function has been lost. *Protanopes* have no functioning L-cones and *deuteranopes* have no functioning M-cones. They can be differentiated by, among other methods, the loss of long-wavelength sensitivity relative to normals that is found in protanopia but not in deuteranopia. Although both protanopes and deuteranopes are unable to distinguish spectral lights in the middle to long wavelengths that appear green to red to normal observers—hence the name red-green color blind—their ability to discriminate nonspectral lights is substantially different. Subjects having any of the three forms of dichromacy will accept all matches made by a normal observer, although not vice versa. Protanopia and deuteranopia are the overwhelmingly most common forms of dichromacy and most cases are the result of recessive inherited abnormalities in genes on the X chromosome that code for the photopigments contained in the L- and M-cones. Consequently red-green color blindness is much more common among males than among females (see Nathans, chapter 10). The third form of dichromacy, *tritanopia*, is much less common and is due to the loss of function of the S-cones. *Monochromacy* is much rarer than dichromacy and is most often due to the loss of all cone function. Monochromatic persons are only able to make light-dark distinctions and are, strictly speaking, color blind.

The genes coding for the three cone photopigments have now been isolated and sequenced. This achievement, described by Nathans in chapter 10, has provided new methods for understanding the early stages of color vision and also for investigations of the evolution of color vision. It is now known precisely what genetic abnormalities are responsible for the two varieties of red-green dichromacy and how these abnormalities affect the spectral sensitivity of the photopigments in color-blind persons. The genetics has also helped in the discovery of the detailed structure of the photopigment proteins themselves, which in turn has led to a more detailed understanding of normal variation in human color vision (see, for example, Neitz, Neitz, and Jacobs 1993). In addition, it is now possible, using the methods of molecular genetics, to trace evolutionary relationships among the photopigments found in different species.

With the precise characterization of the different forms of color blindness in the nineteenth century arose a puzzle as to what the visual experience of color-blind persons is like. Protanopes and deuteranopes, for example, perceive only a single hue in the regions of the spectrum between 550 and 700 nm, but it is difficult to get empirical evidence for which hue it is. Opponent-process theory suggests that, as protanopes and deuteranopes have no functioning red-green opponent channel, they should see only yellow, blue, black, and white. But color-blind persons talk about color just like the rest of us, only making mistakes normal observers would never make. They know that grass is green and tomatoes are red and although deuteranopes may have trouble telling the difference between ripe and unripe tomatoes, they will not say they are yellow or blue. Alpern et al. (chapter 9) describe one example of a rare kind of case that might be thought to shed some light on this issue. Some very unusual people have normal vision in one eye and a color deficiency in the other. These people might seem sent from heaven, since they are familiar with the full range of color experience due to their normal eye and so can report on what they see through their color-deficient eye. In the case reported in chapter 9 the subject is tritanopic in one eye. Unfortunately, the data fit no existing theory of color vision, and the small but much-discussed literature on similar subjects has produced more controversy than consensus (for a brief review, see Boynton 1979, pp. 380–382).

6 Central Defects of Color Vision and Naming

Most defects of color vision are due, like the ones discussed in the previous section, to receptoral abnormalities. A lot is known about such cases, partly because there are many examples to study and partly because the role the photoreceptors play in

color vision is well understood. But receptoral abnormalities are not the only cause of defects of color vision, and there has been a great deal of interest recently in cases that are due to damage to the brain, in particular, damage to areas of the *visual cortex*. These disorders, collectively called *central achromatopsia*, are, in general, less well characterized and understood than the much more common disorders discussed above. In addition, there is little understanding of what contribution the damaged areas make to normal color vision.

The main visual pathway from the retina to the brain originates in two types of retinal ganglion cells, the *Pα* and *Pβ* cells, which project via the optic nerve to the *dorsal lateral geniculate nucleus* (dLGN)[27] of the *thalamus*.[28] The neurons of the dLGN project via the *optic radiations* to the *primary visual cortex* (V1 or striate cortex).[29] Neurons in V1 project to a variety of other cortical areas, many of which are thought to be involved in specialized forms of visual processing. This pathway is divided into two main branches, the *parvocellular* (P) and *magnocellular* (M), which originate respectively in the Pβ and Pα cells of the retina, and involve different areas of the dLGN and V1. The two pathways are functionally as well as anatomically distinct. The P pathway is the primary carrier of information about the wavelength of the stimulus; the M pathway has very few or no wavelength-selective cells and is thus thought not to play an important role in color vision.[30]

It is now well established that cortical damage in the absence of any abnormality of the retina can produce defects in color vision. In some well-studied cases, like the one described by Heywood et al. (chapter 13), it has been established that all three cone types are present and contributing to visual functioning. What is even more striking is that serious impairments of color vision can be accompanied by essentially normal perception of *luminance*; such subjects appear to perceive the world in shades of white, gray, and black. Not all cases of central achromatopsia are total, and there is a great deal of variation in the severity of the impairment. There can be some remaining degree of color vision, and the defect may even be limited to some areas of the visual field. As the discussion by Rizzo et al. (chapter 12) establishes, however, the specific characteristics of the color abnormality in at least some cases of central achromatopsia are very different from the forms of dichromacy discussed in the preceding section.

There is still a great deal of controversy over the specific contributions made by the various *extrastriate*[31] areas to the perception of color.[32] The fact that color vision can be impaired by damage to a particular cortical area while other aspects of visual function are spared, and that it can be preserved in spite of profound impairment to other aspects of vision, has lent some support to the idea that there may be a

particular area of the brain dedicated to color processing. It should be pointed out, however, that a very common accompaniment of achromatopsia is *prosopagnosia*: impairment in the ability to recognize faces visually. This association is thought to be due to anatomical contiguity rather than functional relationship. The patient M.S. described by Heywood et al. is a particularly striking example of how the ability to see color can be lost while other, intuitively closely related, visual abilities can be spared.

M.S. is by most standard tests completely unable to perceive color. He is unable to sort or arrange objects by color or name the colors of objects. Most strikingly, he consistently fails to perform the crudest of color discriminations. Presented with an array of two red squares and one green square, or vice versa, he is unable to identify the odd one out. He also reports that he has no experience of color. Nevertheless, he is able to identify shapes whose boundaries are defined solely by differences in color. The figure is matched for brightness to the background, and the only difference between figure and background lies in the SPD of the light coming from the different areas of the stimulus. The tests done on M.S. by Heywood et al. reveal the presence of a functioning P pathway that contributes to form perception. In spite of his ability to use information about the SPD of the stimulus provided by the P pathway for these purposes, M.S. cannot identify the color of the shapes he is able to segregate from the background in this way. Cases like M.S. may indicate that there is a dedicated color area in the visual cortex and they certainly complicate our understanding of visual experience.

Cortical damage can cause other kinds of color-related deficits without any evident impairment in the perception of color. *Color anomia* is an inability to name the colors of visually presented objects, with color vision remaining apparently intact. The patient H.C., described by Geschwind and Fusillo (chapter 11), performed normally on nonverbal tests of color perception, tests which would have revealed the achromatopsia of M.S.[33] H.C. also had a normal color vocabulary and was able correctly to remember common color associations, for example, that grass is green and blood is red. H.C. was completely unable, however, to name correctly the colors of objects presented visually. He understood the task to the extent that he uniformly supplied a color term when asked for the color of an object but, from his performance, appeared to be guessing. In this respect he was similar to young children, who go through a stage in which they will happily apply color terms to objects, but seemingly at random. H.C., in common with other color anomics, appears to have a disorder specific to color terms: for instance, he was able correctly to supply object names for visually presented items.

7 Comparative Color Vision and Evolution

Some degree of color vision is widely distributed throughout the animal kingdom, and appears to have evolved independently in several groups. Almost all vertebrates that have been studied possess some form of color vision, although many have only a rudimentary ability which may not play a significant role in guiding behavior. Although comparatively few have been tested, many invertebrates also possess color vision, which in some (e.g., bees) is highly developed. The number of photoreceptor types and the spectral characteristics of the photoreceptors varies from species to species. Among mammals, only (some) primates are known to have trichromatic color vision. All other species of mammal that have been studied are dichromats with possibly a few, such as rats, lacking color vision altogether. Some birds and fish appear to be *tetrachromats*.[34] Further, the spectral range over which their vision extends is broader, particularly into the ultraviolet. Color vision in these groups is phylogenetically older, and in some respects more highly developed than it is among mammals.

An organism is said to have color vision if and only if it is able to discriminate between some spectrally different stimuli that are equated for brightness (luminance).[35] There are two basic methods for determining the presence or absence of color vision in nonhuman organisms. The first is behavioral: the organism's ability to discriminate equiluminant stimuli is tested directly. A complication arises because stimuli that are equiluminant for a human observer will not, in general, be equiluminant for a nonhuman observer. The luminance of stimuli for an organism can be equated if its *spectral sensitivity function* (the function from stimulus wavelength to stimulus brightness) can be determined. Alternatively, the relative luminance of the stimuli can be randomly varied over a wide range, assuming that consistently successful discrimination can only be based on color differences. (For a review see Jacobs 1981, pp. 5–11.) Both techniques are somewhat tedious, and consequently have only been used to investigate a relatively small number of animals. The second method is physiological: the visual capacities of an organism are inferred from information about the physiological characteristics of its visual system. For example, it is possible to measure the *absorption spectra* of individual photoreceptor cells using a technique known as *microspectrophotometry*. Establishing the existence of two color photoreceptor types in this way provides reasonably good evidence that the organism in question is a dichromat. These measurements, and other physiological techniques, although not easy to perform, are often less time-consuming than behavioral methods.

What selective advantage does color vision confer? And how is variation in color vision across species connected with variation in the visual environment and ecology? Chapters 14, 15, and 16 are concerned, in one way or another, with answering these questions. Shepard (chapter 14) considers four features of human color vision and argues that these are all adaptations to pervasive regularities found in the terrestrial environment. An assumption important to Shepard's case is that color plays an evolutionarily significant role in object recognition. In particular, Shepard argues that the trichromacy of human color vision is an adaptation to the fact that good linear models of naturally occurring illuminants require only three basis functions (recall the above discussion of Wandell's chapter 6). One apparent difficulty here is that not all organisms with color vision are trichromats. The claimed tetrachromacy of some birds, as Shephard recognizes, is particularly troubling, since his argument seems to imply that there is no advantage to having more than three photoreceptor types if the range of variation in lighting conditions is similar to that of the environment of human evolution.

Lythgoe and Partridge (chapter 15) discuss the relationship between the spectral sensitivity of the photoreceptors found in a variety of species and the variation in the spectral power distribution of the ambient light in the environments those species occupy. Their focus is not on color vision itself, but rather on the amount of information that can be extracted in different lighting environments by photoreceptors with different spectral characteristics. In aquatic environments, where there is predictable illuminant variation with depth and where the amount of light at any appreciable depth is low, it appears that maximizing photon capture is an overriding pressure on the spectral sensitivities of the receptor types. Lythgoe and Partridge also offer an analysis of detection tasks in terrestrial environments where the spectral reflectance characteristics of objects may play an important role in determining the optimal set of photoreceptors.

Mollon (chapter 16) considers the evolution of primate color vision and offers a somewhat broader discussion of the possible adaptive function of color vision than do either Shepard, or Lythgoe and Partridge. To Shepard's hypothesis that color version serves in object recognition he adds two other functions that color vision may perform: detection of targets against variegated backgrounds and perceptual segregation of figure from ground by similarity in color. The blue-yellow opponent system is evolutionarily much older than the red-green system and Mollon conjectures that the latter coevolved with colored fruits in Old World monkeys. This hypothesis fits nicely with the anecdotal evidence that human dichromats are impaired in their ability to locate colored fruits against the complex background provided by the leaves of a tree (see Mollon, chapter 16, pp. 381–2).

8 Color Concepts and Names

There is no physiological or psychophysical evidence for substantial variation in color vision across different human cultures. Although the various forms of hereditary and acquired defects of color vision may differ in frequency from place to place, the majority in every population appear to possess color vision that is substantially the same. Further, over the last 25 years a substantial body of research has arisen that suggests that there are significant cross-cultural regularities in color language (*locus classicus*: Berlin and Kay 1969). These regularities are found at the level of *basic color terms*, some English examples of which are "red," "brown," "black," "yellow," and "pink."[36] Basic color terms name *basic color categories*; a language will be said to "contain" a basic color category just in case it contains a basic color term that names that category.

Kay and McDaniel (chapter 17) summarize and to some extent revise and correct this early work. With the revisions and corrections in place, they claim, for example, that all languages with only two basic color categories have the same categories: white-or-red-or-yellow, and black-or-green-or-blue. Another claimed regularity is that every language that contains the basic color category red also contains the category white, but not conversely. The color vocabularies of all the world's languages are supposed to be divided into only eight kinds, the first being the most simple (the two basic color categories just mentioned) and the eighth being the most complex (the 11 basic color categories: white; red; yellow; green; blue; black; brown; pink; purple; orange; and gray). (See chapter 17, figure 17.13.)

Regularities in color language of this sort are particularly striking in light of the absence of any plausible environmental explanation. With few environmental constraints on color language, it might be thought that the space of colors would be linguistically divided across cultures in a wide variety of ways, depending on differing needs and interests, and accidents of linguistic and cultural history. The evidence that this kind of variation is lacking is usually taken to point to an important effect of human perceptual biology on color language.

Kay and McDaniel present a model of the universal structure of basic color categories that has two important features. First, it attempts to respect the fact that whether an object falls under a basic color category is a matter of degree: something may be more or less red, or more or less blue-green. Here Kay and McDaniel make use of fuzzy set theory. Unlike classical set theory, fuzzy set theory allows for degrees of membership, with 1 being the highest and 0 the lowest (i.e., not in the set to any degree). Thus an object that is a perfect example of red would be assigned a degree of membership of 1 in the category red, and any green object would be assigned a

degree of membership of 0. Second, the model takes very seriously the point noted above, that the linguistic data might be to a large extent explained by the human visual system. In particular, the model identifies the (fuzzy) categories red, yellow, green, blue, black, and white, using the chromatic and achromatic response functions from opponent process theory.[37] For example, the degree of excitation of the red-green process toward red for a spectral light of wavelength λ, is taken to be the degree of membership of light of wavelength λ in the fuzzy category red.[38]

These six categories are the *primary basic color categories*.[39] Kay and McDaniel argue that all other basic color categories in the world's languages are (fuzzy) unions (e.g., green-or-blue), or simple functions of (fuzzy) intersections (e.g., orange), of these primary categories. Categories constructed by such unions and intersections are called *composite* and *derived* categories, respectively.[40]

One interesting question, not dealt with by Kay and McDaniel, is why only a small subset of the possible composite and derived color categories have names in any known language. More recent work has attempted an answer by appealing to further features of human color vision (see, for example, Kay et al. 1991).

There is not yet complete uniformity among linguists, anthropologists, and psychologists on what the empirical evidence reviewed by Kay and McDaniel shows about the existence or extent of biological constraints on the range of variation found in human color vocabularies. Some (in particular Saunders and van Brakel 1997) are highly sceptical. But there is a moderately strong consensus that there are universals of color language, and that a large part of the explanation of this fact is to be found in the nature of the human visual system.

Notes

1. When Nassau discusses the energy of light he is referring to the energy of a single photon, which is relevant to understanding the quantum mechanical interactions between light and matter. In most of the rest of the chapters in this volume it is rather the energy (or most often the power) summed over a large number of photons of a particular kind that is important. Thus, although the energy of a photon of short-wavelength light is greater than the energy of a photon of long-wavelength light, it is perfectly possible to have a high power, long-wavelength light, and a low power, short-wavelength light.

2. The SPD of a light is not a complete physical characterization of it: for example, the state of polarization is not included.

3. An acronym for *Commission Internationale de l'Éclairage*, the body that sets international colorimetry standards.

4. This is not true for objects that transmit or emit light; for simplicity we will restrict our attention to opaque nonluminous objects.

5. This is an oversimplification. Not all surfaces are perfect diffuse reflectors and those that are not will have direction-dependent reflectances. *Fluorescence*—the absorption of light at one wavelength and its reemission at a longer wavelength—introduces a further complication.

6. In the Munsell system of color notation, hue and lightness are called *hue* and *value*. Instead of saturation, the Munsell system uses *chroma*, which (unlike saturation) increases with lightness. See Munsell Color Company 1976; a brief summary is in Hardin 1993, pp. 159–60.

7. A qualification is needed. The test light and the mixture of three lights will always match in hue, but sometimes the mixture will appear less saturated than the test light. In these cases adding one of the three lights to the test light will produce a perfect color match.

8. A spectral light is a light whose wavelength composition is taken from a very narrow band of the visible spectrum.

9. Let $\langle r, g, b \rangle$ and $\langle r', g', b' \rangle$ be tristimulus values of a light with respect to primaries $\langle A, B, C \rangle$ and $\langle D, E, F \rangle$, respectively. Let $\langle a_1, a_2, a_3 \rangle$, $\langle b_1, b_2, b_3 \rangle$, $\langle c_1, c_2, c_3 \rangle$ be the tristimulus values, with respect to $\langle D, E, F \rangle$, of A, B, C, respectively. Then: $r' = a_1 \cdot r + a_2 \cdot g + a_3 \cdot b$; $g' = b_1 \cdot r + b_2 \cdot g + b_3 \cdot b$; $b' = c_1 \cdot r + c_2 \cdot g + c_3 \cdot b$.
This fact—in effect, the linear additivity of color matches for lights—is implied by *Grassmann's laws*.

10. Pigment mixtures and light mixtures differ physically in an important respect. Light mixtures are *additive color mixtures*: the light from each of the components reaches the eye in a state unmodified by the presence of the other components. Colored pigments absorb a proportion of the incident light, and thus pigment mixing typically modifies the light from each component of the mixture. Pigment mixtures are thus *subtractive color mixtures*. Additive and subtractive mixtures can be quite different, for example, the additive result of mixing yellow and blue is white, while the subtractive result (for typical pigments) is green. In practice, the perceived color of additive mixtures is much easier to predict than the perceived color of subtractive mixtures.

11. Four degrees of visual angle is about 2 inches at arm's length. The reason why the size of the sample makes a difference to color appearance is that the relative density of the various photoreceptor types varies across the retina. In particular the short wavelength cones are absent from the central fovea. See, for example, Wandell 1995, p. 51.

12. At intermediate light levels both rods and cones function, and the rods do make a slight difference to color appearance. The effect of rod outputs on color vision is largely ignored throughout this volume.

13. Although these labels have often been used, the peak sensitivity of the long wavelength receptors in fact corresponds to greenish-yellow.

14. The white-black process is different from the other two both in terms of its relation to physical stimuli and in its phenomenology. There is no such thing as a light that all by itself generates the perception of black. The appearance of black always requires a light background against which the stimulus is perceived. Phenomenologically, grays may appear to be mixtures of white and black in a way in which there are no red-green or yellow-blue mixtures.

15. As with the results of colorimetric measurements, the response curves discussed by Hurvich are, strictly speaking, only applicable to a very narrowly specified range of stimuli. Unlike colorimetry, the interest of opponent-process theory is not so much in its practical application, but rather in its potential insight into a fundamental feature of visual information processing.

16. See Boynton 1979; De Valois and De Valois (chapter 4); Hurvich 1981; Hurvich and Jameson 1957.

17. See Hardin 1993, pp. 66–7, Thompson 1995, pp. 135–9. See also Shoemaker 1994 (p. 230, chapter 12, *Readings on Color, vol. 1*), and Byrne and Hilbert 1997 (chapter 14, *vol. 1*).

18. Ganglion cells can also be *spatially opponent*. That is, some ganglion cells are inhibited (or excited) by stimuli in the periphery of their *receptive fields* and excited (or inhibited) by stimuli in the center of the receptive fields. (The receptive field of a neuron is the region of the retina stimulation of which will stimulate the neuron.) Most ganglion cells exhibit both spectral and spatial opponency.

19. The news is not all pessimistic, however. The response properties with respect to wavelength of many cortical neurons have been studied and much is known about the pathways that color information follows in the cortex, especially in the earlier cortical stages of visual processing. What seems to be less clear is exactly how these pathways contribute to color vision. For more discussion see section 6 below, and chapters 12 and 13.

20. It may be a mistake to think that there will be individual neurons whose responses correspond exactly to the psychophysically determined opponent channels. The perceptual responses may very well be the result of the joint operation of populations of neurons rather than determined by a single cell. It is certainly not *necessary* for opponent-process theory to be true that there be individual neurons in the retina or elsewhere whose response characteristics match the opponent processes.

21. See, for example, Hurvich 1981, chapter 13; Hardin 1993, pp. 49–51.

22. For some of the issues here, see the Introduction to *vol. 1*, and Hurvich and Jameson (chapter 7, pp. 178–80). See also Arend and Reeves 1986, and Craven and Foster 1991, for experimental work relevant to this issue.

23. For a helpful discussion of the issues with references to the primary literature, see Wandell 1995, pp. 287–315.

24. The actual retinex algorithm described by Land is more complicated, because it deals with cases in which the illuminant varies across the scene. In the case of spatially uniform illumination the algorithm reduces to the simple procedure given in the text.

25. Color blindness can be the result of abnormalities of the brain or optic nerve as well as defects of the photoreceptors. See section 6 below.

26. More common than dichromacy is *anomalous trichromacy*. Although anomalous trichromats have three functioning receptor types, one of the receptors has its spectral sensitivity shifted from the normal position. Typically, this results in poorer than normal color discrimination performance as well as other abnormalities. Corresponding to each form of dichromacy described below there is a form of anomalous trichromacy.

27. The qualifier "dorsal" is often dropped.

28. The thalamus is an area of the midbrain which serves as an important relay station for sensory information.

29. Primary visual cortex is an area of the occipital lobe which receives its main input from the retina via the dLGN and sends its main output to other cortical visual areas. The terminology for referring to areas of the cortex is still somewhat unsettled. The terms "primary visual cortex," "V1," "striate cortex," "calcarine cortex," and "area 17," are all usually treated as synonymous.

30. The P pathway splits in V1; the V1 cells involved in color processing are primarily located in small regions known as *blobs* (see chapter 13, pp. 291–2).

31. The extrastriate (or *prestriate*) areas are the cortical areas surrounding V1 involved in visual processing.

32. In particular there is continuing debate about whether area V4 in the macaque monkey is specialized for color processing, and whether damage to its presumed human homologue is responsible for achromatopsia. At least two things now seem clear. First, V4 is not crucial to color vision and, second, there is an anatomically restricted cortical area damage to which selectively impairs color vision. For a recent discussion see Heywood et al. 1995.

33. H.C. also suffered from *alexia* (inability to read aloud or comprehend written words) without *agraphia* (inability to write), which is commonly found in association with color anomia. H.C. could produce and comprehend oral language, was unable to read, but was able to write.

34. The receptoral story for birds and nonmammalian vertebrates generally is particularly complex. Their cones contain oil droplets through which light is filtered before interacting with the photopigments, and different types of droplet may be found in combination with the same type of photopigment. (See, for example, Bowmaker 1977.)

35. There has been some discussion of the adequacy of this criterion as a sufficient condition for possession of color vision. See Thompson 1995, pp. 141–214; Thompson et al. 1992; Hilbert 1992.

36. More precisely, a basic color term must be: (i) *monolexemic*, that is, its meaning is not predictable from the meaning of its parts (unlike "reddish-yellow"); (ii) its extension must not be included within the extension of any other color term (with the exception of the word "color" itself) (unlike "scarlet," which is

in the extension of "red") ; (iii) its correct application must not be restricted to a narrow class of objects (unlike "brunette"); (iv) it must be psychologically salient (where marks of salience include frequency and reliability of use) (unlike "chartreuse"). See Berlin and Kay 1969, p. 6, Kay and McDaniel (chapter 17, p. 402).

37. Kay and McDaniel's frequent reference to neural response categories needs to be qualified somewhat. Although the psychophysically measured response functions presumably have a neural basis, it remains a matter of some controversy exactly what the connection is between these psychophysically determined functions and the measured response functions of actual neurons. It is clear that there is no population of neurons early in the visual pathway with response characteristics similar to the response functions. Although color information is certainly neurally encoded in opponent fashion, the measured responses of both ganglion cells and cells in the LGN show considerable variation in their crossover points and typically carry both luminance and chromatic signals. To identify, as Kay and McDaniel do, chromatic response functions with neural response functions, is to take a stand on an open question in visual science.

38. As they point out in note 11, unique red is not produced by any spectral light, although unique red can be produced by mixtures of spectral lights. This fact does not present any real obstacle to their theory although figure 17.6 is quite misleading in this regard. As figure 3.2 of chapter 3 shows, the spectral hue coefficient for yellow never declines to zero.

39. Although sometimes Kay and McDaniel restrict "primary basic color category" to the four chromatic categories.

40. Further research has shown that the list of composite categories given by Kay and McDaniel is incomplete. For example, some languages contain a basic color term for yellow-or-green. See Kay et al. 1991.

References

Arend, L., and A. Reeves. 1986. Simultaneous color constancy. *Journal of the Optical Society of America A* 3, 1743–51.

Armstrong, D. M. 1987. Smart and the secondary qualities. In *Metaphysics and Morality: Essays in Honour of J. J. C. Smart*, ed. P. Pettit, R. Sylvan, and J. Norman. Oxford: Basil Blackwell. Reprinted in *Readings on Color, vol. 1: The Philosophy of Color*, ed. A. Byrne and D. R. Hilbert. Cambridge, MA: MIT Press.

Berlin, B., and P. Kay. 1969. *Basic Color Terms*. Berkeley: University of California Press.

Bowmaker, J. K. 1977. The visual pigments, oil droplets and spectral sensitivity of the pigeon. *Vision Research* 17, 1129–38.

Boynton, R. M. 1979. *Human Color Vision*. New York: Holt, Rinehart & Winston.

Byrne, A., and D. R. Hilbert. 1997. Colors and reflectances. In *Readings on Color, vol. 1: The Philosophy of Color*, ed. A. Byrne and D. R. Hilbert. Cambridge, MA: MIT Press.

Craven, B. J., and D. H. Foster. 1992. An operational approach to colour constancy. *Vision Research* 32, 1359–66.

Hardin, C. L. 1993. *Color for Philosophers: Unweaving the Rainbow* (expanded edition). Indianapolis: Hackett.

Heywood, C. A., D. Gaffan, and A. Cowey. 1995. Cerebral achromatopsia in monkeys. *European Journal of Neuroscience* 7, 1064–73.

Hilbert, D. R. 1987. *Color and Color Perception: A Study in Anthropocentric Realism*. Stanford: CSLI.

Hilbert, D. R. 1992. What is color vision? *Philosophical Studies* 68, 351–70.

Hurvich, L. M. 1981. *Color Vision*. Sunderland, MA: Sinauer Associates.

Hurvich, L. M. and D. Jameson. 1957. An opponent-process theory of color vision. *Psychological Review* 64, 384–403.

Jacobs, G. H. 1981. *Comparative Color Vision*. New York: Academic Press.

Kay, P., B. Berlin, and W. Merrifield. 1991. Biocultural implications of systems of color naming. *Journal of Linguistic Anthropology* 1, 12–25.

Maloney, L. T. 1986. Evaluation of linear models of surface spectral reflectance with small numbers of parameters. *Journal of the Optical Society of America A* 3, 1673–83.

Merbs, S. L., and J. Nathans. 1992. Photobleaching difference absorption spectra of human cone pigments: quantitative analysis and comparison to other methods. *Photochemistry and Photobiology* 56, 869–81.

Munsell Color Company. 1976. *Munsell Book of Color*. Baltimore: Munsell Color.

Neitz, J., M. Neitz, and G. H. Jacobs. 1993. More than three different cone pigments among people with normal color vision. *Vision Research* 33, 117–22.

Saunders, B. A. C., and J. van Brakel. 1997. Are there nontrivial constraints on colour categorization? *Behavioral and Brain Sciences*, forthcoming.

Shoemaker, S. 1994. Phenomenal character. *Noûs* 28, 21–38. Reprinted in *Readings on Color, vol. 1: The Philosophy of Color*, ed. A. Byrne and D. R. Hilbert. Cambridge, MA: MIT Press.

Smart, J. J. C. 1975. On some criticisms of a physicalist theory of colors. In *Philosophical Aspects of the Mind–Body Problem*, ed. C. Cheng. Honolulu: University Press of Hawaii. Reprinted in *Readings on Color, vol. 1: The Philosophy of Color*, ed. A. Byrne and D. R. Hilbert. Cambridge, MA: MIT Press.

Smart, J. J. C. 1987. Reply to Armstrong. In *Metaphysics and Morality: Essays in Honour of J. J. C. Smart*, ed. P. Pettit, R. Sylvan, and J. Norman. Oxford: Basil Blackwell. Reprinted in *Readings on Color, vol. 1: The Philosophy of Color*, ed. A. Byrne and D. R. Hilbert. Cambridge, MA: MIT Press.

Thompson, Evan. 1995 *Colour Vision*. New York: Routledge.

Thompson, E., A. Palacios, and F. J. Varela. 1992. Ways of coloring: comparative color vision as a case study for cognitive science. *Behavioral and Brain Sciences* 15, 1–74.

Wandell, B. A. 1995. *Foundations of Vision*. Sunderland, MA: Sinauer Associates.

I PHYSICS

1 The Causes of Color

Kurt Nassau

What makes the ruby red? Why is the emerald green? On the most superficial level these questions can be given simple answers. When white light passes through a ruby, it emerges with a disproportionate share of longer wavelengths, which the eye recognizes as red. Light passing through an emerald acquires a different distribution of wavelengths, which are perceived as green. This explanation of color is correct as far as it goes, but it is hardly satisfying. What is missing is some understanding of how matter alters the composition of the light it transmits or reflects. Ruby and emerald both derive their color from the same impurity element: Why then do they differ so dramatically in color? What gives rise to the fine gradations in spectral emphasis that constitute the colors of materials?

It turns out that the ultimate causes of color are remarkably diverse. An informal classification I shall adopt here has some 14 categories of causes, and some of the categories embrace several related phenomena. With one exception, however, the mechanisms have an element in common: the colors come about through the interaction of light waves with electrons. Such interactions have been a central preoccupation of physics in the 20th century, and so it is no surprise that explanations of color invoke a number of fundamental physical theories. Indeed, color is a visible (and even conspicuous) manifestation of some of the subtle effects that determine the structure of matter.

The Energy Ladder

The perception of color is a subjective experience, in which physiological and psychological factors have an important part; these matters will not be taken up in detail here. It seems reasonable to assume, however, that perceived color is merely the eye's measure and the brain's interpretation of the dominant wavelength or frequency or energy of a light wave. The meaning of this assumption is clear in the case of monochromatic light, which has a single, well-defined wavelength. The interpretation of light that is a mixture of many wavelengths is more complicated, but it is still the relative contributions of the various wavelengths that determine the color.

Wavelength, frequency and energy are alternative means of characterizing a light wave. Energy is directly proportional to frequency; both energy and frequency are inversely proportional to wavelength. In other words, high frequencies and high energies correspond to short wavelengths, as at the violet end of the visible spectrum (figure 1.1). A common unit of measure for light wavelengths is the nanometer, which is equal to a billionth of a meter. The energy of light is conveniently measured

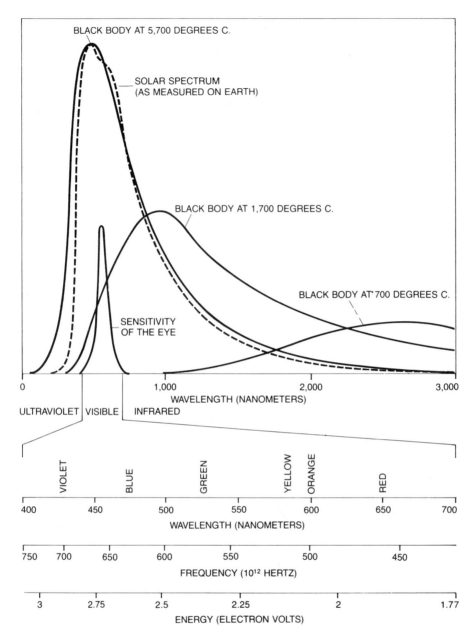

Figure 1.1
Spectrum of sunlight closely matches the sensitivity of the eye; as a result light appears white if its spectrum resembles the solar one, and other colors can be described by how they depart from the solar spectrum. The sun's radiation is approximately that of a black body with a temperature of 5,700 degrees Celsius. The shape of a black-body spectrum is determined entirely by the temperature, becoming steeper and shifting to shorter wavelengths as the temperature increases. Thus as an object is heated its color changes from black (no emission) to red to yellow to white and finally to pale blue. The spectrum can be measured in units of wavelength, frequency or energy, which are merely alternative means of describing a light wave.

in electron volts, one electron volt being the energy gained by an electron when it accelerates through a potential difference of one volt. In terms of wavelength human vision extends from about 700 nanometers, where red light grades into infrared radiation, down to about 400 nanometers, at the boundary between violet light and ultraviolet radiation. The same range in energy units runs from 1.77 electron volts to 3.1 electron volts.

An important constraint on all interactions of electromagnetic radiation with matter is the quantum-mechanical rule that says atoms can have only certain discrete states, each with a precisely defined energy; intermediate energies are forbidden. Each atom has a lowest-possible energy, called the ground state, and a range of excited states of higher energy. The allowed energy states can be likened to the rungs of a ladder, although their spacing is highly irregular. Light or other radiation can be absorbed only if it carries precisely the right amount of energy to promote an atom from one rung to a higher rung. Similarly, when an atom falls from an excited state to a lower-lying one, it must emit radiation that will carry off the difference in energy between the two levels. The energy appears as a photon, or quantum of light, whose frequency and wavelength are determined by the energy difference.

The states that are of the greatest interest in the analysis of color represent various possible energy levels of electrons. In atoms, ions and molecules each electron must occupy an orbital, which describes a particular geometric distribution of the electron's charge around the atomic nucleus. The orbitals in turn are organized in shells. A further constraint on the possible states of the atom is that each rung on the energy ladder can be occupied by only a limited number of electrons. In general, when proceeding from the smallest atoms to the largest ones, electrons are added in sequence from the bottom rung up. Two electrons fill the first shell; each of the next two shells holds eight electrons. The electrons in any filled or closed shell form pairs, and they have a notably stable configuration.

A comparatively large quantity of energy is needed to promote one of the paired electrons from a closed shell to the next vacant position on the ladder. The energy required for such a transition can usually be supplied only by radiation in the ultraviolet or even in the X-ray region of the spectrum; as a result closed shells have no direct influence on the colors of materials. Instead color usually results from transitions of unpaired electrons, which are most often the outermost ones. They are the valence electrons, the ones that participate in chemical bonds.

Atomic Transitions

Consider a vapor of the element sodium in which the density is low enough for each atom to act independently of its neighbors. The sodium atom has 11 electrons, but

10 of them lie in closed shells, and it is only the single valence electron that takes a direct part in the interactions of the atom with light. When the sodium atom is in the ground state the outermost electron occupies an orbital designated $3S_{1/2}$ (figure 1.2, 1.3). The next-highest energy levels (the next rungs on the ladder) are labeled $3P_{1/2}$ and $3P_{3/2}$, and they lie at energies 2.103 and 2.105 electron volts above the ground state. These are the smallest quantities of energy a sodium atom in the ground state can absorb. They correspond to wavelengths of 589.6 and 589.1 nanometers, in the yellow part of the spectrum.

Above the $3P$ orbitals are a multitude of other excited states, where the electron has a greater average distance from the nucleus and a higher average energy. The number of such states is infinite, but the interval between levels becomes smaller as the energy increases, so that the series converges on a finite limit. For sodium the limit comes at 5.12 electron volts, where the outermost electron is no longer merely excited but is torn loose from the atom entirely; in other words the atom is ionized.

Suppose a sodium atom is ionized, perhaps by a quantum of ultraviolet radiation, and the free electron and the ion then recombine. Initially the electron may occupy one of the higher orbitals, but it quickly falls to a lower energy level. If the descent were made in a single step, from the ionization limit to the ground state, the atom would emit a single ultraviolet photon with an energy of 5.12 electron volts. A much likelier route would pass through several intermediate states, accompanied by the emission of a lower-energy quantum at each stage. Not all such cascades are possible; "selection rules" determine which ones are allowed. Most of the allowed pathways proceed through one of the $3P$ orbitals and thence to the ground state. As a result quanta of yellow light with energies of 2.103 and 2.105 electron volts are among those emitted. Indeed, these two lines are by far the brightest in the spectrum of atomic sodium and a vapor of excited or ionized sodium glows bright yellow.

The characteristic yellow radiance of atomic sodium can be observed when a salt of sodium is heated in a flame hot enough to vaporize some of the atoms. In analytic chemistry this property serves as the basis of the flame test for the presence of sodium. The doublet of yellow lines is also prominent in the spectrum of a sodium-vapor lamp, where the sodium atoms are ionized by a high-voltage discharge.

Other atoms also yield distinctive emission lines when they are excited or ionized and then allowed to return to the ground state; in each element, however, the spacing of the energy levels is different, and so the color of the emitted light also differs. In neon the strongest lines are in the red part of the spectrum, which accounts for the red glow of neon lights and signs. The mercury atom has prominent lines in

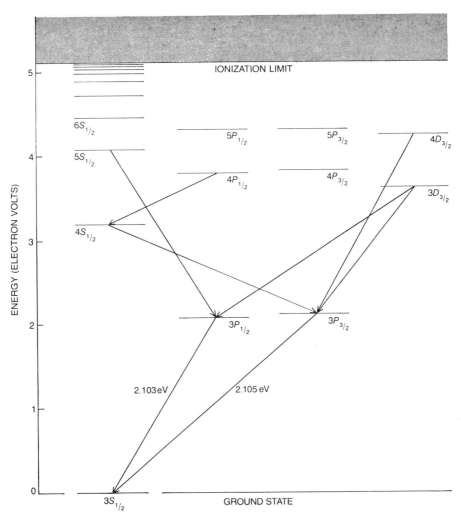

Figure 1.2
Ladder diagram for the sodium atom defines a spectrum of discrete wavelengths, which are the only ones
the atom can emit or absorb. In order to climb to a higher rung the atom must absorb a quantum of
radiation whose energy corresponds exactly to the difference in energy between the initial and the final
states. On falling to a lower rung the atom emits a quantum with the same energy. Most downward tran-
sitions pass through the levels designated $3P_{1/2}$ and $3P_{3/2}$ to the lowest level, or ground state, labeled $3S_{1/2}$.
In these transitions quanta are emitted with energies of 2.103 and 2.105 electron volts, in the yellow part of
the spectrum, and so a vapor of excited sodium atoms glows bright yellow. In the ladder diagram only the
vertical dimension has meaning, but the various series of levels are separated horizontally for clarity.

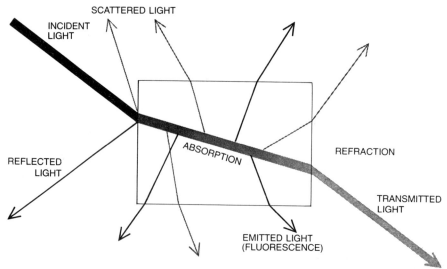

Figure 1.3
Interactions of light with condensed matter include reflection, refraction, scattering and absorption; some absorbed light can also be reemitted (usually at a longer wavelength) as fluorescence. The effects of each of these processes can vary with wavelength and so can give rise to color. For example, the preferential absorption of short wavelengths and reflection or transmission of long ones makes an object appear yellow, orange, or red. In general condensed matter absorbs broad and essentially continuous bands of wavelengths rather than discrete lines.

the green and the violet regions of the visible spectrum, and consequently a mercury-vapor lamp gives off blue-tinged light that is deficient in red and yellow. Lasers whose working medium is a monatomic gas exploit emission lines of the same kind. Lightning and electric arcs also derive their color from electronic excitations of the atoms in gases.

Black-Body Radiation

Sharply defined emission and absorption lines are typical of gases. The spectrum of light emitted by a solid or a liquid is usually quite different, in that it extends over a continuous range of wavelengths.

A universal form of radiation from condensed matter is black-body radiation, which has a continuous spectrum with a distinctive shape. Here "black body" refers simply to an idealized material that absorbs all wavelengths without favor and is also a perfect emitter of all wavelengths. (Real materials all have lower emissivity,

but many approach the black-body spectrum at high temperature.) Such radiation has an important place in the history of physics, since it was through an analysis of the black-body spectrum that Max Planck deduced the quantum principle in 1900. He found he could explain the shape of the spectrum only by assuming the quantization of energy.

In ideal black-body radiation the spectrum is independent of the chemical composition of the emitter and is determined by a single parameter: temperature. At absolute zero all the atoms occupy the lowest energy level available, and no radiation is emitted. As the temperature rises some atoms are promoted to excited states, but the process is a random or statistical one, and the atoms are distributed over a broad range of energies. At any finite temperature the number of occupied states increases gradually with energy up to some maximum value; then it declines again. Thus the shape of the spectrum is somewhat like the profile of an ocean wave about to break. The steepness of the wave and the position of the crest depend on the temperature of the body.

At room temperature the thermal excitations are confined to small energies, and radiation is emitted only in the infrared. When the temperature reaches about 700 degrees Celsius the maximum emissions are still in the infrared, but a little visible light begins to appear; it is perceptible as a dull red glow. As the temperature rises further the peak of the emission curve shifts to higher energies and shorter wavelengths, so that the object glows brighter and its color changes. The sequence of colors runs from red to orange to yellow to white to pale blue, in accord with the colloquial descriptions "red hot," "white hot" and so on.

In a log fire or a candle flame incandescent particles of carbon give off radiation with an effective black-body temperature of at most 1,500 degrees C., where the light ranges from red to yellow. The tungsten filament of an incandescent light bulb has a temperature of about 2,200 degrees and yields a warm yellow-white. A flash bulb, which can reach a temperature of 4,000 degrees, yields a somewhat more accurate version of white.

The solar spectrum has the approximate form of a black-body curve; its shape is determined by the temperature at the surface of the sun, about 5,700 degrees C. The spectrum has a broad peak centered near 2.2 electron volts, or 560 nanometers, a yellow-green wavelength. The eye is most sensitive to just this wavelength. Indeed, the concept of white seems to be conditioned largely by the spectrum of daylight, which is dominated by solar radiation. Roughly speaking, light is perceived as being white if its spectrum resembles that of sunlight; other colors can be defined according to how they depart from the solar spectrum.

Crystal-Field Colors

When atoms combine to form a molecule or condense to form a liquid or a solid, new modes of excitation are introduced. Among them are mechanical vibrations and rotations that are not possible in an isolated atom. For example, the atoms of a diatomic molecule can oscillate as if they were connected by a spring, and they can rotate about their common center of mass. Such motions can occasionally influence the color of a material. In water, for example, a complex bending of the molecules absorbs a little energy at the red end of the spectrum and gives pure water and ice a pale blue cast. For the most part, however, the energy of vibrational and rotational excitations is small, and it is dissipated as infrared radiation, or heat.

Another consequence of the binding together of atoms is a change in the state of the valence electrons. In an isolated atom the valence electrons are unpaired and are the primary cause of color. In a molecule and in many solids, on the other hand, the valence electrons of one atom form pairs with the valence electrons of adjacent atoms; it is these pairs that constitute the chemical bonds that hold the atoms together. As a result of this pair formation the absorption bands of the valence electrons are displaced to ultraviolet wavelengths, and they are no longer available for the production of color. Only electrons in exceptional states remain to give rise to coloration. It is evident, however, that such exceptional states cannot be too rare; if they were, most molecules and solids would be transparent to visible light.

One set of unusual electronic states appears in the transition-metal elements, such as iron, chromium and copper and in the rare-earth elements. The atoms of metals in the transition series have inner shells that remain only partly filled. These unfilled inner shells hold unpaired electrons, which have excited states that often fall in the visible spectrum. They are responsible for a wide range of intense colors. For example, both ruby and emerald derive their color from trace amounts of chromium.

The basic material of ruby is corundum, an oxide of aluminum with the formula Al_2O_3. Pure corundum is colorless, but in ruby a brilliant color results from the substitution of chromium ions (Cr^{+++}) for a few percent of the aluminum ions. Each chromium ion has three unpaired electrons, whose lowest-possible energy is a ground state designated $4A_2$; there is also a complicated spectrum of excited states. All the excited states are broadened to form bands, and they are also modified in another way by the presence of the crystal matrix. Although the identity of the states is defined by the electronic configuration of the chromium ion, the absolute position of each level in the energy spectrum is determined by the electric field in which the ion is immersed. The symmetry and strength of the field are determined in turn by the nature of the ions surrounding the chromium and by their arrangement.

In ruby each chromium ion lies at the center of a distorted octahedron formed by six oxygen ions. The interatomic bonds in ruby are about .19 nanometer long, and they have about 63 percent ionic character, which means that the electron pairs that make up the bonds spend more of the time near the oxygen ions than they do near the aluminum or chromium ions. This distribution of the electronic charge gives rise to comparatively strong electric field, which is called the crystal field or the ligand field. When a chromium ion is immersed in this field, three excited states of its unpaired electrons have energies in the visible range.

The three excited states are designated $2E$, $4T_2$ and $4T_1$. Selection rules forbid a direct transition from the ground state to the $2E$ level, but both of the $4T$ levels can be entered from the ground state. The energies associated with these transitions correspond to wavelengths in the violet and in the yellow-green regions of the spectrum. Because the levels are not sharp lines but broad bands a range of wavelengths can be absorbed. Hence when white light passes through a ruby it emerges depleted of its violet and yellow-green components. Essentially all red is transmitted, along with some blue, giving the ruby its deep red color with a slight purple cast.

Because of the selection rules electrons can return from the excited $4T$ levels to the $4A_2$ ground state only through the intermediate $2E$ level. The initial transitions from $4T$ to $2E$ release small amounts of energy corresponding to infrared wavelengths, but the drop from $2E$ to the ground state gives rise to strong emission of red light. It should be noted that this red light, unlike the transmitted bands, is not present in the beam originally incident on the crystal; it is generated within by the process of fluorescence. Indeed, the red fluorescence of ruby can be observed most clearly when the crystal is illuminated with green or violet light or with ultraviolet radiation. On the other hand, the fluorescence can be quenched by iron impurities, which are often present in natural rubies. The light of a ruby laser derives from red fluorescence in synthetic rubies, which are free of iron.

Ruby and Emerald

The subtlety of crystal-field colors can be made apparent through a comparison of ruby and emerald (figure 1.4). The color-generating impurity in emerald is again the Cr^{+++} ion, and it again replaces aluminum in small amounts. The similarity of the two substances extends further: in emerald too the chromium ions are surrounded by six oxygen ions in an octahedral configuration, and the bond length is again about .19 nanometer. In emerald, however, the fundamental crystal lattice is that of a beryllium aluminum silicate, $Be_3Al_2Si_6O_{18}$. And the most significant difference is in the nature of the chemical bonds, which are less ionic by a few percent, so that the

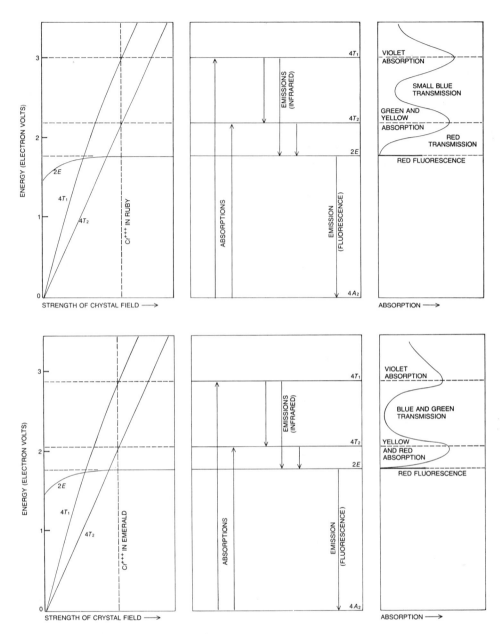

Figure 1.4
Electric field in a crystal can influence color by altering the state of atoms or ions within the crystal structure. In ruby and emerald color results from the absorption of selected wavelengths by unpaired electrons in chromium ions. The transitions that cause the absorption are the same in both cases: ions are promoted from the ground state, $4A_2$ to the excited levels $4T_2$ and $4T_1$. The energies at which these states lie are set by the magnitude of the crystal field. In ruby, the absorption bands block violet light and green and yellow light; red light is transmitted and so is a little blue, which gives the ruby its deep red color with a slight purple cast. In emerald the crystal field is weaker, which depresses both absorption bands. As a result red transmission is eliminated and green and blue are enhanced. In both materials an excited ion returns to the ground state through an intermediate level designated $2E$, whose energy is little affected by the crystal field. Transitions from the $2E$ level to the ground state give rise to red fluorescence that is almost identical in ruby and emerald.

magnitude of the electric field surrounding a chromium ion is somewhat reduced. As a result the two $4T$ levels lie at slightly lower energies; the position of the $2E$ band is essentially unaltered. The major effect of these changes is to shift the absorption band that in ruby blocks green and yellow light downward into the yellow and red part of the spectrum. The emerald therefore absorbs most of the red light, but the transmission of blue and green is greatly enhanced.

Curiously fluorescence in emerald is almost identical with that in ruby. The reason is that the energy of the $2E$ level is scarcely altered by the reduction in the crystal field. The similarity of the fluorescent emissions shows it is merely a coincidence that ruby has a red color and also red fluorescence.

Intermediate in spectral composition between ruby and emerald is the rare (and therefore costly) gemstone alexandrite. Again the color arises from chromium ions that replace aluminum, but in this case the underlying crystal structure is that of a beryllium aluminate, $BeAl_2O_4$. The crystal field that sets the energy scale of the chromium ions is stronger than that in emerald but weaker than that in ruby, with the result that the red and green transmission bands are quite evenly balanced. The near equality of the two bands has an extraordinary consequence: in blue-rich sunlight the gemstone appears blue-green, but in the redder light of a candle flame or an incandescent lamp it appears red.

Crystal-field colors can arise whenever there are ions bearing unpaired electrons in a solid. Aquamarine, jade and citrine quartz get their colors from a mechanism similar to that in ruby and emerald, but the transition-metal impurity is iron instead of chromium. Many compounds and crystals in which the transition metals appear as major constituents rather than impurities are also strongly colored. Among natural minerals in this category are the blue or green azurite, turquoise and malachite, in which the color is produced by copper, and the red garnets, which owe their color to iron. Most pigments in paints are transition-metal compounds.

Color Centers

The physical mechanism responsible for crystal-field colors is not confined to electrons in transition-metal ions; indeed, the electrons need not be an intrinsic component of any atom. An excess electron unattached to any single atom will suffice if the electron can be trapped at some structural defect, such as a missing ion or an impurity. A "hole," the absence of one electron from a pair, can have the same effect. Anomalies of this kind are called color centers or F centers (from the German *Farbe*, color) (figure 1.5).

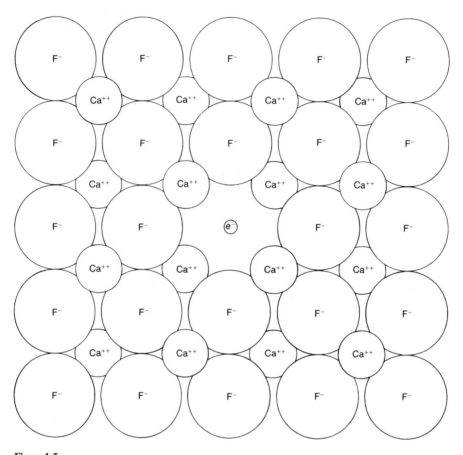

Figure 1.5
Color center can form in a crystal when an electron takes the place of a dislodged ion. In fluorite, or cal-
cium fluoride, the electron fills the vacancy created when a fluorine ion is removed. The electron has a
spectrum of excited states that extends into the range of visible wavelengths. The color centers in fluorite,
which are called *F* centers, give it a purple hue. The original crystal structure can be restored by heating,
whereupon the color fades. There are also electron and "hole" color centers, where a single electron rather
than an entire ion is displaced.

Although many color centers are known, the mechanism of color-production is understood in only a few. One of these is the purple F center of fluorite, a mineral that exhibits a great variety of color-center activities. Fluorite is calcium fluoride, or CaF_2, in which each calcium ion is normally surrounded by eight fluorine ions. An F center forms when a fluorine ion is missing from its usual position. The loss of the fluorine can come about in several ways: by growing the crystal in the presence of excess calcium, by exposing the crystal to high-energy radiation (which can displace an ion from its usual position) or by applying a strong electric field (which removes fluorine by the process of electrolysis). In order to preserve the electrical neutrality of the crystal some other negatively charged entity must take up the position in the lattice left vacant by the absent fluorine ion. When the charge is supplied by an electron, an F center is created. The electron is bound in place not by a central nucleus, as in an atom or an ion, but by the crystal field of all the surrounding ions. Within the field it can occupy a ground state and various excited states similar to those in the transition metals. The movement of electrons between these states gives rise both to color and to fluorescence.

The color of smoky quartz is attributed to a hole color center. The basic lattice of quartz is silicon dioxide (SiO_2), but a prerequisite to the formation of the color center is the presence of aluminum impurities replacing a few silicon ions. Because aluminum has a valence of $+3$ and silicon a valence of $+4$, an alkali metal ion or a hydrogen ion must be nearby to maintain electrical neutrality. Quartz is almost always contaminated with traces of aluminum, but that alone will not give rise to color because there are no unpaired electrons. The color center is created when the quartz is exposed for a few minutes to intense X rays or gamma rays, or when it is exposed to low levels of such radiation over geologic periods. The radiation expels one electron from a pair of electrons in an oxygen atom adjacent to an aluminum impurity, thereby leaving an unpaired electron in the orbital. The absent electron is called a hole, and the remaining unpaired electron has a set of excited states much like that of an excess electron.

Amethyst is another form of quartz that derives its color from a hole color center, but the impurity ion is iron rather than aluminum. Certain old bottles were made of a glass containing iron and manganese; after many years of exposure to intense sunlight the glass turns purple through the development of color centers and is called desert-amethyst glass. The same effect is achieved by a 10-minute exposure to the intense gamma rays emitted by cobalt 60.

Most color centers are stable if the material is not heated excessively. In fluorite raising the temperature makes the displaced fluorine ion mobile, so that it eventually resumes its original position; the color center and the color are then abolished.

a BENZENE

b BENZENE

PI ORBITALS

c CRYSTAL VIOLET

ELECTRON DONOR

ELECTRON ACCEPTOR

Cl⁻

Amethyst when heated changes color, becoming either citrine quartz or a rare greened quartz. Both these colors represent the influence of iron without the amethyst color center. In some materials even the energy of sunlight can cause a color center to fade. For example, some colorless topaz can be irradiated to induce a deep orange-brown tint; the color fades, however, after only a few days in sunlight. Natural topaz of the same color is quite stable.

Molecular Orbitals

It was pointed out above that in molecules and solids the valence electrons are paired in chemical bonds and as a result their excited states are shifted into the ultraviolet. Actually this is true only when the paired electrons remain confined to a particular bond between two atoms. In many cases the electrons can move over longer distances; they can range throughout a molecule or even throughout a macroscopic solid. They are then bound less tightly, and the energy needed to create an excited state is reduced. The electrons are said to occupy molecular orbitals (in contrast to atomic orbitals), and they are responsible for a varied class of colors in nature (figure 1.6).

One mechanism by which molecular orbitals can contribute color is the transfer of electric charge from one ion to another; blue sapphire provides an example of the process. Like ruby, sapphire is based on corundum, but it has two significant impurities, iron and titanium, both appearing in positions normally filled by aluminum. In the lowest energy state the iron has a formal charge of +2 and the titanium has a formal charge of +4. An excited state is formed when an electron is transferred from the iron to the titanium, so that both ions have a formal charge of +3. An energy of about two electron volts is needed to drive the charge transfer. Such transitions create a broad absorption band that extends from the yellow through the red and leaves the sapphire with a deep blue color.

Figure 1.6
Molecular orbitals describe paired electrons distributed over several atoms or over many atoms; they often absorb strongly at visible wavelengths. The pair of electrons that forms a chemical bond ordinarily absorbs only in the ultraviolet, but when alternative configurations of the bonds spread the pair over a number of atoms, the excitation energy of the pair is reduced. The commonest molecular orbitals that cause color are those associated with systems of conjugated bonds (alternating single and double bonds) in organic compounds such as benzene (*a*). By shifting three pairs of electrons in benzene the sequence of bonds is reversed. A better way of representing the structure of the molecule (*b*) shows single bonds between all the carbon atoms, with the extra three pairs of electrons distributed throughout the molecule in "pi" orbitals. It is the pi orbitals that are active in producing color. In benzene the excited states of the pi orbitals still lie in the ultraviolet, and so benzene is colorless, but in molecules with larger conjugated systems, such as the dye crystal violet (*c*), the bands are at visible wavelengths. The color is enhanced by chemical groups called auxochromes that donate and accept electrons.

In a number of materials iron is present in both its common valences, Fe^{++} and Fe^{+++}. Charge transfers between these forms give rise to colors ranging from deep blue to black, as in the black iron ore magnetite.

Molecular-orbital theory also applies to the colors observed in many organic substances in which carbon atoms (and sometimes nitrogen atoms) are joined by a system of alternating single and double bonds, which are called conjugated bonds. The best-known example of such a conjugated system is the six-carbon benzene ring, but there are many others. Because each bond represents a pair of shared electrons, moving a pair of electrons from each double bond to the adjacent single bond reverses the entire sequence of bonds. The two structures defined in this way are equivalent, and there is no basis for choosing between them. Actually the best representation of the structure shows all the atoms connected only by single bonds; the remaining pairs of bonding electrons are distributed over the entire structure in molecular orbitals, which in this instance are called pi orbitals.

The extended nature of the pi orbitals in a system of conjugated bonds tends to diminish the excitation energy of the electron pairs. In benzene the energy of the lowest excited state is still in the ultraviolet, and so benzene is colorless, but in larger molecules, and notably in those built up of multiple rings, absorption can extend into the visible region. Such colored organic molecules are called chromophores (meaning color-bearers). Chemical side groups that donate or accept electrons can be attached to the conjugated system to enhance the color; they are called auxochromes (color-increasers).

A number of biological pigments owe their color to extended systems of pi orbitals. Among them are the green chlorophyll of plants and the red hemoglobin of blood. Organic dyes employ the same mechanism. The *Color Index* of the Society of Dyers and Colourists lists 8,000 such substances.

Some chemical species with extended molecular orbitals are also capable of fluorescence. As in ruby and emerald, the fluorescent light is emitted when an excited state decays through an intermediate level and the energy of at least one of the intermediate transitions corresponds to a visible wavelength. The fabric brighteners added to some detergents achieve their effect by absorbing ultraviolet radiation in daylight and reemitting a part of the energy as blue light. Lasers that have a dye as their active medium operate on the same principle.

Fluorescence is also observed in some systems of molecular orbitals where the energy to create the initial excited state comes from a source other than radiation. The bioluminescence of fireflies and of some deep-sea fishes is driven by a sequence of chemical reactions that culminates in the formation of an excited state of a mole-

cule with extended pi orbitals. Manmade "cold light" devices imitate the biological process.

Metals and Semiconductors

The spatial extent of electron orbitals reaches its maximum possible value in metals (figure 1.7) and semiconductors. Here the electrons are released entirely from attachments to particular atoms or ions and can move freely throughout a macroscopic volume. Their range is limited only by the dimensions of the material. The enormous numbers of mobile electrons (on the order of 10^{23} per cubic centimeter) give metals and semiconductors optical and electrical properties unlike those of any other material.

In a metal all the valence electrons are essentially equivalent since they can freely exchange places. One might suppose, therefore, that they would all have the same energy, but a rule of quantum mechanics forbids that. In a solid as in an isolated atom only a limited number of electrons can occupy the same rung of the energy ladder. Accordingly there must be many energy levels in the metal, and the levels are necessarily spaced very closely. In effect they form a continuum from the ground state up.

At zero temperature this continuous band of states is filled from the lowest level up to an energy designated the Fermi level; all states above the Fermi level are vacant. Any input of energy, no matter how small, propels an electron into one of the empty states of higher energy.

Since a metal effectively has a continuum of excited states, it can absorb radiation of any wavelength. A surface with this property of absorbing all colors might be expected to appear black, but metals are not an absorptive black. The reason again has to do with the agility of the metallic electrons: when an electron in a metal absorbs a photon and jumps to an excited state, it can immediately reemit a photon of the same energy and return to its original level. Because of the rapid and efficient reradiation the surface appears reflective rather than absorbent; it has the luster characteristic of metals. If the surface is smooth enough, the reflection can be specular, as in a mirror.

The variations in the color of metallic surfaces, which, for example, distinguish gold from silver, result from differences in the number of states available at particular energies above the Fermi level. Because the density of states is not uniform some wavelengths are absorbed and reemitted more efficiently than others. Besides absorption and reemission, transmission is also possible in some metals, although it is always weak and can be observed only in thin layers. The transmission varies with

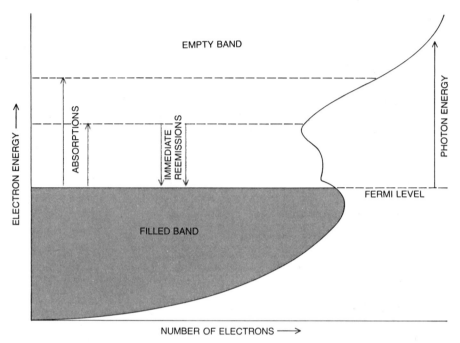

Figure 1.7
Electronic structure of a metal is distinguished by an essentially continuous band of allowed energy levels.
The band is filled from the ground state up to an energy called the Fermi level; all higher energy states are
empty and can therefore accept excited electrons. A consequence of this electronic configuration is that all
wavelengths of radiation can be absorbed, from the infrared through the visible to the ultraviolet and
beyond. A material that absorbs light of all colors might be expected to appear black; metals are not black
because an excited electron can immediately return to its original state by remitting a quantum with the
same wavelength as the absorbed one. The metallic surface is therefore highly reflective.

wavelength, and so it gives rise to color. Beaten gold leaf, in which the gold structure
is highly distorted, transmits only green light. Colloidal gold in ruby glass is not
under strain, and the light transmitted is purple-red.

Band-Gap Colors

Wide, continuous bands of electronic states are a feature of another class of mate-
rials: the semiconductors. The definitive characteristic of these materials is that the
average number of bonding electrons per atom is exactly four. Included are crystal-
line forms of some elements in Group IV of the periodic table, such as silicon,

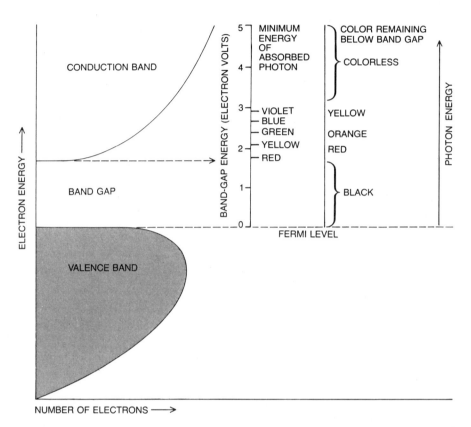

Figure 1.8
Band structure of a semiconductor is similar to that of a metal, except that a gap of forbidden energies separates the filled valence band from the empty conduction band. There is therefore a minimum energy that a quantum of radiation must have in order to be absorbed, namely the energy needed to promote an electron from the top of the valence band to the bottom of the conduction band. The color of a pure semiconductor is determined by the magnitude of the band gap. If it lies in the infrared, all visible wavelengths are absorbed and the material is black. A gap energy in the visible region allows some colors to be transmitted, so that the semiconductor takes on a color ranging from red to yellow. When the gap energy is in the ultraviolet, all visible wavelengths are transmitted and the material is colorless.

germanium and the diamond phase of carbon; there are also many compound semi-conductors, such as gallium arsenide.

What distinguishes a semiconductor from a metal is a splitting of the band of energy levels into two parts (figure 1.8). All the lower energy levels form a valence band, which in the ground state is completely filled. All excited states lie in a separate conduction band, which in the ground state is entirely empty. Separating the two bands is a gap of forbidden energies. The division of the energy band has profound effects on the optical properties of a semiconductor. No longer can the electrons absorb radiation of arbitrarily low energy; the minimum energy is the energy needed to lift an electron from the top of the valence band to the bottom of the conduction band.

The color of a pure semiconductor depends only on the magnitude of the energy gap. If the gap is smaller than the lowest energy of visible light, all visible wavelengths are absorbed. Small-gap semiconductors in which reemission is efficient and rapid have a metal-like luster, as silicon does, but other small-gap semiconductors are black. At the opposite extreme the band gap can be greater than the highest energy of visible light; in that case no visible wavelengths can be absorbed and the material is colorless. Diamond, with a band gap of 5.4 electron volts, is one such large-gap semiconductor and is transparent both to visible light and to a limited range of ultraviolet radiation.

Where the band-gap energy falls in the visible range, the semiconductor has a definite color. The mercury ore cinnabar (which has the formula HgS and is also known as the pigment vermilion) has a band-gap energy of 2.1 electron volts. All photons with energies higher than this level are absorbed, and only the longest visible wavelengths are transmitted; as a result cinnabar appears red. The pigment cadmium yellow, CdS, has a band gap of 2.6 electron volts and absorbs only blue and violet light; after these wavelengths are subtracted from white light the color remaining is yellow. The sequence of band-gap colors, from the smallest gap to the largest, is black, red, orange, yellow, colorless.

Although large-gap semiconductors are colorless when they are pure, they can take on color when they are "doped" with traces of an impurity (figure 1.9). The impurity can be either a donor of electrons or an acceptor of them; in either case it introduces a set of energy levels in the gap between the valence band and the conduction band. Transitions to or from the new levels require a smaller quantity of energy than transitions across the entire gap.

In diamond the replacement of a few carbon atoms with nitrogen creates a donor band about 1.4 electron volts above the valence band. Nitrogen has one electron more than carbon, and it is these extra electrons that form the donor band. The nominal energy needed to promote one of them to the conduction band is four elec-

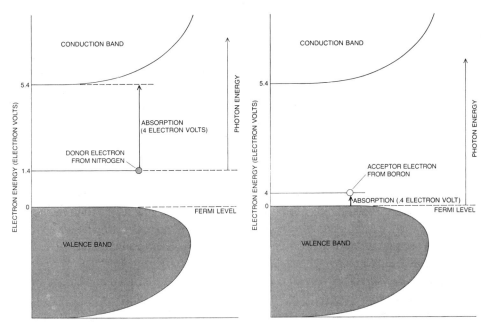

Figure 1.9
Doping of a semiconductor with impurities creates allowed energy levels within the band gap. In diamond, which is a semiconductor with a band gap of 5.4 electron volts, doping with nitrogen introduces a level of filled states 1.4 electron volts above the Fermi level. One of these electrons can be excited to the conduction band by absorbing radiation with an energy of 4 electron volts. Because the level is broadened somewhat, there is some absorption of violet and blue light, and the diamond is colored yellow. Adding boron to a diamond creates holes, or empty states, in a level centered .4 electron volt above the Fermi level. Light of the lowest visible energies can promote an electron from the valence band into this broadened level, so that red and yellow light is absorbed and the diamond becomes blue.

tron volts, which is still in the ultraviolet; the donor level is sufficiently wide, however, for some violet light to be absorbed. At a concentration of one nitrogen atom per 100,000 carbon atoms diamond is yellow; with more nitrogen it becomes green.

Boron has one electron fewer than carbon and gives rise to acceptor, or hole, levels in the band gap of diamond. An electron can be excited from the valence band to occupy one of these holes. The impurity level is centered .4 electron volt above the valence band but extends far enough to absorb some of the longer visible wavelengths. The boron-doped diamond therefore appears blue.

It is well known that doping also alters the electrical properties of semiconductors, making possible all the devices of solid-state electronics. Among these devices are light-emitting diodes and semiconductor lasers, in which an electric current populates excited states and the electrons emit radiation in returning to the ground state.

Doped semiconductors can also function as phosphors, which are materials that give off light with high efficiency when they are stimulated electrically or by some other means. Phosphors are the luminous sources in a fluorescent lamp and in the picture tube of a television set. In a color picture tube three phosphors are distributed over the surface, with emissions at red, green and blue wavelengths. Certain compounds of the transition metals also act as phosphors.

Geometrical Optics

In the phenomena I have described so far color results either from the direct emission of colored light or from the selective absorption of some wavelengths and transmission of others. In a last group of color-producing phenomena interactions of light with matter change the direction of the light (figure 1.10). The change in direction is the primary cause of color in refraction and diffraction, where the magnitude of the deflection can vary with wavelength. In the scattering of light from small particles the deflection of any given ray is not a deterministic function of wavelength, but the average intensity of the scattered light does depend on wavelengh. Interference gives rise to color through an interaction of light with light, but a change in direction is needed to enable one beam of light to interfere with another.

At the most fundamental level these processes can be understood in terms of electronic excitations in matter. Refraction, for example, results from a change in speed when light passes from one medium into another; the speed in each material is determined by the interaction of the electromagnetic field of the radiation with the electric charges of the electrons. An analysis of this kind is always possible, but it is often too cumbersome to be very informative. What is needed is a "higher level" analysis; it is provided by methods of geometrical and physical optics.

A light ray is refracted, or bent, by a transparent prism because light is slowed more by traveling in a solid than it is by traveling in air. (The highest possible speed of light, and the speed that relativity theory says can never be exceeded, is attained only in a vacuum; in any material medium the speed is lower.) Why a change in speed should lead to a change in direction can be understood by imagining the light ray as a series of plane wave fronts. When a wave front strikes a transparent surface obliquely, one edge enters and is slowed before the opposite edge reaches the surface; the edge that is slowed first thus falls behind the rest of the wave front, and the ray is deflected toward the perpendicular. On leaving the solid the ray is bent away from the perpendicular.

The magnitude of the change in direction when a light ray is refracted depends on the angle at which it strikes the surface. For any given angle of incidence it also

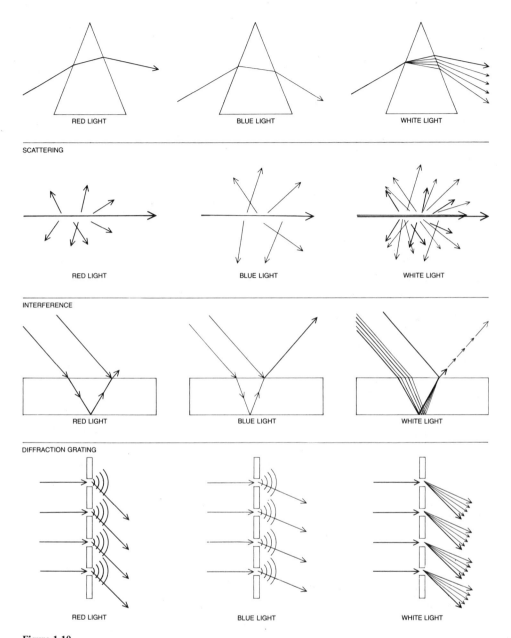

SCATTERING

INTERFERENCE

DIFFRACTION GRATING

Figure 1.10
Physical optics provides the most convenient interpretation of colors generated by several mechanisms that involve a change in the direction of light. The dispersion of white light into its component colors by a transparent prism comes about because short wavelengths are refracted through a larger angle than long wavelengths. In a similar way the scattering of light by small particles is more effective at short wavelengths, so that more blue light is scattered than red. Interference is observed when a light wave is split into two parts that are then brought together again. If the waves are in phase when they recombine, the intensity is enhanced; if they are out of phase, the waves cancel each other. Since the phase difference between the two beams can depend on wavelength, interference can enhance some colors and suppress others. In a diffraction grating light is scattered by many uniformly spaced centers and the resulting multiple wave fronts interfere with one another. Each wavelength is reinforced in one set of directions and canceled in all others, so that white light is dispersed.

depends on the ratio of the speeds of light in the two materials. It turns out that this ratio, which is called the refractive index, is generally not the same for all wavelengths; that is why refraction can give rise to color. The mechanisms that retard light in a transparent medium have a greater effect on high frequencies and short wavelengths than they do on low frequencies and long wavelengths. As a result violet light is refracted through a larger angle than red light, and a beam of white light on passing through a prism is separated into its component colors.

This dispersion of white light according to wavelength was discovered by Isaac Newton in 1704, or at least it was Newton who first recognized its significance. The dispersion of sunlight by refraction in water droplets or ice crystals is responsible for the colors of a rainbow and of other colored halos occasionally seen around the sun and the moon. Dispersion also causes the "fire," or flashes of color, characteristic of diamond and, to a lesser extent, of other faceted transparent gemstones. Dispersion is not always a welcome phenomenon: in telescopes, cameras and other optical systems it gives rise to chromatic aberration, or the misregistration of images in different colors.

Interference was also first investigated in detail by Newton. It can be observed in a system of waves where two waves combine to yield a single new wave whose amplitude at each point is simply the sum of the amplitudes of the original waves. Thus a monochromatic light wave can be split into two components, which follow different paths and then merge again. Where the two components are in phase, so that the peaks and valleys coincide, the waves reinforce each other and the light is bright. Where the components are out of phase the waves cancel and appear dark.

Interference is often observed in thin transparent films, where part of the light is reflected by the first surface and part by the second. Whether the beams reinforce or cancel depends on the nature and thickness of the film, on the angle of reflection and on the wavelength of the light. If the film has a uniform thickness, different wavelengths emerge at different angles. If the layer varies in thickness, then at any given viewing angle different colors appear at different positions. Interference in a thin, transparent cuticle gives rise to the colors of some beetles and butterflies. A thin layer of oil on water swirls with color as a result of the same mechanism.

The Diffraction Grating

Diffraction is the bending or spreading of a light wave at the edge of an opaque obstacle. When the obstacle is a macroscopic object, the effect is generally a minor

one, but it becomes important when the dimensions of the obstacle are comparable to the wavelength of the light. As might be expected, the magnitude of the effect then becomes strongly dependent on wavelength.

Diffraction is an important cause of color in the scattering of light by small particles. Lord Rayleigh showed that the intensity of the scattered light is inversely proportional to the fourth power of the wavelength; accordingly blue light is scattered about four times as much as red light. The disparity in scattering effectiveness is apparent in the daytime sky. Molecules, dust and fluctuations in density in the atmosphere preferentially scatter blue light, so that the sky appears blue. The direct light of the sun, on the other hand, is depleted of blue and therefore appears reddish, particularly at sunrise and sunset when the light must traverse a greater depth of the atmosphere.

The same process can be demonstrated on a smaller scale by passing white light through diluted unhomogenized milk, where the scattering centers are particles of fat. The fluid appears bluish, whereas the directly transmitted beam is reddish. The blue sheen of moonstone almost certainly comes from a similar process. Scattering from much larger inclusions, which do not alter color, accounts for the patterns in star ruby and star sapphire and in tiger's-eye quartz.

Interference and diffractive scattering act in combination in a final mechanism for generating color: the diffraction grating. Such a grating is an array of many equally spaced lines or points in which the spacing is not too large in comparison with light wavelengths. Light passing through the grating is scattered in all directions at each opening, and so waves from adjacent openings interfere. For any one wavelength there are angles at which the interference is constructive; at all other angles the waves cancel one another. The actual value of these angles depends only on the wavelength and on the spacing between lines or points on the grating. When white light passes through a diffraction grating or is reflected from it, each wavelength is enhanced in a different set of directions. Hence the light in any given direction is spectrally pure and monochromatic, but as the grating is rotated a series of spectra comes into view.

A diffraction grating can be made by inscribing fine rulings on a glass plate, and a few natural systems also have the dimensions and the high degree of order needed for an optical grating. For example, in the materials called liquid crystals molecules are stacked with sufficient regularity to act as a diffraction grating. Because the spacing between molecules depends on the temperature so does the color of the material, and it can be employed as a temperature indicator. Similar ordered arrays of molecules produce diffraction-grating colors in some butterflies and beetles.

ELECTRONIC TRANSITIONS IN FREE ATOMS AND IONS; VIBRATIONAL TRANSITIONS IN MOLECULES	ELECTRONIC EXCITATIONS	INCANDESCENCE, FLAMES, ARCS, SPARKS, LIGHTNING, GAS DISCHARGES, SOME LASERS.
	VIBRATIONS	BLUE-GREEN TINT OF PURE WATER AND ICE.
CRYSTAL-FIELD COLORS	TRANSITION-METAL COMPOUNDS	TURQUOISE, MOST PIGMENTS, SOME LASERS, SOME PHOSPHORS, SOME FLUORESCENT MATERIALS.
	TRANSITION-METAL IMPURITIES	RUBY, EMERALD, RED SANDSTONE, SOME LASERS, SOME FLUORESCENCE.
	COLOR CENTERS	AMETHYST, SMOKY QUARTZ, DESERT– AMETHYST GLASS, SOME FLUORESCENCE.
TRANSITIONS BETWEEN MOLECULAR ORBITALS	CHARGE TRANSFER	BLUE SAPPHIRE, MAGNETITE.
	CONJUGATED BONDS	ORGANIC DYES, MOST PLANT AND ANIMAL COLORS, LAPIS LAZULI, FIREFLIES, DYE LASERS, SOME FLUORESCENCE.
TRANSITIONS IN MATERIALS HAVING ENERGY BANDS	METALLIC CONDUCTORS	COPPER, SILVER, GOLD, IRON, BRASS.
	PURE SEMICONDUCTORS	SILICON, GALENA, CINNABAR, DIAMOND.
	DOPED SEMICONDUCTORS	BLUE DIAMOND, YELLOW DIAMOND, LIGHT-EMITTING DIODES, SEMICONDUCTOR LASERS, SOME PHOSPHORS.
GEOMETRICAL AND PHYSICAL OPTICS	DISPERSIVE REFRACTION	THE RAINBOW, "FIRE" IN GEMSTONES, CHROMATIC ABERRATION.
	SCATTERING	BLUE OF THE SKY, RED OF SUNSETS, MOONSTONE, STAR SAPPHIRE.
	INTERFERENCE	OIL FILM ON WATER, LENS COATINGS, SOME INSECT COLORS.
	DIFFRACTION GRATING	OPAL, LIQUID CRYSTALS, SOME INSECT COLORS

Figure 1.11
Causes of color are classified in 14 categories of five broad types. All but one of the color-causing mechanisms (vibrations of the atoms in molecules) can be traced to changes in the state of the electrons in matter. Electronic transitions are the most important causes of color because the energy needed to excite an electron commonly falls in the range that corresponds to visible wavelengths of light.

Spectral colors arising from diffraction also appear when a distant streetlight is seen through the fabric of an umbrella or when the surface of a phonograph record is viewed at a glancing angle.

The preeminent natural diffraction grating is the opal. In this gemstone spheres made up of silicon dioxide and a little water are closely packed in a three-dimensional array with a spacing of about 250 nanometers. The transparent or translucent matrix that fills the space between spheres has a similar composition but a slightly different index of refraction. When white light enters this three-dimensional diffraction grating, pure colors appear inside the stone; the colors change as the eye or the stone is moved. The mechanism of color production in opal came to be understood only in 1964, when the structure was first resolved with the electron microscope. Synthetic opals were created not long thereafter.

The Visible Spectrum

In this catalogue of colors, which is surely not complete, I have described more than a dozen mechanisms. They can be put into five broad categories: excitations of free atoms and ions and vibrations in molecules, crystal-field effects, transitions between states of molecular orbitals, transitions in the energy bands of solids and effects interpreted through physical optics (figure 1.11). It may seem an extraordinary coincidence that such a diversity of phenomena is encompassed in a band of wavelengths that is not even a full octave wide; it may seem still more remarkable that this narrow band happens to be just the one to which the human eye is sensitive.

Actually it may not be a coincidence at all. So much of interest happens in this narrow region of the electromagnetic spectrum because these are the wavelengths where interactions of light with electrons first become important. Waves of lower energy mainly stimulate the motions of atoms and molecules, and so they are usually sensed as heat. Radiation of higher energy can ionize atoms and permanently damage molecules, so that its effects seem largely destructive. Only in the narrow transition zone between these extremes is the energy of light well tuned to the electronic structure of matter.

II COLOR MEASUREMENT

2 The Physical Basis of Color Specification

D. L. MacAdam

People have been conscious of color from the earliest times. Cave dwellers decorated their walls with coloring materials that they dug from the earth. Mineral colors, a few vegetable dyes, and some dyes obtained from insects and mollusks were the only materials available until the last century. The paucity of usable materials was not remedied until after Perkin's synthesis of mauve from coal tar in 1856. That discovery led to the introduction of thousands of synthetic dyes and pigments. In the ever-increasing use of color today, the lack of suitable coloring materials no longer limits the variety of attainable colors.

As frequently happens, the solution of that problem created another. The synthesis of a vast number of new dyes and pigments made it necessary to look for a new method of color specification. When the number of available materials was small, it was feasible to designate the color of a dye or pigment by reference to its origin. Such names as Tyrian purple, madder, henna, and indigo arose in this way. The modern equivalent of that identification method would be to give the chemical composition or structural formula of each new *colorant*. Such a specification would be inadequate for a number of reasons. To mention only one: dyes and pigments are generally used today in mixtures of two or more at a time. This is almost invariably a physical mixture, rather than a chemical combination. Hence, the interpretation of mixture phenomena is to be found by use of laws in the branch of physics known as optics, rather than by application of the laws of chemistry. The purpose of this chapter is to indicate the physical method of color specification and to present formulas, methods, and results that facilitate this specification.

1 Definition of Color

The term *color* is commonly used in three distinctly different senses. The chemist employs it as a generic term for dyes, pigments, and similar materials. The physicist, on the other hand, uses the term to refer to certain phenomena in the field of optics. Hence, the physicist, when confronted with the task of measuring the color of a material, measures the relevant optical properties of the material. Physiologists and psychologists often employ the term in still another sense. They are interested primarily in understanding the nature of the visual process and use the term, on occasion, to denote sensation in the consciousness of a human observer. Color is also a household word and is commonly used indiscriminately in all three senses.

All three definitions of color are so firmly rooted in our language that it would be futile to suggest that two of the meanings be abandoned in order to satisfy the

scientist's desire for a single meaning for every term. Indeed, it would be difficult to obtain any degree of unanimity concerning the single meaning that should be adopted, even among scientists. It seems inevitable that all three definitions of color will continue in use and that ambiguity can be avoided only by reference to the context. There is usually no difficulty in recognizing cases in which the chemical definition is intended. However, the distinction between the use of the objective physical definition and the subjective psychological definition is somewhat more subtle.

The distinction can best be illustrated in terms of another concept, temperature. Temperature may be defined objectively in terms of the expansion of mercury. It may also be defined subjectively in terms of sensations. This analogy suggests at once that there is no one-to-one correspondence between the objective and subjective aspects. We know, for example, that although the ocean may remain at the same temperature, as indicated objectively by a thermometer, it feels warmer on a cold day and colder on a warm day because it is contrasted with air at different temperatures. A hot or cold shower taken prior to entering the ocean has a similar effect. These phenomena have their counterparts in the field of color. The sensation that results when we look at a colored object depends to a considerable extent upon the nature of the surrounding field and the nature of the field to which the observer has previously been exposed.

This chapter is concerned chiefly with a method for specifying the colors of objects or materials. A specification of this sort, which treats color as an inherent property of an object or material, must necessarily be based on objective measurements. Color, in the sense in which it is used throughout this chapter, may be defined explicitly in terms of a definite set of physical operations. Indeed, every genuine definition of any concept is merely a statement of the operations by which that concept is specified. The operations described in this chapter may be regarded as a definition of color.[1]

2 The Spectrophotometric Specification of Color

The basis of the objective method of color specification will be clear from an outline of the procedure that is followed in the solution of a specific problem. Consider an object coated with a paint that would commonly be called green. Let this sample be illuminated by a suitable source of light. Imagine, further, that a prism is placed so as to disperse the light that falls on the sample into its spectral components— violet, blue, green, yellow, orange, and red. Consider for a moment only a single component—the violet, for example. It is evident that a surface cannot reflect more violet light than falls upon it.

The ratio of the amount reflected divided by the amount incident is called the *reflectance* of the surface. Therefore, the reflectance of the surface must have a value between 0 and 1. The exact value can be determined by use of an instrument known as a *spectrophotometer*. Experiment shows that in almost all cases, the value does not depend on the intensity of the measuring beam.[2] The reflectance of a surface for violet light is one of its inherent properties. The same argument applies with equal force to all of the other components of the spectrum. As a consequence, a purely objective specification of the color of a surface can be expressed in terms of the reflectance for each spectral component. In the case of our example, the inherent color characteristics of the green paint might be indicated by:

Spectral region	Reflectance
Violet	0.11
Blue	0.28
Green	0.33
Yellow	0.17
Orange	0.12
Red	0.06

This subdivision of the visible spectrum into six broad regions is arbitrary; the color of the spectrum varies without abrupt change throughout its length. The physical difference between the various regions of the spectrum is wavelength; the wavelength varies continuously from one end of the spectrum to the other. The unit of length that is commonly employed for specifying the wavelength of visible radiation is the *nanometer* (nm) (25,400,000 nanometers equal one inch). In terms of this unit, the spectral regions mentioned above comprise approximately the following ranges of wavelength:

Violet	400–450 nanometers
Blue	450–490 nanometers
Green	490–560 nanometers
Yellow	560–590 nanometers
Orange	590–630 nanometers
Red	630–700 nanometers.

Reflectance measurements for six spectral regions, although useful as an illustration of the principle underlying spectrophotometric analysis, do not, in general, define the color of a reflecting surface with sufficient precision. Instead, the

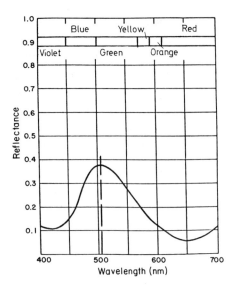

Figure 2.1
Spectral reflectance curve of a typical green paint. The dashed vertical line indicates the dominant wave-length. In this case, the dominant wavelength is 506 nm, which is a bluish green.

reflectance is ordinarily determined for as many wavelength regions as the nature of the problem requires; the results are often exhibited in the form of a chart like figure 2.1. Such a curve is called a spectrophotometric curve. The curve accurately defines the property of the sample that was roughly described by the data in the preceding tabulation. Every possible color can be represented on a chart of this type. For example, a perfectly white surface, which reflects completely all of the visible radiation that falls upon it, would be represented by a horizontal line at the top of the chart. Similarly, an absolutely black surface would be represented by a horizontal line at the bottom.

The spectral reflectance curve of a material constitutes a permanent record that does not require preservation of a sample of the color. Furthermore, the units in which the curve is expressed are universally understood and accepted. The wave-length of light has been adopted internationally as the fundamental standard of length, to which all other standards of length are referred. The values of reflectance are referred to a white standard whose reflectance is 1.00 for all wavelengths. Refer-ence to such a standard is achieved by absolute methods of reflectometry.[3]

Spectral reflectance curves are, at first, somewhat confusing to those who are not acquainted with them, chiefly because the curves convey so much more information than can be obtained by visual examination.

The unaided eye is incapable of analyzing light into its spectral components. For example, even such a common source as sunlight is not intuitively resolved into the various spectral colors that it contains. Those who are accustomed to mixing dyes and pigments sometimes claim to be able to see in the resulting mixture the components that they have added. This is merely a judgment based on experience, not analysis. It is of interest to note that the ear possesses the analytical power that the eye lacks. The ear is capable of analyzing as complex a stimulus as the music of a symphony orchestra into the components produced by the various instruments.

All of the information supplied by the spectrophotometric curve is essential for solution of a great many problems, notably when color matches are required that will be valid under any type of illumination, for establishment and maintenance of color standards, and for interpretation of mixture phenomena. However, there are other problems for which knowledge of the stimulation of the eye is sufficient. A typical problem is the establishment of a color language that conveys no more information than the eye can acquire by ordinary visual examination. The information supplied by a spectral reflectance curve can be used as a basis for evaluating the stimulation that results under any specified set of conditions.

3 Standard Illuminants

The visual stimulation that results when we·look at a colored surface depends upon the character of the light with which the surface is illuminated. If all of the energy radiated by the source of light is confined within a narrow band of wavelengths in the violet end of the spectrum, the surface will reflect only violet light. Stated more generally, if a surface is illuminated by light of substantially a single wavelength, it will reflect only light of that wavelength.[4]

Even though the green paint under consideration is known from the curve in figure 2.1 to reflect green light more effectively than light of other wavelengths, it may nevertheless be made to take on any hue of the spectrum if it is suitably illuminated. In view of this, it may be wondered how such a sample could have been identified with the green region of the spectrum before the advent of spectrophotometry. The reason is simply that daylight, which is the traditional source by which samples are examined, consists of a mixture of all of the components of the visible spectrum in nearly equal proportions. Hence, when light of daylight quality falls upon the surface whose spectral reflectance is indicated by the curve in figure 2.1, a preponderance of blue-green light is reflected into the eye of the observer.

The spectral reflectance curves of a few typical colors are shown in figures 2.2–2.6. In each case, the wavelength of the spectral region with which each color is most

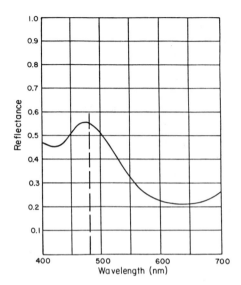

Figure 2.2
Spectral reflectance curve of a typical blue material. It has a dominant wavelength of 482 nm.

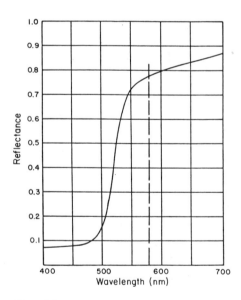

Figure 2.3
Spectral reflectance curve of a typical yellow material. It has a dominant wavelength of 579 nm.

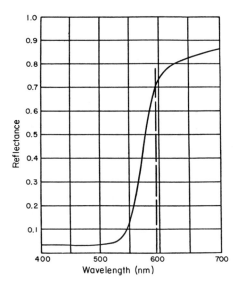

Figure 2.4
Spectral reflectance curve of a typical orange material. It has a dominant wavelength of 595 nm.

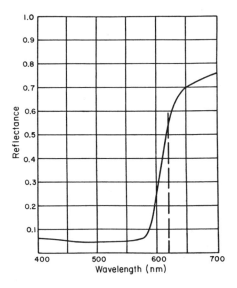

Figure 2.5
Spectral reflectance curve of a typical red material. It has a dominant wavelength of 619 nm.

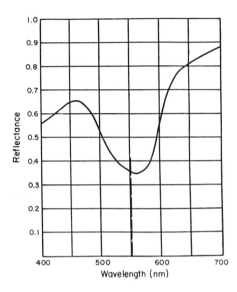

Figure 2.6
Spectral reflectance curve of a typical purple material. It has a complementary wavelength of 550 nm.

closely identified when illuminated by daylight is indicated by the dashed vertical line.[5] The curve for the purple (figure 2.6) requires special mention because it possesses two regions where its spectral reflectance is high. Purple is not a spectral color but is a combination of red light and violet light. It is impossible to find a single region of the spectrum that simulates purple; the wavelength indicated by the dashed line in figure 2.6 is that of the green that is complementary to it. The *complementary* color is the color that would produce a neutral gray in an additive mixture with the purple. An *additive* mixture is one in which the light from each of the components reaches the eye in an unmodified state. That is the case, for example, when the colors (lights) are combined on a projection screen. Mixtures of dyes or pigments are known as *subtractive* mixtures. Each of the dyes or pigments modifies the light from all of the other constituents of the mixture.

The statement that daylight consists of a mixture of all components of the spectrum in nearly equal proportions requires further elaboration. Extensive investigations into the distribution of energy in the spectrum of daylight have been made over long periods of time, in order to average the effect of the state of the weather and the altitude of the sun. Briefly, the method employed in determining the spectral distribution of energy in a source of light consists of dispersing the light into a spectrum by means of a prism. Each spectral region is then isolated in turn, and the amount of

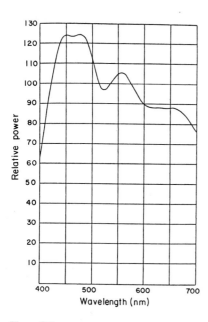

Figure 2.7
Relative spectral distribution of the power (energy radiated per unit time) from CIE illuminant C.

energy present in each region is determined. Instruments for such measurements are called *spectroradiometers*. On a clear day, daylight is a mixture of sunlight and blue light from the sky. This mixture is found to have substantially the same quality as the light from any part of the sky on an overcast day.

A filter has been prepared which, when used with a tungsten lamp operated at the proper temperature, provides a source that is a close approximation to average daylight. The spectral distribution of energy in this source is shown by the curve in figure 2.7. At the meeting of the International Commission on Illumination (Commission Internationale de l'Eclairage, CIE)[6] in 1931, the representatives of the various countries adopted a source that has this distribution of energy as an international standard of illumination to be used for the purposes of colorimetry except when special conditions dictate the use of other sources. This standard is known as CIE illuminant C.

Another standard adopted at the same meeting is designated illuminant A. It represents a source that has an energy distribution similar to that of a gas-filled incandescent-tungsten lamp.

If light that has the spectral quality of illuminant C falls on the surface of green paint whose spectral reflectances are represented by the curve in figure 2.1, the spectral distribution of the energy reflected into the eye of an observer is obtained by

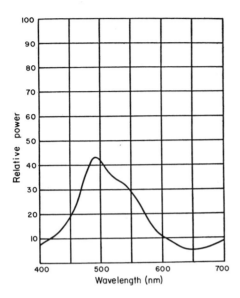

Figure 2.8
Spectral distribution of power in the light reflected from the green paint of figure 2.1 when the illuminant has the spectral-power distribution of figure 2.7 (illuminant C).

multiplying, at each wavelength, the value shown in figure 2.7 by the corresponding value in figure 2.1. The result of this is shown in figure 2.8. Because the curve in figure 2.7 is relatively flat, the shape of the new curve differs only slightly from that of figure 2.1. This is merely a special case, which serves to illustrate the principle that multiplying at each wavelength the incident energy by the reflectance of the surface gives the distribution of energy in the light reflected by the surface.

The next problem is to determine how light with a known distribution of energy stimulates the eye of an observer. No two observers respond in precisely the same manner, but the differences are small, except for about 2% of the population who demonstrably have anomalous color vision. Colorimetry is designed for the other 98%.

4 Color Specification in Terms of Equivalent Stimuli

No one can describe the sensation produced by light of any particular spectral quality. We can no more do this than we can describe the sensation produced by being pricked with a pin. Of course, we might say that being pricked with a pin evokes the same sensation as contact with a hot object or contact with a high-tension wire. Such

a reply is not a description of the sensation. It furnishes the useful information that another stimulus evokes the same sensation. The analogy suggests the possibility of evaluating a color in terms of certain standard or primary stimuli. Indeed, it has been known for nearly two hundred years that a normal observer can duplicate the effect of any color stimulus by combining the light from three primary sources in the proper proportions. A simple experimental technique by which this may be accomplished in the majority of cases is as follows. The observer looks into an optical instrument that contains a two-part field of view. The light whose color is to be matched is introduced into one part of the field, and light from the three primary sources is combined in controlled amounts in the other part. By manipulation of the controls of those amounts, a combination can be found that produces an exact color match between the two parts of the field. Only one setting for each of the three controls produces a color match. By calibrating the controls, the amount of each primary can be recorded. The unknown color can then be specified by those amounts. These are known as the *tristimulus values*; each number represents the amount of one of the primary stimuli.

Instruments of this type, which synthesize an equivalent stimulus, are known as *colorimeters*. The tristimulus values obtained with a properly designed colorimeter constitute a color specification for a given test sample and for the observer who determines the equivalent stimulus. Another observer who performs the same experiment will also obtain a valid specification of the color, in terms of an equivalent stimulus. The two specifications may be slightly different, even though neither observer has demonstrably anomalous color vision. Consequently, for interlaboratory comparisons or for long-time color-standardization programs based on the use of colorimeters, a large group of observers would have to be employed.

The CIE recommended an alternative procedure for international use. This consisted of determining color-matching data for a large group of carefully selected observers. These basic data can be used in conjunction with spectrophotometric data to compute, for any test sample, the average tristimulus values that would have been obtained by that group of observers if they had used a colorimeter. Because the readings obtained with a spectrophotometer are independent of peculiarities of an observer's eye, this procedure provides a basis for specification of color in terms of the average chromatic properties of an internationally accepted group of observers.

The data required for computation of such a result had to be obtained by use of colorimeters. Because these data had to be determined only once, observance of the various precautions associated with colorimetry was feasible. The procedure by which the basic data were determined was substantially as follows. One half of the photometric field of a colorimeter was illuminated by a measured quantity of light of

approximately a single wavelength—400 nm, for example. An observer was then asked to determine the amount of each of three primaries required to make the two halves of the field match. Those amounts of the primaries are the tristimulus values for this quantity of light of that wavelength. The wavelength of the light was then changed, say to 410 nm. Again a color match was made and the tristimulus values were recorded. This process was continued until the entire visible spectrum was examined. In the report of the data, adjustment was made for the amount of energy of the wavelength that was used in each determination.[7]

Investigations of this sort were carried out by Maxwell,[8] by König and Dieterici,[9] and by Abney.[10] The results were chiefly of academic interest until 1922 when the Colorimetry Committee of the Optical Society of America summarized and republished them in a convenient form.[11] The publication of the OSA data was an important event in the development of the science of colorimetry. Before 1922, spectrophotometers were used only when the nature of the problem demanded a wavelength-by-wavelength analysis; colorimeters were used when only the evaluation of an equivalent stimulus was required. After the publication of the OSA data, it became feasible to compute tristimulus specifications, i.e., the amounts of three primaries whose combination would match a specimen, from spectrophotometric data. A spectrophotometer can now be made to do the work of both instruments, and the precautions, individual differences, and uncertainties associated with colorimetry can be avoided.

However, the OSA data were based on work that had been done when the experimental facilities were barely adequate. About 1928, Wright[12] and Guild[13] in England independently redetermined the fundamental data, each employing a number of carefully selected observers. When their results were reduced to a comparable basis, their data were found to be in good agreement with each other and in fairly good agreement with the OSA data. Because the subject had assumed considerable importance, the International Commission on Illumination (CIE) in 1931 recommended international agreement on them.[14]

Although supplementary data, based on extensive redeterminations by Stiles and Burch[15] (in England) and Speranskaya (USSR)[16] were recommended (in 1964) by the CIE[17] for optional use with samples that subtend 4° or larger visual fields, the 1931 CIE data are, half a century later, still recommended and generally used.

In the experiments by Wright, the primaries employed were spectrum colors whose wavelengths were 650, 530, and 460 nm. In Guild's experiments, on the other hand, the primaries were produced by passing light from an incandescent lamp through red, green, and blue filters. Each investigator determined the tristimulus values for the various spectrum colors in terms of the set of primaries that he had adopted.

Because Wright and Guild used different primaries, they obtained different tristimulus values. For the purposes of colorimetry, however, either set of data is adequate; the primaries are employed merely as intermediates in terms of which two colors can be compared. Any well-defined set of primaries is adequate; the advantage of one set over any other set reduces merely to a matter of convenience.

There is one complication common to the primaries used by both Wright and Guild. When matching the various spectrum colors, both investigators found it necessary to use negative amounts of at least one of the primaries. A negative amount of a primary is obtained, in effect, by diverting the light from one primary to the side of the field opposite that illuminated by the other two primaries. There it is combined with the radiation whose tristimulus values are being determined, in order to produce a mixture that can be matched by the other two primaries. Because of the presence of both positive and negative values, the results are in a form inconvenient for use in computation. It will be clear later that no set of real primaries can be found that will match all colors (including the spectrum colors) without employing negative amounts of at least one of the primaries. If negative tristimulus values are to be avoided, the primaries must be chosen outside the realm of real colors. Fortunately this is no hardship because, when the basic data have been determined for one set of primaries, the results that would have been obtained with any other set, real or imagined, can easily be calculated by a simple linear transformation,

$$\bar{r}' = k_1\bar{r} + k_2\bar{g} + k_3\bar{b}, \quad \bar{g}' = k_4\bar{r} + k_5\bar{g} + k_6\bar{b}, \quad \bar{b}' = k_7\bar{r} + k_8\bar{g} + k_9\bar{b},$$

where \bar{r}, \bar{g}, and \bar{b} are tristimulus values based on one set of primaries, \bar{r}', \bar{g}', \bar{b}' are tristimulus values based on another set of primaries, and $k_1, k_2 \ldots k_9$ are the tristimulus values of the first primaries on the basis of the second set of primaries. The transformation is called linear because \bar{r}, \bar{g}, and \bar{b} are used, not any functions of them, such as powers or logarithms.

The tristimulus values that were adopted by the International Commission on Illumination for the various spectrum colors are given in abridged form in Table 2.1 and are represented graphically in figure 2.9. The values of \bar{x}, \bar{y}, \bar{z} in Table 2.1 indicate the amount of each of the CIE primaries that is required to match the color of one watt of radiant power of the indicated wavelengths. That none of these values is negative results from linear transformation of the data of both Wright and Guild to a set of primaries that lie outside the gamut of real colors. Although, as mentioned before, the choice of primaries is essentially immaterial, it may assist the reader in the interpretation of CIE tristimulus values to have in mind some idea of the characters of those primaries. The value of X (which is conventionally designated \bar{x} in the case of spectrum colors) represents the amount of a reddish primary that has higher

Table 2.1
Tristimulus values of the spectrum colors (CIE 1931 color-matching data, per watt of indicated wavelength)

Wavelength [nm]	\bar{x}	\bar{y}	\bar{z}
400	0.0143	0.0004	0.0679
410	0.0435	0.0012	0.2074
420	0.1344	0.0040	0.6456
430	0.2839	0.0116	1.3856
440	0.3483	0.0230	1.7471
450	0.3362	0.0380	1.7721
460	0.2908	0.0600	1.6692
470	0.1954	0.0910	1.2876
480	0.0956	0.1390	0.8130
490	0.0320	0.2080	0.4652
500	0.0049	0.3230	0.2720
510	0.0093	0.5030	0.1582
520	0.0633	0.7100	0.0782
530	0.1655	0.8620	0.0422
540	0.2904	0.9540	0.0203
550	0.4334	0.9950	0.0087
560	0.5945	0.9950	0.0039
570	0.7621	0.9520	0.0021
580	0.9163	0.8700	0.0017
590	1.0263	0.7570	0.0011
600	1.0622	0.6310	0.0008
610	1.0026	0.5030	0.0003
620	0.8544	0.3810	0.0002
630	0.6424	0.2650	0.0000
640	0.4479	0.1750	0.0000
650	0.2835	0.1070	0.0000
660	0.1649	0.0610	0.0000
670	0.0874	0.0320	0.0000
680	0.0468	0.0170	0.0000
690	0.0227	0.0082	0.0000
700	0.0114	0.0041	0.0000

saturation than any obtainable red. The value of Y (or \bar{y} for a spectrum color) represents the amount of a green primary that is considerably more saturated but of the same hue as the spectrum color whose wavelength is 520 nm. The value of Z (or \bar{z}) represents the amount of a blue primary that is considerably more saturated than, but of the same hue as, the spectrum color whose wavelength is 477 nm.[18]

We now have the data necessary to evaluate the stimulus that is equivalent to the sample of green paint when the latter is illuminated with light that has the spectral quality of illuminant C and when the sample is viewed by the CIE 1931 standard observer. [...] In simplest form, the method consists of dividing the visible spectrum into a suitable number of equal wavelength intervals, determining the contribution

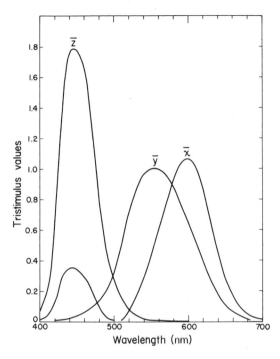

Figure 2.9
Tristimulus values per watt of indicated wavelengths, for CIE 1931 standard observer. These values for the spectrum are the CIE 1931 color-matching data.

to the tristimulus values made by the light within each interval, and summing the results. In the case of the green paint selected for illustration, the tristimulus values that result from that computational procedure are $X = 15.50$, $Y = 24.19$, and $Z = 22.64$. These values provide a measure of the stimulation in the sense that each number indicates the amount of one of the three primary stimuli that would be required for a color match if the CIE observer were to use a colorimeter that incorporated the CIE X, Y, Z primaries.

The computational procedure just indicated is unnecessarily tedious. [...] Spectrophotometers have been combined with computers that automatically perform the calculations, either simultaneously with spectrophotometry or after storage of the spectrophotometric data with any desired illuminant and observer data.

Photoelectric colorimeters have been designed for determination of tristimulus values without calculation. In these instruments, the response of a photoelectric detector to the light reflected from the sample is recorded when each of three filters is

placed in the beam. To yield valid results, the spectral transmission characteristics of the filters must be designed strictly with regard to the spectral energy distribution of the source and the spectral sensitivity of the detector, so that tristimulus values are either indicated directly or can be derived by linear transformation. Even if such an instrument were so constructed, it would give valid colorimetric results only as long as the spectral characteristics of the light source, detector, and filter did not change.

An instrument that consists of a photoelectric detector and a set of filters may be used for some purposes, even though it does not adequately determine tristimulus values. For example, in many problems a sample is to be compared with a standard that has very similar spectral reflection characteristics. The filters should preferably be selected in such a manner as to isolate the region or regions of the spectrum where departures of the sample from the standard are most likely to occur. The resulting instrument would not yield CIE tristimulus values but abridged spectrophotometric data.

5 Two Methods of Color Matching

The tristimulus values just given for the green paint represent a stimulus that is equivalent to the paint only when the paint is illuminated by light that has the spectral quality of illuminant C, when the sample is observed by the CIE standard observer, and when the observing conditions are like those used for determination of the basic CIE data. A green appears bluer on a yellow background and yellower on a blue background. Phenomena of this sort are important to artists and designers and also to those who try to understand the nature of the visual process.[19] In the vast majority of instances, however, the chief problem is to know how to indicate that a sample from one lot of material can be used interchangeably with a sample from another lot. If the tristimulus values are the same in the two cases, the two samples will be regarded as a match by a normal observer, in the sense that they may be used interchangeably under light that has the same spectral quality as was used for determination of the tristimulus values.

If the additional condition is imposed that the two samples must match for all observers under all conditions of illumination (including such extreme cases as illumination by light of a single wavelength), the two samples must have identical spectral reflection characteristics. Strictly speaking, the two samples must also be alike in all other respects. In particular, they must have identical surface structures and identical gloss characteristics.[20]

Occasionally, it is necessary to match the colors of materials that differ widely in some of their other characteristics. For example, it is sometimes desired to match the

color of a glossy automobile finish with the color of a pile upholstery fabric. It is impossible to make such materials so that they could be used interchangeably. The best that can be done is to produce a color match for some particular mode of illumination and observation. Experience has shown that samples of glossy and matte materials that have identical tristimulus values for diffuse illumination and normal observation are regarded as a commercial color match. [...]

6 Need for a Universal Color Language

Students of history agree that human progress was slow until language developed by which experience acquired by one person could be imparted to others. Until the development of spectrophotometry, there was no unambiguous basis upon which to build a universal language of color. Because spectrophotometers have been developed quite recently in the history of the uses of color, the existence of the instrument and the concepts associated with it are still unknown even to many who deal with color as a matter of daily routine. However, the spectrophotometric method is so straightforward that, as soon as people become familiar with the concept, they find it virtually impossible to think in any other terms. In fact, until they have sensed the possibility of a universal and unambiguous language of color, they are not likely to realize the handicap caused by the lack of such a language. It does not strike them as incongruous that, when purchasing almost any article, they can read and understand the specifications of all of its important physical characteristics (such as size and weight) but are unable to get even an approximate idea of its color without seeing a sample. To construct a color language on the basis of samples of colored materials is not a satisfactory solution of the problem, because samples are of questionable permanence and difficult to reproduce and distribute. On the other hand, spectrophotometry depends only on measurements of the wavelength of light and measurements of reflectance or transmittance, both of which can be determined with accuracy. Although tristimulus values do not provide so much information as spectrophotometric data, they are adequate for color matching and can be derived from spectrophotometric data by a straightforward computation procedure. They therefore provide a fundamental basis for a language of color.

7 Lightness

If two materials have identical tristimulus values, they constitute a color match under the conditions for which the tristimulus values were determined. However,

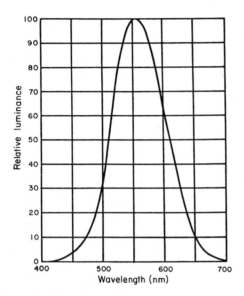

Figure 2.10
Luminosity of radiant power. One watt of any wavelength produces the indicated multiple of 683 lumens of light. The wavelengths of maximum luminous efficiency (1.0) is 555 nm. Luminous efficiency is substantially zero at 400 nm and 700 nm.

tristimulus values do not indicate in a readily comprehensible manner the nature of the color difference, when a difference exists. In a simple case, if two colors are represented by $X = 40$, $Y = 50$, $Z = 30$ and $X' = 20$, $Y' = 25$, and $Z' = 15$, respectively, it can be reasoned that the two colors are alike in chromatic quality, but that one is lighter than the other, in the sense that it reflects twice as much light. If the ratios of the tristimulus values are different, the comparison of lightness would be more difficult if it were not for the foresight employed when the basic CIE data were derived. Seven years before its 1931 meeting, the International Commission on Illumination obtained general agreement concerning the relative luminances, called *luminosities*, of equal amounts of energy at various wavelengths. These data are shown in figure 2.10. When the data obtained with the actual primaries used in the experiments of Wright and Guild were transformed by linear combinations to a set of primaries that avoided negative tristimulus values, those primaries were also chosen so as to make one of the three functions (the \bar{y} function given in table 2.1) exactly equal to the luminosities shown in figure 2.10. Hence, the relative luminance of a sample is indicated directly by the value of Y, on a scale that represents an absolute black by zero and a perfect white by 100. Thus, the green whose tristimulus

values are given in section 4 has a luminance relative to the white standard of 24.19%. That ratio is called the luminance factor.

8 Chromaticity Coordinates

The evaluation of the quality of a color (chromaticity) is accomplished by defining three new quantities:

$$x = \frac{X}{X + Y + Z} \tag{a}$$

$$y = \frac{Y}{X + Y + Z} \tag{b}$$

$$z = \frac{Z}{X + Y + Z}. \tag{c}$$

These quantities are called *chromaticity coordinates*. Only two of these quantities are independent, because

$$x + y + z = 1,$$

regardless of the values assigned to X, Y, and Z. Hence, to specify the chromaticity of a sample, it is only necessary to give the values of two of the coordinates; x and y are generally selected for this purpose. Instead of using the tristimulus values for color specification, more easily understood information is given if the color is specified in terms of Y, x, and y. As a practical example, compare the color considered in section 4, specified by $X = 15.50$, $Y = 24.19$, $Z = 22.64$ with another for which $X' = 25.26$, $Y' = 39.42$, $Z' = 36.89$. When these are specified in the new notation, they become, respectively, $Y = 24.19$, $x = 0.2487$, $y = 0.3881$, and $Y' = 39.42$, $x' = 0.2487$, $y' = 0.3881$. It is then apparent that the two colors have the same chromaticity; the difference between them is merely a difference of luminance factor. This relationship is not immediately evident from the tristimulus values.

9 Graphical Representation of Chromaticity

For the same reason that it would be very difficult to learn geography without the use of maps, it is impossible to understand the subject of color without some graphical representation of the relationships of various colors one to another. To represent tristimulus values graphically would require a three-dimensional structure; this

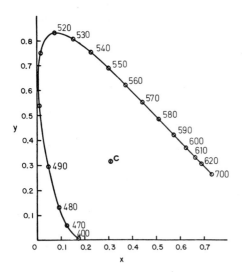

Figure 2.11
Chromaticity diagram, showing the locus of the spectrum colors and also the location of white in illuminant C.

spatial relationship is not clearly perceived and is mechanically impracticable. Chromaticity can be conveniently represented, however, merely by plotting the trichromatic coefficients, x and y, on a flat "map." This has been done in figure 2.11 for certain colors of outstanding interest. The solid curve is the locus of all of spectrum colors. This locus is determined by computing the chromaticity coordinates of each of the spectrum colors from the tristimulus values that were given in table 2.1. Thus, in the case of radiation that has a wavelength of 600 nm, the tristimulus values are $\bar{x} = 1.0622$, $\bar{y} = 0.6310$, and $\bar{z} = 0.0008$. From these, we can calculate that the chromaticity coordinates are $x = 0.6270$ and $y = 0.3725$. The tristimulus values of illuminant C can be determined, by a numerical integration process to be $X = 98.04$, $Y = 100.00$, and $Z = 118.12$. The corresponding coordinates, $x = 0.3101$ and $y = 0.3163$, locate the chromaticity of illuminant C.

The graphical representation in figure 2.11 is called the chromaticity diagram. Earlier graphical representations of colors employed trilinear coordinate systems, rather than the cartesian system that is used in figure 2.11. In trilinear coordinate systems, the primary stimuli appeared in the apices of an equilateral triangle, and the diagram was called a color triangle. The term still persists although it is not so appropriate in reference to the CIE x, y chromaticity diagram.

In the CIE chromaticity diagram, figure 2.11, the chromaticity coordinates of the primaries are $x = 1$, $y = 0$; $x = 0$, $y = 1$; and $x = 0$, $y = 0$.

10 Dominant Wavelength and Purity

A chromaticity diagram has one property that makes it of immense value in connection with the additive mixture of two or more colors. This property of the diagram follows directly from the fact that the tristimulus values of an additive mixture are the sums of the tristimulus values of the components. [...] The tristimulus specification is not adequate for calculation of the results of subtractive mixtures such as mixtures of dyes and pigments; in this case it is necessary to use spectrophotometric data.

In figure 2.12, suppose that a certain red is located at R and a certain green at G. Regardless of the proportions in which these colors are additively mixed, the resultant color will always lie on the line segment that joins R and G. [...] Because of this additive property of the diagram, all real colors must lie within the area enclosed by the solid line, because every real color can be considered to be an additive mixture of its spectral components. Furthermore, any real color that lies within the solid line

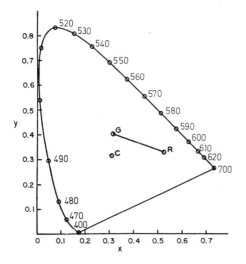

Figure 2.12
Additive mixtures of colors R and G lie on the line RG in the chromaticity diagram. Extension of this rule to all mixtures of spectrum colors shows that all realizable colors are represented by points within the region enclosed by the solid line. That region is called the gamut of chromaticities of real colors.

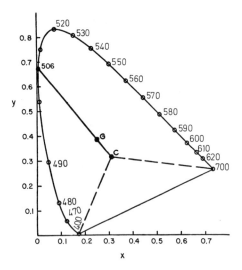

Figure 2.13
Green (G) may be produced by mixtures of illuminant C with 506 nm spectrum color. Its dominant wavelength is 506 nm.

but above the dashed line in figure 2.13 can be considered to be a mixture of illuminant C and spectrum light of a certain wavelength. For example, the green G whose tristimulus values were previously computed is shown to be a mixture of illuminant C and spectrum light that has a wavelength of 506 nm. This wavelength is known as the dominant wavelength. It was referred to previously without definition in connection with figures 2.1–2.6. Because green G lies on a line that terminates at a pure spectrum color at one end and at the illuminant point at the other end, the sample is evidently not so pure a green as the corresponding spectrum color. A numerical specification for the purity of this sample can be obtained by merely determining on the chromaticity diagram the relative distances of the sample point and the corresponding spectrum point from the illuminant point. In this case, the distance of the sample point from the illuminant point is 20% of the distance of the spectrum locus from the illuminant point. The sample is therefore said to have a purity of 20%.

The portions of the diagram that lie within the solid line but below the dashed line in figure 2.13 represent the purples or magentas. It is evident that purple cannot be obtained by mixing white light with a single spectrum color. Hence, an artifice is necessary if the concepts of dominant wavelength and purity are to be extended to the specification of purples. The artifice makes use of the principle that the comple-

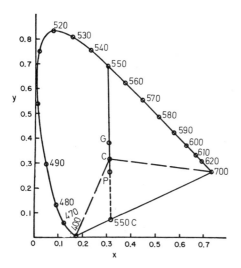

Figure 2.14
Purple (P) is characterized by the complementary wavelength, which is determined by extending the line PC until it intersects the spectrum locus. In this case, the complementary wavelength is 550 nm, which is written 550c to indicate the complementary.

ment of a color always lies on the opposite side of the illuminant point, on the line through the illuminant point. Thus, in figure 2.14 the complement of the purple P is green with a dominant wavelength of 550 nm. The wavelength that characterizes the purple P is generally written 550c, which is called the complementary wavelength.

The concept of purity is likewise inapplicable to a purple unless some arbitrary procedure is adopted. The most plausible procedure is to regard the lower boundary of the area of real colors as the locus of purples of highest purity. When a purity of 100% is assigned to each color that lies on this line, the purity of the color represented at P is found to be 21%.

Figure 2.15, which is a reduced-scale reproduction of Chart 23 from the *Handbook of Colorimetry*, is very useful for determination of dominant or complementary wavelength and purity, for the CIE 1931 observer and any preferred illuminant (white point). Figure 2.16, which is a reduced-scale reproduction of Chart 12A from the *Handbook of Colorimetry*, provides highly accurate evaluations of dominant and complementary wavelengths and purities for low-purity colors for the CIE 1931 observer and illuminant C. Figure 2.17, a reduced-scale reproduction of Chart 18, is an example of 22 large-scale charts in the *Handbook of Colorimetry* that facilitate determinations of all dominant and complementary wavelengths and purities for the

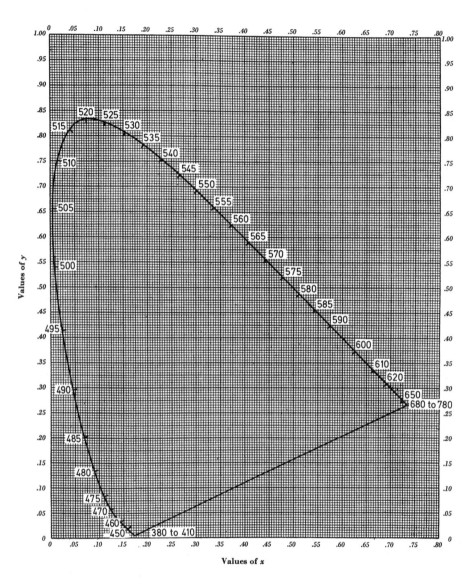

Figure 2.15
Chromaticity diagram for CIE 1931 observer.

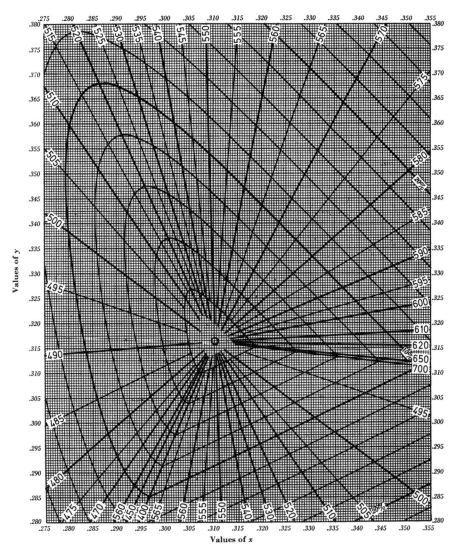

Figure 2.16
Portion of chromaticity diagram for CIE 1931 observer, showing dominant and complementary wavelengths and low purities, based on illuminant C.

Figure 2.17
Portion of chromaticity diagram for CIE 1931 observer, showing dominant wavelengths and purities in yellow region, based on illuminant C.

CIE 1931 observer and illuminant C. For those charts, the *Handbook of Colorimetry* is an indispensable tool for serious colorimetry.

The procedure of regarding every color as a mixture of illuminant C and spectrum light of some wavelength is the basis of the monochromatic-plus-white method of colorimetry. Visual colorimeters have been constructed in which one part of a two-part field of view is filled with the sample color that is to be measured and the other part is filled with a mixture of controlled amounts of white light and light of an adjustable wavelength. By adjustment of the wavelength and the luminances, the colors of the two parts of the field can be made to match. In the case of purple, the match is made by adding the spectral component (usually green) to the sample part of the field. In that sense, purple can be regarded as a mixture of white light and a negative amount of green light of the appropriate wavelength. In every case, the dominant or complementary wavelength of the unknown color is determined directly from the wavelength scale of the instrument. The luminance of the sample color is the sum (or, in the case of purple, the difference) of the luminance of the white and the luminance of the spectral component. In such colorimetry, purity is usually taken as the ratio of the luminance of the spectral component to the sum (or difference) of the luminance of the white and the luminance of the spectral component. Purity determined in this manner is called the *colorimetric purity*. Because the values of colorimetric purity are negative in the case of purple samples and the lines of constant purity on a chromaticity diagram are discontinuous near dominant wavelengths 400 and 700 nm, the definition of purity given previously is preferred. Purity, thus defined, in terms of ratios of distances on the chromaticity diagram, has been called *excitation purity* to distinguish it from colorimetric purity. Throughout this [chapter], the term *purity* will mean excitation purity. For reasons similar to those mentioned in connection with visual colorimeters in general, monochromatic-plus-white colorimeters are rarely used.

Table 2.2. may be of interest to those who are accustomed to associate color names with certain colors. In this table are listed the luminance factor, dominant wavelength, and purity of a few colors whose names have been used so widely that some degree of standardization of nomenclature has been achieved. This table is not intended as a dictionary for translation from one color language into another; neither is the table to be interpreted as an attempt to standardize color nomenclature. It is included merely to illustrate the reasonableness of color specification in terms of luminance factor, dominant (or complementary) wavelength, and purity.

The colors whose spectral reflectance curves were shown in figures 2.1–2.6 are specified in terms of luminance factor, dominant (or complementary) wavelength, and purity in table 2.3.

Table 2.2
Typical luminance factors, dominant (or complementary) wavelengths, and purities of a few common colors

	Luminance factors [%]	Dominant Wavelength [nm]	Purity [%]
Cardinal	9	617	55
Baby Pink	50	610	10
Old Rose	23	608	20
Blood Red	17	600	65
Maroon	7	600	35
Henna	8	587	60
Chocolate	5	586	30
Russet	12	585	45
Goldenrod	45	576	70
Ivory	55	575	25
Olive Green	14	572	45
Apple Green	35	568	40
Turquoise	32	500	30
Lupine	32	476	27
Slate	12	476	10
Navy Blue	3	475	20
Royal Purple	4	560c	50
Orchid	33	500c	16

Table 2.3
Luminance factors, dominant (or complementary) wavelengths, and purities of specimens whose spectral reflectances are shown in figures 2.1–2.6

Figures	Luminance Factor [%]	Dominant Wavelength [nm]	Purity [%]
2.1	24	506	20
2.2	33	483	31
2.3	63	576	80
2.4	32	595	87
2.5	13	619	60
2.6	46	550c	21

11 Color Tolerances

The value of an explicitly defined color language expressed in numerical terms is immediately obvious, but it is not always appreciated that such a language provides the solution to another important problem—namely, the specification of color tolerances. In every field where a system of measurement has been established, the custom of specifying tolerances has soon been developed. For example, no one conversant with machine-shop practice would submit a drawing that shows a set of dimensions without at the same time indicating the allowable departures from those dimensions. The machinist, in the absence of any information concerning the tolerances, would not know whether the part was intended to be used as a Johansson gauge, which may not deviate more than a micrometer (μm) from its nominal value, or whether the crudest machine work would be satisfactory. In the field of color, use of the expression "color match" without indication of the allowable departure is similarly ambiguous; it is the cause of a great deal of misunderstanding. A method of specifying color tolerances is also useful as a means of indicating the extent to which a color can be allowed to vary with time as a result of exposure to light or to some other deleterious agent.

The physical basis of color specification has been presented in some detail in order that the reader may be assured of the rigor of every step of the procedure. Some may be disappointed to find that it is based upon the use of a spectrophotometer as the fundamental measuring instrument. Such an approach is inevitable, because the eye is not analytical. Specification for color in terms of equivalent stimuli may at times be useful, but many color problems require the wavelength-by-wavelength analysis furnished by a spectrophotometer. Furthermore, the concepts associated with spectrophotometry are of considerable usefulness in themselves.

Notes

This chapter is an abridgment (with revisions and additions) of text in the *Handbook of Colorimetry*, which was prepared by the staff of the Color Measurement Laboratory of the Massachusetts Institute of Technology under the direction of Professor Arthur C. Hardy. I participated in its preparation. The handbook was published in 1936 by The Technology Press. It contained extensive tables and charts that are uniquely useful, especially for colorimetry with the CIE 1931 color-matching data and illuminant C. The abridgments have been revised and are included in this chapter by permission of The MIT Press.

1. For a discussion of operational definitions, see P. W. Bridgman: The Logic of Modern Physics (Macmillan, New York 1927).

2. Reflectance can depend on intensity of the incident beam in the case of *photochromic* materials, or when the intensity is so great that it burns or otherwise irreversibly changes the sample. Long periods of exposure to light can also cause irreversible changes of reflectance, which are usually referred to as *fading*. Fading is rarely encountered in modern spectrophotometric practice, because the measuring beams are not

very intense. Fading is usually accelerated, or even occurs in the absence of light, by high temperatures and/or high humidity, or exposure to other vapors. Photochromic changes are temporary; the rapidity and magnitudes of photochromic changes and the time required for recovery from them are proportional to the intensity of the exposing beam. The intensities and durations of exposure to the measuring beams in modern spectrophotometers are so low and short that appreciable photochromic effects are rare in spectrophotometry of materials ordinarily encountered. Photochromic glass is used in some sunglasses, and in industrial and military goggles. Those sunglasses darken on continued exposure to sunlight. The goggles darken rapidly on exposure to extremely intense light, as from nuclear explosions or lasers. An increasingly common example of photochromic change of color occurs in house paint that contains the rutile variety of titanium dioxide. Normally, being exposed continually to daylight, the paint is an untinted white, but paint fresh out of the can has a more or less distinct ivory or cream tint. That tint fades or bleaches in daylight to the white. But storm sash stored in the dark may revert to the cream or ivory over the summer and exhibit a dismaying mismatch when reinstalled. A few days in daylight restores the match by *photochromism*. A more expensive variety of titanium dioxide, anatase, is always white; it is not photochromic.

3. For use in double-beam spectrophotometers, or for calibrating single-beam spectrophotometers, actual white materials are used as working standards. Around 1930, freshly scraped blocks of magnesium carbonate were used. Later, the fresh surface of such blocks was coated with a 1- or 2-mm-thick layer of magnesium oxide, deposited as smoke from freely burning metallic chips or ribbon of magnesium. More recently, such a layer of MgO deposited in a 2-mm cavity machined in an aluminum plate has been widely used, because it is more durable and has constant reflectance as high as MgO on $MgCO_3$ throughout the visible spectrum. More durable and more easily prepared working standards of purified barium sulfate have also been used recently, in the form of disks prepared under pressure and a paint made with polyvinyl alcohol. A proprietary material named Halon® (Allied Chemical Corp.) has recently become available, with which very durable and high-reflectance working standards can be prepared very conveniently. Disks of beryllium oxide are available; they are extremely durable and easily cleaned to assure constant reflectance, although their reflectance is not quite so high as MgO, $BaSO_4$, or Halon®.

Whatever working standard is used should be calibrated by absolute reflectometry. Spectrophotometers determine the ratios of spectral reflectances of samples to the reflectance of the working standard. That ratio should be multiplied by the absolute reflectance of the working standard, to determine the absolute spectral reflectances of the sample. Because most laboratories lack means for determination of absolute reflectances of working standards, it is necessary to use very durable, accurately replaceable, and easily cleaned working standards of a type whose absolute reflectance has been determined in some standardizing laboratory, such as the US National Bureau of Standards, the National Physical Laboratory in Teddington, England, the National Research Council in Ottawa, Canada, or the Bundesanstalt für Materialprüfung in Berlin. Durability and precise interchangeability are more desirable attributes of such working standards than highest possible or constant reflectance.

In the most recent spectrophotometers, which incorporate computers, the absolute spectral reflectances can be stored and automatically multiplied by the measured ratios of the reflectances of samples and the working standard.

4. That a surface illuminated by a single wavelength will reflect light of only that wavelength is not true of fluorescent materials. In general, they also emit wavelengths longer than the illuminating wavelength. Such materials greatly complicate the concept and measurement of spectral reflectance. Those complications will not be discussed in this [chapter]. The problem is dealt with by F. Grum, C. J. Bartleson (eds.): *Optical Radiation Measurements, Vol. 2: Color Measurements* (Academic, New York 1980). Here, it is sufficient to state that the method presented in this [chapter] may be used to evaluate the color of the light received by the eye from any material, whether or not it is fluorescent.

5. The wavelengths indicated by the dashed vertical lines in figures 2.1–2.5 are the dominant wavelengths, which will be defined in section 10. The dashed line in figure 2.6 indicates the complementary wavelength, which will also be defined in section 10.

6. The initials (ICI) of the English translation of the name of the Commission Internationale de l'Eclairage are frequent in the literature of colorimetry from 1932 until about 1950. The initials (CIE) of the official French name have generally been used more recently, although IBK (the initials of the German name)

and MKO (the initials of the Russian name) are still encountered. The initials CIE will be used in this [chapter].

7. This account of the fundamental experiments of colorimetry is schematic and greatly simplified. It is valid in principle and adequate for this discussion. Complicating details of procedure and results, some of which will be mentioned later, are of more concern in relation to the psychology and physiology of color vision than for colorimetry.

8. J. C. Maxwell: On the theory of compound colours and the relations of the colours of the spectrum. Proc. Roy. Soc. London **10**, 404, 484 (1860); Phil. Mag. (4) **21**, 141 (1860); *Scientific Papers* (Cambridge Univ., Cambridge 1890) pp. 149, 410.

9. A. König, C. Dieterici: Die Grundempfindungen in normalen und anomalen Farbensystemen und ihre Intensitätsverteilungen im Spektrum. Z. Psychol. Physiol. Sinnesorg. **4**, 231 (1892); A. König: *Gesammelte Abhandlungen* (Barth, Leipzig 1903) p. 214.

10. W. deW. Abney: The colour sensations in terms of luminosity. Phil. Trans. Roy. Soc. London **193**, 259 (1905).

11. L. T. Troland: Report of Committee on Colorimetry for 1920–21. J. Opt. Soc. Am. **6**, 527–596 (1922).

12. W. D. Wright: A redetermination of the trichromatic coefficients of the spectral colours. Trans. Opt. Soc. London **30**, 141–164 (1928–29).

13. J. Guild: The colorimetric properties of the spectrum. Phil. Trans. Roy. Soc. London **A230**, 149–187 (1931).

14. CIE *Proceedings 1931* (Cambridge Univ., Cambridge 1932) p. 19.

15. W. S. Stiles, J. M. Burch: NPL colour-matching investigation, final report. Opt. Acta **6**, 1–26 (1959).

16. N. I. Speranskaya: Determination of spectrum color coordinates for twenty-seven normal observers. Opt. Spectrosc. (USSR) **7**, 424–428 (1959).

17. CIE *Proceedings 1963*, Bureau Central de la CIE, 52, Boulevard Malesherbes, 75008 Paris, France. If copies are available, they may be obtained from K. Mielenz, Secretary USNC/CIE, National Bureau of Standards, Washington, D.C. 20234.

18. Specification of hue in terms of wavelength is not strictly correct. The wavelengths mentioned here are dominant wavelengths, which are defined in section 10. In the present instances, the straight lines drawn from the white (illuminant C) point to the points on the spectrum locus of the wavelengths mentioned are extended beyond the spectrum locus to the points that represent the green and the blue primaries (at $x = 0$, $y = 1$ and $x = y = 0$, respectively). The "red" primary, at $x = 1$, $y = 0$ does not have a dominant wavelength. It has the complementary wavelength 496 nm.

19. Simultaneous color contrast is discussed in G. A. Agoston: *Color Theory and Its Application in Art and Design*, Springer Series in Optical Sciences, Vol. 19 (Springer, Berlin, Heidelberg, New York 1979) pp. 5, 61.

20. Gloss and other appearance characteristics are discussed by Richard S. Hunter: *The Measurement of Appearance* (Wiley, New York 1975).

III PHYSIOLOGY AND PSYCHOPHYSICS

3 Chromatic and Achromatic Response Functions

Leo M. Hurvich

Chromatic and Achromatic Response Functions

It should be clear by now that object color is not physical light radiation itself, that it is not something that inheres in objects, having to do exclusively with the chemical makeup of the object, nor is it only the nervous excitation that occurs in the eye and brain of an observer. In our perception of object color all these elements are involved: there is light radiation, which is selectively absorbed and reflected in different ways by objects that differ physically and chemically; when the light rays coming from objects are imaged on the retina, they set off a complex series of neural events that are associated with the visual experience of color.

Color perceptions are assumed to provide a direct readout of the net effect of particular activities in the nervous system. Thus the appearance of the spectrum at different wavelength regions is related to the activation of the different relevant neural processes. For example, if the region at 440 nm looks bluish red, we assume that two different neural processes, one related to blueness, the other related to redness, have been activated; if at 550 nm the spectrum looks yellowish green, two still different neural processes, one related to yellowness, the other related to greenness, have been activated; and so on. Furthermore, since the different regions of the spectrum do not appear equally bright or white, we must also look for different degrees of excitation of whiteness-related neural processes by different spectral lights, in addition to the excitation of the various neural processes associated with the hues. For example, the 440-nm region has very little perceived whiteness along with the bluish-red appearance, as compared with the 550-nm region, which is seen as a very whitish yellow-green. Thus according to our assumptions, the "white/black" neural process is excited less by a 440-nm spectral light than it is by a 550-nm spectral light.

But a 410-nm spectral stimulus, like the 440-nm one, looks bluish red; and a 530-nm spectral stimulus, like the 550-nm stimulus, looks yellowish green. Thus the 410-nm and 530-nm stimuli must also excite the same neural processes as do the 440-nm and 550-nm stimuli, respectively. In fact, very many spectral stimuli excite the same neural processes. For example, all wavelengths from 440 nm to about 470 nm appear to be made up of blues and reds. If we look closely, however, the perceived proportions of blue and red differ; the 400-nm stimulus is redder than the 470-nm stimulus.

Is there some way we can *measure* how much of each "hue response" is present at each spectral position? Precisely how much blueness and redness does a unit of stimulus energy (measured at the front of the eye, the corneal surface) produce at

400 nm? at 420 nm? at 470 nm? How much greenness and yellowness at 520 nm? at 540 nm? at 560 nm? The same question can be raised about whiteness (and blackness).[1] Can we measure how much whiteness the various wavelengths in the visible spectrum produce? More generally stated, can we measure the relative magnitudes of the chromatic and achromatic processes throughout the spectrum? The answer is yes, and the experimental procedure used to measure the chromatic processes is based on the fact that the hue pair red/green and the hue pair yellow/blue are opponent or antagonistic. Both members of any one pair are not seen simultaneously in the same place.

If we consider a short-wavelength stimulus, say, 420 nm, we know that it is seen as having a certain amount of blueness. If we increase the amount of energy of this stimulus, the amount of blueness increases. The same is true of a different short-wavelength stimulus, say 440 nm. It, too, has a bluish appearance, and the amount of blueness increases with an increase in energy. But if we take a unit of energy of each of these two short-wavelength stimuli, we find that the amount of blueness differs. How shall we measure the amount of blueness there is in each instance? Since we know that a long-wavelength stimulus, say 580 nm, has a certain yellowness at an arbitrary energy value and that the yellowness increases as the energy increases (just as blueness does with an increase in energy), and since we know that yellowness is opposite to blueness, it is possible to intermix the 580-nm stimulus with fixed amounts of short-wavelength stimuli and, by varying the energy of the 580-nm yellow-appearing stimulus, cancel the blueness seen in the short-wavelength stimuli.

The procedure is a *null method*. It might also be called a *cancellation* (or "bucking") *technique*. The measure of a given chromatic response is obtained by determining how much of the antagonistic response is necessary to "zero" or "null" the system to an equilibrium position.

Null methods are very common in physics; the simplest example is the balance scale. To determine the weight of an unknown object placed in one of the scale pans, weights of known values are added to the other scale pan until a balance or null position is reached. Once equilibrium is reached, the unknown can be precisely specified in terms of the known. The principle also finds wide application in electrical measures. To measure voltages, for example, potentiometers are used whereby the unknown voltage to be measured is evaluated by the amount of known specified voltage required to balance the current flow to zero. Similarly, with a Wheatstone bridge, resistance can be adjusted in the circuit to evaluate one of unknown value (figure 3.1).

These analogies only illustrate the null principle, since physical quantities balance physical quantities. In the perceptual situation, physical quantities (wavelengths,

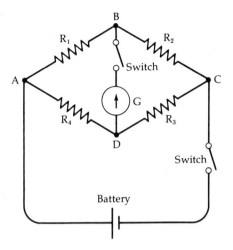

Figure 3.1
The Wheatstone bridge provides a way to measure an unknown electrical resistance. When there is no current flowing through bridge wire BD and the galvanometer registers a zero or null response, the arms of the two bridges are in balance: $R_1/R_4 = R_2/R_3$. If R_1 is an unknown resistance, R_2, R_3, and R_4 are adjusted by known amounts to balance the current to zero and thus R_1 can be determined in accordance with the equation given.

light energies) are used and measured, but the balancing or nulling is done in the visual system, with the perceptual response serving as the meter.

Let us be more specific. I have described the appearance of the spectrum, in which the hues normally range from a violet (reddish blue) at one end, through blue, blue-green, green, yellow-green, yellow, reddish yellow, and slightly yellowish red at the other end. We first restrict ourselves to the long-wavelength end of the spectrum, where we see red-yellows, yellows, and green-yellows, and set ourselves the task of measuring the amount of yellow chromatic response in this region. By means of a monochromator, which permits us to isolate narrow spectral bands, we will isolate the region centered on 510 nm and look at it through the eyepiece of a short-focus "telescope." What we see is a small field that looks roughly like the full moon on the horizon but is uniform in color; it is mainly green with a slight tinge of yellow. By means of a transparent mirror standing at 45 degrees to the beam of light coming from the first monochromator (I), we introduce and intermix with this beam the light that comes from a second monochromator (II) to the right of the observer (figure 3.2; monochromator III is not used in these experiments). The wavelength drum of this second instrument is fixed in one wavelength position. It is fixed at, say, 475 nm, which appears to the observer to be a blue that is neither reddish nor

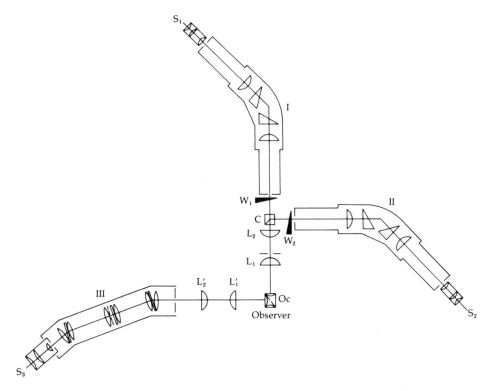

Figure 3.2
Optical system with three monochromators is depicted in the diagram above. Monochromators I and II mix lights in cancellation or nulling experiment; monochromator III is not used in these experiments. S = sources; W = wedges to vary light energies; L = lenses; C = mixing cube; Oc = ocular.

greenish (i.e., what I am calling a "unique" blue). To measure the amount of yellow process produced by the 510-nm stimulus of monochromator I, the observer is asked to adjust a light-absorbing wedge that varies only the energy of the fixed-wavelength (475 nm) blue-appearing light until he reports that the yellow originally seen in the yellow-green field is canceled. If too much energy of the 475-nm stimulus is introduced, the observer will see a bluish-green field, if too little is introduced, he will see a yellowish-green one. We now record the amount of 475-nm light that is used to just balance the small amount of yellow seen in the 510-nm stimulus. When the blue just cancels the yellow, what is the appearance of the test field?

Now we replace the 510-nm stimulus of monochromator I with an equally bright 520-nm stimulus. The latter appears slightly more yellowish green than the 510-nm field did. We again intermix the 475-nm blue stimulus coming from monochromator

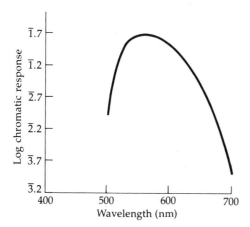

Figure 3.3
Amount of yellow response in the spectrum between wavelengths 510 and 700 nm. Logarithmic representation.

I with the 520-nm stimulus and determine (by adjusting the energy) how much of 475 nm is now needed to cancel or "null out" the yellow in the 520-nm stimulus. It turns out that we need a little more of the 475-nm stimulus than we used for the 510-nm situation. We can proceed to make measurements of the amount of 475 nm needed to null out the yellow in 530 nm, 540 nm, 550 nm, 560 nm, 570 nm, and so on, to the end of the spectrum at 700 nm. (We could, of course, make our measurements at any wavelengths in this part of the spectrum—510 nm, 511 nm, 514 nm, 541 nm, and so on—but our interest is in the form of the spectral yellow-response curve and measurements made at equal 10-nm steps are convenient and not too widely separated to trace out the form of the curve.) Note that with the 580-nm stimulus, which evokes a whitish-yellow appearance that is neither reddish nor greenish, the intermixture with it of 475 nm (a blue) leaves as a perceptual remainder a whitish- or grayish-appearing field. Beyond 580 nm, to the end of the spectrum at 700 nm, the initial stimulus fields coming from monochromator I look reddish yellow, red-yellow, then yellowish red. When the amount of 475 nm that is needed to just balance or cancel yellow has been added at these wavelengths, the observer finds himself or herself looking at test fields that are slightly reddish in hue. For all wavelengths where the amount of yellow response is measured by canceling it with blue, the end point is a test field that is neither yellow nor blue in appearance.

In figure 3.3 a graphical representation is given of the amount of yellow response in the spectrum between the wavelengths 510 nm and 700 nm. The curve shown is, of

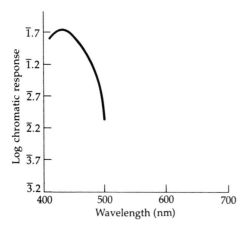

Figure 3.4
Amount of blue response in the spectrum between wavelengths 400 and 490 nm. Logarithmic representation.

course, a plot of the amount of the 475-nm stimulus required to produce the equilibrium state: the state that is neither yellow nor blue. We are simply assuming that the amount of yellow response that was canceled at each wavelength is proportional to the amount of the opponent stimulus (the blue-appearing 475-nm stimulus) necessary to cancel the yellow.

We now carry out a similar set of observations, but this time place in the viewing field wavelengths that range from 490 nm down to 400 nm. This series of stimuli is provided by monochromator I. Each stimulus is adjusted to look equally bright to the observer. They will vary in appearance from bluish-green hues to bluish-red ones.

For example, let us place a 490-nm stimulus in the field. We then add a 580-nm stimulus from monochromator II to the field. The 580-nm stimulus by itself looks uniquely yellow (i.e., it has no red or green) and we intermix it with the 490-nm bluish-green–appearing wavelength. The amount of the 580-nm light is then varied until the test field is judged to look neither blue nor yellow. What will the test field look like?

We then place a 480-nm stimulus in the field and repeat the canceling procedure, recording the amount of the 580-nm stimulus used for balancing. Then 470 nm, 460 nm, 450 nm, and so on, are used in turn. When the mixed field in each instance looks neither yellow nor blue, we have a measure of the blue chromatic response as given by the amount of the yellow-appearing 580 nm used for balancing it out. This curve looks as shown in figure 3.4.

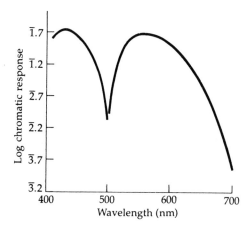

Figure 3.5
Amounts of yellow and blue responses throughout the visible spectrum. Logarithmic representation.

Since both the 475-nm and 580-nm stimuli are common to each set of the chromatic functions shown in figures 3.3 and 3.4, the separate "yellow" and "blue" curves can be combined in one graph as in figure 3.5 by an appropriate adjustment of their relative heights.

The relative response values are plotted in logarithmic steps in figures 3.3, 3.4, and 3.5. Logarithmic steps are geometric steps progressing as do the numbers 1, 2, 4, 8, 16,..., or 1, 10, 100, 1000,.... We can convert the logarithmic steps to simple arithmetic ones, as in the progression 1, 2, 3, 4, 5, 6,..., and we have done this in figure 3.6. One of the two chromatic response curves can, at the same time, be represented as having negative values and the other one as having positive ones. The plus and minus values express the opposition between the paired response systems and the fact that when lights that would separately excite both processes are mixed, their simultaneous action is a subtractive one. Plotted in this way, the yellow and blue hue responses are distributed in the visual spectrum at each measured wavelength, as shown in figure 3.6.

The fact that "blue" is shown here as negative is strictly arbitrary and has no particular significance. We could, if we chose, reverse the signs of the two curves and treat the yellow portion as negative and the blue as positive. The important point is that blue and yellow are opposite or antagonistic, and this is expressed by assigning negative values to one limb and positive values to the other limb of the combined curve. The nervous system processes are in each instance real and represent some sort of electrochemical activities of the nervous system—activities, however, whose natures are opposite in their physiological properties.

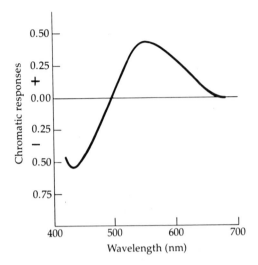

Figure 3.6
Amounts of yellow and blue responses throughout the visible spectrum. Arithmetic representation. Yellow
is arbitrarily assigned plus values and blue negative values to indicate their opposition.

The wavelengths between 500 and 700 nm are not only yellow-appearing; they
look greenish yellow from about 500 to 570 nm and reddish yellow from about 590
to 700 nm. The spectrum at the short-wavelength end from 400 to about 470 nm
or so looks reddish as well as blue. To measure the amount of red there is at these
various wavelengths we simply use the cancellation principle already outlined. We
repeat the presentation, one at a time, of individual wavelengths that look reddish
blue or reddish yellow and intermix with them a green-appearing stimulus of, say,
500 nm, whose energy is varied until cancellation is achieved. Figure 3.7 shows how
the redness response or process is distributed in the spectrum.

We proceed in similar fashion to measure the green response. For the cancellation
stimulus a long-wavelength stimulus, say 700 nm, is used.[2] This response function is
shown in figure 3.8 and the combined red/green function is shown in figure 3.9. In
figure 3.10 the red/green function is converted to arithmetic values and red is arbi-
trarily labeled positive and green negative.

Let us now combine the separate graphs of figures 3.6 and 3.10 in a single graph.
The two sets, the yellow/blue chromatic response function and the red/green chro-
matic response function, are shown in figure 3.11. Their relative heights are adjusted
at that wavelength where redness and yellowness are judged to be equal.

What about the achromatic aspect of the spectral stimuli? How does it vary across
the spectrum? Most objects are characterized as having both chromatic and achro-

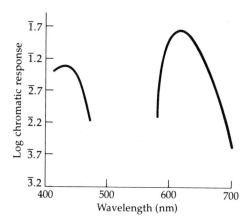

Figure 3.7
Amount of red response in the spectrum between 590 and 700 nm and between 400 and 470 nm. Logarithmic representation.

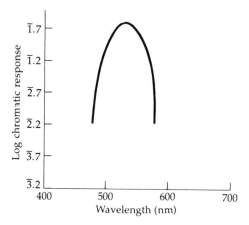

Figure 3.8
Amount of green response in the spectrum between wavelengths 480 and 580 nm. Logarithmic representation.

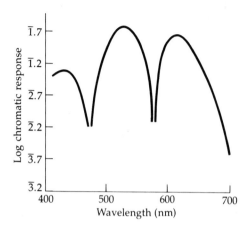

Figure 3.9
Amounts of red and green responses throughout the visible spectrum. Logarithmic representation.

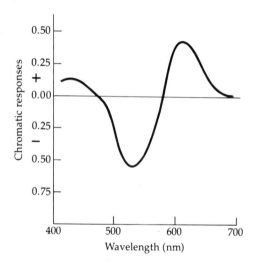

Figure 3.10
Amounts of red and green responses throughout the visible spectrum. Arithmetic representation. Red is arbitrarily assigned plus values and green negative values to indicate their opposition.

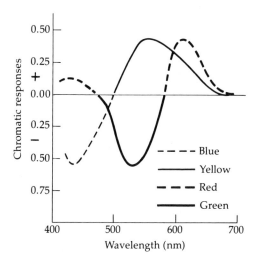

Figure 3.11
Yellow/blue and red/green response functions throughout the visible spectrum combined in a single graph.
Arithmetic representation.

matic aspects; in addition to their hue qualities, all objects are also seen as having
some degree of whiteness, grayness, or blackness. In referring to spectral stimuli they
can be seen to contain various degrees of whiteness. For example, when I referred to
a stimulus at 580 nm, I called it a whitish yellow. It is also true that the yellowish-
green and greenish-yellow midspectral stimuli seem relatively whitish when compared
to the extreme violets (reddish blues) and yellow-reds of the two spectral extremes. In
this respect, then, the spectral hues are very much like some object colors.

What about the blackness of spectral stimuli? When spectral lights or, for that
matter, broad-band light distributions are seen in isolation, they look like glowing
lights and contain no blackness.

The blackness response *cannot* be produced by direct light stimulation applied on
a given retinal locus. Blackness responses are obtained indirectly, as it were. We
could see an isolated spectral light go black if we surrounded it with very intense
illumination. One way to produce a black response in a given part of the visual field
is to stimulate a neighboring region with a stimulus that looks white. Another way is
to stimulate the eye with the white-appearing stimulus and then remove it or block it
out. We can produce blackness in the small center field by rotating the upper stim-
ulus field toward the incoming light and thus increase the relative amount of light on
the area surrounding the small field. Similarly, when afterimages are produced, it is
the sudden cessation of "white" light stimulation that produces a black afterimage.

Blackness is not evoked by the direct action of light from any particular portion of the spectrum; blackness does result indirectly from the contrast between stimuli (one of which is "white") presented side by side to different places on the retina. It also results at the same place on the retina when "white" stimulation is terminated.

The whiteness response of spectral stimuli is approximately equivalent to spectral brightness.[3] I have already said that we can measure the way whiteness is distributed in the spectrum, separately from the chromatic components, red/green and yellow/blue, and there are a number of ways to do this. We cannot use the null procedure to do this because, as we have just seen, there is no way of directly varying a stimulus to generate blackness. Other techniques have to be used to measure the whiteness response.

One way to obtain a measure of the whiteness distribution for the bright-adapted state of the eye is to measure the light threshold at various wavelengths throughout the spectrum, for example at every 10 nm.[4] A light-threshold measure is simply a measure of the amount of energy necessary at a given wavelength for the observer to *first* detect the stimulus. In the actual experiment one common procedure is to expose briefly the stimulus at a level of energy at which it is not visible and to gradually increase the light energy until the observer reports a flash of light. When the stimuli are first seen, they tend to be reported as without hue, or as achromatic (i.e., gray or white). It has therefore been assumed that when the stimulus is first seen at the threshold, the white (black) system has been tapped to the exclusion of the chromatic system. What does a "whiteness" curve measured in this way look like? The answer is given in figure 3.12, where the reciprocal of the threshold energy is plotted against wavelength. This reciprocal measure is a measure of sensitivity and thus indicates that there is relatively more "whiteness" response in the midspectral region than at the spectral extremes. But more than that, the form of the curve shows precisely how "whiteness" is distributed throughout the spectrum: it is low at the spectral extremes and relatively high in the midspectral region.

Another way in which the whiteness curve can be measured is by making what are called *heterochromatic brightness matches*. This method, which involves making brightness matches between fields that differ in hue, is not an easy one. One half of a circular test field contains a standard that looks, say, yellowish green. The other half contains one of a series of violets, blue-greens, oranges, and so on, and, as we just saw, the amount of hue varies from one wavelength to the next. Whiteness must be abstracted from these other qualities in order for the observer to make the match between the yellowish-green standard and the other stimuli. This can be done, and probably the best approach to making the abstraction is to minimize the clarity of the apparent border between the two fields.

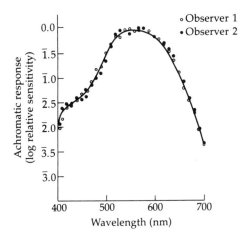

Figure 3.12
Whiteness response in the visible spectrum for two observers. Reciprocal of energy necessary to first perceive light represents the achromatic or whiteness response. This is sometimes referred to as a measure of spectral light sensitivity and is also called the luminosity function.

In addition to threshold measures and heterochromatic brightness matching, other indices have been used to measure the *luminosity function*, as this curve is now most frequently called. For example, measures of pupillary size, visual acuity, and flicker perception have also been used to specify this curve. The general form of the curve remains approximately the same for all criteria (figure 3.13).[5]

The spectral luminosity function, shown in logarithms of energy, can also be plotted in arithmetic values. This curve appears in figure 3.14.

If this is the way whiteness is distributed in the spectrum, we can superimpose this curve on the chromatic response curves of figure 3.11. Combined in a single figure, the chromatic and achromatic (whiteness) functions then look as shown in figure 3.15.

One final point: all the measurements referred to in this chapter are made with the observer in a "neutral equilibrium state of adaptation." The observer usually sees the test fields after remaining in the dark for a short time, say 10 minutes. Spectral lights change their appearance when the observer is first "adapted" or exposed to various chromatic background fields. Under these conditions it becomes impossible to obtain meaningful measures of the chromatic response functions.

Chromatic and Achromatic Response Functions and Appearance of Spectral Lights

Knowledge of the precise forms and spectral distributions of the red/green, yellow/blue, and white/(black)[6] response functions enable us to understand the appearance

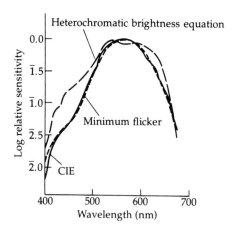

Figure 3.13
Whiteness response in the visible spectrum obtained with alternative techniques. (a) Heterochromatic brightness matches. (b) Flicker. The standardized curve labeled CIE (Commission International d'Éclairage) was obtained with yet a different method, called step-by-step brightness matching.

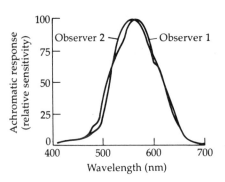

Figure 3.14
Whiteness response in the visible spectrum for two observers. Arithmetic representation.

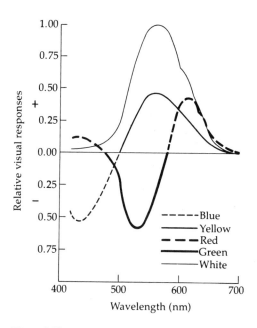

Figure 3.15
Chromatic (yellow/blue and red/green) and achromatic responses (whiteness) throughout the visible spectrum. One observer. Arithmetic representation.

of the variety of narrow- and broad-band stimuli. We need only assume that these functions represent the way the physiological neural mechanisms respond to spectral light stimulation, that they correlate directly with perception, and that the response effects produced by individual wavelengths sum in algebraic fashion when more than single wavelengths make up the stimulus.

On inspection these functions tell us what color is associated with any given wavelength. For example, at 450 nm in figure 3.15, the value for red is +0.08, blue −0.44, and white +0.04; the response at 450 nm is thus a reddish blue that contains more blue than red and is also a little whitish. At 520 nm, to take another example, the responses evoked are yellow, +0.23; green, −0.58; and white, +0.65. This is a whitish, yellowish-green–appearing stimulus that contains more green than yellow and more white than the 450-nm stimulus. At 640 nm we have red equal to +0.23, yellow equal to +0.12, and white equal to +0.26. This is slightly yellowish red and less white than the 520-nm stimulus. The chromatic and achromatic values can, of course, be read off these curves at any wavelength of interest.

We have discussed the unique hues several times earlier and noted their use in measuring the chromatic response functions. The individual wavelengths that evoke

unique hues are given directly in figure 3.15. Look at wavelength 475 nm. Notice that here the red/green chromatic response function intersects the ordinate at the value zero. At this red/green balance position the blue response equals −0.30; thus the 475-nm stimulus sets off a blue response that is neither red nor green, although we see that it does have some whiteness (about +0.08). At 500 nm on the wavelength scale we find that the yellow/blue response function is in balance at the zero ordinate value and green equals −0.24 and white equals +0.22; at 580 nm the red/green function again intercepts the zero baseline, and here yellow equals +0.40 and white equals +0.95. There is no single wavelength in this graphical representation of the response functions that evokes a redness response alone in the complete absence of either a blueness or yellowness response. Thus there is no single spectral stimulus that evokes a unique red response. This fact was known to Newton and to Goethe, the German poet, dramatist, and naturalist, whose scientific interests took him into problems of color and color vision. Even the most extreme long wavelength used, say 700 nm, stimulates some yellow (and white) response, however small, along with the red process.

Mixtures of pairs of spectral stimuli can also evoke the unique hues blue, green, and yellow. The unique blue hue evoked by 475 nm (for an average standardized observer) can be matched by mixing on the retina two wavelengths, say 440 nm and 490 nm; unique green evoked by 500 nm can be matched by intermixing two wavelengths, 490 nm and 540 nm, and unique yellow produced by 580 nm can also be matched by intermixing two wavelengths, 540 nm and 670 nm.

The intermixing of the different stimuli is a simple matter. The superposition or additive light mixture of the different spectral stimuli can be efficiently done with an apparatus such as that shown in figure 3.2. The individual wavelengths used for the mixture come from the two monochromators I and II and are simply imaged on the same retinal area as in the experiments described for the measurement of the chromatic response functions. By introducing the third monochromator (figure 3.2) we can compare the mixture of two spectral lights with lights from monochromator III, which is used to provide a surround field for the intermixed stimulus pair. The principle underlying the generation of unique hues by mixing pairs of wavelengths is precisely the same as that of the cancellation experiments described at length earlier.

If we look at the response functions in figure 3.15, we see that wavelength 440 nm excites the blue, red, and white processes; 490 nm excites the blue, green, and white processes. By manipulating the relative energies of wavelengths 440 and 490 nm, the red and green opponent systems can be brought to a balanced state of equality. When this is achieved we are left with a net excitation of blue (and white). If we

consider two wavelengths, one on the shorter side of 500 nm—490 nm—and one on the longer side of 500 nm—540 nm—we see in figure 3.15 that the latter excites the green, yellow, and white processes. Here, too, then, by appropriately varying the relative energies of the 490-nm and 540-nm stimuli, and precisely balancing the blue and yellow excitations to equality, we are left with a remainder that corresponds to the unique green hue, but one that is somewhat whiter than that produced by the single wavelength 500 nm. (A unit of energy at 500 nm has a white response of 0.22; unit energies at 490 and 540 nm sum to 1.04 of white response. The 1.04 comes from a 490-nm value of +0.13 and a 540 value of +0.91.) Finally, the two wavelengths 540 and 670 nm, located one on the shorter side of 580 nm, the other on the longer side of 580 nm, evoke yellow, green and white, and yellow, red and white responses, respectively. When the green and red processes are balanced by adjusting the relative intensities of 540 and 670 nm, the outcome is a unique yellow hue.

Many combinations of two different wavelengths will generate a unique hue just as long as one member of the wavelength pair lies on the shorter-wavelength side and the other on the longer-wavelength side of the single wavelength that evokes the unique hue. The proportions of the components entering into the mixture will, of course, differ for different wavelength pairs.

If, for example, we were to mix 670 nm and 540 nm to evoke a unique yellow, it would be necessary to balance the red and green responses. Since

1 unit of energy of 670 nm → 0.06 red

1 unit of energy of 540 nm → 0.55 green

we would have to increase the 670-nm stimulus by a factor of about 10 to balance red and green. If instead of 540 nm we were to use 560 nm and mix it with 670 nm, then since

1 unit of energy of 670 nm → 0.06 red

1 unit of energy of 560 nm → 0.30 green

then we would need to increase the 670-nm stimulus energy only by a factor of about 5.0 instead of 10.

The proportions of any other stimulus pairs, say, 620 nm and 540 nm or 610 nm and 560 nm, can be determined in the same way. The fact that different stimulus pairs when mixed evoke different amounts of yellow and white is, of course, a matter of indifference. In all cases the outcome will be a unique yellow since neither red nor green will be visible in any instance.

As we noted above, there is no single spectral stimulus that gives a unique red hue: extremely long wavelengths are yellowish red, and extremely short ones are bluish red. How would one go about generating a unique red hue?

Many pairs of spectral stimuli are complementary (i.e., when mixed in a proper energy ratio, many pairs of wavelengths lead to an achromatic or white appearance). We are now in a position to examine the chromatic and achromatic response curves to see how this comes about.

The most obvious wavelengths to start with are 475 nm and 580 nm. As we have seen, only blueness and whiteness are stimulated by 475 nm, and 580 nm is the wavelength associated with the unique yellow sensation, a yellow that is somewhat whitish in appearance. By intermixing these two wavelengths on the retina and adjusting the relative energies of the two stimuli, we balance the blue excitation with an equal amount of yellow, and the remainder, or *net excitation*, is the sum of the two white excitations produced by each of these wavelengths. Thus 475 nm and 580 nm are complementary wavelengths. If we were to intermix 470 nm (a red, blue, white) with 580 nm, there is no greenness in 580 nm necessary to balance the red evoked by 470 nm. Similarly, if we move to 480 nm (a green, blue, white), there is no redness in 580 nm necessary to balance the green in 480 nm. Many other pairs of spectral stimuli that do not evoke unique hues are also complementary.

Thus if the wavelength 460 nm evokes a red response for unit energy equal to +0.05, a blue response equal to −0.35, and a white response equal to +0.05 unit, the wavelength that is complementary to it will have to evoke a green response of −0.05, and a yellow response of +0.35. Since red and green responses are opponent, they are represented by plus and minus values, respectively, and the same is true of yellow and blue. The situation can be represented in algebraic from as follows:

For 460 nm:	+0.05 red;	−0.35 blue;	+0.05 white
Complementary wavelength:	−0.05 green;	+0.35 yellow;	$+x$ white[7]
Sum:	0.0;	0.0;	$+0.05 + x$

In short, the redness response evoked by 460 nm is exactly canceled by the greenness evoked by an appropriately selected stimulus, and the blueness also evoked by 460 nm is also exactly canceled by the yellowness evoked by this same stimulus. Since both stimuli excite a whiteness response that is not balanced by an antagonistic response, these excitations sum and remain effective in generating the white perception.

Precisely the same reasoning applies to all other complementary wavelength pairs. Calculations show that all complementary wavelengths are simply those that evoke equal amounts of opponent chromatic responses. In all cases the net effective re-

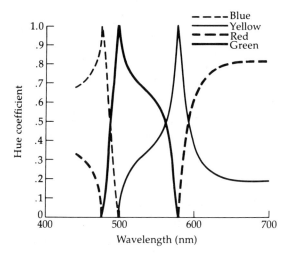

Figure 3.16
Spectral hue coefficients represent the relative amounts of paired hues seen at each wavelength. These are values for an average observer at a moderate light level.

sponse is the whiteness excitation that is common to each wavelength. It should be clear from the earlier discussion of cancellation experiments that when the opponent chromatic responses are not in precise balance, the hue of the relatively more energetic stimulus is seen.

Once we realize that the whiteness aspect is simply the uncanceled excitation produced by both stimuli of the complementary pair, we need only seek out two stimuli in the spectrum whose chromatic excitations are opposite and equal in order to find stimuli properly characterizeable as complementary. A simple way of presenting the complementary light situation is therefore to restrict ourselves to the hue responses of the various wavelengths, knowing as we now do that the whiteness response is always evoked by the individual stimuli and is not canceled.

The relations between perceived hues and the chromatic response functions in the spectrum are given in "absolute terms" in figure 3.15. That is, the amount of chromatic response at each wavelength is specified per unit of light energy. We can alternatively set up a direct expression of the relation between perceived hue and spectral wavelength in ratio or percentage terms. At any given wavelength we can state the ratio of each separate chromatic response to the sum of the total chromatic responses. This ratio or percentage value has been given the name *hue coefficient*. Graphical representation of the spectral hue coefficients is given in figure 3.16 for an average standardized observer. The blue curve represents the hue coefficient values

for the blues (B/B + R and B/B + G) as a function of wavelength; yellow represents the yellow ratios (Y/Y + G and Y/Y + R); reds are the values for the reds (R/R + B and R/R + Y); and green represents the green ratios (G/G + B and G/G + Y). These coefficients have been calculated for an equal whiteness or brightness level throughout the spectrum. The light level is moderate.

The numerical ratios at any given wavelength are taken to correlate directly with our hue perceptions in the spectrum. Thus for the average observer "blue" has a value of 100 percent or 1.0 at about 475 nm, where the red and green values are zero; green has a value of 1.0 at about 500 nm and yellow a value of 1.0 at about 580 nm. At the wavelength 500 nm, both blue and yellow are zero, and at 580 nm, green and red are zero. Blue-green, green-yellow, and yellow-red are equally strong at a hue coefficient value of 0.50, and these three wavelength loci are 485, 560, and 595 nm, respectively. Other hue coefficient values are taken to represent the relative amounts of the two hues seen at the wavelength in question. At least a half-dozen experiments in which observers scale hues directly in percentage terms or estimate them in some related fashion confirm the essential correctness of the derived hue coefficient measure.

Using the hue coefficient functions, we can now determine complementary color pairs directly and simply. We can, for a given wavelength, say 640 nm, read off on the hue coefficient graph the percentage of red as 80 percent and yellow as 20 percent. To find the wavelength that is complementary to it, we need only locate the wavelength for which the opponent green value is 80 percent and the opponent blue value is 20 percent. A horizontal straightedge shows that this wavelength intercept lies at 492 nm. This can be repeated for all long-wavelength positions, and the result is that when we plot the pairs of wavelengths that are complementary, we obtain a rectangular hyperbola. The intermediate yellow-green–appearing wavelengths do not have spectral complementaries. The wavelength 560 nm, for example, is 50 percent green and 50 percent yellow. Inspection of the hue coefficient function makes it instantly clear why there is no single spectral wavelength complementary to 560 nm. Why is this true?

When describing the hues associated with given wavelengths, I have pointed out that the discussion was being limited to a moderate level of illumination. The reason for this is simple: it is a well-known fact that a physical object changes its perceived hue as the light energy or intensity level changes. Therefore, unless we restricted our discussion initially to a single moderate fixed level of illumination, it would be impossible to discuss the connection between wavelength and hue.

Now that we have this association in hand for an average moderate level, we must look at the way perceived hue varies with illumination changes. For the same light distribution, red and green hues tend to predominate over yellows and blues at rela-

tively low light levels, and the reverse is true at relatively high light levels. Blues and yellows tend to become relatively "stronger" at higher light levels. For example, a yellowish-green object will tend to look relatively greener when we see it at a low light level than when it is illuminated by the same light at a relatively high light level: at the higher level, it looks yellower.

This phenomenon, called the *Bezold-Brücke phenomenon* (after two nineteenth-century vision investigators), has been the subject of considerable experimental work. These experiments vary in detail, but a simple type involves asking an observer to match two halves of a split field in hue appearance when the two light levels differ. One half-field is first set at a fixed wavelength and low energy, and the other at the same fixed wavelength and high energy. If the wavelength is 610 nm and looks yellow-red at the low energy, the high-energy 610 nm field will look much yellower. If the two fields are to be equated in hue, the observer must change the wavelength of the brighter field to make it appear redder. To make it redder requires that the wavelength be adjusted to 630 nm. Thus the increased yellowness of 610 at high energy is offset by a wavelength change.

A related change occurs at the short-wavelength end of the spectrum. Here the high-energy stimulation for a fixed wavelength produces a relatively "bluer" appearance than for the low-energy stimulus. Again the wavelength of the high-energy stimulus has to be adjusted but this time to offset the increased blueness that takes place with an energy increase. To do this means that the short-wavelength stimulus used initially at the higher energy level must be moved to shorter wavelengths, thereby increasing the redness of the stimulus to reestablish a hue match.

Figure 3.17 summarizes the results of one such experiment. The lines connecting the different wavelengths at the different energy levels used are called *constant hue contours*. If the adaptation is neutral (i.e., if we start with a balanced equilibrium state), we find that there are three places in the spectrum where the appearance of a spectral light does not change as the light level changes. These *invariant hues*, as they are called, correspond to the three unique spectral hues, blue, green, and yellow.

If the hues associated with given wavelengths change in appearance with energy changes, what about the hue coefficient functions, which supposedly represent the way the hues look at different spectral positions? Not surprisingly, they change. In principle, raising the energy level means that the yellow/blue chromatic response function must increase its values relative to the red/green chromatic response function. Figure 3.18 summarizes the way the paired functions behave as stimulus energy increases. If we apply this principle to the curves of the average standard observer, we find that for a spectrum at a high level, the hue coefficient functions look as shown in figure 3.19. It is important to note that although there is a relative increase

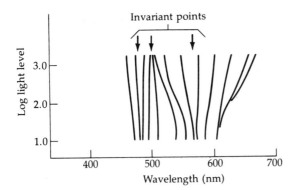

Figure 3.17
Constant hue contours. Except for the three wavelengths labeled invariant points, which are wavelengths that continue to look uniquely blue, uniquely green, and uniquely yellow (for a neutral adaptation condition) as light energy is increased, at all other spectral positions, the hue associated with a fixed wavelength changes as the light level is varied. The various curved lines link the wavelength/light intensity combinations that have the same hue.

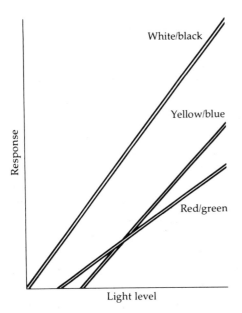

Figure 3.18
Relative rates of rise of paired chromatic and achromatic responses with an increase in the light level. This schematic representation shows that the white/black system has the lowest threshold (it is activated at a lower light level than either of the other paired systems) and that its response increases faster than either the red/green or yellow/blue paired systems. The red/green system has a lower threshold than the yellow/blue one, but its rate of rise is slower than that of the yellow/blue system.

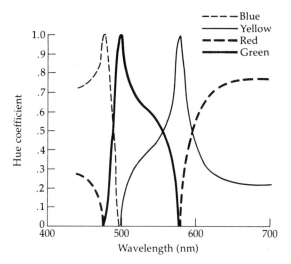

Figure 3.19
Spectral hue coefficients for a high light level. Comparison with figure 3.16 shows that a given wavelength
has more yellow (or blue) at this light level than at the moderate light level.

in the blue and yellow hue coefficients, and a relative decrease in the red and green
ones, the unique blue, green, and yellow spectral loci remain unchanged. We see,
however, that the loci of the intermediate binary hues, those with 50 percent of each
hue component, shift. The wavelength 485 nm, which was equally blue and green for
the standard moderate light level, is now more strongly blue than green, and the hue
that is equally blue and green occurs at about 490 nm. At 560 nm, where the hue
for the standard light level was equally yellow and green, the hue is now more
strongly yellow, and the equally yellow-green hue is found at about 553 nm. The
wavelength that formerly elicited the equal red-yellow sensation, 595 nm, now elicits
a more strongly yellow sensation and the wavelength for equal yellow and red hue
coefficients has moved closer to 600 nm.

It might at first glance seem that the complementary wavelength function as
derived from the hue coefficient function at a moderate level of illumination would
change its form. But this is not true, as we see if we use the high-light-level coefficient
function (or, say, one that is calculated for an illumination lower than the standard
illumination). The form of the complementary function does not change because the
percentage increase (or decrease) in the opponent hue coefficient values remains the
same at the higher level for the complementary wavelengths selected at the moderate
light level.

The discussion in this section of the appearance of individual spectral lights, those that are unique (blue, green, yellow) as well as those that have a binary hue (i.e., red-yellow, green-blue, etc.); how the unique appearance of individual spectral lights can be duplicated by mixtures of pairs of spectral stimuli; and how mixtures of pairs of spectral stimuli can produce whites, should help clarify some of the puzzles referred to earlier. Once we understand how the opponent principle operates, these puzzles are solved.

Notes

1. Black is placed in parentheses here to indicate that there is no direct measurement of this function. Author's note, 1996: Blackness induction experiments reported in 1984 confirmed Jameson and Hurvich's assumption that the whiteness/blackness spectral efficiency functions are mirror images of one another. See Werner et al. 1984.

2. There is a small amount of yellow in the 700-nm stimulus, but this does not affect the cancellation procedure. The observer's task is to produce a field that looks neither red nor green. The yellow associated with the 700-nm stimulus is simply part of the "remainder" perceived when red and green are balanced. It is, in fact, not necessary to use unique stimuli to obtain any of the chromatic response functions.

3. Some investigators have recently resurrected the notion that brightness is not equivalent to whiteness. They reserve the term "brightness" for a response that combines whiteness plus a component from the chromatic responses. This is a complex issue that is not fully resolved. In the interests of simplicity we shall consider whiteness as equivalent to brightness.

4. We are not concerned here with the light threshold measured in a dark-adapted state, in which the rods are relatively more sensitive than the cones.

5. If one is interested in expressing light energies in relation to the eye's sensitivity, light-energy distributions would have to be weighted by the luminosity curve. This procedure gives us stimulus intensities in photometric terms called luminance units. Unfortunately, there are many differently defined luminance units in use. Fortunately, however, they are not needed in order to understand the principles of color and color perception as developed in this book.

6. See note 1 above.

7. x represents a variable amount of white that changes as the energy of the complementary wavelength is adjusted to balance the two opponent chromatic processes. As in the case of the unique hues, its amount is a matter of indifference.

Background Readings

Cohen, J. D. 1975. Temporal independence of the Bezold-Brücke hue shift. *Vision Res. 15*: 341–351.

Dimmick, F. L., and Hubbard, M. R. 1939. The spectral location of psychological unique yellow, green, and blue. *Amer. J. Psychol. 52*: 242–254.

Donnell, M. L. 1977. Individual Red/Green and Yellow/Blue Opponent-Isocancellation Functions: Their Measurement and Prediction. Michigan Mathematical Psychology Program, Technical Report MMPP 77–9. Ann Arbor, Mich.

Helmholtz, H. v. 1896. *Handbuch der physiogloischen Optik*, 2nd ed., p. 456. Voss, Hamburg.

Hurvich, L. M., and Jameson, D. 1953. Spectral sensitivity of the fovea. I. Neutral adaptation. *J. Opt. Soc. Amer. 43*: 485–494.

Hurvich, L. M., and Jameson, D. 1954. Spectral sensitivity of the fovea. III. Heterochromatic brightness and chromatic adaptation. *J. Opt. Soc. Amer.* *44*: 213–222.

Hurvich, L. M., and Jameson, D. 1955. Some quantitative aspects of an opponent-colors theory. II. Brightness, saturation, and hue in normal and dichromatic vision. *J. Opt. Soc. Amer.* *45*: 602–616.

Hurvich, L. M., and Jameson, D. 1958. Further developments of a quantified opponent-colours theory. In *Visual Problems of Colour II*, Chap. 22, pp. 691–723. Her Majesty's Stationery Office, London.

Hurvich, L. M., Jameson, D., and Cohen, J. D. 1968. The experimental determination of unique green in the spectrum. *Percept. Psychophys.* *4*: 65–68.

Indow, T., and Takagi, C. 1968. Hue-discrimination thresholds and hue-coefficients. *J. Psychol. Res.* *10*: 179–190.

Ives, H. E. 1912. Heterochromatic photometry. *Phil. Mag.* *24*: 845–883.

Jameson, D., and Hurvich, L. M. 1955. Some quantitative aspects of an opponent-colors theory. I. Chromatic responses and spectral saturation. *J. Opt. Soc. Amer.* *45*: 546–552.

Purdy, D. McL. 1931. Spectral hue as a function of intensity. *Amer. J. Psychol.* *43*: 541–559.

Purdy, D. McL. 1937. The Bezold-Brücke phenomenon and contours for constant hue. *Amer. J. Psychol.* *49*: 313–315.

Romeskie, M. 1978. Chromatic opponent-response functions of anomalous trichromats. *Vision Res.* *18*: 1521–1532.

Sloan, L. L. 1928. The effect of intensity of light, state of adaptation of the eye, and size of photometric field on the visibility curve. *Psychol. Monogr.* *38* (173).

Sternheim, C., and Boynton, R. M. 1966. Uniqueness of perceived hues investigated with a continuous judgmental technique. *J. Exp. Psychol.* *72*: 770–776.

Wagner, G., and Boynton, R. M. 1972. Comparison of four methods of heterochromatic photometry. *J. Opt. Soc. Amer.* *62*: 1508–1515.

Werner, J. S., and Wooten, B. R. 1979. Opponent chromatic mechanisms: Relation to photopigments and hue naming. *J. Opt. Soc. Amer.* *69*: 422–434.

Werner, J. S., et al. 1984. Spectral efficiency of blackness induction. *J. Opt. Soc. Amer. A* *1*: 981–986.

Further Readings

Boynton, R. M. 1973. Implications of the minimally distinct border. *J. Opt. Soc. Amer.* *63*: 1037–1043.

Larimer, J., Krantz, D. H., and Cicerone, C. M. 1974. Opponent-process additivity. I. Red/green equilibria. *Vision Res.* *14*: 1127–1140.

Larimer, J., Krantz, D. H., and Cicerone, C. M. 1975. Opponent process additivity. II. Yellow/blue equilibria and nonlinear models. *Vision Res.* *15*: 723–731.

Werner, J. S., and Wooten, B. R. 1979. Opponent chromatic response functions for an average observer. *Percept. Psychophys.* *25*: 371–374.

4 Neural Coding of Color

Russell L. De Valois and Karen K. De Valois

I Introduction

Whenever one attempts to understand some aspect of human function by study-
ing other animals, as is so often done in physiological psychology, the problems
of interspecies comparisons become of prime importance. It is probably no more
extreme a problem in the case of color vision than elsewhere, but is immediately
obvious because of the wide recognition of the fact that animals differ greatly in their
color vision. Although it now appears unlikely that as many domestic animals are
completely color blind as was once thought, there are nonetheless enormous quanti-
tative and qualitative variations in color vision among species, and indeed within
man. Thus, whereas the cat, for instance, has some ability to discriminate colors
(Mello & Peterson, 1964; Sechzer & Brown, 1964), it has great difficulty in distin-
guishing even the 150-nm wavelength difference between green and red and can do
so only under optimal conditions. Such a miniscule sensory capability can play little
if any role in the cat's ordinary behavior. A macaque monkey or normal human,
on the other hand, can, with ease, discriminate, say, a 5-nm wavelength difference
between 590 and 595 nm, and color differences are so dominant in our vision (and
that of macaques) that it is notoriously difficult for us to make brightness judgments
between objects of different colors. It is thus unlikely that the physiology of such
common laboratory species as cats, rats, or dogs will tell us much about the neural
basis for color vision.

There are numerous animals with excellent color vision, especially among the
birds and fish. Most of these species differ so greatly from man, however, that inter-
species comparisons become quite difficult. Birds, for example, have oil droplets on
their retinas which act as filters and significantly affect the transmission of colored
light. And fish, whereas they show some neural mechanisms that are very similar to
ours, have retinas that differ greatly in structure from those of man. In order to try
to infer the nature of the human visual system, it would obviously be of great ad-
vantage to study an animal with which we could make direct anatomical, physio-
logical, and behavioral comparisons. The more similar to man a given species is, the
more accurate our inferences are likely to be. In addition to the obvious fact of the
closeness of macaque monkeys to man on the phylogenetic scale, there is the advan-
tage of the knowledge we possess about their visual abilities. A series of behavioral
tests has been made (De Valois, Morgan, Polson, Mead, & Hull, 1974; De Valois &
Morgan, 1974) of macaque monkeys and human observers on many classical visual
psychophysical tasks, using the same apparatus and procedures for the two species.

On each task (spectral sensitivity, wavelength discrimination, purity discrimination, anomaloscope tests, spatial frequency discrimination) the performance of the macaques was very similar, if not identical, to that of the humans. Thus, in view of the anatomical and behavioral similarities of their respective visual systems, we can with confidence extrapolate to the human visual system from physiological studies on macaque monkeys. For this reason, we have chosen to restrict our discussion here largely to the results of physiological studies conducted on monkeys. A thorough review of color processing in other animals can be found in Daw (1973).

An initial requirement for color vision is the presence of at least two different receptor types containing pigments of different spectral sensitivity. When a photopigment molecule absorbs a photon of light, it is isomerized and starts the chemical events that lead eventually to neural activity. But this isomerization is quite independent of the energy level (or wavelength) of the photon captured. The spectral sensitivity of a pigment is an expression of the probability that photons of different wavelengths will be captured by the pigment, but any photon absorbed has exactly the same effect on the photopigment. Thus, wavelength information (independent of intensity) is lost to a receptor with the initial visual response, the photopigments being capable of signaling only how many photons they have captured.

How then can the wavelength of a light be identified? Clearly, it can only be on the basis of a comparison of the outputs of two or more receptors of different spectral sensitivity. If one absorbs long-wavelength photons more readily, and the other absorbs short-wavelengths photons better, then a long-wavelength light, regardless of intensity, will activate the first receptor type more than the second, and a short-wavelength light more the second than the first. The critical information for specifying the wavelength, clearly, is not the extent to which the receptors are activated, but the *relative* activation of the two receptor types. On the other hand, the intensity of the light is obviously related to the total receptor output. As we shall see, it is just these two types of information that are extracted in retinal interactions, in parallel neural systems.

Color vision requires, then, a limited number of receptors of different spectral sensitivity, plus a neural system that compares the output of different receptor types. Each of these essential basic components was postulated over a century ago, by Helmholtz (1863) and Hering (1872), respectively. But they and their numerous followers, even to the present, saw their respective theoretical contributions as being mutually exclusive (a position aided by the fact that Hering postulated that the opponent process occurred at the receptor level). There is now ample direct physiological evidence to indicate that both three separate receptor types and spectrally opponent

interactions are present, but at different neural levels. It would seem that a reluctance to let a good argument die plus an apparent need for mystery in color vision mechanisms act to keep this old pseudoissue alive. Certain terminologies that have tenaciously maintained their hold have also helped to generate some mystification in what would otherwise be a straightforward problem.

In his book on audition, Helmholtz (1863) postulated that the analysis of complex tones into their sine wave components was accomplished by independent resonators in the cochlea, each of which could be set into vibration only by a particular sound frequency. The sound frequency would be recognized, then, on the basis of which resonator was activated. (We now know, above all from the work of Békésy, that this is not the case; rather each section of basilar membrane vibrates to a broad frequency range.) Helmholtz's model of how color vision takes place had much the same characteristics as his tonal theory: he postulated three types of color receptors—red, green, and blue—with independent paths to the brain. The color of an object would be recognized, then, on the basis of which color receptor was activated. He postulated three receptor types from considerations of the trichromacy of normal human color matches. The actual receptor curves he postulated have considerable overlap in their spectral sensitivity (thus raising questions about his giving them color names), but in general peak at distinctly different spectral regions. Actual cone pigments in man (and monkey) we now know, are quite different.

As a heuristic exercise, we might extend such a Helmholtzian receptor-specific color vision system to its logical limit (which he did not do) and postulate a set of color receptors, each sensitive to a different discrete spectral band. Such receptors we could truly term "red receptors," "yellow receptors," "green receptors," etc., since they would only respond to wavelengths that we see as those particular colors. Such a system would have the virtue of requiring no neural processing. Which receptor was activated by a light would immediately signal the wavelength. But such a system would have major disadvantages, such crippling ones that no known animal has ever evolved such a system. First, color vision itself would be very poor. One spectral range could readily be discriminated from another, but within the range covered by one receptor type there would be no color discrimination at all: As already discussed, a single receptor responds identically to any photon it captures. So with three color receptors, we could only discriminate three colors from each other (instead of the hundreds we in fact can); there would be no discrimination among the various reds or between them and oranges or yellows. One could, in principle, compensate for this by having many color receptors, but that would magnify the second problem, which is that visual acuity and form vision would seriously suffer in colored light. If

long wavelengths were only absorbed by "red receptors" among three or more color receptor types, then the retinal mosaic would be very coarse in long-wavelength light, since only a scattered receptor here and there would respond. The same would obviously be true in any other monochromatic light. Since white light, on the other hand, would activate all receptors, one would predict from such a formulation that visual acuity with white light would be far better than with monochromatic. In fact, the reverse is the case (as one would predict from purely optical considerations: The image of a white object is necessarily a little more blurred than a monochromatic one because the human cornea and lens cannot simultaneously bring all the wavelengths in white light to a focus at the same plane). Having more than three color receptors would of course make acuity in monochromatic light even worse.

In fact, the human visual system does not have color receptors, each sensitive to a selective spectral range. Rather, each receptor type responds to lights of almost any wavelength (the short-wavelength cones are something of an exception to this, as to most other general statements about color vision, but they seem to be quite rare in the retina). Under ordinary conditions, then, all receptor types are stimulated by light from any visual object whether white or monochromatic, thus providing for high visual acuity and form perception. The spectral sensitivities of the various receptor types are slightly different from each other, however, and the later neural processing detects and magnifies this difference to extract the color information. Later neural elements, then, are color-specific, but receptors are not.

This mode of operation, with broadly tuned receptors feeding into neural circuits that compare and contrast the outputs of different receptors to extract specific information, seems to be general to all sensory systems. The auditory receptors respond to a wide range of frequencies, but later neural interactions produce a great narrowing of tuning curves so that many cells higher in the pathway respond only to narrow frequency bands. In the gustatory and olfactory systems, higher centers have not been extensively investigated, but the receptors certainly show very broad tuning to tastes and smells, not the specificity one would expect from nineteenth-century notions of sensory physiology. And, of course, within vision such an organization characterizes not just color vision: We do not have form-specific receptors responding only to lines of particular orientation. Rather, the receptors fire to any shape of object and the shape is detected later in the neural pathway by comparing the output of different receptors. Quite the same holds for color vision, although this fact is hidden by tenacious old theories and the continued use of color names for receptor types.

II Neurophysiology of Color Systems

A Receptors

1 Photopigments Four critical questions, from the point of view of color vision, about the visual photopigments are (a) the number of photopigments involved, (b) their spectral sensitivities, (c) their photosensitivity and prevalence in the retina, and (d) whether they are segregated into separate receptor types or sometimes combined in one. No single experimental procedure has provided definitive answers to any of these questions, but a variety of quite different approaches, each with its own limitations, have converged on the same answers to these questions. Such agreement reached among psychophysical, physiological, and optical approaches is perhaps even more convincing than apparently definitive answers from just one procedure.

The trichromacy of vision has been adequately established in extensive psychophysical studies over the last century. It was first clearly realized by Young (1807) that this requirement for three and only three physical variables to match all colors could be explained by the presence of just three receptor types each containing a different photopigment. Such an explanation is hardly without other plausible alternatives, however. There could be more than three photopigments but combined into only three different receptor types; or there could be more than three photopigments and receptor types, but only three different pathways to the brain, etc. But Young's explanation is the simplest and, without much doubt, the correct one since other lines of evidence lead to the same conclusion.

A very direct spectrophotometric approach to answering this question for the primate was taken by Marks, Dobelle, and MacNichol (1964), following a successful application of those procedures to goldfish receptors (Marks, 1963). A tiny spot of monochromatic light was focused on the receptor outer segment in a fragmented mixture of retinal components on a microscope slide. The spectral absorption of the receptor was directly measured by measuring with a photocell the amount of light that passed through the outer segment while sweeping across the spectrum with the monochromator. This was done for each of a sample of receptors from macaque monkey and human eyes. Although the procedure is straightforward in concept, it has its difficulties in practice, among them that the spectral light used to measure the spectral sensitivity of the receptor bleaches it at the same time, and the amounts of light involved were so extremely small as to be at the limits of measurement. The net result of these limitations was that one could not be absolutely certain about either the shape of the absorption curve or the point in the spectrum at which it peaked.

Despite these limitations, however, several interesting findings did emerge. They found evidence for three (and only three) separate pigments with peak absorptions in the region of 445, 535, and 570 nm, and with broad spectral sensitivity. These results from the macaque monkey and the human eyes were virtually identical. Furthermore, their results suggest that only one pigment is found in any given cone, although Wald and Brown (1965), on the basis of similar experiments, suggest that some cones may possibly contain two long-wavelength pigments. Both of these studies found many more cones containing the medium- and long-wavelength absorbing pigments than the short-wavelength pigment. Marks, Dobelle, and Mac-Nichol, for example, found only two cones with the short-wavelength pigment in a sample of 56 receptors. (We may term the three receptors containing pigments with long-, middle-, and short-wavelength maxima, the L, M, and S cones, respectively.)

Further support for these findings comes from physiological studies of the responses of single cells at the LGN or ganglion cell level after chromatic adaptation. For various reasons that will be discussed later, it seems probable that spectrally opponent cells in the LGN receive their inputs from two cone types. If this is so, and if each cone type contains only one photopigment, then one should be able to reveal the shape of the absorption curve of one pigment input by selectively chromatically adapting the other input to a given cell. When this is done, three separate spectral sensitivity functions are revealed, corresponding to photopigments with absorption peaks at approximately 445, 540, and 570 nm, respectively (Abramov, 1968; De Valois, 1965).

Still other evidence for the existence and better evidence for the shape of the two long-wavelength pigments comes from Rushton's (1963, 1965) studies on the human eye using reflection densitometry. This technique involves shining lights of various wavelengths into the eye, then measuring the light which is reflected back out. By taking the difference between the light which was shone in and that which is reflected out and then correcting for various interfering factors (absorption by nonphotopigments, light scatter, etc.), one can obtain an estimate of the amount of light at each wavelength that was absorbed by the photopigments. Rushton utilized the fact that no rods and few S cones are present in the fovea and that the S cones do not absorb at longer wavelengths, so the normal fovea contains just two pigments sensitive at long wavelengths. Furthermore, color-blind protanopes and deuteranopes, according to the most prevalent theory of color blindness, which his data strongly support, are missing one or the other of the two longer wavelength pigments. Therefore, foveal reflection densitometry on protanopes and deuteranopes should (and did) reveal just a single pigment absorption, that of the M and the L cones, respectively. His

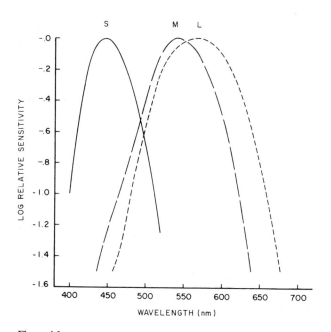

Figure 4.1
Normalized absorption curves for the three cone pigments in the macaque monkey (and human) eye. Based on spectrophotometric, physiological, and psychophysical evidence.

results show that these pigments have peak absorptions at about 540 and 570 nm, respectively, and that they have broad spectral sensitivity functions.

Cone pigment curves have also been determined from psychophysical measurements of protanopes and deuteranopes (Pitt, 1944) and, indirectly, from other types of psychophysical experiments. The vast majority of studies agree rather well with those reported here. Thus there are, apparently, three cone pigments, and their peak absorptions are approximately 440–450, 530–540, and 560–570 nm, respectively. Figure 4.1 gives the best estimate of the absorption curves of the three human (and macaque) cone types based on the consideration of many of these factors (Vos & Walraven, 1971).

2 Receptor Response Receptors differ from most later neurons in the visual system in that they do not show all-or-none spikes but rather graded depolarization or hyperpolarization responses. In an elegant recording from single receptors in *Necturus* and *Gekko*, Toyoda, Nosaki, and Tomita (1969) demonstrated that they respond with graded hyperpolarization to light. In consideration of the surprise often expressed at the fact that vertebrate photoreceptors show a hyperpolarizing response

to light (that is, to light increments), we should note that the visual world as often consists of objects darker than the mean luminance level as of objects lighter than the mean light level. And the one type of stimulus is as important for the organism to detect and characterize as the other. In response to decrements in light the photoreceptors show depolarization (and secretion of synaptic chemicals). Under normal circumstances, the light falling on any given receptor is constantly fluctuating up and down as our eyes scan a scene. The receptor responds with a fluctuating polarization of the receptor membrane (depolarizing to decrements and hyperpolarizing to increments in light), which results in a fluctuating amount of synaptic chemical being released to activate the bipolar and horizontal cells with which the receptor synapses.

Although the direction of the receptor response is determined by whether the stimulus is incremental or decremental, its magnitude depends on both the intensity of the stimulus and the adaptation state of the receptor. For very small changes in intensity, the graded receptor response is approximately linear. But when the intensity change is of greater magnitude, the receptor output becomes roughly proportional to the log of the intensity. Boynton and Whitten (1970) argue that the intensity–response function of receptors can be best fitted by a power function.

In our later description of spectrally opponent cells, we discuss the fact that these cells seem to difference the outputs of two cone types. Since, as we have just noted, the receptor intensity-response function is quasi-logarithmic, the opponent cells are, thus, approximately responding to the ratio of the absorbances.

B Ganglion and Lateral Geniculate Cells

The single most important—if by now commonplace—finding of twentieth-century sensory physiology is that every neuron in the sensory pathways has a combination of excitatory and inhibitory influences playing on it. Before evidence from single neurons was available, many theorists postulated "private" lines from receptors to the brain, that is, noninteracting pathways. Thus, for instance, Polyak (1957) postulated a private path from each foveal cone in primates to the brain by way of midget bipolars and ganglion cells, one cone to one bipolar to one ganglion cell, to account for our high visual acuity. And Helmholtz (1866) postulated separate non-interacting paths for each cone type to the brain. Neither of these nor other similar notions has any basis in fact. We can now see, on the contrary, that it is the comparison of the excitatory and inhibitory inputs at each synaptic level which forms the very basis of the information processing that takes place in sensory systems.

The most important interaction involved in analyzing wavelength information is the comparison of the outputs of different cone types seen in the responses of spectrally opponent cells. These were first seen in the primate visual system in recordings

from single cells in the lateral geniculate nucleus (LGN) (De Valois, Smith, Karoly, & Kitai, 1958). But the principal interactions clearly do not take place there, but earlier, since ganglion cells show very similar behavior (Gouras, 1968; Marrocco, 1972). Spectrally opponent ganglion cells are also found in goldfish (MacNichol & Svaetichin, 1958); similar interactions (involving depolarization and hyperpolarization) are seen even earlier in this animal, at the level of horizontal and bipolar cells (Svaetichin & MacNichol, 1958). Thus it is entirely possible—in fact likely—that the spectrally opponent interactions in primates also take place before the ganglion cell level in the retina, but there is a paucity of direct evidence from primates. Since evidence is lacking about earlier interactions, and since ganglion and LGN cells are highly similar in respect to color processing, only the evidence from these latter two levels will be considered, and they will be treated as one.

Two principal interactions take place before the cortex in the primate visual system: (a) a comparison by later neurons of the receptor activity in different spatial locations, to form a spatially opponent organization, and (b) a comparison of the receptor activity among different cone types to form a spectrally opponent organization. Some cells show just one and others just the other, but most show both types of interactions.

1 Spatially Opponent Organization The spatially opponent organization of visual neurons was first seen by Kuffler (1953) and Barlow (1953) in the responses of single ganglion cells of cat and rabbit, respectively. The vast majority of cells in these animals (and of others with little or no color vision) consist of one or the other of two types. Both cell types show either excitation (an increase in firing from the maintained discharge rate seen in the absence of stimulation) or inhibition (a decrease in firing), depending on the location of a tiny stimulus within their receptive field (RF: that limited portion of the environment about which the cell is signaling or equivalently, those particular receptors from which the cell is receiving its input).

One of these cell types, commonly but misguidedly called on-center cells, responds to a tiny light spot (a tiny incremental stimulus) with excitation, or on-responses, when the spot is in the center of the RF, and inhibition (with off-responses at the termination of stimulation) when the spot is anywhere within an annular surround. The responses to a tiny dark spot would be just the reverse, that is, off-responses in the RF center and on-responses in the surround. It is only if one ignores decremental stimuli (which, fortunately, the visual system does not do) that one could call such cells on-center cells. One might better think of the conventional RF map in figure 4.2 as indicating whether an increment ($+$) or a decrement ($-$) produces firing in that portion of the RF. It can be seen that the optimal stimulus for firing such a cell

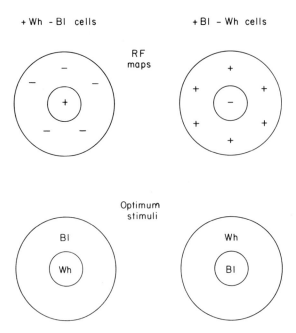

Figure 4.2
Receptive field maps for spectrally nonopponent cells, and optimal stimuli to fire the cells. The + and −
signs conventionally refer to on or off responses, respectively, to (incremental) stimuli. They might better be
thought of as areas in which incremental (+) or decremental (−) stimuli fire the cell. The size of RFs varies
enormously; the area represented in the RF map might encompass anything from a dozen to tens of
thousands of receptors.

would be an incremental spot on a decremental background or, in other words, a
white spot on a black background. The reverse stimulus, a black spot on white
background, would produce the maximum inhibition. We (De Valois, 1972) have
thus termed such cells +Wh −Bl cells, since they fire to white and inhibit to black
spots.

Found equally frequently are mirror image cells, see figure 4.2, which show inhib-
ition in the RF center and excitation in the surround to incremental stimuli, and
hence were called by Kuffler (1953) off-center cells. They might better be termed
+Bl −Wh cells, since they fire to black spots on a white background, and inhibit to
white spots.

The centers of the RFs are dominant over the surrounds, if both are stimulated,
in the case of ganglion cells and of most LGN cells (Jacobs & Yolton, 1968), so a
+Wh −Bl cell will fire to an increment of light covering the whole RF (but much less
so than to a discrete white spot) and a +Bl −Wh cell will also fire to a uniform

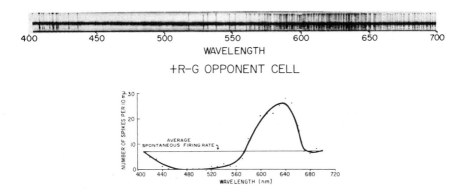

Figure 4.3
Example of responses to different spectral lights of an opponent cell. On the top line are the spikes evoked in a +R −G cell by sweeping across the spectrum with a monochromator. Below is a graph of the record at top, in which is plotted the number of spikes fired to each 10-nm section of the spectrum. It can be seen that this cell fires to long wavelengths (red) and is inhibited by shorter wavelengths (green).

decrement. These two cell types, which constitute virtually the whole population of cat ganglion or LGN cells, are also found in the macaque (and presumably human) visual system (De Valois, 1960), but make up less than 30% of the total (De Valois, Abramov, & Jacobs, 1966; Wiesel & Hubel, 1966).

All of the preceding discussion is with respect to responses to increments and decrements in the intensity of light, and it is clear that the visual system is roughly symmetrically organized into cells responding to increments and to decrements (De Valois, Jacobs, & Jones, 1962; Jacobs, 1965; Jung, 1961). After examining the spectral responses of such cells, we have termed them together *spectrally nonopponent cells*, since such a cell gives the same type of response to monochromatic lights of any wavelength. The +Wh −Bl cells fire to any incremental monochromatic light; the +Bl −Wh cells inhibit to any incremental monochromatic light (and fire to any decremental lights); see figure 4.4. The basis for this is that the same cone types feed into both the center and surround of such cells (De Valois, 1969) and the center and surround thus have the same spectral sensitivity (Wiesel & Hubel, 1966).

2 Spectrally Opponent Organization Far more commonly found in the macaque visual system than the cells just discussed are those we have termed *spectrally opponent cells*: those that fire to some wavelengths and inhibit to others (De Valois et al., 1958; De Valois, 1965; Gouras, 1968; Wiesel & Hubel, 1966). See figure 4.3 for an example of the responses of one such cell to lights of various wavelengths. Since opponent cells show different responses to various spectral regions, they would appear to be carrying color information.

As one samples the responses of a large number of ganglion or LGN cells, one encounters a wide variety of different opponent cells, with considerable variation in the wavelengths that produce peak excitation and inhibition. Whether there is truly a huge number of different cell types, or a much more limited number, with some random variation in their interconnections, is a difficult question to answer definitively. We have presented evidence from the distributions of peak response and of cross-points from excitation to inhibition which suggests the presence of just four spectrally opponent cell types (De Valois, Abramov, & Jacobs, 1966; Abramov, 1968). One of these cell types, an example being the cell in figure 4.3, we have termed *red-excitatory, green-inhibitory* (+R −G) cells, so named because the spectral region to which the cell fires maximally is that which appears red to us, and it inhibits to those wavelengths we see as green. Found equally frequently are cells which are mirror images of these, in terms of the spectral regions to which they fire or inhibit: +G −R cells. Together we can class these as the RG system. There are other cells that show maximum excitation to somewhat shorter wavelengths than the +G −R cells, to that region we see as yellow; and their maximum inhibition is also to wavelengths we see as blue rather than green. These cells we have termed +Y −B cells; together with their mirror-image cells +B −Y, they constitute what we may call the BY system. In figure 4.4 are the average firing rates of a sizable sample of each of these six opponent and nonopponent cell types in response to flashes of monochromatic light of different wavelengths. (It should be noted that in every case their response to a *decrement* would be opposite.)

The receptive fields of these various cell types found in a given location in the LGN overlap, and it is highly probable that each small section of the central retina projects up to cells of each of these varieties. Furthermore, both opponent and nonopponent cells of a particular type vary considerably in RF size, some +R −G cells having tiny receptive fields, others somewhat larger, still others quite large, etc. So it is likely that some dozens of LGN cells receive inputs from each small central region, reporting on the color and size of objects in that portion of the environment.

3 Receptor Inputs to LGN Cells It is clear that the spectrally opponent cells must be receiving inputs from at least two different receptor types, containing photopigments of different spectral sensitivity. Thus the +G −R cells have a short-wavelength excitatory and a long-wavelength inhibitory input. But since the spectral sensitivities of the cones probably overlap to a great extent, it is by no means obvious which particular cone types feed into these cells, or what their spectral sensitivities are. There have been several attempts (De Valois, 1965; Wiesel & Hubel, 1966; Abramov, 1968; Gouras, 1968) to determine this, with somewhat conflicting results.

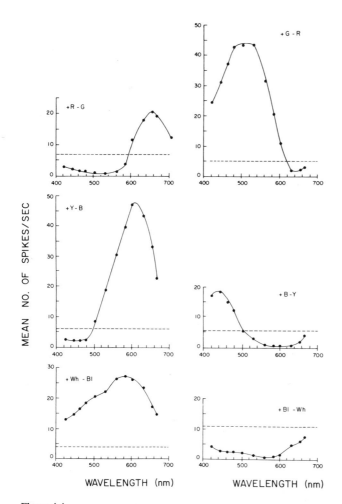

Figure 4.4
Plots of the average firing rates of a large sample of cells of each of the six LGN cell types in response to flashes of monochromatic light. The top four are spectrally opponent cells which fire to some wavelengths and inhibit to others. The bottom two are spectrally nonopponent cells (it should be noted that these are responses to increments; the +Bl −Wh cells fire to decrements).

Chromatic adaptation can be used to isolate the individual cone inputs to an LGN cell, in much the same fashion as it was used psychophysically by Stiles (1949). A long-wavelength light, in the case of the +R −G cell in figure 4.3, would be mainly absorbed by the longer wavelength pigment feeding into it and should thus desensitize the long-wavelength excitatory input to the +R −G cell, revealing the short-wavelength inhibitory input more or less in isolation. When this is done, it is found that the cell now inhibits to wavelengths across virtually the whole spectrum and gives its maximum inhibition not to 500 nm, as before adaptation, but to about 530–540 nm. The spectral sensitivity of the cell now corresponds very closely to a 535-nm cone pigment, that is, to the sensitivity of the M cone. When the converse experiment is done, using a short-wavelength adaptation, one sees excitation all across the spectrum, with the point of maximum excitation shifted from about 640 nm to approximately 570 nm, or the point of maximum absorption of the L cone. Thus, in a +R −G cell, the M pigment is presumably feeding in an inhibitory manner, and the L pigment gives an excitatory input. In +G −R cells the same two pigments are implicated, but the M cones now give an excitatory input, while the L cones feed in an inhibitory manner.

The same conclusion, namely that the RG cells are differencing the M and the L cones, is supported by two other approaches. Wiesel and Hubel (1966) measured the spectral sensitivity of LGN cells using discrete stimuli in either the center or surround of the RF to attempt to isolate the separate cone inputs, which are nonuniformly distributed spatially. They found that the L and M cones fed into these cells. Abramov (1968) tested the responses of units of mixtures of two wavelengths equated for absorption by these two putative cone inputs and found equal responses, thus confirming the same conclusion.

Although there is general agreement concerning the cone inputs to cells in the red-green opponent system, the cone inputs to blue-yellow cells are in dispute. When the chromatic adaptation procedure just discussed was used with a sizable sample of BY cells, it revealed isolated opponent inputs with peak absorptions at 445 and 570 nm, or the S and L cone types (De Valois, 1965). Wiesel and Hubel (1966), however, again measuring sensitivity to spots in discrete areas in the center or surround of the cells' RFs, concluded for the two BY cells they studied that the cone inputs were from the S and M cones. Gouras (1968) has presented evidence from ganglion cell recordings of macaque that also suggest that it is the S and M cone types that are involved. Abramov (1968), on the other hand, has argued on both theoretical and experimental grounds that the S and L cone types provide the inputs to these BY cells. So although most of the data suggest that the BY cells are differencing the outputs of

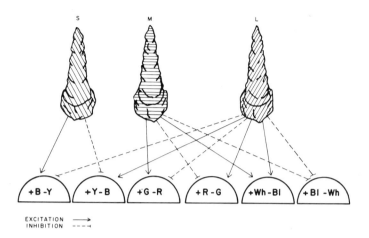

Figure 4.5
A model of how the three cone types interact to form the six LGN cell types. Note that the L cones feed into all pathways.

the S and the L cones, this cannot be considered a firm conclusion. It is conceivable, of course, that both the S-L and the S-M types of connections exist.

From this evidence, it should be clear that the pathway from receptors to brain has nowhere the outputs of single cone types. All LGN cells have inputs from at least two cone types: the nonopponent cells summing the outputs of L and M cones (and rods and, perhaps, S cones); the opponent cells differencing the outputs of the different cone types in pairs; see figure 4.5.

The spectral sensitivities of the L and the M cones are very nearly the same, peaking as they do at about 530–540 and 560–570 nm (both in the part of the spectrum we see as greenish yellow, compounding the absurdity of calling them "green" and "red" receptors as too many people do). But the $+R-G$ and $+G-R$ cells, by differencing the outputs of these cone types, have maximum activity rates at about 500 and 640 nm (which *are* the regions we see as green and red, respectively); see figure 4.6. That is, although the L cone is maximally sensitive to 565 nm, the *difference* between the sensitivities of the L and M cones, which is what fires the $+R-G$ cells, is greatest at around 640 nm.

4 Combined Spatially and Spectrally Opponent Organizations As was already stated, the two main types of neural interactions seen in the precortical visual system are a spatial-opponent organization and a spectral-opponent organization. We have seen how the one is characteristic of spectrally nonopponent cells, and the other of

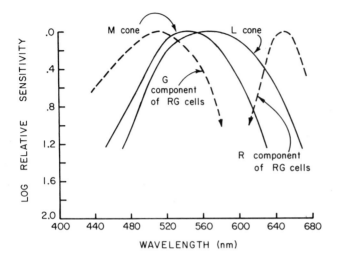

Figure 4.6
An indication of how the excitatory-inhibitory interaction between L and M cones in the RG opponent
cells leads to a narrowing of the spectral response curves and a shift toward the spectral extremes. The
cones absorb all across the spectrum and both peak at middle wavelengths (greenish-yellow); the RG cells
by differencing their outputs respond to only narrow spectral regions, peaking at 500 nm (green) and 650
nm (red).

spectrally opponent cells. But almost all spectrally opponent cells also have spatial
opponency in the organization of their RFs. This was first shown by Wagner, Mac-
Nichol, and Wolbarsht (1960) for goldfish ganglion cells, and by Wiesel and Hubel
(1966) for the primate retina. If one measures the spectral sensitivity of a +G −R
cell, for instance, with a spot covering the center of the RF one may find that the cell
fires to increments across virtually the whole spectrum, and shows maximum sensi-
tivity at about 530 nm. On the other hand, an annular stimulus of almost any wave-
length covering all but the RF center would evoke inhibition from the cell and the
maximum sensitivity might now be to, say, 590 nm. This is what one might expect if
this +G −R cell had an excitatory input from M cones in the RF center and an
inhibitory input from L cones in the RF surround; see figure 4.7.

 Since the cone pigments—particularly the L and M cones—respond to wave-
lengths across virtually the whole spectrum, a +G −R cell with an RF like that
depicted in figure 4.7 would be expected to respond to a black-white figure virtually
the same as would a nonopponent +Wh −Bl cell. And so it does (De Valois &
Pease, 1971; De Valois, 1972), firing to a small white spot on a black background. It
would respond thus, of course, not just to black-white patterns, but to almost any

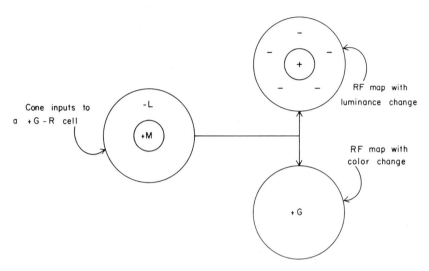

Figure 4.7
Receptive field map for a spectrally opponent cell that also shows spatial opponency. Such a cell responds to both luminance changes and color changes, but with entirely different receptive field maps for the two types of stimuli. When mapped with a luminance change, the cell shows a spatial antagonism and an RF like a +Wh −Bl cell; when mapped with a color change the RF is uniform in sign, the cell firing to a shift toward green (and inhibiting to red) anywhere in the field.

stimulus based on luminance (as opposed to color) differences. The maximum inhibition, with such luminance-difference patterns, would be to a black spot on a white background.

If one now examined the RF organization of this same cell with patterns containing not luminance differences but only color differences, one would obtain quite a different RF organization and size. The optimum *color* stimulus would not be a small spot, but a large field and the direction of the response would be the same throughout the field, i.e., there would be no center-surround organization. It can be seen, figure 4.7, that a green light would also produce minimum inhibition from the RF surround. So the optimal color stimulus would be green on green, that is, a uniform green stimulus across the whole RF (such as that used in the experiments of De Valois et al., 1958; De Valois, 1965, etc.). Of course, the maximum inhibition from a pure color stimulus would correspondingly be a uniform red field.

A spectrally opponent cell can thus be thought of as having two quite different RF organizations depending on the nature of the stimulus: an antagonistic center-surround RF from luminance-based stimuli, and a uniform RF for pure-color stimuli. As a result, it responds both to luminance changes and to color changes, but

with quite different spatial tuning in the two cases; see figure 4.7. To a luminance change, the cell responds optimally to small bars, the response falling almost to zero for large bars, but for a color change the optimum stimulus is large.

Other spectrally opponent cells have inhibitory centers and excitatory surrounds to luminance stimuli; that is, they act like +Bl −Wh cells to those stimuli. A few— Wiesel and Hubel's (1966) Type II cells—have no center-surround organization even to luminance figures. It is not clear whether such cells are in fact a discrete class or extreme examples of overlapping receptive field inputs. Most of the evidence from studies of goldfish ganglion cells (Wagner, MacNichol, & Wolbarsht, 1963) and macaque LGN cells (Mead, 1967) indicates that even in the case of cells like that just discussed and depicted in figure 4.7 (and the nonopponent cells discussed earlier), the excitatory and inhibitory inputs overlap spatially. That is, a +Wh −Bl cell (or the +G −R cell, which responds like that to luminance figures) would have both excitation and inhibition in the RF center and surround, but the excitation would dominate in the center and the inhibition in the surround. Since the cells vary considerably in the spatial distribution of excitatory and inhibitory inputs, a Wiesel and Hubel Type II cell might be just an extreme example in which the distribution of the two inputs was virtually the same.

C Cortex

The visual cortex at least equals in complexity of organization the whole earlier retinal and thalamic centers, yet has been investigated far less, particularly with respect to color. It is not surprising, then, that we have only the most rudimentary idea of what happens to color information when it reaches this level. Any statements made in this discussion should be viewed even more skeptically than those in earlier sections.

There have been fewer than a dozen studies of the color responses of cortical cells in monkeys (Anderson, Buchmann, & Lennox-Buchthal, 1962; Hubel & Wiesel, 1968; Gouras, 1968; Boles, 1971; Poggio, Mansfield, & Sillito, 1971; Zeki, 1973; Dow & Gouras, 1973; Michael, 1973). In many of these, the color investigations were incidental to studies of other aspects of visual processing. As a result, nothing approaching a complete account of cortical color processing can be given. But the evidence suggests to us the following picture: LGN color information may go into two directions in the cortex: (*a*) into color-specific channels that separate color and luminance information, and (*b*) into multiple-color channels that generalize across many color inputs while extracting form information.

1 Color-Specific Striate Cells As we have already pointed out, one of the problems in understanding the physiological basis for color vision from the LGN results is that

the spectrally opponent cells are carrying not only color but luminance information, with a $+G-R$ cell, for instance, responding in the same way to a white spot on black as to an extended green surface. Since we can obviously distinguish between these stimuli, one would expect that at some cortical level cells should be found that respond to color changes but not to luminance changes. Unfortunately, most investigators have only tested cells with flashes of colored light, which consist of both color and luminance changes. With such a technique one cannot tell which aspect of the stimulus is driving the cell. (It is as if one were to test a person's color vision by asking him whether he can see various flashes of colored light projected in turn on a screen. Even a totally color-blind individual could of course do so, detecting the flashes on the basis of the brightness change. To detect presence or absence of color vision, one must eliminate luminance differences and test detection of pure color figures, as in the Ishihara or HRR color-blindness plates.) Nonetheless, reports of cells in striate cortex (area 17), which respond to monochromatic lights but not to white light (Hubel & Wiesel, 1968; Boles, 1971; Dow & Gouras, 1973) indicate an increase in color specificity from the LGN. As will be discussed, this is particularly true for a poststriate region of cortex (termed V4), in which Zeki (1973) reports finding all of the cells to be color-specific.

Hubel and Wiesel (1962), in their pioneering studies of cat cortex cells, found that virtually all striate cortex cells were responsive to lines of some orientation, rather than having radially symmetrical RFs like ganglion and LGN cells. They classified these orientation-specific cells as simple, complex or hypercomplex according to their apparent position in a hierarchical order of processing. Nonoriented cells, however, have been reported in cat (Baumgartner, Brown, & Schulz, 1965), and such cells are clearly very prevalent in monkey cortex forming perhaps 40% of cells related to the fovea (Poggio, 1972). Although such cells superficially resemble LGN cells, it should not be assumed that they are the earliest cells in the cortical chain. In many respects, such cells are quite unlike LGN cells or other cortical cells; they may in fact constitute several levels of a side-chain in the cortical information processing scheme.

In addition to cortical cells that appear similar to LGN cells in their color responses, two types of color-specific cells have been reported in monkey striate cortex. One variety consists of nonoriented cells, which both respond to narrower spectral bands than do LGN cells, and are less responsive to achromatic patterns (Boles, 1971; Poggio et al., 1971; Dow & Gouras, 1973). There may well be many such cells within the sample of units in mangabey cortex studied with diffuse light flashes by Anderson et al. (1962). Unfortunately, little is known of how such cells are related to LGN opponent cells, or of how they respond to pure color figures.

A second variety of color-specific cell that has been reported in the monkey striate cortex is termed double-opponent cells (Hubel & Wiesel, 1968; Michael, 1973). Cells of these characteristics were first found by Daw (1968) in the goldfish retina, where they apparently constitute the majority of the ganglion-cell populations. Such cells in goldfish have a concentric center-surround organization like the monkey LGN cells already described, but, in addition, a large far surround of the opposite spectral response characteristic to the near center-surround. Thus, a +R −G cell would have a +G −R far surround. It is clear that such a cell would not respond to a uniform red surface but would to a red surface on a green background.

The monkey cortical double-opponent cells appear mainly to be "simple" cells, with line-orientation specificity and discrete RFs. The central region responds like a LGN opponent cell and the flanks like opponent cells of the mirror-image type. Such a cell will clearly not respond to a large colored surface, as LGN cells optimally do, for such a surface would produce antagonistic responses from the center area and the flanks.

2 Multiple-Color Striate Cells The color-specific cells found in monkey striate cortex form only a small proportion of striate cells—far fewer than the 70–80% of LGN cells that are carrying color information. This poses the question of what happens to all the color information that reaches the cortex. One answer seems to be the presence of many cortical cells which are receiving a color input, but in such a manner that they have doubtless been misclassified previously.

To understand the nature of these cells, we must make a few observations about geniculate cells. They are all, in the broadest sense, opponent cells: The spectrally opponent cells fire to one spectral range and inhibit to another; the spectrally nonopponent cells fire to white (luminance increment) and inhibit to black, or vice versa. If one flashes lights of different wavelengths on a screen (as Hubel and Wiesel did in their experiments), the spectrally nonopponent cells will respond to them, but in the same way to lights from each spectral region—+Wh −Bl cells, for example, will fire to them all. Such a stimulus differs from the background both in color and in luminance. Since the nonopponent cells fire to all the different colors, one may presume that it is the luminance increment accompanying each to which they are responsive. We have shown that this is indeed the case, since if one matches the different wavelengths for luminance the nonopponent cells cannot detect a change in wavelength (De Valois, 1971).

In their recordings from striate cells, Hubel and Wiesel again examined the responses to colored flashes of light. Finding that almost all cortical cells responded to flashes of any wavelength, they concluded that they were all nonopponent cells

with no color input. A far better way to establish that, however, would be to equate various wavelengths for luminance, and then see whether the cells can detect a pure color change (a sort of Ishihara color blindness test). We have done that with a considerable population of cells in monkey striate cortex and find that, quite contrary to first impressions and to Hubel and Wiesel's (1968) conclusions, many of these cells clearly can discriminate wavelength differences. However, they seem quite indifferent to the particular colors involved. That is, a cell will fire to a red line on an equal-luminance green background (to which a nonopponent cell would be quite blind), but will also fire to a green line on a red background. It appears to us that such cells must be receiving excitatory inputs from multiple geniculate cell types, opponent and nonopponent, and thus can discriminate color differences quite indifferently to the particular colors involved.

The presence—and great prevalence—of such multiple-color cells leads us to the view that the form or shape discriminating systems in the cortex must operate on visual stimuli in large part quite independent of color or contrast. One can suggest that such multiple-color cells are responding to a particular form—a line of a particular orientation and width or spatial frequency—regardless of whether the line differs from its background in color or in brightness, and regardless of the particular color differences involved or whether the lines are white or black. That is, it is abstracting out "form" information and generalizing across color.

3 Color-Specific V4 Area Cells The visual path from the striate cortex is very complex, with multiple pathways to other cortical areas in the occipital and temporal lobes as well as to subcortical regions such as the superior colliculus and pulvinar. Of particular importance for color processing is an area, termed V4, anterior to the classically described visual areas 17, 18 and 19 (V1, 2 and 3). In the first recordings from single cells in this area, Zeki (1973) found all the cells to be color specific. Not only, like geniculate cells, do they fire only to light from a particular spectral region but they also are reported not to respond to white light, thus showing greater color specificity than LGN cells. The color responses have not been analyzed in detail to see whether the range of wavelengths to which they respond is narrower or different from that of LGN cells. Nor have they been tested with pure color versus luminance stimuli, but the fact that those cells which respond to limited spectral regions do not respond to white suggests that luminance and color information have been separated by this stage. (It should be noted that Zeki also finds cells in this area which respond just to white light but not to any narrow spectral band, so the color specificity apparently extends to the white-black domain.)

This visual area V4 appears to be organized into color columns. Zeki (1973) finds that the cells in a given column will all respond to the same color, e.g., red, but have

different demands as to the shape of the red object. For some cells, any red light in the appropriate visual location suffices; others require a red object of a particular shape, or a red border of a particular orientation before they will fire. The cells in a neighboring column might be similarly diverse in their shape requirements but all demand that the objects be blue.

Our conclusion, then, is that color information in the cortex must go two ways: into color-specific paths, which maintain and even increase the color specificity seen at the LGN, and into multiple-color cells, which use color (and luminance) information to detect form but do not care what colors are involved.

D Summary of Physiology of Color Vision

There is now very convincing evidence from many types of experiments indicating the presence in trichromatic man and monkey of rods plus three types of cones, containing photopigments peaking at about 505 nm for rods, and about 445, 535, and 565 nm for the S, M, and L cones, respectively. These cone pigments have a very broad spectral sensitivity, the M and the L cones, at least, being stimulated by lights of virtually all wavelengths. It is very misleading to consider the cones as color receptors or give them color names, both because of their lack of anything approaching the color selectivity associated with color names, and because they are involved in signaling many other things—black and white, movement, etc.—as well as color. Rather, the cones should be thought of as light receptors, responding to increments and decrements in light regardless of color, or form, whether the light is moving or stationary, etc. The specific information about color, brightness, form, movement, etc., comes from later neural interactions which in every case involve a comparison of activity in different receptors.

There appear to be six principal types of cells between the retina and cortex: four types of opponent cells and two types of nonopponent cells. Color information is extracted from the cones by spectrally opponent cells, which subtract the (log) output of one cone type from that of another. The responses of these cells, then, do not correspond to the responses of any cone type, but rather to the extent that one cone type absorbs more light than another. The +R −G cells, for instance, difference the L and M cones: although each of these cone types fires across the whole spectrum, the +R −G cells fire only to very long wavelengths (those we see as red), since it is only at these wavelengths that the L cones absorb more than the M cones. The four opponent cell types (+R −G, +G −R, +B −Y, +Y −B) appear to difference the L and M and the L and S cones.

Black-white information is extracted by a spatially opponent organization in the spectrally nonopponent cells. These cells receive the same type of input from all

cone types (and from rods) but have an antagonism between the center and surround of their RFs. They fire, then not to the extent to which the receptors are activated, but to the extent to which the receptors in the centers of their RF are activated more than those in the surround (+Wh −Bl), or vice versa (+Bl −Wh). Most of the spectrally opponent cells have a similar center-surround RF and thus can be thought of as multiplexing color and luminance-contrast information.

In the cortex, it appears that color information goes in two directions: into color-specific cells, which extract specific color information, and into multiple-color cells, which appear to combine the outputs of various LGN cell types to extract form information from either color or luminance differences, but generalize across colors.

III Relation to Color Vision

In order to claim that the physiological organization just described actually underlies our color vision, one must be able to show a relationship between the physiology and the characteristics of color vision that have been derived psychophysically. In the following subsections, we examine these relationships between physiology and psychophysics. We will also see to what extent we can explain various aspects of color vision, to try to give a comprehensive picture of where we stand at present in being able to understand the physiological underpinnings of color vision. We are clearly far from being able to explain all the intricacies and the second and third-order effects that have been found in a century's study of color vision in man. But our current understanding of the primate visual system is sufficient to account for many of the primary, first-order aspects of our color vision.

A Color Discrimination

1 Cells Responsible for Color Vision The term *color vision* implies the ability to discriminate among lights of different wavelengths regardless of whether or not they differ in intensity. If color vision is present, then one should be able to discriminate between lights of, say 640 and 520 nm even if they were perfectly matched in luminance, or if they were mismatched in either direction.

Since photopigments obey the law of invariance—they give the same type and size of response to any captured photons, regardless of their wavelength—then single receptors obviously cannot be responsible for color vision. In order to obtain the same response from a receptor to lights of 520 and 640 nm, their relative intensities would only have to be adjusted so that the probability of capturing a given number of photons would be the same in each case.

Correspondingly, the nonopponent cells found in the LGN also are not responsible for color vision. They respond in the same manner (either excitation or inhibition, depending on the particular cell) to light from any part of the visible spectrum. In order to evoke the same response from lights of, say, 520 and 640 nm, all one must do is equate those lights in luminance. When they are luminance-equated so that the shift from one to the other is thus a pure color change, the nonopponent cells are unable to discriminate between them, giving no response to the shift between two lights of different colors or between white and a monochromatic light (De Valois, 1971).

The opponent cells in the LGN, on the contrary, can discriminate between lights from different spectral regions whatever their respective luminances. A $+R -G$ cell, for example, will show excitation to a 640-nm light and inhibition to a 520-nm light, regardless of whether they are matched in luminance or whether they are mismatched in either direction. Thus, these and the other three types of spectrally opponent cells all meet the requirements for carrying color vision information and provide, therefore, the precortical basis for our color vision.

The spectrally opponent cells, however, can only discriminate between wavelengths in the case of fairly large stimuli or, more accurately, for low spatial frequency stimuli. With high spatial frequency stimuli (in which stimulus changes would occur *within* the extent of the RF of a single opponent cell) the spectrally opponent and nonopponent cells become alike in their responses: The opponent cells lose their ability to discriminate colors and instead become responsive to luminance differences. The loss of color discrimination on the part of the opponent cells does not cause an embarrassment for our argument that they are responsible for our color vision because under these circumstances we behaviorally lose our color vision (van der Horst & Bouman, 1969). Roughly speaking, we cannot see nearly as fine detail in a scene possessing only color differences as we can in one with luminance differences, and a fine color grid becomes uniform in color.

What does pose a problem is the fact that an opponent cell will respond identically to, say, a tiny white spot as to a large green surface, as seen in figure 4.8. Since the opponent cells give every evidence of true color discrimination with extensive figures, we can best think of them as carrying both color and luminance information, but multiplexed in such a way that it can be separated at later levels. This is perhaps what happens in the organization involving color-specific cells in the cortex.

The multiple-color cells present an interesting problem for classification. Many can clearly discriminate pure color changes, but respond similarly to changes in different spectral directions, e.g., responding the same to a shift from red to green as to a shift from green to red. They can thus discriminate colors yet cannot tell which color is which.

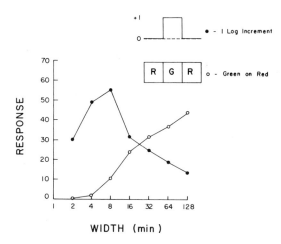

Figure 4.8
Responses of an LGN +G −R cell to stimuli of different widths, each centered on the RF. This experiment was carried out with two types of stimuli: a 1-log-unit increment in white light (solid dots); and a shift from a red field to a green line on a red field, the red and green being equated for luminance to produce a pure color change (open dots). Spatial tuning is seen for the luminance but not the color stimulus.

One could predict that a brain lesion which destroyed the color-specific cells of V4 but spared the multiple-color cells of the striate cortex would leave a patient with a color agnosia. He should have an unimpaired ability to discriminate color differences (i.e., to point out, in an Ishihara chart, the numbers which can only be seen on the basis of color differences) but would be unable to name colors. In fact, patients with such a color agnosia have often been reported (e.g., Kinsbourne & Warrington, 1964). Such patients have perfectly normal color vision as shown by the Ishihara or HRR tests, for instance, but when asked to name the colors of objects do so at random. They are as likely to call a red shirt green or blue as they are to call it red. It has been argued that patients with such brain lesions may not have a true color agnosia (loss of the percept or recognition of color but merely a language problem, an inability to associate color names with the various color percepts. But the physiological evidence for two separate cortical regions concerned with color, one containing color-specific and the other mainly multiple-color cells, makes it entirely conceivable that true color agnosias might in fact occur, since a loss of the color-specific region would leave a patient with cells which can use color differences to detect form but which do not carry information about the particular colors involved.

2 Wavelength Discrimination The classical technique for measuring wavelength discrimination is to present a subject with a bipartite field, the two halves of which

are matched in luminance and variable in wavelength. The subject's task is to adjust the wavelength of the test field until hue is just discriminable from that of the standard field. The difference between the wavelength of the two fields ($\lambda_a - \lambda_b$) defines the wavelength discrimination threshold ($\Delta\lambda$) at that point in the spectrum. When $\Delta\lambda$ is obtained for many wavelengths across the entire visible spectrum, the result is the standard wavelength discrimination function. This function (Judd, 1932, for example) which we have replicated (De Valois et al., 1974) with both human observers and macaque monkeys in a four-alternative forced choice procedure, shows two minima (i.e., regions of best discrimination) at approximately 490 and 590 nm. It rises to essentially infinity at both extremes and shows a secondary maximum around 540 nm.

It is interesting to note that the two minima in the wavelength discrimination function occur in the same spectral regions as the crosspoints of the two pairs of spectrally opponent cell types in the LGN, the +R −G and the +G −R cells having their crosspoint at approximately 590 nm, and the +B −Y and +Y −B at approximately 500 nm. If, as one might reasonably expect, fine discriminations are based on the activity of the cell type which is most sensitive, then one would predict just such a double minimum in the wavelength discrimination funtion. Since the RG cells have their crosspoints around 590 nm, they should be extremely sensitive to small changes in wavelength in that region. A wavelength shift of, say, 5 nm might be sufficient to shift a +R −G cell from inhibition to excitation if it occurred near the crosspoint, where the cell is most sensitive. A shift of 5 nm in a spectral region where the cell is *not* particularly sensitive, however, might have little or no effect.

De Valois, Abramov, and Mead (1967) examined the wavelength-discrimination ability of spectrally opponent and nonopponent cells. The nonopponent cells were found to be quite unable to discriminate (by a change in firing rate) among different wavelengths. The opponent cells, on the other hand, were extremely sensitive to wavelength changes in certain spectral ranges; see figure 4.9. As can be seen (middle line of the top trio, figure 4.9), this +G −R cell shows a large firing change to a shift between 560 and 593 nm, firing to the 560 and inhibiting to the 593 (in fact, it showed in other tests a considerable response to even a 5-nm wavelength change). It also responds to the 27-nm wavelength difference between 593 and 620 nm with a large change in firing (middle line of bottom trio, figure 4.9). As can be seen in the top and bottom lines in each group, the discrimination between these wavelengths occurs even in the presence of large intensity differences, the direction of the firing change being determined by the wavelength, not the intensity relations.

From data, like the sample shown in figure 4.9, obtained for different size wavelength shifts around each of several spectral points for each of a large number of

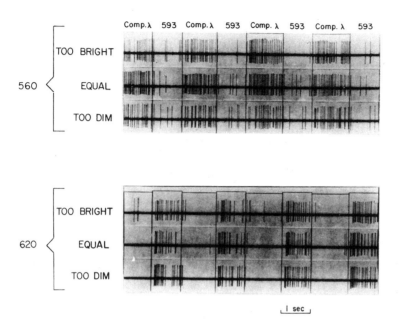

Figure 4.9
Examples of the responses of a $+G -R$ cell to shifts in wavelength around 593 nm. The middle line in each shows the wavelength discrimination is in the same direction even if the intensity is varied up or down a half-log-unit.

opponent cells of various types one can determine, for each spectral point, the minimum wavelength difference necessary to produce a criterion change in firing rate in whatever cell type was most sensitive at that spectral point. The function they found fit quite well the classical wavelength-discrimination function described by Judd (1932), with the shapes of the two functions being quite similar and their maxima and minima occurring at the same spectral loci. In general, the RG cells account for our wavelength discrimination at long wavelengths and the BY cells for it at short wavelengths. This relationship is reinforced by a comparison of macaque and squirrel monkeys (De Valois & Jacobs, 1968). Squirrel monkeys have color vision similar to that of severely protanomalous human color defectives (Jacobs, 1963). Their wavelength-discrimination function shows the short but not the long wavelength minimum; their color discrimination is extremely poor at long wavelengths (De Valois & Morgan, 1974). A sampling of a large population of LGN cells in this species shows that most of the (limited number of) opponent cells are of the BY cell types ($+Y -B$ and $+B -Y$). The presence of these BY cells accounts for the squirrel monkey's good wavelength discrimination at short wavelengths, and the

absence of many RG cells accounts for their poor discrimination among long-wave-length lights.

3 Saturation Saturation is a psychophysical quality of light that might be described as the degree to which a color appears to be free of whiteness or blackness, or the extent to which it is colored as opposed to achromatic. Although many variables can affect saturation (for example, intensity, retinal locus of stimulation, stimulus size, temporal factors), the two most important determinants are colorimetric purity and wavelength. The colorimetric purity of a white-monochromatic light mixture is specified by the proportion of colored light, with a pure monochromatic light having a purity of 1. For a given white-monochromatic mixture, saturation varies with purity, generally increasing as a power function (Onley, Klingberg, Dainoff, & Rollman, 1963).

The second important variable affecting saturation is wavelength. The plethora of studies investigating this relationship (Jones & Lowry, 1926; Purdy, 1931; Martin, Warburton, & Morgan, 1933; Wright & Pitt, 1937; Priest & Brickwedde, 1938) have agreed that saturation is greatest at the spectral extremes and decreases to a minimum in the region of 570 nm. Thus, no yellow light will appear as saturated as a red or blue light of the same purity and luminance.

Appropriate behavioral tests have shown that macaque monkeys have a purity discrimination ability that is essentially identical to that of normal human observers (De Valois & Jacobs, 1968; De Valois, Morgan, & Snodderly, 1974), and physio-logical studies of the responses of single cells in the LGN of macaques have demon-strated a mechanism which could account for the classical purity discrimination function (De Valois, Abramov, & Jacobs, 1966; De Valois & Marrocco, 1973). Consider first the spectrally nonopponent cells in the LGN. A $+Wh -Bl$ or $+Bl -Wh$ cell will give the same response to any light, regardless of its spectral composition, if its luminance is matched for that of the light to which it is being compared. If, say, a mixture of white and any monochromatic light is systematically varied in purity from 0 (pure white) to 1 (pure monochromatic), while its total luminance is kept constant, the response of a nonopponent cell will not change (De Valois & Marrocco, 1973). Since these cells cannot discriminate even the grossest changes in purity, they cannot be responsible for our perception of saturation differences among lights.

The responses of the spectrally opponent cells, on the other hand, change quite systematically with both purity and wavelength. For any shift from, say, a white light to a white-monochromatic mixture equated for luminance, the direction in which a given opponent cell responds (i.e., excitation or inhibition) will be deter-mined by the wavelength of the monochromatic component, and the magnitude

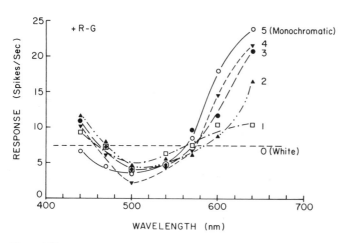

Figure 4.10
Saturation discrimination data from a sample of +R −G cells. Shifts were made from white light to various white-monochromatic mixtures, all equated for luminance. This was done at each of several spectral points. It can be seen especially clearly in the responses to 640 nm that the greater the purity (i.e., the more monochromatic light in the white-monochromatic mixture) of the red light the more the +R −G cells fire.

of its response will be determined by its purity (De Valois & Marrocco, 1973). See figure 4.10 for an example. The response rate of these +R −G cells to the various 640-nm–white mixtures, for instance, is monotonically related to the purity of the mixture.

De Valois and Marrocco (1973) also examined the sensitivity of the various cell types to changes in purity at different points across the spectrum. Since the +R −G cells and the +G −R cells show virtually identical curves, they were combined into one RG system for purposes of this study. The same was true of the +B −Y and +Y −B cells. When one compares their sensitivities to purity changes at various spectral loci, and then assumes that the most sensitive cell type is responsible for threshold discrimination at any given point, the classical purity discrimination function can be replicated by plotting for each point the discrimination ability of the cell types most sensitive at that point. By adopting different criteria for detection of a change in a cell's response rate the curve can be pushed up or down, but its shape remains the same. One can argue, therefore, that our ability to discriminate purity differences among equally bright lights (and thus, probably, our perception of saturation) is dependent on the activity rate of the spectrally opponent cells seen in the LGN.

Another approach to the problem is to consider, for any given wavelength, what proportion of total activity occurs in the nonopponent versus the opponent cells. For

a given luminance level and purity, the proportion of total response produced by the nonopponent cells is least at the spectral extremes and greatest around 570 nm, the least saturated portion of the spectrum. The opponent cells, on the other hand, give large responses to light from either spectral extreme, more so than to the middle of the spectrum. If one plots the log ratio of the opponent and nonopponent spectral sensitivities as a function of wavelength, the resulting curve closely resembles the purity discrimination function (De Valois, Abramov, & Jacobs, 1966). Thus, saturation is greatest in spectral regions to which the spectrally opponent cells are most sensitive, and the saturation of lights corresponds to the relative activity rate of these two groups of cells.

One can argue strongly to this same point from comparative studies. In macaque monkeys, spectrally nonopponent cells make up less than 30% of the LGN cell population (the remainder being, of course, opponent cells). In squirrel monkeys (De Valois & Jacobs, 1968) nonopponent cells make up some 80% of the LGN cells; in cats nonopponent cells make up perhaps 99% of the population. If the saturation of lights depends on the proportion of the total activity produced by opponent versus nonopponent cells, one would expect that the spectrum must be much more saturated overall for macaque monkeys (and man) than for squirrel monkeys, and far, far more saturated for macaques than for cats. Direct behavioral comparisons have been carried out on macaques and squirrel monkeys (De Valois & Morgan, 1974) confirming this prediction: Over most of the spectrum macaques can discriminate a considerably smaller admixture of monochromatic light with white from a pure white than can squirrel monkeys. Such direct comparisons have not been made with cats, but the great difficulty cats have in discriminating even a pure monochromatic light from white indicates that the whole spectrum must be of a vanishingly small saturation to them.

B Color Appearance

1 Color Space We can think of perceptual color space as being a three-dimensional solid, and, in fact, it was often represented as such in early phenomenological accounts of vision. Imagine three axes, each at right angles to the others; see figure 4.11 (left), in which one axis consists of the white-black lightness dimension, another the red-green dimension, and the third the yellow-blue dimension. Since intermediate points can occur between these axes, what one obtains is a three-dimensional solid something like a double cone. The axis from tip to tip would be the white-gray-black dimension; distance from this axis to the outside would correspond to the saturation; and location around the circle in any cut at right angles to the black-white axis would give the hue; see figure 4.11 (right).

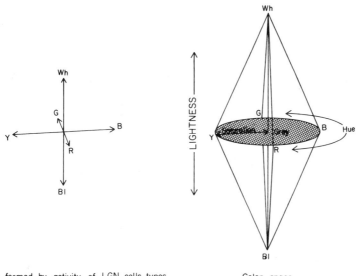

Axes formed by activity of LGN cells types Color space

Figure 4.11
A suggestion of how the location of a stimulus in color space (right) might be determined by the relative activity rates of each of the six LGN cell types (left). The hue would be determined by the activity rates among the four opponent cell types, i.e., which were most active; the lightness by the two activity rates of the two nonopponent cells; and the saturation by the relative activity rates of the opponent and non-opponent cells.

We can postulate that the relative activity rate to a stimulus of the LGN cell types already discussed (Wh-Bl, RG, and BY cell pairs) gives the location of the stimulus in this perceptual color space. Thus, if a stimulus activated the +R −G cells but none of the other cell types to any great extent we would see it as red; if the +R −G and +Y −B cells were equally activated, we would see it as orange, etc. If some light of 500 nm were added to the 640-nm red light, this would have the effect of decreasing the activity of the +R −G cells (and decreasing the inhibition of the +G −R cells). Such a stimulus would be perceived as a desaturated red, or pink. If white were added to the red (e.g., by means of adding a dark surround) it would also lighten and desaturate the red because now the +Wh −Bl cells would be highly active as well as the +R −G cells. The red appearance of the 640-nm light could also be desaturated by the addition of black (e.g., by adding a light surround) to produce a brown appearance. In terms of the cell activity we can see that both +R −G and +Bl −Wh cells would now be active.

The validity of such postulated relationships between the color appearances of objects and which cell types are active in the visual pathway could be semi-

quantitatively tested a number of ways. One such test that has been examined is the color naming of spectral lights.

2 Color Naming If the spectrally opponent cells in the primate LGN do indeed constitute the physiological system at that level which underlies our color vision, then it should be possible to correlate the outputs of these cells when stimulated with various monochromatic lights with the color names which are given to those same stimuli.

Boynton and Gordon (1965) studied color naming by presenting subjects with various monochromatic lights and then recording the color names given to them. Subjects were allowed to specify the color as red, yellow, green or blue, using the color names either singly or in combinations of two. The results were combined across subjects to look at the proportion of times a given color name was used to describe a flash of light of a specified wavelength.

De Valois, Abramov, and Jacobs (1966) looked at the relative contributions of each of the four spectrally opponent cell types by summing all of the spikes given to a flash of light of a particular wavelength by a large sample of LGN cells, and then calculating the proportion of the total spike discharge which had been contributed by each of the cell types. If one compares these psychophysical and physiological data, a very good correspondence is seen between the incidence of the color name "red" given by subjects to different wavelengths and the proportion of the LGN activity to different wavelengths contributed by the $+R -G$ cells; see figure 4.12. The occurrence of the color name "yellow" corresponded with the contribution to the total spikes of the $+Y -B$ cells, etc. The correlation is quite high for stimuli of 500 nm or higher wavelength; below 500 nm there are some disparities: Although the color name "green" is essentially never used for very short wavelengths, the RG cells continue to contribute a large proportion to the total spike discharge. The later cortical processing (which we have indicated must take place to separate color and luminance information) must also introduce some modifications in the responses to short wavelengths. But at long wavelengths, at least, the schema given here for color space seems to be supported.

A further test can be made of this schema in the modifications introduced by chromatic adaptation. Jacobs and Gaylord (1967) systematically examined the shift in color produced by chromatic adaptation, using the Boynton and Gordon color-naming technique. Dramatic changes in color appearance take place with chromatic adaptation. For instance, adaptation to a green light of 500 nm produces a shift of longer wavelengths toward red so that a 500-nm light that was previously called greenish-yellow would now be seen as a yellowish red. The changes that are pro-duced in the relative firing rates of various LGN opponent cell types with chromatic

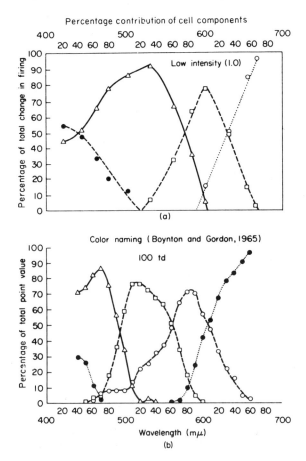

Figure 4.12
Comparison of the color names given spectral lights by human observers (bottom) with percentage of the total opponent cell firing-rate contributed by each of the four opponent cell types. At long wavelengths the agreement is good; knowing that the +R −G cells fired far more to a stimulus than any other cell type, one could predict that a human observer would see it as red, etc.

adaptation are in excellent qualitative agreement with the perceptual changes (De Valois, 1973). Thus, for instance, in the example just discussed, a 500-nm adaptation light produces changes in the firing of RG cells such that a 500-nm light, which previously inhibited a +R −G cell, will now fire it; and the +G −R cell, which previously fired to this light, is now inhibited by it.

C Contrast and Similitude

1 Successive Color Interactions a. DESCRIPTION OF PHENOMENA As is well known, the brightness and color of a surface are determined not only by the present stimulation but by the aftereffects of previous stimulation. These aftereffects are also sometimes termed *successive induction* or *successive contrast effects*. An excellent summary discussion of the phenomena and of the variables involved can be found in Brown (1965).

If one looks at a uniform gray surface after inspecting a red square for a period of time, one sees a rapidly fading image of a blue-green square. This is termed a *negative afterimage*, since it is of approximately the complementary hue to the original inducing image. Correspondingly, a blue-green square would induce a red afterimage; a yellow square a blue afterimage, etc. The same is true for black and white; the afterimage of a black square is white, and vice versa. All such aftereffects are termed *negative aftereffects*; since the effects result from successive stimulation and produce changes in a direction opposite in color to the original stimulus they are also termed *successive color contrast*.

Afterimages can also be of the same color as the original stimulus. These positive afterimages might also be termed *successive color assimilation* or *similitude*. The conditions that promote positive versus negative afterimages are complex, and often both positive and negative afterimages appear, in alternation. Short intense flashes produce predominantly positive afterimages; following longer-duration stimuli, one is more likely to see negative afterimages. An easy way to see a positive afterimage is to look at a light bulb briefly, then turn off the light.

The afterimage and color of the subsequently presented surface combine in determining the color seen, so if, in the example above, one projected the afterimage of a red square not on a gray surface but on a yellow one, the color of the afterimage would be yellowish-green rather than blue-green. Or if the inspection surface were blue-green the result would be a more saturated blue-green (one can thereby get supersaturated colors: more colored than monochromatic light).

b. PHYSIOLOGICAL BASIS There are at least three physiological processes that are likely involved in producing the various types of afterimages: (*a*) photopigment

bleaching and receptor adaptation; (*b*) neural rebound combined with an opponent-color organization; and (*c*) receptor afterdischarge. The first two of these would lead to negative afterimages; the last to positive afterimages. There is independent evidence from various types of experiments for the existence of each of these processes; how they combine together to produce various types of afterimages has not been thoroughly investigated.

Helmholtz (1866) offered a physiological explanation for successive color contrast or negative afterimages in terms of photopigment depletion. His explanation, for instance, of the example of looking at a gray surface after prolonged inspection of a red square, would be that the inspection of the red square would lead to bleaching of the photopigments in the long-wavelength receptors. Subsequent stimulation with the gray surface would therefore set off all but these receptors, and one would therefore see this area as being blue-green (since the adapted retinal area and that in the surround would be responding differently, simultaneous contrast effects would also enter into the picture).

There is ample evidence from psychophysical, physiological, and spectrophotometric studies of retinal function to support the existence of such photochemical bleaching and resulting retinal adaptation (or desensitization). Such a process, then, doubtless forms one basis for negative afterimages. But, as pointed out long ago by Hering (1872) and amply supported since, such a process cannot be the whole story. One sees powerful negative afterimages and successive contrast effects at light levels at which little receptor bleaching could have occurred; high intensity levels, which produce much bleaching, are, in general, more likely to lead to positive rather than negative aftereffects. But most tellingly, one does not need subsequent retinal stimulation to see negative afterimages. Turning off all stimuli after an exposure to a red surface can lead to the appearance in the dark of the negative afterimage. Since there is here no stimulation in the dark to set off all but the long-wavelength receptors, that can hardly account for the percept.

It can now be seen that a second, quite different physiological process is also involved in producing successive color contrast or negative aftereffects: the spectrally opponent neural organization of visual cells combined with neural rebound. A fairly ubiquitous property of neurons anywhere in the brain is that at the termination of prolonged stimulation their firing rate rebounds into the opposite state. Thus, if a stimulus which excited the cell is turned off, one sees a rebound into inhibition; termination of an inhibitory stimulus evokes rebound excitation. Since cells in the visual path to the brain are organized in terms of either spectral or black-white opponency, such rebound produces firing changes which should lead to negative afterimages quite in the absence of any further receptor stimulation. Thus, a $+R -G$

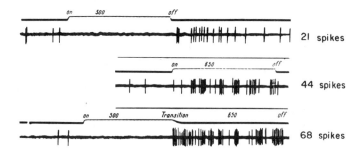

Figure 4.13
Example of neural rebound in a +R −G opponent cell. Such a rebound must contribute to successive color contrast. Top record: Response to a 500-nm (green) light. Note the inhibition during the light and rebound firing at the termination of the light. Middle record: response to a 650-nm (red) light, which fires the cell. Bottom record: green light followed by red. Note the larger response than to the red light alone.

cell fires to a red light and inhibits to a green. At the termination of prolonged stimulation with a red light (even at quite low, nonbleaching intensities) the cell rebounds into inhibition, giving the same response that it would to a green light. At the same time, a +G −R cell would be rebounding from inhibition to excitation. The effect of these firing changes at the termination of the red stimulus must be indistinguishable to higher centers from those produced by the onset of a green stimulus. We have shown that such neural changes corresponding to successive contrast do occur at the level of the LGN (De Valois & Jones, 1961) and that the off-responses to the termination of one color add together with the on-responses to the initiation of the complementary color to produce more firing than the on-response alone; see figure 4.13. This would be comparable to a greenish surface appearing to be a more staturated green after a red surface had been viewed for a time.

Neural rebound, or off-responses, in opponent-color systems should produce very powerful, but quite brief, negative afterimages, which are not dependent on subsequent stimulation. Receptor adaptation or bleaching, on the other hand, would provide a long-duration process that would also tend to produce negative afterimages, but ones dependent on subsequent retinal stimulation to "reveal" the desensitized receptors. Under ordinary conditions, with fairly brief exposures to the light from low-intensity colored objects, neural rebound in the opponent cells is doubtless the dominant process; with exposures to intense lights, such as looking at a light bulb, or with very long fixation of brightly lit colored objects, receptor adaptation is dominant.

As is the case with simultaneous induction of colors, the fact that there is not only successive color contrast but also sometimes changes in the anticontrast (or what we

have termed *similitude*) direction is often forgotten. But such positive aftereffects—or an alternation of positive and negative aftereffects—often occur.

The effects of light on the receptor outer segments (Falk & Fatt, 1972) is probably to open holes in the receptor disk membranes as the isomerized photopigment molecules break away. This in turn leads to Ca^{++} ion flow which diffuses to the receptor outer membrane and there acts to decrease the Na^+ permeability of the membrane (which eventually leads to decreased synaptic chemical release at the receptor–horizontal-cell–bipolar-cell synapse). Since it takes a considerable time (a half life of about 4 min in cones and 8 min in rods) for the photopigment molecule to be regenerated, one would expect continued receptor output after the termination of a stimulus. Such continued receptor activity has indeed been recorded (Brown, Watanabe, & Murikami, 1965), and should lead to positive aftereffects. In response to a brief intense flash of light, the late receptor potential (LRP) shows an extended hyperpolarizing response, with duration far longer than the stimulus. When a long-duration flash is used, the LRP response falls abruptly at stimulus offset, but not completely back to the resting membrane potential (Brown et al., 1965). Rather, there is an afterhyperpolarization (larger with rod than with cone stimulation) which takes some seconds at least to die away.

These three processes are ordinarily involved to some extent at the termination of any stimulation. Whether one sees positive, or negative, or an alternation between positive and negative afterimages depends on the extent to which the conditions of the initial and the subsequent stimulation promote one or another of the underlying processes. Some of the complexities of the interactions, as well as a partial dissection of the separate processes can be seen in the situation studied by De Valois and Walraven (1967). They inspected an intense spot of red light with the right eye, then measured the color of monochromatic lights seen subsequently with that and with the other eye. When test stimuli are presented to the adapted (right) eye, all three of the processes we have been discussing are involved, with receptor adaptation being dominant due to the prolonged stimulation. One therefore sees large negative afterimages or successive contrast effects: Monochromatic lights from anywhere in the middle of the spectrum (ordinarily seen as green or yellow) appear a spectacularly supersaturated emerald green. The nonadapted (left) eye has, of course, no receptor adaptation; only rebound and receptor afterdischarge from the other eye, mixing at cortical levels, can influence the color seen upon subsequent stimulation of that eye. When neural rebound has died away, a few seconds after stimulus offset, one sees large positive aftereffects and successive color similitude: Lights that would ordinarily appear yellow now look orange when viewed with that eye. And the region of the spectrum complementary to the (red) adaptation light appears quite colorless

when viewed with the nonadapted eye. That this is due to continued afterdischarge from the adapted eye mixing with the stimulus light can be seen by the fact that temporarily blinding the adapted eye by pressing on it abolishes the color shift seen with the unadapted eye (Gestrin & Teller, 1969).

Most of us devote only limited portions of our day to looking at burning light bulbs or staring fixedly for minutes at colored papers under a spotlight, so these powerful successive color changes play a small role in our perceptual life. But extrapolations from experimental studies show that even the fleeting glances we give to naturally lit objects should produce much larger effects than they apparently do in everyday life. One should expect that our percepts of the world would be an indecipherable melange of color and forms from present and past stimuli. That this does not occur reflects the presence of inhibitory interactions between different forms or contours. Daw (1962), examining this specific question, noted that the colored afterimages of a scene to which one adapts for a few seconds can be readily seen, as in the usual demonstration, when one subsequently views a uniform surface. If, however, one subsequently views a black-white scene in which the contours do not coincide with those of the adaptation stimulus, the colored afterimages are not seen at all. On the other hand, if the contours in the second stimulus coincide with those in the first (as when one adapts to a colored photograph and then views a black and white reproduction of the same photograph maintaining the same fixation point throughout) the negative color afterimages are the strongest of all. All this would follow if there were inhibitory interactions (presumably at cortical levels) between cells signaling the presence of different forms in the same location. When the adaptation and the present stimuli are identical in form, there is no inhibition and the full-blown afterimages are seen; when the present stimulus is an uncontoured surface the afterimages are only slightly weakened, but when the contours of the present stimuli are different from those of the adaptation stimuli, the (weaker) afterimage is inhibited to oblivion. (Of course, one could doubtless arrange a situation in which the afterimage was more powerful than a blurred scene seen subsequently; one would then expect the afterimage to obliterate the percept of the subsequent stimulus.) Since under normal conditions we are constantly looking from one scene to a different one, such a process would have the adaptive value of having the information from each new percept cancel the aftereffect from the previous one.

2 Simultaneous Color Interactions a. PERCEPTUAL PHENOMENA The color seen in a region of space is determined not only by the characteristics of the stimuli in that region, but also by those simultaneously present in surrounding regions. These lateral interactions can affect both the color and the brightness (or better, the

whiteness-blackness or lightness) of a region. And the direction of the effects can be such as to change the region in a direction opposite to the surround (color and lightness contrast), or in a direction toward that of the surround (color and lightness assimilation).

Contrast effects are widely known and extensively investigated. In a popular textbook demonstration of color contrast, one can see that a gray square on a red background looks slightly greenish, whereas on a green background it appears reddish. And, in demonstrations of lightness contrast a gray square on a white background appears blackish and on a black background appears whitish.

These textbook demonstrations suffice to give one the flavor of contrast effects but do not adequately demonstrate their enormous influence (particularly that of lightness contrast) in ordinary vision. Most people, when asked what characterizes a black object, would say an absence of light, but this is totally false. As the Gestalt psychologists emphasized, what appears as white or black is almost completely independent of the amount of light it reflects to the eye, but rather is determined by the amount it reflects relative to its surround. Thus, a piece of coal in bright sunlight may reflect thousands of times the amount of light (per unit area) to the eye as does a white piece of paper in an adjacent shadow. But the coal is seen as black and the paper as white. Whether we see an object as white, gray, or black, then, is almost totally determined by the relative amounts of light it and its surround reflect; it is almost totally a function of the contrast rather than of the intensity of the light. This is less true for color contrast, although the demonstrations of Land (1959a,b) show the power of color contrast, too.

Although, under most visual conditions, simultaneous color and lightness induction is in the contrast direction, there are circumstances in which the lateral interactions produce perceptual changes in quite the opposite direction. These anticontrast changes have been called variously the *spreading effect of von Bezold* and *assimilation*. Although they probably do not need a third name, we (De Valois, 1973) have referred to them as *similitude effects* to emphasize that the lateral interactions operate to make objects more similar to their backgrounds in color and/or lightness, as opposed to contrast interactions, which operate to make them more dissimilar.

There have been relatively few studies of the factors determining whether the lateral interactions operate in the contrast or similitude direction. A major factor is the size of the inducing surround: When it is large, contrast induction is seen; when it is small, the tendency is toward similitude (Helson & Rohles, 1959). Blurring of the visual image, as, for instance, would happen along certain planes with astigmatism, also tends to produce similitude effects (Wright, 1969).

Both similitude and contrast interactions are primarily determined by the immediately adjacent surround of an object. That is, the color and lightness of an object are determined by the wavelength and intensity of light coming from that object in relation to that of the background on which it lies. The characteristics of more distant objects also play a role, but it is a secondary one, involving as it does not only direct interactions between the object and the far surround but also the influence of the far surround on the immediately adjacent surround of the object. Many classical studies of contrast effects (Leibowitz, Mote, & Thurlow, 1953; Fry & Alpern, 1953) have only concerned themselves with such second-order interactions.

An important characteristic of contrast effects—and one which presents an intriguing puzzle to understand physiologically—is that objects of virtually any size have their lightness and color determined by their relation to the surround. Thus, when we look at a nearby white wall, it may subtend 20° or more visual angle. Yet our percept of it as being white (rather than gray or even black) depends completely on the amount of light from it with respect to other surrounding objects, that is, on the contrast relationships. Furthermore, our immediate percept of the wall is of its being uniformly white. This may seem like a nonproblem until we consider, as we discuss further later, that all the likely retinal processes for explaining contrast effects only operate over much smaller distnaces—a degree or less of visual angle. So the white appearance of the center of the wall is determined by the contrast situation 10° or more in the periphery, whereas neurons signaling information about the center of the visual field are quite uninfluenced by stimuli even 1° away.

b. PHYSIOLOGICAL BASIS The first point to be made about the physiological basis for simultaneous lateral interactions is that the retinal image is such as to produce similitude rather than contrast effects. The retinal image is blurred, due to the limitations of the optics of the cornea and lens even in the best of eyes. There is also some light scatter in the course of passage through the eye. Both of these effects are greatly enhanced by such common optical effects as myopia or presbyopia, or by astigmatism and by diseases, such as cataracts or intraretinal hemorrhages. As a result, the image of a gray square on a white surround, see figure 4.14, will actually be lighter than that same square on a black surround. So also, a gray square on a red background actually has some long-wavelength ("red") light scattered onto it, whereas on a green background it would be slightly greenish. There are some circumstances, as we have mentioned (and termed similitude), when we actually see a gray square on a white background as lighter than when it is on a black background; or when we see a gray on a red background as redder than the same gray on a green background. Under these similitude conditions, then, our percept corresponds to the actual retinal stimulation.

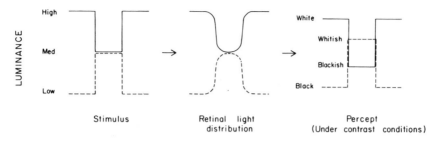

Figure 4.14
Diagram of a classical lightness contrast situation: a gray disk on a white (solid line) versus on a black (dotted line) background. The optics of the eye produce some light scatter so the gray on white is lighter, in the image at the receptors, than the gray on black. Under similitude conditions it is so seen. More frequently, however, contrast operates and the percept on the right is seen, with the gray on white looking blacker than the gray on black.

That we do not always see similitude effects—in fact, seldom do—implicates the existence of very powerful neural interactions operating in the contrast direction. Such interactions indeed take place (as far as the achromatic lightness-darkness processing is concerned) at the first retinal synapse. The first evidence for such a process was found by Kuffler (1953), in ganglion cell recordings in the cat. He found evidence for two different types of neurons in the cat (these correspond to the two types of spectrally nonopponent cells in the primate visual system). As already discussed, one variety fires to a light increment in the center of its receptive field and is inhibited by a light increment in the surround; a light decrement in the center of the RF, on the other hand, inhibits such a cell, whereas a light decrement in the surround fires it. Thus, the optimal stimulus for firing the cell is an increment in the RF center combined with a decrement in the surround. The total amount of light is almost irrelevant; it is the difference between the amount of light in center and surround (i.e., the contrast) that is critical. We have termed such cells +Wh −Bl for the good reason that they fire to those objects we see as white, i.e., more light in the center than in the surround, and inhibit to black.

Such cells would completely counter the blur-induced similitude effects. Consider the response of a +Wh −Bl cell to the light distributions in figure 4.14. The gray on a white background would provide an excitatory stimulus, but the high-intensity background, falling on the inhibitory surround would more than counteract this excitation and the net effect would be inhibition, signaling black. But consider now the gray on the black background. The gray would produce less excitation than the gray on white, but the black background would produce no inhibition, so the net effect would then be excitation, signaling white. This is, of course, how we would see the two grays under most conditions.

The surround of RFs of cells are far more extensive than the centers and are relatively less sensitive per unit area than the centers. Even in the case of stimuli with extensive surrounds, the center tends to dominate the surround, but if the surround is made very small the center would be totally dominant. In the example of the gray on white and black backgrounds, the gray area, stimulating the RF center of our hypothetical cell, would produce responses in the similitude direction; it is only the counteracting influence of the background on the RF surround that produces the contrast-like response. If the effect of the surround would be lessened, as with narrow borders around an area, one might very well expect the responses of retinal neurons to shift in the similitude direction.

Found equally frequently in cat (and primates) are mirror-image cells, which also respond to contrast rather than to the amount of light, but these cells fire to a decrement in the RF center and are inhibited by an increment. Again, the RF surround is opposite. Such cells we have termed +Bl −Wh because they fire optimally to black objects, i.e., ones which reflect less light than their surrounds.

Among each of these classes of nonopponent cells there is a wide variation in receptive field size (Wiesel, 1960). (This presumably acts as the first step in an analysis of the size or spatial frequency characteristics of objects.) But even the largest receptive fields found in the central part of the primate visual system are scarcely larger than a degree, and most are far smaller, averaging around 8' of arc (De Valois & Pease, 1971). So, although such cells show strong lightness contrast effects, it is only for very small stimuli or at the borders of large stimuli; the 20° white wall discussed earlier would cover uniformly the RFs of all central neurons, presenting them with no contrast stimulus. The retinal center-surround organization is just a partial step toward explaining perceptual lightness contrast.

As we have discussed, a center-surround organization is also seen in the case of most spectrally opponent cells. The difference here is that the opposing center and surround inputs are from different cone types. For instance, the +G −R cell diagrammed in figure 4.7 has M cones feeding into the RF center in an excitatory way, and L cones feeding into the surround in an inhibitory fashion (in response to increments in light). Since the spectral sensitivity of L and M cones are not very different and each is responsive to light from virtually all spectral regions, such a cell will respond to luminance changes in a way very similar to +Wh −Bl cells (De Valois, 1972), showing strong contrast effects. That is, the optimal achromatic excitatory stimulus will be a light object on a dark surround.

Such a center-surround organization of spectrally opponent cell RFs does *not* produce color contrast, however. Quite the contrary: it acts in the anticontrast or similitude direction, as far as color differences are concerned. The +G −R cell fires

optimally to a green object on a green surround, i.e., with no contrast. A maximum color contrast stimulus of green on red would be a quite ineffective stimulus, the green producing excitation from the RF center, but the red evoking inhibition from the surround. Or, consider the classical example of gray on green versus gray on red (the latter appearing greener by contrast). The gray center would produce some excitation in each case, but the red background would produce more inhibition from the RF surround than would the green. Therefore this $+G -R$ cell would fire more to the gray on a green background than to the gray on red, i.e., in the similitude direction.

The center-surround antagonism of spectrally opponent cells thus gives them the property of responding to lightness contrast but not to color contrast. We are therefore left with two puzzles with respect to simultaneous lateral inductions: the absence of a process (before the cortex) for producing color contrast; and the fact that the precortical processes producing lightness contrast operate only over very limited distances, only for small stimuli. For neither of these are there, as yet, certain physiological solutions.

What we are led to in considering the physiological basis of contrast is a two-stage model: a very powerful lightness contrast process, in the center-surround organization of retinal cells, operating over short distance; and a weaker but long-distance cortical process operating for both lightness and color contrast. Such a proposal would be in accord with the fact that color contrast effects are far weaker than lightness contrast effects. Békésy (1968) proposed something similar from phenomenological and psychophysical considerations: a strong, narrow, "Mach" lateral inhibition and a weak, diffuse, "Hering" lateral inhibition, as he termed them. At stimulus discontinuities one sees lightness (and saturation) differences—Mach bands—but not hue shifts. So the "Mach"-type inhibition operates in the achromatic but not the chromatic domain. But the weaker "Hering" inhibition he believed operated for both lightness and color.

A double-opponent organization, such as found in fish retina (Daw, 1968), has been put forth as a possible basis for color contrast. But such double-opponent cells as have been found in monkey cortex (Hubel & Wiesel, 1968; Michael, 1973) have far too small fields to account for long-distance color interactions. A model based on colored-edge detectors, such as that proposed by Yund (1970), would seem more plausible, but the physiological evidence for such is weak as yet.

c. CONTRAST AND CONSTANCY One might finally consider the functional significance of lightness contrast mechanisms for the organism, what makes it of such importance that it constitutes the very first step of retinal processing. The answer would appear to be to maintain object constancy. There are two types of visual objects: those that

are self-luminous and those that merely reflect some part of whatever light strikes them. With the exception of such things as the sun and fireflies, most self-luminous objects are recent human inventions, and even now the vast majority of visual objects we encounter are just reflective.

A self-luminous object puts out a constant amount of light and can therefore be characterized by its absolute intensity. If we lived in a world filled with self-luminous objects, we might well have developed a visual system that gave absolute intensity information. But reflective objects, which is what we are mainly concerned with detecting and identifying, send wildly varying amounts of light to the eye, depending on the illumination conditions. A black piece of paper may reflect 8% of what light falls on it; if 100 photons per unit area are shined on it, it will reflect 8; if 1,000,000, it will reflect 80,000. A white piece of paper may reflect 80% of the light and in the same two situations send 80 and 800,000 photons per unit area to the eye. It is clear that what would allow us to identify and characterize these two papers is not the absolute amount of light from either, but the relative amounts or the contrast: The white always reflects 10 times the amount as the black. To maintain object constancy in a self-luminous visual world, then, one would want a visual system that signals absolute intensity, but in our actual reflective visual world what is required is relative intensities or contrast. And that is what is, in fact, signaled to the brain by both nonopponent and opponent cells.

The same argument can be made for color contrast, but with a different conclusion. If our world were lit by monochromators which were constantly fluctuating in wavelength (instead of by sunlight which fluctuates massively in intensity with time of day and cloud cover but not much in spectral characteristics), it would be advantageous for us to develop a completely relative-wavelength encoding system. But color variations are relatively small, and objects can be well characterized by their absolute-wavelength characteristics. Therefore, a largely absolute color signaling system preserves object constancy in the color domain.

References

Abramov, I. Further analysis of the responses of LGN cells. *Journal of the Optical Society of America*, 1968, **58**, 574–579.

Anderson, V. O., Buchmann, B., & Lennox-Buchthal, M. A. Single cortical units with narrow spectral sensitivity in monkey (*Cercocebus torquates atys*). *Vision Research*, 1962, **2**, 295–307.

Barlow, H. B. Summation and Inhibition in the frog's retina. *Journal of Physiology (London)*, 1953, **119**, 69–88.

Baumgartner, G., Brown, J. L., & Schulz, A. Responses of single units of the cat visual system to rectangular stimulus patterns. *Journal of Neurophysiology*, 1965, **28**, 1–18.

Békésy, G. v. Mach- and Hering-type lateral inhibition in vision. *Vision Research*, 1968, **8**, 1483–1499.

Boles, J. Colour and contour detection by cells representing the fovea in monkey striate cortex. Paper presented at Society for Neuroscience First Annual Meeting, Washington, D.C., October, 1971.

Boynton, R. M., & Gordon, J. Bezold-Brücke hue shift measured by color naming technique. *Journal of the Optical Society of America*, 1965, **55**, 78–86.

Boynton, R. M., & Whitten, D. N. Visual adaptation in monkey cones: Recordings of late receptor potentials. *Science*, 1970, **170**, 1423–1426.

Brown, J. L. Afterimages. In C. H. Graham (Ed.), *Vision and visual perception*. New York: Wiley, 1965.

Brown, K. T., Watanabe, K., & Murikami, M. The early and late receptor potentials of monkey cones and rods. *Cold Spring Harbor Symposium on Quantitative Biology*, 1965, **30**, 457–482.

Daw, N. W. Why after-images are not seen in normal circumstances. *Nature*, 1962, **196**, 1143–1145.

Daw, N. W. Goldfish retina: Organization for simultaneous color contrast. *Science*, 1968, **158**, 942–944.

Daw, N. W. Neurophysiology of color vision. *Physiological Review*, 1973, **53**, 571–611.

De Valois, R. L. Color vision mechanisms in the monkey. *Journal of General Physiology*, 1960, **43**, 115–128.

De Valois, R. L. Analysis and coding of color vision in the primate visual system. *Cold Spring Harbor Symposium on Quantitative Biology*, 1965, **30**, 567–579.

De Valois, R. L. Physiology of color vision. In *Tagungsbericht Internationale Farbtagung COLOR 69*, Stockholm, 1969. Pp. 29–47.

De Valois, R. L. Contributions of different lateral geniculate cell types to visual behavior. *Vision Research*, 1971, **11**, 383–396.

De Valois, R. L. Processing intensity and wavelength information. *Investigative Ophthalmology*, 1972, **11**, 417–427.

De Valois, R. L. Central mechanisms of color vision. R. Jung (Ed.), In *Handbook of sensory physiology*, Vol. VII/3A. New York: Springer-Verlag, 1973. Pp. 209–253.

De Valois, R. L., Abramov, I., & Jacobs, G. H. Analysis of response patterns of LGN cells. *Journal of the Optical Society of America*, 1966, **56**, 966–977.

De Valois, R. L., Abramov, I., & Mead, W. R. Single cell analysis of wavelength discrimination at the lateral geniculate nucleus in the macaque. *Journal of Neurophysiology*, 1967, **30**, 415–433.

De Valois, R. L., & Jacobs, G. H. Primate color vision. *Science*, 1968, **162**, 533–540.

De Valois, R. L., Jacobs, G. H., & Jones, A. E. Effects of increments and decrements of light on neural discharge rate. *Science*, 1962, **136**, 986–988.

De Valois, R. L., & Jones, A. E. Single-cell analysis of the organization of the primate color-vision system. In R. Jung & H. Kornhuber (Eds.), *The visual system*. Berlin: Springer, 1961.

De Valois, R. L., & Marrocco, R. T. Single-cell analysis of saturation discrimination in the macaque. *Vision Research*, 1973, **13**, 701–711.

De Valois, R. L., Morgan, H. C., Polson, M. C., Mead, W. R., & Hull, E. M. Psychophysical studies of monkey vision: I. Macaque color vision and luminosity tests. *Vision Research*, 1974, **14**, 53–67.

De Valois, R. L., & Morgan, H. C. Psychophysical studies of monkey vision: II. Squirrel monkey wavelength and saturation discrimination. *Vision Research*, 1974, **14**, 69–73.

De Valois, R. L., Morgan, H. C., & Snodderly, D. M. Psychophysical studies of monkey vision: III. Spatial luminance contrast sensitivity tests of macaque and human observers. *Vision Research*, 1974, **14**, 75–81.

De Valois, R. L., & Pease, P. L. Contours and contrast: Responses of monkey lateral geniculate nucleus cells to luminance and color figures. *Science*, 1971, **171**, 694–696.

De Valois, R. L., Smith, C. J., Karoly, A. J., & Kitai, S. T. Electrical responses of primate visual system. I. Different layers of macaque lateral geniculate nucleus. *Journal of Comparative & Physiological Psychology*, 1958, **51**, 662–668.

De Valois, R. L., & Walraven, J. Monocular and binocular aftereffects of chromatic adaptation. *Science*, 1967, **155**, 463–465.

Dow, B. M., & Gouras, P. Color and spatial specificity of single units in the rhesus monkey foveal striate cortex. *Journal of Neurophysiology.* 1973, **36**, 79–100.

Falk, G., & Fatt, P. Physical changes induced by light in the rod outer segment of vertebrates. In H. J. A. Dartnall (Ed.), *Handbook of sensory physiology*, Vol. VII/1. New York: Springer-Verlag, 1972. Pp. 200–244.

Fry, G. A., & Alpern, M. The effect of a peripheral glare source upon the apparent brightness of an object. *Journal of the Optical Society of America*, 1953, **43**, 189–195.

Gestrin, P. J., & Teller, D. Y. Interocular hue shifts and pressure blindness. *Vision Research*, 1969, **9**, 1267–1272.

Gouras, P. Identification of cone mechanisms in monkey ganglion cells. *Journal of Physiology (London)*, 1968, **199**, 533–547.

Helmholtz, H. L. F. von. *Die Lehre von den Tonempfindungen als physiologische Grundlage für die Theorie der Musik*. Brunswick: Viewig, 1863.

Helmholtz, H. L. F. von *Handbuch der Physiologischen Optik*. Hamburg-Leipzig: Voss, 1866.

Helson, H., and Rohles, F. H., Jr. A quantitative study of reversal of classical lightness contrast. *American Journal of Psychology*, 1959, **72**, 530–538.

Hering, E. *Zur Lehre vom Lichtsinn. Ueber successive Lichtinduction*. Sitzungber. Akad, Wissensch., Wien, math. nat. Kl., 1872.

Hubel, D. H., & Wiesel, T. N. Receptive fields, binocular interaction and functional architecture in the cat's visual cortex. *Journal of Physiology (London)*, 1962, **160**, 106–154.

Hubel, D. H., & Wiesel, T. N. Receptive fields and functional architecture of monkey striate cortex. *Journal of Physiology (London)*, 1968, **195**, 215–243.

Jacobs, G. H. Spectral sensitivity and color vision of the squirrel monkey. *Journal Comparative & Physiological Psychology*, 1963, **56**, 616–621.

Jacobs, G. H. Effects of adaptation on the lateral geniculate response to light increment and decrement. *Journal of the Optical Society of America*, 1965, **55**, 1535–1540.

Jacobs, G. H., & Gaylord, H. Effects of chromatic adaptation on color naming. *Vision Research*, 1967, **7**, 645–653.

Jacobs, G. H., & Yolton, R. L. Distribution of excitation and inhibition in receptive fields of lateral geniculate neurons. *Nature (London)*, 1968, **217**, 187–188.

Jones, L. A., & Lowry, E. M. Retinal sensibility to saturation differences. *Journal of the Optical Society of America*, 1926, **13**, 25–37.

Judd, D. B. Chromaticity sensibility to stimulus differences. *Journal of the Optical Society of America*, 1932, **22**, 72–108.

Jung, R. Korrelation von Neuronentätigkeit und Sehen. In: R. Jung and H. H. Kornhuber (Eds.), *Neurophysiologie und Psychophysik des visuellen Systems*, New York: Springer, 1961. Pp. 410–435.

Kinsbourne, M., & Warrington, E. K. Observations on colour agnosia. *Journal of Neurology Neurosurgery & Psychiatry*, 1964, **27**, 296–299.

Kuffler, S. W. Discharge patterns and functional organization of mammalian retina. *Journal of Neurophysiology*, 1953, **16**, 37–68.

Land, E. H. Color vision and the natural image, Part I. *Proceedings of the National Academy of Science, U.S.A.*, 1959, **45**, 115–129. (a)

Land, E. H. Color vision and the natural image, Part II. *Proceedings of the National Academy of Science, U.S.A.*, 1959, **45**, 636–644. (b)

Leibowitz, H., Mote, F. A., & Thurlow, W. R. Simultaneous contrast as a function of separation between test- and inducing-field. *Journal of Experimental Psychology*, 1953, **46**, 453–456.

MacNichol, E. F., Jr., & Svaetichin, G. Electric responses from the isolated retinas of fishes. *American Journal of Ophthalmology*, 1958, **46**, 26–39.

Marks, W. B. Difference spectra of the visual pigments in single goldfish cones. Unpublished doctoral dissertation. Baltimore: Johns Hopkins University, 1963.

Marks, W. B., Dobell, W. H., & MacNichol, E. F, Jr. Visual pigments of single primate cones. *Science*, 1964, **143**, 1181–1182.

Marrocco, R. T. Responses of monkey optic tract fibers to monochromatic lights. *Vision Research*, 1972, **12**, 1167–1174.

Martin, L. C., Warburton, F. L., & Morgan, W. J. The determination of the sensitiveness of the eye to differences in saturation of colors. Great Britain Research Council Special Report Series, 1–42, 1933.

Mead, W. R. Analysis of the receptive field organization of macaque lateral geniculate nucleus cells. Unpublished doctoral dissertation. Bloomington, Indiana: Indiana University, 1967.

Mello, N. K., & Peterson, N. J. Behavioral evidence for color discrimination in cat. *Journal of Neurophysiology*, 1964, **27**, 323–333.

Michael, C. R. Double opponent-color cells in the primate striate cortex. Paper presented at the Association for Research in Vision and Ophthalmology Spring Meeting, Sarasota, Florida, May, 1973.

Onley, J. W., Klingberg, C. L., Dainoff, M. J., & Rollman, G. B. Quantitative estimates of saturation. *Journal of the Optical Society of America*, 1963, **53**, 487–493.

Pitt, F. H. G. The nature of normal trichromatic and dichromatic vision. *Proceedings of the Royal Society (London), Series B*, 1944, **132**, 101–117.

Poggio, G. F. Spatial properties of neurons in striate cortex of unanesthetized macaque monkey. *Investigative Ophthalmology*, 1972, **11**, 368–376.

Poggio, G. F., Mansfield, R. J. W., & Sillito, A. M. Functional properties of neurons in the striate cortex of the macaque monkey subserving the foveal region of the retina. Paper presented at Society for Neuroscience First Annual Meeting, Washington, D.C., October, 1971.

Polyak, S. L. *The vertebrate visual system.* Chicago: University of Chicago Press, 1957.

Priest, I. G., & Brickwedde, F. G. The minimum perceptible colormetric purity as a function of dominant wavelength. *Journal of the Optical Society of America*, 1938, **28**, 133–139.

Purdy, D. M. On the saturation and chromatic thresholds of the spectral colours. *British Journal of Psychology*, 1931, **21**, 283–313.

Rushton, W. A. H. A cone pigment in the protanope. *Journal of Physiology (London)*, 1963, **168**, 345–359.

Rushton, W. A. H. A foveal pigment in the deuteranope. *Journal of Physiology (London)*, 1965, **176**, 24–37.

Sechzer, J. A., & Brown, J. L. Color discrimination in the cat. *Science*, 1964, **144**, 427–428.

Stiles, W. S. Increment thresholds and the mechanisms of color vision. *Documenta Ophthalmologica den Haag*, 1949, **3**, 138–165.

Svaetichin, G., & MacNichol, E, F., Jr. Retinal mechanisms for chromatic and achromatic vision. *Annals of the New York Academy of Science*, 1958, **74**, 385–404.

Toyoda, J., Nosaki, H., & Tomita, T. Light induced resistance changes in single receptors of *Necturus* and *Gekko*. *Vision Research*, 1969, **9**, 453–463.

van der Horst, G. J. C., & Bouman, M. A. Spatiotemporal chromaticity discrimination. *Journal of the Optical Society of America*, 1969, **59**, 1482–1488.

Vos, J. J., & Walraven, P. L. On the derivation of the foveal receptor primaries. *Vision Research*, 1971, **11**, 799–818.

Wagner, H. G., MacNichol, E. F., Jr., and Wolbarsht, M. L. The response properties of single ganglion cells in the goldfish retina. *Journal of General Physiology*, 1960, **43**, Suppl. 6, part 2, 45–62.

Wagner, H. G., MacNichol, E. F., Jr., & Wolbarsht, M. L. Functional basis for "on"-center and "off"-center receptive fields in the retina. *Journal of the Optical Society of America*, 1963, **53**, 66–70.

Wald, G., and Brown, P. K. Human color vision and color blindness. *Cold Spring Harbor Symposium on Quantitative Biology*, 1965, **30**, 345–359.

Wiesel, T. N. Receptive fields of ganglion cells in the cat's retina. *Journal of Physiology*, 1960, **153**, 583–594.

Wiesel, T. N., & Hubel, D. H. Spatial and chromatic interactions in the lateral geniculate body of the rhesus monkey. *Journal of Neurophysiology*, 1966, **29**, 1115–1156.

Wright, W. D. *The measurement of colour*, 4th ed. London: Hilger, 1969.

Wright, W. D., & Pitt, F. H. G. The saturation discrimination of two trichromats. *Proceedings of the Physical Society, London*, 1937, **49**, 329–331.

Young, T. On the theory of light and colours. In *Lectures in natural philosophy*, Vol. 2. London: Printed for Joseph Johnson, St. Paul's Church Yard, by William Savage, 1807.

Yund, E. W. A physiological model for color and brightness contrast effects. Unpublished doctoral dissertation. Boston: Northeastern University, 1970.

Zeki, S. M. Colour coding in rhesus monkey prestriate cortex. *Brain Research*, 1973. **53**, 422–427.

IV COLOR CONSTANCY

5 Recent Advances in Retinex Theory

Edwin H. Land

It is a cultural commonplace deriving from Newton that the color of an object in the world around us depends on the relative amounts of red, green, and blue light coming from the object to our eyes. In contradiction, it has long been known that the color of an object when it is part of a general scene will not change markedly with those considerable changes in the relative amounts of red, green, and blue light which characterize illumination from sunlight versus blue skylight versus grey daylight versus tungsten light versus fluorescent light. The visual phenomena associated with this contradiction were named "color constancy." We will not examine here the interesting explanations of color constancy by Helmholtz and those who have followed him during the last century because, from the point of view of Retinex Theory, as the following experiments show, the paradox does not really exist: the color of an object is not determined by the composition of the light coming from the object.

The first group of experiments is carried out with an arrangement of real fruits and vegetables. A photograph of the scene is shown in color plate 1.

In a dark room with black walls, three illuminating projectors with clear slides in the slide-holders are directed on the scene. The brightness of the projectors is individually controllable. An interference filter passing 450 nm is placed in front of one projector, 550 nm in front of the second, and 610 nm in front of the third. The measurements in this experiment are all carried out with a telescopic photometer that reads the flux towards the eye from a circular area about 8 mm in diameter on the surface of an object. The readings are in watts per steradian per square meter. All readings are made with light from *only one* projector at a time. Three synchronized camera shutters on the illuminating projectors make possible the comparison of the colors in the fruit and vegetables as seen with continuous illumination and as seen with illumination for only a fraction of a second.

The meter is directed at an orange, the fluxes towards the eye on the three wavebands are set equal to each other, and the orange is observed when the whole scene is illuminated with the combined light from the three illuminators. The orange is orange-colored.

The process is repeated for a green pepper so that the identical radiation comes to the eye—the same three equal wattages as came from the orange. The green pepper is green.

Similarly, when the identical radiation reaches the eye from a yellow banana, the banana is yellow.

When the identical radiaton reaches the eye from a dark red pepper, the pepper is dark and the pepper is red.

Observations in a Pulse of Light

One of the most important experiments in this group is to compare the scene as viewed in continuous illumination with the scene viewed in a fractional-second pulse. In view of the historic tendency to involve adaptation and eye-motion as causal factors in "color constancy," it is impressive to see that for every new setting, as we turn our attention from object to object, the colors seen in a pulse are correct: whether the scene is viewed in continuous illumination or in a fractional-second pulse, straw is straw-color, rye bread is rye-bread-color, limes are lime-color, green apples are green and red apples are red—with the illuminators of the scene so set in each case that the very same ratio of wattages of long, middle and short wave radiation comes to the eye from each of the objects in this list. That is, observed through a spectrophotometer, they would all look alike. Since this experiment establishes that the color of an object is not a function of the composition of the light coming from the object, there is nothing surprising about the failure of the objects to change color when the composition of the illumination changes: within the framework of Retinex Theory, "color constancy" is the name of a non-existent paradox.

In plate 1, a pile of pigment is located in front of the peppers. The pigment is red lead oxide, or minium, referred to in Newton's *Opticks* (1704) in Proposition X, Problem V

"... Minium reflects the least refrangible or red-making rays most copiously, and thence appears red.... Every Body reflects the Rays of its own Colour more copiously than the rest, *and from their excess and predominance in the reflected Light has its Colour.*"

The demonstrations in this group of experiments prove that the part of Newton's proposition which we have italicized is incorrect. When the scene is so illuminated that the minium sends to the eye fluxes with the same three equal wattages, the minium continues to look its own brilliant orange-red color—even though there is not at all an "excess and predominance in the reflected light" of "red-making rays."

This group of experiments leads to the first statement in Retinex Theory:

I. The composition of the light from an area in an image does not specify the color of that area.

When the fruit and vegetable scene is illuminated by light of one waveband, we observe that the very light objects stay very light and the very dark objects stay very dark as we alter the brightness of the illumination over nearly the whole range

between extinction and maximum illumination. For example, with middle-wave illumination the red pepper will be always almost black and the green pepper always a light grey-green. This situation will be reversed when we change to long wave illumination; that is, the red pepper will always be light and the green pepper always dark.

Based on these observations of the peppers, it is reasonable to venture the hypothesis that an object which always looks light with middle-wave illumination on the scene and always looks dark with long-wave illumination on the scene will look green when the scene is illuminated with both illuminators and *will continue to look green* as we change the relative brightness of the long- and short-wave illuminators and hence the relative fluxes from the object to the eye. Similarly, an object which is dark in middle-wave illumination and light in long-wave illumination will look red when the scene is illuminated with both illuminators and *will continue to look red* as we change the relative brightness of the two illuminators. Similar relationships can be established for the short-wave illumination.

Since these experiments indicate that color can indeed be predicted on the basis of the three lightnesses at a point, we are led to the question of how to predict *for each waveband separately*, each of the three lightnesses of a point in an image. We would like to know how to compute the number on which lightness is based with the expectation that we will find that a given trio of numbers will always be a single color, a color uniquely corresponding to the given trio.

These expectations lead to the second statement in Retinex Theory:

II. The color of a unit area is determined by a trio of numbers each computed on a single waveband to give the relationship for that waveband between the unit area and the rest of the unit areas in the scene.

This suggests testing the simple hypothesis that (for each of the three wavebands) the lightness of an object and of a unit area on it might be determined by the ratio of the flux from that unit area to the average of the fluxes from all the unit areas in the display. As we contemplate the real still-life arrangement, still illuminating with one waveband, we note that the lightness of any given object does not change no matter where we put it in the whole arrangement, no matter what the background. If we then put a neutral wedge into the slide-holder of the illuminating projector so that the illumination transversely across the display is changing, for example, by a factor of ten from one side to the other, we find that the lightness of an object still does not change as we move it from one side of the display to the other. The dark pepper is dark on either side; the light pepper is light on either side. Clearly the simple

hypothesis is threatened: the ratio of flux per unit area from the pepper to the average flux per unit area from the whole field must change by a factor of ten as the pepper is moved across the field; yet the *lightness* of the pepper is almost unchanged. Nevertheless, in spite of this significant difficulty with the simple hypothesis, there is great appeal to this method for finding one of the three numbers for three wavebands, numbers which we hope will be our new designators for the color of that unit area.

Since this simplest of approaches for the computation on a single waveband involves the ratio of the unit area flux to the average of all the unit area fluxes in the field of view, let us note that there are two initially equivalent ways of stating the averaging process. The first is to take the ratio of the flux from the one unit area to the average of the flux from all the other unit areas. The second, which may seem somewhat esoteric, is to take the ratio of the unit area flux to each of the other unit area fluxes in the field, separately, and then to average all of these ratios. We might say that in the first case we have established the relationship between the unit area and the average of *all* the other unit areas, whereas in the second case, we have found the average of all the *separate* relationships between the unit area and each of all the other unit areas. These two procedures yield identical results. The second one, however, lends itself to modification that will cause the computation to give the same value for the unit area when the overall illumination is altered to be mottled or uniform or oblique, whereas the first procedure will give variable results with such variation in the regularity of illumination.*

The useful modification of the second procedure comprises noting any chain of unit areas from a distant one to the one we are characterizing and using the chain of ratios from the distant one to give the relationship to the distant one. It is required that when the individual ratios in the chain approximate unity, they act as if they *are* unity. With this procedure, in the presence of irregular illumination, the relationship of the unit area being evaluated to the distant unit area will yield approximately the same number as the ratio of their fluxes in uniform illumination. If we now average a large number of relationships of our terminal unit area to many distant unit areas, we arrive at the number which characterizes that unit area for that waveband.

This second type of relationship is represented in the algorithm below which contains inherently all of the procedures necessary to satisfy the conditions to generate one number which will be a member of the trio of numbers that will be the color.

Thus the third statement in Retinex Theory is the algorithm itself.

III. The Retinex algorithm:

The relationship of i to j:

$$R^\Lambda(i,j) = \sum_k \delta \log \frac{I_{k+1}}{I_k}$$

$$\delta \log \frac{I_{k+1}}{I_k} = \begin{cases} \log \dfrac{I_{k+1}}{I_k} & \text{if } \left| \log \dfrac{I_{k+1}}{I_k} \right| > \text{threshold}, \\ 0 & \text{if } \left| \log \dfrac{I_{k+1}}{I_k} \right| < \text{threshold}. \end{cases}$$

Average of relationships at area i:

$$\bar{R}^\Lambda(i) = \frac{\sum_{j=1}^{N} R^\Lambda(i,j)}{N}$$

The relationship of the flux at i to the flux at j, at one of the three principle wavebands, Λ, is given by the first two equations. The third equation gives the number which is one of the trio of numbers we have been looking for. Its value is the average of the relationships between unit area i and each of several hundred unit areas, j's, randomly distributed over the whole field of view. This number, \bar{R}^Λ, is the *designator* for one waveband. There will be three designators, one for each waveband. Together they can be represented as a point in a Retinex three-space (figure 5.1).

When an image of a collage of colored papers (plate 2) or of a colored Mondrian (plate 3) is formed and the computational technique proposed is pursued, it is found that the three-space is populated in an orderly way. The points on one of the internal diagonals turn out to look black at one end, run through gray, and are white at the other end of the diagonal. There is a domain in which the greens reside, another for the reds, still another for the blues, and yet another for the yellows. It is a triumph of this computational technique that the overall variation in the composition of the illumination in terms of flux at a given wavelength or in terms of relative flux between wavelengths does not disturb the reliability with which a paper which looks

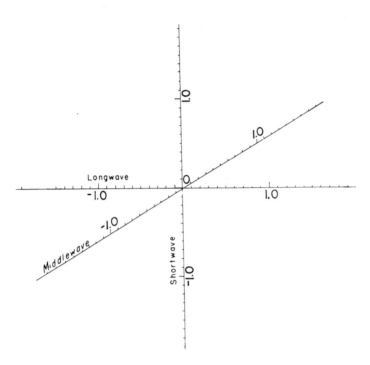

Figure 5.1
Axes of the Retinex three-space.

red, no matter where it resides in the Mondrian, will have the same three designators as the other papers which look red. It will therefore be part of a family of reds which appears in one domain of the three-space. Similarly, all the blues or greens or yellows, *wherever resident in the Mondrian* and however haplessly illuminated, will appear in their appropriate domains in the three-space (plate 4). It is the computation that leads each paper to have its position in the three-space; the proof of the pudding is that all things that appear in the same region of the three-space are the same color as one another, whatever their history in terms of geography and illumination on the Mondrian may have been.

Measurements and Computations

The relative simplicity of the algorithm as a formula for determining the color of a unit area in any situation, natural or artificial, demanded the design of an instrument that could be swept across the surface of a display, whether projected, or planar like

Figure 5.2
Diagram of optical mouse. The rectangular aperture in top view (right) rests on the surface of the collage or screen. The projected radiation passes through the aperture to the surface where it is scattered back toward the (sloping) photosensitive element. A large number of rapid readings are integrated and read into the minicomputer every third of an inch of travel.

the real collages, to compute first the relationship between a unit area and any distant unit area (all on one waveband) and then, with the aid of a compact associated computer, the average of the relationships between the unit area and a large number of randomly selected unit areas throughout the field of view.

An "optical mouse" (figure 5.2) and the associated circuits have been designed by William Wray to carry out the algorithmic computation for a unit area in the Mondrian or the fruit scene. An observer is allowed to see the display only in one waveband while the optical mouse system is swept along the random pathways to give a number for that waveband for the unit area. The observer has not been allowed to see the display in full color. Then the waveband is changed and the process is repeated for the same unit area. Finally, the number for the third waveband is computed. We now have the three designators. The three-space, populated by a large number of previously computed colors such as those listed in table 5.1, is projected in three dimensions onto a neighboring screen. The designators are located in the three-space with the aid of a three-dimensional pointer, the design of which takes advantage of the fact that the spectators are already wearing orthogonally polarized lenses to see the three-space steroscopically. The color where the three-dimensional pointer locates itself, as dictated by the three designators, is noted. Then and only then all three illuminators or projectors are turned on together to see if the color predicted by the designators is indeed the color of the unit area in the display. The predictions for the Mondrian have been strikingly good. The predictions for the fruit

Table 5.1
These numbered Coloraid (C) and Munsell (M) papers are those referred to in the Retinex three-space in plate 4

<div align="center">Table of Colors</div>

Loc.	Color	Loc.	Color	Loc.	Color
0	(M)5G 5/2	4G	(C)RO T-3	8S	(C)BGB S-3
2	(M)5B 6/4	4L	(C)RV T-3	8U	(C)GBG S-3
5	(M)5B 3/4	4S	(C)BGB T-3	91	(M)2.5Y 8/10
6	(M)7.5B 7/6	4U	(C)GBG T-3	92	(M)2.5Y 7/10
7	(M)7.5B 6/6	4X	(C)YG T-3	96	(M)2.5Y 6/8
A	(M)10RP 5/8	4Z	(M)2.5R 6/8	97	(M)5Y 8.5/12
B	(M)N 4.75	52	(M)2.5YR 6/14	9R	(C)WHITE
C	(C)VBV HUE	5H	(C)ROR T-4	9X	(C)SIENNA
D	(C)VBV T-1	5Q	(C)BVB T-4	A6	(M)5Y 6/8
I	(M)5G 4/4	5R	(C)B T-4	AM	(M)10RP 7/8
P	(M)5G 4/2	5S	(C)BGB T-4	AP	(M)10RP 4/8
X	(M)5G 4/1	5U	(C)GBG T-4	B1	(M)5Y 9/6
Z	(M)5G 2.5/1	5V	(C)G T-4	B4	(M)7.5Y 9/10
09	(M)2.5R 6/6	5Z	(M)2.5R 4/8	B6	(M)7.5Y 8/10
13	(M)5R 5/12	62	(M)5YR 7/10	BF	(M)7.5YR 7/16
17	(M)5R 4/10	68	(M)5YR 6/6	BH	(M)5B 4/10
1H	(C)ROR HUE	6A	(C)Y S-1	BJ	(M)5P 4/12
1J	(C)R HUE	6B	(C)YOY S-1	BL	(M)N 1.75
1X	(C)YG HUE	6C	(C)YO S-1	BM	(M)N 2.75
1Y	(C)YGY HUE	6D	(C)OYO S-1	BN	(M)N 3.75
1Z	(C)COBALT	6R	(C)B S-1	BP	(M)N 5.75
26	(M)7.5R 5/12	6S	(C)BGB S-1	BQ	(M)N 6.75
2A	(C)Y T-1	6U	(C)GBG S-1	BR	(M)N 7.75
2J	(C)R T-1	6Y	(C)YGY S-1	BS	(M)N 8.75
2Q	(C)BVB T-1	6Z	(M)5B 8/4	BT	(M)N 9.5
2R	(C)B T-1	71	(M)7.5YR 7/10	BW	(M)2.5R 6/4
2T	(C)BG T-2	74	(M)7.5YR 6/8	C5	(M)10Y 8.5/10
2U	(C)GBG T-1	75	(M)7.5YR 5/8	CK	(M)5R 6/4
2V	(C)G T-1	79	(M)7.5YR 5/6	CR	(M)5R 6/2
2W	(C)GYG T-1	7A	(C)Y S-2	D9	(M)2.5GY 8.5/10
2X	(C)YG T-1	7C	(C)YO S-2	E2	(M)2.5GY 8.5/8
2Y	(C)YGY T-1	7E	(C)O S-2	E3	(M)2.5GY 8/8
3B	(C)YOY T-2	7J	(C)R S-2	E4	(M)2.5GY 7/8
3J	(C)R T-2	7L	(C)RV S-2	E5	(M)2.5GY 6/8
3K	(C)RVR T-2	7S	(C)BGB S-2	F0	(M)2.5GY 6/6
3L	(C)RV T-2	7Y	(C)YGY S-2	F3	(M)5GY 8/10
3M	(C)VRV T-2	84	(M)10YR 6/8	F4	(M)5GY 7/10
3Q	(C)BVB T-2	8A	(C)Y S-3	F7	(M)5GY 7/8
3T	(C)BG T-3	8C	(C)YO S-3	F8	(M)5GY 6/8
3U	(C)GBG T-2	8E	(C)O S-3	G3	(M)5GY 6/6
3V	(C)G T-2	8J	(C)R S-3	G5	(M)7.5GY 7/10
45	(M)10R 5/8	8N	(C)V S-3	G6	(M)7.5GY 6/10
4D	(C)OYO T-3	8R	(C)B S-3	G7	(M)7.5GY 8/8

Table 5.1 (continued)

	Table of Colors						
Loc.	Color		Loc.	Color		Loc.	Color
G8	(M)7.5GY 7/8		L8	(M)2.5BG 5/6		V0	(M)5P 6/8
G9	(M)7.5GY 6/8		L9	(M)7.5BG 6/6		V1	(M)5P 5/8
GA	(M)7.5YR 5/4		LI	(M)5GY 6/4		V2	(M)5P 4/8
GS	(M)10YR 5/2		LX	(M)5GY 6/1		V3	(M)5P 3/8
GZ	(M)10YR 5/1		M0	(M)7.5BG 5/6		W0	(M)7.5P 6/10
H2	(M)7.5GY 7/6		M3	(M)10BG 6/6		W4	(M)7.5P 5/8
H3	(M)7.5GY 6/6		M4	(M)10BG 5/6		W7	(M)10P 4/10
H5	(M)10GY 6/10		M6	(M)10BG 7/4		X0	(M)10P 4/8
H7	(M)10GY 6/8		N0	(M)10BG 3/4		X1	(M)10P 3/10
H8	(M)10GY 5/8		N8	(M)5B 4/6		X8	(M)2.5RP 6/8
HH	(M)2.5Y 6/6		N9	(M)5B 3/6		XT	(M)2.5P 4/4
HI	(M)2.5Y 5/6		NE	(M)10GY 4/2		Y0	(M)2.5RP 4/8
HN	(M)2.5Y 6/4		NF	(M)10GY 3/2		Y6	(M)5RP 6/10
HU	(M)2.5Y 6/2		NK	(M)10GY 7/1		Y7	(M)5RP 5/10
I2	(M)10GY 6/6		NN	(M)10GY 4/1		Y9	(M)5RP 6/8
I4	(M)2.5G 7/8		NP	(M)10GY 2.5/1		YY	(M)5P 4/1
I5	(M)2.5G 6/8		NT	(M)2.5G 5/4			
I6	(M)2.5G 5/8		P1	(M)10B 5/8			
I7	(M)2.5G 8/6		P7	(M)10B 3/6			
I8	(M)2.5G 7/6		P9	(M)2.5PB 5/8			
I9	(M)2.5G 6/6		PP	(M)10G 8/2			
IC	(M)5Y 6/4		PR	(M)10G 6/2			
IR	(M)5Y 6/1		PT	(M)10G 4/2			
J0	(M)2.5G 5/6		PU	(M)10G 3/2			
J1	(M)2.5G 4/6		PV	(M)10G 2.5/2			
J2	(M)5G 5/8		Q1	(M)2.5PB 7/6			
J4	(M)5G 7/6		Q2	(M)2.5PB 6/6			
J5	(M)5G 6/6		Q3	(M)2.5PB 5/6			
J6	(M)5G 5/6		Q5	(M)2.5PB 3/6			
J7	(M)5G 4/6		Q6	(M)5PB 5/10			
J8	(M)7.5G 7/6		Q7	(M)5PB 4/10			
K1	(M)7.5G 4/6		Q9	(M)5PB 5/8			
K2	(M)10G 6/6		R1	(M)5PB 3/8			
K3	(M)10G 5/6		RP	(M)7.5BG 5/4			
K5	(M)10G 6/4		S0	(M)7.5PB 3/12			
K6	(M)10G 5/4		S2	(M)7.5PB 5/10			
K7	(M)10G 4/4		S4	(M)7.5PB 3/10			
K8	(M)10G 3/4		S5	(M)7.5PB 2/10			
K9	(M)2.5BG 6/8		S6	(M)10PB 5/10			
KT	(M)2.5GY 6/4		S7	(M)10PB 4/10			
L0	(M)2.5BG 5/8		S8	(M)10PB 6/8			
L1	(M)2.5BG 6/6		S9	(M)10PB 5/8			
L3	(M)2.5BG 4/6		T9	(M)2.5P 6/8			
L4	(M)5BG 6/8		U1	(M)2.5P 4/8			
L7	(M)5BG 5/6		U7	(M)5P 5/10			

scene are good with uniform illumination but for irregular illumination seem to require that the optical mouse treat the ratio of adjacent readings as unity when the ratio is farther from unity than is necessary for the obliquely illuminated collages. This suggests that, for the extreme intricacy of some parts of the pictures of real objects, the optical mouse may need a smaller aperture and a closer spacing of adjacent readings than employed in these tests.

Applications of Retinex Theory and the Retinex Algorithm

The predictive power of the algorithm is shown not merely by the examples we have discussed but also by many other experiments. Of fundamental importance is the ability of the algorithm to predict darks, lights, shadows, highlights, light sources, and extended areas in surrounds with extremely low reflectivity. As a quite different example, the color of an area located on the Mondrian can be predicted and determined, while the flux to the eye is held constant, by modifying the designators within the area by computed changes in the rest of the field, for each waveband separately. Thus, the area can be changed from a specified white to a specified dark purple— without changing the flux to the eye from the area—by changes in the whole Mondrian computed for each waveband. In an important corollary experiment the area which is being changed from white to purple is surrounded by a very wide black border (produced by blocking the light at the slide-holder of the illuminating projector). The computed changes in the Mondrian, which had altered the designators for the area to make it white or purple, continue to be effective in the presence of the wide black border. While the experiment with this black annulus shows that the computation for the lightness of a point is carried out over extensive areas of the field of view, there is nothing in the experiment to tell us to what extent the computation is carried on in the retina as opposed to the cortex.

The following experiment (figure 5.3), carried out in collaboration with David Hubel and Margaret Livingstone of Harvard Medical School and Hollis Perry and Michael Burns of The Rowland Institute, shows that the cortex is essential to the computation (Land *et al.*, 1983). A Mondrian was modified by covering half of it with velvet. In the middle of and just to the velvet side of the vertical line where the velvet met the rest of the Mondrian, we placed a target area having a fixation point within it. The flux from the target area to the observer's eye was kept constant while the illumination of the Mondrian was altered to create a new set of designators for the target area. For the normal observer, this procedure altered the color of the target area from purple to white. An observer who was normal, *except that for medical purposes his corpus callosum had been cut through*, sat in a chair several feet in front

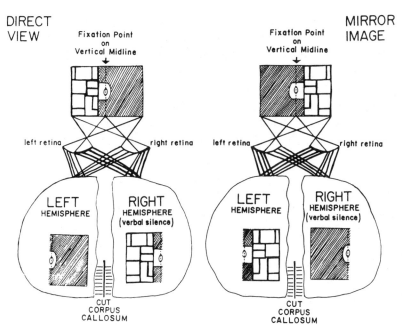

Figure 5.3
Diagram of split brain experiment.

of the target area. For everyone, the two lefthand sides of the retinas are connected to the left sides of our brains, and the two righthand sides of our retinas are connected to the right sides of our brains. Consequently, one half of the field of view is served by one half of the brain and the other half of the field of view by the other half of the brain. If the computation for the Mondrian were carred out entirely in the retina, the results of the computation for any point in the field of view would be independent of which half of the brain was used to read the results. The subject with the split brain would report "white" when the rest of us saw white and "purple" when the rest of us saw purple. This was not the case.

If the computations are carried out *not* in the retina, but in the cortex, there should be a striking difference between the results for a normal observer and results for a subject with a severed corpus callosum. If we assume that normally the computation extends over the whole field of view, it follows that the computation would extend across both halves of the brain by way of the corpus callosum. When the normal observer regards a Mondrian, half of which is velvet and half of which is the standard Mondrian, the color he sees in the target area depends on the whole

computation across the whole field of view. When our subject with the severed corpus callosum regards the same field of view, one half of his brain will be computing for Mondrian plus target and the other half of his brain, for black velvet plus target. When the verbal half of his brain is dealing with *Mondrian* plus target, he reports "purple" or "white," as the case may be, at the same time that we do. When the verbal half of his brain is dealing with *velvet* plus target, then he reports only "white" while we are seeing the changes from white to purple. (We determined this choice of presentations by having him look at the display directly or with a mirror.) Thus, the experiment establishes that the computations (i) are long-range and (ii) require the cortex.

A most dramatic application of Retinex Theory is the quantitative prediction of the colors available in the classical experiment of projecting with red and white light. As you will remember from our two-color projection experiments, we project two records, a middle-wave record and a long-wave record. Let us consider the red-and-white pictures in terms of designators. The middle-wave and short-wave designators are equal to each other because when we project the middle-wave record with white light, we are, in effect, placing on the screen three identical images in superposition

(i) the image carried by the portion of the white light to which the short-wave photosensitive cells respond,

(ii) the image carried by the portion of the white light to which the middle-wave photosensitive cells respond, and

(iii) the image carried by the portion of the white light to which the long-wave photosensitive cells respond.

When we add a second projector equipped with a red filter and project the long-wave record, the energies transmitted by this red projector are combined geographically with the energy from the long-wave portion of the white light that previously had been placed on the screen. From this summation of long-wave energies, a final image, in terms of lightness, is then computed for the long-wave retinex.

Thus, the short-wave and middle-wave retinexes will have equal designators for every place in a projected red-and-white image, and the long-wave retinex will have designators computed from the combined long-wave energies. When we photograph a variegated colored scene and compute the trio of designators for the colors that will appear in a red-and-white picture, all the points in three-space that represent the original scene fall on a plane that cuts through the whole array of colors in the three-space. The x's in the plane are points representing colors in the original scene (plate 5). It is obvious that, although all the colors are confined to a plane, that plane

passes through enough color domains in the color space to yield a very colorful picture. There are many other interesting experiments that can be carried out to study this plane. For example, when we move the red filter from the long-wave record to the middle-wave record, all the colors change to quite different new ones falling on the same plane in predictable new positions.

If the two projections of the red and white light are made in combination through a large long-wave transmitting filter and then through a large middle-wave transmitting filter and then through a large short-wave transmitting filter, the optical mouse, reading the image on each of the three wavebands separately, will correctly predict the three designators for locating the correct colors in the three-space.

Ingle (1985) undertook the investigation of the question. "Is the goldfish a Retinex animal?" The answer is dramatically in the affirmative: a goldfish selects a color he has been trained for when he is removed from the training tank and placed in a tank at one end of which is a Mondrian. In a series of tests, the Mondrian is so illuminated as to send to the fish's eye from an area of whatever color he is trained for the same number of photons of the same frequency as came from each of many other colors in the Mondrian under some standard illumination (figure 5.4). Nevertheless, the fish continues to choose the correct color. In recent tests, we used a whole series of Mondrians in each of which the color for which the fish was trained was randomly located amongst all the other colors of the Mondrian. In these tests, the fish

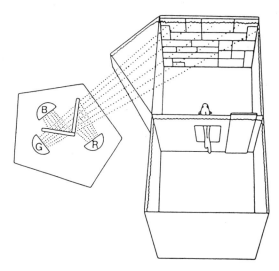

Figure 5.4
Goldfish entering Mondrian chamber.

swam to the color he had been trained for even though the display was completely new to him and the flux to his eye on the three wavebands was what would come in some standard white light from each of a series of differently colored papers.

When the goldfish makes his choice from some 50 papers on the basis of the color of the piece of paper for which he was trained, he is ignoring completely the luminance of the piece of paper. Not only is the luminance of the paper to which the fish directs himself arbitrary, so also are the luminances from other areas in the Mondrian. These Retinex experiments show that it is not the luminance on each waveband or the aggregate luminance to which he is conditioned, rather it is the three lightnesses. Thus, if having measured the fluxes in a normal white light, from a piece of dark blue paper, we then cause those same three fluxes to be reflected from a bright yellow paper in the Mondrian, the bright yellow paper, as we have learned, continues to look bright yellow to us and the fish will direct himself to the bright yellow paper for which he was trained. In short, the experiment shows that the permanence in terms of which he was trained did not involve the value of three fluxes or three luminances on three wavebands but rather the value of three lightnesses.

It has been our practice to check all experiments with humans by carrying them out from time to time with a pulse of light—as short as a microsecond, and to reject results which are not apparent in a single pulse. We could not apply this particular check to the experiments with goldfish but we have made every effort to minimize accidental adaptation and adaptation time. In the 1923 experiments by Burkamp [the serious limitations of which are discussed in Ingle's (1985) paper], the adaptation time was chosen in response to one long-held theory that adaptation is a basic constituent of a color constancy mechanism and was extended to several hours.

Daw's early discovery of double-opponent cells in the goldfish opened the way for correlation between the opponent ideas of Hering and physiological investigations. Although most naturally implemented with simple color cells, the Retinex algorithm is compatible with double-opponent cells. A simple linear combination of the long, middle and short inputs to the Retinex procedure can give three "wavebands" which correspond to double-opponent terminology [figure 5.5(a)]. Using these new "wavebands" as input to the Retinex algorithm, the same color space is generated except that the coordinate axes are rotated [figure 5.5(b)]. Thus predictions of Retinex Theory in the two implementations are very similar. They are not identical, however, because the threshold operation in the algorithm is nonlinear. Because of Daw's (1984) important comprehensive paper we will not go further into discussion of the neurophysiological role of Retinex Theory.

Livingstone and Hubel (1983), in their extensive report on, "The anatomy and physiology of a color system in the primate visual cortex," say that their results

$$\mathbf{RG} = \tfrac{1}{\sqrt{2}}\mathbf{L} - \tfrac{1}{\sqrt{2}}\mathbf{M}$$

$$\mathbf{YB} = \tfrac{1}{\sqrt{6}}\mathbf{L} + \tfrac{1}{\sqrt{6}}\mathbf{M} - \sqrt{\tfrac{2}{3}}\mathbf{S}$$

$$\mathbf{BW} = \tfrac{1}{\sqrt{3}}\mathbf{L} + \tfrac{1}{\sqrt{3}}\mathbf{M} + \tfrac{1}{\sqrt{3}}\mathbf{S}$$

$$\mathbf{L} = \tfrac{1}{\sqrt{2}}\mathbf{RG} + \tfrac{1}{\sqrt{6}}\mathbf{YB} + \tfrac{1}{\sqrt{3}}\mathbf{BW}$$

$$\mathbf{M} = -\tfrac{1}{\sqrt{2}}\mathbf{RG} + \tfrac{1}{\sqrt{6}}\mathbf{YB} + \tfrac{1}{\sqrt{3}}\mathbf{BW}$$

$$\mathbf{S} = -\sqrt{\tfrac{2}{3}}\mathbf{YB} + \tfrac{1}{\sqrt{3}}\mathbf{BW}$$

Figure 5.5(a)
An example of a linear transformation between simple and double-opponent wavebands. The specific numbers are meant to be taken suggestively and not literally.

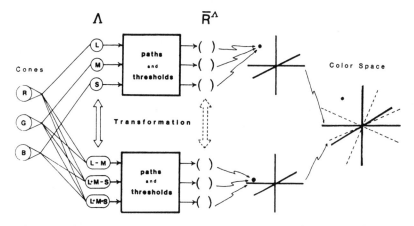

Figure 5.5(b)
The color space with a coordinate system corresponding to the above transformation.

"suggest that a system involved in the processing of color information, especially color-spatial interactions, runs parallel to and separate from the orientation specific system. Color encoded in three coordinates by the major blob cell types, red-green, yellow-blue, and black-white, can be transformed into the three coordinates, red, green, and blue, of the Retinex algorithm ..."

Zeki (1980) has discovered color-reading cells in the V4 region of the prestriate visual cortex of the rhesus monkey. The image of a Mondrian is formed on the retina of the anesthetized monkey, and Mondrian experiments analogous to those carried out on humans are carried out with the animal. The results for the monkey,

as reported by his cortical cells, are strikingly similar to the experiential results as reported by humans.

In summary the three propositions of Retinex Theory are:

I. The composition of the light from an area in an image does not specify the color of that area.

II. The color of a unit area is determined by a trio of numbers each computed on a single waveband to give for that waveband the relationship between the unit area and the rest of the unit areas in the scene.

III. The trio of numbers, the three \bar{R}^{Λ}'s, as computed by the Retinex algorithm, are the designators for the point in Retinex three-space which is the color of the unit area.

Acknowledgements

I wish to express my gratitude to Dr M. M. Burns for developing the transformation shown in figures 5.5(a) and (b) to S. H. Perry for extended discussion and analysis of the substance of the lecture, and for help with the manuscript, to C. S. Easson for operating the experimental laboratory, and to B. W. Young for preparation of experimental displays. The technical photography was prepared by J. J. Scarpetti, M. A. Nilsson, and R. Hansen. Over the last few years Professors David Hubel and Margaret Livingstone have been patient and careful observers and discussants of these experiments and the implied relation to neurophysiology.

Notes

* In the Heisenberg lecture at the Bavarian Academy of Sciences in Munich on 28 May 1985, and in the Beckman lecture at the University of Illinois at Urbana-Champaign on 21 November 1985, the author described techniques for arriving at a useful "relationship to the average." With this approach, the thresholds and individual pathways required for computing "the average of the relationships" become unnecessary (Land, 1986).

References

Blake A. (1985) On lightness computation in Mondrian world. In *Central and Peripheral Mechanisms of Colour Vision* (Edited by Ottoson D. and Zeki S.), pp. 45–49. MacMillan, New York.

Burkamp W. (1923) Versuche über das Farbenwiedererkennen der Fische. *Z., Sinnesphysiol.* **55**, 133–170.

Daw N. (1984) The psychology and physiology of color vision. *Trends Neurosci.* **7**, 330–335.

Hering E. (1920) *Grundzüge der Lehre vom Lichtsinn.* Springer, Berlin.

Horn B. K. (1974) Determining lightness from an image. *Comput. Graphics Image Processing* **3**, 277–299.

Ingle D. (1985) The goldfish is a Retinex animal. *Science* **227**, 651–654.

Land E. (1959) Color vision and the natural image, Parts I and II. *Proc. natn. Acad. Sci., U.S.A.* **45**, 115–129. 636–644.

Land E. (1960) Some comments on Dr Judd's paper *J. opt. Soc. Am.* **50**, 268.

Land E. (1964) The Retinex. *Am. Scient.* **52**, 247.

Land E. (1983) Recent advances in retinex theory and some implications for cortical computations: Color vision and the natural image. *Proc. natn. Acad. Sci.* **80**, 5163–5169.

Land E. (1986) An alternative technique for the computation of the designator in retinex theory. *Proc. natn. Acad. Sci. U.S.A.* **83**, 3078–80.

Land E., Hubel D., Livingstone M., Perry S. and Burns M. (1983) Color-generating interactions across the corpus callosum. *Nature* **303**, 616–618.

Land E. and McCann J. (1971) Lightness and Retinex Theory. *J. opt. Soc. Am.* **61**, 1–11.

Livingstone M. and Hubel D. (1984) Anatomy and physiology of a color system in the primate visual cortex. *J. Neurosci.* **4**, 309–356.

McCann J., McKee S. and Taylor T. (1976) Quantitative studies in Retinex Theory. *Vision Res.* **16**, 445–458.

Newton I. (1704) *Opticks.* (London) Prop X, Prob. V, p. 135.

Zeki S. (1980) The representation of colours in the cerebral cortex. *Nature* **284**, 412–418.

6 Color Constancy and the Natural Image

Brian A. Wandell

1 Preamble

The perceptual mechanisms of color offer a unique opportunity to study the encoding, transformation, and analysis of information in the visual pathways. The importance of the color pathways as a model system for other areas of visual analysis derives from our good understanding of three factors: the physical stimulus of color, the initial encoding of this stimulus in the nervous system, and the measurement methods for assessing color appearance.

In my presentation at the Nordita meeting, I discussed some of the recent work on the methods of transforming raw color sensor data into a transformed representation that is more useful to a visual system engaged in recognizing and identifying object color. The work I described at the conference talk has already been published in much more complete form than is possible in this context. For more complete statements of the results the reader may wish to consult the papers by Buchsbaum, Maloney and me that are cited in the references [1–5].

1.1 Introduction

If one takes a picture of the same objects under two different lights, say first illuminated by daylight and then illuminated by fluorescent light, the colors in the pictures appear very different. Because fluorescent light generally has more energy in the middle (green-appearing) part of the visible spectrum, pictures taken under the fluorescent light generally appear too green and are easily identifiable as the work of an amateur. Yet, when one is working immersed in fluorescent light the world does not appear to become suddenly too green. The difference between the film record and the appearance when one is working in the environment can be summarized, roughly, by the following approximation. The appearance of an object in a scene is generally predicted somewhat better by the tendency of the *surfaces to reflect light* rather than by the actual light arriving at the eye. The camera and development process, on the other hand, are designed to represent the light arriving at the instrument. Until recently we have not had a method for correcting for the ambient light and representing the surface.

The phrase *human color* constancy refers to the human ability to use an estimate of surface reflectance to assign object color. The precise extent of the human ability to be color constant is not currently known, although recent measurements using test stimuli on computer screens that sweep out rather small patches of the visual field

report that color constancy is quite limited [6]. These reports contradict the interest-
ing demonstrations by Land, using very large fields, in which a naive audience often
leaves convinced that human color constancy is quite excellent. Several recent
reviews of Land's [7] empirical and theoretical work have appeared, and the inter-
ested reader might consult these [8, 9]. A widely shared view is that we have not yet
devised a satisfactory laboratory procedure for measuring the color constancy that
occurs when the ambient lighting in the natural environment is changed.

2 An Ideal Device

Some form of color constancy is a pre-requisite for having a useful color system.
For mobile animals like us, whose environment is constantly changing, color vision
would be rather useless unless some means of correcting for changes in the ambient
light are available. If the color of your car is different depending on the time of day
or weather conditions, or whether it is left in shadow or direct light, then the car
color would not be a useful cue in recognition and identification.

Figure 6.1 illustrates the approach my colleagues and I have taken to study human
color recognition. We suppose that a principal goal of the visual pathways is to form
an internal representation of a physical variable: surface reflectance. To achieve this
computation the visual pathways must unpack the data in the initial photoreceptor
encoding so that the surface information is derived separately from the ambient light
information.

Figure 6.1
The structure of a biological system with ideal color constancy. The visual system would accept the image
as input, but then eliminate the effects of the ambient lighting in order to form a judgment of color-
appearance based only on the surface reflectances of objects in the image.

In our recent work we have tried to clarify to what extent it is possible—in principle—to use photoreceptor data to estimate surface spectral reflectance. To the physicist this is a familiar procedure: rather than address the biological system immediately, with all of its complexity and competing demands, we first try to understand how a simple, ideal system might perform.

3 The Solution Method

3.1 Ambient Lights

As figure 6.1 illustrates, the information that arrives at the observer's eye is due in part to the character of the ambient lighting and in part to the surface reflectance of the objects in the image. The goal of an ideal color system is to unpack these two types of information. The encoding and unpacking of this information is the focus for the solution I will describe.

The problem is difficult for two reasons. First, we do not know what the ambient light will be. If we knew the ambient light precisely—for example if we were building a vision system that worked only in a closed environment on an assembly line—then the problem would not be difficult, as we shall see later. A second difficulty, that is sometimes overlooked, is that we cannot be certain that any particular object will be in the image. Thus, the context of objects that may be present in the image is a second source of uncertainty.

One might wonder whether solving the problem for this particular situation is of any great practical value. For example, in a television studio, one can compensate for lighting changes by measuring the ambient light that is reflected from a gray card. On a factory floor one can attempt to control the lighting. In many common problems, however, such control is not possible. In remote sensing, for example, it is not possible to insert gray cards into the image or to control the lighting. And, I should add, the correct method for performing the color balance even with gray cards or a known light has only recently been described by Gershon Buchsbaum at the University of Pennsylvania based on methods that are similar to those described by Maloney and me [4, 5]. Suprisingly, Buchsbaum's method has not yet found its way into normal industrial application.

4 The Solution Method

We start by defining the representation of the physical stimuli that give rise to the appearance of color: light and surfaces.

Figure 6.2
Newton's hand-drawing of his experiments on the nature of light.

I am particularly fond of figure 6.2 which is a hand-drawing by Isaac Newton of an apparatus he used to investigate the properties of sunlight. The principal discovery made by Newton, which is brilliantly illustrated in this experimental apparatus, is that sunlight is not unitary in its nature, but that if one passes sunlight through a prism—as shown in the drawing—then it can be broken up into more primitive components that correspond to the components of the light at what are called the different wavelengths. These are shown at the far end of the apparatus, splayed out in the spectrum.

Notice that this drawing illustrates a second in the series of experiments that Newton carried out. In the wall where the spectrum is cast, Newton punched a hole, and he placed a second prism. He noted that passing the narrowband lights through the prism yet again does not produce another spectrum, but rather leaves the light unchanged. Moreover, in other experiments he demonstrated that this entire process is reversible.

This experiment leads to one natural representation of lights and surfaces, in which we plot the amount of energy measured at each wavelength. One might ask how frequently do we have to sample across the wavelength spectrum to estimate accurately these functions of wavelength? Or more generally, what is the expected range of variation in these functions of wavelength and can we find an efficient sampling strategy that permits us to capture this variation?

In fact, the amount of variation that can be measured in the spectral power distribution of natural daylight has been studied quite closely by a variety of color scien-

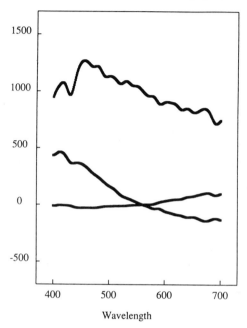

Wavelength

Figure 6.3
The mean and first two principal components of daylight as measured by Judd et al. [10]. These three terms can be used for the linear model of lights.

tists. The first important study was carried out by Judd, MacAdam and Wyszecki [10–13]. Judd et al. performed a principal components analysis of the variation in the spectral power distribution of daylights around the world and under different weather conditions. The mean and first two principal components of their measurements are shown in figure 6.3.

Judd et al. reported that nearly all of the variations in the spectral power distribution of natural daylight can be described using a linear model consisting of three terms. This was confirmed in the later studies by Sastri & Das as well as Dixon. Maloney [2] has shown that the principal components that describe the observed variations in daylight also describe the observed variations across another important class of light sources: the blackbody radiators. From these results it follows that we can express the amount of energy in a typical light source—be it daylight or a tungsten light—by specifying the weights of only a few principal components.

This permits us to characterize the spectral power distributions of lights in a rather parsimonious way using a linear model of the form

$$E(\lambda_n) = \sum_{i=1}^{N} \varepsilon_i E_i(\lambda_n) \tag{1}$$

where $E(\lambda_n)$ is the spectral power distribution measured directly, from Newton's wall, $E_i(\lambda_n)$ are the most efficient basis functions, and ε_i are the weights of these functions. While we can only be sure that equality is possible when there are as many basis functions as independent measurements of $E(\lambda_n)$, for most practical conditions an excellent approximation can be obtained when the number of basis functions, N, is small. To be precise we should use the notation for approximation with respect to the linear models, but we use equality for simplicity.

4.1 Surfaces

When the ambient lighting, such as daylight, interacts with a surface some fraction of the energy is reflected towards the viewer. It is usual, again, to represent the tendency of a surface to reflect light on a wavelength basis, so that we plot a fractional variable on the vertical axis as a function of wavelength on the horizontal axis to characterize the surface spectral reflectance of an object. The spectral reflectance function is not entirely a function of the object, but also depends upon the viewing geometry. Some authors have attempted to use the specularity of real surfaces in developing procedures for estimating the spectral power of the ambient lighting from image data [14, 15].

The recovery procedure is further simplified because in the visible range surface spectral reflectance functions of many naturally occurring substances are rather dull, uninteresting functions. For example, Jozef Cohen of the University of Illinois [16], see also [3], has performed a principal components analysis of the surface reflectances of the Munsell chips. These are a set of widely available papers that are used in the color industry. Their spectral reflectance functions were measured by Nickerson [17]. Cohen found that over 99 percent of the variance of the spectral reflectance functions of the Munsell chips can be expressed using only three principal components. I re-plot these functions in figure 6.4. This analysis has been confirmed and extended by Maloney [3]. There is nothing particularly unique about these basis terms. The surface reflectance functions of the Munsell chips and most commonly occurring objects are slowly varying functions. For example, if instead of using principal components one uses sinusoidal and cosinusoidal basis functions to estimate the surface reflectances of the Munsell chips, the number of independent terms needed to account for a large percentage of the variance is quite small [5].

Cohen Surface Basis Functions

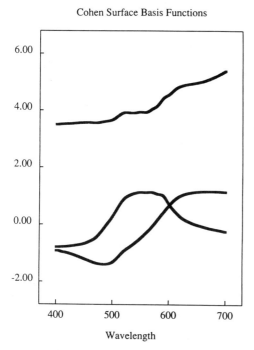

Wavelength

Figure 6.4
Three terms derived for a linear model of surface reflectance of the Munsell chips [16].

It follows we can describe the surface reflectance function at a point, $S^x(\lambda_n)$, parsimoniously using a linear model

$$S^x(\lambda_n) = \sum_{j=1}^{N} \sigma_j^x S_j(\lambda_n) \tag{2}$$

where the functions $S_j(\lambda_n)$ are basis functions and the scalar σ_j^x is the weight of the jth basis function at the spatial position x.

5 Photoreceptors

Within the eye, the incident light is absorbed by photopigments contained in the photoreceptors. The photopigments in the receptors are differentially sensitive to various wavelengths of light. For each wavelength, the fraction of the incident illuminant effectively absorbed at different wavelengths for the kth photoreceptor type

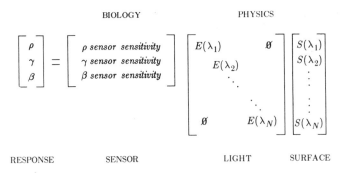

BIOLOGY PHYSICS

RESPONSE SENSOR LIGHT SURFACE

Figure 6.5
Representation of the interactions of surfaces, lights and receptors with respect to the wavelength co-ordinate frame. See eq. 3.

is denoted $R_k(\lambda_n)$ and called the spectral sensitivity of the photopigment. The density of the pigment does not change greatly during normal viewing conditions so that corrections for self-screening of the pigment can be neglected.

When all of the terms are represented with respect to wavelength we customarily summarize the contributions of the ambient light, surface reflectance, and receptor sensitivities by the equation

$$\rho_k^x = \sum_{n=1}^{N} R_k(\lambda_n)E(\lambda_n)S^x(\lambda_n) \tag{3}$$

where ρ_k^x is the number of quantal absorptions of the receptor in the kth class at position x on the retina. For human vision it is customary to refer to the three receptor types as ρ, γ and β. We can express the equation in expanded matrix form as shown in figure 6.5.

To the extent that the linear models of surfaces and lights in the original equation offer a good physical description of the lights and surfaces, it becomes possible to re-duce the number of unknowns in the matrix equation. If the surfaces at different posi-tions, x, are represented by the linear model weights, σ^x, and we collapse the light basis functions and receptors into a single matrix, then we obtain the matrix equation

$$\rho^x = \Lambda_E \sigma^x \tag{4}$$

in which Λ_E is a single matrix whose entries depend upon the ambient lighting and the receptor spectral sensitivities. The kth row and jth column of this matrix has the entry

$$\sum_{n=1}^{N} R_k(\lambda_n)E(\lambda_n)S_j(\lambda_n) \tag{5}$$

Qualitatively, however, the equation still represents the fact that we are mapping the surface information through a linear transformation (determined by the lighting) into the photoreceptor response.

This simple linear equation is the key to understanding how the information is packed and can be unpacked. The information that we seek is the surface reflectance function or equivalently the weights on the basis terms of the surface reflectance functions. The ambient light spectral power distribution and the receptor spectral sensitivities define a matrix, Λ_E, that maps the surface reflectance function into the receptor responses.

To solve this equation we need some co-operation from physics. As an example, consider a three sensor system. If the world confronts us with surface reflectances that must be characterized by using more than three different weights in the vector σ^x, then we cannot uniquely recover the surface reflectance description from the sensor data: there are more unknown variables than measurements. Thus, if the surface reflectance functions are not well-described by a few basis terms, then even knowledge of Λ_E is insufficient to permit recovery of the surface reflectance functions. Aliasing caused by the additional degrees of freedom will distort the estimation procedure.

A necessary condition is that we have as many sensors as there are degrees of freedom in the surface reflectance functions. But even this case cannot be solved because the ambient lighting is unknown! Thus, we cannot use a simple matrix inversion to recover three independent values of the surface reflectance function. In this case a solution is possible if we know the reflectance of a single surface, or if we know the light. These are the kinds of assumptions that Buchsbaum [1], Brill and West [18] and others have made.

Finally, then, we come to the case where the situation can be solved even when the lighting is unknown. This is the case in which we have one more sensor class than there are degrees of freedom in the surface reflectance functions. It is here that Maloney and I have been able to develop a closed form solution which is implemented in the Color Analysis Package that Dave Brainard and I have built at Stanford.

The idea of the method is illustrated in figure 6.6 for the three-dimensional receptor case. The general method works well for any number of sensors, but drawing pictures is easier for three. The key principle is that there must be *one more class of receptors than degrees of freedom in the surface reflectance functions.*

When the surface reflectance functions are two-dimensional but we have three sensors, the resulting sensor data will be mapped into three-dimensional vectors that fall within a two-dimensional subspace. In this case there are two types of information in the output values of the sensors. One type of information is the

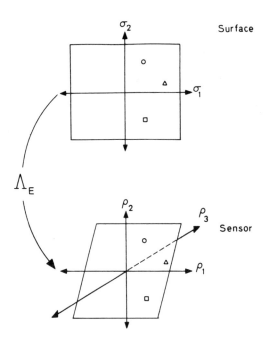

SUB-SPACE ANALYSIS

Figure 6.6
The linear mapping from a two-dimensional surface reflectance representation into a three-dimensional photoreceptor response will fall on a plane that passes through the origin. The identity of the plane as specified, say, by the unit normal to the plane, permits a estimate of the spectral power distribution of the ambient light. The position of a point within the plane then permits an estimate of the surface reflectance function.

location of the sensor co-ordinate point within the subspace. Each surface reflectance will map into different positions within the subspace, which gives us a clue about the identity of the surface.

The second type of information available is the identity of the subspace. The identity of the subspace provides the information we need to estimate the spectral power distribution of the ambient light [5]. We use this to estimate the matrix Λ_E and then solve the linear equations.

I find it interesting to understand that the two types of information can be encoded in this way. The information about the light is not contained in the specific value at any point, but rather in an implicit null space that is defined by a set of receptor responses. The interpretation of surface spectral reflectance at a single point depends

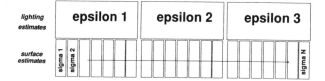

**Lighting parameters (epsilon) are
assumed to be constant across local
regions of the image**

surface estimates (sigma) can
vary at the image resolution rate

Figure 6.7
It is necessary to assume that either the ambient lighting varies more slowly than the surfaces, or the converse. We assume that the ambient lighting varies more slowly across space. For a three-dimensional sensor system the color representation at a point can consist of four parameters: two degrees of freedom in the surface and two degrees of freedom in the ambient lighting. The parameters representing the ambient lighting are correlated across space while the parameters derived from the surface reflectances can vary at the sampling resolution. In principle, the two-dimensional subspace can be determined from the data at only two locations so that the lighting parameters need only be identical at two spatial locations. The figure shows identical lighting parameters at more than two locations since for practical reasons one ordinarily includes more than the minimal number of measurements to estimate the subspace of the sensor response.

upon the values of other points in the image since only from a set of points can we define the subspace. The distributed coding of the information is illustrated in figure 6.7.

This method does not impose the constraint that *color appearance* is two-dimensional. The color appearance is still left free to depend on the lighting and on the surfaces, and in principle we can use this method to recover as many as four parameters at each point. The ambient lighting parameters at neighboring points, however, are correlated so that there is a match between the information in the sensor data and the representation of surfaces and lights.

6 Natural Images

The analysis I have provided has the virtue of being precisely right: when the set of surfaces and lights in the environment match our assumptions, there is little noise in the sensors, and the surface and light functions are within the linear models. Under these conditions, perfect recovery is possible.

The questions of human performance and viable machine algorithms, in the presence of natural surfaces and sensor noise, remain open. We plan to investigate the

extent to which our framework for thinking about color constancy can help both in the analysis of surface reflectance data in natural images, and in the analysis of human performance in color discrimination. And I will close by saying a few words about each.

7 Computer Images

When we acquire a color image, we acquire a tremendous amount of data. A small image (128 by 128) has some 25000 different locations, each of which has a red, green and blue sensor response. In order to reduce the quantitative burden we can use various summary plots of the data in color images to show the relationship among the color sensors. Figure 6.8 displays the data acquired in three sensor images from a camera in my laboratory. The spectral sensitivities of the three sensors are shown in part (a) of the figure. The two sets of sensor images were acquired under two different lighting conditions. To understand the effect of changing the spectral power distribution of the ambient light on the sensor responses, it is useful to look at cross-correlograms generated by plotting samples of the value of one sensor response against another for corresponding spatial positions in the image. Figure 6.9 shows such a cross-correlogram for the green and blue components of these two images at randomly selected locations. The green sensor response is plotted on the horizontal axis and the blue sensor response is plotted on the vertical axis. The data shown in this cross-correlogram are typical of natural image data. The sensor sensitivities are sufficiently different so that physically realizable lights could cause data points to fall nearly anywhere on the graph. But still, the sensor responses tend to cluster together. (It is this clustering that permits us to make great savings in the bandwidth requirements for transmission of television images.)

The effect of changing the spectral power distribution of the ambient lighting is illustrated by comparing the difference in clustering between the filled and open symbols. These points are the sensor responses from the same set of objects illuminated by two different lights. Shifts in the ambient lighting change the quantitative properties of the correlation, but do not disturb the existence of the strong correlation. The procedure that Maloney and I have developed uses the complete covariance structure of the data to estimate the spectral power distribution of the ambient lighting.

8 Conclusion

The work on an ideal observer for color constancy has informed our work on human color vision. We treat the visual performance as if the system's goal is to form an

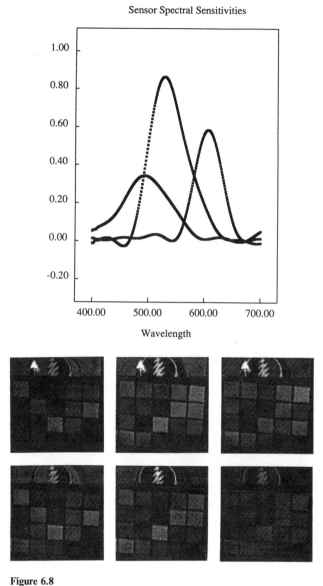

Figure 6.8
(a) Spectral sensitivity of the camera imaging system. (b) Within each row we show three sensor images of the same scene (red, green, and blue images). The images in the two rows were acquired under different lighting conditions. Notice that the variation in the component images across lighting conditions is similar to the variation one sees between the images within a single row.

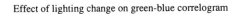

Effect of lighting change on green-blue correlogram

Figure 6.9
Cross-correlogram of the green and blue sensor images in figure 6.8 at sampled positions within the images. The change in ambient light causes a shift in the correlation. The data from the two different images are plotted as open and closed symbols.

internal representation of the physical variable of interest: the surface spectral reflectance function. We have shown that the proper calculation to form this estimate is to apply a matrix multiplication to the linear sensor data. The proper matrix multiplication must be determined from the image data and depends upon the ambient lighting. This type of process is embodied in visual light adaptation. We believe that many important properties of human color vision may be understood, including the regulation of sensitivity under light adaptation, if we can develop procedures to measure the current mapping from sensor responses to color appearance.

Acknowledgements

I thank L. T. Maloney and D. H. Brainard. This work was supported by NASA grant NC2-307 and NEI grant RO1EY03164.

References

1. Buchsbaum, G., A Spatial Processor Model for Object Color Perception. J. Franklin Institute **310**, 1 (1980).

2. Maloney, L. T., Computational approaches to color vision. Unpublished Ph.D. dissertation (1984).

3. Maloney, L. T., J. Opt. Soc. Am. **A3**, 10, 1673 (1986).

4. Maloney, L. T. and Wandell, B., J. Opt. Soc. Am. **A3**, 1, 29 (1986).

5. Wandell, B. A., The synthesis and analysis of color images. IEEE PAMI, PAMI-9 2 (1987).

6. Arend, L. and Reeves. A., J. Opt. Soc. Am. **A3**, 10, 1743 (1986).

7. Land, E. H., Vision Res. **26**, 7 (1986).

8. Shapley, R. M., Vision Res. **26**, 1, 45 (1986).

9. Brainard, D. H. and Wandell, B. A., J. Opt. Soc. Amer. **A3**, 10, 1651 (1986).

10. Judd, D. B., MacAdam, D. L. and Wyszecki, G. W., J. Opt. Soc. Am. **54**, 1031 (1964).

11. Sastri, V. D. P. and Das, S. R., J. Opt. Soc. Am. **58**, 3, 391 (1965).

12. Sastri, V. D. P. and Das, S. R., J. Opt. Soc. Am. **56**, 829 (1966).

13. Dixon, R. E., J. Opt. Soc. Am. **68**. 4, 437 (1978).

14. D'Zmura, M. and Lennie, P., J. Opt. Soc. Am. **3**, 10, 1662 (1986).

15. Shafer, S. A., Color Research and Application **10**, 4, 210 (1985).

16. Cohen, J., Psychon. Sci. **1**, 369 (1964).

17. Nickerson, D., Spectrophotometric data for a collection of Munsell samples. Washington D.C.: U.S. Department of Agriculture (1957).

18. Brill, M. H. and West, G., J. Math. Biology, **11**, 337 (1981).

7 Essay Concerning Color Constancy

Dorothea Jameson and Leo M. Hurvich

Introduction

Current Interest

Issues of constancy have arisen in the study of perception whenever the senses have been examined as information systems that mediate knowledge of the characteristics of the physical world. The kinds of constancy are manifold. They include mappings on sensory surfaces that are somehow converted into external space location maps so integrated that they serve not only as efficient and precise indicators of distance and direction information, but as mediators of sensorimotor integration and skill control as well (Guthrie et al. 1983; Jay & Sparks 1984). Objects, moreover, preserve their objective identities despite a variety of changes in the energy maps projected on the sensory receiving surfaces whether these changes relate to the object (or event) sizes, shapes, intensities, or qualities. At the same time, objects are systematically dependent, in terms of their phenomenal appearances, on the different local contexts in which they are embedded in the objective environment. Emphasis on only one or the other of these factors—i.e. identity preservation or context-dependent perception— tends to ignore the richness of the total information that our sensory mechanisms contribute to the cognitive systems that fashion the so-called real world as we know it.

Some of the current resurgence of interest in the constancy problem can be attributed to the advent of the computer in its various degrees of technological sophistication and processing capacity; the computer as a tool for testing intricately detailed hypotheses, as a tool for developing simulations, and as a would-be substitute for a human perceiver—i.e. a perceptual robot or a "task" robot with "machine vision." The last use, or better, goal, is one that seems to encourage an understandable tendency toward oversimplification of the problem. We would have no quarrel with such a tendency if it were not that the oversimplification that might be useful for the machine as tool to perform specific tasks in the robot context is somehow carried over into the analysis of perception, even though the oversimplification distorts the nature of the human perceptual problem.

In a 1986 issue of the *Journal of the Optical Society*, a Feature Section was devoted to computational approaches to color vision.[1] In his introduction the feature editor explicitly recognized the focus on the machine task aspect of the approach. "If we want to address robots in higher-level languages that we understand about objects, we must make them see the way we do" (Krauskopf 1986).

Eight of the twelve feature papers dealt with color constancy, and the primary aim was to find algorithms or computational approaches that would yield means for deriving constant surface reflectance properties of objects for different and initially unknown illuminants.[2] Apart from its use in the computation of surface reflectance characteristics for object recognition, perceptual information about the different conditions of illumination as relevant in its own right was largely if not totally ignored in these papers. Our own judgment is that human visual systems (including both higher- and lower-order processes) are likely to have evolved a design that provides perceptual information about change as well as constancy—about light, weather, and time of day, as well as about the relatively constant physical properties of mainly opaque objects within a scene. To what extent current technology might or might not find such information relevant for the tasks of present-day or near-future robots we are not prepared to say, but that luminosity information, as well as opaque surface information, is relevant for biological organisms of human or other species is an assumption that we are prepared to make.

Historical Overview

Early experimental studies of the perceptual constancies typically examined the degree of constancy manifested under different conditions. [For an integrative theoretical discussion of the various constancies, with an emphasis on Gestalt principles, see Koffka (1935).] With respect to color (including both the chromatic and achromatic brightness or lightness properties), the central issue was the same as it is today. How can the surface reflectance characteristics of the distal object be recovered to achieve an approximately constant surface percept despite the fact that the retinal image of the object depends on both its surface reflectance (R) and the incident illumination (I), $R \times I$, when R is constant but I is both unknown and changes from one situation to the next? Helmholtz's conjecture was both best known and most widely accepted. In his text on experimental psychology, Woodworth (1938) included Helmholtz's own statement of his view, which we quote here.[3]

Colors are mainly important for us as properties of objects and as means of identifying objects. In visual observation we constantly aim to reach a judgment on the object colors and to eliminate differences of illumination. So, we clearly distinguish between a white sheet of paper in weak illumination and a gray sheet in strong illumination. We have abundant opportunity to examine the same object colors in full sunlight, in the blue light from the clear sky, and the reddish yellow light of the sinking sun or of candlelight—not to mention the colored reflections from surrounding objects. Seeing the same objects under these different illuminations, we learn to get a correct idea of the object colors in spite of difference of illumination. We learn to judge how such an object would look in white light, and since our interest lies entirely in the object color, we become unconscious of the sensations on which the judgment rests.

Woodworth also cites Hering's views on color constancy. Hering, not surprisingly, disagreed with Helmholtz's analysis. He called attention to the various peripheral factors (pupillary changes, retinal adaptation, and physiological contrast mechanisms) that actually must alter the sensory effects of visual stimulation under different conditions of illumination, and that, with continued visual experience, Hering thought would also alter the state of the central mechanisms involved in perception —the kinds of changes we would today refer to as visual plasticity. Hering's view led directly to his concept of "memory color."

The color in which we have most consistently seen an external object is impressed indelibly on our memory and becomes a fixed property of the memory image. What the layman calls the real color of an object is a color of the object that has become fixed, as it were, in his memory; I should like to call it the memory color of the object.... Moreover, the memory color of the object need not be rigorously fixed but can have a certain range of variation depending on its derivation.... All objects that are already known to us from experience, or that we regard as familiar by their color, we see through the spectacles of memory color. (Hering 1920)

Woodworth's summary chapter on the perception of color captures the flavor of the experimental work on approximate color constancy during the period between 1900 and the late 1930s. Typically, the experiments were designed to determine the degree of lightness constancy for various conditions, sometimes by sample matches made to a display of surfaces of different reflectances under different levels of illumination and/or shadow conditions, sometimes by matches made between rotating disks of various average reflectances. The term "albedo" came into common use as the relative reflectance index, and the measure in these experiments was the degree to which the albedo determined the visual matches for the different conditions. Arithmetic (Brunswik) or logarithmic (Thouless) ratios were developed to express the departures of the experimental matches from those predicted for perfect lightness constancy. Ordinarily the data fell somewhere between perfect retinal image light matches and perfect object constancy, although occasionally overcompensation for illumination differences was observed. Considerable effort was devoted to determining the efficacy of various cues for judging illumination, a requirement, in the Helmholtz context, for solving the reflectance problem; and in the same context, measures were compared for children of various ages. For the most part, children did not seem very different from adults, although the results differed for different experiments and were particularly susceptible to effects of instructions. Instructions have always been recognized as crucial in such experiments (MacLeod 1932; Katz 1935; Hurvich & Jameson 1966), and they continue to recur as an experimental variable (Arend & Reeves 1986; Arend & Goldstein 1987). The extremes can best be summarized by the difference between making an adjustment to make a particular part of a display *look*

identical to the same area in a differently illuminated display, as contrasted with an adjustment to make a particular surface in a display *seem identical in its surface characteristics* to the same object in a differently illuminated display. Behavioral experiments on nonhumans used "identification" as indexed by a trained response, and these results, too, suggested that fish and primates are able to identify objects in different illuminations in terms of their surface reflectances.

Not included in Woodworth's summary was the classical experiment of Hess & Pretori (1894). Although their aim was to measure the effects of brightness contrast between two (adjacent) center/surround displays, their results can readily be analyzed in constancy terms. That is, for a center area of one reflectance and a surround of different reflectance, a uniform increase in illumination would produce a proportional increase in light reflected from each surface, and the ratio of reflected light of center-to-surround in the retinal images would remain unchanged despite the proportional increase in each. The measured contrast ratio for the matched area in the center/surround comparison display would also be constant if the observers were exhibiting perfect lightness constancy. Our own replot of the Hess & Pretori data (Jameson & Hurvich 1964, 1970) shows that their observations encompass a range of findings that depend systematically on the surround-to-center contrast ratio of each test display. When this ratio is low (equivalent to surround reflectance lower than center's), the center appears to increase in perceived brightness as center and surround are both increased proportionally in illumination; as the contrast ratio is made higher (equivalent to surround reflectance higher than center's), the center appearance approaches constancy; and as the contrast ratio is made still higher (equivalent to surround reflectance much higher than center's), the dark center appears to become blacker with proportional increase in illumination of both center and surround. We have reported findings similar to these for a patterned array of different achromatic patches, and cite in our report concordant results from other laboratories (Jameson & Hurvich 1961a, 1964).

Relevant Variables

Visual Sensitivity

Light sensitivity is so well known to be controlled by the level of illumination to which one is adapted that it hardly needs documentation here. Although it is most often illustrated by the dark-adaptation curve, for relevance to the important constancy issue, only the photopic segment of that threshold sensitivity function, the cone region, describes the course of sensitivity recovery of interest. Moreover, the

reflection of this recovery function, which shows the increasing threshold energy requirement with increase in level of background light, makes clear the decrement in light sensitivity with increase in adaptation level. Because the visual response depends on the product of stimulus × sensitivity, a major part of the compensation for illumination changes (in addition to the small contribution of pupillary changes) obviously occurs at a very peripheral level, and largely in the retinal light receptors. For the range of adaptation levels within which Weber's law holds, it is often assumed that contrast sensitivity (and by extension, suprathreshold contrast perception) will be constant, and thus account for perceived lightness constancy. It is essentially another statement of the ratio hypothesis proposed by Wallach (1948). Were this a perfectly compensatory mechanism, then there would certainly be no need for experience with, or judgments of, different levels of illumination, because their effects, at least for uniform illuminations and diffuse object surfaces, would never be registered at all beyond the most peripheral level of the visual system. But the situation is not quite this simple. If contrast sensitivity is measured with sine-wave stimuli as a function of spatial frequency to determine the human contrast-sensitivity function, both the level and the form of this function change with average level of illumination. This dependence on illumination has important implications for visual perception; it is one of the findings that make it most unlikely that form perception depends on a straightforward Fourier processing of a scene by the visual system (Kelly & Burbeck 1984). It also suggests that all sharply focused edges between surfaces of different reflectances will not appear equally sharp at different light levels. Kelly & Burbeck believe that at low spatial frequencies, contrast sensitivity is closely related to mechanisms of lateral inhibition, which are spatially more diffuse than the excitatory processes. The dependence of the effectiveness of such mechanisms on illumination level is consistent with our own long-held conviction that visual adaptation must involve postreceptoral changes as well as receptoral sensitivity adjustments (Hurvich & Jameson 1958, 1960, 1961, 1966; Jameson 1985; Jameson & Hurvich 1956, 1959, 1961b, 1964, 1970, 1972; Varner et al. 1984).

Chromatic Sensitivity

In 1905, von Kries made an analysis of the way the visual system might compensate for changes in the spectral quality of illumination to make it possible to identify object colors, and proposed that the three different spectrally selective mechanisms of the retina (cone types) suffer relative decrements in overall light sensitivity in proportion to the relative strengths of their individual stimulation by the prevailing illumination. This analysis is qualitatively consistent with the way both the threshold and suprathreshold spectral luminosity functions vary in form with chromatic

adaptation (Jameson & Hurvich 1953; Hurvich & Jameson 1954). Thus, for example, exposure to longwave light selectively reduces light sensitivity in the same region of the spectrum, as it should if the contribution of the longwave cone signal to light sensitivity were reduced in amplitude. However, von Kries's postulated changes in the balance of sensitivities would not change the forms of the three individual wavelength vs receptor sensitivity functions, but only their amplitudes; hence additive color matches that depend on the selective absorptions of the three different cone pigments would be unaffected by the sensitivity adjustments. Within reasonable limits, such matches are so unaffected, but only if the state of adaptation is uniform throughout retinal image areas of both the test and matching fields.

If this is not the case and the matches are "asymmetric" (for example between test field in one eye for one state of chromatic adaptation and matching field in the other eye for a different adaptation), then differences in responsiveness between the two states of adaptation can be registered by changes in the proportions of the matching lights. Such asymmetric color matches make it clear that the von Kries rule of linear, proportional changes in amplitude of receptor sensitivities cannot account for all the data (Hurvich & Jameson 1958; Jameson & Hurvich 1972). Departures from this rule are systematic. That is, the measured changes in proportions of the matching lights vary systematically with the luminance level of the test field relative to the surround luminance to which the eye is adapted. The departures from the proportionality rule are, moreover, in the directions that would have been predicted from a nonconstancy phenomenon known as the Helson-Judd effect (Helson 1938; Judd 1940). Spectrally nonselective surfaces seen against a spectrally nonselective background all appear achromatic (white through grays to black) in white light. When illuminated by chromatic light, samples whose reflectances are near the background level continue to appear gray, those above the background level take on the hue of the illuminant, and those below take on a hue that is complementary to that of the illuminant. Hue shifts for chromatic samples tend to behave similarly—i.e. as if intermixed with the illuminant hue or with its complementary, depending on the relative reflectances of sample and background. Such departures from perfect color constancy with changes in spectral quality of illumination are reminiscent of those described above for lightness constancy, and both sets of phenomena imply that perceived contrast between objects of different surface reflectance varies with the level and kind of illumination in which they are seen and to which the visual system is adapted.

We should emphasize that the magnitudes of these perceptual changes are not so great as usually to prevent object identification by color, particularly for distinctly colored surfaces that, under most ordinary illuminants, undergo perceived hue, satu-

ration, or brightness shifts that still do not move them out of one color category and into another, which would certainly be the case were there no compensatory changes in visual sensitivities (Jameson 1983).

For particular kinds of arrays that contain strong colors, but with subtle color differences, however, the state of chromatic adaptation can make the difference between seeing a pattern and failing to perceive that the surface is anything but uniformly colored. This statement is based on our studies of wavelength discrimination for test lights viewed within surrounds to which the observer is adapted (Hurvich & Jameson 1961). The consequences of chromatic adaptation for such discriminations are not a priori obvious. It might be anticipated that exposure, for example, to longwave light, which reduces the sensitivity of the longwave receptor, would selectively impair discriminability between just detectably different long wavelengths. Instead, the opposite occurs. In the longwave spectral region, the threshold wavelength difference is actually decreased; thus discriminability is improved, relative to what it is for neutral adaptation. And conversely, wavelength discrimination is relatively impaired in the midwave spectral region (where light sensitivity remains high). Qualitatively, what happens in this situation is that the perceived redness is somewhat depressed in the longer wavelengths, making slight differences in the yellowness of these same lights more obvious, whereas the perceived midspectrum greenness is enhanced, and tends to mask slight differences in the yellowness of these lights that can be detected reliably in a neutral state of adaptation. Changes analogous to these occur in other spectral regions for other kinds of chromatic adaptation.

Anyone who has had the opportunity to observe paintings hung in the same surroundings in both daylight and at night under incandescent illumination is likely to be aware of the disappearance or enhancement of such subtle hue differences. In most of these situations, the state of chromatic adaptation is probably determined primarily by the spectral quality of the illuminant. This assumes that the different surfaces in the field of view will be sufficiently varied so that the space average reflectance will not be far from neutral or spectrally nonselective. Some paintings, of course, are sufficiently large so that only the gamut of reflectances within the painting itself enter, with the illuminant, to affect the adaptation state. But here too the discriminability of similar hues and saturations will be dependent on the quality as well as level of the average light reflected from the surface area within the field of view as one inspects the painting, and it will differ for different illuminants.

In connection with paintings of the sort just mentioned, it should be pointed out that even for a very large painting that is very nearly monochromatic, such as Ad Reinhart's canvas called "Red Painting" (red geometric figure against red background, 6.5 ft by 12.5 ft), which hangs in the Metropolitan Museum of Art in New

York, continued inspection of the painting does not rob it of its redness and transform it into a gray painting. Fortunately for the artist, chromatic adaptation of the von Kries sort need not be complete; that is, the balance of sensitivities need not be completely compensatory so that the space average product of the reflectances × illumination yields a neutral or achromatic response. For highly selective reflectances or illuminants this is seldom the case; rather, the sensitivity balance only partially compensates for the effective adapting light rather than completely compensating for it. In brief, there are degrees of chromatic adaptation (Jameson & Hurvich 1956), as well as degrees of light and dark adaptation. Complete adaptation to strongly chromatic light is a special case; it does occur in a so-called *Ganzfeld* situation—that is, when the eye is exposed to completely uniform illumination throughout the entire surface of the retina (Hochberg et al. 1951). With prolonged exposure to a *Ganzfeld*, all visual effect of light fades away and we become, as it were, sightless.

Surface Metamers Surface metamers constitute a special case of an illuminant-dependent departure from color constancy. This case comes about because the appearance of a given surface material under one illuminant can be precisely matched for the same illuminant by a variety of different dyes and paint mixtures used to color other material samples. The spectral reflectance distributions of the samples can differ markedly, but the samples are visually identical. Such surfaces are thus, by definition, all surface-color metamers for this one illuminant. If the illuminant is changed, the surface color matches no longer hold. The different samples take on different hues and saturations that deviate, one from the next, in directions and amounts that are governed by their particular spectral reflectances in relation to the spectral characteristics of the new illuminant. [For a detailed technical discussion of surface metamers, illuminants, and distortion transformations, see Wyszecki & Stiles (1967).] The color changes cannot be predicted without prior knowledge of the spectral distributions that are involved, but, in general, they will be more significant the more irregular the spectral reflectance and illuminance distributions. With the increased use of fluorescent light sources that contain localized spectral energy peaks, the so-called "color rendering" properties of illuminants have required the increased attention of lighting engineers and illuminant manufacturers. Visual mechanisms of color adaptation do not, even in principle, solve this problem caused by illuminant energy peaks and high degrees of surface-color metamerism.

Neutral Adaptation and White Light

Chromatic adaptation is, by commonsense definition, measured as a departure from adaptation to white light. By common sense as well, white light is light that looks

white or achromatic. But what looks white or achromatic is, quite obviously, any one of a variety of very different spectral distributions depending on other variables in the viewing situation. Consider only one series of such illuminants whose energy varies smoothly and systematically across the visible spectrum in a way that nearly parallels the energy output of a physicist's ideal *black body* raised to increasing temperatures. Such illuminants are characterized by so-called *color temperatures* (*kelvin*, K); lights of high color temperatures (such as light from the north sky, about 10,000 K) have their energy output more heavily weighted in the short wavelengths. whereas artificial incandescent light of the sort used for indoor illumination (2400–2800 K) is relatively impoverished in shortwave energy but has comparatively high energy output in the longwave region of the visible spectrum. Illumination that is a mixture of skylight and noonday sunlight (color temperature of about 5500 K) has a relatively balanced energy distribution. This continuum of illuminants is approximately the one referred to in Helmholtz's statement that "we have abundant opportunity to examine the same object color in full sunlight, in the blue light from the clear sky, and the reddish-yellow light of the sinking sun or of candlelight ...", although our incandescent lights are less "'reddish-yellow" than either the sinking sun or Helmholtz's candlelight. In controlled laboratory test situations, uniform light fields from this whole gamut of color temperatures can be perceived as white light, but the perception depends on a multiplicity of interacting variables that include level of total light energy, exposure duration, area of light field, and prior light exposure (Hurvich & Jameson 1951a,b; Jameson & Hurvich 1951b). The gamut of color temperatures perceived as white increases with energy level whatever the parametric value of each of the other variables. That is, at high levels the relatively desaturated blue or yellow hues seen at lower light levels are somehow veiled or weakened. Since the cone system adapts rapidly, chromatic adaptation might well be a contributing factor responsible for the neutral percept for all illuminants except the one that approximates an equal-energy distribution. The latter illuminant (with some individual variation probably due to differences in ocular media) in our experiments had no perceptible hue at any energy level for any of the exposure durations or field sizes we examined. Results of other experiments designed to test for chromatic adaptation effects were consistent with the conclusion that it is only a near equal-energy illuminant that leaves the visual system in a neutrally balanced equilibrium state (Jameson & Hurvich 1951a).

For opaque surfaces of spectrally nonselective reflectances, it is only for conditions that produce such a physiologically neutral equilibrium state of adaptation that all gray-scale levels of the nonselective surfaces can be expected to appear equally achromatic as whites through grays to blacks. Illuminants that produce other adaptation

states will alter the perceived neutrality in accord with the Helson-Judd effect, tinting the lighter samples toward the illuminant hue and the darker ones toward its complementary. The extent of the perceived departures from strict neutrality of such surface colors will be minimal for illuminants very similar to the physiologically neutral one, and increasingly more noticeable for illuminants that are more heavily weighted toward one or another end of the spectrum. If the visual scene includes a variety of spectrally selective as well as nonselective surfaces, then the neutral or nonneutral appearances of the latter will further depend on the other surfaces in the array. In addition to illumination and reflectance characteristics, additional variables such as size and proximity become relevant for all the perceived surface colors.

Contrast, Assimilation, and Receptive Fields

The systematic departures from color constancy that carry information about illumination are essentially color contrast effects. They include both (a) brightness or lightness contrast that accentuates the perceived difference between the lightest and darkest objects or reflectances as mentioned above for both surfaces (Jameson & Hurvich 1961a, 1964) and sine-wave gratings (Kelly & Burbeck 1984), and (b) color contrast that accentuates perceived differences in the complementary yellow-to-blue and red-to-green hue dimensions (Jameson & Hurvich 1961b). In retinal images of natural scenes that contain three-dimensional objects and surface reflectances made up of both specular and diffuse components, contrast accentuates the differences between highlight and shadow, and contributes to the three-dimensionality of the scene, even if the image is not of the scene itself but of a two-dimensional photographic display. Shadowing is so effective a cue for three-dimensional shape that even shadowing that is produced by border contrast, rather than a gradation in either illumination or reflectance, can result in perceived depth variations across a perfectly flat surface. A good example is the familiar Mach scallop or fluted effect that perceptually "curves" adjacent edges forward and back into the surface plane when one views contiguous rectangular samples of a gray scale that is regularly ordered from light to dark.

Lateral interactions are common to the anatomy and neurophysiology of visual systems. Although at least in some species there may be contact influences that spread across the retinal receptor layer itself, in primates and thus probably also in humans, the more significant lateral interactions seem to occur at postreceptoral levels. In the color processing system, the three-variable spectral analysis of retinal image light occurs, as it were, in three parallel classes of cone receptors, each with a characteristic spectral sensitivity determined by its particular cone photopigment. Light absorption is signalled by graded hyperpolarizing electrical responses in each

cone class, and gives rise to synaptic changes that result, ultimately, in postreceptoral "neural images."

A significant recombination in the color processing system involves a transformation from the three different light absorption maps of the receptor mosaic that yields another set of three maps essentially based on a set of three different sums and differences governed by the signal strengths in the different receptor types. In our model based on psychophysical evidence (see Hurvich 1981), one of the neural systems is activated in accord with a difference between the weighted signal strengths of the midwave-sensitive receptor and the summed short- and longwave-sensitive receptors, a second in accord with a difference between the weighted signal strengths of the shortwave-sensitive receptor and the summed mid- and longwave-sensitive receptors, and a third in accord with the weighted signal strengths of the signals summed from all three receptor types. It should be noted here that opponent neural processing as fundamental to color vision is by now universally accepted, but the specific models proposed by different investigators differ in their detailed formulations. A recent computational proposal (not yet implemented by experiment) suggests use of sine-wave spectral power distributions to most efficiently evaluate a subset of these formulations, including our own (Benzschawel et al. 1986). All models require differencing mechanisms for hue processing, in accord with Hering's original hypothesis. The three overlapping spectral separations achieved by the selective photopigments are thus sharpened in the two differencing systems of the neural map, and essentially lost in the third. But since this spectral sharpening requires neural activation related to more than any single one of the adjacent cones, it comes at the expense of the spatial discreteness potentially available at the retinal receptor level. Thus the effective spatial grain in the neural maps is necessarily coarsened relative to that of the individual cones of the retinal mosaic.

Spatial, simultaneous color contrast has been a recognized characteristic of perception since at least the time of Leonardo da Vinci, and it has been exploited by artists who often exaggerate both hue and brightness contrast for pictorial effect (Jameson & Hurvich 1975). Because of contrast, any formal process expression for perceived color for a specified retinal light image array must include not only (a) the spectral sensitivities of the three classes of photopic light receptors, (b) coefficients to express the amplitude balance of these receptors brought about by adaptation of the von Kries type, and (c) the interactions that give rise to the difference and sum functions that characterize spectral opponent processing in the neural image but also (d) the mutual lateral neural interactions that occur within each class of the triplex of processing systems at this level (Jameson & Hurvich 1959). The effects of the last are readily measured by perceptual scaling techniques and by color matches made to

individual, uniform samples within an array compared with matches to the same samples in the presence of parts or all of the remaining array. Quantitative modeling of the effects by simultaneous equations that include spatial terms can describe them to a rough approximation (Jameson & Hurvich 1961b, 1964), but a physiologically more realistic model, and one that intrinsically subsumes more spatial variables, involves filtering by a difference of Gaussians (DOG) at the opponent neural level. Such functions are idealized representations of neural receptive fields of the circularly symmetric, spatially antagonistic, center/surround type. Psychophysically determined threshold interaction effects have been used to estimate the critical spatial dimensions within which only excitatory summative effects (receptive field center effects) occur within a small central foveal region of the visual field (Westheimer 1967). When such estimates are compared with those derived from other kinds of psychophysical experiments, such as measures of sine-wave contrast sensitivity that typically involve larger retinal areas, there are differences in calculated receptive field center diameters, although the shapes of the derived sensitivity profiles are very similar (Kelly & Burbeck 1984). The nonhomogeneity of the receptor mosaic—that is, the decline in numbers of cones per unit area from fovea to periphery of the retina (and corresponding decline in numbers of related postreceptoral cells)—is accompanied by expansion of receptive field center diameters with increasing distance from the foveal projection; but there is also considerable size variation within any particular projection area (Hubel & Wiesel 1960). Thus, the spatial grain of the neural maps, although coarser, follows the grain of the retinal receptor mosaic, but in a graded band, so to speak, rather than being singularly determined by retinal location.

Spatial mixture and blending of hue and/or lightness are effects that are opposite to border contrast since they reduce, rather than accentuate, differences in contiguous image areas. In our own analyses of these phenomena, the variation in receptive field size within a particular locus referred to above has seemed to provide the kind of physiological basis needed to account for the fact that both sharp edges between adjacent image areas and apparent spreading of different hues across the image boundaries can occur. Such effects, variously called *assimilation* or *spreading*, are particularly striking in repetitive patterns whether striped or curvilinear, and they can readily be observed in decorative fabrics and other motifs as well as in the paintings of some contemporary artists (Jameson & Hurvich 1975).

What is seen in such patterns depends on the sizes of the uniform elements within the pattern imaged on the retina relative to the cone diameters, and to the diameters of both the center and surround regions of the related neural receptive fields. If the image elements are small relative to the cone diameters, then true spatial light mix-

ture occurs; if they are small relative to the receptive field centers, then some degree of spatial blending or assimilation occurs; and if they are larger, then assimilation gives way to spatial contrast. These changes can be observed most easily by decreasing or increasing viewing distance from the pattern, thus controlling the relative sizes by increasing or decreasing, respectively, the width (in the stripe example) of the pattern elements in the retinal image. In this case, color constancy fails with change in distance: For example, stripes that are seen close up as red alternating with blue become increasingly reddish purple and bluish purple stripes farther away. Complete light mixture with failure of spatial resolution requires very distant viewing. Far enough away, a striped pattern can look uniform. It is the intermediate range that is of most interest, because here there is both good pattern resolution and partial hue mixture. Also, at just the right distance within the intermediate range, it is possible to attend to the striped field as a whole and see the stripes as reddish purple and bluish purple, or, alternatively, to concentrate on the adjacent stripes at the center of gaze (where the receptive fields are smallest in the foveal region) and see them as vividly red and blue with no trace of the purple mixture hue. To the casual viewer, the nonconstancy of adjacent stripe color that can occur when scanning such a pattern at the critical viewing distance is usually not noticed as such without deliberate attention, but what is noticed is a kind of visual liveliness that fabric designers sometimes strive for.

Since resolution and mixture depend on neural receptive field center sizes, the fact that, for some retinal image dimensions, both can occur simultaneously and at the same location suggests that the two effects result from processing in different neural systems with different receptive field dimensions; and indeed, process modeling using scaled receptive field (DOG) filtering gives a good qualitative match to the perceptual effects (Jameson 1985). Receptive fields of different scales are used commonly in computational models, and their dimensions have typically been based on analyses of psychophysical data indicating that sine-wave contrast sensitivity requires a number of different spatial processing "channels" for different regions of the spatial frequency dimension. [A good critical summary and relevant references can be found in Kelly & Burbeck (1984).] It is also concluded from the dependence of sine-wave contrast sensitivity on luminance level that the effectiveness inhibitory surround region of receptive fields is decreased at low luminances and increased at higher ones. Thus, the relative effectiveness of the mutual lateral interactions that give rise to spatial contrast both at edges and across more extended retinal image areas (see von Békésy 1968) would be expected to vary with luminance in the same way and provide a physiological basis for the perceived increase in object color contrast in bright light.

Postreceptoral Adaptation or Biasing

It seems clear that change in the spectral quality and quantity of the adapting illuminant not only changes the balance of sensitivities at the receptor level, but that it also changes the balance of excitatory and inhibitory influences that are related to both spectral and spatial processing in the color related systems at the postreceptoral level. In addition to the evidence from our own studies of asymmetric color matches, perceptual scaling data, and discrimination functions discussed earlier in this essay, and the evidence from sine-wave contrast functions mentioned above, additional evidence for the involvement of postreceptoral mechanisms comes from a very different experimental and analytical paradigm. This paradigm is the two-color increment threshold technique employed in the many exemplary experiments and analyses carried out by W. S. Stiles. Pugh & Kirk (1986) have published a comprehensive historical review of this work, including references to others (among whom Pugh was an important contributor), that outlines the changes in Stiles's own interpretation of such discrimination thresholds and provides the basis for the current interpretation that the mechanism for adaptation to the background light in this paradigm cannot be restricted exclusively to the triplex of retinal light receptors but must also involve postreceptoral adaptation effects in the neural differencing mechanisms—i.e. at the spectrally opponent level of neural color processing. In their review, the authors emphasize that, although Stiles had started from the hypothesis that analysis of his psychophysical data would reveal activities and adaptation effects only in the cones, by 1967 he himself pointed out that difference signals may also make an important contribution to the discriminations in his experimental paradigm.[4]

We do not intend to imply here that the postreceptoral influences envisaged by all investigators concerned with this issue are necessarily identical with those that we have hypothesized to account for a variety of different psychophysical and perceptual findings. For example, D'Zmura & Lennie (1986) postulate variable weights that are adaptation-dependent applied to the adaptation-scaled cone signals at the differencing level. Whether their specific formulation would yield effects at the cortical level equivalent to our postulated postreceptoral, incremental or decremental, equilibrium level or set-point shifts that depend on lateral opponent interactions is not directly evident. Their discussion of physiological mechanisms leaves uncertain the level (or levels) of neural processing at which the postreceptoral adaptation effects occur (as does our own model of these effects), and even includes an expression of uncertainty about whether the kinds of adjustments to scaled cone signals that they postulate for their second stage are actually made by the visual system. Clearly, independent evidence on this issue from visual neurophysiology is both

lacking and needed. Some of our own psychophysical experiments that compare adaptation to steady light fields with adaptation to the same lights for an equivalent duration but with interpolated dark intervals that permit partial recovery of cone sensitivity have led us to the conclusion that postreceptoral mechanisms (at some level) recover from chromatic adaptation shifts very slowly before the neutral equilibrium level is restored (Jameson et al. 1979). Such relatively long-term biasing suggests a potential contribution to the adaptation effects at processing levels as far removed from the retinal receptors as the visual projection areas of the cortex.

Visual Cortex and Double-Opponent Cells

Cells that show opponent spectral characteristics are known to exist in the primate all the way from the retina, through the lateral geniculate nucleus (LGN), to various cortical projection areas. Although cortical cells in area 17 and beyond usually have receptive fields that are organized in such a way that the cells are preferentially sensitive to lines and edges with particular orientations, some of which have been reported also to be spectrally selective and opponent, there are also cortical cells with circularly symmetric receptive fields that are characterized by spectral opponency both in the centers and in the antagonistic surrounds (De Valois et al. 1982; Michael 1978a,b; Jameson 1985 for additional references). Recent work by Livingstone & Hubel (1984; Hubel & Livingstone 1987) has localized such cells, thought to be related to the parvocellular system of the LGN, in cluster-like formations, *blobs*, in area 17, and has suggested that these double-opponent blob cells feed into *thin stripe* formations in area 18, from which there are also anatomical connections back to area 17 as well as with other visual projection areas. Such double-opponent cells conveniently display characteristics similar to the DOG receptive fields combined with spectral differencing for two hue systems and broadband spectral sensitivities for an achromatic system, which are consistent with our interpretations of psychophysical and perceptual data. Despite this convenient convergence, we do not intend to imply either that these are *the* relevant physiological findings for neural color processing or that our own analyses are anything but oversimplified and incomplete. It is with this caveat, and the further caveat that these are certainly not the only collections of cells or brain areas involved, that they are included in the digest shown in table 7.1. The suggestion in this digest that the connections to area 17 from area 18 as well as from 17 to 18 might be related to changes in state related to the establishment of "memory color" is our own speculation, and it is no more than that. Interconnections with other subdivisions and other brain areas would certainly be required for colors of particular hue categories to be regularly associated with objects of particular forms and particular contexts.

Table 7.1
Some relevant aspects of color processing

Retinal light stimulus	Space (and time) average of: Direct light Illuminant × surface reflectances (specular and diffuse components)
von Kries adaptation (proportionality rule weighted for degree of adaptation)	Influence on: Amplitudes of three phototopic sensitivity functions Control of magnitudes of input signals to postreceptoral spectral differencing mechanisms and summative luminosity mechanism
Additional postreceptoral activation	Locally weighted space (and time) average of: Difference and sum effects within adjacent postreceptoral neural elements
Receptive field effects (control by spatial sums and differences)	Influence on: Set points of spectrally and spatially opponent mechanisms (R+G−, R−G+, Y+B−, Y−B+, W+Bk−, W−Bk+)
Activation of cortical sensory area 17	Inputs from parvocellular system to: Blob-like subdivisions of retinotopic organization containing cells with double-opponent receptive fields
Area 17 local cortical connections between blobs	Influence on: Spatial extent of lateral influences on individual double-opponent cells
Activation of cortical area 18	Inputs from blob cells of area 17 to: Cells segregated in thin stripe subdivisions containing cells with double-opponent, nonoriented receptive fields
Reciprocal cortical connections between area 17 and area 18	Influence on: Possible recurrent activation for hypothetical synaptic weighting in successive approximation to a "memory color"

From the point of view of understanding visual perception, or even a circumscribed aspect of the mechanism such as color processing, in terms of visual neurophysiology, we are barely at the starting line ready for the first halting step. From a perspective of 20 or more years back, progress in visual neurophysiology has been rapid and impressive. But examined from today's perspective, the missing details and the nearly totally unexplored functional specializations of the different relevant brain areas, as well as of their mutual interrelations, loom even more impressively large.

Remarks on Computational Approaches

We mentioned in the introductory paragraphs of this essay that issues related to object color constancy are a common focus of computational approaches; in Hurlbert's (1986) words, computations that will "extract the invariant spectral-reflectance

properties of an object's surface from the varying light that it reflects." Part of
the problem considered by some computational studies is the separate extraction
of the illuminant properties from specular highlights in a three-dimensional scene
or representation thereof (D'Zmura & Lennie 1986; Lee 1986), and another part
is the separation of shadows from material changes (Gershon et al. 1986). Many
of these approaches are concerned to some extent with one or another version of
the *retinex* algorithm proposed by Land (1983, 1986; Land & McCann 1971) to
specify lightness and color in constant terms related to constant reflectances and
independently of illumination (Arend & Reeves 1986; Brainard & Wandell 1986;
D'Zmura & Lennie 1986; Hurlbert 1986; Worthey & Brill 1986). Land's computa-
tional procedures for describing perceived colors have undergone a number of mod-
ifications since he was first surprised by his own observation that the wide gamut of
hues he was able to recognize in a photographic slide projection did not require
wavelengths in the projected image that he associated with those hues, nor did they
require mixtures of wavelengths from three different parts of the spectrum as he
would have anticipated from the technology of colorimetry (Land 1959). Although
others saw his demonstrations as instances of simultaneous color contrast, Land
was not interested in contrast explanations, whether cognitive or physiological. As a
physicist looking for another account from the physics of light, he proposed that the
different colors seen in the *natural image* could be attributed to (and computed by)
the ratios of almost any pair of longer and shorter wavelengths or wavelength dis-
tributions used to form the projected image or to illuminate the original scene. The
first significant change in this anti-trichromatic, or at least nontrichromatic, idea was
in the direction of traditional color theory. The two-record account was modified to
a three-layer, three-light-record account in which lightness ratios were computed for
each record separately, with the maximum lightness in each assigned a value of 1.0.
Such a procedure yields a three-variable chromaticity and photometric lightness
space normalized with respect to the maximum lightness, taken to represent "white,"
with hue designations assigned to various regions in the space in accord with the hue
names assigned to the three different light records. We would describe this procedure
as akin to the application of a von Kries adaptation rule for the normalization, and
a Young-Helmholtz type of theory for the color coding. Further modifications of the
specifics of the retinex procedure include the computation of each lightness ratio
record across reflectance boundaries, akin to Wallach's (1948) account of achromatic
lightness constancy; a reset correction to retain a maximum of 1.0; a logarithmic
transformation; and the introduction of a ratio threshold. The last serves to dis-
count gradual lightness changes within reflectance boundaries of the sort that
would be produced by an illumination gradient, thus eliminating the gradient from

the computation and presumably from the perception as well. In his 1983 paper, Land includes a transformation from what we described above as a chromaticity and lightness space, which he calls the *color three-space*, to a red-green, yellow-blue, white-black opponent color three-space. This is another step in the direction of currently accepted color theory. In a still more recent report (Land 1986), an alternative algorithm is presented that involves photometric measurements of the surface pattern with a small and a large photometer aperture (the latter having a diminishing sensitivity profile), a log transform of the record at each of the two very different scales, and then a differencing operation. This alternative algorithm for the first time in retinex computations relaxes the strict coupling between computed lightness at a point on a surface and surface reflectance at that location. The procedure, although described differently, is implicitly akin to the mechanism proposed by von Békésy (1968) to account for simultaneous contrast. This most recent change in retinex formulation thus brings the computational approach closer to the center/surround receptive field based modeling that we, and many others, have been engaged in for some time. The retinex operations do not yet, however, include the receptive field dependences required to subsume the systematic departures from lightness and color constancy that occur with change in level and quality of illumination. Nor do they yet include in the photometric procedures provision for change in retinal image size with change in viewer-to-surface distance, and thus the distance-dependent departures from perceived color constancy that can vary from assimilation to contrast effects for the same reflectance pattern which we discussed above (see the section on *Contrast, Assimilation, and Receptive Fields*).

It seems predictable that computational approaches to the old issue of color constancy will not for long continue to seek direct and precise perceptual correlates of constant surface reflectances, but will increasingly embody the more realistic approach of object identification through approximate invariance of color category. As we have pointed out elsewhere, there are some colors (e.g. the colors of haystacks, concrete and other masonry) that are difficult to categorize under any illuminant and that change quite noticeably with change in viewing conditions. For objects of this sort, color identification, rather than contributing to object identification, is more likely a result of it. It also seems predictable that approaches that include computations to extract illumination information as well as surface color will probably begin to incorporate shadow, as well as highlight effects, and to recognize the biological significance of such information as such for purposes other than being discounted. We have already cited attempts to separate shadow from material changes across surfaces, but we should add here that with no change in shadow, illumination, or reflectance, perceived differences can also result from apparent dif-

ferences in object shape and orientation. Thus, a surface seen as a trapezoid under glancing illumination can appear less light than it does when the observer's set is manipulated so that the same surface is seen as a normally illuminated square lying flat on a receding plane (Hochberg 1978). Effects of this sort, when they occur, are clearly not under the control of any variables in the light stimulus, but rather point to mutual influences between different specialized processing systems tempered by well-practiced adaptive behavioral responses of the individual.

In the long run, the kind of widely encompassing computational approach that seems to us to offer the most promise for modeling of perceptual effects is exemplified by Edelman's *neuronal group selection theory* (Reeke & Edelman 1988). The theory is based on biological considerations, with both variability and selection emphasized not only as evolutionary but also as developmental principles. In development, selection for neuronal connectivity is elaborated by selective mechanisms for differential cell growth and survival, and followed during early experience by selection, through modification of synaptic strengths, among diverse preexisting groups of cells to shape and adapt the behavior of the organism. An appealing feature of the computational model based on this theory is the processing in parallel of unique responses to individual stimuli (the automaton sampling system called *Darwin*), and of generic responses to stimulus class (the automaton sampling system called *Wallace*). There is high-level reciprocal connectivity between these systems, and a natural emergence of similarity-based categories that are relevant to the adaptive needs of organisms.

It seems to be agreed that surface color recognition is a useful component of object identification, and it is our judgment that such recognition is adequately accomplished by category matching and does not require precise matching-to-sample by the three color variables of hue, brightness, and saturation. It seems also to be agreed that context and instructions can modify actual experimental matching between extremes that approximate reflectance matches, on the one hand, and on the other hand, an illumination-dependent range of perceived hues, saturations, and brightnesses that include, but are not restricted to, a set of approximate reflectance matches. Both the systematic changes and the categorical constancies are perceptually available for recording in experiments, and more importantly, for adaptive responses to objects recognized in the environment and to the illumination conditions of that environment. Recognition and identification require some degree of perceived constancy, but we could cite too many examples of identification and recognition, whether of persons, objects, buildings, or landscapes, despite aging, fading, season, and illumination, to assume that the systematic changes related to such different conditions are not also perceptually informative in important ways.

Notes

1. The phrase "computational vision" is already gaining wide currency (e.g. Boynton 1988).

2. Stanford University has applied for a patent based on research directed toward this goal, a fact that emphasizes its obvious relation to machine design (Maloney & Wandell 1986).

3. The statement quoted here from Woodworth was abstracted by him from the first edition of Helmholtz's *Physiological Optics* (1866, p. 408). In Southall's (1924) English translation of the third edition, Helmholtz's discussion appears in Volume 2, pp. 286–87.

4. For an earlier suggestion that this might be so, see Hurvich 1963.

References

Arend, L., Goldstein, R. 1987. Simultaneous constancy, lightness, and brightness. *J. Opt. Soc. Am. A* 4: 2281–85.

Arend, L., Reeves, A. 1986. Simultaneous color constancy. *J. Opt. Soc. Am. A* 3: 1743–51.

Benzschawel, T., Brill, M. H., Cohn, T. E. 1986. Analysis of human color mechanisms using sinusoidal spectral power distributions. *J. Opt. Soc. Am. A* 3: 1713–25.

Boynton, R. M. 1988. Color vision. *Ann. Rev. Psychol.* 39: 69–100.

Brainard, D. H., Wandell, B. A. 1986. Analysis of the retinex theory of color vision. *J. Opt. Soc. Am. A* 3: 1651–61.

De Valois, R. L., Yund, E. W., Hepler, N. 1982. The orientation and direction selectivity of cells in macaque visual cortex. *Vision Res.* 22: 531–44.

D'Zmura, M., Lennie, P. 1986. Mechanisms of color constancy. *J. Opt. Soc. Am. A* 3: 1662–72.

Gershon, R., Jepson, A. D., Tsotsos, J. K. 1986. Ambient illumination and the determination of material changes. *J. Opt. Soc. Am. A* 3: 1700–7.

Guthrie, B. L., Porter, J. D., Sparks, D. L. 1983. Corollary discharge provides accurate eye position information to the oculomotor system. *Science* 221: 1193–95.

Helson, H. 1938. Fundamental problems in color vision. I. The principles governing changes in hue, saturation, and lightness of nonselective samples in chromatic illumination. *J. Exp. Psychol.* 23: 439–76.

Hering, E. 1920. *Outlines of a Theory of the Light Sense*. Transl. from German by L. M. Hurvich, D. Jameson, pp. 7–8, 1964. Cambridge: Harvard Univ. Press.

Hess, C., Pretori, H. 1894. Messende Untersuchungen über die Gesetzmessigkeit des simultanen Helligkeitskontrastes. *Arch. Ophthalmol.* 40: 1–24.

Hochberg, J. E. 1978. *Perception*. Englewood Cliffs, NJ: Prentice-Hall. 280 pp. 2nd ed.

Hochberg, J. E., Triebel, W., Seaman, G. 1951. Color adaptation under conditions of homogeneous stimulation (Ganzfeld). *J. Exp. Psychol.* 41: 153–59.

Hubel, D. H., Livingstone, M. S. 1987. Segregation of form, color and stereopsis in primate area 18. *J. Neurosci.* 7: 3378–415.

Hubel, D. H., Wiesel, T. N. 1960. Receptive fields of optic nerve fibers in the spider monkey. *J. Physiol. London* 154: 572–80.

Hurlbert, A. 1986. Formal connections between lightness algorithms. *J. Opt. Soc. Am. A* 3: 1684–93.

Hurvich, L. M. 1963. Contributions to color-discrimination theory: review, summary, and discussion. *J. Opt. Soc. Am.* 53: 196–201.

Hurvich. L. M. 1981. *Color Vision*. Sunderland, Mass: Sinauer, 328 pp.

Hurvich, L. M., Jameson, D. 1951a. A psychophysical study of white. I. Neutral adaptation. *J. Opt. Soc. Am.* 41: 521–27.

Hurvich, L. M., Jameson, D. 1951b. A psychophysical study of white. III. Adaptation as variant. *J. Opt. Soc. Am.* 41: 787–80.

Hurvich, L. M., Jameson, D. 1954. Spectral sensitivity of the fovea. III. Heterochromatic brightness and chromatic adaptation. *J. Opt. Soc. Am.* 44: 213–22.

Hurvich, L. M., Jameson, D. 1958. Further development of a quantified opponent-colours theory. In *Visual Problems of Colour.* Ch. 22. London: Her Majesty's Stationery Office.

Hurvich, L. M., Jameson, D. 1960. Perceived color, induction effects, and opponent-response mechanisms. *J. Gen. Physiol.* 43(6): 63–80 (Suppl.)

Hurvich. L. M., Jameson, D. 1961. Opponent chromatic induction and wavelength discrimination. In *The Visual System: Neurophysiology and Psychophysics,* ed. R. Jung, H. Kornhuber. Berlin: Springer.

Hurvich, L. M., Jameson, D. 1966. *Perception of Brightness and Darkness.* Boston: Allyn & Bacon.

Jameson, D. 1983. Some misunderstandings about color perception, color mixture and color measurement. *Leonardo* 16: 41–42.

Jameson, D. 1985. Opponent-colours theory in the light of physiological findings. In *Central and Peripheral Mechanisms of Colour Vision,* ed. D. Ottoson, S. Zeki. London: Macmillan, pp. 83–102.

Jameson, D., Hurvich, L. M. 1951a. Use of spectral hue-invariant loci for the specification of white stimuli. *J. Exp. Psychol.* 41: 455–63.

Jameson, D., Hurvich, L. M. 1951b. A psychophysical study of white. II. Area and duration as variants. *J. Opt. Soc. Am.* 41: 528–36.

Jameson, D., Hurvich, L. M. 1953. Spectral sensitivity of the fovea. II. Dependence on chromatic adaptation. *J. Opt. Soc. Am.* 43: 552–59.

Jameson, D., Hurvich, L. M. 1956. Some quantitative aspects of an opponent colors theory. III. Changes in brightness, saturation, and hue with chromatic adaptation. *J. Opt. Soc. Am.* 46: 405–15.

Jameson, D., Hurvich, L. M. 1959. Perceived color and its dependence on focal, surrounding, and preceding stimulus variables. *J. Opt. Soc. Am.* 49: 890–98.

Jameson, D., Hurvich, L. M. 1961a. Complexities of perceived brightness. *Science* 133: 174–79.

Jameson, D., Hurvich, L. M. 1961b. Opponent chromatic induction: experimental evaluation and theoretical account. *J. Opt. Soc. Am.* 51: 46–53.

Jameson, D., Hurvich, L. M. 1964. Theory of brightness and color contrast in human vision. *Vision Res.* 4: 135–54.

Jameson, D., Hurvich, L. M. 1970. Improvable, yes; insoluble, no: a reply to Flock. *Percept. Psychophys.* 8: 125–28.

Jameson, D., Hurvich, L. M. 1972. Color adaptation: sensitivity, contrast, after-images. In *Handbook of Sensory Physiology,* Vol. 7/4. Visual Psychophysics, ed. D. Jameson, L. M. Hurvich, pp. 568–81. Berlin: Springer.

Jameson, D., Hurvich, L. M. 1975. From contrast to assimilation: in art and in the eye. *Leonardo* 8: 125–31.

Jameson, D., Hurvich, L. M., Varner, F. D. 1979. Receptoral and postreceptoral processes in recovery from chromatic adaptation. *Proc. Natl. Acad. Sci. USA* 76: 3034–38.

Jay, M. F., Sparks, D. L. 1984. Auditory receptive fields in primate superior colliculus shift with changes in eye position. *Nature* 309: 345–47.

Judd, D. B. 1940. Hue, saturation, and lightness of surface colors with chromatic illumination. *J. Opt. Soc. Am.* 30: 2–32.

Katz, D. 1935. *The World of Color.* Transl. from German by R. B. MacLeod, C. W. Fox. London: Kegan Paul, Trench, Trubner. Reprinted 1970. New York: Johnson Reprint.

Kelly, D. H., Burbeck, C. A. 1984. Critical problems in spatial vision. *CRC Crit. Rev. Biomed. Eng.* 10: 125–77.

Koffka, K. 1935. *Principles of Gestalt Psychology*. New York: Harcourt Brace. 720 pp.

Krauskopf, J. J. 1986. Computational approaches to color vision: Introduction. *J. Opt. Soc. Am. A* 3: 1648.

Land, E. H. 1959. Color vision and the natural image. Part I. *Proc. Natl. Acad. Sci. USA* 45: 115–29.

Land, E. H. 1983. Recent advances in retinex theory and some implications for cortical computations: color vision and the natural image. *Proc. Natl. Acad. Sci. USA* 80: 5163–69.

Land, E. H. 1986. An alternative technique for the computation of the designator in the retinex theory of color vision. *Proc. Natl. Acad. Sci. USA* 83: 3078–80.

Land, E. H., McCann, J. J. 1971. Lightness and retinex theory. *J. Opt. Soc. Am.* 61: 1–11.

Lee, H.-C. 1986. Method for computing the scene-illuminant chromaticity from specular highlights. *J. Opt. Soc. Am. A* 3: 1694–99.

Livingstone, M. S., Hubel, D. H. 1984. Anatomy and physiology of a color system in the primate visual cortex. *J. Neurosci.* 4: 309–56.

MacLeod, R. B. 1932. An experimental investigation of brightness constancy. *Arch. Psychol.* 23(135): 1–102.

Maloney, L. T., Wandell, B. A. 1986. Color constancy; a method for recording surface spectral reflectance. *J. Opt. Soc. Am. A* 3: 29–33.

Michael, C. R. 1978a. Color vision mechanisms in monkey striate cortex: dual-opponent cells with concentric receptive fields. *J. Neurophysiol.* 41: 572–88.

Michael, C. R. 1978b. Color vision mechanisms in monkey striate cortex: simple cells with dual opponent-color receptive fields. *J. Neurophysiol.* 41: 1233–49.

Pugh, E. N., Kirk, D. B. 1986. The Π mechanisms of W. S. Stiles: An historical review. *Perception* 15: 705–28.

Reeke, G. N. Jr., Edelman, G. M. 1988. Real brains and artificial intelligence. *Daedalus* 117: 143–73.

Varner, D., Jameson, D., Hurvich, L. M. 1984. Temporal sensitivities related to color theory. *J. Opt. Soc. Am. A* 1: 474–81.

von Békésy, G. 1968. Mach- and Hering-type lateral inhibition in vision. *Vision Res.* 8: 1483–99.

von Helmholtz, H. 1924 (1911). *Physiological Optics*. ed. J. P. Southall, 2: 286–87. Rochester, NY: Optical Soc. Am. 3rd ed.

von Kries, J. 1905. Die Gesichtsempfindungen. In *Handbuch der Physiologie der Menschen*, ed. W. Nagel, pp. 109–282. Brunswick: Wieweg.

Wallach, H. 1948. Brightness constancy and the nature of achromatic colors. *J. Exp. Psychol.* 38: 310–24.

Westheimer, G. 1967. Spatial interaction in human cone vision. *J. Physiol.* 190: 139–54.

Woodworth, R. S. 1938. *Experimental Psychology*. New York: Holt, 889 pp.

Worthey, J. A., Brill, M. H. 1986. Heuristic analysis of von Kries color constancy. *J. Opt. Soc. Am. A* 3: 1708–12.

Wyszecki, G., Stiles, W. S. 1967. *Color Science*. New York: Wiley.

V COLOR DEFECTS AND GENETICS

8 Color Blindness

Yun Hsia and C. H. Graham

Persons with normal color vision are called *normal trichromats*. [Trichromats] require a mixture of two monochromatic primary colors, of a set of three, to match a mixture composed of a monochromatic spectral color plus the remaining primary.

Color-blind individuals may be classified as dichromats, monochromats, or anomalous trichromats.

Dichromats are individuals who match any color of the spectrum with an appropriate combination of two primaries. Frequently the combinations of colors are such that one of the primaries is combined with the color to be matched. In other cases (e.g., tritanopes) the color to be matched is compared with the mixture of the two primaries.

Monochromats match any color of the spectrum with any other color of the spectrum or a white. They cannot discriminate differences in hue.

Anomalous trichromats can, like color-normal persons, combine a test light of the spectrum with one of three primaries so as to match a mixture of the two remaining primaries. It must be observed, however, that the respective amounts of the primaries required for the match are different from those required by the normal trichromat.

Dichromatism

The forms of dichromatism that occur most frequently are *protanopia* and *deuteranopia*. [These two categories were referred to as red blindness and green blindness by Helmholtz (1866, 1911, 1924).] The third type, *tritanopia*, occurs much less frequently than the other two. A fourth type called tetartanopia has been listed, but its status is as yet unclear (see Walls and Mathews, 1952).

The terms protanopia and deuteranopia were originally proposed by von Kries (see Helmholtz, 1911, 1924, p. 402) with no implication of theoretical consequences. They refer only to types of dichromatism—the first type and the second type, respectively. However, von Kries considered dichromatism "as comprising reduction forms of vision" or as being due to a lack of "component factors of the visual organ as assumed in the Helmholtz theory."

Screening Tests

A number of screening tests are used for the detection and specification of dichromats. A final classification may be buttressed by more precise measurements.

The so-called pseudo-isochromatic plates use printed dots to form differently colored figure-and-ground configurations for testing color discrimination. In this group the Stilling Test (German) (1st ed., 1875) is the earliest. Many workers in the field of color, however, prefer the Ishihara Test (Japanese) (1st. ed., 1917) for detecting protanopic and protanomalous as well as deuteranopic and deuteranomalous types of color deficiencies. The Rabkin Test (Russian) (1st ed., 1939) and Dvorine Test (American) (1st ed., 1944) are also useful. Most of these tests do not supply a test for tritanopia. The H-R-R Plates (Hardy, Rand and Rittler, 1955) do supply such a test, as well as one for tetartanopia. The Stilling Test has four plates for the yellow-blue types of color deficiencies.

Farnsworth's (1943) 100-Hue Test and D-15 Test use Munsell (1929) colored paper chips which are arranged in order of hue by the normal subject. Farnsworth's tests differentiate color-blind individuals (on the basis of their color confusions) into protan, deutan, and tritan classifications. The classification *protan* includes protanopic and protanomalous cases. The term *deutan* includes deuteranopic and deuteranomalous cases. The term *tritan* applies to tritanopic and tritanomalous individuals. Farnsworth (1954) used the combination classifications because he felt that his tests could not clearly differentiate dichromats from anomalous cases.

Anomaloscope

Another screening device used primarily with protanopes and deuteranopes makes use of the Rayleigh equation established in an anomaloscope. The Rayleigh equation involves matching yellow with a mixture of red and green, a performance that has been known since Seebeck (1837) and Maxwell (1855) to be possible for the normal eye. Lord Rayleigh (1881) discovered the usefulness of the match as a basis for differentiating certain types of color-blind individuals from normal persons; hence his name is attached to the procedure.

The instrument devised to measure the Rayleigh equation is known as the anomaloscope. The most widely used one, the Nagel anomaloscope (1898), uses spectral lights and is, according to Willis and Farnsworth (1952), the most effective. Another, the Hecht-Shlaer anomaloscope, uses narrow-band color filters (see Willis and Farnsworth, 1952). Normal eyes produce a Rayleigh equation with little variation in the ratio of red to green; anomalous trichromats, on the other hand, give a wide distribution of ratios. Protanopes and deuteranopes match yellow with *any* ratio of red to green (provided that the mixture is sufficiently bright) including red or green alone; in a word, yellow is matched by any sufficiently bright red-green mixture. The deuteranope requires about the same brightness of red as a normal subject; the protanope requires a brighter red.

Neutral Point

The neutral point is an important characteristic of dichromatic vision. It many be defined as the spectral band chosen by a dichromatic subject from a randomly or serially presented sequence of colors to match a white light in hue and brightness. A true dichromat has no difficulty in selecting a spectral color to match white, a performance that is impossible for the normal trichromat or the anomalous trichromat. The neutral point obtained in actual measurements is not invariably a sharp point but usually covers a range of several millimicrons.

Each class of dichromat is characterized by a neutral point having a characteristic position on the spectrum. Determinations by Donders (1883) (see Parsons, 1924) gave an average neutral point of 494.8 mμ for protanopes and 502 mμ for deuteranopes. Later data do not deviate greatly from these values. Neutral points of protanopes and deuteranopes as measured by König (1884), Meyer (1932), Pitt (1935), and Hecht and Shlaer (1936) are given in Walls and Mathews' review (1952), which includes their own measurements. The values as well as more recent data by Walls and Heath (1956) are presented in table 8.1.

The position of the neutral point depends on at least two factors. First, it depends on the specific white used as a standard for matching. When whites of different color temperature are plotted on different coordinate values of the CIE chromaticity chart, one white may be more bluish or more yellowish than another. The higher the color temperature of the white, the shorter the wavelength of the neutral point setting.

A second factor may be the pigment layer that serves as a yellow filter. As such it may modify the quality of the white standard and affect the measured value of the neutral point. This notion was suggested by von Kries (1897) and elaborated by Judd (1944).

Table 8.1
Average neutral points of protanopes and deuteranopes

Authors	White Standard	Protanopes	Number of Cases	Deuteranopes	Number of Cases
König	Daylight	494.3 mμ	6	497.7 mμ	7
Meyer	"Subjective"	497.0	4	495.0	8
Pitt	4800°K	495.7	5	500.4	6
Hecht and Shlaer	5000°K	498.2	10	510.2	12
Walls and Mathews	6500°K	491.1	19	496.7	14
Walls and Heath	6500°K	492.3	39	498.4	38
Walls and Heath	7500°K	490.3	13	496.2	15

Although neutral points for protanopes and deuteranopes have been generally found to overlap (Pitt, 1935; Hecht and Shlaer, 1936), it is assumed that the average difference between neutral points for the two types of dichromats, which is only a few millimicrons, is a genuine one. Walls and Mathews (1952) insisted that the overlapping found in earlier lists was due to errors of measurement; there was no overlapping in their own data. Walls and Heath (1956) substantiated this claim with an extended number of cases. It should be noted that Walls and his colleagues used surface colors (Munsell papers), whereas most other workers used spectral lights for measurement.

Göthlin (1943) discussed one case of tritanopia whose neutral point was at 571 mμ. König (1897) observed six cases of acquired tritanopia and located the neutral point between 566 and 570 mμ. A case studied by Fischer, Bouman, and Doesschate (1951) gave a neutral point at 570 mμ for a white standard of 4800°K.

Wright (1952) studied a group of tritanopes, 17 of a larger group of 29 whom he found in a nationwide search in England. He did not formally measure or report their neutral points, but examination of his confusion data (see section on chromaticity confusion) reveals that he has such information on five subjects. Among the Munsell papers he used to determine the confusion lines was one labeled N/7 (i.e., a medium light neutral gray), which was found to match *ca* 571 mμ (yellow) under Illuminant B (approximately 4800°K).

Color Mixture

Maxwell, as early as 1855, was able to demonstrate that the red blind (i.e., protanope) matched the spectrum with only two primaries.

König and Dieterici (1892) determined the color mixture functions of protanopes and deuteranopes and found they could match any test color of the spectrum with two primaries, one in the long-wave part of the spectrum and the other in the short-wave. Similar work has been performed by von Kries and Nagel (1896).

Pitt (1935) obtained color mixture data from eight protanopes and seven deuteranopes. Hecht and Shlaer (1936) examined one protanope and one deuteranope. The data of these authors again demonstrated that protanopes and deuteranopes require only two primaries to match spectral colors. The authors used different primaries, but Judd (1944) transformed one set of data so that the two groups could be directly compared. They were, in fact, quite similar to each other. Pitt's data on the color mixture of dichromats are reproduced in figure 8.1. The curves for the protanope and deuteranope are very much alike. They do not, as Pitt pointed out, serve as a dependable basis to distinguish between the two dichromatic groups. However, the ratios of the primaries for the long wavelength end of the spectrum do differ slightly

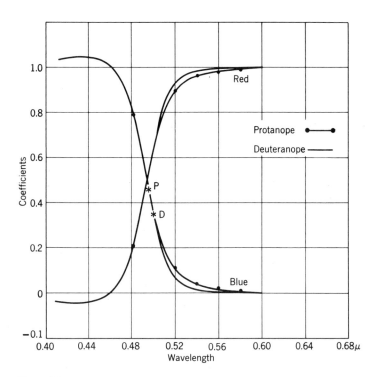

Figure 8.1
Mean dichromatic coefficient curves for eight protanopes and seven deuteranopes. Neutral points marked with asterisks. (From Pitt, 1935.)

for the two types of dichromats. Pitt's average data indicated that both deuteranopes and protanopes require that the red primary be mixed with a blue test light for a match with the blue primary. The deuteranopes need relatively less of the blue primary to be mixed with the red primary in a match for long-wave test lights. Hecht and Shlaer's (1936) data indicated that the deuteranopes needed relatively more blue. Von Kries and Nagel's (1896) data were in agreement with the latter finding.

Wright (1952) obtained the color mixture data for seven tritanopes, and Sperling (1960) reported on another case. Both authors confirm the fact that tritanopes require only two primaries for color mixture. Figure 8.2 presents an example from Wright. It is interesting to note that a range of wavelengths exists over the violet end of the spectrum in which the same dichromatic coordinates (WDW system), apply as in the yellow region.

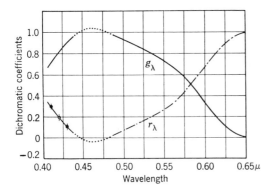

Figure 8.2
Average dichromatic coefficient curves for seven tritanopes. Vertical bars in violet represent average deviations. (From Wright, 1952.)

Chromaticity Confusions

We should probably apply the term color blindness only to cases of total color blindness; it is, strictly speaking, not applicable to other forms of defective color vision. Dichromats have their own color systems, and they should probably be referred to as color confusers. They confuse both (1) pure spectral hues and (2) mixed colors including purples. These colors are specifiable as stimuli for the normal eye by their chromaticity coordinates.

Let it be supposed that some stimuli of specified chromaticities for the normal eye are compared by a dichromatic individual. It will then be found that, when the chromaticities of the various stimuli (as specified for normal individuals) are plotted for the dichromat, the samples that are confused seem to fall on straight lines.

Figure 8.3a presents a diagram to show the theoretical basis for chromaticity relations in the normal eye. Figure 8.3b represents the basis for stimulus confusions in the dichromatic eye on the hypothesis that a dichromatic condition is based on a reduction system.

Let R', G' and V' be the three fundamentals of a trichromatic system positioned in an appropriate chromaticity diagram, in this case the CIE diagram. c_1, c_2, and c_3 are stimuli specified by their CIE chromaticity values. The c stimuli in the CIE chromaticity diagram are at different centers of gravity of the $R'G'V'$ fundamentals in such a manner that c_1, c_2, and c_3 lie on the same straight line passing through V'.

What happens to the positions of c_1, c_2, and c_3 if one of the fundamentals, for example, V', is absent or removed, the situation representing the reduction mechanism present in a tritanope? Under these circumstances, as shown in figure 8.3b, no

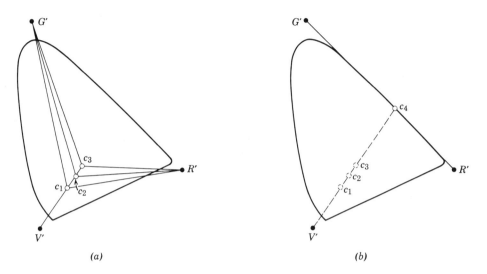

Figure 8.3
(*a*) Diagram of chromaticity relations for trichromatic theory based on fundamentals $R'G'V'$. Specifications of stimuli referred to CIE chromaticity diagram. (*b*) Basis for stimulus confusions when fundamental V' is removed.

effect is exerted by the missing primary V', and c_1, c_2, and c_3 move to position c_4 on the line $G'R'$. For the type of dichromat, a tritanope, represented by this situation, the stimuli c_1, c_2, and c_3 are indistinguishable from c_4, for on moving to $G'R'$ they all lie on the same point; the dichromatic coordinates of all these stimuli are identical.

In a word, all stimuli, specified in chromaticity coordinates, that fall on a straight line (the chromaticity confusion-locus) drawn from the position of the missing fundamental to a point of intersection with the line joining the remaining fundamentals are indistinguishable to a dichromatic eye.

There can be, for a given type of dichromat, many such lines, all emanating, as for example, in figure 8.3a, from V' and intersecting the opposite line $G'R'$ as represented in figure 8.3b; their number is determined by the number of just noticeable steps of wavelength discrimination by the dichromatic subject.

For the normal person, a difference in chromaticnesses represented by two closely adjacent points on the chromaticity diagram is just noticeable when it is equal to the appropriate values given by MacAdam's ellipses; for dichromats a just discriminably different value is much larger. Pitt based his calculations on wavelength discrimination steps $\Delta\lambda$ for the protanope and deuteranope. He divided his diagram into 17 zones for the protanope and 27 for the deuteranope.

The line $G'R'$ in figure 8.3b represents the locus of all mixtures possible, by Grassman's law, for a tritanopic subject. For the case of a reduction system, as in protanopia and tritanopia, the line opposite the missing fundamental is the line of all dichromatic coefficients.

All stimuli on a confusion locus have the same appearance as the stimulus that occurs at the intersection of the confusion locus with the line joining the chromaticity values of the remaining fundamentals.

Conversely, when a tritanopic subject's confusion loci are traced by the experimental determination of stimuli (specified in normal chromaticity coordinates) that are confused, such stimuli should, if the theory is correct, intersect (in the present case) at V' on the chromaticity diagram.

But V' is theoretically the tritanope's missing fundamental. In other instances, protanopia, for example, the confusion loci converge at R'. The point of convergence, wherever it may be, is called the copunctal point. Theoretically it represents the coordinates of the missing color process. The chromaticity value of the copunctal point specifies the chromaticity that would match the chromaticity theoretically given by stimulation of the missing fundamental process.

The linear part (figure 8.4) of the spectrum locus between 550 mμ and the far red is a confusion locus common to protanopes and deuteranopes; it is a zone of single hue for these dichromats. Another confusion locus joins the point W (representing the white light taken as standard) to the neutral point on the spectrum (as shown by the line through N and W in figure 8.4). It is possible by drawing these lines to

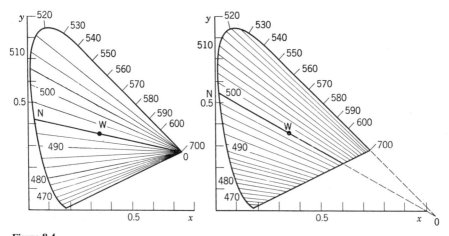

Figure 8.4
Chromaticity confusions of protanopes (*left*) and deuteranopes (*right*). N refers to the neutral point; W to white light; and O the copunctal point. (From Le Grand, 1957; after Pitt, 1935.)

determine the coordinates of the copunctal point and to verify that other confusion loci pass through it. Pitt (1935) calculated from his mixture data (figure 8.1) the purples that matched the monochromatic radiations near 495 mμ and observed that the line thus given was copunctal with the line extended from N to W in figure 8.4 as well as the line from 550 mμ to the extreme red.

The coordinates (in the XYZ system) of Pitt's centres of confusion are, on the average, as follows:

Protanopes $x_p = 0.747$ $y_p = 0.253$

Deuteranopes $x_d = 1.08$ $y_d = -0.08$

Figure 8.4 shows Pitt's confusion loci for protanopes and deuteranopes, determined as described earlier.[1]

The center of confusion for tritanopes lies in the violet end of the spectrum (Wright, 1952), as shown in figure 8.5.

The confusion loci for tritanopes obtained by matching spectral colors and surface colors (Wright, 1952) do not converge sharply to a point. A reconstruction of the confusion loci was made by Thomson and Wright (1953) using another method. Since there is a series of violet-blues which have the same mixture values as a range of yellow-greens (see figure 8.2), they can be joined directly to form the confusion loci, which, for the tritanope, were found to converge at a point having the coordinates: $x = 0.170$, $y = 0.000$.

Farnsworth (1954), using color match data obtained with colored chips based on Munsell color standards, found the copunctal points as follows: protan, $x = 0.460$, $y = 0.280$; deutan, $x = 0.900$, $y = 0.000$; tritan, $x = 0.170$, $y = 0.020$.

The fact that it is possible to specify color confusions of dichromats on the usual chromaticity diagram means that the color vision of dichromats may be thought of as a reduction form of trichromatic vision. This possibility is emphasized by the fact that a color match made by a normal subject is accepted by a dichromat and that matches made by protanomalous and deuteranomalous subjects are also accepted by protanopes and deuteranopes. What remains (Le Grand, 1957) after suppression of a part of the power of color discrimination seems to continue to obey ordinary rules. Deuteranopia is usually considered not to represent a reduction system; rather it is thought of as a transformation system of the Fick-Leber type with possible modifications.

Wavelength Discrimination

Dichromatic wavelength discrimination is considerably poorer than it is for normal subjects. The dichromat requires a just discriminable wavelength difference that is

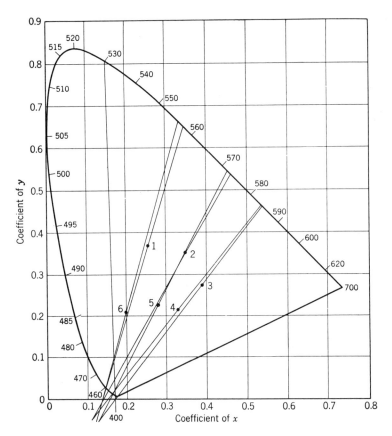

Figure 8.5
The average confusion loci for five tritanopes on the CIE chromaticity chart. (From Wright, 1952.)

often ten or more times as great as the corresponding $\Delta\lambda$ for a trichromat. It is only in a small region in the spectrum near the neutral point that discrimination approaches a normal value.

Wavelength discrimination curves for the protanope and the deuteranope have a single minimum around 500 mμ. $\Delta\lambda$ increases rapidly on both sides of this region.

At the extreme ends of the spectrum, wavelength discrimination is indeterminate. The characteristic U-shape implied by this description is found in the experiments of Brodhun (1887; also see König, 1903). This type of result has been confirmed by Steindler (1906), Laurens and Hamilton (1923), Rosencrantz (1926), Sachs (1928), Ladekarl (1934), Hecht and Shlaer (1934), Pitt (1935), and Kato and Tabata (1957).

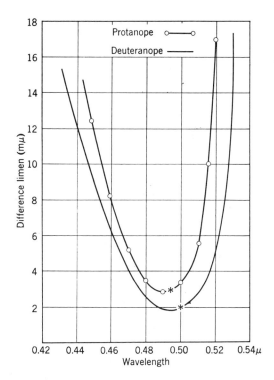

Figure 8.6
Mean wavelength discrimination curves for six protanopes and six deuteranopes. (Mean position of neutral points marked with asterisks.) (From Pitt, 1935.)

Figure 8.6 reproduces Pitt's average curves of wavelength discrimination for six protanopes and six deuteranopes. It can be seen that the two curves are similar in shape. Data of individuals in the two groups show considerable overlap. It seems that wavelength discrimination data do not provide a dependable basis for distinguishing protanopia from deuteranopia.

It is interesting to note in figure 8.6 that the neutral point in each curve falls near the minimum but not exactly on it. Neutral point position, of course, depends on the color temperature of the white standard used. Pitt used Illuminant B. This white (color temperature about 4800°K) is slightly yellowish in comparison with other whites of higher color temperatures. Perhaps the divergence between the position of the minimum and the neutral point is attributable to the character of the testing white. The neutral point may, in fact, be the minimum of the wavelength discrimination curve under certain test conditions.

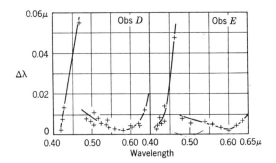

Figure 8.7
Wavelength discrimination curves for two tritanopes. (From Wright, 1952.)

Some of Steindler's (1906) wavelength discrimination curves for dichromats showed secondary minima in the long wavelength end and perhaps also in the short wavelength end. She theorized that these secondary minima were real effects. On the other hand, they may be interpreted to mean that these subjects might not be true dichromats. Hecht and Shlaer's (1936) wavelength discrimination curves for the protanope and deuteranope, like those of Pitt, have a single minimum that is drawn out to cover a long range of the spectrum; the minimum is not so sharp as Pitt's. This result is perhaps a consequence of using a continuous step-by-step method in the determination of $\Delta\lambda$.

Wright (1952) obtained wavelength discrimination curves from a number of tritanopes; two are reproduced in figure 8.7. Like other dichromats, the tritanope has a minimum in his wavelength discrimination curve near the location of his neutral point, that is, in the yellow region, but he may also have a second minimum in the violet region, where some workers have suspected a secondary neutral point (see Göthlin, 1943).

Luminosity Function

Since dichromats confuse colors that the normal eye can discriminate, the question arises: Do certain portions of their spectrum appear darker or brighter than they do to the normal eye? Seebeck (1837) found two kinds of luminosity curves among color blinds. Helmholtz (1911, 1924) theorized that the red should appear darkened for the red blind, as indeed it does. This darkening, sometimes called shortening of the red end of the spectrum, was demonstrated by Macé and Nicati (1879), von Kries and Küster (1879), and Donders (1881) for photopic vision. It was also found that the maximum of the protanopic luminosity curve is shifted (as compared with its position in trichromatic vision) toward the short-wave end of the spectrum, whereas that

of the deuteranope seems to remain at the position of the trichromat or possibly slightly shifted toward the long-wave end. This result was supported by Brodhun (1887), König (1903), Abney (1913), Exner (1921), Kohlrausch (1931), Pitt (1935), and Hecht and Shlaer (1936).

The term "shortening of the red end" of the spectrum is poor usage. It can be misinterpreted to mean that the protanope cannot see the red end at all. The truth is that the protanope does see the red end of the spectrum if enough energy is provided above that required by a trichromat.

Early measurements of luminosity curves failed to present results based on an equal energy spectrum. In consequence, the spectral energy distribution in a given experiment varied with the light source used; hence the spectral positions of maxima in normal and dichromatic curves are not directly comparable for different authors. Hecht and Shlaer did measure spectral energies and used an equal energy spectrum. Pitt also made computations for an equal energy spectrum. The two latter sets of data are similar. Since Pitt used more subjects, we reproduce his data in figure 8.8. The curves for dichromats were plotted by Pitt in comparison with the curve of one typical normal observer.

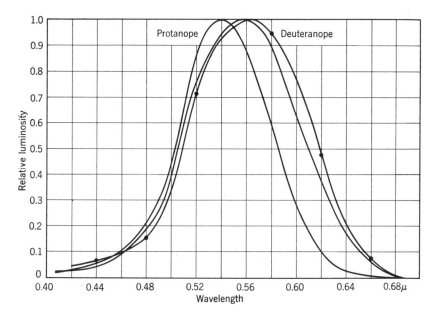

Figure 8.8
Mean luminosity curves (equal energy spectrum) for six protanopes and six deuteranopes. Normal curve for one observer represented in middle. Equal energy spectrum. (From Pitt, 1935.)

A predominance of recent evidence shows that a loss of deuteranopic luminosity occurs in the green and blue regions of the spectrum with no gain elsewhere. Some researchers have, however, reported a gain in deuteranopic luminosity without any loss (Heath, 1958). Others have suggested that there are two types of deuteranopes, one who shows loss and another who does not (Willmer, 1955). [...]

Cron (1959) measured the green : red ratio (i.e., ratio of luminosity at 530 mμ to luminosity at 650 mμ) of a large number of color-blind and normal subjects. He hypothesized that the protans might show a large ratio because of deficiency in the red, whereas the deutans would show a small ratio. His measurements did demonstrate three groups; the distribution for the normals appeared between that for the protans and that for the deutans. Each distribution seemed to have its own peak, although the deutan and normal distributions overlapped.

The average tritanopic luminosity curve falls slightly below the normal over the short-wave end of the spectrum, as can be seen in the data provided by Wright (1952). Wright did not interpret this decrease as a significant loss, while others (Farnsworth, 1955; Fischer, Bouman and Doesschate, 1951) considered it to be a tritanopic loss of luminosity. Sperling (1960) thought that the case he examined represented a luminosity curve within the normal range.

Spectral Saturation

[...] For the trichromat the least saturated part of the spectrum is in the yellow; saturation increases as one approaches the two ends of the spectrum.

What is the spectral saturation function of the dichromat?

One way to answer this question is to mix white of different luminances L_w with luminances L_p of the long-wave primary so as to match the saturation of test wavelengths in the spectral range above the neutral point. One then plots the ratio L_p/L_w that matches in saturation the test wavelengths in the spectrum above the neutral point. The same procedure is followed with L_p', the luminance of the short-wave primary. Values of L_p'/L_w that match, in saturation, wavelengths below the neutral point are also determined (von Kries and Küster, 1874; Hecht and Shlaer, 1936). It is possible to make these matches in the two parts of the spectrum because of the fact that dichromats see only a single hue above the neutral point and another one below it.

An inverse estimate of spectral saturation in the trichromat, who has no neutral point, consists in determining colorimetric purity. $(L_w + L_\lambda)/L_\lambda$ is taken to be the saturation index. Its reciprocal is colorimetric purity.

Chapanis (1944) measured the colorimetric purity of some protanopes and deuteranopes. His curves are reproduced in figure 8.9. Each curve comprises two

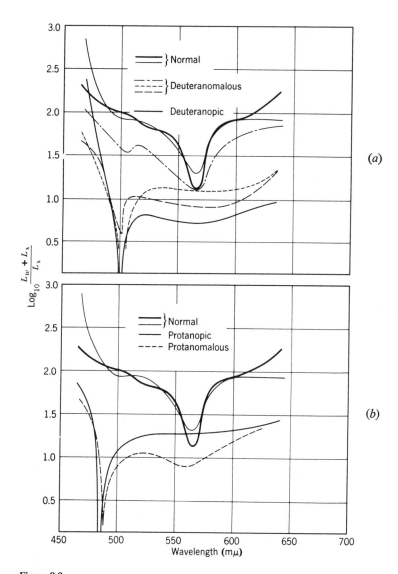

Figure 8.9
(a) Saturation thresholds for two normal, three deuteranomalous, and one deuteranopic observers. (From Chapanis, 1944.) (b) Saturation thresholds for two normal, one protanomalous, and one protanopic observers. (From Chapanis, 1944.)

branches in such a way as to indicate that saturation increases from the neutral point toward the two ends of the spectrum.

No one has yet obtained the saturation curve of a tritanope.

Monochromatism

A monochromat is a person who can match the spectrum with any chosen wavelength provided he is allowed to adjust luminances. Two types exist—rod-monochromats and cone-monochromats. A rod-monochromat is said to have no normal cones in his retina; he possesses only rods. However, it is sometimes supposed that he may have some special cones which may act like rods. The cone-monochromat is supposed to have, besides rods, only one particular kind of cone, not three as the trichromat may have. In neither type of monochromat is there any evidence for wavelength discrimination; the rod-monochromat sees all wavelengths as gray, whereas the cone-monochromat sees them presumably as one hue. There is no evidence for color mixture, not only in the case of the rod-monochromat but also, probably, in the case of the cone-monochromat, who may see color but not mixtures of colors. Luminosity functions, however, are different in the two types. In the rod-monochromat the photopic curve is like the normal scotopic curve. In the cone monochromat the scotopic curve is normal, but the photopic curve may have a maximum at a spectral position between a normal subject's photopic and scotopic peaks. It may also have a maximum, for example, around 440 mμ as in some of Blackwell and Blackwell's (1954, 1961) subjects.

Rod-monochromats, sometimes called totally color-blind persons, are also called achromats, for they do not see color. Other characteristics apply to them. For example, they are photophobic, that is, they wince or blink in the presence of high luminances. They show nystagmus. Their visual acuity is low. All these characteristics are consistent with the assumption that they possess only rods and, possibly, other elements that act like rods, receptors that function at ordinary luminances. If, in fact, there be such receptors, their resolving power must be lower than that of the cones possessed by normal persons.

The characteristics of rod-monochromats or typical achromats were well known at the beginning of this century. Nagel (1911), for example, wrote about them and their bearing on the Duplicity theory.

Hillebrand (1889) was the first to discover the similarity between the photopic luminosity curve of the typical achromat and the scotopic curve of the normal person. His observation was confirmed by König and Dieterici (1892), von Kries (1897), May (1907), and others.

Sloan (1954), studied some cases of typical achromatopsia who showed a luminosity function having a maximum near 500 mμ, as in the case of the scotopic curve of normal subjects. For further analysis, she also measured their dark adaptation in the fovea. In contrast to the normal foveal dark adaptation curve, which shows a single curve dropping to a high plateau, the achromatopic foveal curve showed two branches, an early one and a later one, similar to a dark adaptation curve determined in the periphery of the normal eye. The initial threshold for the achromat is above normal, but a few minutes later in the process it starts to fall and eventually drops below normal values. Sloan concluded that two types of receptors must be functioning—one, the normal rods, and two, cones that have turned into "photopic rods." Photopic rods may have light sensitivity different from ordinary rods but do not have the color sensitivity of cones. Such elements were considered to be "black and white" cones by Hess and Hering (1898) or "day" rods by König (1894). (See Walls and Heath, 1954.)

Cone-monochromats are rare and cannot properly be called true achromats. They sometimes are called atypical achromats. Secondary symptoms, such as nystagmus and low acuity, are absent in cone-monochromats, Pitt (1944) found a case who had no color discrimination but whose luminosity curve had a maximum at 545 mμ and whose dark adaptation and visual acuity were normal. He exhibited no symptoms of photophobia or nystagmus. Pitt believed that this subject possessed the green receptor.

Weale (1953) made a nationwide search in England for cone-monochromats. He was able to bring three of them into the laboratory for detailed study. He found their luminosity maxima at photopic level to be at about 545 mμ; the curves exhibited a narrowing of the long-wave end of the spectrum. On considering the shape of these curves and the absorption spectra of visual pigments, he concluded that the curves did not represent the green receptor. He suggested that the color defects might be located in the post-receptor structures.

Blackwell and Blackwell (1957, 1961) reported several cases of blue cone-monochromats whose luminosity maxima occurred near 440 mμ at high luminance levels. The authors suggested that the subjects possessed one type of cone, the blue receptor, in addition to rods. Both rod and cone functions appeared in acuity and dark adaptation measurements. The subjects exhibited no nystagmus.

Anomalous Trichromatism

Anomalous trichromats are persons who require, as do normal subjects, three primaries plus the spectral sample in the dyad of pairs that give a colorimetric match.

Such a match is made, however, with different proportions of primaries as compared with that of the normal trichromat. Dichromats will accept matches made by the normal trichromat, but the anomalous trichromat will not accept normal matches. These facts were described by von Kries (1911, 1924). According to him, König was the first to use the expression *anomalous trichromatic system*, which he considered to be an alteration system in contrast with the reduction system that may hold in the case of dichromats, and Nagel (1911, 1924) created the terms *protanomalous* and *deuteranomalous*. In many respects the anomals are similar to their associated dichromats, especially in the color confusions that appear in diminished degree in anomalous cases. Theoretically the quality of colors seen by anomalous trichromats is due to the fact that one or more types of their color receptors do not have as great sensitivity as those in the normal eye. As a group, the anomalous cases show great heterogeneity.

Anomalous trichromats are sometimes considered to be cases that link dichromats and normal trichromats (see Wright, 1947); they are thought of as less severe cases of color deficiency. Anomaly is, therefore, sometimes called color weakness. Some workers, however, consider it to be relatively unrelated to the other groups. Pickford (1951, p. 47), for example, stated that: "The so-called anomalous trichromats are not intermediates between the color blind and the normal." He based his conclusion mainly on the noncontinuity of the statistical distributions of these groups.

Rayleigh (1881), was the first to pay special attention to anomalous cases. He found that they used proportions of red and green which do not fall within the limits of a normal subject's variation on the anomaloscope.

The luminosity curve of the protanomalous subject is similar to that of the protanope. The two types cannot be differentiated (McKeon and Wright, 1940) on this basis. Chapanis and Halsey (1953) did obtain a continuous frequency distribution of protans, deutans, and normals, but, with the deutans excluded, the normals and protans become separate groups. With a limited number of subjects, Collins (1959) found deuteranomalous luminosity to lie between normal and deuteranopic luminosities, but the author did not believe the result to be statistically significant.

The wavelength discrimination curves for the protanomalous (McKeon and Wright, 1940) and the deuteranomalous (Nelson, 1938) do not have single minima like those of comparable dichromats; they may have two or more minima. Although these curves can be so arranged as to indicate bridging gradations between the trichromat and the various dichromats, we lack a strong external criterion for establishing the nature of such gradations.

Heredity

Color blindness may be congenital or acquired through injury or disease. The word "congenital" was traditionally used to mean that the defect is inborn and is free from detectable pathological conditions. It suggested that the defect was probably inherited but did not necessarily make such a commitment. Now that the geneticist has carefully ascertained the general nature of inheritance, at least for protanopia and deuteranopia, many workers may prefer the word "hereditary" rather than "congenital." In any case it is to be remembered that the mechanisms of heredity for color blindness are not fully worked out; some forms of color blindness have been shown to be definitely hereditary, whereas others less frequently encountered have not as yet had their genetic basis fully accounted for. In general, it may be appropriate to call specific cases congenital so long as no history of pathology exists.

Protan-Deutan Defects

Geneticists now agree that protan and deutan types of defect are inherited as sex-linked Mendelian recessive characteristics. (It will be recalled that, according to Farnsworth's classification, these defects include protanopia and protanomaly under the classification protan and deuteranopia and deuteranomaly under the classification deutan.)

The influence of heredity in relation to color blindness was suspected long before Mendel's time, especially on the strength of the record of the Scott (1779) family tree (see Cole, 1919) in which three successive generations were identified as having red-green abnormalities. However, it was Wilson (1911) who correlated the facts long known about the transmission of color blindness with the newer discoveries about genes and sex-linkage.

The sex chromosome pair comprises one of the 23 pairs of chromosomes that the human being normally possesses. In the female, the two sex chromosomes, known as XX, are structurally similar. The male, with only one X, has a Y chromosome that is about one-fifth the length of the X. Much of the genetic material contained in the X chromosome is, therefore, not present in the Y. Most sex-linked genes are carried on the X but not the Y chromosome; males are called hemizygotes for such genes.

According to Wilson (1911) and later investigators, the gene influencing color vision is carried in the X chromosome. In its normal form, the gene leads to normal color vision, while its alleles (i.e., the alternative forms of the gene) may produce defective color vision. The defective alleles are recessive to the normal form. Therefore, a recessive allele is one that ordinarily expresses its phenotypic effects only in

a homozygote, that is, in an individual who carries the recessive in both members of the X chromosome pair. Thus, if a female is to be color blind, she must receive the defective recessive allele in the X chromosome from each of her parents. Her daughter, to whom she transmits the defective allele, will be a heterozygote if the allele received in the X chromosome from the father is normal. Heterozygotes (the bearers of dissimilar alleles of a given gene) show the phenotypic expression of the dominant allele, in this case normal color vision. Such women are phenotypically normal, that is, their visual functions are normal in appropriate color-vision tests, but they are genotypic carriers who may transmit the defective allele to their children. All the sons of the homozygous female and, on the average, one-half the sons of the heterozygous female, receive an allele for color defect in their X chromosome. Since a sex-linked gene is carried in single dosage in the male, the recessive form shows its full effect in the phenotype. If a male's X chromosome carries a defective color-vision allele, he is then color blind.

Figure 8.10 illustrates the inheritance of red-green color blindness as a sex-linked recessive characteristic according to Mendel's law of segregation.

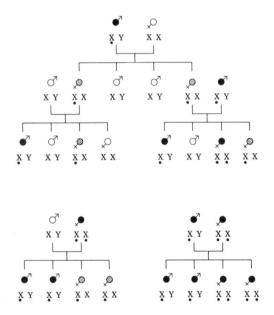

Figure 8.10
Hypothetical patterns of sex-linked inheritance of protan and deutan defectives. Dot under X indicates recessive defective gene. Filled circles represent color-blind individuals, hatched circles, carriers, and open circles, color-normal individuals.

Table 8.2
Percentages of protans and deutans in various populations as reported by different investigators

	Waaler (1927)	von Planta (1928)	Schmidt (1936)	François, Verriest, Mortier, and Vanderdonck (1957)	Kherumian and Pickford (1959)
			Population		
	Norwegians	Swiss	Germans	Belgians	French
Males	9049	2000	6863	1243	6635
Females	9072	3000	5604	None	6990
Protanope	0.88	1.60	1.09	0.97	2.62
Protanomalous	1.04	0.60	0.68	1.05	
Deuteranope	1.03	1.50	1.97	1.37	6.33
Deuteranomalous	5.06	4.25	4.01	4.91	
Male total (observed)	8.01	7.95	7.75	8.30	8.95
Female total (observed)	0.40	0.43	0.36	—	0.50
Female total calculated on male total	0.64	0.63	0.60	—	0.80
Female total* calculated on basis of male protans and deutans	0.41	0.38	0.39	—	0.47

* We are indebted to Dr. Loise F. Erlenmeyer-Kimling, Department of Medical Genetics, New York State Psychiatric Institute, for aid in these computations and related matters.

The sons of a color-blind man and a color-normal woman will not be color blind nor will they transmit the defect, but the daughters, as carriers of the recessive allele, may have color-blind sons. Sex-linkage accounts for the fact that there are more color-blind males than females. With no selective mating for color blindness, and on the assumption of no detrimental effects with respect to survival or fertility, the proportion of color-blind females in a population is generally estimated to be the square of the proportion of color-blind males. For a population in which 8% of the males are color blind, 0.64% of the females would then be expected to show the defect (Gray, 1943). However, it will be noted in table 8.2, which presents actual incidences in various populations, that a better fit to the observed frequencies for females is obtained (lowest row) by calculating the protan and deutan frequencies separately (Waaler, 1927). In a population at genetic equilibrium, the proportions should remain constant from generation to generation.

Kherumian and Pickford (1959) report on the incidence of color blindness in various populations and show a lower frequency among Negro and Indian males (2 to 4%) than among white males. Five Chinese studies listed in Kherumian and Pickford give a range of 4.97 to 6.87% occurrence among Chinese males and 0.71 to 1.68% among Chinese females.

It is also interesting to note that the Japanese census (1960) recorded the following data on the incidence of color blindness in Japanese schoolchildren who were universally required to take the Ishihara test: elementary school males, 2.9%, females, 0.3%; junior secondary school males, 3.9%, females, 0.4%; senior secondary school males, 3.8%, females, 0.2%; college and university males, 3.6%, females, 0.2%. These frequencies are, of course, much lower than those generally reported for white populations, especially white males.

Some recent data on populations of immigrants to Israel, obtained by Kalmus, Amir, Levine, Barak, and Goldschmidt (1961) and summarized by Goldschmidt (1963) list a range of deutan-protan totals as percentages of each parent population. The percentages vary from 3.9 to 10.1 in 11 groups with different origins. Deutan/protan ratios vary in the same groups over a range from 1.1 to 3.7.

Post (1962) has compiled the most elaborate evidence on protan-deutan frequencies established in more than 70 studies.

A female may inherit two different defective genes from her parents and still manifest normal color vision. As a carrier she may have both protan and deutan sons. This consideration leads to the theory that the protan and deutan alleles are at different loci on the X chromosome (Waaler, 1927; Brunner, 1930; Göthlin, 1924; Walls and Mathews, 1952). Other authors (e.g., Stern, 1958) are dubious about the two-locus theory. In either case, it is generally considered that protanomaly is dominant over protanopia, and deuteranomaly is dominant over deuteranopia.

Crone (1959) demonstrated not only that the protans, deutans, and the normals form different groups on the basis of the luminosity ratio $V_{530\,m\mu}/V_{650\,m\mu}$ but also that the heterozygotic mothers of these color-blind individuals distinguished themselves from the normals in the same fashion but in smaller degree. The pseudonormal nature of the carriers had long been suspected by Waaler (1927), Wieland (1933), Schmidt (1934), Brunner (1930), and Pickford (1951).

Tritan Defects

Pedigrees of tritans (tritanopes and tritanomals) are incomplete at best; hence a genetic theory is difficult to formulate. Walls and Mathews (1952) think the gene may be carried on a third locus of the X chromosome. Kalmus (1955) believes that tritanopia may be due to a dominant autosomal gene (one carried on a chromosome

other than a sex chromosome), whereas tritanomaly is associated with a sex-linked recessive gene. The fact that the frequency of female tritans as a percentage of the total of tritan males and females is higher than that of female protans and deutans to their totals suggests that the mechanisms of inheritance may be different in the respective cases.

Monochromatism

Typical achromatopsia (or rod-monochromatism) is generally agreed to be a simple autosomal recessive character. Evidence for this is drawn essentially from the fact that the incidence of rod-monochromatism is almost the same in both sexes, thus ruling out the likelihood of sex-linkage. Of course, it has not yet been possible to specify which of the 22 autosomal pairs carries the gene or genes involved in this defect. On the other hand, there are pedigrees showing only male members affected (Sloan, 1954; Blackwell and Blackwell, 1961; Goodman, Ripps and Siegel, 1963) which suggests that in some families at least a sex-linked pattern is present.

There is evidence to indicate a possible relationship between monochromatism and consanguinity. Hessberg (1909) described a woman who married twice; the first time to a cousin by whom she had one normal and three rod-monochromatic children; the second time to an unrelated man, by whom she had three children with normal vision. Lundborg (1913) showed the statistical relation of consanguinity to monochromatism.

Although cone-monochromatism (atypical achromatopsia) may not be a heritable condition (Weale, 1953), Blackwell and Blackwell (1961) studied three brothers all of whom were blue cone-monochromats.

Unilaterally Color-Blind Persons

Unilaterally color-blind persons are rare individuals, one of whose eyes is color defective while the other is color normal. These defects may be either congenital or acquired. The congenital cases are probably inherited.

The main value of studying such cases lies in the fact that they, and they alone, can compare what is seen by a color-blind individual with what is seen by a normal person.

Unfortunately, in most of these cases the normality of the trichromatic eye is not clearly established. In addition, the precise specification of the type of deficiency encountered in the color-blind eye has in most cases been open to doubt due to a lack of application of standardized and appropriate tests, particularly in the cases observed before about 1930. The fact that most subjects in early studies had to be examined under pressure of practical circumstances means that repeated observations, involving precise instrumentation, could not usually be made.

Judd (1948) states that 37 cases of unilateral color blindness have been reported. Because of inadequate procedure or lack of background information characterizing most cases, only about 8 of these have proved useful for theory. The most recent research reported by Judd is the experiment by Sloan and Wollach (1948). [...] Graham, Hsia, et al. (1957) studied the normal and dichromatic eyes of a unilaterally color-blind woman. The reader is referred to that study for a consideration of theoretical and experimental aspects of this type of study.

As to the mode of inheritance of color blindness in unilateral cases, little is known at present. It can only be said that some of the cases may have relatives who are bilaterally color blind. For further detailed discussion of this topic see Hirsch and Erlenmeyer-Kimling (1964).

Acquired Color Blindness

Many of the facts and theories of color blindness due to acquired factors have been discussed by François and Verriest (1961). A good deal of information has been summarized earlier and classified by Koellner (1929) and by Hembold (1932).

Acquired color blindness may be due to any factors that cause pathological changes in the visual system, such as chemical poisoning, physiological imbalances, and injuries.

Some of the differences between acquired and the usual congenital forms of color blindness have been summarized by François and Verriest. Among the main differences is the fact that acquired defect can progress or retrogress as long as the pathology changes. The defect can differ in severity in different parts of the affected eye and may seem to change in extent when the intensity or size of the stimulus is increased. Contrast effects, except certain aspects of color contrast, are usually reduced in subjects with acquired defects.

The defect, as examined by such devices as the Farnsworth tests, usually seems to simulate one of the usual congenital forms. It is probable, however, that the simulation does not extend to all of the functions that may be tested in the eye of the acquired color-blind subject. For example, Graham, Hsia, and Stephan (1963) obtained seemingly typical tritanopic results on (1) the Farnsworth D-15 test, (2) determination of the neutral point (about 570 mμ), (3) the binocular matching of colors seen in the tritanopic and normal eyes, and (4) the copunctal point, which was found to be near the violet end of the spectrum. However, the luminosity function was different from that found with the usual tritanope; it appeared with depressed values in the middle of the spectrum.

François and Verriest believe that acquired forms of color blindness can proceed from normal trichromatism toward the dichromatic state and can progress farther to a monochromatic state before complete blindness may ensue. As soon as the acquired condition has become dichromatic, the acquired defect usually closely resembles a congenital dichromatism. If, however, concomitant impairment may occur with the acquired condition, the acquired defect resembles a color abnormality and later simulates a kind of atypical congenital form of total color blindness. Hong (1957) feels that acquired forms are not comparable with those of the congenital type.

In general, it seems that the Farnsworth D-15 and 100-Hue tests are the most useful for testing acquired color blindness. Other tests such as the Hardy-Rand-Rittler are also important as, in some cases, is also the anomaloscope. The Farnsworth tests owe their value to the fact that they can be used in cases of reduced visual acuity.

Clinical data seem to indicate (Koellner, 1929; François and Verriest, 1961; Cox, 1960; Hong, 1957) that lesions of the ganglion layers and the optic nerve cause red-green deficiencies, whereas those in the receptor and other plexiform layers cause blue-yellow deficiencies. However, exceptions to this rule have been observed (Franceschetti; Klein and Wardenburg, 1963).

Acknowledgments

Prepared under a contract between Columbia University and the Office of Naval Research.

Note

1. Pitt's original protanopic and deuteranopic confusion charts were made in terms of the W. D. Wright system. Judd (1943) transformed them to the CIE system.

References

Abney, W. *Researches in colour vision and the trichromatic theory*. London: Longmans, Green, 1913, pp. 418.

Adam, A. Linkage between enzyme deficiency of erythrocyte and colour blindness. *Second Internat. Conference in Human Genetics*. Rome: Excerpta Medica Foundation, 1961. E53–E54.

Blackwell, H. R. and O. M. Blackwell. Blue monocone monochromacy, a new color vision defect. *J. opt. Soc. Amer.*, 1957, **47**, 338.

Blackwell, H. R. and O. M. Blackwell. Rod and cone receptor mechanisms in typical and atypical congenital achromatopsia. *Vision Res.*, 1961, **1**, 62–107.

Brodhun, E. *Beiträge zur Farbenlehre*, Dissertation, Berlin. 1887, pp. 42.

Brunner, W. Ueber den Vererbungsmodus der verschiedenen Typen der angeborenen Rotgrünblindheit. *Arch. Ophth.*, 1930, **124**, 1–52.

Chapanis, A. and R. M. Halsey. Photopic threshold for red light in an unselected sample of color deficient individuals. *J. opt. Soc. Amer.*, 1953, **43**, 62–63.

Chapanis, A. Spectral saturation and its relation to color-vision defects. *J. exp. Psychol.*, 1944, **34**, 24–44.

Cole, L. J. An early family history of colour blindness. *J. Heredity*, 1919, **10**, 372–374.

Collins, W. E. The effects of deuteranomaly and deuteranopia upon the foveal luminosity curve. *J. of Psychol.*, 1959, **48**, 285–297.

Cox, J. Colour vision defects acquired in diseases of the eye. *Brit. J. Physiol. Optics*, 1960, **17**, 195–216.

Crone, R. A. Spectral sensitivity in color-defective subjects and heterozygous carriers. *Amer. J. Ophthal.*, 1959, **48**, 231–238.

Donders, F. C. Ueber Farbensysteme. *Arch. Ophthal.*, Berlin, 1881, **27**, (1), 155–223.

Dvorine, I. *Dvorine Pseudo-Isochromatic Plates.* 2nd ed. Baltimore: Waverly Press 1953.

Exner, F. Helligskeitsbestimmungen im protanopen Farbensystem. *Sitz. Wien. Akad. Wiss.*, 1921, Abt. IIa, **130**, 355–361.

Farnsworth, D. An introduction to the principles of color deficiency. *Med. Res. Lab. Reports*, U.S. Navy, New London, 1954, **13**, No. 15, 1–15.

Farnsworth, D. Farnsworth-Munsell 100-hue and dichotomous test for color vision. *J. opt. Soc. Amer.*, 1943, **33**, 568–578.

Farnsworth, D. Tritanomalous vision as a threshold function. *Die Farbe*, 1955, **4**, 185–196.

Fischer, F. P., M. A. Bouman, and J. ten Doesschate. A case of tritanopy. *Docum. Ophthal.*, 1951, **5–6**, 73–87.

Franceschetti, A., D. Klein, and P. S. Wardenburg. *Genetics and ophthalmology.* Oxford: Blackwell Sci. Publications, 1963.

François, J., G. Verriest, V. Mortier, and R. Vanderdonck. De la fréquence de dyschromatopsies congénitales chez l'homme. *Annals d'Oculistique*, 1957, **189**, 5–16.

François, J. and G. Verriest. On acquired deficiency of color vision. *Vision Res.*, 1961, **1**, 201–219.

Goodman, G., H. Ripps, and I. M. Siegel. Cone dysfunction syndromes. *Arch. Ophthal.* (Chicago), 1963, **70**, 214–231.

Goldschmidt, E. (Ed.). *The genetics of migrant and isolate populations.* pp. 280–281. New York: Williams and Wilkins, 1963.

Göthlin, G. F. Congenital red-green abnormality in colour-vision, and congenital total colour-blindness, from the point of view of heredity. *Acta Ophthal.*, 1924, **21**, 15–34.

Göthlin, G. F. The fundamental colour sensation in man's colour sense. *Kungl. Svenska Vetensk. Handl.*, 1943, **20(7)**, 1–76.

Graham, C. H., H. G. Sperling, Y. Hsia, and A. H. Coulson. The determination of some visual functions of a unilaterally color-blind subject: Methods and results. *J. of Psychol.*, 1961, **51**, 3–32.

Graham, C. H., Y. Hsia, and F. F. Stephan. Visual discriminations of a subject with acquired unilateral tritanopia. *Science*, 1963, **140**, 381–382.

Gray, R. C. Incidence of green-red blindness. *Arch. Ophthal.*, 1943, **29**, 446–448.

Hardy, L. H., G. Rand, and J. M. C. Rittler. *H-R-R Pseudoisochromatic Plates.* Amer. opt. Co., 1955.

Heath, G. G. Luminosity curves of normal and dichromatic observers. *Science*, 1958, **128**, 775–776.

Hecht, S. and S. Shlaer. The color vision of dichromats. *J. gen. Physiol.*, 1936, **20**, 57–93.

Helmholtz, H. L. F. von. *Handbuch der physiologischen Optik.* 1st ed. Hamburg and Leipzig: Voss, 1866.

Helmholtz, H. L. F. von. *Handbuch der physiologischen Optik.* 3rd ed. W. Nagel, A. Gullstrand, and J. von Kries (eds.). Hamburg and Leipzig, Voss, 1909–1911. 3 vols.

Helmholtz, H. L. F. von. *Treatise on physiological optics.*, J. P. C. Southall (Trans), Rochester, N.Y.: Opt. Soc. Amer., 1924–25. 3 vols.

Hembold, E. *Kurzes Handbuch der Ophthalmologie*, 1932, **2**, 320–331.

Hertel, E. (Ed.). *Stillings Pseudo-Isochromatische Tafeln.* 19 aufg., Leipzig: Georg Thieme, 1936.

Hess, C. and E. Hering. Untersuchungen an totale Farbenblinden. *Arch. ges. Physiol.*, 1898, **1**, 105–127.

Hessberg, R. Ein Beitrag zur angeborenen totaler Farbenblindheit. *Klin. Monatsbl. Augenheilk.*, 1909, **47**, 129–138.

Hillebrand, F. Über die specifische Helligkeit der Farben. (mit Vorbemerkungen von E. Hering.) *Sitz. Wiener. Akad. Wiss.*, 1889, Abt. III, **98**, 70–120.

Hirsch, J. and Erlenmeyer-Kimling, L. Review of behavior genetics. In *Advances in genetics* (E. Caspari, Ed.). New York: Academic Press, 1964.

Hong, S. Types of acquired color vision defects. *Arch. Ophthal.*, 1957, **58**, 505–509.

Ishihara, S. *Tests for color-blindness.* 11th ed. Tokyo: Kanehara Shuppan, 1954.

Japan Statistical Yearbook. School sanitation rate of persons affected by diseases of physical anomalies. Tokyo: Population Census Bureau, 1960, Section 288.

Judd, D. B. Facts of color-blindness. *J. opt. Soc. Amer.*, 1943, **33**, 294–307.

Judd, D. B. Standard response functions for protanopic and deuteranopic vision. *J. Res. Nat. Bur. Standards*, 1944, **33**, 407–437.

Judd, D. B. Color perceptions of deuteranopic and protanopic observers. *J. Res. Nat. Bur. Standards*, 1948, **41**, 247–271.

Kalmus, H. The familial distribution of tritanopia with some remarks on similar conditions. *Ann. Human Genetics*, 1955, **20(1)**, 39–56.

Kalmus, H., A. Amir, O. Levine, E. Barak, and E. Goldschmidt. The frequency of inherited defects of colour vision in some Israeli populations. *Ann. Human Genetics*, London, 1961, **25**, 51–55.

Kato, K. and S. Tabata. The hue discrimination of normal and color defective subjects. *Acta Soc. Ophthal.* (Japan), 1957, **61**, 1647–1655.

Kherumian, R. and R. W. Pickford. *Hérédité et fréquence des anomalies congénitales du sens chromatique.* (Dyschromatopsies.) Paris: Vigot Frères, 1959, pp. 111.

Koellner, H. Die Abweichungen des Farbensinnes (mit Nachträgen ab 1924 von E. Engelking). *Handbuch der normalen und pathologischen Physiologie.* Berlin: Springer, 1929, **12(1)**, 502–535.

Kohlrausch, A. Tagessehen, Dammersehen, Adaptation. In Bethe, A., G. von Bergmann, G. Embden, A. Ellinger (Ed.) *Handbuch der normalen und pathologischen Physiologie.* Berlin: Springer, 1931, **12(2)**, 1499–1594.

König, A. Ueber "Blaublindheit." *Sitz. Akad. Wiss.* (Berlin), 1897, 718–731.

König, A. Ueber den menschlichen Sehpurpur und seine Bedeutung für das Sehen. *Sitz. Akad. Wiss.* (Berlin), 1894, 577–598.

König, A. Ueber die neuere Entwickelung von Thomas Young's Farbentheorie. Reprinted in *Gesammelte Abhandlungen zur physiologischen Optik*, Leipzig: J. H. Barth, 1903, 88–107.

König, A. Zur Kenntniss dichromatischer Farbensysteme. *Ann. Physik Chemie*, 1884, **22**, 567–578.

König, A. and C. Dieterici. Die Grundempfindungen in normalen und anomalen Farbensystemen und ihre Intensitätsverteilung im Spectrum. *Z. Psychol. Physiol. Sinnesorg.*, 1892, **4**, 241–347.

Kries, J. von. Normal and Anomalous Color Systems. In: Helmholtz, H. L. F. von, *Handbuch der physiologischen Optik.* 3rd ed., 1909–1911; *Treatise on physiological optics*, English translation by Southall (1924), Vol. II, 395–421.

Kries, J. von. Über Farbensysteme. *Z. Psychol. Physiol. Sinnesorg*, 1897, **13**, 241–324.

Kries, J. von and F. Küster. Ueber angeborene Farbenblindheit. *Arch. Physiol.*, 1879, 513–524.

Kries, J. von and W. A. Nagel. Über den Einflufs von Lichtstarke und Adaptation auf Sehen des Dichromaten (Grunblinden). *Z. Psychol. Physiol. Sinnesorg.*, 1896, **12**, 1–38.

Ladekarl, P. M. Über Farbendistinktion bei Normalen und Farbenblinden. *Acta Ophthal.* (Copenhagen), 1934, **12**, Suppl. III, pp. 128.

Laurens, H. and W. F. Hamilton. The sensitivity of the eye to differences in wavelength. *Amer. J. Physiol.*, 1923, **65**, 547–567.

Le Grand, Y. *Light, colour and vision* (R. W. G. Hunt, J. W. T. Walsh, and F. R. W. Hunt, trans.). New York: Wiley, 1957.

Lundborg, H. *Medizinisch-biologische Familiensforschungen in Schweden*. Jena. 1913, p. 420.

Macé, J. and W. Nicati. Recherches sur le daltonisme. *Comp. rend. Acad. Sci.*, 1879, **89**, 716–718.

McKeon, W. M., and W. D. Wright. The characteristics of protanomalous vision. *Proc. Phys. Soc.* (London), 1940, 52, 464–479.

Maxwell, J. C. Experiments on colour, as perceived by the eye, with remarks on colour-blindness. *Trans. Roy. Soc.* (Edinburgh), 1855, **21**, 275; also in *Scientific papers of James Clerk Maxwell*, New York: Dover Publications.

Maxwell, J. C. On the theory of colours in relation to colour-blindness (a letter to Dr. G. Wilson). Jan. 4, 1855. Reprinted in the *Scientific Papers of James Clerk Maxwell*, New York: Dover Publications, 119–125.

May, B. Ein Fall totaler Farbenblindkeit. *Z. Sinnesphysiol.*, 1907, **42**, 69–82.

Meyer, H. Ueber den Gelb-Blausinn der Protanopen und Deuteranopen im Vergleich mit dem der normalen Trichromaten. *Klin. Monatsbl. Augenheilk.*, 1932, **88**, 496–507.

Munsell Book of Color. Baltimore: Munsell Color Co., 1929. (Available at Munsell Color Co., 2441 N. Calvert St., Baltimore 18, Md.)

Nagel, W. A. Beitrage zur Diagnostik, Symptomatologie und Statistik der angeborenen Farbenblindheit. *Arch. Augenheilk.*, 1898, **38**, 31–66.

Nagel, W. Duplicity theory and twilight vision. In Helmholtz, *Handbuch der physiologischen Optik*, 2nd ed., 1911; English trans. *Treatise on physiological optics*, by J. P. C. Southall, Opt. Soc. Amer., 1924, **II**, 343–394.

Nelson, J. H. Anomalous trichromatism and its relation to normal trichromatism. *Proc. Phys. Soc.* (London), 1938, **50**, 661–697.

Parson, J. H. *An introduction to the study of colour vision*, 2nd ed., Cambridge: University Press, 1924.

Pickford, R. W. *Individual differences in colour vision*. London: Routledge and Kegan Paul, 1951, pp. 386.

Pitt, F. H. G. Characteristics of dichromatic vision. *Med. Res. Council Spec. Rep. Series* No. 200, 1935, 1–58.

Pitt, F. H. G. The nature of normal trichromatic and dichromatic vision. *Proc. Roy. Soc.* (London), 1944, **B132**, 101–117.

Planta, P. von. Die Häufigkeit der angeborenen Farbensinnstörungen bei Knaben und Mädchen und ihre Feststellung durch die üblichen klinischen Proben. *Arch. Ophthal.*, 1928, **120**, 253–281.

Post, R. H. Population differences in red and green color vision deficiency. *Eugenics Quarterly*, 1962, **9** 131–146.

Rabkin, E. B. *Polychromatic plates for studying color deficiency*. 6th ed. (in Russian). Moscow: State Pub. House for Med. Liter., 1954.

Rayleigh, Lord (J. W. Strutt). Experiments on colour. *Nature* (London), 1881, **25**, 64–66.

Rosencrantz, C. Über die Unterschiedsempfindlichkeit fur Farbentöne bei anomalen Trichromaten. *Z. Sinnesphysiol.*, 1926, **58**, 5–27.

Sachs, E. Die Unterschiedsempfindlichkeit für Farbentone bei Verschiedenen Farben systemen. *Z. Psychol. Physiol. Sinnesorg.*, 1928, **59**, 243–256.

Schmidt, I. Ergebnis einer Massenuntersuchung des Farbensinns mit dem Anomaloscope. *Z. Bahnarzte,* Nr. 2, 1936, 1–10.

Schmidt, I. Ueber manifeste Heterozygote bei Konduktorinnen für Farbensinnstörungen. *Klin. Monatsbl. Augenheilk.*, 1934, **92**, 456–471.

Scott, J. An account of Mr. Scott's to the Rev. Mr. Whisson. *Phil. Trans. Roy. Soc.* (London), 1779, **8(2)**, 612–614.

Seebeck, A. Ueber den bei manchen Personen vorkommenden Mangel an Farbensinn. *Pogg. Ann. Phys. Chem.*, 1837, **42**, 177–233.

Sloan, L. L. and L. Wollach. A case of unilateral deuteranopia. *J. opt. Soc. Amer.*, 1948, **38**, 502–509.

Sloan, L. L. Cogenital achromatopsia: a report of 19 cases. *J. opt Soc. Amer.*, 1954, **44**, 117–128.

Sperling, H. G. Case of congenital tritanopia with implications for a trichromatic model of color reception. *J. opt. Soc. Amer.*, 1960, **50**, 156–163.

Steindler, O. Die Farbenempfindlichkeit des normalen und Farbenblinden Auges. *Sitz. Wiener Akad. Wiss.*, Abt. IIa, 1906, **115**, 39–62.

Stern, C. Le daltonisme lié au chromosome X, a-t-il une location unique ou double? *J. genet. Humaine,* 1958, **7**, 302–307.

Thomson, L. C. and W. D. Wright. The convergence of the tritanopic confusion loci and the derivation of the fundamental response functions. *J. opt. Soc. Amer.*, 1953, **43**, 890–891.

Waaler, G. H. M. Ueber die Erblichkeitsverhältnisse der verschiedenen Arten von angeborener Rotgrünblindheit, *Z. indukt. Abstammungs. Vererbungsl.*, 1927, **45**, 279–333.

Walls, G. L. and G. G. Heath. Typical total color blindness reinterpreted. *Acta Ophthal.*, 1954, **32**, 253–297.

Walls, G. L. and G. G. Heath. Neutral points in 138 protanopes and deuteranopes. *J. opt. Soc. Amer.,* 1956, **46**, 640–649.

Walls, G. L. and R. W. Mathews. New means of studying color blindness and normal foveal color vision. *Univ. Cal. Publ. Psychol.*, 1952, **7(1)**, 1–172.

Weale, R. A. Cone-monochromatism. *J. of Physiol.*, 1953, **121**, 548–569.

Wieland, M. Untersuchungen über Farbenschwäche bei Konduktorinnen. *Arch. Ophthal.*, 1933, **130**, 441–462.

Willis, M. P. and D. Farnsworth. Comparative evaluation of anomaloscopes. *Med. Res. Lab. Report*, U.S. Navy, New London, 1952, **11(7)**, 1–89.

Willmer, E. N. A physiological basis for human color vision. *Docum. Ophthal.*, 1953, **56**, 235–313.

Wilson, E. B. The sex chromosomes. *Arch. mikroskop. anat. Entwicklungsmech.*, 1911, **77**, 249–271.

Wright, W. D. The characteristics of tritanopia. *J. opt. Soc. Amer.*, 1952, **42**, 509–521.

Wright, W. D. *Researches on normal and defective colour vision.* St. Louis: C. V. Mosby, 1947, pp. 383.

9 Perception of Colour in Unilateral Tritanopia

M. Alpern, K. Kitahara, and D. H. Krantz

Introduction

Alpern et al. 1983 gives results of colour matching and colour discrimination for each eye separately of a subject who acquired tritanopia in his left eye while remaining a normal trichromat with his right one. We report here experiments in which the colour perceptions from his two eyes were compared, either directly (by dichoptic matching) or through a common standard (by colour naming).

A dichromat fails to distinguish stimuli that, to a normal person, look strikingly different in colour. For example, a tritanope sees as identical a gamut of mixtures of 420 nm and 530 nm lights at constant brightness. Such mixtures vary in appearance from violet through blue and pale blue-green to green for a normal observer. It is natural to ask what colour is perceived by the tritanope for such a gamut: is it one of those perceived by the normal observer, some other colour in the normal repertoire, or something entirely outside normal experience? Such a question is prompted not merely by curiosity: its answer would tell us how the central perceptual mechanisms respond to drastically altered peripheral input, such as the loss of one visual photopigment, and this in turn could provide an important clue to the organization of colour coding in normal as well as abnormal observers.

Unilateral dichromacy offers a particularly favourable opportunity for investigating this question. The unilateral dichromat can attempt to adjust the inputs to his two eyes separately so as to equate the outputs of the central perceptual mechanisms driven by each eye. In the colour perception literature, such data have been relied on heavily for inferences about the central colour mechanisms of both bilateral dichromats and normal observers (von Hippel, 1880; Holmgren, 1881; von Kries, 1919; Dieter, 1927; Judd, 1948; Sloan & Wollach, 1948; Walls & Mathews, 1952; Graham & Hsia, 1958, 1967; Graham, Sperling, Hsia & Coulson, 1961; MacLeod & Lennie, 1976). These inferences depend on the assumed normality of the central colour mechanisms of the unilateral dichromat. This crucial but heretofore implicit assumption will be evaluated in the Discussion.

Methods

Dichoptic Matching

A binocular colorimeter was assembled around a mirror haploscope, with a Badal optical system and a 3 mm (diameter) artificial pupil in the eye's spectacle plane mounted on each

arm. The left (tritanopic) eye viewed a 4.2° × 1.4° horizontal rectangle whose dominant wave-length (the independent variable) was changed by placing one of twenty-nine Baird-Atomic 10 nm half-bandwidth (h.w.) interference filters in a beam of parallel light. The haploscope arms were converged to abut the right edge of this field with the left edge of a 1° × 2.6° vertical rectangle seen by the normal eye. The light making up this field comprised a Nutting (1913) colorimeter. The three degrees of freedom in this device were: i, the wavelength of monochromatic (2 nm h.w.) light from a double monochromator of Czerny-Turner design with two 1200 grooves/mm diffraction gratings; ii, the luminance of this light, varied by adjusting a calibrated neutral wedge in the path of the monochromator beam; and iii, the luminance of a desaturating 'white' (4200 K) light (mixed with the monochromatic beam), varied by adjusting a counterbalanced 'neutral' wedge in the 'white' beam. The radiances of all monochromatic lights were obtained in situ with a calibrated PIN 10 silicon photodiode (United Detector Technology). The transmission of the monochromator wedge was similarly calibrated. The luminance of the desaturating white light was measured in the usual way with an S.E.I. photometer by allowing the light passing through the artificial pupil to fall on a white standard test plate ($r = 0.82$) at a distance of 10 cm.

The light presented to the dichromatic eye originated from a horizontal tungsten ribbon filament and was attenuated by each one of a set of interference filters. The radiance of monochromatic light entering the eye varied from one run to the next. In the experiment yielding the results in figure 9.1 it had the smallest value (9.13 log photons sec^{-1} deg^{-2}) at 400 nm and the largest value (10.16 log photons sec^{-1} deg^{-2}) at 700 nm; between 410 nm and 530 nm the radiance values were more or less constant (± 0.1 log$_{10}$ unit) at around 9.38 log photons sec^{-1} deg^{-2}, except at 450 nm (9.56 log photons sec^{-1} deg^{-2}). For wave-lengths longer than 530 nm log radiance increased approximately linearly with increasing test wave-length at a rate of 0.0036 log$_{10}$ units per nm.

Colour Naming

The field consisted of a circular monochromatic (2 nm h.w.) disk 1° in diameter surrounded by a 3° (outside diameter) annulus of the monocular colorimeter (Alpern et al. 1983). The surround was the 'white' light of the xenon arc (about 5200 K) attenuated by inconel 'neutral' filters and wedges to 1000 trolands for most of the spectrum. A heterochromatic match between surround and centre was achieved by adjusting the intensity of the centre for all monochromatic lights of $\lambda \geqslant 450$ nm. For $\lambda \leqslant 440$ nm constraints on the intensity of the light emerging from the monochromator required the latter to be set at its full intensity and the luminance of the surround reduced accordingly to achieve the heterochromatic brightness match. At the short-wave spectral extreme this was 100 trolands, with intermediate levels in the wave-length region between.

For each spectral wave-band tested, the subject first made a left-eye brightness match between the monochromatic centre and the 'white' surround, then adapted to

Plate 1
Still life with minium. (See chapter 5.)

Plate 2
Collage of colored paper objects. (See chapter 5.)

Plate 3
Mondrian collage. (See chapter 5.)

Plate 4
(*a*) Stereoscopic view of the Retinex color three-space. Left eye view on the left. Three designators were determined for each paper according to the algorithm described here in order to locate the colored papers in the three-space. Note that black, greys, and white fall on a diagonal running from the lower left to the upper right. Other colors form colonies generating color domains. (The accuracy of this representation as opposed to the actual papers is limited by the sequence of photo-engraving procedures.) (See chapter 5.)

Plate 4
(*b*) Stereoscopic key to the color three-space. The colored papers used are listed in table 5.1. (See chapter 5.)

Plate 5
Stereoscopic view of three-space. Left-eye view on the left. X's showing location of colors seen in red and white projection. (See chapter 5.)

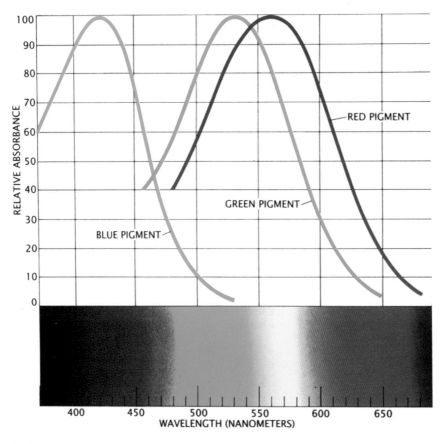

Plate 6
Spectral-sensitivity curves show the sensitivity of the three color pigments to the visible spectrum of light. The curves were plotted on the basis of data obtained by James K. Bowmaker of the University of London and H. J. A. Dartnall of the University of Sussex. What is called the blue pigment is particularly responsive to the short-wavelength region of the spectrum; the green and red pigments are more sensitive to intermediate and long wavelengths. The pigments themselves have still not been isolated; hence Bowmaker and Dartnall determined their sensitivities by measuring the light absorbed by individual cones that were obtained from cadavers. (See chapter 10.)

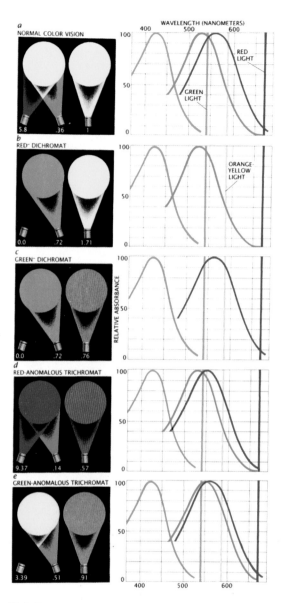

Plate 7

Color matches (*left*) made in a test of red-green color discrimination are depicted next to the subjects' spectral-sensitivity curves (*right*). The testing device, a Rayleigh anomaloscope, superposes a red and a green light on one half of a white screen and projects an orange-yellow light onto the other half. Subjects adjust the ratio of red light to green and the intensity of the yellow light until the two sides of the screen appear to match—that is, until the light absorbed by each type of pigment from one side of the screen is equal to the amount absorbed from the other side. The numbers below the lights show the relative intensities. Normal subjects (*a*) require both the red and the green light to match the yellow, choosing a high intensity of red and a low intensity of green. (The red and green pigments both absorb the red light less efficiently and the green light more efficiently than they do the yellow.) People who lack the red (*b*) or the green (*c*) pigment are identified by their ability to match the yellow light with the red or the green alone. (Only the green matches are shown.) Subjects whose red (*d*) or green (*e*) pigments have abnormal spectral sensitivities require both red light and green light to match the yellow but, compared with normal subjects, choose an excess of red or green respectively. (See chapter 10.)

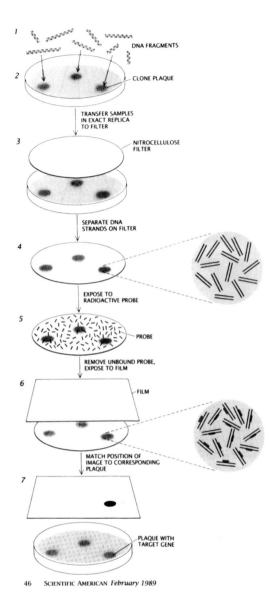

Plate 8

DNA hybridization enabled the author and his colleagues to identify the genes for human rhodopsin—the pigment responsible for (colorless) vision in dim light—and its close relatives, the cone pigments. They chemically cut double-strand DNA (*1*), separated the fragments by size and cloned them in bacterial viruses grown on a lawn of bacteria. Each virus multiplied to form a plaque, a zone of viral multiplication (*2*). Nitrocellulose filter paper was placed over the dishes so that a sample from every plaque adhered (*3*). The DNA on the filter was chemically separated into single strands (*4*) and exposed to a radioactively labeled probe (*red*): a single-strand DNA from the bovine rhodopsin gene (*5*). If the probe was structurally similar to the genes for the human pigments, as it was expected to be, it would hybridize with (bind to) the pigment genes. To determine whether the probe did in fact bind, the filters were covered with photographic film (*6*). Dark spots appeared at binding sites (*7*), indicating the radioactive probe had bound. The workers then identified the clones containing the pigment genes by aligning the spots on the film with the corresponding plaques. (See chapter 10.)

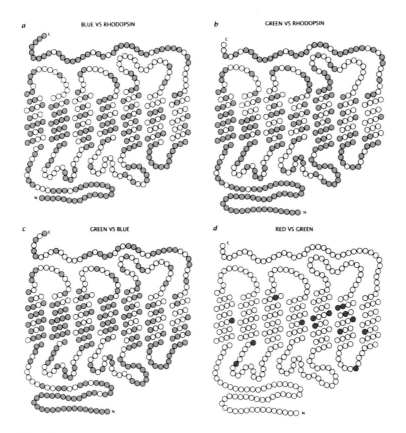

Plate 9

Structural comparisons of the four visual pigments on the basis of their nucleotide sequences indicate that rhodopsin and the color pigments all have similar amino acid sequences. (Each colored dot represents an amino acid difference.) The red and the green pigments are most alike; in fact, they are almost identical with one another (*d*). When the molecules being compared have different lengths, the longer molecule is depicted and the unshared "extension" is colored in. (See chapter 10.)

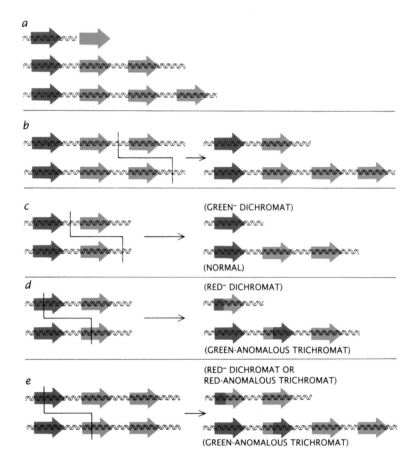

a

b

c

(GREEN⁻ DICHROMAT)

(NORMAL)

d

(RED⁻ DICHROMAT)

(GREEN-ANOMALOUS TRICHROMAT)

(RED⁻ DICHROMAT OR
RED-ANOMALOUS TRICHROMAT)

e

(GREEN-ANOMALOUS TRICHROMAT)

Plate 10
Exchange of genetic material between normal X chromosomes, which bear the red-pigment and green-pigment genes (*colored arrows*), can give rise to either normal or abnormal red-green color discrimination. X chromosomes derived from normal individuals have one normal red-pigment gene and one, two or three green-pigment genes (*a*). Such normal variation can readily arise when a chromosome with one red- and two green-pigment genes loses one of the green-pigment genes to its mate (*b*). Dichromacy and anomalous trichromacy commonly arise from genetic exchanges that result in the loss of a pigment gene (*c*) or the creation of a hybrid gene derived in part from a red- and in part from a green-pigment gene (*d, e*). The light sensitivity of a hybrid pigment depends on the point of crossing-over within the hybrid gene. (See chapter 10.)

Plate 12 ▶
The figure illustrates static displays used in tasks of colour detection and the detection and discrimination of form. *A* shows an example of a trial where M.S. was unable to detect the coloured square. However, when the square was more conspicuous to the normal observer as in *B*, M.S. reliably detected it. In *C*, the range of greys of which the checkerboard is composed has been extended and M.S. fails to indicate the location of the coloured square. *D* illustrates the task requiring M.S. to detect the small coloured square concealed in the 38 × 38 checkerboard. *E* and *F* are examples of displays used in form detection and discrimination, respectively. (See chapter 13.)

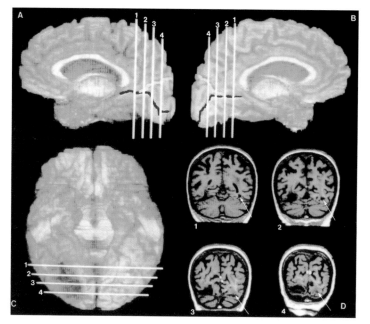

Plate 11
The three-dimensional reconstruction of a T_1-weighted MRI in patient 1 (A, B, and C) allows the location of the brain lesions in the original coronal MRI slices (D) with respect to surface features including the calcarine (red) and parieto-occipital (yellow) fissures. (A) Right hemisphere mesial surface; (B) left hemisphere mesial surface; (C) ventral surface. We hypothesize that the lesion of the left hemisphere (white arrows, D) caused damage in a possible human homologue of the monkey's area V4 (see text, chapter 12).

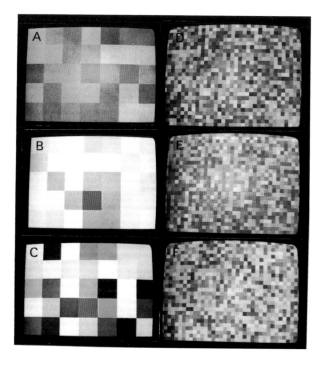

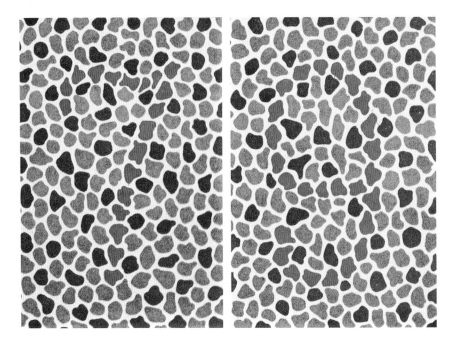

Plate 13
Test patterns from the pseudoisochromatic plates of Stilling. Note that the figure and field are made up of discrete patches, varying in lightness and each having its own contour. (See chapter 16.)

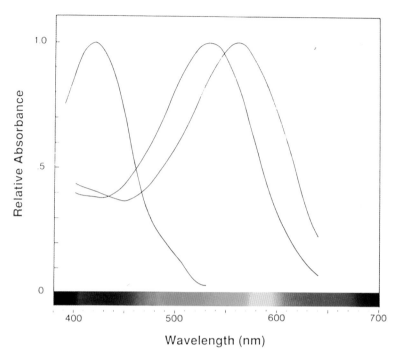

Plate 14

The absorbance spectra of the human cone pigments. These curves are replotted from table 2 of Dartnall et al. (1983) and were obtained by microspectrophotometric measurements of individual photoreceptors from human eyes removed in cases of ocular cancer. The ordinate represents the (normalized) logarithm of the factor by which monochromatic light is attenuated as it passes through the outer segment of an isolated receptor. (See chapter 16.)

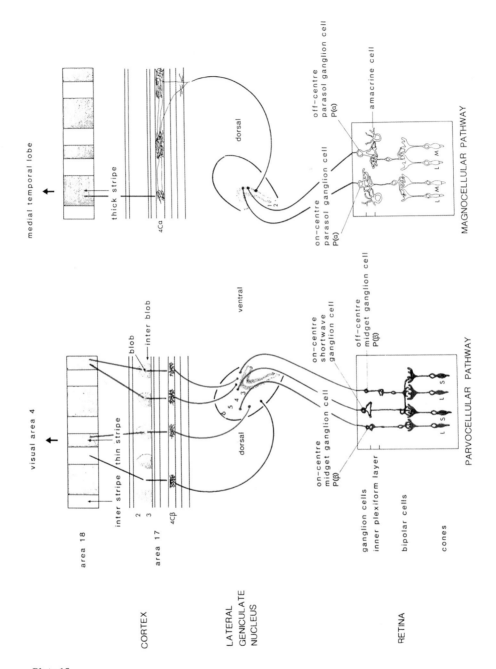

Plate 15

The parallel channels of the geniculostriate pathway of the primate visual system. To the right is represented the magnocellular system, which carries little chromatic information: the large Pα cells of the retina project to the magnogeniculate nucleus and thence to layer 4Cα of the visual cortex and the 'thick stripes' of area 18, which stain strongly for cytochrome oxidase. A second parallelism is represented within the parvocellular pathway on the left; and here the parallelism is between a channel that carries almost purely chromatic information (the primordial subsystem of colour vision) and a channel that carries information about both colour and spatial contrast (the second subsystem of colour vision). The two subsystems, represented by blue and red, respectively, appear to remain independent, at least as far as the cytochrome oxidase 'blobs' of area 17 of the cortex. (See chapter 16.)

the surround alone, and finally reported left-eye colour names, viewing the entire pattern (surround plus centre). This process was then repeated for the (normal) right eye, before moving on to another wave-length.

Brightness matches were made by adjustment, with the surround field steady and the centre field exposed repeatedly for 2 sec, with an inter-stimulus interval of 6 sec. After completing the brightness match the subject adapted for at least 20 sec to the surround, and then began naming colours, with the central field again exposed one or more times for 2 sec, with 6 sec between exposures.

>The colour-naming method was as follows. First the subject selected one or more names from the following five: 'red', 'yellow', 'green', 'blue', 'white'. After his initial choice, he was asked explicitly whether or not 'traces' of the omitted qualities were present. Finally, he divided ten total points among the selected qualities, with 'trace' not counting in the total. For example, a response might be: " 'red', 5; 'white', 5; trace of 'yellow' "; or again, " 'red', 5; 'white', 4; 'yellow' 1"; or again, " 'red', 5; 'white': 5". (In this last case we scored 'yellow' as 0, as well as 'green', 0 and 'blue', 0.)

In this fashion, the spectrum was covered in a haphazard order, in 10 nm intervals from 410 nm to 630 nm, plus 650 nm and 670 nm, for both eyes, in a single session. Two repetitions a week apart yielded essentially identical results.

Results

Dichoptic Matching

Three general findings from dichoptic matching justify comments before the details are examined:

First, a match of this kind was feasible for each wave-band, from 400 nm to 700 nm, presented to the left eye. Such a match would likewise be possible for any mixture of wave-lengths presented to this eye (since, by dichromacy and Grassmann's laws, any such mixture is metameric to some single wave-length). Therefore, the entire gamut of colour perceptions attainable through left-eye stimulation corresponds to colour percepts attainable through stimulation of the normal right eye. This fact excludes certain theories of colour coding; for example, straightforward versions of the Young-Helmholtz theory predict that the tritanope, lacking the short-wave receptors, should perceive a green more saturated than any attainable by a normal eye under the same viewing conditions.

Secondly, adjustment of all three variables was usually necessary to attain a match. No previous study of unilateral dichromats has used a three-variable dichop-

tic match. Yet the use of only two controls is impractical unless the matching right-eye lights fall on a particularly convenient surface in the right-eye tristimulus space, for example on a plane (which would mean Grassmann's additivity laws held dichoptically). Studies with only two controls may end up with only approximate colour matches unless the controls generate precisely the right surface.

Thirdly, the matching lights, in the trichromatic eye, were predominantly 'red', 'white' and 'blue'. In two spectral regions, around 485 nm and 660 nm, the wave-bands in the left eye were matched by approximately the same light presented to the right eye (i.e. same wave-length, purity and luminance). We call such a light, perceived the same by either eye, an *isochrome*. Mixtures of the blue and the red isochromes presented to the normal eye look purple, but the same mixtures look desaturated, and, in the correct proportion, white, to the dichromatic eye. This shows, among other things, that Grassmann's additivity law is grossly wrong for dichoptic matches, though it holds for monocular matches within either eye. Grassmann's law of scalar multiplication apparently also fails for dichoptic matches, (see below).

In all, three sets of dichoptic colour matches were attempted. The first used only a two-variable colorimeter, omitting a desaturating channel. Approximate matches obtained in this way gave rough agreement, in wave-length of the matching light, with subsequent data. The two later runs used three variables. Because the other run was not done at exactly the same intensity level and because some experience was required in making precise matches, the results of only the final run are shown in figure 9.1. These results differ from those of the first three-variable run only in being more saturated (\log_{10} purity higher by about 0.4, an effect which was not wave-length-dependent).

The colorimeter settings are plotted in figure 9.1 in terms of the dominant wave-length, colorimetric purity, and luminance of the right-eye field (moving respectively from the top to the bottom of the figure). Dominant wave-length and purity are measured relative to the 4200 K desaturating beam; thus, the former is just the wave-length setting of the double monochromator, the latter is the ratio of the luminance in the monochromatic channel to the sum of the luminances in the monochromatic and the desaturant channels.

In the top graph of figure 9.1 the central point of the wave-band presented to the tritanopic eye is plotted on the lower horizontal line and connected to the matching dominant wave-length for the right eye, plotted on the upper line. (This kind of plot was used by Graham et al. 1961.) It is striking that a wide span of left-eye wave-bands, from 400 nm to 550 nm, are all matched close to 485–490 nm in the right eye.

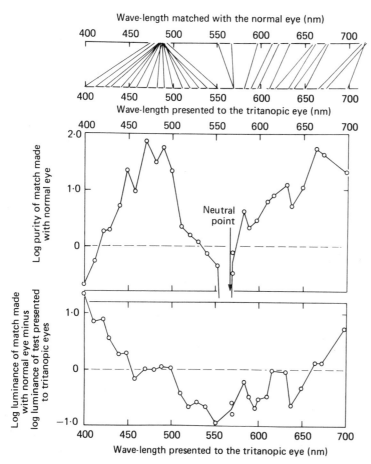

Figure 9.1
Results of the final set of dichoptic colour matches. The abscissa scale (for all three graphs) is the peak wave-length of the narrow-band spectral distribution presented to the tritanoptic eye with the radiances as described in the text. At the top (also on the abscissa) is the peak wave-length of the distribution with which these respective lights were matched in the trichromatic eye. The middle graph shows the log of percentage colorimetric purity (p_c) of the dichoptic match ($p_c = (100)L_\lambda/(L_w)$, where L_λ, L_w are the luminances of the respective monochromatic and white lights of the Nutting colorimeter at the match). The bottom figure shows the ratio log $[(L_\lambda + L_w)/L']$, in which L' is the test luminance of the monochromatic light presented to the tritanopic eye.

In particular, 485 nm itself is an isochrome—matched by the same dominant wave-length (top), at nearly 100% purity (middle graph), and at the same radiance (zero luminance difference, shown in the lower graph).

The middle and bottom graphs of figure 9.1 show that while matching wave-length varied little, the purity and relative luminance of the matching field varied greatly from 400 nm to 550 nm. At both extremes of this range the matching purity was low, indicating that the stimulus presented to the left eye looked very pale. At the short-wave end, the total luminance of the right-eye field needed for a match was considerable, relative to the test luminance in the extreme violet; the opposite was true near 550 nm.

The small variations in matching wave-length shown in the top graph (475–495 nm) are hard to interpret in view of the large variations in the intensity and relative amount of the not-quite-neutral desaturant (4200 K) and in view of some shift in adaptation level from one match to another. Colour-naming data, presented below, indicate that the predominant colour appearance of wave-lengths in this region for the normal eye is 'blue'; rough determinations of spectral unique 'blue' and 'green' for this eye, around 475 nm and 515 nm, are consistent with later colour-naming data; but the latter reveal that the actual 'blue-green' band is around 495–500 nm under neutral adaptation.

For test wave-lengths near the neutral point of the tritanopic eye, matching purity fell nearly to zero and the match wave-length is indeterminate. Above 580 nm all matching wave-lengths fell in a part of the spectrum perceived as reddish (above the unique 'yellow' point, roughly 590 nm). In view of the variability and poor hue discrimination of this (and every other) normal eye in this part of the spectrum, lights from 640 nm to 700 nm are once more approximate isochromes. The perceived colour is predominantly 'red', though on some trials slight yellowness is reported as well.

Clearly it would have been desirable to replicate these dichoptic colour matches several more times; unfortunately, the observer was not available for a sufficient period of time to do this.

The results can be viewed another way by plotting the right-eye matching fields as chromaticity vectors (figure 9.2, open circles, labelled by the left-eye wave-band that was matched). Since a fixed-primary colorimeter was not used, chromaticity must be calculated from spectral colour-matching functions for a normal eye. In the figure, the C.I.E. standard observer's colour-matching functions were used; the picture is essentially the same if they are replaced by the observer's own right-eye colour-matching functions (Fig. 2 of Alpern et al. 1983).

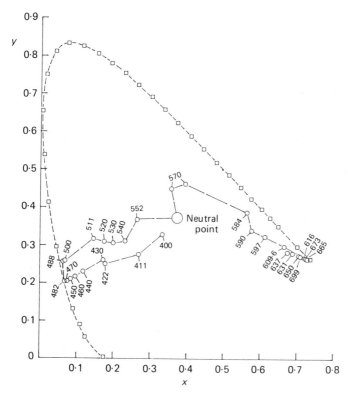

Figure 9.2
Re-plot of the dichoptic matches shown in figure 9.1 in the chromaticity co-ordinates of the 1931 C.I.E.
standard observer (open circles). Squares show the chromaticities of monochromatic lights at 10 nm inter-
vals in the visible part of the spectrum as matched by the standard observer. The dichoptic matches are
with respect to 'white' light of colour temperature 4200 K (large open circle: $x = 0.372$, $y = 0.372$) rather
than for an 'equal-energy white' ($x = 0.333$, $y = 0.333$).

Near the isochromes, the match points fall on the spectrum locus; elsewhere, as is
clear from the lower purity in the middle graph of figure 9.1, the results fall on a
curve inside the spectrum locus.

If Grassmann's scalar multiplication law held for dichoptic matching, then the
right-eye chromaticity would be determined by the left-eye chromaticity, indepen-
dent of intensity. That this fails is shown by the failure of the short-wave end of the
left-eye chromaticity curve to double back on itself around 455 nm. Alpern et al.
1983 showed that left-eye chromaticity is non-monotonic, attaining an extreme value
at about 455 nm and doubling back for spectral lights less than the wave-length (Fig.
3 of Alpern et al. 1983). For example, 422 nm and 523 nm have the same left-eye
chromaticity. Had these two lights been presented in the intensity ratio proper for a

metameric match, they would necessarily have been matched by the same right-eye field. As it was, they were presented at about equal radiance in the dichoptic matches, i.e. the 422 nm stimulus was about one-sixteenth as intense as that needed for the tritanopic match to 523 nm. It is clear from the different right-eye chromaticities (interpolating between 520 nm and 530 nm for the latter one) that this intensity factor produces a substantial shift in the dichoptic match.

It must be emphasized, therefore, that the quantitative results in figures 9.1 and 9.2 are valid only for the radiances used. However, the qualitative features of these results are not very likely to change with overall radiance level, as can be judged from the colour-naming results, described below.

If the Grassmann additivity and scalar multiplication laws were valid dichoptically, then the results in figure 9.2 would fall on a straight line. The clear curvature shown in the figure is thus further evidence against Grassmann's laws.

The failure of Grassmann's linearity laws shows that the dichoptic matches are not simply matches for the long- and middle-wave cone pigments, nor for any two channels whose responses are a function of a linear combination of cone pigment quantal absorptions (Krantz, 1975).

Colour Naming

For both eyes, 'red' and 'green' were used in opponent fashion, as were 'yellow' and 'blue'. That is, if any amount of one of these qualities was reported, even a trace, then no amount of the paired opponent quality was reported, not even a trace. There was no constraint in the method that forced this result, and indeed, care was taken not to suggest in any way that opponent pairs should exist. The subject was always prompted for all five colour names, in the invariable order 'red', 'yellow', 'green', 'blue' and 'white'.

For the tritanopic left eye, 'blue' and 'red' were also used in opponent fashion and 'green' was not used at all. That is, the only response combinations ever used were 'blue' with 'white', or 'red' with 'white', and sometimes with 'yellow' also. To put matters another way, the only two chromatic qualities that occurred together were 'red' and 'yellow'. The subject never reported 'green' and never reported 'purple' or 'violet' ('red' mixed with 'blue').

Quantitative colour-naming results are shown on the three graphs in figure 9.3. The ordinate scales give the average point score for each name for every monochromatic light. The graphs are arranged in a display consistent with the observed opponent pairs. In the upper right graph, large positive numbers indicate strong weight to 'red', large negative numbers to 'green'. In the upper left, positive numbers indicate 'yellow', negative numbers 'blue'. Plotted below (positive numbers only

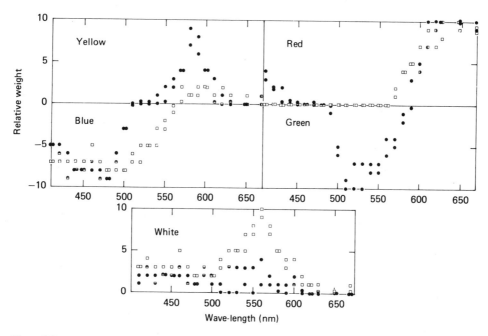

Figure 9.3
Results of two repetitions of colour naming with neutral surround, as seen monocularly by the trichromatic (filled circles) and dichromatic (open squares) eyes respectively. The abscissae in each graph give the peak wave-length of the 'monochromatic' spectral distribution, the ordinates the relative weights (as defined in the text) in the 'red'/'green' (upper right), 'yellow'/'blue' (upper left) and 'white' (below) dimensions respectively.

since 'black' was not an option) is the weight given to 'white' in the responses evoked by these monochromatic lights. The responses evoked when the flashes were presented to the normal trichromatic (i.e. the right) eye are shown by filled circles. These responses are consistent with those found more generally with normal observers (Boynton, Schafer & Neun, 1964; Boynton & Gordon, 1965).

The names obtained with the dichromatic eye are illustrated by the open squares in figure 9.3. These data are consistent with the inferences drawn from dichoptic matching even though the retinal illuminance (in photopic trolands) was very nearly constant in the naming experiment and varied over a range of slightly more than 3.8 \log_{10} units in matching. Once more, there is the suggestion that monochromatic lights very near, if not identical to, the short wave-length seen by the normal eye as neither 'red' nor 'green', i.e. unique 'blue', have the same appearance whether seen by the normal or by the tritanopic eye. Furthermore, naming experiments provide even better evidence for the existence of an isochrome in the long-wave end of the

spectrum ($\lambda \sim 660$ nm). Monochromatic lights other than at these two isochromes generally appear more or less desaturated when presented to the tritanopic eye than these same lights exciting the normal retina alone.

Other features in tritanopic naming include absence of 'green', greatly reduced weight of 'yellow', and a psychological neutral point: 'yellow/blue' crosses the horizontal axis at the same locus that 'red' goes to zero, just above 560 nm. This makes 'red' and 'blue' opponent in the same sense as 'yellow' and 'blue'. Most of these features can be identified in the spectral naming functions of the unilateral tritan observer of Ohba & Tanino (1976), though there are differences (notably the presence for their observer of some slightly greenish and slightly reddish blues and a lesser desaturation at wave-lengths other than the isochromes).

An additional tritanopic colour-naming study was performed a few weeks later, using a different apparatus, to examine the effects of simultaneous contrast on perceived colour. The configuration was 1° central test field with a 0.5° annular surround (1° inner diameter, 1.5° outer diameter). The wave-length of the continuously exposed surround was either 430 nm ('blue') or 650 nm ('red'), at 150 trolands, or a mixture of those two ('pink'). The central 1° field was approximately 150 trolands (matched to the surround) and was exposed for 1.5 sec at a time, with 6 sec or more between stimuli.

With the 'pink' (nearly 'white', to the tritanopic eye) surround, the colour-naming data were very similar to those in figure 9.3, except no 'yellow' responses occurred. The 430 nm surround shifted the neutral point by about 30 nm down to 530 nm, but otherwise the results remained the same: no 'green', very little 'yellow', and the striking crossover between long-wave-length 'red' and short-wave-length 'blue'. Similar results were obtained with the 650 nm surround, except that the neutral point moved up to 570 nm and once more 'yellow' was suppressed completely. No 'green' appeared under any simultaneous contrast conditions. Of course, no 'purple' inducing field could be presented to the tritanopic eye.

Discussion

Previous Results

How do a unilateral tritanope's perceptions compare with those in other kinds of tritanopia? In 'transient tritanopia' they are different: a light normally seen as 'blue' is called 'green' (Mollon & Polden, 1977). But at perimetric angles where the sensitivity of short-wave-sensitive cones is depressed (Wooten & Wald, 1973) small flashes of

monochromatic light exposed to the normal peripheral retina are named remarkably similarly to those reported by our unilateral tritanope (Gordon & Abramov, 1977).

'Foveolar tritanopia' (Willmer, 1949) falls between these extremes. Threshold (1.3′ subtense, 0.7 msec) flashes were named 'blue' and 'green' with a fixed ratio of frequencies independent of wave-length (Krauskopf & Srebro, 1965; Krauskopf, 1978); but 'green' was used about 3 times more frequently (J. Krauskopf, personal communication). Brighter foveolar fixated flashes were named by some normal observers in very nearly the same way as the one employed by the tritanopic eye studied here (Ingling, Scheibner & Boynton, 1970). One who did not (using 'green' and 'blue' discriminatively) became similar to the unilateral tritanope if the flashes were viewed on a bright *blue* background. Some normals match asymmetrically small 1′ or 2′ foveal fields similar to the dichoptic matches in figure 9.2 (Middleton & Holmes, 1949).

Even more striking is the similarity between the results for the dichromatic eye in figure 9.3 and the names employed by a congenital tritanope (Smith, 1973). There are differences, of course, which is not too surprising given that cultural factors are bound to influence how congenital dichromats use colour names. Still, for this congenital tritanope 'Blue replaced green almost completely in the middle spectrum' (Smith, 1975, pp. 211–212). Finally, cerebral infarctions involving the medial and lingual occipitotemporal gyri bilaterally (8 years before testing) caused a defect labelled 'acquired tritanopia' (Birch-Cox, 1976). This patient named colours in a pattern nearly identical to the one followed by the present subject viewing with his tritanopic eye (Pearlman, Birch & Meadows, 1979).

Adaptation or Suppression?

In everyday life, a unilateral dichromat views a coloured object binocularly and therefore passes different inputs from the two eyes to his brain. If the conflicting inputs are disturbing, they may be dealt with in two ways: by suppression of one of them, or by adaptation of the central mechanisms so that the two conflicting inputs each produce the same output, i.e. the conflict is abolished. In the literature on perceptual adaptation, striking instances of the second resolution occur (Kohler, 1962; Hochberg, 1971). But in strabismus, suppression is a common resolution (Crone, 1973; Burian & von Noorden, 1974). In the present case of conflicting inputs, resolution by suppression would lead to the assumption that the central mechanisms are substantially normal, and hence would permit inferences from the dichromatic results to the normal mechanisms; resolution by adaptation would greatly complicate such inferences.

One fact that might suggest adaptation was pointed out to us by J. D. Mollon: the short-wave isochrome roughly maximizes the ratio of absorptions of the middle-wave to the long-wave cone pigment. Thus, concurrent (or recent) conflict is minimized where the chromatic signal from the tritanopic eye is greatest. However, there are several lines of evidence suggesting that suppression is the main mechanism of resolution in this case. First, the subject approached us because he noticed differences in the colours perceived by his two eyes for the same object. Secondly, if the subject resolved the conflict such that the normal and abnormal eyes produced the same perceptual outputs, a degree of freedom would have to be lost centrally, and the subject would be dichromatic through both eyes. His excellent sensitivity through the trichromatic eye suggests that little, if any, such adaptation has occurred. Thirdly, there are remarkable similarities in naming between the tritanopic perceptions reported here and those acquired from bilateral cerebral vascular accidents (8 years before testing). Such persistence is the antithesis of adaptation, which regresses in time towards 'normality', and points to the possibility that this behavior is characteristic of the normal colour code rather than a specific adaptation to minimize discrepancies between (recent or concurrent) signals from 'bad' and 'good' retinas. Finally, in an experiment designed to test directly whether suppression occurs, the subject was asked to fuse a monochromatic 'blue' light (481.9 nm) presented to one eye and monochromatic 'yellow' (590 nm) presented to the other and to match the mixture to a broad-band 'white' viewed in the adjacent field only by the normal eye. Every one of eleven normal subjects achieved this fairly readily, but the unilateral tritanope was unable to do so; instead he perceived only the colour of whichever light was presented to the normal eye, unless the intensity of the light to the dichromatic eye was increased about a log unit above the average value normals used to match the white. At that point, rivalry occurred; at higher intensities still, the dichromatic eye dominated; but normal fusion was never achieved.

On this basis we tentatively propose that central mechanisms of colour perception are normal in this observer, and ask what can be learned about their organization from the results detailed above.

Theoretical Implications

The surprising facts are that although exhaustive attempts to uncover a short-wave cone pigment in this subject's tritanopic eye failed, this eye sees the entire spectrum on the short-wave side of the neutral point as 'blue' (with various degrees of saturation). The field-sensitivity spectrum (allowing for prereceptor colour differences in the two eyes) of $\Pi_4(\mu)$ is normal in his dichromatic eye; but he sees no 'green' anywhere in the spectrum with this eye!

Traditional colour theories do not easily deal with this enigma: in standard Young-Helmholtz interpretation (von Helmholtz, 1896) a tritanope missing short-wave cones is expected to see the spectrum as 'red', 'green' and 'yellow' and their combinations; neither 'blue' nor 'white' should be seen. In the modern view of the Hering theory (Hurvich & Jameson, 1955), tritanopia is regarded as a loss of the 'yellow-blue' sense; 'white', 'red' and 'green' should appear as for the normal eye, while the mixture of 'red' and 'green' would be achromatic. But, in fact, this trita-nope sees the spectrum largely as 'red', 'white', and 'blue' with only a very small amount of 'yellow' and no 'green'.

Deleting the photopigment input that primarily drives the central mechanism for blueness does not thereby delete the perception of blueness; hence, this central mechanism must instead receive inputs mediated by other photopigments. At the same time, this change must result in the loss of perceived greenness; in the Appendix we outline a general mathematical framework in which this notion is expressed more precisely and discuss attempts to fill in details.

Another conclusion about normal organisation derives from the very fact that dichoptic matches are possible. There must be a limitation to only three degrees of freedom at the level of central mechanisms, not merely at the level of photopigments. For if there were n functionally independent central mechanisms a dichoptic match would be an attempt to solve n equations in three unknowns, whence $n \leqslant 3$ (see Appendix).

Finally, it is noteworthy that the failures of Grassmann's laws in dichoptic matching point to essential non-linearities in the central mechanisms of colour perception.

Appendix

A theory of colour coding must specify the relationship between the outputs of the central neural mechanisms that correspond to the perception of colour (Stiles, 1967) and the receptor inputs and other parameters of visual stimulation. Let α, β, γ respectively denote the outputs (assumed monotonic with photon absorbance) of the short-wave, middle-wave and long-wave cones of the normal central retina, and let y_1, \ldots, y_n represent the outputs of n functionally independent central mechanisms that correspond to the perception of colour. Let Ω denote the parameter vector that specifies all the various conditions that modify the relationship between the y values and α, β, γ, including spatial and temporal configuration of stimulus presentation, preadapting light, contrast stimuli. The general input-output relation, which must be specified in a colour theory, consists of n functions f_1, \ldots, f_n:

$$\left.\begin{array}{l} y_1 = f_1(\alpha, \beta, \gamma, \Omega) \\ \qquad \cdots \\ y_n = f_n(\alpha, \beta, \gamma, \Omega). \end{array}\right\} \tag{1}$$

Specific examples of such functions f_1, \ldots, f_n are found in various quantitative developments of colour theory (e.g. Jameson & Hurvich, 1959).

The functional independence of f_1, \ldots, f_n means that the value of y_n cannot be predicted from the values of y_1, \ldots, y_{n-1}. (More precisely, the range of y_1, \ldots, y_n is topologically n-dimensional.) The fact that input is limited to α, β, γ does not entail that $n \leqslant 3$. For example, there is no necessary upper limit to the number of functionally independent y_i that can be defined by linear equations of the form $y_i = \Omega_{i1}\alpha + \Omega_{i2}\beta + \Omega_{i3}\gamma$, where the coefficients Ω_{ij} depend on the parameter vector Ω in a different way for each i. Nonetheless, most colour theorists, including Stiles (1967) and Jameson & Hurvich (1959), have assumed that $n = 3$. This assumption has been justified heretofore in two ways: on subjective grounds (colours vary independently only in hue, saturation and brightness) or on the grounds that asymmetric (cross-Ω) trichromatic matches are possible (Stiles, 1967). The data from dichoptic matching in unilateral colour blindness, as shown below, provide yet another argument that $n = 3$.

The results in the previous paper (Alpern et al. 1983) suggest that in the modified input-output relationship of the tritanope, the short-wave-sensitive input, α, is lost. But what does this mean in terms of eqn. (1)? It is meaningless, mathematically, to 'delete' α from a function which depends on α: the variable α must be replaced by something, e.g. by a constant such as 0 or 1 or, more generally, by a function $\alpha = T(\beta, \gamma, \Omega)$. One way simply to 'delete' α would be to assume that only certain of the outputs y_i have an actual dependency on α, and that those outputs are gone entirely in the tritanope. This, indeed, is the underlying assumption of the Young-Helmholtz approach and is also seen in the Hering approach in the assumption that the yellowness-blueness mechanism (one of the y values) is missing in tritanopia. But the present results suggest that this approach to deletion is utterly wrong: those central mechanisms which, in the normal observer, correspond to blueness (and, we assume, have heavy dependence on α), are most active indeed in the tritanope. We, therefore, assume that α is replaced in eqn. (1) by a constant or a non-constant function of β, γ and Ω:

$$\alpha = T(\beta, \gamma, \Omega). \tag{2}$$

This leads to the modification of eqn. (1): for $i = 1, \ldots, n$.

$$y_i = f_{iT}(\beta, \gamma, \Omega) = f_i[T(\beta, \gamma, \Omega), \beta, \gamma, \Omega]. \tag{1_T}$$

In binocular viewing for a unilateral tritanope, the inputs α, β, γ from one eye and β, γ from the other lead to conflicting values for y_i, via f_i (eqn. 1) and f_{iT} (eqn. 1_T); and the latter is suppressed, as we have argued in the Discussion. But in dichoptic viewing, each portion of the visual field receives input from only one eye, and there is no conflict. For any specified values of β, γ in the tritanopic eye, corresponding values α', β', γ' of the normal inputs can be found, such that a dichoptic match is made: for $i = 1, \ldots, n$

$$f_i(\alpha', \beta', \gamma', \Omega) = f_{iT}(\beta, \gamma, \Omega). \tag{3}$$

The facts of dichoptic matching have two important consequences. First, $n = 3$; i.e. *there are exactly three functionally independent y_i values at the central level at which dichoptic matches are determined.* For if $n \geqslant 4$, eqn. (3) would require the solution of four or more equations in only three variables, α', β', γ'; and, of course $n \leqslant 2$ is impossible by trichromacy of normal vision. (A similar line of argument, for asymmetric colour matching, is implicit in Stiles, 1967.) Secondly, *the f_i values must be non-linear* in such a way as to produce a violation of Grassmann's laws for dichoptic matching.

To go further, one must suggest specific forms for eqns. (1) and (2) consistent with the known facts about normal colour perception and with the results of the present study. We have not succeeded in this task. The approach was to assume that y_1, y_2, y_3 correspond respectively to perceived redness/greenness, perceived yellowness/blueness, and perceived whiteness, and to specify non-linear colour-opponent forms for f_1, f_2 and f_3 that would both: (i) violate Grassmann's additivity law in eqn. (3) (the functions suggested by Jameson & Hurvich (1959), though non-linear, predict that adaptivity would hold) and (ii) be consistent with other linear and non-linear findings in colour perception (Purdy, 1931; Indow & Stevens, 1966; Larimer, Krantz & Cicerone, 1974, 1975; Moeller, 1976). For eqn. (2) we assumed a linear form, $\alpha = r\beta + s\gamma$, independent of Ω. Important constraints included the fact that the tritanopic redness/greenness function, f_{1T}, could be positive but never negative (no perceived green), and that f_{2T} must cross zero at the same spectral locus where f_{1T} reaches zero (see figure 9.3). But no functions fitting all these constraints have yet been found.

These difficulties are not easily circumvented by dropping the opponent-colours approach to central mechanisms. A Young-Helmholtz alternative, in which the output of each mechanism is a function of only a single cone absorption function, leads to the equations (replacing eqn. 3)

$$f_1(\alpha', \Omega) = f_1[T(\beta, \gamma, \Omega), \Omega)],$$

$$f_2(\beta', \Omega) = f_2[\beta, \Omega],$$

$$f_3(\gamma', \Omega) = f_3[\gamma, \Omega].$$

These have the solution

$$\gamma' = \gamma,$$

$$\beta' = \beta,$$

$$\alpha' = T(\beta, \gamma, \Omega).$$

If T has the form $r\beta + s\gamma$, then Grassmann's linearity laws are predicted to hold for dichoptic matching, regardless of the non-linearities in the functions f_1, f_2, f_3. So no such theory will do. A non-linear and/or Ω-dependent substitution T might be pursued within a Young-Helmholtz or an opponent-colour theory, but neither the data nor knowledge of physiology suggest an appropriate choice.

It is possible that the tritanopic vision of this observer is changed from the normal in more than one way; for example, α could enter each of the normal functions f_i in several ways (additively, multiplicatively, etc.) and each such occurrence could involve a different substitution of form (2). Because of the similarity to congenital tritanopia we are reluctant to accept such a complication and, in any case, to do so would open such a wide range of possibilities that it seems hopeless to narrow them down again with the constraints presently available. The present data resist a full explanation. They serve to place strong constraints on, and provide a challenge to, the formulation of theories of colour perception.

Acknowledgments

This work was assisted by a grant EY-00197-23 from the National Eye Institute to M. Alpern. We are indebted to John Patterson, Jr, for dedicated and concentrated effort as a meticulous observer throughout the extended period of measurements required in this study. We also thank Dr. E. H. Adelson for helpful discussion.

References

Alpern, M., Kitahara, K. & Krantz, D. H. (1983). Classical tritanopia. *J. Physiol.* **335**, 655–681.

Birch-Cox, J. (1976). A case of acquired tritanopia. *Mod. Probl. Ophthal.* **17**, 325–330.

Boynton, R. M. & Gordon, J. (1965). Bezold-Brücke hue shift measured by color-naming technique. *J. opt. Soc. Am.* **55**, 78–86.

Boynton, R. M., Schafer, W. & Neun, M. E. (1964). Hue-wavelength relation measured by color-naming method for three retinal locations, *Science, N. Y.* **146**, 666–668.

Burian, H. M. & von Noorden, G. K. (1974). Binocular vision and ocular motility. In *Theory and Management of Strabismus*, pp. 216–219. St Louis: C. V. Mosby.

Crone, R. A. (1973). *Diplopia*, pp. 118–120. Amsterdam: Excerpta Medica.

Dieter, W. (1927). Ueber die subjektiven Farbenempfindungen bei angeborenen Störungen des Farbensinnes. *Z. Sinnesphysiol.* **58**, 73–79.

Gordon, J. & Abramov, I. (1977). Color vision in the peripheral retina, II. Hue and saturation. *J. opt. Soc. Am.* **67**, 202–207.

Graham, C. H. & Hsia, Y. (1958). The discriminations of a normal and a color-blind eye in the same person. *Proc. Am. Phil. Soc.* **102**, 168–173.

Graham, C. H. & Hsia, Y. (1967). Visual discriminations of a subject with acquired unilateral tritanopia. *Vision Res.* **6**. 469–479.

Graham, C. H., Sperling, H. G., Hsia, Y. & Coulson, A. H. (1961). The determination of some visual functions of a unilaterally color-blind subject: methods and results. *J. Psychol.* **51**, 3–32.

Grützner, P. (1972). Acquired color vision defects. In *Handbook of Sensory Physiology* VII/4, ed. Jameson, D. & Hurvich, L. M., pp. 642–659. Berlin, Heidelberg & New York: Springer-Verlag.

Hochberg, J. (1971). Perception II. In Woodworth & Schlosberg's *Experimental Psychology*, ed. King, J. W. & Riggs, L. A., pp. 532–546. New York: Holt, Rinehart & Winston.

Holmgren, F. (1881). How do the colour-blind see the different colours? *Proc. R. Soc. Lond.* **31**, 302–306.

Hurvich, L. M. & Jameson, D. (1955). Some quantitative aspects of an opponent-colors theory, II. Brightness, saturation, and hue in normal and dichromatic vision. *J. opt. Soc. Am.* **45**, 602–616.

Indow, T. & Stevens, S. S. (1966). Scaling of saturation and hue. *Percept. Psychophys.* **1**, 253–271.

Ingling, C. R., Jr, Scheibner, H. M. O. & Boynton. R. M. (1970). Color naming of small foveal fields. *Vision Res.* **10**, 501–511.

Jameson, D. & Hurvich, L. M. (1959). Perceived color and its dependence on focal surroundings, and preceding stimulus variables. *J. opt. Soc. Am.* **49**, 890–898.

Judd, D. B. (1948). Color perceptions of deuteranopic and protanopic observers. *J. Res. natn. Bureau Standards* **41**, 247–271.

Kitahara, S. (1936). Ueber klinische Beobachtungen bei der in Japan haeufig vorkommenden Chorioretinitis centralis serosa. *Klin. Monatsbl. Augenheilkd.* **97**, 345–362.

Kohler, I. (1962). Experiments with goggles. *Sci. Am.* May, 2–12.

Krantz, D. H. (1975). Color measurement and color theory: I. Representation theorem for Grossmann structures. *J. math. Psychol.* **12**, 283–303.

Krauskopf, J. (1978). On identifying detectors. In *Visual Psychophysics and Physiology*, ed. Armington, J. C., Krauskopf, J. & Wooten, B. R., pp. 283–295. New York & London: Academic Press.

Krauskopf, J. & Srebro, R. (1965). Spectral sensitivity of color mechanisms: derivations from fluctuation of color appearance near threshold. *Science, N.Y.* **150**, 1477–1479.

Larimer, J., Krantz, D. H. & Cicerone, C. M. (1974). Opponent-process additivity. I. Red/green equilibria. *Vision Res.* **14**, 1127–1140.

Larimer, J., Krantz, D. H. & Cicerone, C. M. (1975). Opponent-process addtivity. II. Yellow/blue equilibria and nonlinear models. *Vision Res.* **15**, 723–731.

MacLeod, D. I. A. & Lennie, P. (1976). Red-green blindness confined to one eye. *Vision Res.* **16**, 691–702.

Middleton, W. E. K. & Holmes, M. (1949). The apparent colors of surfaces of small subtense—a preliminary report. *J. opt. Soc. Am.* **39**, 582–592.

Moeller, J. R. (1976). Measuring the red/green quality of lights: a study relating the Jameson and Hurvich red/green cancellation valence to direct magnitude estimation of greenness. Ph.D. Thesis, University of Michigan.

Mollon, J. D. & Polden, P. G. (1977). An anomaly in the response of the eye to light of short wavelength. *Phil. Trans. R. Soc.* **278**, 207–240.

Nutting, P. G. (1913). A new precision colorimeter. *Bull. Bureau Standards* **9**, 1–5.

Ohba, N. & Tanino, T. (1976). Unilateral colour vision defect resembling tritanopia. *Mod. Probl. Ophthal.* **17**, 331–335.

Pearlman, A. L., Birch, J. & Meadows, J. C. (1979). Cerebral color blindness: an acquired defect in hue discrimination. *Ann. Neurol.* **5**, 253–261.

Purdy, D. M. (1931). On the saturations and chromatic thresholds of the spectral colors. *Br. J. Psychol.* **21**, 283–313.

Sloan, L. L. & Wollach, L. (1948). A case of unilateral deuteranopia. *J. opt. Soc. Am.* **38**, 502–509.

Smith, D. P. (1973). Color naming and hue discrimination in congenital tritanopia and tritanomaly. *Vision Res.* **13**, 209–218.

Stiles, W. S. (1946). A modified Helmholtz line-element in brightness-colour space. *Proc. phys. Soc.* **58**, 41–65.

Stiles, W. S. (1967). Mechanism concepts in colour theory. *J. Colour Group* **11**, 106–123.

Verriest, G. (1963). Further studies on acquired deficiency of color discrimination. *J. opt. Soc. Am.* **53**, 185–195.

von Helmholtz, H. (1896). *Handbuch der Physiologischen Optik*, 2nd edn. pp. 275–376. Hamburg & Leipzig: L. Voss.

von Hippel, A. (1980). Ein Fall von einseitiger, congenitaler Roth-Gruenblindheit bei normalem Farbensinn des anderen Auges. *von. Graefe Arch. Ophthal.* **26** (2), 176–185.

von Kries, J. (1919). Uebereinen Fall von einseitiger angeborener deuteranomalie. *Z. Sinnesphysiol.* **50**, 137–161.

Walls, G. L. & Mathews, R. W. (1952). *New Means of Studying Color Blindness and Normal Foveal Color Vision*, pp. 1–172. University of California Publications in Psychology 7.

Willmer, E. N. (1949). Further observations on the properties of the central fovea in colour-blind and normal subjects. *J. Physiol.* **110**, 442–446.

Wooten, B. R. & Wald, G. (1973). Color-vision mechanisms in the peripheral retinas of normal and dichromatic observers. *J. gen. Physiol.* **61**, 125–145.

Wyszecki, G. & Stiles, W. S. (1967). *Color Science: Concepts and Methods, Quantitative Data and Formulas*, p. 519. New York: Wiley.

10 The Genes for Color Vision

Jeremy Nathans

"Colors," said Leigh Hunt, a 19th-century poet, "are the smiles of Nature." Just how does an observer distinguish one smile from another? To a great extent the answer lies in the three classes of cone-shaped, color-sensing cells in the retina of the eye. Each class responds differently to light reflected from a colored object, depending on whether the cells have within them red, green or blue pigments: light-absorbing proteins particularly sensitive to wavelengths in either the long-wave (red), intermediate-wave (green) or short-wave (blue) region of the visible spectrum. The relative amounts of light absorbed by each class of cones are translated into electrical signals by retinal nerves and then transmitted to the brain, where the overall pattern evokes the sensation of a specific hue.

The role of the pigments in color discrimination has been known for decades, and yet their structures were not elucidated until recently. My colleagues and I have now identified the genes that code for the pigments, deciphered their structures and thereby deduced the amino acid sequences of the encoded proteins. This work, completed at the Stanford University School of Medicine, should soon lead to the isolation of the pigments themselves and a detailed examination of how they function. Our studies have also provided clues to the evolution of normal color perception and the variant color vision that is often called color blindness. (Actually the term is a misnomer: few people perceive no color at all.)

The new findings add detail to a picture of color vision pieced together over the past several centuries. Isaac Newton made the first major contribution some 300 years ago when he discovered the color spectrum. He found that sunlight, or white light, decomposes into a continuous sequence of colors when it is refracted by a glass prism. He also recognized that light at each angle of refraction has a characteristic color, ranging from red for the least-refracted rays through orange, yellow, green, blue and violet for rays that are refracted progressively more. Today each angle of refraction, and hence each pure color, is known to correspond to light of a distinct wavelength.

Newton further observed that the human eye often cannot distinguish between colors formed by quite different combinations of lights. He found, for example, that certain pairs of lights with different angles of refraction, such as red and green, could be mixed to produce a color sensation indistinguishable from the sensation produced by a pure third light—yellow in this case—whose angle of refraction was intermediate between those of the original lights.

By the late 18th century workers had extended Newton's observations and learned that color vision is trichromatic. This means most colors can be matched by

a mixture of three primary lights; in all other instances a match can be achieved by mixing two of the primaries as before but adding the third primary to the given color. A variety of monochromatic, or pure, lights can act as primaries, but all sets of primaries consist of one long-wave, one intermediate-wave and one short-wave light; when the three primaries are mixed in equal parts, they produce the sensation of white. By convention, red, green and blue lights are today considered to be "the" primaries.

The English physician and physicist Thomas Young suggested in 1802 that trichromacy is a reflection of human physiology. He proposed that the colors one sees are determined by the relative extents of excitation of three types of sensors. "As it is almost impossible to conceive each sensitive point of the retina to contain an infinite number of particles, each capable of vibrating in perfect unison with every possible undulation," he noted, "it becomes necessary to suppose the number limited, for instance, to the three primary colors." It took time, but Young was eventually shown to be correct. The three classes of sensors—the cones—are now known to have overlapping but distinct sensitivities to light. For instance, the red and green receptors both absorb orange light, but the red receptor does so more efficiently (plate 6).

Shortly before Young put forward his theory, a contemporary, John Dalton (the father of atomic theory), helped to arouse interest in the study of variant color vision. Such work has paralleled and greatly informed the study of normal color vision. In Dalton's first paper to the Manchester Literary and Philosophical Society, published in 1794, he reported that he did not see colors as others saw them. "That part of the image which others call red appears to me little more than a shade or defect of light," he said. He also added that orange, yellow and green appeared to him as "what I should call different shades of yellow." Today deficiencies in the ability to discriminate between colors in the red-to-green region of the spectrum ("red-green discrimination"), which are found in roughly 8 percent of Caucasian males and 1 percent of females, are sometimes referred to as Daltonism. Defects in the ability to distinguish among colors in the blue part of the spectrum also occur but are rare; I shall not discuss them in detail.

In the mid-19th century the Scottish physicist James Clerk Maxwell identified two types of Daltonism by displaying various colors to his subjects and then systematically examining the colors they could not distinguish [see "Visual Pigments and Color Blindness," by W. A. H. Rushton; Scientific American, March, 1975]. Following Young's three-receptor theory, Maxwell estimated the light sensitivities of the three receptors and divided his color-variant subjects according to whether they confused colors that equally excited either the red and blue or the green and blue receptors; presumably subjects with normal color vision distinguished such colors by

differences in the excitation levels of their green and red receptors respectively. Maxwell correctly inferred that one group of color-variant subjects was missing the green receptor and the other group was missing the red. I and others refer to these groups as green$^-$ (green-minus) or red$^-$ (red-minus) dichromats.

Later in the 19th century the English mathematician and physicist John William Strutt, better known as Lord Rayleigh, introduced the anomaloscope, a device that even to this day is the centerpiece of color-vision testing. The anomaloscope projects three different monochromatic lights onto a screen. In studies of color discrimination in the red-to-green part of the spectrum a deep red and a green light are projected onto half of the screen so that they mix, and a yellow light is projected separately onto the other half; subjects adjust the ratio of the red light to the green as well as the intensity of the yellow light until the two halves of the screen appear to be matched.

The design of the anomaloscope relies on the fact that people with normal color vision have two classes of color detectors—the red and the green—operating at the red-to-green end of the color spectrum. (The blue sensors are not affected by the test lights.) Subjects with normal color vision perceive a match when the red and the green sensors each absorb an equal amount of light (now quantified as an equal number of photons per second) from both sides of the screen. They match the yellow with a highly reproducible ratio of red light to green light (plate 7). In contrast, red$^-$ and green$^-$ dichromats can match the yellow light with either the red or the green light alone; they can also match any ratio of red and green with the yellow light. They can make such matches because all three lights are detected by a single class of receptors; by adjusting the intensity of a single light, a dichromat can always equalize the number of photons captured from the two sides of the screen.

Such differences between normal subjects and red$^-$ and green$^-$ dichromats enabled Rayleigh to readily pick out the dichromats with his new device. He also identified two additional groups of color-variant subjects by testing his friends and relatives. Like normal subjects (and unlike the dichromats), these variant individuals required some mixture of red and green lights to match the yellow, but they chose unusual ratios. One group required more green and less red; the other group required the reverse. Rayleigh concluded that these subjects, now known as green-anomalous and red-anomalous trichromats, had green or red receptors with atypical spectral sensitivities.

By the mid-20th century such psychophysical studies, which depended on the judgment of subjects, strongly supported Young's three-receptor theory, and other studies had suggested that the cone cells of the retina served as those receptors. Finding direct proof for these ideas remained technically challenging, however. One

major obstacle was that the cones were difficult to isolate. They are intermingled throughout the retina with the much more numerous rod cells, photoreceptors responsible for black-and-white vision in dim light.

Nevertheless, ingenuity won out. In the 1960's Paul K. Brown and George Wald of Harvard University and Edward F. MacNichol, Jr., William H. Dobelle and William B. Marks of Johns Hopkins University built microspectrophotometers capable of determining the absorbance of a single photoreceptor cell. The device passes a variable-wavelength light (one whose wavelength is changeable) through the color-detecting region of a cone and passes an identical beam through a different region, testing wavelengths across the spectrum; the difference in the intensity of the emerging beams at a specific wavelength is a measure of the absorbance of the color-detecting region at that wavelength. The studies employing the device demonstrated that cones taken at autopsy from human retinas did indeed exhibit three distinct absorbance spectra. The observed spectra agreed well with the sensitivities predicted by psychophysical studies.

A plot of the relative fraction of photons absorbed per second by each class of cones against the wavelengths of the visible spectrum yields three bell-shaped curves. The blue cones absorb wavelengths ranging from 370 nanometers (billionths of a meter) to 530 nanometers and are most sensitive to wavelengths of 420 nanometers. Both the green and the red cones are active across most of the spectrum but are particularly sensitive to wavelengths between about 450 and 620 nanometers. The green cones are most efficient at 535 nanometers, the red cones at 565 nanometers.

Beginning in the 1970's new evidence that dichromats lack one or another class of receptors emerged. William A. H. Rushton of the University of Cambridge directed a variable-wavelength light into the eyes of dichromats and measured the light reflected from—and hence not absorbed by—the retina; he thereby demonstrated that specific wavelengths are not absorbed normally by dichromats. More recently, James K. Bowmaker of the University of London, John D. Mollon of Cambridge and H. J. A. Dartnall of the University of Sussex showed with a microspectrophotometer that a retina obtained from a green⁻ dichromat did not have the green class of cones.

New evidence also yielded clues to the basis of anomalous trichromacy. By means of psychophysical techniques Rushton and, separately, Thomas P. Piantanida and Harry G. Sperling, who were then at the University of Texas, demonstrated that the spectral-sensitivity curves of anomalous red and green receptors lie in the interval between the normal red and green absorbance curves.

With the existence of three distinct classes of cones firmly established, in the early 1980's my colleague David S. Hogness and I turned our attention to the genetic

bases of normal and abnormal color vision. In addition to aiding in the effort to isolate the pigment proteins, we hoped to supplement the findings of classical genetic studies that traced the inheritance of aberrant color vision within families.

Such studies built on the old observation that deficiencies in red-green discrimination are commoner in males than in females. Analysis of this pattern indicated that genes on the X (sex) chromosome are responsible for the variation. Males will have variant red-green discrimination if their single X chromosome (inherited from the mother) carries the trait; females will be affected only if they receive a variant X chromosome from both parents. The studies also indicated that variations in blue sensitivity are rooted in a gene on some nonsex chromosome. We planned to test the most straightforward explanation for these inheritance patterns, namely that color-vision variations result from inherited alterations in the genes encoding the cone pigments. Presumably mutations in such genes could result in the loss of a functional pigment or in the production of a pigment with an abnormal absorbance spectrum.

Our approach involved isolating the genes that code for the color pigments and comparing their structures in people with normal and variant color vision. Frequently one isolates genes by determining the amino acid sequences of the proteins they encode and parlaying that information into clues about the structure of the genes. Because virtually nothing was known about the structure of the color-pigment proteins when we began our work, we settled on a less direct strategy.

We started with the assumption that the cone pigments and the rod pigment, rhodopsin, all evolved from a common ancestral visual pigment and that as a result the present-day genes probably have some similar sequences of nucleotide bases: the four different chemical units whose sequence along the DNA helix encodes information. If we knew the structure of the rhodopsin gene, we reasoned, we could learn something about the structure of the cone-pigment genes. At the time neither human rhodopsin nor its gene had been isolated, but investigators had successfully isolated bovine rhodopsin from the retinas of cattle. Even better, Yuri A. Ovchinnikov and his colleagues at the M. M. Shemyakin Institute of Bioorganic Chemistry in Moscow and Paul A. Hargrave and his co-workers at Southern Illinois University had deciphered the amino acid sequence of the protein. That information would be our springboard for identifying the cone-pigment genes.

We planned to isolate the bovine rhodopsin gene and then use it as a probe to identify the human rhodopsin gene and the cone-pigment genes. The plan relied on a technique known as DNA hybridization, which exploits the fact that a single strand of DNA will form a stable double helix with a second strand if the sequence of nucleotide bases along one strand is complementary to the sequence along the other

strand. In particular, the base adenine always pairs with thymine, and guanine always pairs with cytosine.

The hybridization technique has many steps, but in essence an investigator chemically cuts up the double strand of DNA to be probed and produces multiple copies of each fragment by cloning it. A sample from each clone is split into single-strand DNA, and a radioactively labeled probe, another piece of single-strand DNA, thought to be complementary to the gene one hopes to identify is added to the samples. If all goes well, the probe binds stably to its complement, thereby picking out the target gene (plate 8).

Normally we would set about developing a probe that would accomplish our first aim—identifying the bovine rhodopsin gene—by generating a list of all possible base sequences that could give rise to the known amino acid sequence of rhodopsin. Then we would test a variety of probes constructed on the basis of that list. Fortunately we were spared much of the time-consuming process, because a probe for identifying the bovine rhodopsin gene was at hand. H. Gobind Khorana, Daniel D. Oprian and Arnold C. Satterthwait of the Massachusetts Institute of Technology and Meredithe L. Applebury and Wolfgang Baehr of Purdue University had already identified a DNA sequence that bound efficiently to messenger-RNA molecules encoding bovine rhodopsin. (Messenger RNA is the single-strand molecule that carries information from DNA in the nucleus to the cytoplasm, where it directs production of the encoded protein. RNA is virtually identical with the coding strand of the DNA from which it is transcribed.) Based on the DNA sequence of Khorana and Applebury and their colleagues, we synthesized a probe and used it to identify the bovine rhodopsin gene.

In the second stage of our plan we enlisted a strand of the newly identified bovine rhodopsin gene as a hybridization probe to search for the human rhodopsin and color-pigment genes. The probe bound strongly to only one segment of human DNA, which subsequent tests identified as the gene encoding human rhodopsin. Our probe also bound, although not as strongly, to three other DNA segments. When we determined their nucleotide sequences, we found the segments had coding regions that were homologous to those of the human and bovine rhodopsin genes (plate 9). Analyses of the amino acid sequences of the encoded proteins showed that the molecules were also similar to one another: some 40 percent of each protein chain was identical with the sequence of rhodopsin.

We naturally suspected that the DNA segments bound by our probe were the three cone-pigment genes, but we wanted further evidence. For instance, we hoped that messenger RNA corresponding to the probe-bound sequences would be found in the retina of the eye, the only place where visual pigments, and hence visual-

pigment RNA's, are produced. Sure enough, the retina did yield RNA corresponding to the probe-bound DNA.

To evaluate whether our findings were consistent with those of classical genetic studies, which would provide more evidence that we had found the color-pigment genes, we determined where on the chromosomes the DNA segments pinpointed by our probe lie. In collaboration with Thomas B. Shows and Roger L. Eddy of the Rosewell Park Memorial Institute in Buffalo, N.Y., we found that two of the three weakly hybridizing genes reside in exactly the region of the X chromosome where classical analyses had placed the source of variant red-green discrimination. We therefore concluded that these genes encode the red and green pigments, and later studies we did with Piantanida confirmed this belief. The third gene, now known to encode the blue pigment, came from chromosome 7, a finding that is consistent with the notion that variant blue color vision is determined by a nonsex chromosome.

The significant homology between the rhodopsin gene and the three cone-pigment genes suggested that all four genes had indeed evolved from the same ancestor. The available evidence supported the notion that at some early stage a primordial gene had given rise to three others: the rhodopsin gene, the blue-pigment gene and a third gene that encoded a pigment sensitive to light in the red-to-green part of the visible spectrum. This third gene recently duplicated, yielding a red- and a green-pigment gene.

We think the red- and green-pigment genes are the product of fairly recent duplication, because they have a strikingly high degree of homology: a full 98 percent of their DNA is identical, suggesting it has had little time to change. The idea that the event took place not long ago, at least in evolutionary terms, is supported by the findings of Gerald H. Jacobs of the University of California at Santa Barbara, who worked with Bowmaker and Mollon. They have shown that New World (South American) monkeys have only a single visual-pigment gene on the X chromosome. In contrast, Old World (African) monkeys, which are more closely related to human beings, appear to have two visual-pigment genes on that chromosome. The addition of the second X-chromosome gene must have occurred sometime after the separation of South America and Africa, and hence of the gene pools of the New and Old World monkeys, some 40 million years ago.

The discoveries described so far were not entirely unexpected, but another finding was. When we studied the visual-pigment genes from the X chromosome of 17 of our male colleagues, all of whom had normal color vision, we found that the red-pigment gene was always present in a single copy, but the other gene—the one encoding the green pigment—was present in one, two or three copies (plate 10).

The existence of multiple copies was surprising, because one green-pigment gene is presumably sufficient for normal color vision.

Recent experiments suggest that the visual-pigment genes lie in a head-to-tail array on the X chromosome and that the tandem arrangement accounts for the variability in gene number. Tandem genes that are similar have a tendency to undergo changes in copy number in the course of meiosis, the process of cell division that gives rise to sperm and eggs. Cells carry somewhat different versions of each chromosome; during meiosis the matching chromosomes pair up and recombine, or swap segments. Ordinarily the exchange is equal, so that each chromosome neither gains nor loses genes. Occasionally, however, two segments that are highly homologous can recombine erroneously, undergoing what is called unequal homologous recombination. Either one chromosome gains one or more copies of an existing gene at the expense of the other chromosome or the two chromosomes swap material from related but different genes. The chromosomes that result are then passed on in sperm or eggs.

It is quite easy to imagine how unequal homologous recombination might have given rise to the varied configuration of green-pigment genes in people with normal color vision. Consider two matching chromosomes, each carrying one red-pigment gene next to two green-pigment genes. If a green-pigment gene on one of the chromosomes crossed over to the other chromosome during meiosis, one daughter cell would carry a chromosome that had one red- and one green-pigment gene, but the other would have one red-pigment gene and three green-pigment genes—precisely the kind of variation seen in our subjects with normal color vision. There is only a single red-pigment gene in every case because that gene lies at the very edge of the array of color-pigment genes. A gene in that position is highly unlikely to be duplicated (or deleted) by homologous recombination.

Unequal homologous recombination appears to be responsible not only for the duplication of green-pigment genes in people with normal color vision but also for the great majority of deficiencies in red-green discrimination. In collaboration with Piantanida we studied DNA from 25 men who according to Rayleigh anomaloscope tests had variant red-green discrimination. All but one of the subjects had abnormal configurations of red- and green-pigment genes as a consequence of unequal homologous recombination.

Which configurations of genes yield red⁻ or green⁻ dichromats and which produce anomalous trichromats? We found that most of the green⁻ dichromats (those who apparently lacked the green receptor) had simply lost all green-pigment genes. In some green⁻ dichromats, however, the green-pigment gene had been replaced by a

hybrid gene: the DNA sequences near the start of the gene were derived from a green-pigment gene and the remaining sequences were derived from a red-pigment gene. Apparently the chromosome with the hybrid gene resulted from recombination in which part of the normal green-pigment gene changed places with part of a red-pigment gene.

Why did the hybrid gene not result in a functioning green receptor? It seems likely that the DNA sequences at the start of either normal or hybrid genes determine the cell type in which the gene will be active, and that the more distal sequences determine the type of pigment produced. This would result in the production of red pigment in cells that would normally become green cones, allowing them to function only as red receptors.

Among men whose Rayleigh anomaloscope tests indicated an absence of the red receptor (red$^-$ dichromats), the great majority did not lack red-pigment sequences entirely. Instead their single red-pigment gene had been replaced by a hybrid in which only the initial DNA sequences were from a red-pigment gene. We surmise that this hybrid gene results in the production of a green pigment in cells that would normally have become red cones, in effect endowing people who carry the gene with all green cones and no red ones.

All the subjects with anomalous trichromacy had at least one hybrid gene in addition to some or all or the normal visual-pigment genes. We suppose that in these individuals the hybrid genes encode proteins that have anomalous spectral sensitivities. Our findings suggest that a variety of anomalous pigments are possible and that the particular spectral sensitivities of these pigments are determined by the exact point of crossing-over within the hybrid gene. The larger the fraction of the hybrid derived from the green-pigment gene is, the more greenlike the encoded pigment will be; likewise, if a large fraction of the hybrid is derived from the red-pigment gene, the encoded pigment will be more redlike. If we are correct, our data would account well for the psychophysical observation that anomalous receptors most efficiently absorb wavelengths lying in the interval between the wavelengths that are most efficiently absorbed by normal red and green cones.

Exciting questions concerning the role of cones and pigments in color vision remain. What is it about the visual pigments that gives them their distinctive absorbance spectra? How does each photoreceptor cell determine which visual pigments to produce? How are connections between photoreceptor cells and high-order neurons formed during development? For those seeking answers to these and related questions, inherited variations in human color vision are a gift, offering a unique window to the inner workings of the eye.

Bibliography

Three-pigment color vision. Edward F. MacNichol, Jr., in *Scientific American*, Vol. 211, No. 6, pages 48–56; December, 1964.

The molecular basis of visual excitation. George Wald in *Nature*, Vol. 219, No. 5156, pages 800–807; August 24, 1968.

Molecular genetics of human color vision: The genes encoding blue, green, and red pigments. Jeremy Nathans, Darcy Thomas and David S. Hogness in *Science*, Vol. 232, No. 4747, pages 193–202; April 11, 1986.

Molecular genetics of inherited variation in human color vision. Jeremy Nathans, Thomas P. Piantanida, Roger L. Eddy, Thomas B. Shows and David S. Hogness in *Science*, Vol. 232, No. 4747, pages 203–210; April 11, 1986.

VI CENTRAL DEFECTS OF COLOR VISION AND NAMING

11 Color-Naming Defects in Association with Alexia

Norman Geschwind and Michael Fusillo

Disturbances of color identification in association with the syndrome of pure alexia without agraphia have been repeatedly recognized in the past. Lange[1] reviewed these extensively. More recently Critchley[2] has reviewed the literature on such disturbances of color identification. He expressed skepticism as to the existence of the syndrome of aphasia for color names and advanced the view that such cases probably represented the combination of a perceptual deficit with a minimal aphasia.

We have recently had the opportunity to clarify the problem of color-name aphasia by repeated study of a patient with the syndrome of pure alexia without agraphia over several months. On the basis of these studies, we believe that the evidence is now clear that a disturbance of color-naming, or more correctly, of matching the spoken name of the color to the seen color, can be shown to exist in the demonstrated absence of any perceptual disturbance. The patient to be described eventually came to postmortem examination and demonstrated, as will be pointed out, the classic pathology of the syndrome of pure alexia without agraphia as first described by Dejerine[3] and repeatedly confirmed since then. A preliminary description of this case has been published.[4]

Report of a Case

H. C. (MMH 426–89), a 58-year-old machinist had been known to be diabetic for 17 years. He was transferred to the Massachusetts Memorial Hospital (where he was under the care of Dr. Charles Kane) from another hospital on Sept 24, 1962, because of right-sided weakness, confusion, and difficulty expressing himself of several days' duration. These difficulties had come on abruptly during a hospitalization for reinvestigation of a long-standing severe sensorimotor polyneuropathy.

The past history was not contributory except for long-standing diabetes mellitus and episodes of postural hypotension in the few months preceding his admission. There was no history of hypertension or previous signs or symptoms of cerebral vascular disease.

Lumbar punctures performed at the other hospital on previous admissions had shown on one occasion a protein of 113 mg/100 cc, and on another 330 mg/100 cc. Pressure, cell count, and serology were normal on both occasions. On these admissions serum proteins were normal and a rectal biopsy for amyloidosis was negative. Except for the evidence of diabetes, the results of other laboratory studies were normal. Before admission to the Massachusetts Memorial Hospital the patient's medications had included protamine zinc insulin suspension (60 units per day), chlorpropamide (Diabinese) (25 mg three times per day), thiamine (100 mg daily), and liver extract and cyanocobalamin (Vitamin B_{12}) injections every other day.

General physical examination on admission to the Massachusetts Memorial Hospital revealed a well-developed, well-nourished white man in no acute distress who, although

right-handed, showed lack of spontaneous use of the right arm. The vital signs were as follows: blood pressure, 128/78 mm Hg, pulse, 120 beats per minute and regular; respirations 24 breaths per minute and regular; and temperature, 98.6 F. If the patient remained erect for 15–20 minutes, his blood pressure would drop and he would develop a shock-like syndrome so that he had to be maintained almost continuously in bed. The skin revealed stasis dermatitis, dependent rubor, and trophic changes over both lower extremities. There was a trace of pretibial edema. The results of the remainder of the general physical examination were within normal limits.

On neurological examination the patient knew his name but did not recall his address. He stated his age incorrectly. He felt that he was still at the other hospital and that it was probably the fall of 1933. He realized, however, that his memory was poor and had insight into the fact that he had been having difficulty naming objects over the past several days prior to admission. He was able to perform simple one-digit calculations. He could recall none of four objects after one minute. There was mild difficulty in naming familiar objects or parts of objects. The patient could obey spoken commands reasonably well but had more difficulty with written commands. He had difficulty in writing, manifested by holding the pen clumsily and by misspelling of words. His ability to write was clearly better than his comprehension of written material. There was minimal right-left confusion. The optic fundi revealed micro-aneurysms, deep punctate hemorrhages, and waxy exudates consistent with diabetic retinopathy. There was no papilledema. There was a dense right homonymous hemianopia. The right pupil was slightly larger than the left, but both reacted to light and on convergence. The rest of the cranial nerve functions were normal. There was a tendency for the right arm to drift downward and laterally when the patient's eyes were shut. There was severe wasting of all four extremities, especially distally. No fasciculations were observed. There was weakness of all four extremities in a distal distribution. Muscle tone was normal throughout. Fine movements were performed clumsily with the right hand. The deep tendon reflexes were absent throughout. The plantar responses were also absent. The patient showed an unsteady, wide-based gait. Sensory examination revealed that pinprick, light touch, and vibratory appreciation were impaired in a fading stocking distribution over both feet to the level of the knees. In addition, position was impaired in the toes of the right foot and the fingers of the right hand. Two-point discrimination, tactile localization, and stereognosis were impaired in the right hand. The patient manifested extinction to touch over the right side of the body on double simultaneous stimulation.

During the first few days of his hospital stay, the patient developed congestive heart failure, pulmonary emboli, diabetic keto-acidosis and gastrointestinal bleeding, for all of which he was treated successfully. Serial electrocardiograms were consistent with a diagnosis of pulmonary emboli. A bilateral superficial femoral vein ligation was performed. A lumbar puncture showed normal pressures, clear cerebrospinal fluid with 2 red blood cells, a sugar of 133 mg/100 cc (with a corresponding blood sugar of 200 mg/100 cc), and a protein of 256 mg/100 cc. The colloidal gold curve was flat. The patient's serum proteins were 5.2 gm/100 cc, and there was a reversal of the albumin-globulin ratio. Serum electrophoresis was within normal limits. X-rays of the skull were also within normal limits. An electroencephalogram on the second hospital day was abnormal, with left postcentral preponderance due to the presence of theta waves at 4 to 7 per second. A repeat EEG about ten days later showed no essential change.

Because of the patient's condition, detailed examination of the higher functions was not possible until the fifth hospital day. At this time he was unable to name simple objects, written words, or letters. He was, however, able to name a circle, a triangle, and a square. There was no right-left confusion and no finger agnosia. The patient was able to follow verbal commands well. There was now some minimal weakness of the right lower extremity, above and beyond the weakness due to the patient's chronic sensorimotor polyneuropathy. On the 22nd hospital day the patient was still unable to name even simple letters, such as C or S. He could not read the words cat, dog, or his own first name. Using his left hand, he demonstrated that he could write much better than he could read. Although he could not read, he was able to copy letters as well as words without any difficulty. He was able to add simple 1-and 2-digit numbers in his head, but was unable to add the same numbers when they were written down on paper.

The patient was finally transferred to a nursing home on the 31st hospital day. The disability in reading was still present, although the medical problem had become well stabilized. During the next eight months, through the kindness of Dr. J. Litter, the patient's private physician, we were enabled to study the patient in detail, first at the nursing home, then at his own home, and finally (through the courtesy of Dr. William Timberlake) at the Lemuel Shattuck Hospital.

When the patient was first seen at the nursing home seven weeks after the acute episode, he demonstrated the following residual picture: The distal symmetrical sensorimotor polyneuritic signs were still present, as well as the right hemianopia. Speech production and comprehension were normal. The recent memory deficits had, however, cleared completely (except for the special difficulties in topography to be mentioned below). The right-sided sensory loss which had appeared at the time of his acute episode had cleared (leaving only the symmetrical distal loss due to the polyneuropathy). Right-left orientation and finger-naming were normal, and he could perform mental arithmetic well. There were no disturbances of consciousness or abstract thought. He could spell words correctly and write them with either hand separately. Handwriting was normal but he wrote slowly. There were no constructional difficulties. Optokinetic nystagmus was present and grossly equal to both the right and left sides. These aspects of his clinical picture remained stable over the next few months.

He showed severe disturbances in spatial orientation and topography. Thus, he could not tell us where the nursing home or his own home were located and incorrectly answered questions about how to get to various points in the Boston area with which he had had extensive experience in the past. It should be stressed, however, that these disturbances cleared to normal in the next few weeks.

In the last months of his life, he developed some new symptoms consisting of vague pains over the right side of the body, especially the thorax, which were diffuse and difficult to characterize. They were increased by repetitive sensory stimulation. Although these raised the suspicion of an incipient thalamic syndrome and were repeatedly complained of, they never became agonizing.

In addition to the findings listed earlier, he showed certain disabilities which remained essentially stable over the next eight months and which were the object of special study. He complained of distortions of his visual field which we failed to be able to characterize. These, however, did not in any way affect his ability to copy visual forms or words correctly. He could neither read words aloud nor comprehend their meaning but could copy them correctly. He could not match words to appropriate pictures. He could read only some single letters;

two-digit numbers, by contrast, were usually read correctly. Only one error was made in several months in the naming of objects, photographs, or line drawings. He could spell words presented to him orally and could comprehend words spelled to him orally. He could write spontaneously and to dictation but could not read his own handwriting if it was shown to him later. Also, in striking contrast to his correct object identification was his difficulty in color identification, which was as persistent as his alexia. We will give in the next section a detailed account of the tests employed to study this color identification difficulty and the results obtained.

Studies of Color Identification

Naming of Seen Colors

Colored sheets of paper were presented to the patient. He misnamed in almost all cases, and there was no consistency to his misnaming except that the response "gray" or "grayish" was the most common. His misnamings applied not only to colors in the narrow sense of the term but appeared also when he was presented with black, white, or gray.

Arbitrary Colored Objects Colored pictures of objects which are not usually of a fixed shade, eg, neckties, crayons, dresses, blankets, or curtains, were then presented to the patient. His errors were similar to those produced with colored pieces of paper.

Distinctively Colored Objects or Pictures Objects or pictures of objects which are usually of a certain color or are conventionally regarded as being of a certain color, eg, apple, banana, telephone, milk, bricks, were presented to the patient. He failed in these as he had in the first two categories. These errors occurred although the patient could name the objects correctly and could, as shown below, tell what colors these objects normally were. Thus, the patient, shown a pad of writing paper, said it was tan; but when asked, said that writing paper was usually white. He insisted that this pad "looked tan" to him. He misnamed the color of the red bricks in the fireplace in his own living room.

Verbal Memory for Colors of Objects

The patient was asked to state the usual colors of specified objects, eg, apples, bananas, the sky, etc. He performed without error on this task.

Verbal Memory for Objects Having a Certain Color

The patient was asked to name the usual colors of objects named by the examiner. He performed without error on this task.

Comprehension of Names of Seen Colors (Matching of Seen Colors to a Name Given Verbally)

The patient was shown a group of colored objects or sheets of paper and was asked to select a specific color, eg, "Show me the red sheet of paper." The patient failed in this task almost always. He would also fail in simpler forms of this task: being shown an object and asked, "Is this red?" he would answer at random.

Color-Matching

Several versions of this test were carried out and all were performed correctly. Thus, the patient, when given two rows of colored papers, would successfully match each paper in one row to the same color in the other row. In order to rule out that the patient was doing this task by means of brightness differences, a more complex form of the test was set up whereby the colors differed markedly in brightness and saturation. The patient performed without error in this task.

A still more complex task was set up in which the patient was given a pile of colored chips of papers and permitted to sort them. He correctly collected all of the items of a particular kind. Thus, he correctly sorted a group of chips of two slightly different shades of green into two separate piles.

Ordering Shades of One Color

The patient could correctly arrange a series of reds in order from bright red at one end to pink at the other.

Matching Seen Colors to Pictures of Objects

The patient was given a group of colored papers or crayons and a group of line drawings of objects. He correctly matched the colors to the objects, eg, a yellow crayon to a banana.

Pseudo-Isochromatic Color Tests

The patient was given both the American Optical Company and the Ishihara pseudo-isochromatic tests of color vision. He performed both without error. The American Optical test was performed readily because it uses geometrical forms which the patient could name readily. On the Ishihara test the patient either named the digits (as we have noted above the patient could read most two-digit numbers although he could not generally read two-letter pairs) or traced them out with his finger. On those parts of the Ishihara test using colored paths he traced these correctly. It should be noted that one of the examiners (NG), who is moderately

red-green blind, performed very poorly on these tests, while the patient performed as well as the examiner (MF) with normal color vision. Despite this the patient's descriptions of the color in which the correct answer was printed were grossly inaccurate. Thus, one of the cards which shows a bright red 7 on a gray background was described as having a gray 7.

In addition to these tests of the patient's color identification ability, certain features of his performance on these tasks deserve to be mentioned here. On of these was the fact that the patient never replied with a simple "I don't know" to the demand for naming a color. Furthermore, when offered the correct name from a group, he would not accept it. In fact, if the patient had replied "gray" and was told by the examiner that the correct answer was "red," he would often say, "It may look red to you, doctor, but it looks gray to me" or " Well, maybe it's a reddish-gray." When pressed, he would almost always insist that the color "looked" to him as he had named it. Sometimes he would explain his response by saying that his eyes weren't working well. On one occasion, shown a pad of writing paper, he said that it was tan. When we asked him what color writing paper normally was, he said, "It's usually white but this looks tan." When we told him that the paper was actually white, he suddenly said, "I don't understand what happened: it now looks white." We will return to this in the Comment section.

The patient only once made an error in sorting. Our usual technique for this task was to hand him a colored chip (without naming the color) and the patient was told to select all the chips which looked like the one demonstrated. This he did without error. His only faulty sorting occurred on a variant of the task. We showed him a chip and said. "This is red. Now pick out all the red chips." He proceeded to form a pile which contained all the red chips but also all the chips of one of the two shades of green that were in the group. When asked what his pile contained, he picked up a red chip and said, "This is red." He then picked up one of the chips of the particular shade of green that he had selected and said, "This is another shade of red." We then had him match the chips from his pile (without our mentioning any color names) to the green chips of the shade he had not chosen. He carefully matched all of the shades of green he had chosen to these but did not select out any of the red ones. We will return to this curious result in our Comment section.

Pathological Examination

The patient died on Dec 21, 1963, 15 months after the onset of his original difficulty, at the Lemuel Shattuck Hospital. The brain after removal was fixed in formaldehyde solution (formalin).

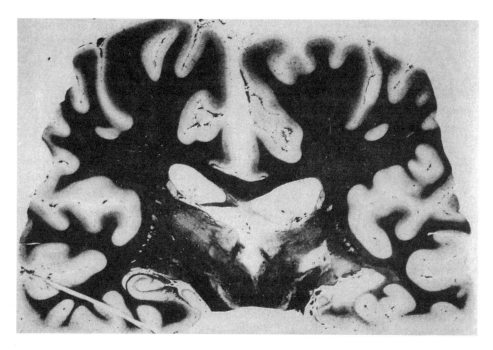

Figure 11.1
In this section (2200) the total degeneration of the left fornix is seen as well as the cystic lesion in the left posterolateral-ventral nucleus of the thalamus. Destruction of the left hippocampus and enlargement of the temporal horn of the left lateral ventricle are also evident.

On gross examination of the uncut brain fixed in formaldehyde solution, the only obvious finding was an old softening in the region of the left occipital pole.

The brain was embedded in celloidin, and sections were cut at 35μ intervals with alternate sections being stained for myelin and cells. Representative sections are shown in the figures.

The right hemisphere was normal except for secondary degenerations resulting from lesions in the left hemisphere. Figure 11.1 (section 2200) shows that the left hippocampus was infarcted with resulting complete degeneration of the left fornix. In addition, an infarct is seen in the posterolateral ventral nucleus of the thalamus. The corpus callosum is intact in this section. Figure 11.2 (section 2500) shows that the splenium is infarcted. Figure 11.3 (section 3200) shows the destruction of the left calcarine cortex by the infarct. No other lesions were found in the brain. It was concluded that the areas of infarction noted were all within the distribution of the left posterior cerebral artery.

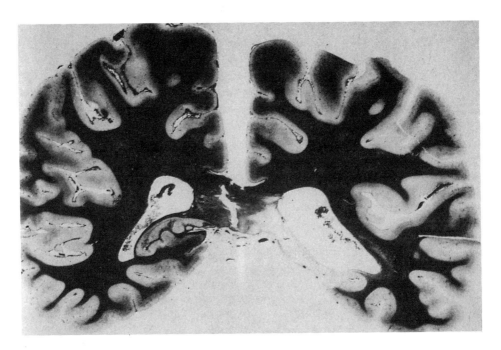

Figure 11.2
Total infarction and degeneration of the splenium of the corpus callosum is seen (section 2500). The cavity
in the center of the splenium is the result of artifact and was not seen in adjacent serial sections of this
region. The gross destruction of the hippocampus on the left is also evident.

Comment

This 58-year-old man entered the hospital originally for investigation of a sensori-
motor polyneuritis which was thought probably to be a complication of his diabetes.
He exhibited severe postural hypotension which appeared after 15 to 20 minutes in
the upright position and was thought to be a manifestation of the polyneuropathy.
This may well have contributed to the acute episode of cerebral infarction from
which the patient suffered. We will try to relate the lesions found at postmortem to
the clinical picture. In essence, we found a long-standing infarction in the distribu-
tion of the left posterior cerebral artery. The left calcarine cortex, the splenium, and
the left hippocampal region were extensively involved, and there was also an infarct
in the ventroposterolateral (VPL) of the left thalamus.

Certain aspects of this clinical picture cleared during our period of observation.
The early general recent memory deficit and the later difficulty in topographic mem-
ory were in this category, as well as the right-sided sensory loss. It seems reasonable

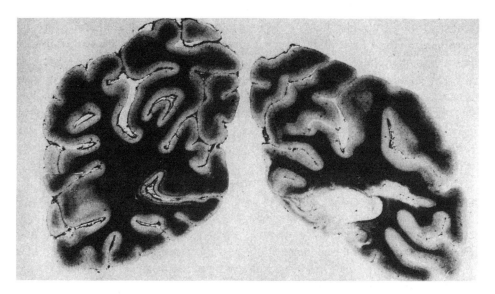

Figure 11.3
The visual cortex on the right is intact and on the left is completely destroyed (section 3200). The optic radiations are also affected. The cystic cavity on the left communicates with the posterior horn on the same side.

that the right-sided sensory loss was a neighborhood effect of the thalamic infarct seen at postmortem. We had conjectured that during his life the patient's complaint (appearing late in his course) of ill-defined vague pains over the right side of the body but sparing the face, and made worse by repeated stimulation was an early thalamic syndrome, and this too may be attributable to the thalamic infarct which involved VPL but spared the trigeminal representation in ventroposteromedial nucleus (VPM). The early recent memory defect may have been only a nonspecific result of an acute episode or may have reflected bilateral ischemia of the medial temporal regions which produced transient but reversible damage on the right side, while leading to a permanent infarct on the left. The alternative possibility should, however, be kept in mind that an infarct of the medial temporal region on one side alone, particularly if that side is the dominant one, might itself be sufficient to cause transient recent memory disturbance despite complete normalcy of the nondominant side. The left medial temporal region might normally be most involved in verbal memory tasks since this is the side of the brain on which speech is localized. Thus, Meyer and Yates[5] and Milner[6] have shown that removal of the left temporal lobe back to 9 cm may produce a severe deficit in verbal memory, while a lesion of the right side does not have this effect. Both the findings of these earlier investigations

and our own might be accounted for by assuming that the normal pathway for verbal memory is from left temporal speech areas to other areas of left temporal neocortex lying more anteriorly which project in turn to the medial temporal region. A left medial temporal lesion would thus produce a recent memory disturbance at least for verbal material. The impairment would probably be transient since impulses from the left speech region could eventually follow an alternative route. Instead of the probable normal route, speech area to the left anterior temporal neocortex to the left medial temporal region, the following route could be taken: speech area to the left anterior temporal neocortex to the right anterior temporal neocortex (via the anterior commissure) to the right medial temporal region. We carefully checked the anterior commissure in the sections of our patient since, in its role as the major commissural connection between the temporal lobes (with the exception of the first temporal gyrus), it would play an essential role in such a compensatory mechanism. The anterior commissure was intact in our patient. Because we cannot rule out that the patient had more widespread ischemia during the acute stage, particularly of the medial temporal regions bilaterally, we can do no more than suggest the possibility of this alternative mechanism.

The difficulty in topographic memory was less transient, since it was still present more than six weeks after onset. It did, however, disappear subsequently. This might be attributable to transient damage to the posterior parietal regions which were not far from his permanent lesions. It is, however, of interest that he did not at this time show a full Gerstmann's syndrome. Another possibility is that the difficulty in topographic memory was simply a part of his more widespread recent memory deficit and had merely cleared more slowly.

The more stable deficits included the right hemianopia which is clearly the result of the infarct of the left optic radiation and calcarine cortex. The persistent complaint of distortion of the visual field was of interest and is similar to phenomena reported by other patients with posterior lesions. We did not investigate this in detail and can only comment briefly on its possible significance. Whitteridge,[7] confirming earlier suggestions by Hubel and Wiesel, and Myers, has recently brought evidence to show that the midline of the visual field is represented by a thin strip of cortex, area 18s (or juxtastriate 18). This region, unlike the primary cortical representation of the other parts of the visual field, has callosal connections; and Whitteridge has hypothesized that these fibers, running in the splenium of the corpus callosum, may serve to maintain continuity of the two visual fields and also to insure that direction of line is preserved across the vertical meridian. A lesion of the fibers of the splenium which interrupted these fibers might lead to a disruption of this mechanism so that lines crossing the vertical meridian might be distorted. For this to be operative in our

patient, it would be necessary to assume that a small midline strip of the right visual field would have had to be intact. While our fields showed no gross sparing, we cannot in retrospect rule out a mild degree of such sparing. We can only mention this mechanism here with the hope that this possibility may be looked into more closely in the future.

The features which were the major objects of our interest were the reading disorder and the difficulty in color identification. The reading disorder cannot be attributed to any elementary visual disturbance, such as the distortion complained of above, since the patient correctly copied the words he could not read and because there was no difficulty in describing complex nonverbal visual arrays. The patient clearly showed the classic syndrome of pure alexia without agraphia,[3] many of whose aspects we have discussed elsewhere.[8,9] The postmortem findings of infarction of the left calcarine cortex and of the splenium coincide with the findings in Dejerine's case which have repeatedly been confirmed.

Our primary reason for presenting this patient is that he provided an especially rich opportunity for prolonged study of the difficulty in color identification, the results of repeated study of which over several months we have summarized above. Inspection of these results shows that the patient's pattern of disabilities can be summed up in one simple formula: The patient failed in all tasks in which he was required to match the seen color with its spoken name. Thus, the patient failed to give the names of colors and failed to choose a color in response to its name. By contrast, he succeeded on all tasks where the matching was either purely verbal or purely nonverbal. Thus, he could give verbally the names of colors corresponding to named objects and vice versa. He could match seen colors to each other and to pictures of objects and could sort colors without error.

By no nonverbal criterion could our patient be shown to have any deficit in color vision. In fact, a laboratory animal testable only by nonverbal means, who scored as well as our patient did on the nonverbal tasks, would clearly be accepted as having normal color vision. Our patient's perfect performance on pseudo-isochromatic tests of color vision reinforces this conclusion.

Our patient's one error on a special variant of the sorting test mentioned above is easily understood. We told the patient that a certain chip was red and to select all the other red ones. He picked up each chip and very slowly examined it. By specifying that we wanted "red" chips, we forced him to name every chip rather than simply to match to the sample chip. By misnaming a chip of one shade of green, he made an error. This error, because of the forced introduction of verbal mediation, may be called a secondary sorting error. Pick[10] referred to the possibility of this type of error. The importance of this type of error is that one must be very careful in testing

for nonverbal matching or sorting not to introduce inadvertently forced verbal mediation which may lead to errors and confuse the examiner into believing that the patient had made a primary perceptual error. We suspect that some errors in sorting or matching described in the older literature may be on this basis.

One might describe the deficit as one of the naming of colors, but this might obscure the fact that the disturbance is a more widespread one since, in fact, the patient also fails to comprehend color-names under circumstances specified above. It is interesting that a similar defect occurs frequently in normal children. Thus, at the time of this study, the same tests applied to our patient were given to the four-year-old son of one of us. He also named colors incorrectly and showed incorrect comprehension of color names yet correctly sorted and matched colors and traced out the correct responses on the Ishihara test. This is not uncommon in children of this age and usually clears within a couple of years, as has indeed been the case for this child.

Color-name aphasia, as it was called, was well recognized by the classic German neurologists (as summarized by Lange[1]). There was, however, some reluctance to accept the defect as one of color-naming alone. Some of the patients made errors in matching or sorting tasks. We have already alluded to some of the difficulties in the interpretation of such tasks. Another problem was the fact that these patients commonly refuse to accept the correct name, as our patient did, or to insist as he did that the color really looks to them like the color they have mentioned and not like the correct color named by the examiner. These facts led to an assertion that these patients were manifesting an "agnosic" defect in addition to the naming defect. In order to consider this thesis, one must consider the anatomical lesions of these cases. Most typically the lesion, as first described by Dejerine[3] for his case of alexia without agraphia, destroys the left calcarine cortex and the fibers of the splenium which carry the callosal fibers of the visual regions. Thus, the left visual cortex is destroyed and the right visual region has lost its commissural connections, so that it is cut off from the speech area in the left hemisphere. This visual-verbal disconnection explains both the reading deficit and the inability to name colors or comprehend their names. It is also evident that the patient will not accept the correct name if offered to him since, if his lesion is extensive enough, he will not be able to compare the name heard in the left hemisphere with the color seen in the right hemisphere. Nor can he describe his color-vision experiences correctly since the part giving the description, ie, the speech area, is disconnected from the part having the visual experience. It is of interest that in this situation the patient does not deny knowing the name but produces confabulatory responses. It has been pointed out elsewhere extensively

that many of the so-called "agnosic" syndromes are actually produced by disconnections of primary sensory regions from speech area, with the resultant confabulatory responses.[9]

A final problem is presented by the discrepancy between color-naming and object-naming. Adolf Meyer[11] hinted at a possible mechanism. Thus, object-naming might be preserved despite the loss of reading in cases of pure alexia without agraphia because an object could arouse tactile associations further forward in the right hemisphere which could then get across the callosum over its intact portions anterior to the splenium. Written words lack tactile associations and, thus, would not reach the speech area via this roundabout route. Colors, like words, have verbal associations (their names)—but unlike objects, no tactile ones. The same explanation could account for the preserved readings of numbers[3,12] in many cases of pure alexia, since numbers have powerful tactile associations as a result of the strong tendency to count on the fingers in childhood. The role of tactile associations in the syndrome of pure alexia without agraphia has been discussed more fully elsewhere.[9]

It is evident that our case effectively answers Critchley's[2] skepticism concerning the existence of amnestic color aphasia and would seem to go against his alternative suggestion that these cases might be accounted for on the basis of the combination of minimal dysphasia with minimal perceptual deficit. Our patient was exhaustively examined to rule out any defect in color perception, and his normal speech and the presence of only one error in object naming over months of repeated examination rules out the possibility of a general anomic aphasia. Furthermore, since the combination of a readily observable mild anomia with a visual field defect is not rare, such striking disturbances of color-naming and comprehension should be common. In fact, they are rare and are not commonly seen in such cases with mild anomias and visual field deficits, as would be demanded by Critchley's hypothesis. The close association of color-name aphasia to pure alexia without agraphia and to a highly specific anatomical lesion clearly runs against the highly nonspecific hypothesis suggested by Critchley.

We do not wish to suggest, however, that all disturbances of color identification are clinically identical with the type discussed here or result from the mechanisms we have outlined. Some of the cases with distortions of color vision (rather than with difficulties of color-naming) presented by Critchley may well be the result of complex alterations in color perception. It is clearly of great theoretical importance not to confuse such cases with the type of problem we have discussed here. Thus, Kinsbourne and Warrington[13] described a patient who had disturbances similar to those of our patient but also showed some difficulties in nonverbal matching, unlike our patient.

Summary

A case history is presented of a patient exhibiting the syndrome of pure alexia without agraphia who also showed marked difficulties in color identification. The patient failed to name seen colors correctly and could not select a color from a group when given its name: in other words, he showed an isolated difficulty in uttering or comprehending the names of seen colors. By contrast, difficulties in color perception were ruled out by the following tests: the patient correctly matched colors by hue, despite great differences in saturation or brightness, correctly matched colored papers to uncolored pictures of objects, and performed without error on two pseudo-isochromatic tests of color vision. Verbal memory for color names was intact since he correctly named objects corresponding to named colors and named colors corresponding to named objects.

It was pointed out that the best characterization of his syndrome is "an inability to match seen colors to their spoken names."

At postmortem the patient showed the classic lesion of pure alexia without agraphia, ie, infarction of the left calcarine cortex and of the splenium of the corpus callosum. The symptomatology is interpreted on the basis of these anatomical findings as a disconnection of the intact right visual cortex from the speech regions. Alternative interpretations are discussed. In particular, we show that the findings in our case cannot be interpreted as resulting from a minimal aphasia combined with a minimal perceptual disturbance.

Acknowledgments

Dr. Julius Litter was the patient's private physician; Drs. Charles Kane and William Timberlake were in charge of the patient in different hospitalizations; Dr. Raymond D. Adams made the brain available for study; and Dr. Paul Yakovlev permitted the use of his laboratory for the preparation of the brain sections.

Some of the work reported was supported by NIH grants M-1802 and NB-6209 to Boston University.

References

1. Lange, J.: "Agnosien," in Bumke, O., and Foerster (eds.): *Handbuch der Neurologie*, Berlin: Springer Verlag OHG, 1936, vol 6, pp 807–885.

2. Critchley, M.: Acquired Anomalies of Colour Perception of Central Origin, *Brain* 88: 711–724, 1965.

3. Dejerine, J.: Contribution à l'étude anatomopathologique et clinique des différentes variétés de cécité verbale, *Mem Soc Biol* 4: 61–90, 1892.

4. Geschwind, N., and Fusillo, M.: Color-Naming Defects in Association With Alexia, *Trans Amer Neurol Assoc* 89: 172–176, 1964.

5. Meyer, V., and Yates, H. J.: Intellectual Changes Following Temporal Lobectomy for Psychomotor Epilepsy, *J Neurol Neurosurg Psychiat* 18: 44–52, 1955.

6. Milner, B.: "Laterality Effects in Audition," in Mountcastle, V. B. (ed.): *Interhemispheric Relations and Cerebral Dominance*, Baltimore: Johns Hopkins Press, 1962, pp 177–195.

7. Whitteridge, D.: "Area 18 and the Vertical Meridian of the Visual Field," in Ettlinger, G. (ed.): *Functions of the Corpus Callosum*, London: Churchill Co., 1965.

8. Geschwind, N.: "The Anatomy of Acquired Disorders of Reading," in Money, J. (ed.): *Reading Disability*, Baltimore: Johns Hopkins Press, 1962, pp 115–129.

9. Geschwind, N.: Disconnexion Syndromes in Animals and Man, *Brain* 88: 237–294 and 585–644, 1965.

10. Pick, A.: "Aphasie," in Bethe, A., et al (eds.): *Handbuch der normalen und pathologischen Physiologie*, Berlin: Springer Verlag OHG, 1931, vol 15, pp 1416–1524.

11. Meyer, A.: Aphasia, *Psychol Bull* 2: 261–277, 1905.

12. Symonds, C. P.: Aphasia, *J Neurol Neurosurg Psychiat* 16: 1–6, 1953.

13. Kinsbourne, M., and Warrington, E.: Observations on Colour Agnosia, *J Neurol Neurosurg Psychiat* 27: 296–299, 1964.

12 Color Perception Profiles in Central Achromatopsia

Matthew Rizzo, Vivianne Smith, Joel Pokorny, and Antonio R. Damasio

Central achromatopsia is a defect of color perception caused by acquired damage in the visual cortex.[1,2] Patients report that their world looks dull, dirty, faded, gray, washed out, or devoid of color like a black and white TV. The impairment is typically restricted to a quadrant or hemifield but often spares the regions near fixation; thus, it is difficult to characterize achromatopsia with standard color tests, since the tests used to probe the most frequent color defects (eg, congenital and acquired color vision defects of retinal origin) are generally aimed at viewing near fixation.[3] When such tests are administered to central achromatopsic patients, they are able to view the stimuli using regions of spared color vision near the fovea. As a result, most patients with central achromatopsia achieve normal color scores despite having a true color vision defect. Testing color vision outside fixation is complicated by the need for larger stimulus sizes to compensate for the decreased photoreceptor density and the concomitant decreased spatial and chromatic discrimination,[4] and by the need to suppress rod activity, which alters color discrimination.[5] Furthermore, it is necessary to monitor eye position in the patients under study, or to present the color stimuli rapidly enough to preclude fixation shifts. The psychophysical underpinnings of central achromatopsia have remained poorly defined, probably because of these reasons.

Here we report on the perceptual profiles in two patients with central achromatopsia due to bilateral lesions of the visual cortex. Both had dense left visual field defects for light detection. Because their color impairments involved the entire remaining visual fields including fixation, we could test the patients in detail using some of the same standardized color tests that allow detailed profiles in retinal cone defects. Our primary goal was to probe their color defects along critical dimensions of color space.[6-8] The first direction in chromaticity space is the so-called tritan axis along which the level of short-wavelength–sensitive ("blue" or S-cone) excitation varies with an unvarying ratio of long-wavelength–sensitive ("red" or L-cone) to middle-wavelength–sensitive ("green" or M-cone) excitation. (The "names" of cones are based on the look of the spectral wavelengths that provide optimal excitation of these receptors. "Red" cones do not transmit only red [long] wavelengths, or "see" only red-looking surfaces; a red surface appearance does not depend only upon red cone signals.) The second direction in chromaticity space is the red-green (R-G) axis along which the ratio of L-cone and M-cone excitation varies at a fixed level of S-cone excitation. The third direction evaluated is the achromatic axis along which the ratio of stimulation of the three cone types remains constant and the total flux varies.

By testing the patients residual vision along S-cone, R-G, and achromatic axes, we were able to characterize the psychophysical correlates of their abnormal experience and compare how color processing fails after cortical as opposed to retinal lesions. Our secondary goals were to evaluate a role of target size in central achromatopsia, and to ask whether the defect in central achromatopsia precludes the appreciation of transparency, specularity, and other surface reflectance and light-source effects that differ from color.

Methods

Patients

We identified two patients who complained of abnormal color vision following destructive lesions of the visual cortex. Patient 1 was a 72-year-old woman who had had a cerebral infarct in the right occipital lobe in 1985 that caused left homonymous hemianopia. A second cerebral infarct in 1990, this time in the left occipital lobe, rendered her alexic and also caused prosopagnosia and achromatopsia. Patient 2 was a 33-year-old man who sustained a cerebral infarct in the setting of a closed head injury in 1982. He had three stable visual impairments: a dense left homonymous hemianopia, prosopagnosia, and achromatopsia.

Patient 1, a retired schoolteacher, gave articulate accounts of her persistent color impairments. For example, she could see the form and detail in a traffic light, but the red, green, and yellow signals appeared only as different shades of gray. Patient 2 noted special difficulty with the identification of hues of less saturated colors, especially blues and greens. But even highly saturated colors looked "wrong" to him, ie, definitely different than they looked prior to the onset of his condition. Before the accident he had been a landscape architect, a profession he had to abandon. Neither patient had any history of previous color impairment, psychiatric disease, toxin exposure, or use of drugs or medications known to affect color vision.

Both subjects were alert, attentive, and pleased to participate in this study. Neuro-ophthalmologic assessment showed visual acuity of 20/20 in patient 1 and 20/15 in patient 2. Neither showed evidence of optic nerve, retinal, or other eye disease to explain their color defect. Both subjects had dense left visual field defects for detecting light on Goldmann perimetry.[9] Luminance detection thresholds were normal in their remaining fields,[10,11] where color perception was tested. Neuropsychological assessments revealed normal intellectual processes.

The lesion analysis in our patients was performed by Hanna Damasio, and was based on a standard neuroanatomic technique[12] and on the Brainvox technique,

which performs three-dimensional voxel reconstructions from raw MRI data.[13] Three-dimensional reconstruction of a T_1-weighted MRI of patient 1 allowed precise localization of the lesions with respect to surface topography (see color plate 11). The mesial surface of the right hemisphere is reconstructed in panel A and the left hemisphere in panel B. The ventral surface is in panel C (the cerebellum and brain-stem were removed). The white lines through the reconstructed brain show the relative positions of the four coronal slices shown in panel D. The calcarine fissure is traced in red and the parieto-occipital fissure in yellow. The tracings automatically transfer to the original MRI slices to allow easy identification of these fissures. Patient 1 had bilateral lesions that involved the fusiform gyrus and undercut the most posterior segment of the lingual gyrus. The more extensive lesion in the right hemisphere affected the white matter (in which optic radiations travel) above and below the calcarine fissure. The lesion in the left hemisphere does not reach the surface of the hemispheres and can be seen only in the coronal sections (white arrows). It lies entirely below the calcarine fissure. We have hypothesized that such a lesion would cause damage in a possible human homologue of the monkey's area V4, or at least disrupt connections to and from such an area. The lesions in patient 2 were similar to those in patient 1, and have been reported elsewhere.[14,15]

Color Procedures

Several color-matching and color-discrimination tests were used to study how central achromatopsia affects discrimination along the chromatic (R-G and tritan) and the achromatic axes of color space. Procedures 1 to 3, including anomaloscopic, color plate, and arrangement tasks, were administered using the procedures described by Working Group 41.[3] Procedure 4 was a color brightness-matching task of new design. Color plate, arrangement, and brightness-matching tasks (procedures 2, 3, and 4, explained below), were presented at arm's length under an approximation to Standard Illuminant C.[16] The light source, a 150-watt quartz halogen source filtered with Macbeth (USA) cobalt filters gave an average surface illumination of 450 lux with a correlated color temperature of 6,740 K. Procedures 1 through 3 did not rely on color naming or associations, aspects of which were evaluated separately in procedure 5 (and to some extent in procedure 4).

Procedures 6 and 7 included further observations in patient 1. Procedure 6 evaluated the role of target size on color appearance. Procedure 7 evaluated non-color sensations triggered by reflectant surfaces, including transparency, specularity (a quality of mirrors or metals), opacity, and iridescence, and required judgments on the quality of ambient light.

Procedure 1: The Nagel Anomaloscope (Model I, Schmidt and Haensch, Berlin, Germany) is an instrument designed to detect and diagnose congenital color vision defects. It consists of two adjacent fields, one containing monochromatic 589-nm ("yellow") light and the other a mixture of 545-nm ("green") and 670-nm ("red") lights. Normal trichromats but not color defectives rapidly find the unique proportion of the mixture lights needed to match the yellow target. This is known as the "Rayleigh" (1881) match.[17] Test administration was according to standardized procedures.[18] Subjects viewed the 2° field, split at the horizontal meridian, through an eyepiece. The experimenter controlled the mixture ratio in the top half. A series of proportions of 545/670-nm light (instrument scale readings from 0 to 73) were presented to the subject. The subject could alter the luminance of the 589-nm light (instrument scale readings 0 to 87) in the bottom half-field and report for each proportion whether a satisfactory match could be obtained. Color-normal observers make a narrow match (ie, they accept only one or a few mixture proportions). Observers with anomalous trichromacy may make narrow matches but they are displaced in the proportion of 545/670 they find acceptable. The cause of anomalous trichromacy is believed to be a displaced spectral sensitivity of one of the cone pigments.[18] Deuteranomalous trichromats accept matches with more 545-nm light than normal, and they are believed to have an M-cone pigment shift toward longer wavelengths than normal. Protanomalous trichromats accept matches with more 670 nm light than normal, and they are believed to have an L-cone pigment shift toward shorter wavelengths than normal. Dichromats accept all proportions: deuteranopes (missing M-cone pigment) make matches with about the same luminance value for all proportions; and protanopes (missing L-cone pigment) make matches with more luminance being required as the proportion of 670-nm light increases.

Results Normal trichromats (subjects P.K., J.P., V.S., and M.R.) chose similar metameric matches over a narrow range (matching proportion [matching radiance]): P.K. 42 [15], J.P. 45 [13.5], V.S. 44 [15], M.R. 44 [15]. The two patients understood what was asked of them although neither could use correct color names to describe what they saw. Patient 1 performed as though she had no discrimination in the long-wavelength region evaluated by this test. She made a full-range match (0 to 73, with deuteranopic settings) in each eye. These findings suggest that signals from the long-wavelength-cone and middle-wavelength-cone inputs, presumed intact at the level of the retina, were interrupted by her cortical lesions. Patient 2 matched over a range of 40 to 42 with the right eye and 40 to 45 with the left. Thus, his R-G vision was normal on this test.

Procedure 2: Color Plates We used (a) the American Optical Hardy-Rand-Rittler (AO-HRR)[19] and (b) the Standard Pseudoisochromatic Plates, Part 2 (SPP2)[20] tests. Both employ pseudoisochromatic plates (28 and 12, respectively) made of colored circles of different size, hue, and lightness. The elements composing the SPP2 are isoluminant. Consistent differences from background by color alone define a target figure such as a letter, number, or shape. Both screen for R-G color defect. Their advantage over the Ishihara and other commonly used tests is that they also screen for blue-yellow (B-Y) (tritan) defects. Subjects were asked to report the target figure in each plate. If they could not do so, they were instructed to trace any perceived pattern with their finger. This method precluded our mistaking an abnormal performance due to alexia or related defects of pattern perception for a color vision defect.

Results (a) AO-HRR Patient 1 failed the screening plates for R-G and B-Y, saw some pieces of the medium diagnostic plates, and saw the strongest diagnostic plates. Patient 2 missed the left half of R-G screening plate no. 5 and failed the screening tritan and one diagnostic B-Y plate.

(b) SPP2 Patient 1 could trace the numbers on the two demonstration plates but saw nothing in the remainder of the plates. A notable complaint in patient 1, not reflected in the scoring of the color plate tasks, was that the colors she saw appeared to "bleed" outside the circles and figures that ought to have contained them. Patient 2 made errors on B-Y plates 4 to 7.

Procedure 3: Arrangement Tests The Farnsworth[21] (D-15), Lanthony New Color Test[22] (LNCT), Farnsworth-Munsell (FM) 100-Hue,[23] Lightness Discrimination Test[24] (LDT), and Sahlgren's Saturation Test[25] (SST) all consist of color chips mounted in caps, which can be arranged in a unique sequence. They vary in the number of chips, the degree of discrimination ability needed, and the sector of color space they probe. All utilize chips from Munsell's color space except for the SST, which relies on the Natural Color System,[16] Sweden's standard.

(a) The D-15 screens for severe color discrimination loss by looking for confusions among 15 isoluminant color tokens along protan, deutan, or tritan axes.

(b) The LNCT resembles the D-15, and tests chromatic discrimination at four different saturation levels (Munsell 2, 4, 6, and 8); it also asks which colors are confused with grays. In this study, we employed intermediate- and high-saturation levels, boxes 4 and 8.

(c) The FM 100-Hue evaluates just noticeable differences around a hue circle in 85 equidistant steps at isoluminance. Different sectors of the circle are tested with four different racks containing 21 or 22 colors each.

(d) The LDT consists of a series of gray caps and resembles a rack from the FM 100-Hue test.[24] We used an abbreviated version[26] that tests the ability to discriminate lightness differences among 16 gray caps (range 2.00 to 9.50 on the Munsell scale).

(e) The SST evaluates loss of saturation discrimination by testing the ability to separate five greenish-blue and five bluish-purple caps of varying saturation from two gray caps.

Results (a) D-15 Both patients made extensive color confusions. Patient 2 showed a tritan error pattern.

(b) LNCT Box 8: Patient 1 classified yellow-green and blue-purple as dark gray; purple, purple-blue, and green-blue were classified as light gray. Color arrangement was chaotic. Patient 2 confused blue, blue-purple, and purple-blue with grays. Arrangement errors consistently paralleled the tritan axis. Box 4: Only patient 2 was tested. He identified blue-purple as a light gray. Arrangement errors were mostly tritan.

(c) FM 100-HUE Both patients made many errors. Patient 1 had an error score of 932. Patient 2 had an error score of 492. Evaluation of quadrant errors[27] showed no particular axis in either case.

(d) LDT On this test, patient 1 performed normally. Despite her virtual absence of hue discrimination, her error score of 14 fell within expectations for age. Patient 2 had an error score of 16, abnormal for age but less grave than his hue discrimination performance.

(e) SST Patient 1 had an error score of 130. She identified all color caps as gray except for both 40 caps. Patient 2 had an error score of 40. He identified all greenish-blue caps except for no. 5, calling them green. He missed bluish-purples 20, 10, and 5. He identified bluish-purples 30 and 40 as colored, calling them brown.

Procedure 4: Matching the Brightness of Color Samples to Gray Samples We used color samples from the Optical Society of America's Uniform Color Scales.[28] The lightness was 0, and the hues and saturations varied. There were eight gray samples varying in lightness from −1 to +4. Each colored sample was presented in turn, and the subject picked the gray sample that matched in brightness. Then the subject attempted to name the hue of the colored sample.

Results For normal observers, colored samples appear brighter than the gray of equal value. Thus a subject with normal color vision will choose grays with values of

2 to 4 to match highly saturated color samples of value 0. Patient 1 chose a luminance match (values −0.5 to +0.5). Patient 2 chose dimmer grays (values below 0) for the blue and purple patches. He named these incorrectly as brown or white. A pink and a violet were described as "blue." Green patches were matched to values near 0 and were correctly named. Red and orange patches were matched to high-value grays and were described as "bright pink" or "light red." These results are characteristic of an S-cone (or tritan) deficit.

Procedure 5. Color Naming and the Association of Color Names with Object Names
Two different tasks were used: (a) color naming: the patients were asked to name the color of 10 different Munsell tokens; (b) association of color names with object names. The patients were asked to state the names of colors associated with 10 items by completing 10 short sentences spoken by the examiner. For some items, the color name is a frequent verbal associate of the object or substance name (eg, "blood is____," "grass is____"). For others (eg, lead), the color name is an uncommon associate.

Results (a) Both patients usually chose appropriate achromatic names (white, gray, and black) for hueless targets. For targets with hue, they made major naming errors or used achromatic names (table 12.1).

(b) Both patients stated the color name associated with the items that are part of high-frequency verbal pairs, (eg, grass-green; blood-red; spoon-silver), but failed the infrequent verbal pairs (in items such as lead or eggplant) (table 12.2).

Procedure 6. Effect of Target Size on Color Appearance Patient 1 viewed 2 × 2-cm tokens comprising glossy, highly saturated red, yellow, green, and comparable black and white chips. These tokens had different shapes (eg, circle or square). The colors in these chips are easily identified by normal individuals. Since the patient could not reliably identify the proper colors at any distance, we asked her to report on changes in color appearance as the chips were moved closer or further away.

Results When color targets were moved from far to near, they looked gray up to the vicinity of 30 cm (where they subtended about 4° of visual angle). At that point, the subject thought she could detect some color in the chips, although she was not sure what the colors were and guessed them incorrectly. Receding targets appeared fully gray again beyond approximately 110 cm. The patient was able to report the target shapes correctly at all distances.

Procedure 7. Perceiving Surface and Light-Source Effects Other than Color There are no standard probes of effects such as transparency, specularity, iridescence, and

Table 12.1
Color naming

	Response	
Target	Subject 1	Subject 2
Orange	Green	Yellow
Brown	Gray-red	Brown
Gray	White	Off-white
White	White	White
Red	Gray-rose	Red
Yellow	Beige	Pink ("because it's a lightish color")
Purple	Rose	Light brown
Black	Black	Black
Blue	Gray	A white green
Green	Gray	"Unknown to me. Maybe some type of green."

Table 12.2
Association of color names with object names

	Response	
Object name	Subject 1	Subject 2
Milk	White	White
Blood	Red	Red
Clear Sky	Blue	Blue
Mud	Brown, or black like good Iowa dirt	Black
Broccoli	Green	Green
Banana	Yellow	Green ("It's a plant. Most plants are green.")
Eggplant	Green—well, not exactly green	Maybe green
Spoon	Silver	Silver
Egg yolk	Yellow	Yellow
Grass	Green	Green
Lead	Green	Brownish black
Plum	Purple	"Maybe green because a plum is a plant"
Rose	Red	Red
Lake water	Blue	Light greenish. "I can't really visually recollect what it looks like."
Sand	Tan or white	Sort of white

fluorescence. Moreover, the physical inputs necessary to derive these properties and how or where in the nervous system this information is processed is unclear, although it appears that multiple inputs are involved.[29] The virtual absence of hue discrimination in patient 1 (to whom most things also looked gray) allowed preliminary observations on whether some surface and light-source effects depend on or are processed separately from hue.

(a) Transparency discrimination. Patient 1 was asked to arrange in order of their optical density seven neutral-density glass photographic filters (relative log unit values 0.3, 0.3, 0.3, 0.6, 0.9, 1.2, 1.5). The filters each had a diameter of 3 cm and were randomly spaced on a white paper.

(b) Differentiation among surface properties. Patient 1 was presented with sixteen 1 × 1-cm squares arranged in a spatially random pattern on a white paper. She was asked to select from this set the targets that were iridescent (two); mirror-like (two); transparent (two); translucent (two); or non-glossy/opaque (eight: two pink, two yellow, two blue, and two white).

(c) Determining boundaries between specular surfaces. (i) Patient 1 viewed a mirror-like metallic surface with six small (approximately 3 mm) irregularly spaced water droplets on it, and was asked to report what she saw. (ii) She viewed a glass. She was asked to determine whether there was water in the glass and if so, to point to the water level. The water surface was still on all presentations.

(d) Judging light sources. The patient was asked to evaluate several ambient lighting conditions and requested to judge the light source without looking directly at it.

Results (a) Transparency discrimination. Patient 1 correctly arranged the six neutral glass filters according to their optical density.

(b) Differentiation among different surface properties. The patient could correctly select among the 16 targets the iridescent, mirror-like, transparent, and translucent pairs. She correctly characterized the pink, yellow, and blue pairs as opaque and non-glossy, but thought they were gray. Twice, however, she identified a white paper as transparent.

(c) Determining boundaries between specular surfaces. (i) Patient 1 reported that she saw a bright shiny surface, knew that it was metal without touching it, pointed to each of the six drops upon it, and correctly identified them as water. (ii) Based on its appearance, patient 1 knew she was viewing a glass, knew if it was full or not, and correctly identified the water levels by pointing to the side of the glass.

(d) Judging light sources. The subject correctly identified fluorescent, incandescent, and sunlight even when the light source was hidden. Looking toward a window, she

reported a transparent surface and made proper judgments on the conditions beyond it including bright sun, sun on a cloudy day, and evening light. No attempt was made to develop standardized procedures to test these observations further.

Discussion

In this study, we characterized the psychophysical abnormalities behind the abnormal color experience in two patients with central achromatopsia. We were able to take advantage of the same standardized tasks that allow detailed profiles of retinal cone defects. Some tasks have seldom been used before in central achromatopsia. The results allow direct comparisons on how color processing fails with cortical as opposed to retinal lesions, and provide clues on how retinal color-opponent channels contribute to chromatic and luminance channels at cortical levels.

The Profiles of Central Achromatopsia

A possible explanation for cortical color vision defects, such as we observed, presumes an underlying disorder of color constancy. "Color constancy" refers to a relative stability in the appearance of the colors of surfaces under different lighting conditions. It helps explain why plants look green in the morning and afternoon sun as well as under tungsten and fluorescent lights. The phenomenon would be mediated by portions of the CNS, specifically by the retina and visual cortex that compose the "retinex" system of Land and McCann[30] and Land.[31] These structures perform corrections for ambient changes in illumination across a scene.

According to Zeki,[32] the lesions in central achromatopsia would damage the connections required for the comparison of information among different cortical maps, or damage "the region where colors are synthesized from such comparisons." This would disturb "long-range" interactions among different portions of the visual field, leading to dramatic fluctuations in the appearance of surface colors based on the environmental lighting conditions and probably also upon the surrounding surface colors. However, our patients did not experience such difficulties. Colors appeared gray or desaturated and were difficult to discriminate, yet a defect of color constancy would predict that surface colors still have hue and that neighboring colors look different and be discriminable. We do not think that reducing central achromatopsia to a defect of color constancy really captures the full range of phenomena behind their symptom complex. We hypothesize that color constancy and lightness constancy as well are already determined at the level of the human visual association cortex that includes the possible human homologue for the monkey's area V4.[15]

Here we conceptualize achromatopsia by envisioning normal perceptual color space as a three-dimensional solid with two chromatic axes (R-G and B-Y) and one achromatic axis.[6-8] If, as the result of damage in the visual association cortex, such a perceptual color space were reduced to a smaller yet congruent space, or "clipped" at the boundaries, the range of visible colors would be less although the relationships among visible colors might remain normal. If, however, color space became deformed in a less regular way, color appearances might shift. The results could differ dramatically depending on the type of transformation applied to this hypothetical color space. For instance, an isolated patch illuminated with spectral red light might shift toward a spectral blue, or it might even assume the appearance of a surface color such as a maroon or brown, which for the normal observer exist only under conditions of color contrast.[33] (The essence of such a problem was realized by Locke, about 1692, in his *Essay Concerning Human Understanding*.[34] He considered that a given object could produce in several minds different "Ideas" at the same time. The Idea "violet" produced in one mind might correspond to "marigold" in another, yet we might never prove the inversion.[35])

The results in the two patients we studied are compatible with the idea that central achromatopsia encompasses a range of impairments. In patient 1, perceptual color space was fully collapsed along both R-G and B-Y dimensions of the perceptual color solid. Otherwise, discriminations along achromatic dimensions (of lightness and brightness) were relatively intact compared with hue (as in two other recent cases[36,37]). In other words, patient 1 functioned like a light meter. Patient 2 also showed relative preservation of color processing along a hypothetical achromatic axis. Compared with patient 1, his color-processing defect was skewed to B-Y, although R-G discriminations were also affected. The different findings in our two cases, taken together with the findings in other reports,[32,38] suggest that central achromatopsia may comprise a family of color disorders.

We found that the color vision impairments in central achromatopsia did not resemble the usual retinal color vision disorders. The abnormalities in our patients different from the profiles of protanopes, deuteranopes, or tritanopes because their hue-processing defects were more extensive. Like tritanopes, who lack function of the short-wavelength cones, both patients had a profound defect along the B-Y axis on the AO-HRR, and SPP2 plates that target such defects. The susceptibility of B-Y discriminations to cortical damage might relate to the relative paucity of S-cones in the retina and, by inference, a smaller (and relatively vulnerable) central representation of their inputs. Unlike tritanopes, however, both subjects also had color discrimination defects along the R-G dimension. The R-G defect was profound in patient 1, who made full-range metameric matches on the anomaloscopic task.

This suggests that the R-G and B-Y channels, which originate early in the visual system and are impaired selectively by hereditary retinal lesions, either combine or occupy closely related anatomic structures in the visual cortex. Thus, neither's function is fully dissociable from the other's by a macroscopic cortical lesion.

Finally, our results suggest that the use of the term central "achromatopsia" to describe all forms of color loss following lesions of the visual cortex is inadequate. Central "dyschromatopsia" probably conveys more accurately the defects described here.

Processing of Color Names

Color-naming performance must always be considered in context. Patients with fully normal color perception may fail to name colors if they are aphasic or have a circumscribed defect known as "color anomia" (most often associated with alexia without agraphia[39]). Conversely, color naming may actually remain normal in a color-aberrant field.[40] This is because the million (or so) colors discriminable by the visual system subtend no more than a dozen categorical names in any language.[41] Thus, there may be shifts in color appearance, but these alterations may not be sufficient to shift color percepts across the boundaries of differently named categories. Most often, however, achromatopsics make major hue-naming errors and our patients were no exception (table 12.1). Both patients could still produce the appropriate color name associated with most items in a list of objects (table 12.2) because the names for the item and the color are frequently used, and the process is thus restricted to verbal paired-associate recall. The subject has no need to revisualize the object and its color. On the other hand, on items whose names and colors are infrequently paired (eg, lead), the subject must rely on recalling the item's color in order to produce a response. Achromatopsics, however, are generally unable to retrieve colors in their mind's eye.

Color and Target Size

The observations in procedure 6 suggest that central achromatopsia can depend critically on the size of the stimulus. When patient 1 was presented with highly saturated tokens, they finally appeared colored if they subtended about 4° of visual angle. With smaller stimuli, however, all chips appeared gray even though she could still report their shapes. Normal observers have a tendency to reduced color perception with smaller target size or with increased spatial frequency,[42] but not to this extent.

Perception of Surface and Light Source Effects

Procedure 7 in patient 1 allowed new observations on the relation of color to other surface and light-source effects. She could still perceive or make simple judgments on

transparency, opacity, specularity, iridescence, and fluorescence. Even though she confused a white paper with a transparent one, she could discriminate transparent objects and use reflections from colorless, transparent objects to define object boundaries (procedure 7c). By comparison, her complaint on pseudoisochromatic plates that colors seemed to "bleed" outside of the forms suggests an inability to localize color contrast boundaries, pertinent perhaps to her recognition defect. These preliminary observations motivate the hypothesis that certain effects of surface reflectance and lighting depend on different computations than color and are processed at different or earlier sectors in the human nervous system.

References

1. Meadows JC. Disturbed perception of colors associated with localized cerebral lesions. Brain 1974; 97: 615–632.

2. Damasio A, Yamada T, Damasio H, Corbett J, McKee J. Central achromatopsia: behavioral, anatomic, and physiologic aspects. Neurology 1980; 30: 1064–1071.

3. Working Group 41, NAS-NRC Committee on Vision. Procedures for testing color vision. Washington, DC: National Academy Press, 1981.

4. Abramov I, Gordon J. Color vision in the peripheral retina II: hue and saturation. J Opt Soc Am 1977; 67: 202–206.

5. Stabell U, Stabell SB. Color vision in the peripheral retina under photopic conditions. Vision Res 1982; 22: 839–844.

6. MacLeod DLA, Boynton RM. Chromaticity diagram showing cone exitation by stimuli of equal luminance. J Opt Soc Am 1979; 69: 1183–1186.

7. Boynton RM, Kambe N. Chromatic difference steps of moderate size measured along theoretically critical axes. Color Research Application 1980; 5: 13–23.

8. Krauskopf J, Williams D, Heely D. Cardinal directions of color space. Vision Res 1982; 22: 1123–1131.

9. Anderson DR. Testing the field of vision. St Louis: Mosby, 1982: 22–42, 180–196.

10. Allergan Humphrey. The field analyzer primer. 2nd ed. San Leandro, CA. 1987.

11. Octopus Manual. Octopus: tomorrow's perimeter today. Visual field atlas. 2nd ed. Bern. Switzerland: A. G. Interzeag, Shlieren, 1978.

12. Damasio H, Damasio A. Lesion analysis in neuropsychology. New York: Oxford University Press, 1989.

13. Damasio H, Frank R. Three-dimensional in vivo mapping of brain lesions in humans. Arch Neurol 1992; 49: 137–143.

14. Tranel D, Damasio AR, Damasio H. Intact recognition of facial expression, gender, and age in patients with impaired recognition of face identity. Neurology 1988; 38: 690–696.

15. Rizzo M, Nawrot M, Blake R, Damasio A. A human visual disorder resembling area V4 dysfunction in the monkey. Neurology 1992; 42: 1175–1180.

16. Wyszecki G, Stiles WS. Color science: concepts and methods, quantitative data and formulae. 2nd ed. New York: John Wiley and Sons, 1982.

17. Rayleigh Lord (Strutt JW). Experiments in colour. Nature 1881; 25: 64–66.

18. Pokorny J, Smith VC, Verriest VG, Pinckers AJLG. Congenital and acquired color vision defects. Current ophthalmology monographs. New York: Grune and Stratton, 1979.

19. Hardy LH, Rand G, Rittler MC. AO-HRR pseudoisochromatic plates. 2nd ed. American Optical Co, 1957.

20. Ichikawa K, Ichikawa H, Tanabe S. Detection of acquired color vision defects by standard pseudo-isochromatic plates, part 2. Doc Ophthalmol Proc 1987; 46: 133–140.

21. Farnsworth D. The Farnsworth dichotomous test in color blindness, panel D-15. New York: Psychological Corporation, 1947.

22. Lanthony P. Manual du New Color Test de Lanthony selon Munsell. Paris: Luneau Ophthalmologique, 1975.

23. Farnsworth D. The Farnsworth-Munsell 100-hue and dichotomous task for color vision. J Ophthalmol Soc Am 1943; 33: 568–578.

24. Verriest G, Uvijls A, Aspinall P, Hill A. The lightness discrimination test. Bull Soc Belge Ophtalmol 1979; 183: 162–180.

25. Frisen L, Kalm P. Sahlgren's saturation test for detecting and grading acquired dyschromatopsia. Am J Ophthalmol 1981; 92: 252–258.

26. Pinckers A, Verriest G. Results of a shortened lightness discrimination test. In: Verriest G, ed. Colour vision deficiences VIII. Dordrecht, The Netherlands: Martinus Nijhoff/Dr. W. Junk, 1987: 163–166.

27. Smith VC, Pokorny J, Pass AS. Color-axis determination on the Farnsworth-Munsell 100-hue Test. Am J Ophthalmol 1985; 100: 176–182.

28. MacAdam DL. Uniform color scales. J Opt Soc Am 1974; 64: 1691–1702.

29. Ullman S. On vison detection of light sources. Biol Cybern 1976; 21: 205–212.

30. Land E, McCann JJ. Lightness and retinex theory. J Opt Soc Am 1971; 61: 1–11.

31. Land EH. Recent advances in retinex theory. Vision Res 1986; 26: 7–21 [Chapter 5, this volume].

32. Zeki S. A century of cerebral achromatopsia. Brain 1990; 113: 1727–1777.

33. Pokorny J, Shevell SK, Smith VC. Colour appearance and colour constancy. In: Gouras P, ed. Vision and visual dysfunction, vol. 6: the perception of colour. London: Macmillan, 1991: 43–61.

34. Locke's essay concerning human understanding. Maurice Cranston, ed. London: Collier Books, 1965.

35. Shoemaker S. The inverted spectrum. J Philosophy 1982; 79: 357–381.

36. Heywood CA, Wilson B, Cowey A. A case of cortical colour "blindness" with relatively intact achromatic discrimination. J Neurol Neurosurg Psychiatry 1987; 50: 22–29.

37. Victor JD, Maiese K, Shapley R, Sidtis J, Gazzaniga M. Acquired central dyschromatopsia with preservation of color discrimination. Clin Vis Sci 1987; 3: 183–196.

38. Plant GT. Disorders of colour vision in diseases of the nervous system. In: Foster DH. ed. Inherited and acquired colour vision deficiencies: fundamental aspects and clinical studies. Vision and visual dysfunction, vol. 7: Cronly-Dillon J. ed. Boca Raton. FL: CRC Press, 1991: 173–198.

39. Damasio AR, Damasio H. The anatomic basis of pure alexia. Neurology 1983; 33: 1573–1583.

40. Rizzo M, Damasio AR. Acquired central achromatopsia. In: Kulikowski JJ, Dickinson CM, Murray IJ, eds. Seeing contour and colour. Oxford, UK: Pergamon Press, 1989; 758–763.

41. Berlin B, Kay P. Basic color terms. Berkeley: University of California Press, 1969.

42. DeValois RL, DeValois KK. Sensitivity to spatial variations. In: Spatial vision. New York: Oxford University Press, 1988: 212–238.

13 On the Role of Parvocellular (P) and Magnocellular (M) Pathways in Cerebral Achromatopsia

Charles A. Heywood, Alan Cowey, and Freda Newcombe

Introduction

Cerebral achromatopsia is a clinical condition where brain damage abolishes colour vision (Meadows, 1974; Zeki, 1990*a*). Positron emission tomography in normal observers viewing coloured displays (Corbetta et al., 1991; Zeki et al., 1991) has identified an area in the region of the lingual and fusiform gyri where cerebral blood flow increases when the observer inspects or actively searches for coloured stimuli. Post-mortem neurohistology (Meadows, 1974; Damasio et al., 1980; Plant, 1991) and MRI in patients (Kölmel, 1988) have implicated this region of ventral occipital cortex in the syndrome of achromatopsia.

Although achromatopsic patients have repeatedly been reported to describe their visual surroundings as consisting of shades of grey, there is nevertheless wide variation in the quality of their residual abilities. Some patients can fail to identify any colour, whereas others can correctly report vivid reds but are grossly deficient for greens and blues (Meadows, 1974; Victor et al., 1989). This is also reflected in performance on a task of colour ordering, the Farnsworth-Munsell 100-Hue Test, where fewer errors are made in the red-purple region of colour space. Performance can also be unimpaired on tasks requiring detection of coarse colour differences, even though the colours themselves cannot be identified (Victor et al., 1989). There is similar variation in the ability to identify figures concealed in the Ishihara pseudo-isochromatic plates, designed to assess red/green colour deficiency (Meadows, 1974; Albert et al., 1975; Heywood et al., 1987, 1991).

The magnitude of the deficit in cerebral achromatopsia could simply reflect the extent to which underlying neural substrates are damaged and the syndrome can be interpreted in terms of what is known about the organization of the visual pathways in the monkey (for reviews, *see* Hubel and Livingstone, 1987; Livingstone and Hubel, 1987; Zeki and Shipp, 1988; Schiller et al., 1990; Zeki, 1990*a,b*). Pathways that process different attributes of the visual scene such as colour, form and movement, originate in the retina and maintain substantial anatomical and functional segregation up to and including the primary and secondary cortical visual areas (Felleman and Van Essen, 1991). Retinal ganglion Pβ cells project to the parvocellular (P) layers of the dorsal lateral geniculate nucleus (dLGN) which, in turn, project to the cytochrome oxidase (CO)-rich blobs and the interblobs of cortical area V1. The thin stripes and interstripes of area V2, revealed by CO staining, receive inputs from the CO-rich blobs and interblobs, respectively, which then project to cortical area V4. This pathway constitutes the colour-opponent P channel of visual

processing. Cells in the CO-rich blobs are largely selective for wavelength but not orientation. Conversely, orientation selectivity is prevalent in cells in the interblobs of V1, which are not wavelength selective. The P channel is thus composed of two arms even at this early stage of cortical processing, conveying chromatic and orientation information relatively independently to V2, where extensive, although not complete functional segregation is maintained in the cells of the thin stripes and interstripes, respectively. The second channel, the M channel, arises from Pα retinal ganglion cells, projects via the magnocellular (M) layers of dLGN to area V1 where it terminates chiefly in layer 4B. Layer 4B projects both directly, and via the CO thick stripes of V2, to V3 and V5. The orientation and direction selectivity, and absence of wavelength selectivity, of cells in the M system is consistent with its proposed role in processing motion and form.

A possible explanation for achromatopsia is that the brain damage disrupts the cortical P channel, although why an encephalitic lesion should have such selective effects is as unclear as the reasons for the selective effect of carbon monoxide poisoning on the M channel (Milner and Heywood, 1989). Damage could compromise all or part of the pathway, depending on the cortical stage at which the disturbance occurs. However, the locus in medial prestriate cortex of the causal lesion suggests that the functional loss occurs at a stage beyond the striate cortex.

Victor et al. (1989) reported a single case of 'incomplete' achromatopsia in which colour contrast sensitivity was preserved and visual evoked potentials could be elicited by isoluminant chromatic checkerboards. In addition, the patient had no difficulty in selecting the single coloured square (e.g. red) from among 39 squares which were of the complementary opponent colour (e.g. green) and could identify eight out of nine Ishihara plates. They inferred that in cases such as this, wavelength-opponent processes in intact striate cortex mediated residual colour ability, whereas the deficits in the identification and sorting of colours were accounted for by damage to ventromedial extrastriate regions. In contrast, patients such as those reported by Damasio et al. (1980) in whom the cortical visual evoked potential to chromatic gratings was absent and the patient's subjective report is that the world appears in shades of grey, suggest that either the chromatic compartments of striate cortex or their colour-opponent input is compromised. An alternative interpretation is that in the case examined by Victor et al. (1989), the lesion to the lingual and fusiform gyrus is incomplete, leaving some residual chromatic processing. This interpretation is attractive since some patients have intact visual fields, but complete achromatopsia as indicated by their failure to identify any pseudo-isochromatic Ishihara plates, a test that readily distinguishes 'incomplete' from 'complete' achromatopsia (Zeki, 1990a). However, the latter cases could equally well result from damage restricted to

the colour pathway where, for example, the CO-rich blobs of striate cortex may be differentially vulnerable to a metabolic or vascular lesion which, as a result, disrupts the entire cortical colour pathway.

In an attempt to tease apart these possibilities we report here the results of testing a particularly striking patient, M.S., who fulfils the criteria of complete achromatopsia in that his performance on the Farnsworth-Munsell 100-Hue Test is no better than would be expected on the basis of random responding and he fails to identify all but the first of the Ishihara plates (which does not require colour vision) at the conventional reading distance. Furthermore, M.S. is unable to perform the most rudimentary colour discrimination and is quite unable to identify colours. Moreover, he is hemianopic, but with no evidence of involvement of striate cortex representing the intact field as judged on the basis of MRI, static perimetry and the recording of visual evoked potentials to isoluminant chromatic and achromatic gratings. In addition, and remarkably, his colour contrast sensitivity is indistinguishable from that of normal observers (Nicholas, 1993). An earlier proposal was that colour deficits in patients like M.S. were the result of interruption of the entire cortical P channel and that their residual and achromatic vision was mediated by the M channel alone (Heywood et al., 1991). However, while his ability to detect chromatic borders could be explained by the weak opponent properties of some cells in the M channel, at both the retinal (Valberg et al., 1992) and the cortical level (Saito et al., 1989), measurement of his spectral sensitivity function revealed the peaks and troughs indicative of a prominent contribution from the colour-opponent P channel. The present study is concerned with characterizing the properties of his chromatic vision in an attempt to resolve the thorny question of how he detects and uses chromatic information despite being densely colour-blind and to clarify the nature of cerebral achromatopsia.

Methods

Case History

Patient M.S., who gave full and informed consent for the present investigation, has been reported in detail elsewhere (Newcombe and Ratcliff, 1975; Ratcliff and Newcombe, 1982) and is summarized here. He became ill in 1970 while serving as a police cadet. No brain biopsy was taken, and although blood serum was subsequently immunonegative for herpes the presumptive diagnosis was herpes encephalitis. Within a year of onset the initially profound visual disturbances were no longer apparent and M.S. was left with achromatopsia, left homonymous hemianopia with

macular sparing and normal Snellen acuity in each eye. His other prominent visual disorder is a severe agnosia for objects and faces. There are no alexic, agraphic or aphasic symptoms. M.S. remains densely achromatopsic, scoring 1245 on the Farnsworth-Munsell 100-Hue Test (a score that is no better than achievable on the basis of random responding) (Victor, 1988), and is unable to identify colours or perform the coarsest of chromatic discriminations (Heywood et al., 1991). Nevertheless, he retains three functional cone mechanisms (Mollon et al., 1980), as revealed by the increment threshold technique of Stiles (1978), and a spectral sensitivity function consistent with the presence of colour-opponent processing (Heywood et al., 1991).

Magnetic resonance imaging carried out in 1989 (Heywood et al., 1991) revealed bilateral ventral and ventromedial damage to temporo-occipital regions. In the left hemisphere the cortex of the occipital lobe is largely spared and damage includes the temporal pole, the parahippocampal and fourth temporal gyri of the temporal lobe, the collateral sulcus and the mesial occipito-temporal junction. It is the latter damage that presumably caused the achromatopsia (for review, *see* Zeki, 1990*a*). The first, second and third temporal gyri are intact and the frontal and parietal lobes are preserved in their entirety. In the right hemisphere the same regions were damaged but the striate cortex was additionally destroyed, producing a left homonymous hemianopia.

Apparatus

Visual stimuli were presented on a 14 inch colour monitor (Microvitec 895). The CIE (Commission Internationale de l'Eclairage) coordinates for the phosphors were as follows: red, $x = 0.625$, $y = 0.34$; green, $x = 0.310$, $y = 0.592$; blue, $x = 0.15$, $y = 0.063$ (figure 13.1). Visual stimuli were generated by a Pluto II graphics device (Electronic Graphics Ltd., Barnet, UK) controlled by a Viglen 386 computer. This produced a screen resolution of 786 horizontal by 576 vertical pixels and an 8-bit resolution, i.e. 256 levels, for the intensity of each of the red, green and blue guns. The luminance of each of the three guns, at each of the 256 intensity levels, was measured using a Minolta LS-110 digital luminance meter calibrated for human CIE photopic spectral sensitivity. This provided a table of values, accessible in software, enabling the selection of appropriate input voltages to the three guns for the presentation of visual displays of known luminance.

Visual Displays

For all tests the VDU was placed at eye level for the seated subject. Dim room lighting at mesopic levels was provided by one or two tungsten desk lamps, positioned so that they cast no light directly on the screen.

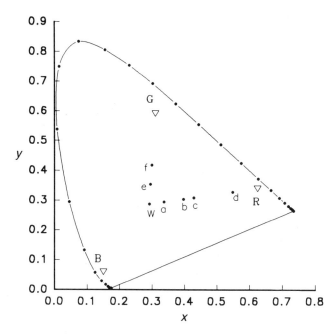

Figure 13.1
The color gamut of the red, green and blue phosphors are plotted on the CIE diagram and shown as R, G, and B, respectively. The white point is shown by W. Points a, b, c and d represent the range of reds and points e and f the range of greens used in tasks of colour and form detection and discrimination. Their respective saturations are: for reds, 13, 29, 38 and 70%; for greens, 16 and 29%.

Colour Detection The visual display was a checkerboard composed of a 7 × 5 array of 4 cm grey squares, each subtending 2.5° of visual angle at the viewing distance of 90 cm. The intensity of each square was randomly selected from among 10 possible values. The range of these 10 values, which determined the contrast of the checkerboard, was varied according to task demands. From trial to trial one of the grey squares was randomly selected and replaced by either a red or green square of equivalent brightness, i.e. within the range of the greys. In this and subsequent tasks we used heterochromatic brightness matching with M.S. to ensure that the chromatic stimulus lay within the range of brightness of the greys. The display was presented under four conditions. (i) The display was static and the coloured square was saturated, i.e. a pure primary colour containing no contribution from the remaining two guns, and from trial to trial the voltage to the single gun was varied while maintaining the brightness within the range of grey values of the remainder of the checkerboard. (ii) From trial to trial the saturation of the coloured square was varied by the

addition of varying but equal increments to the other guns. This is equivalent to adding white to or subtracting white from the colour. Again the brightness of the coloured patch was always within the range of the surrounding grey squares. (iii) and (iv) In these other two conditions the display was dynamic such that the brightness of each of the grey patches was randomly incremented or decremented by a random luminance step within preset limits. The coloured square was similarly modulated in brightness by changes in the voltage to either the single gun, resulting in the modulation of the brightness of a pure colour, or to the remaining two guns in order to vary saturation. Increments or decrements in voltages were randomly determined, carried out at 25 Hz, and resulted in a random luminance change of between 1 and 10 cd/m^2. From trial to trial the location of the coloured square was again random, i.e. locating it by guessing has a probability of one out of 35.

In separate tests an identical display was presented except that the checkerboard was now composed of 0.8 cm squares in a 38×28 array. Each square now subtended a visual angle of 0.5° and locating it by guessing has a probability of one out of 1064. Under some conditions green checkerboards were used with a single square replaced by red, as described above.

M.S. was seated 100 cm from the display monitor and for each trial was asked to indicate the position of the coloured patch. At least 20 trials were carried out in this and subsequent tasks under each condition. At the beginning of each trial M.S. fixated a yellow spot on the left edge of the monitor in order to ensure that the entire display was presented to his intact right hemifield. He was allowed an unlimited period to make his choice but encouraged to guess if uncertain. He always responded.

From Detection Using the 38×28 checkerboard, nine of the grey squares were replaced by a colour to form a cross (+), using identical procedures to those described above. Each of the nine component squares of the cross varied in saturation and brightness and were independently modulated in the dynamic condition of viewing along with the grey checkerboard surround. The task was again to indicate the location of the cross, which changed in position randomly from trial to trial (*see* plate 12). In the dynamic condition the random modulation of both the coloured and the grey squares should prominently stimulate the M channel and mask any weaker signals that chromatic borders might evoke in this channel. Such a procedure has also been used by Barbur et al. (1993).

Form Discrimination A coloured square, composed of 25 smaller squares, and a coloured cross identical to that used in the form detection task were embedded in the 38×28 array of grey squares. Two crosses and a square, or vice versa, were pre-

sented in a column in the centre of the screen, with a vertical separation of 2 cm. The task was to select the odd one out where the choice of target and distracter and their spatial arrangement varied randomly from trial to trial. For static and dynamic conditions of viewing, the procedures described earlier were again adopted. The total length of the chromatic border of the cross and square was identical, and the same as in the preceding form detection task.

Colour Discrimination Three large squares, each composed of 5×5 smaller squares, were arranged in a vertical column in a manner identical to that of the form discrimination task. Two of the squares were red and one, selected at random, was green, or vice versa, and M.S. was asked to point to the odd one out. For the static and dynamic viewing conditions the brightness and/or saturation of each of the smaller squares defining the target and the two distracters, along with those of the grey checkerboard, were modulated independently. To ensure that colour discrimination could not be performed on the basis of luminance cues, i.e. the red or green target might look, on average, brighter or darker, the colours were modulated around their point of isoluminance. Isoluminance was determined by flicker photometry by asking M.S. to adjust the luminance of a 3.8 cm green patch that was replaced by a red patch at 25 Hz, against a grey background of the same mean luminance used in the task display, until perceived flicker was minimal. When this point was reached the red and green patches were deemed to be isoluminant for M.S. This was confirmed by his inability to perform above chance levels on a three-choice oddity task using uniform red and green squares of these luminances.

Control Tasks

For each task it was important to rule out the use of possible artefacts in their solution. This was particularly true for dynamic displays where several artefacts are possible. First, the temporal change for the target and surround can have the same frequency but the depth of modulation may differ, causing the target to look less variable than the surround. Secondly, the temporal frequency might be different for the target and the surround. Control procedures were adopted to assess such artefacts. All displays were viewed by us through a monochrome video camera to ensure that performance by a normal observer was no better than that expected on the basis of random responding, which it was not, no matter how we adjusted the contrast response of the camera and monitor to which it was attached. Additionally, for tasks where the saturation of the target was modulated, the luminance of the red gun was increased by using the high impedance (HI-Z) switched termination on the red or green gun alone. This has the effect of flooding the entire display with red or green

light and making the red or green target invisible with respect to colour. M.S. and normal observers were tested under these conditions to assess the possibility that temporal artefacts could be used as a basis for stimulus detection or discrimination. Controls for chromatic aberration and binocular artefacts are mentioned under results.

Discrimination of Direction of Apparent Movement .

Chromatic and achromatic, horizontal square- and sine-wave modulated gratings were presented on a colour monitor to M.S. The gratings, with a spatial frequency of 0.5 or 1 cycle/degree and a contrast of 0.5, subtended $17 \times 12°$ of visual angle. Achromatic and isoluminant chromatic gratings were produced by modulating the red and green guns of the monitor in phase and in antiphase, respectively. The peak amplitude of the red and green guns was 27.2 and 32 cd/m^2, respectively. These values were isoluminant to M.S. on the basis of flicker photometry.

During each trial the grating was phase shifted by 90° at 1 Hz, either upwards or downwards, where the direction was randomly determined for each trial and until M.S. responded. He was asked to indicate the perceived direction of the apparently moving grating. The same procedure was carried out with a 180° phase shift which produces an alternating grating where, for the normal observer, the perceived direction of apparent movement is ambiguous and frequently changes. In the absence of any information about which bars are red and which are green, a phase shift of a chromatic grating by 90° in one direction will be indistinguishable from an identical phase shift in the other.

Brightness Additivity

A 3.8 cm yellow reference square, composed of the addition of 26.6 cd/m^2 each of red and green, was presented on a black background that filled the screen. M.S. was asked to adjust the brightness of a second square, either red or green, which appeared 2 cm beneath the yellow one until the two appeared equally bright. The adjustment was made in steps of ~ 0.3 cd/m^2, by keyboard responses. The match with yellow was carried out for both red and green. The same procedure was used for normal observers. The purpose of this task was to assess the extent of any departure from straightforward additivity, in this case between red and green. When a normal observer looks at a mixture of red and green under the conditions we used, the resulting yellow looks conspicuously dimmer than expected from simple brightness additivity as a result of opponent interactions between the two chromatic channels. In the absence of opponent chromatic processing it should not look dimmer.

Stereopsis

Red/green anaglyph random dot patterns were generated on the colour monitor and viewed with a red and green filter covering each eye, so that each eye sees a pattern of dark dots on a light surround. Colour vision plays no part in this of course. The displays were viewed by M.S. from 2 m. The display subtended $10° \times 7°$ and each pixel subtended 1 minute of arc. The dot density was 50%. For the first display the background disparity of the pixels was 2 minutes of arc and a $2° \times 2°$, 5 cycle square-wave grating was generated by producing additional disparities between the two images of ± 4 minutes of arc with respect to the background. M.S. was asked to report whether the grating appeared either in front of, or behind, the plane of fixation where the display changed randomly from trial to trial. A second display was generated where the background disparity was doubled and two shapes, a square and a triangle (each $2° \times 2°$) were produced by increasing the disparity of the pixels that defined the shapes by an additional 4 minutes of arc with respect to the background. The shapes were presented side by side and M.S. was asked to indicate the position of the square, which appeared randomly to the left or right from trial to trial. Twenty-five trials were given for each condition. The purpose of assessing binocular stereopsis based on small disparity cues alone was to reveal whether a perceptual ability widely attributed to the P channel was still present (Schiller et al., 1990; but see Hubel and Livingstone, 1987).

Results

Colour Detection

M.S. was asked to select the 'different' patch from a stationary (7×5) checkerboard of different greys where one of the squares was red or green, of maximum saturation, and both the target square and the greys varied in brightness from trial to trial. It should be remembered that random responding yields only one out of 35. When the range of grey values was small ($19.4–38.48$ cd/m^2), and the brightness of the target square fell within this range. M.S. identified the target on 11 out of 20 occasions. Greatly increasing the range of possible grey values ($0.01–122.2$ cd/m^2) abolished this ability (score none out of 20). M.S. readily detected a red square concealed among greens of random, but similar luminances ($19.4–38.5$ cd/m^2), scoring 16 out of 20. Similar results were found for detecting the saturated coloured square embedded within the 38×28 checkerboard where, with the restricted range of luminances, he scored 16 out of 20 (chance = one out of 1064). This was also true for dynamic displays (where the luminance of each square increased or decreased at 25 Hz, while

staying within the range 19.4–38.5 cd/m^2) where he scored 18 out of 20 for detecting either the large or small red target and 20 out of 20 for indicating the red square concealed among large green squares. It was abundantly clear that M.S. could distinguish the square with static or dynamic saturated chromatic borders from squares with achromatic borders, where the two types of border had a similar mean luminance contrast and the borders between a red square and the adjacent grey patches could therefore not be detected on the basis of a luminance difference. However, luminance and saturation are clearly confounded for M.S. such that chromatic borders are indistinguishable from luminance borders of high contrast. This is consistent with his comments on the tasks, for he describes the indicated target as different from or more prominent than the surround whether or not the indicated target is coloured (correct) or grey (incorrect).

The saturation of a colour is defined as the distance between the point on the CIE diagram that represents the coloured stimulus and the white point, expressed as a percentage of the length of a line drawn between the white point, passing through the colour and extending to the spectrum locus. The range of saturations is displayed in figure 13.1. When the saturation of the square was varied from trial to trial (in the range 13–38% for the reds and 16–29% for the greens) and the luminance of each component square was varied (in the ranges 73.4–122.2 cd/m^2 and 78.7–92 cd/m^2 for the reds and greens, respectively), M.S. correctly identified the coloured square as follows: red from greys, three sessions, 12 out of 20, six out of 20, 14 out of 20; green from greys, 15 out of 20; red from greens, nine out of 20. He showed a similar ability in selecting the coloured square from among the 38 × 28 array (see color plate 12D), scoring four out of 10, but required up to 60 s to make his choice. Imposing a 10 s limit reduced his score to one out of 20. When dynamic displays were presented, where the saturation of the target continuously varied from moment to moment (but remaining within the saturation range), M.S. was still able to detect the coloured square in the larger array: green from greys, seven out of 20; red from greys, 16 out of 20. However, when the 38 × 28 dynamic display was presented, M.S. scored only one out of 20 and three out of 10 for green and red targets, respectively.

In the larger static checkerboard, it was apparent to us as observers alongside him that M.S. tended to select the most salient patch whether he chose correctly or incorrectly. The salient patch is the one that appeared most conspicuous to us either because it was brighter or darker or by virtue of saturation. Examples of trials at which M.S. failed and succeeded in detecting the coloured square are shown in plate 12A and B, respectively. Thus, the task could readily be manipulated to ensure that M.S. succeeded or failed to select the coloured square. If the red square was saturated but embedded among greys of similar brightness then he could detect it

because it was for him, as us, more conspicuous. When the targets were desaturated by reducing the range (saturation 13–29%, luminance range 85.4–122.2 cd/m^2) his performance fell to 1/20 for selecting the reds from static greys and two out of 20 for selecting the desaturated red from greens.

Another way of disrupting performance for the selection of a more saturated square was to ensure that some of the accompanying squares were very bright or dim, i.e. to ensure that there are several equally salient squares, as illustrated in plate 12c. Thus, when the range of possible saturations was 13–70% and the luminance range was increased in the range 48.6–122.2 cd/m^2, M.S. scored only two out of 40.

Our original intention was to use random luminance masking to saturate the luminance channel (M channel) in order to confound colour and luminance. Then, detection of the coloured square should rely solely on residual chromatic processing. Since performance was not disrupted by using dynamic displays, it was essential to rule out display artefacts before concluding that chromatic signals are indeed present. First, the change for the target and surround may have the same temporal frequency but the depth of modulation may differ. Secondly, the temporal frequency may be different for the target. When these artefacts were deliberately introduced M.S. performed slowly but flawlessly. When they were removed (and this was confirmed by the inability of normal observers to detect the different square when red was added to the entire display) the results were consistent with those described above and similar to those with a stationary display (score: red from greys, seven out of 10; green from greys, seven out of 20). When red or green light was added M.S. scored none out of 20 and one out of 20, respectively.

In summary, M.S. was able to detect a saturated coloured square in a checkerboard of greys of the same mean luminance. However, the target was indistinguishable from surrounding squares when the latter were of high luminance contrast. Finally, the saturated target remained conspicuous in dynamic displays even though the latter should prevent detection by the broad band luminance channel.

Form Detection

A measure of the detectability of coloured boundaries masked by static or dynamic changes in brightness and saturation was M.S.'s ability to locate a cross which changed in position on the screen from trial to trial. The cross was again composed of small squares where each of the small squares differed in brightness and/or saturation. A typical trial is displayed in plate 12e. With saturation differences (red '+', 13–29%, luminance range 85.4–122.2 cd/m^2; green '+', 0–16%, luminance range 92–103.2 cd/m^2) for which, as described in the preceding section, a single coloured, large or small, square was invisible to M.S., he swiftly and deftly located the concealed

cross, scoring 19 out of 20 and 20 out of 20 for the red and green crosses, respectively. Moreover, he did not merely detect a target; when asked he described its shape both visually and by drawing a cross with his finger. Nor was his latency apparently longer than our own, although it was not accurately measured. Performance was comparable for the dynamic display, where the respective scores were 20 out of 20 and 17 out of 20. Performance was 20 out of 20 for brightness masking alone. Responses remained rapid and errorless even when tracing paper was placed over the screen, eliminating all sharp boundaries, or when the display was defocused with spectacle lenses. Finally, MS performed just as effectively when viewing monocularly in order to exclude possible binocular disparity cues that could arise from lateral chromatic aberration.

Form Discrimination

M.S. flawlessly performed a pattern discrimination between two squares and a cross (each composed of smaller coloured squares), or vice versa, where the shapes were coloured against a surround of greys of variable luminance (see plate 12F). He scored 20 out of 20 for each of the four conditions where the display was dynamic or stationary, and when saturation and/or brightness was modulated. The stimulus parameters were identical to those used for the task of form detection. As with form detection, choices were made within 1–2 s. He described the three shapes correctly and was not impaired when one eye was covered.

Colour Discrimination

When M.S. was presented with three large squares (each composed of 25 small squares), either one green and two red or vice versa, he was quite unable to select the odd one out under any condition, i.e. dynamic or static and differing in brightness or saturation. When the brightness of the pure colour alone was modulated, M.S. scored eight out of 20 and seven out of 20 for the dynamic and static conditions, respectively. For this condition, each of the smaller squares which made up the red and green discriminanda and the grey checkerboard, were modulated around their point of isoluminance at 33 cd/m^2, within a range of 10 cd/m^2. M.S. performed no better when the task was simplified by ensuring that the odd one out appeared at the top or bottom of the display and never centrally, where random responding would result in 50% correct responses. Under this condition, when saturation was varied between points 'a' and 'd' of figure 13.1, M.S. scored 14 out of 25 and 12 out of 25 for the dynamic and static conditions, respectively. These results demonstrated that M.S. is densely colour defective.

Sensitivity to the Sign of Chromatic Contrast

Despite his utter colour blindness, M.S. correctly reported the direction of apparent movement produced by a 90° phase shift for both chromatic and achromatic gratings, presented at 0.5 and 1 cycle/degree, where he scored 10 out of 10 for each condition. In contrast, presentation of alternating gratings, where direction is ambiguous, invariably resulted in the response 'down', although he spontaneously reported that the direction sometimes reversed while he inspected the display. M.S.'s ability to detect the 0.5 cycle/degree red/green sinusoidal horizontal grating and its direction of apparent movement is particularly important because there is no perceptually detectable chromatic aberration at such a low spatial frequency (Cavanagh and Anstis, 1986). He could also do this task monocularly. When asked to describe what he saw he reported a pattern of stripes moving up or down across the entire screen.

Brightness Additivity

M.S. selected a brightness match between a 53.5 cd/m^2 yellow square and a red or a green square, when the luminance of the red and green squares was 65.8 and 63.7% of that of the yellow reference square, respectively. The mean values for two normal observers (A.C. and C.A.H.) were 73.2 and 47.2%. M.S. thus showed similar nonadditivity in that the red and green squares appeared brighter than the yellow square of the same objective luminance, a cardinal feature of colour opponent coding.

Stereopsis

M.S. performed flawlessly in tasks of shape discrimination based on retinal disparity and judgements of whether a figure lay in front of or behind the plane of fixation. He scored 25 out of 25 on each task.

Discussion

M.S. is invariably and totally achromatopsic as assessed by his subjective reports, in which he describes his surroundings as grey or uses colour words inappropriately, and by conventional measures in that he fails to identify surface colours, responds randomly on the Farnsworth-Munsell 100-Hue Test and is unable to distinguish between *any* two colours when they are, for him, matched for brightness. None the less, and at first sight paradoxically, he is strikingly unimpaired at detecting a single coloured square concealed in a grey checkerboard when the colour is

maximally saturated and the range of luminance contrasts is small. In short, saturated chromatic and achromatic boundaries are conspicuously different to M.S., particularly in dynamic displays, when they are of similar luminance contrast. Increasing the luminance contrast of the achromatic boundary renders the achromatic and chromatic boundaries perceptually similar. Thus saturation and brightness are confounded for M.S. and for him under these conditions all squares of the checkerboard differ perceptually along a single dimension. This suggests that his contrast vision is mediated by a mechanism that extracts colour or luminance contrast without readily distinguishing between them. However, what is remarkable is that he can readily locate a desaturated coloured *form* embedded in a dynamic or static grey checkerboard, yet is unable to detect a single coloured square that is equally desaturated. Blurring the boundaries within the display did not affect performance. In other words, chromatic and luminance borders can be confused when their outlines are identical, e.g. all squares, but they can be perceptually segregated into figure and ground when their outlines are different, e.g. a coloured cross on grey surroundings.

M.S. can detect and describe a monochromatic cross on a static or dynamic grey surround. Why then can he not detect, at normal reading distance, the shapes in the Ishihara pseudo-isochromatic plates? The latter are perceptually more difficult for ourselves, presumably because the target shapes vary, are made up of elements of different sizes and chromaticities, and their contours are discontinuous. When some of these differences are minimized by defocusing or by viewing from a greater distance, M.S. can detect the concealed figure in the plates (Heywood et al., 1991).

In an earlier study (Heywood et al., 1991), it was proposed that the achromatic broad band M channel might mediate residual vision in M.S. Consistent with this was the demonstration that he could detect isoluminant chromatic borders without any knowledge of, and no ability to discriminate between, the colours of which the border was composed. However, the same study indicated that he indeed has access to P channel processes in that his photopic spectral sensitivity showed a 'Sloan-Crawford' notch separating two peaks that were displaced from the absorbance peak sensitivities of middle- and long-wavelength cones (Sloan, 1928). The present results amply confirm and extend these findings by showing, in addition, that M.S. shows normal sub-additivity of mixtures of middle- and long-wavelength lights. This can be attributed to the presence of colour-opponent processing (Guth, 1965). Furthermore, a more recent study (Nicholas, 1993) demonstrates that M.S. has normal contrast sensitivity to chromatic sinusoidal gratings.

The results of measurements of binocular stereopsis provide further evidence that M.S. processes signals in the P channel at a cortical level. His errorless ability to

detect small differences in disparity in random dot stereograms was no different from our own, showing that any impairment must be very small indeed. Impairments on similar tasks have been demonstrated in monkeys following ablation of posterior inferotemporal cortex (Cowey, 1985), which is thought to receive signals predominantly from the P channel. Also, destruction of the parvocellular, but not magnocellular, layers of the dLGN abolishes or seriously disrupts global stereopsis in monkeys where the disparities are small (Schiller et al., 1990). Although the broad band M channel could play a role in coarse stereopsis it is difficult to see how it alone could sustain the registration of small disparities and the perception of subtle differences in depth planes that depend on them.

M.S. clearly possesses, and can use, visual processing beyond that which is present in the broad band M channel. One possibility is that his intact striate cortex mediates chromatic form detection and contrast sensitivity. This explanation was proposed by Victor et al. (1989) to account for the residual ability in their patient who, like M.S. (Nicholas, 1993), showed normal colour-contrast sensitivity, intact Snellen acuity and clear visual evoked potentials to isoluminant chromatic patterns. However, quite unlike M.S. (Heywood et al., 1991) he was able to detect colour differences in an oddity task and identify figures embedded in the Ishihara plates at the conventional reading distance, i.e. he was not completely achromatopsic. Single neurons sensitive to chromatic properties are common in primate striate cortex and an important distinction can be made between 'simple' and 'complex' cells. Simple cells are sensitive to spatial phase and respond in an opposite manner to different spectral regions. Complex cells are sensitive to chromatic boundaries and will respond to an isoluminant chromatic grating regardless of its spatial phase, i.e. their responses to a red bar on a green background or vice versa, are indistinguishable (Thorell et al., 1984). They also respond to a counterphase-flickered red-green isoluminant grating but provide no information about the phase of the pattern, to use the term of De Valois and De Valois (1988, p. 231). It is plausible to suggest that chromatic contour detection in achromatopsia is mediated by a population of complex cells whose lack of sensitivity to chromatic phase renders them insensitive to the sign of contrast and hence unable to signal genuine chromaticity. However, the present results make this simple hypothesis untenable because M.S. readily perceives the direction of motion of a square- or sine-wave isoluminant chromatic grating that is phase shifted by 90°, a clear demonstration that he can respond to the direction of chromatic contrast.

A further possibility exists that would reconcile differences in the quality of residual vision displayed in achromatopsia. Loss of one arm of the P channel, namely that which conveys information via the cortical 'blobs', would leave the second arm,

in addition to the M channel, primarily responsible for residual vision. The conscious cortical registration of colour may depend on the integrity of the former pathway which could be compromised either at the level of striate cortex, either directly or by interruption of the visual radiations, or by destruction of cortical regions to which the 'blobs' directly or indirectly project. In 'interblob' regions the majority of cells are orientation tuned, but chromatic properties are present in $\sim 50\%$ of them.

It may well be that the striking ability of M.S. to detect chromatic form relies on properties of the 'interblob' pathway. When viewing the checkerboard and asked to 'select the different square', he clearly picks the most salient one, i.e. most saturated, brightest, etc. If the coloured one is desaturated and the brightness variation among the squares is small, then they are all, to him, of similar appearance. If the brightness variation is large and the target is saturated then all squares are perceptually dissimilar and he fails to pick the coloured square. This is true for large or small checkerboards and for dynamic or static displays. When the coloured cross is presented, M.S. can resolve both the individual patches that make up the checkerboard and each component square of the cross and it might be expected that the cross would remain inconspicuous. However, presumably each of the component squares of the cross share a quality which we call colour, and which he too perceives, and the task is no longer to detect the 'different' item from amongst many items but merely to locate the figure embedded in the checkerboard. M.S. performs this task flawlessly. He can thus use wavelength to extract form but his performance on tasks of colour discrimination suggest he has no phenomenal experience of colour itself. The 'interblob system' has been implicated in computational accounts of processes that derive boundary information. Grossberg (Grossberg and Mingolla, 1985; Grossberg, 1987) has argued for the existence of a boundary-contour system that is sensitive to orientation but oblivious to the direction of stimulus contrast. These are just the receptive field properties possessed by complex cells prevalent in 'interblob' regions. Nevertheless, this account should not disguise that fact that M.S. can determine the sign of colour contrast without experiencing the colours, an ability presumably mediated by cortical simple cells. This suggests that activity in simple cells of the blobs does not lead to the phenomenal experience of colour or can be disconnected from it by the cortical damage.

Substantial variations in the degree of residual ability observed in achromatopsia may be better explained by the proposal that when there is partial damage to the 'colour centre' the result is a continuing contribution to residual vision as in the case of Victor et al. (1989). Under these circumstances residual abilities are more substantial than in the present case, i.e. preserved ability to detect the 'different'

coloured square in an oddity paradigm. If damage to the 'colour centre' in the lingual and fusiform gyri is complete or if the P channel is compromised at an earlier stage then impairments in colour processing will be more substantial, as in patients like M.S.

Acknowledgments

We wish to thank Dr D. Popplewell and Dr P. Azzopardi for their help in generating visual displays and M.S. for his continuing enthusiastic co-operation. This research was supported by the Medical Research Council (Grant G971/397/B) and the Human Frontiers Science Program.

References

Albert ML, Reches A, Silverberg R. Hemianopic colour blindness. J Neurol, Neurosurg Psychiatry 1975; 38: 546–9.

Barbur JL, Harlow JA, Plant G, Williams C. Colour discrimination measurements in patients with cerebral achromatopsia. In: Non invasive assessment of the visual system technical digest, Vol. 3. Washington (DC): Optical Society of America, 1993: 356–9.

Cavanagh P, Anstis SM. Do opponent-color channels contribute to motion? [abstract]. Invest Ophthalmol Vis Sci 1986; Suppl 27: 291.

Corbetta M, Miezin FM, Dobmeyer S, Shulman GL, Petersen SE. Selective and divided attention during visual discriminations of shape, color and speed: functional anatomy by positron emission tomography. J Neurosci 1991; 11: 2383–402.

Cowey A. Disturbances of stereopsis by brain damage. In: Ingle DJ, Jeannerod M, Lee DN, editors. Brain mechanisms and spatial vision. Dordrecht: Martinus Nijhoff, 1985: 259–78.

Damasio A, Yamada T, Damasio H, Corbett J, McKee J. Central achromatopsia: behavioral, anatomic, and physiologic aspects. Neurology 1980; 30: 1064–71.

De Valois RL, De Valois KK. Spatial vision. New York: Oxford University Press, 1988.

Felleman DJ, Van Essen DC. Distributed hierarchical processing in the primate cerebral cortex. [Review]. Cereb Cortex 1991; 1: 1–47.

Grossberg S. Cortical dynamics of three-dimensional form, color, and brightness perception: 1. Monocular theory. Percept Psychophys 1987; 41: 87–116.

Grossberg S, Mingolla E. Neural dynamics of form perception: boundary completion, illusory figures, and neon color spreading. [Review]. Psychol Rev 1985; 92: 173–211.

Guth SL. Luminance addition: general considerations and some results at foveal threshold. J Opt Soc Am 1965; 55: 718–22.

Heywood CA, Wilson B, Cowey A. A case study of cortical colour 'blindness' with relatively intact achromatic discrimination. J Neurol Neurosurg Psychiatry 1987; 50: 22–9.

Heywood CA, Cowey A, Newcombe F. Chromatic discrimination in a cortically colour blind observer. Eur J Neurosci 1991; 3: 802–12.

Hubel DH, Livingstone MS. Segregation of form, color, and stereopsis in primate area 18. J Neurosci 1987; 7: 3378–415.

Kölmel HW. Pure homonymous hemiachromatopsia: findings with neuro-ophthalmologic examination and imaging procedures. Eur Arch Psychiatry Neurol Sci 1988; 237: 237–43.

Livingstone MS, Hubel DH. Psychophysical evidence for separate channels for the perception of form, color, movement and depth. [Review]. J Neurosci 1987; 7: 3416–68.

Meadows JC. Disturbed perception of colours associated with localized cerebral lesions. Brain 1974; 97: 615–32.

Milner AD, Heywood CA. A disorder of lightness discrimination in a case of visual form agnosia. Cortex 1989; 25: 489–94.

Mollon JD, Newcombe F, Polden PG, Ratcliff G. On the presence of three cone mechanisms in a case of total achromatopsia. In: Verriest G, editor. Colour vision deficiencies. Bristol: Hilger, 1980; 130–5.

Newcombe F, Ratcliff G. Agnosia: a disorder of object recognition. In: Michel F, Schott B, editors. Les syndromes de disconnexion calleuse chez l'homme. Lyon: Colloque International de Lyon, 1975: 317–41.

Nicholas JJ. Information processing in parallel visual pathways [D. Phil thesis]. Oxford: University of Oxford, 1993.

Plant GT. Disorders of colour vision in diseases of the nervous system. In: Foster DH, editor. Inherited and acquired colour vision deficiences: fundamental aspects and clinical studies. Vision and visual dysfunction. Vol. 7. Basingstoke: Macmillan Press, 1991: 173–98.

Ratcliff G, Newcombe F. Object recognition: some deductions from the clinical evidence. In: Ellis AW, editor. Normality and pathology in cognitive functions. London: Academic Press, 1982: 147–71.

Saito H, Tanaka K, Isono H, Yasuda M, Mikami A. Directionally selective response of cells in the middle temporal area (MT) of the macaque monkey to the movement of equiluminous opponent color stimuli. Exp Brain Res 1989; 75: 1–14.

Schiller PH, Logothetis NK, Charles ER. Functions of the colour-opponent and broad-band channels of the visual system [see comments]. Nature 1990; 343: 68–70. Comment in: Nature 1990; 343: 16–17.

Sloan LL. The effect of intensity of light, state of adaptation of the eye, and size of photometric field on the visibility curve. Psychol Monogr 1928; 38(1): 1–87.

Stiles WS. Mechanisms of colour vision. London: Academic Press, 1978.

Thorell LG, De Valois RL, Albrecht DG. Spatial mapping of monkey V1 cells with pure color and luminance stimuli. Vision Res 1984; 24: 751–69.

Valberg A, Lee BB, Kaiser PK, Kremers J. Responses of macaque ganglion cells to movement of chromatic borders. J Physiol (Lond) 1992; 458: 579–602.

Victor JD. Evaluation of poor performance and asymmetry in the Farnsworth-Munsell 100-hue test. Invest Ophthalmol Vis Sci 1988; 29: 476–81.

Victor JD, Maiese K, Shapley R, Sidtis J, Gazzaniga MS. Acquired central dyschromatopsia: analysis of a case with preservation of color discrimination. Clin Vis Sci 1989; 4: 183–96.

Zeki S. A century of cerebral achromatopsia. [Review]. Brain 1990a; 113: 1721–77.

Zeki S. Colour vision and functional specialisation in the visual cortex. Disc Neurosci 1990b; IV (2): 64.

Zeki S, Shipp S. The functional logic of cortical connections. [Review]. Nature 1988; 335: 311–17.

Zeki S, Watson JDG, Lueck CJ, Friston KJ, Kennard C, Frackowiak RSJ. A direct demonstration of functional specialization in human visual cortex. J Neurosci 1991; 11: 641–9.

VII COMPARATIVE COLOR VISION AND EVOLUTION

14 The Perceptual Organization of Colors: An Adaptation to Regularities of the Terrestrial World?

Roger N. Shepard

Those taking an evolutionary approach to the behavioral, cognitive, and social sciences have been emphasizing the natural selection of mechanisms and strategies that are specific to particular species, genders, and problem domains. This emphasis on the particular is understandable as a reaction against the tendency, long dominant in these sciences, to proceed as if human and animal behavior could be explained in terms of just two things: (a) general laws of learning and cognitive constraints that hold across species, genders, and domains, and (b) the particular set of environmental (including cultural) circumstances to which each animal can adapt only by learning through its own individual experience. Evolutionary theorists' emphasis on specific adaptations may also reflect the tendency of such adaptations to catch our attention through the very diversity of their specificity. Adaptations to universal features of our world are apt to escape our notice simply because we do not observe anything with which such adaptations stand in contrast.

In this chapter I consider some characteristics of the perception and representation of colors that, although not universal in animal vision, do appear to be universal in the normal color vision of humans, prevalent in other primates, and common in a number of other quite different but also highly visual species, including the birds and the bees. The questions raised are (a) whether these characteristics of color perception and representation are merely arbitrary design features of these particular species, (b) whether these characteristics arose as specific adaptations to the particular environmental niches in which these species evolved, or (c) whether they may have emerged as advanced adaptations to some properties that prevail throughout the terrestrial environment. My discussion here will principally concern four remarkable characteristics of the colors that we so immediately and automatically experience when we look at the objects around us.

1. *The perceptual constancy of colors.* Opening our eyes seems like simply opening a window on a surrounding world of enduring objects and their inherent colors. Closer consideration shows, however, that our experience of the colors of objects depends on a process of visual analysis that, although largely unconscious, must be highly sophisticated and complex. Because most terrestrial objects do not shine by their own light, the light that strikes our eyes from those objects and by which we see them generally originates in a very different, extraterrestrial source—namely, the sun. Moreover, depending on the circumstances in which an object is viewed, that solar illumination is subject to great variation in spectral composition. For example, light striking an object directly from an overhead sun may be strongest in middle

wavelengths (yellows), light scattered to an object from clear sky may be strongest in short wavelengths (blues), and light from a setting sun may be strongest in long wavelengths (reds). Depending on such viewing conditions, the light scattered back to our eyes from any given object can accordingly be strongly biased toward the middle, shorter, or longer wavelengths and, so, toward the yellows, blues, or reds. Yet despite these great variations in the light that a surface scatters back to our eyes under these different conditions, the color that we perceive a surface to have remains a fixed, apparently inherent property of the surface itself.

The adaptive significance of such perceptual constancy of surface color is clear. In order to respond appropriately to an object we must recognize it as the same distal object despite wide variations in the illumination and in the resulting composition of the light striking our retinas. After centuries of investigation, the question of how our visual systems achieve color constancy has been considerably clarified and, perhaps, essentially answered (see Maloney & Wandell, 1986). Although the principle of color constancy underlies virtually everything I have to say in this chapter, that principle (if not yet the specific physiological mechanism by which it is achieved) has long been accepted as fundamental in psychology and visual science. To the extent that I have any new ideas to present, these will primarily concern the following three other characteristics of human color perception and representation—characteristics that, although well established, still have no generally accepted explanations.

2. *The three-dimensional structure of colors.* In terms of its chromatic composition, the light reaching our eyes from any one point in the visual field can vary in an unlimited number of dimensions. Each such dimension would specify the amount of energy in the light that is of one particular wavelength within the range of visible wavelengths—between about 400 nm (nanometers) at the violet end of the visible spectrum and about 700 nm at the red end. Yet the surface colors experienced by humans with normal color vision (in addition to being essentially constant for each surface) vary between different surfaces in only three dimensions (Helmholtz, 1856–1866; Young, 1807). In operational terms, normal observers can match the color appearance of any given surface by adjusting three—but no fewer than three—knobs on a suitable color-mixing apparatus.

Accordingly, the surface colors experienced by normally sighted human observers are representable as points in a three-dimensional *color space*, whose three dimensions can be taken to be those called *lightness*, *hue*, and *saturation* (see figure 14.1a). Why is the number of dimensions of our representation of colors exactly three—rather than, say, two or four? Furthermore, given that we experience colors as properties of the surfaces of external objects, in what sense, if any, does this three-dimensionality of our color experience reflect a three-dimensionality in the world?

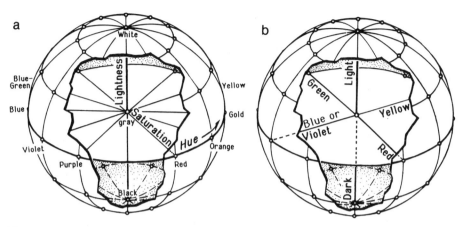

Figure 14.1
Schematic representations of three-dimensional color space in terms of three polar dimensions of lightness, hue, and saturation (a) or in terms of three dimensions of opponency between lightness versus darkness, blueness versus yellowness, and redness versus greenness (b).

3. *The circular structure of spectrally pure colors.* The colors that correspond to the hues of the rainbow—chromatically pure colors that are maximally saturated in the sense that they differ as much as possible from a (correspondingly light, medium, or dark) neutral or achromatic gray—can each be matched by light that is spectrally pure, that is, composed of a single wavelength. (The only saturated colors that cannot be matched by a single wavelength are the purples, which arise from mixtures of a long-wavelength red and a short-wavelength blue or violet.) Given that the pure colors of the rainbow thus correspond to a single physical dimension (wavelength), it is not surprising that these colors are represented by a single dimension of three-dimensional color space—namely, the dimension we call *hue*. What does need explaining, is why this dimension of hue is not rectilinear, like the physical dimension of wavelength to which it corresponds, but circular (as schematically illustrated by the equatorial line around color space in figure 14.1a).

The circular representation of hue, originally described by Isaac Newton (1704) and accordingly referred to as *Newton's color circle*, is entailed by an elementary perceptual fact: The hues at the two ends of the physical continuum of visible wavelengths—namely, long-wavelength red and short-wavelength violet—are experienced by individuals with normal color vision as more similar to each other than either is to intermediate-wavelength green. This psychological proximity between the physically most widely separated (red and violet) ends of the hue continuum can be achieved in color space only by bending this continuum into a circle. Is this

circularity of hue a manifestation of an arbitrary characteristic of our perceptual system, then? Or might it have some deeper source, if not simply in the wavelengths of spectrally pure lights, in some more subtle regularity of the physical world?

4. *The universal organization of colors into categories and prototypes.* The three-dimensional space of surface colors (figure 14.1)—including the one-dimensional circle of hues around the perimeter of that space—is continuous in the sense that between any two distinctly different colors, we can obtain, by color mixing, a color of intermediate appearance. At the same time, however, this continuous space seems to divide into relatively discrete regions within which the colors appear relatively more homogeneous than colors that cross the boundaries between such regions. Within such a region, moreover, the colors tend to be described by a single basic color word, such as our English words "red," "yellow," "green," or "blue." With even greater consistency, we generally agree with each other about what highly localized subregion within each such general region contains the best or most proto-typical examples of the color prevailing throughout that general region.

Indeed, across human cultures, regardless of the duration and distance of their geographical separation and the number of basic color terms that their very different languages include, there seems to be a universal underlying hierarchy of regions and, especially, prototypical subregions of color space to which native speakers assign whatever basic color terms their individual languages include (Berlin & Kay, 1969). Thus, most languages have terms that native speakers apply to colors in the very same regions of color space for which we use the words "red" and "green." If, in addition, a given language also includes words corresponding (for example) to our "orange" or "purple," those words, too, are applied to essentially the same regions of color space for which we use "orange" or "purple." There is, moreover, especially great consistency in the locations of the colors that are picked out as the best or purest example of any particular color. Is this categorical organization of human color representation the manifestation of an arbitrary design feature of the human visual system? Or, again, is it a reflection of some general property of the world?

I do not claim to have final and definitive answers for these last three questions—concerning the three-dimensionality of colors, the circularity of hues, and the con-sistent organization of colors into categories and prototypes. Believing, however, that these questions are worth exploring from an evolutionary standpoint, I shall tentatively propose some hypotheses as to where in the world we might look for pervasive and enduring regularities to which these structural properties of the human visual system may have accommodated through natural selection. First, however, I attempt to situate my proposals within the broader context of human perceptual and cognitive constraints generally.

Structure in Human Perception and Cognition in General

For over a century, psychological researchers have been probing the structures and processes of perception, memory, and thought that mediate the behaviors of humans and other animals. Typically, this probing has taken the form of behavioral experiments suggested by evidence from one or more of three sources: (a) introspections into one's own experience and inner processes, (b) information gleaned about the anatomy or physiology of the underlying physical mechanisms, and (c) results obtained from previous behavioral studies. More recently, in seeking to understand not only the nature but also the origins of psychological principles, some of us have been turning to a fourth source for guidance—namely, to the ecological properties of the world in which we have evolved and to the advantages to be realized by individuals who have genetically internalized representations of those properties.

Taken by themselves, findings based on introspective, behavioral, and physiological evidence alike, however well established and mutually consistent they may be, remain as little more than "brute facts" about the human or animal subjects studied. What such findings reveal might be merely arbitrary or ad hoc properties of the particular collection of terrestrial species investigated. Even our own perceptual and cognitive capabilities, as much as our own bodily sizes and shapes, may be the products of a history of more or less accidental circumstances peculiar to just one among uncounted evolutionary lines. Certainly, these capabilities do not appear to be wholly dictated by what is physically possible.

The following are just a few of the easily stated and well known of our perceptual/cognitive limitations, as these have been demonstrated under highly controlled but nonnaturalistic laboratory conditions:

1. Although a physical measuring instrument can reliably identify a vast number of absolute levels of a stimulus, we reliably identify only about seven (Miller, 1956).

2. Although a physical recording instrument can register a vast number of dimensions of variation of the spectral composition of light, the colors we experience vary, as I have already noted, along only three independent dimensions (Helmholtz, 1856–1866; Young, 1807).

3. Although the red and violet spectral colors differ the most widely in physical wavelength, these colors appear more similar to each other than either does to the green of an intermediate wavelength (leading, as noted, to Newton's color circle).

4. Although a camera can record and indefinitely preserve an entire scene in a millisecond blink of a shutter, the "iconic" image that our visual system retains from a single brief exposure decays in less than a second and, during this time, we are able

to encode only about four or five items for more permanent storage (Sperling, 1960).

5. Although a computer can store an essentially unlimited number of unrelated items for subsequent retrieval, following a single presentation, we can reliably recall a list of no more than about seven items (Miller, 1956).

6. Although a computer could detect correlations between events separated by any specified time interval and in either order of occurrence, in virtually all animals with nervous systems, classical conditioning generally requires that the conditioned stimulus last for a short time and either be simultaneous with the unconditioned stimulus or precede it by no more than a few seconds (Pavlov, 1927, 1928).

7. Although a computer can swiftly and errorlessly carry out indefinitely protracted sequences of abstract logical operations, we are subject to systematic errors in performing the simplest types of logical inferences (e.g., Tversky & Kahneman, 1974; Wason & Johnson-Laird, 1972; Woodworth & Sells, 1935)—at least when these inferences are not of the kind that were essential to the fitness of our hunter-gatherer ancestors during the Pleistocene era (Cosmides, 1989).

Our performance in a natural setting is, however, a very different matter. There, our perceptual and cognitive capabilities vastly exceed the capabilities of even the most advanced artificial systems. We readily parse complex and changing visual scenes and auditory streams into spatially localized external objects and sound sources. We classify those objects and sources into natural kinds despite appreciable variation in the individual instances and their contexts, positions, or conditions of illumination. We infer the likely ensuing behaviors of such natural objects—including the recognition of animals and anticipation of their approach or retreat, the recognition of faces and interpretation of their expressions, and the identification of voices and interpretation of their meanings. We recode and transfer, from one individual to another, information about arbitrary or possible states of affairs by means of a finite set of symbols (phonemes or corresponding written characters). And we plan for future courses of action and devise creative solutions to an open class of real-world problems.

To the extent that psychological science fails to identify nonarbitrary reasons or sources for these perceptual/cognitive limitations and for these perceptual/cognitive capabilities, this science will remain a merely descriptive science of this or that particular terrestrial species. This is true even if we are able to show that these limitations and capabilities are consequences of the structures of underlying neurophysiological mechanisms. Those neurophysiological structures can themselves be

deemed nonarbitrary only to the extent that they can be seen to derive from some ultimately nonarbitrary source.

Where, then, should we look for such a nonarbitrary source? The answer can only be, "In the world." All niches capable of supporting the evolution and maintenance of intelligent life, though differing in numerous details, share some general—perhaps even universal—properties. It is to these properties that we must look for the ultimate, nonarbitrary sources of the regularities that we find in perception/cognition as well as in its underlying neurophysiological substrate.

Some of the properties that I have in mind here are the following (see Shepard, 1987a, 1987b, 1988, 1989): Space is three-dimensional, locally Euclidean, and endowed with a gravitationally conferred unique upward direction. Time is one-dimensional and endowed with a thermodynamically conferred unique forward direction. Periods of relative warmth and light (owing to the conservation of angular momentum of planetary rotation) regularly alternate with periods of relative coolness and darkness. And objects having an important consequence are of a particular natural kind and therefore correspond to a generally compact connected region in the space of possible objects—however much those objects may vary in their sensible properties (of size, shape, color, odor, motion, and so on).

Among the genes arising though random mutations, then, natural selection must have favored genes not only on the basis of how well they propagated under the special circumstances peculiar to the ecological niche currently occupied, but also, as I have argued previously (e.g., Shepard, 1987a), even more consistently in the long run, according to how well they propagate under the general circumstances common to *all* ecological niches. For, as an evolutionary line branches into each new niche, the selective pressures on gene propagation that are guaranteed to remain unchanged are just those pressures that are common to all niches.

Motivated by these considerations, much of my own recent work on perception and cognition in humans has sought evidence that our perceptual/cognitive systems have in fact internalized, especially deeply, the most pervasive and enduring constraints of the external world. In previous papers, I have primarily focused on evidence concerning two types of perceptual/cognitive capabilities: The first is our capability for representing rigid transformations of objects in three-dimensional Euclidean space—as revealed in experiments (a) on the perception of actually presented motions, (b) on the illusion of visual apparent motions, and (c) on the imagination of possible motions (Shepard, 1981, 1984, 1988; Shepard & Cooper, 1982; and, for a recent group-theoretic formulation, Carlton & Shepard, 1990). The second is our capability for estimating the conditional probability that a particular object is

of the natural kind having some significant consequence, given that another particular object has already been found to have that consequence—as revealed in experiments on stimulus generalization and transfer of learning (Shepard, 1987b).

I turn now to the specific questions raised at the outset concerning four major characteristics of our perception and mental representation of surface colors— namely, their constancy, their three-dimensionality, their circularity with respect to hue, and their organization into categories and prototypes. In addition to reviewing the basic empirical phenomena to be explained in each case, I argue that these phenomena may arise not from merely accidental features of the human visual system but from genetic accommodations to identifiable regularities in the terrestrial world.

The Perceptual Constancy of Colors

Among the four major characteristics of human color perception mentioned, that of color constancy is undoubtedly of the most obvious and well-understood functional significance. This is not to say that the achievement of constancy is in any way trivial. The light that reaches our eyes from an external surface is a product of both the spectral reflectance characteristics of a surface and the spectral energy distribution of the light that happens to fall on that surface. In fact, as I shall shortly note, each of two surfaces can retain its own distinct color appearance even when the two surfaces are viewed under such different conditions of illumination that the light that each surface reflects back to our eyes is of identical composition. This could happen, for example, if a reddish object is illuminated solely by the bluish light of the sky, while a bluish object is illuminated solely by the reddish light of the setting sun. Constancy in the appearance of surfaces under such different conditions of illumination can be achieved only to the extent that the visual system can successfully infer the separate contributions—of the surfaces and of the lighting—that have jointly given rise to the retinal stimulus.

By what mechanism does the visual system make such an inference and, hence, attain constancy in the perceived colors of objects? Two computational theories of color vision have been especially influential in the development of my own thinking about a possible evolutionary basis for the way in which humans represent colors. The first was the *retinex* theory proposed by Edwin Land (1964). Although that theory turns out to provide an incomplete solution to the problem of color constancy, it first suggested to me that the principal features of color vision may have arisen as an accommodation to regularities in the world. The second is the general linear model for color vision more recently put forward by Maloney and Wandell (1986). In addition to providing what I take to be the first satisfactory solution to the

problem of color constancy, this model finally led me to an evolutionary argument as to why human vision should be trichromatic, that is, should have exactly three dimensions of color representation.

Land's Retinex Scheme for Color Constancy

The possibility that the subjective phenomena of color may reflect an objective property of the world began to intrigue me on attending Land's strikingly illustrated William James Lectures, at Harvard University in 1967, on his *retinex theory* (see Land, 1964, 1986). Previously, textbook accounts of color vision had focused on phenomena attributable to peripheral, often retinal, sensory mechanisms. Principal examples of such phenomena are the gradual adjustment of visual sensitivity, called *adaptation*, following a change in general level of illumination, and the illusory shift in appearance of a surface (toward the lighter or darker, redder or greener, bluer or yellower), called *simultaneous* or *successive contrast*, when that surface is surrounded or preceded by a surface that is, contrastingly, darker or lighter, greener or redder, yellower or bluer, respectively. (Such phenomena of adaptation and contrast, incidentally, are characteristic of most sensory mechanisms and not specific to color or even to vision.) A major thrust of Land's approach, conditioned perhaps by his practical interest in contributing to color photography, was to look beyond the sensory mechanisms to the world outside and to consider the problem that the world presents and that the sensory mechanisms must solve. This is essentially the approach taken to vision in general by David Marr (1982) and, originally (but without the goal of also developing a computational model), by James Gibson (1950, 1966, 1979).

Land's demonstrations showed, in a particularly compelling way, that the color that we experience of a patch of surface is not determined by the composition of the light reaching our eyes from that patch. Instead, the color we experience somehow captures an invariant property of the surface itself, despite the enormous illumination-contingent variations in the composition of the light reflected back to our eyes. For example, Land illuminated a large display composed of rectangular sheets of many different colored papers (called a "Mondrian" because it resembled the abstract paintings by Mondrian) by means of three projectors—one projecting short-wavelength (violet) light, one projecting middle-wavelength (green) light, and one projecting long-wavelength (red) light. The intensity of the colored light from each projector could be independently controlled. On a screen above the Mondrian display, the projected image of the dial of a telescopic spot photometer registered the intensity of the light reflected back from any rectangular patch in the Mondrian at which the photometer was currently pointed.

With one setting of the intensities of the three illuminating projectors, Land pointed the spot photometer at a patch of the Mondrian that appeared a rust-colored reddish brown. In turn, pairs of the three projectors were turned off, and, from the projected image of the dial of the spot photometer, we could see how much light from the successively isolated short-, middle-, and long-wavelength projectors was being reflected back to our eyes from that rust-colored patch. Next, Land pointed the spot photometer at a very different, green patch. Again, all pairs of the three projectors were successively turned off (yielding, of course, very different readings of the amounts of short-, middle-, and long-wavelength light reflected from this green patch). The intensity of each projector was then adjusted so that according to the spot photometer, the very same amount of light from that projector—when it alone remained on—was reflected back to our eyes by the green patch as had previously been reflected back (from that projector) by the reddish brown patch. For example, in order to get the same amount of red light reflected back from the green patch as had previously been reflected back from the reddish brown patch, the red projector had to be turned way up; and in order to get the same amount of green light reflected back, the green projector had to be turned way down.

As a result of these adjustments, when all three projectors were then turned back on, our eyes were receiving light from the green patch that was virtually identical in physical composition to the light our eyes had previously been receiving from the reddish brown patch. Astonishingly, under this greatly altered lighting the originally reddish brown patch still appeared reddish brown, and the originally green patch still appeared green! In fact, the entire Mondrian display appeared essentially unchanged. Clearly, color is in the eye of the beholder in the sense that it does not have a one-to-one correspondence to the physical composition of the light that, striking the retina, gives rise to that color (or even, as we shall see, to the dimensionality of the variations that occur in that composition). Yet the resulting subjective experience of color, evidently, does capture an invariant property of the surface of the distal object.

Land proposed his retinex theory to account for this remarkable feat of color constancy by positing that the visual system automatically computes an independent brightness normalization within each of three color channels (which, for present purposes, we can think of as associated with the short-, middle-, and long-wavelength receptors). In effect, he assumed that the gain of each chromatic channel is increased or reduced so that the output for that channel, when that output is integrated over the entire visible scene, maintains a fixed, standard level of lightness. Thus, when the relative amount of long-wavelength light in the illumination increases—whether because the intensity of a red projector is turned up or because

the sun is setting—there is a correlated increase in the amount of red light reflected from the scene as a whole. But the visual system automatically compensates for this increase in the average redness of the light reflected back from the entire scene by decreasing the overall gain of the long-wavelength input channel. The consequence is that the scene (including a reddish brown patch and a green patch) continues to look essentially the same.

Land's approach to color vision appealed to me because it pointed toward the possibility that fundamental aspects of color vision may not be by-products of accidental design features of the visual system arising in a particular species but may represent a functional accommodation to a quite general property of the world in which we and other terrestrial animals have evolved. Land himself suggested something of this sort when he spoke of our "polar partnership" with the world around us (Land, 1978).

Still, Land's retinex theory does not in itself provide an answer to the questions of why we have specifically three chromatic input channels and hence specifically three dimensions of color vision. Moreover, the retinex theory has been shown to fall short of providing a satisfactory account of color constancy itself. Normalization of lightness within each of three color channels independently will achieve color constancy only if the whole scene viewed includes a typical representation of short-, middle-, and long-wavelength-reflecting surfaces. If the scene is strongly biased toward the reds (as in a canyon in the southwestern U.S.), toward the greens (as in a rain forest), or toward the blues (as in a sky and water scene), the proposed normalization will strive to remove the overall red, green, or blue complexion of the light reflected back from the scene even though, in each of these cases, the complexion is an inherent characteristic of the scene itself and not a bias imposed by the currently prevailing illumination. Indeed, in photography and television, color rendering is similarly attempted by separately adjusting the intensities of each of three color channels— with results whose inadequacies are all too familiar.

Maloney and Wandell's General Linear Model for Color Constancy

Building on work by Sälström (1973), Brill (1978; Brill & West, 1981; West & Brill, 1982), Buchsbaum (1980), and others, Laurence Maloney and Brian Wandell more recently put forward a general linear model for color vision that overcomes the principal limitations of Land's retinex theory (Maloney & Wandell, 1986). It was the advent of Maloney and Wandell's model at Stanford University that finally (nearly 20 years after Land's William James Lectures) suggested to me the possibility, to which I will soon turn, of a nonarbitrary basis for the three-dimensionality of human color vision.

Maloney and Wandell's theory does not require the restrictive assumption that the distribution of intrinsic colors in each scene always be the same. In their model, surface colors are estimated by applying a transformation to all three chromatic channels jointly, rather than to each channel separately. The resulting general linear transformation yields estimates of the intrinsic surface colors that approximate invariance both under natural variations of illumination and under wide variations of the distribution of surface colors (such as arise in a red canyon, a green rain forest, or a blue sky and water scene). Although the mathematical formulation of Maloney and Wandell's model is not essential here, it is worth one paragraph and one equation for those who are able to appreciate its elegance and generality.

The three central components of the model specify the dependencies on wavelength of (a) the illumination falling on the scene, (b) the light-reflecting characteristics of the surfaces making up the scene, and (c) the light-absorbing characteristics of the light-sensitive receptors in the eye viewing the scene. Specifically, for each point x of a surface in the scene and for each wavelength of light λ, the three components are: *the spectral power distribution of the illumination*, a function of wavelength $E^x(\lambda)$ specifying the amount of light (e.g., in quanta per second) of each wavelength λ falling on the surface point x; *the spectral reflectance distribution of the surface*, a function of wavelength $S^x(\lambda)$ specifying the proportion of any light quanta of wavelength λ falling on the surface at point x that will be scattered back from that surface (rather than being absorbed by the surface); and *the spectral sensitivity characteristics of the photoreceptive units*, functions of wavelength $R_k(\lambda)$ giving, for retinal receptors (cones) of each type k the sensitivity of receptors of that type to light of wavelength λ. The response of a receptor of type k to light scattered from the point x on the surface is then given by integration of the product of these three components over the entire spectrum of wavelengths:

$$\rho_k^x = \int E^x(\lambda) S^x(\lambda) R_k(\lambda) d\lambda \quad k = 1, 2, \ldots, N$$

(where, for humans, who have three types of cones, $N = 3$).

Crucial to the application of this model to the problem of color constancy is the evidence, reviewed by Maloney and Wandell (1986), that the first two of these functions of wavelength, $E^x(\lambda)$ and $S^x(\lambda)$, each have only a limited number of degrees of freedom in the natural environment. That is, although the functions characterizing individual conditions of illumination and individual physical surfaces can each take on a potentially unlimited number of different shapes, in the natural terrestrial environment each of these shapes can be approximated as some linear combination of a small number of fixed underlying functions, called the *basis lighting functions* and the

basis reflectance functions, respectively. (For those familiar with factor analysis or principal components analysis, this is merely another instance of the way in which redundancies or correlations in multivariate data permit the approximate reconstruction of those data from a relatively small number of underlying factors.)

Thus, although the complete specification of the light-reflecting characteristics of a surface must give, for each wavelength of light striking that surface, the proportion of the light of that wavelength that will be scattered back from the surface (rather than being absorbed), for most naturally occurring surfaces the spectral reflectance distributions $S^x(\lambda)$ turn out to be smooth, well-behaved functions of wavelength (Barlow, 1982; Stiles, Wyszecki, & Ohta, 1977). There is, moreover, a well-understood physical reason for this in terms of the Gaussian smoothing entailed by the very large number of quantum interactions among numerous neighboring energy states in surface atoms that mediate the absorption and re-emission of incident photons (Maloney, 1986; Nassau, 1983). In any case, the smoothness and, hence, redundancy in the empirically obtained spectral reflectance functions permits these functions to be approximated as linear combinations of a few basis functions (Cohen, 1964; Krinov, 1947; Yilmaz, 1962)—although evidently not as few as three (Buchsbaum & Gottschalk, 1984; Maloney, 1986).

For natural conditions of lighting, on the other hand, spectral energy distributions $E^x(\lambda)$ apparently can be adequately approximated as linear combinations of just three basis lighting functions (Judd, MacAdam, & Wyszecki, 1964; also see Das & Sastri, 1965; Dixon, 1978; Sastri & Das, 1966, 1968; Winch, Boshoff, Kok, & du Toit, 1966). For example, Judd et al. found that 622 empirically measured spectral power distributions, measured under a great variety of conditions of weather and times of day, could be accurately approximated as weighted combinations of just the three functions plotted in figure 14.2. (As in factor analysis, these particular basis functions are not uniquely determined by the data. Other sets of three basis functions that differ from these by a nonsingular linear transformation, such as a rotation, would account for the data just as well. The important point is that whichever of the alternative basis functions are used, they must be three in number.)

Maloney and Wandell (1986) showed that the unknown surface reflectance functions $S^x(\lambda)$—that is, the intrinsic colors of the surfaces—can be approximated, up to a *single* multiplicative scalar, solely from the responses of the N classes of photoreceptors, provided that two conditions are met: (a) The number of chromatically distinct classes of photoreceptors, N, must be one greater than the number of degrees of freedom of the surface reflectances; (b) the number of chromatically distinct visible surfaces in the scene viewed must be at least $N - 1$.

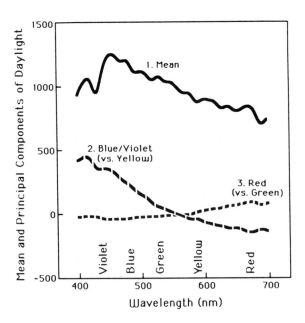

Figure 14.2
Three basis functions of wavelength that can be linearly combined to account for the major variations in the spectral compositions of natural daylight. (Based on table 1 on page 1035 of Judd, MacAdam, & Wyszecki, 1964; copyright by the American Institute of Physics, 1964).

The single multiplicative scalar that remains indeterminate in Maloney and Wandell's model corresponds to an overall (achromatic) lightness that, according to the general linear model, cannot be unambiguously apportioned between the surfaces and the illumination falling on those surfaces. The light reflected from surfaces, alone, contains, in fact, insufficient information for any scheme of visual analysis to distinguish between darker surfaces under brighter lighting and corresponding but lighter surfaces under dimmer lighting. Maloney and Wandell nevertheless achieved a decisive advance by reducing the residual indeterminacy to a single scalar. Moreover, that single scalar can probably be adequately approximated, in most natural settings, by estimating the overall brightness of the illumination in ways not explicitly taken into account by the linear model (as originally framed solely in terms of the light scattered from surfaces). For example, the brightness of the illumination might be estimated, independently of the light scattered from surfaces, from the brightness of the sky (together with visual evidence for the presence of objects shading the surfaces viewed).

In contrast, Land's retinex model included not one but three indeterminate scalars —one for the overall lightness level within each of the three (red, green, and blue) chromatic channels. Brainard and Wandell (1986) have shown, further, that attempts to approximate surface color by correcting lightnesses within each chromatic channel separately, as in retinex schemes, rest on the unjustifiable assumption that the set of basis lighting functions $E^x(\lambda)$ can be chosen (by some linear transformation) so that variations in the weight of any one basis function affects the response of only one chromatic channel.

In fact, by striving for lightness constancy within each chromatic channel separately, retinex schemes necessarily forfeit not only constancy of colors, as such, but also constancy of the relative, purely achromatic lightnesses of different objects. In a chromatic world, even the ordering of recovered lightnesses within each channel will depend on the spectral balance of the illumination—unless the ability to see under dim illumination is seriously compromised by restricting each channel to a very narrow band of wavelengths. With broadly tuned and hence efficient channels (like those actually found in animals), a retinex system could estimate a patch of surface that reflects only shorter wavelengths to be either lighter or darker than a patch that reflects only longer wavelengths, depending on whether the illumination contains primarily shorter or longer wavelengths, respectively. This indeterminacy in the estimation of relative lightnesses of surfaces cannot be eliminated by any comparison between the outputs of separate channels, which, as in retinex schemes, each contain their own arbitrary multiplier. Such an indeterminacy can be eliminated only by transforming all three channels jointly, as advocated by Maloney and Wandell (1986).

I have gone into theories of color constancy at such length not only because color constancy is of obvious adaptive significance but also because I believe the mechanisms that have evolved for the achievement of color constancy may underlie the other major features of human color representation that I will be considering in the ensuing sections. If I am correct in this, these features, too, are not arbitrary but reflect pervasive and enduring regularities of the terrestrial environment in which we have evolved.

The Three-Dimensionality of Colors

The three-dimensionality of human color perception reveals itself, as I already noted, in the ability of a normally sighted observer to match the color appearance of any presented surface by adjusting three, but no fewer than three, unidimensional

controls on a suitable color-mixing apparatus. One of these three dimensions is most naturally taken to be the (achromatic) dimension of *lightness*—as represented, in purest form, by the shades of gray ranging from black to white. The two remaining (chromatic) dimensions can be taken to be a circular dimension of *hue*, which, in cycling through the spectrally pure colors of red, orange, yellow, green, blue, and violet, forms Newton's color circle; and a radial dimension of *saturation*, which varies between each of these spectrally pure hues and a central, neutral gray of the same lightness. (Again, see figure 14.1a.)

Alternatively, and in agreement with the opponent-process theory of color vision proposed by Ewald Hering (1878/1964) and given a modern development by Hurvich and Jameson (1957), the two chromatic dimensions can be taken to be a rectilinear red-versus-green dimension and an orthogonal yellow-versus-blue (or yellow-versus-violet) dimension—as illustrated in figure 14.1b. Whether we thus describe the underlying three-dimensional color space using polar chromatic coordinates of hue and saturation (figure 14.1a) or using rectangular chromatic coordinates of redness versus greenness and of yellowness versus blueness (figure 14.1b), all colors can be obtained by an appropriate combination of values on the three chosen dimensions.

Inadequacy of Some Proposed Explanations for Trichromacy

Given that the human visual system normally provides just three dimensions for the representation of colors, a question immediately presents itself: Why exactly three dimensions, rather than, say, two or four? Three answers that might first suggest themselves all prove, on closer consideration, to be inadequate.

Is Trichromacy Explained by the Physical Properties of Surfaces? Inherent physical properties of the surfaces in the external world do indeed determine which colors we perceive those surfaces to have—out of a three-dimensional set of alternative colors that we are capable of representing. Those physical properties of surfaces evidently do not, however, determine the dimensionality of our set of alternative color representations. What the inherent physical properties of a surface really determine is the spectral reflectance distribution of the surface; and the spectral reflectance distribution, being defined over a continuum of wavelengths, can require an unlimited number of quantities in order for us to specify the relative amount of light that would be reflected back for each wavelength between 400 and 700 nm. True, the spectral reflectance functions of wavelength for naturally occurring surfaces are generally smooth functions, and such smoothness implies the possibility of some dimensional reduction. Evidently, though, the smoothnesses are only sufficient to permit a reduction to somewhere between five and seven dimensions (Maloney, 1986). The further

compression to the three dimensions of color that we experience cannot be attributed to a property of the surfaces of objects, therefore, but must be imposed by our visual system. The empirically verifiable consequence is that there are surfaces (called *meta-meric* surfaces) that have different spectral reflectance distributions according to physical measurements and yet to our eyes are perceptually indistinguishable in color.

Is Trichromacy Explained by Our Possession of Just Three Types of Cone? As is well known, human color vision is mediated by three types of retinal cones, whose photochemical pigments have peak sensitivities tuned, respectively, to longer, middle, and shorter wavelengths in the visible range. This fact can certainly be taken to explain *how* the dimensional compression is imposed by the human visual system. But it only transforms the question of *why* there is such a dimensional compression from the question of why we experience just three dimensions of color into the still unanswered question of why our retinas possess just three classes of color sensitive units.

Is Trichromacy Explained by a Trade-off Between Chromatic and Spatial Resolution? Possibly the majority of contemporary vision scientists regards the three-dimensionality of human color representation as a more pragmatic, somewhat arbitrary compromise between competing pressures toward the one-dimensional simplicity of achromatic (colorless) vision and the high-dimensional complexity of the truly full-color vision that would wholly capture the intrinsic spectral reflectance distribution of each and every external surface. Among our distant hunter-gatherer ancestors, those having only two types of cones and, hence, only two-dimensions of color vision might have been at a slight but (in the long run) significant disadvantage in identifying foods, mates, predators, and the like. At the same time, any ancestors that, through spontaneous mutation, might have had cones of more than three types and, hence, four or more dimensions of color vision might have lost in precision of form discrimination more than they gained in refinement of object identification through color. For, in order to accommodate an additional class of color-sensitive retinal receptors, the receptors of some class or classes would necessarily have to be less densely distributed across the retina. Indeed, there may be some validity to this third answer. Still, it is unsatisfyingly nonspecific and post hoc. It makes plausible that the number of chromatically distinct receptor classes has some optimum value, but it gives no reason why this optimum number is specifically three. Essentially the same argument could have been offered if our color vision were instead, say, two-dimensional or four- or five-dimensional.

An Alternative Basis for Trichromacy in the Degrees of Freedom of Terrestrial Illumination In order to explain the specifically three-dimensional character of our

color representation, I have been advancing a fourth, quite different possible answer (Shepard, 1990, 1991; see also, Shepard, 1987a). Given that our visual systems do not capture the full reflectance characteristics of a surface anyway, perhaps we should shift our focus away from the question of how we perceive the true color of a surface and focus, instead, on how the color that we do perceive is nevertheless the *same* color each time we view the same surface. It is after all this constancy of color that is most essential for identifying objects and, hence, for behaving appropriately with respect to them. In particular, the possibility I have been putting forward is that our visual systems analyze inputs into three color dimensions because three is the number of degrees of freedom of terrestrial illumination—degrees of freedom that must be compensated for in order to achieve constancy of perceived surface colors.

I was led to this possibility by what I took to be an implication of the general linear model for color vision proposed by Maloney and Wandell (1986). This implication concerns a hypothetical animal whose survival and reproduction depends only on its perception of the shapes and relative lightnesses of objects and not at all on their chromatic colors. It appeared to me that such an animal, although requiring only a shades-of-gray representation of its world, could nevertheless achieve constancy of its (achromatic) representation only if its visual system first analyzed the optical input into three chromatic channels. (I am assuming, again, that those channels—like actual photoreceptors—are sufficiently broad-band to make efficient use of available light.) Only in this way could the animal's estimates of the achromatic lightnesses of surrounding surfaces be stabilized against the three degrees of freedom of chromatic composition of natural illumination. (The same would be true, incidentally, for a camera, television system, or robot that was to generate a lightness-constant shades-of-gray, or "black-and-white," image.)

Maloney and Wandell (1986) themselves did not specifically address the question of the minimum number of dimensions needed to achieve color constancy. Rather, they focused on the somewhat different question of the number of dimensions needed to determine, for any surface, the full spectral reflectance function of that surface. As I noted, Maloney and Wandell concluded that, for such a determination, the number of chromatic channels N must exceed by one the number of degrees of freedom of the ensemble of reflectance functions, a number that may itself lie between five and seven (Maloney, 1986).

Suppose, however, that the principal criterion for success of the visual system's chromatic analysis is not that it represent the full complexity of the spectral reflectance function for each surface but that it ensure that the (possibly reduced) representation of each such function is constant under natural variations of illumination. We do not need to make a commitment, here, as to the particular computational

method that the visual system uses to estimate the characteristics of the prevailing illumination. It could be an improved version of Land's retinex method, Maloney and Wandell's general linear method, or a method that uses (in addition) more direct information about the characteristics of the illumination (available, say, from a view of the sun, sky, shadows, or specular reflections). For any such method, the general linear model indicates that correction for the momentary characteristics of the illumination that will achieve constancy in the representation of surface colors requires that the number of chromatic channels N equal the number of degrees of freedom of natural illumination—that is, essentially three.

I am not claiming that the chromatic colors of objects themselves are of no biological significance to us, or that we experience color only as a by-product of a mechanism that has evolved to achieve invariance of lightness under changes of illumination. Perceptual constancy is important, but we undoubtedly benefit from having a perceptual representation of the chromatic colors themselves. Laboratory studies have found chromatic color to be a more effective cue for guiding visual search than either lightness or shape (see the review by Christ, 1975). And in a natural setting, a purely shades-of-gray representation of the world, even if lightness-constant, would not enable us to discriminate, say, red from green berries or even to spot ripe berries, with sufficient ease and speed, from a background of green leaves. Undoubtedly, then, a perceptual representation of chromatic surface color is itself favored by natural selection—as is suggested by the important roles it has been found to play in the behaviors of many animals (e.g., Fernald, 1984; Hardin, 1990; Jacobs, 1981; Lythgoe, 1979).

For most human purposes, however, the gain in going to the six or more chromatic channels that (according to Maloney, 1986) might be required to discriminate between all naturally occurring surface reflectance functions would probably not offset the costs of reduced spatial resolution and increased computational burden. It is, then, on the assumption that some relatively small number of color dimensions suffices for the discrimination and recognition of biologically significant objects that I propose that the precise number of dimensions of our color representation may have been determined, instead, by the number of degrees of freedom of terrestrial illumination that must be compensated for in order to obtain perceptual constancy of the colors that we do experience.

The Physical Basis of the Three Degrees of Freedom of Natural Illumination

The solar source of significant terrestrial illumination has probably been essentially invariant in the spectral composition of its output throughout recent evolutionary history. The energy distribution of the portion of that sunlight illuminating any

particular terrestrial scene has nevertheless varied greatly from circumstance to circumstance (e.g., see Condit & Grum, 1964; Judd et al., 1964; McFarland & Munz, 1975a, 1975b; Sastri & Das, 1968). Yet, this variation has evidently been constrained by terrestrial conditions to essentially three independent dimensions (see Judd et al., 1964). Indeed, these three environmental degrees of freedom appear to bear a close correspondence to the three dimensions of color opponency that Hering (1878/1964) and Hurvich and Jameson (1957) proposed for the human visual system on the basis of entirely different (psychophysical rather than ecological) considerations.

The Light-Dark Variation There is, first, the dimension of variation in overall intensity of illumination between midday and deep shade or moonlight. This variation can occur, moreover, without much shift in chromatic composition. Under natural conditions, the brightest extreme of this variation is generally provided by the full complement of light from an overhead sun on a clear day—including both the yellow-biased, middle- to long-wavelength portion that directly penetrates to a scene and the blue-biased, short-wavelength portion that is indirectly scattered to the scene by the surrounding sky. Much less bright illumination that nevertheless has a similar spectral composition can arise through the chromatically nonselective filtering that may occur when, for example, the same sort of light (from sun and sky) reaches a scene only after being scattered to it from chromatically neutral surfaces such as white clouds, grey cliffs, or the moon. Indeed, moonlight, though vastly reduced below daylight intensities, has essentially the same spectral composition, because the lunar surface reflects all solar wavelengths within the visible range about equally (Lythgoe, 1979).

The Yellow-Blue Variation This second, chromatic dimension of variation arises primarily as a result of Rayleigh scattering (see Born & Wolf, 1970; Lythgoe, 1979). The shortest (blue and violet) wavelengths of light are most scattered by the smallest particles in the atmosphere—particularly the molecules of the air itself. (As the particles in the air become larger, the distribution of scattered wavelengths becomes more uniform—so that larger water droplets, for example, give rise to the achromatic, white or gray appearance of haze, fog, or clouds.) A blue extreme in natural lighting therefore occurs when a relatively localized object (such as a tree or cloud) blocks direct sunlight from striking the scene, while permitting unobstructed illumination of that scene by the light scattered to it from an otherwise clear sky—particularly from those portions of the sky that are separated from the sun by a large celestial angle (see Lythgoe, 1979; McFarland & Munz, 1975a). The contrasting yellow extreme occurs under the complementary condition in which a portion of a scene is illuminated only by direct sunlight—as by a beam of sunlight admitted by a

small opening in a cave, leafy canopy, or handmade shelter—with all skylight cut off. Such purely direct solar light does not of course consist solely of wavelengths in the yellow region of the spectrum. Rather, I call it yellow because, after removal of the shortest (blue and violet) wavelengths, the center of the remaining band of visible wavelengths falls in the yellow region of the spectrum and because these remaining wavelengths, when combined, can given rise (like the disk of the overhead sun itself) to a correspondingly yellow appearance.

The Red-Green Variation This third dimension of variation depends both on the elevation of the sun and on the atmospheric burden of water vapor. The longest (red) wavelengths are least scattered by air molecules and other small atmospherically suspended particles (such as dust). But those wavelengths are also most absorbed by any water that they encounter. In the relative absence of water vapor, the sunlight that directly strikes a scene will have retained a relatively greater proportion of its longest-wavelength, red component as the sun approaches the horizon, and, hence, its light must penetrate a longer and (at the lower altitude) denser column of air and suspended particles before striking the scene. When the atmosphere carries a high burden of water vapor, on the other hand, the penetrating light will contain a reduced component of long-wavelength red light. (There is, incidentally, an asymmetry between the lighting conditions at sunrise and sunset because even when the sun is in the same proximity to the horizon, the preceding temperature and hence burden of water vapor will generally by different in the two cases.) For both sources of the red variation (elevation of the sun and presence of water vapor), the argument for putting green in opposition to red is essentially the same as the argument for putting yellow in opposition to blue. After removal of the longest-wavelength, red end of the visible spectrum, the center of the remaining band of visible wavelengths falls in the green portion of the spectrum.

From a purely mathematical standpoint, of course, any (nondegenerate) coordinate system is equivalent to any other in the sense that either can be obtained from the other by a suitable (nonsingular) transformation. Thus, as I have already noted, the points of three-dimensional color space can be represented by either the polar or the rectangular coordinate systems shown in figure 14.1a and 14.1b. Similarly, as I also noted, a linear transformation could convert the three basis functions plotted in figure 14.2 into three differently shaped, but functionally equivalent basis functions. With respect to simplicity and efficiency of computation, however, a visual system that represents color in terms of the particular light-dark, yellow-blue, and red-green dimensions that correspond most directly to the underlying physical dimensions of variation of natural illumination in the terrestrial environment might most effectively compensate for these variations and, thus, attain color constancy.

Recapitulation and Consideration of Some Counterexamples and Methodological Issues

Recapitulation of the Argument Concerning the Source of Trichromacy The visual system starts with a retinal input in which, at any one moment, each receptor unit (cone) receives some distribution of intensities of wavelengths between roughly 400 and 700 nm. For the purposes of identifying objects and responding adaptively to them, the visual system must analyze this complex input into two components— one corresponding to the biologically significant, invariant properties of objects (regarded as the "signal") and one corresponding to the biologically less significant momentary circumstances of viewing and lighting (regarded as the "noise"). With regard to the perception of the colors of objects, this is just the color constancy problem of analyzing the distribution of spectral energies impinging at each point of the retina into a component that captures some invariant characteristic of the surface of an object and a complementary component attributable to the momentary conditions of illumination.

I have suggested that the visual system has solved the problem of performing this analysis and hence of attaining color constancy by first analyzing the visual input into the minimum number of chromatic channels needed to carry out the required analysis, namely, three. If this suggestion is correct, the human visual system provides for three dimensions of representation of colors because there are, in fact, three corresponding degrees of freedom in the world. But these three degrees of freedom in the world are not the degrees of freedom of the intrinsic colors of surfaces, which evidently are greater than three (Maloney, 1986). Instead, the critical degrees of freedom in the world may be those of natural illumination in the terrestrial environment.

The overall (400 to 700 nm) range of spectral sensitivity of the human eye has long been regarded as an evolutionary accommodation to the range of solar wavelengths that reach us through the earth's atmosphere (and through the aqueous medium of our eyes—and, originally, of the sea from which our distant ancestors emerged) (e.g., see Jacobs, 1981; Lythgoe, 1979). Possibly, the three-dimensionality of human color vision may similarly represent an evolutionary accommodation to the essentially three degrees of freedom of terrestrial transformation of the solar wavelengths passed by the earth's atmosphere.

Based on considerations of the physical causes of these natural variations of terrestrial lighting (cf. Condit & Grum, 1964; Judd et al., 1964; McFarland & Munz, 1975a, 1975b; Sastri & Das, 1968), I have further conjectured that these three degrees of freedom may be essentially characterized as a light-dark variation

(between unobstructed midday illumination versus illumination of the same composition but greatly reduced intensity that reaches the scene only by scattering from clouds, cliffs, or the moon), a yellow-blue variation (between illumination primarily reaching an object directly from an overhead sun versus indirectly by Rayleigh scattering from clear sky), and a red-green variation (depending on the proximity of the sun to the horizon and the amount of water vapor in the air). If so, a selective advantage may have been conferred on genes for the development of a neural mechanism that combines and transforms the outputs of the three classes of retinal receptors into the three specific opponent-process dimensions proposed, on quite different grounds, by Hering (1878/1964) and by Hurvich and Jameson (1957).

Consideration of Some Apparent Counterexamples Color constancy is neither perfect nor unconditional, however (e.g., see Helson, 1938; Judd, 1940; Worthy, 1985). Our own visual mechanisms have been shaped by the particular selective pressures that have operated under the natural conditions generally prevailing on planet Earth during mammalian evolution. Not surprisingly, therefore, our color constancy can break down under artificial lighting. On an evolutionary time scale, such lighting has begun to fall on our indoor or nocturnal surroundings for too short a time for selection pressures on our visual mechanisms to compensate for the new degrees of freedom introduced by such lighting. At night, we may thus fail to recognize our own car in a parking lot illuminated only by sodium or mercury vapor lamps.

To claim that the selection pressure that prevailed until very recently in the natural environment has been toward three dimensions of color representation is not, of course, to claim that this pressure has been great enough to override all other selection pressures and, hence, to ensure trichromacy in all highly visual terrestrial species. Although the once widespread belief that color vision is absent in many mammals, even including cats or dogs, is undoubtedly incorrect (Jacobs, 1981), a number of species with otherwise well-developed visual systems have been reported to lack three-dimensional color representation. Thus, while old-world monkeys evidently tend, like humans, to be trichromatic, evidence concerning new-world monkeys has pointed to dichromacy and to trichromacy in different species.

Even in humans, approximations to dichromacy occur in about 8% of the population (primarily in males, because nearly all forms of congenital color deficiencies are determined by sex-linked genes—Jacobs, 1981; Nathans, Thomas, & Hogness, 1986). Most typically, human color deficiency takes the form of some degree of collapse of color space along the red-green dimension (see figure 14.1b). In extreme cases of this particular type of collapse (*protanopia*), human trichromacy may be reduced to pure dichromacy. Total color blindness, that is, *monochromacy*, also

occurs in otherwise sighted humans—either because the color-selective retinal
cones are absent (leaving only the achromatic retinal receptors, called rods) or
because the neural circuitry necessary for the proper analysis of the outputs of
the cones is missing or defective (see Alpern, 1974; Jacobs, 1981). Pure mono-
chromacy of this sort is extremely rare in humans, however, as might be expected if
color vision and/or lightness constancy significantly contributed to the adaptation of
our ancestors.

Because a relatively large portion of the variance in the spectral distributions of
natural light can be accounted for by as few as two dimensions (see, e.g., Dixon,
1978; Judd et al., 1964), a degree of color constancy that is acceptable under most
natural conditions may be attainable with just two classes of cones and, hence, with
just two chromatic channels of visual input. Moreover, the addition of each new
class of retinal receptors entails both costs of reduced spatial resolution for each class
and costs of additional neural processing structures. Nevertheless, in the long run,
genes for three-dimensional color vision—genes that are already being identified and
localized on human chromosomes (Nathans, Thomas, & Hogness, 1986)—may pro-
vide a sufficient contribution to color constancy so that such genes eventually tend to
prevail in the most visually developed evolutionary lines. Even as remote a species
as the honey bee, the insect whose color vision has been most thoroughly studied
(Lythgoe, 1979), has been reported to be trichromatic (Daumer, 1956) with, in fact,
color vision very much like our own (LeGrand, 1964), except that its visual sen-
sitivity is somewhat shifted, as a whole, toward the shorter wavelengths (von
Helverson, 1972).

Methodological Issues Concerning the Determination of Dimensionality From the
standpoint taken here, the dimensionality of an animal's perceptual representation of
colors is perhaps the single most fundamental characteristic of that animal's color
vision (cf. Jacobs, 1981, pp. 21–22). Yet, this dimensionality remains undetermined
for most highly visual species. The dimensionality of color representation is in fact
quite difficult to determine in nonhuman species, and it becomes more difficult in
more remote species. (In a closely related primate species we might make an in-
ference as to the dimensionality of color vision from the anatomical presence or
absence of each of the three types of cones that mediate trichromacy in our own
case.) As I have mentioned, the number of unidimensional variables whose adjust-
ment is sufficient to achieve a visual match with any given color is equivalent to the
dimensionality of color space for the species doing the matching. But, for a very dif-
ferent species, how do we know which of the potentially countless dimensions along
which spectral distributions can differ are to be varied? And, although we might train

an animal to make a particular response when and only when two displayed colors are indiscriminable for that animal, how do we train the animal to adjust several unidimensional controls, simultaneously, to achieve such a visual match?

In principle, the dimensionality of a space can be determined from the relations among a fixed, finite set of points (or stimuli), without requiring continuous adjustment or matching. The difficulty with this approach is that the dimensionality of the space is not a property of single points or, indeed, of pairs or of triplets of points. Rather, it is a property determined by the distances between all points (or, in the case under consideration, the dissimilarities between all colors) in sets containing a number of points (or colors) that is one greater than the number of dimensions of the space (Blumenthal, 1953). Multidimensional scaling—particularly multidimensional scaling of the so-called nonmetric variety (Kruskal, 1964; Shepard, 1962, 1980)— can permit a determination of the dimensionality of a finite set of stimuli. Such a method requires, however, obtaining estimates of the animal's perceived similarities or dissimilarities between most of the stimuli in the set. Humans readily give numerical ratings of similarity, but in the case of other animals such estimates may have to be based on the extent to which a response learned to each stimulus generalizes to each of the others or on latencies or frequencies of errors in matching-to-sample responses (e.g., see Blough, 1982; Shepard, 1965, 1986). Unfortunately, the training and data collection would require a major research effort for each species and each set of colored surfaces investigated.

Rather than attempting to determine the dimensionality of color representation in different species by means of multidimensional scaling, researchers have mostly pursued their comparative studies of the color capabilities of different species (a) anatomically or physiologically, by trying to determine the number of distinct types of receptor units (such as retinal cones having photosensitive pigments or oil-droplet filters with different wavelength characteristics), or (b) psychophysically, by measuring discriminability between neighboring spectrally pure colors at different locations along the continuum of wavelength. Neither of these methods provides, however, a reliable indication of the dimensionality of the animal's perceptual representation of colors.

From anatomical examination, one may never be sure that one has found every chromatically distinct type of receptor unit. Even if one could, there is no guarantee that the number of dimensions of color representation is as large as the number of types found. The outputs of two or more types of photoreceptors with different spectral sensitivities might be neurally combined into one chromatic channel somewhere up the line. (Indeed, humans, normally have four identified types of retinal photoreceptors—namely, cones of three types and rods of one type, each type with

its peak sensitivity at a different wavelength. Yet, humans normally have only three dimensions of color representation.)

The psychophysically determined wavelength discrimination function is even less informative about the dimensionality of an animal's color representation. For example, an animal could discriminate an arbitrarily large number of wavelengths and still represent all those spectrally pure colors on a single dimension of hue, just as an individual could discriminate an arbitrarily large number of intensity levels and still represent those shades of gray on a single dimension of lightness. The question of dimensionality depends not on the number of discriminably different wavelengths but on the discriminabilities of all possible mixtures of such wavelengths. But the number of pairs of mixtures that might be tested increases radically with the number of discriminable wavelengths to be mixed.

A single example may suffice to illustrate the problem. The color capabilities of pigeons have been extensively investigated psychophysically as well as anatomically. Their wavelength discrimination function has been measured (Hamilton & Coleman, 1933; Wright, 1972), and evidence has been found for at least six chromatically distinct types of retinal cones—having different wavelength-selective combinations of photopigments and colored oil-droplet filters (Bowmaker, 1977; Bowmaker & Knowles, 1977). Nevertheless, to my knowledge, the question remains open as to whether the pigeon is trichromatic, as we are, or whether it has as many as four, five, or six dimensions of color representation. Conceivably, in the pigeon there has been sufficient selection pressure not only toward the three chromatic channels needed for the achievement of color constancy in the natural environment, but also toward the additional chromatic channels that, according to Maloney and Wandell's (1986) general linear model together with Maloney's (1986) estimate of the number of degrees of freedom of the spectral reflectance distributions of natural surfaces, might be required to capture fully the intrinsic reflectance characteristics of natural objects or foods.

The Circular Structure of Spectrally Pure Colors

Another one of the facts that I included in my initial, illustrative list of structural constraints on human perception and cognition is the fact that the physically rectilinear continuum of wavelength is transformed by the human visual system into the psychologically circular continuum of perceived hues—that is, into Newton's (1704) color circle, schematically portrayed as the equator of color space in figure 14.1a. Such a circle can be recovered with considerable precision by applying methods of

multidimensional scaling to human judgments of the similarities among spectral hues (Shepard, 1962; Shepard & Cooper, 1992). The circularity is implied, as I noted, by the observation that red and violet, although maximally separated in physical wavelength, appear more similar to each other than either does to green, which is of an intermediate wavelength.

I conjecture that this circularity of hue may have arisen as a consequence of the transformation by which the human visual system carries the responses of three classes of retinal photoreceptors (the cones most sensitive to long, medium, and short wavelengths) into the three opponent processes (the light-dark, yellow-blue, and red-green processes). If so, not only the three-dimensionality of color space but also the specifically circular character of the hue dimension, rather than being an arbitrary design feature of the human visual system, may be traceable to an enduring regularity in the terrestrial world in which we have evolved.

The Circularity of Hue as an Accommodation to the Degrees of Freedom of Terrestrial Illumination

In rough outline, the argument runs as follows: The extremes of the range of solar wavelengths admitted through the terrestrial "window" on the solar spectrum are, naturally, the most affected by any variations in that "window." Thus, the longest wavelengths (the red components) are both least scattered by atmospherically suspended particles and most absorbed by water vapor, and the shortest wavelengths (the blue and violet components) are most scattered by the smallest atmospheric particles—particularly by the molecules of the air itself. Now, if the variable component of longest visible wavelengths (the reds) is put in opposition to the rest of the visible wavelengths, the central tendency of those opposing wavelengths will be what we call green—not the visible wavelengths that are physically most remote from the reds (namely, the short wavelength violets). Similarly, if the independently variable component of shortest visible wavelengths (the blues and violets) are put in opposition to the rest of the visible wavelengths, the central tendency of those opposing wavelengths will be what we call yellow—not the visible wavelengths that are physically most remote from the violets and blues (namely, the long wavelength reds).

Accordingly, a transformation by the visual system from the outputs of three classes of cones to an opponent process representation has the effect of bending the physically rectilinear continuum of wavelength into a closed cycle of spectral hues. Whereas in the original physical continuum, the extreme opposites were red and violet, in the resulting cycle of hues, the opposites (schematically thought of as the diagonally opposite corners of a square) are red and green (across one diagonal) and

yellow and blue/violet (across the other diagonal). The originally most remote hues of red and violet, being now separated by only one edge of the (schematic) square, become closer together than the now diagonally separated red and green or the now diagonally separated yellow and blue/violet. (The red, yellow, green, and blue "corners" are in fact quite evident in the [squarish] version of the color circle that emerged when Carroll and I applied multidimensional scaling to color naming data collected by Boynton and Gordon [1965] for 23 spectral hues [see Shepard & Carroll, 1966, Figure 6, p. 575].)

Evidence Suggestive of an Innate Structure for the Representation of Colors at Higher Levels of the Brain

Color vision requires, in any case, not only wavelength-selective receptors (the retinal cones) but also some processing machinery for estimating from the variable outputs of those receptors the invariant colors of distal objects. Presumably, moreover, the genes specifying the structure of such neuronal circuitry will generally lead to the development of that circuitry in each individual whether or not that circuitry is destined to receive normal signals from that particular individual's retinal receptors. For example, an individual who is missing the gene for one of the classes of wavelength-selective cones may, through an inability to discriminate between certain presented colors (such as red and green), give evidence of a collapsed, two-dimensional color space. But this does not preclude that individual's possession, at higher levels of the nervous system, of the circuits that have been evolutionarily shaped for representing the full, three-dimensional system of colors.

In an investigation of the representation of colors by normally sighted, color-blind, and totally blind individuals (Shepard & Cooper, 1992), Lynn Cooper and I found evidence that suggests this is the case and thus contradicts the central tenet of the British empiricist philosophers—that everything that each individual knows must have first entered through that individual's own sensory experience. We asked the individuals with the different types of normal and anomalous color vision to judge the similarities among saturated hues under two conditions: (a) when pairs of those hues were actually presented (as colored papers), and (b) when the pairs of hues were merely named (e.g., "red" compared with "orange"). We applied multidimensional scaling to the resulting similarity data for each type of individual and for each of the two conditions of presentation. Most striking were the results for the red-green color-blind individuals (*protans* and *deutans*). As expected, when the colors were actually presented to these individuals, multidimensional scaling yielded a degenerate version of Newton's color circle with the red and green sides of the circle collapsed

together. Significantly, however, when only the names of the colors were presented, multidimensional scaling yielded the standard, nondegenerate color circle obtained from color-normal individuals (cf. Shepard, 1962, p. 236; 1975, p. 97).

One particularly articulate protan insisted that although he could not distinguish the (highly saturated) red and green we showed him, neither of these papers came anywhere near matching up to the vivid red and green he could imagine! In a sense, then, the internal representation of colors appears to be three-dimensional even for those who, owing to a purely sensory deficit, can only discriminate externally presented colors along two dimensions (most commonly, the dimensions of light versus dark and yellow versus blue indicated in figure 14.1b).

Incidentally, it was in the domain of colors that the preeminent British empiricist. David Hume, acknowledged what he considered to be the one possible exception to the empiricists' central maxim. Hume, on supposing "a person to have enjoyed his sight for thirty years, and to have become perfectly well acquainted with colours of all kinds, excepting one particular shade of blue," confessed to favoring an affirmative answer to the question of "whether 'tis possible for him, from his own imagination, to supply this deficiency, and raise up to himself the idea of that particular shade, tho' it had never been conveyed to him by his senses?" Despite this admission, Hume concluded, somewhat lamely, that "the instance is so particular and singular, that 'tis scarce worth our observing, and does not merit that for it alone we should alter our general maxim" (Hume, 1739/1896, p. 6).

The Organization of Colors into Categories and Prototypes

Phenomena of color vision run counter not only to the central tenet of the British empiricists but also to the views of the more recent American linguistic relativists. According to the latter, as represented particularly by Sapir (1916) and Whorf (1956), each language lexically encodes experience in a way that is unique to the culture in which that language evolved. Color offers a particularly suitable domain for testing this idea because each color, as experienced by human observers, is a relatively "unitary" or "unanalyzable" percept (Shepard, 1964, 1991; Shepard & Chang, 1963), corresponding to a single point in the color space schematically portrayed in figure 14.1. If linguistic relativity were valid, the way continuous color space is divided into regions for the purposes of assigning discrete names to colors would be expected to differ in more or less arbitrary ways from one language to another. Empirical studies, however, have uncovered a striking degree of cross-cultural uniformity.

The Cross-Cultural Findings of Berlin and Kay

Together with their co-workers, Berlin and Kay (1969) presented native speakers of 20 diverse languages with an array of 329 Munsell color chips, including 320 maximum saturation colors differing in equally spaced steps of hue and lightness, which had originally been used in a comparison of English and Zuni color terminology by Lenneberg and Roberts (1956), and 9 additional zero-saturation shades of gray. For each basic color term, x, in an informant's native language, the informant was asked to use a black grease pencil to encircle, on an acetate sheet overlaying the array of color chips, (a) the set of colors that the informant "would under any conditions call x" and, then, (b) the subset of those colors that the informant regarded as "the best, most typical examples of x" (Berlin & Kay, 1969, p. 7).

Berlin and Kay found that the color terms in different languages did not correspond to arbitrarily overlapping regions in color space. Instead, the terms were essentially consistent with a universal underlying hierarchy of nonoverlapping regions in color space for each of the 20 languages directly investigated (and these results appeared to be consistent with the reports, by others, of the use of color terms in some 78 other languages). The languages differed primarily in the number of basic color terms they included. They differed very little in the locations of the regions corresponding to the basic color terms that they did include. In particular, the languages generally conformed with a partial order of color categories (that is, regions of color space) that—in terms of the English names that we assign to these categories—is as follows:

$$
\begin{Bmatrix} \text{white} \\ \text{black} \end{Bmatrix} < \{\text{red}\} < \begin{Bmatrix} \text{green} \\ \text{yellow} \end{Bmatrix} < \{\text{blue}\} < \{\text{brown}\} \begin{Bmatrix} \text{purple} \\ \text{pink} \\ \text{orange} \\ \text{gray} \end{Bmatrix}
$$

"where, for distinct color categories (a, b), the expression $a < b$ signifies that a is present in every language in which b is present and also in some language in which b is not present" (Berlin & Kay, 1969, p. 4).

The regions in color space corresponding to these apparently universal color categories are (with the exception of the region for the completely unsaturated grays) conveniently displayed on the hue-by-lightness rectangle, which (as indicated in figure 14.3) can be thought of as a Mercator projection of the maximum-saturation surface of the sphere of colors previously illustrated in figure 14.1. (Because the achromatic color gray corresponds to the center of the sphere, it is not representable on the projection of the surface of the sphere.) The placement of the English names

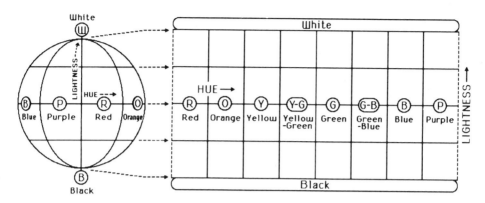

Figure 14.3
Schematic diagram of how the surface of the three-dimensional color space in figure 14.1 can be un-
wrapped (by Mercator projection) into a rectangular map in which each point represents the most satu-
rated color of a corresponding hue and lightness.

for the successive hues, "Red," "Orange," "Yellow," etc., is only schematic in figure
14.3; hue and lightness turn out to be universally correlated in the locations of pro-
totypical colors in such a way that yellow, in addition to falling between red and
green in hue, is much lighter than these (and the other) basic hues.

Figure 14.4 is my adaptation of the figure in which Berlin and Kay summarized
the results of their own study of color naming by native speakers of 20 different lan-
guages. The consistently found locations of the basic color categories are displayed
within the two-dimensional hue-by-lightness Mercator projection of the maximum-
saturation surface of color space. The encircled regions approximate the areas within
which the colors chosen as "the best, most typical examples" of the corresponding
basic color terms consistently fell according to informants from the various cultures.
These focal color categories are labeled, for our convenience, by the basic terms that
we use for these colors in English.

Surrounding each of these encircled focal regions, a larger region to which
informants indicated the same color term might be extended under some condition
is roughly indicated by the penumbra of corresponding initial letters, "G" for
"Green," "Br" for "Brown," and so on. Again, however, some of the languages did
not have basic color terms for some of the lower categories in the hierarchy, such
as the categories here labeled "Pink," "Purple," or "Orange." In these cases, the
penumbra surrounding the neighboring focal color regions that were represented in
the language might extend through the region lacking its own basic color term. Thus,
if the language contained no basic term specifically for the colors in the category

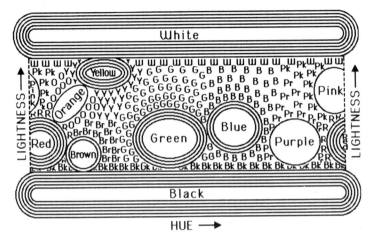

Figure 14.4
Schematic representation of regions, within the rectangular map of saturated colors (as diagrammed in figure 14.3), for which color names are commonly used in different cultures. The name printed within each region is the color word most often used by English-speaking informants. The number of lines drawn around each region indicates the cross-cultural prevalence of assigning a distinct color term specifically to that region. The penumbra of letters ("Gr" for "Green," "Br" for "Brown," etc.) indicates a larger region that the color term might be extended to under some conditions, according to informants. (Adapted from figure 3 on page 9 of Berlin & Kay, 1969; copyright, University of California Press, 1969.)

here labeled "Purple," the terms for the neighboring regions here labeled "Blue" or "Red" might be extended into the region to which we apply the word "Purple." Also, of course, the colors falling in the penumbra around a given focal color region might be distinguished by the basic color term together with a qualifier. In English, for example, "light green" or "pale green" might be used for colors falling above the focal region for green, and "blue-green" might be used for colors falling between the focal regions for blue and green. And some languages have single terms for still lower levels of the hierarchy. Thus, in English we might use the word "lavender" for light purple, "chartreuse" for yellow-green, and "navy" for dark blue (or blue-black).

I have indicated the hierarchical structure that Berlin and Kay found for the focal colors by encircling each corresponding subregion of color space by an appropriate number of lines. Thus I have drawn six lines around the universally named focal color categories corresponding to our "White" and "Black," five lines around the next most prevalently named category, corresponding to our "Red," and so on for successively lower levels in the hierarchy—"Green" and "Yellow" (four lines each), "Blue" (three lines), "Brown" (two lines), and "Pink," "Purple," and "Orange" (a single encircling line for each).

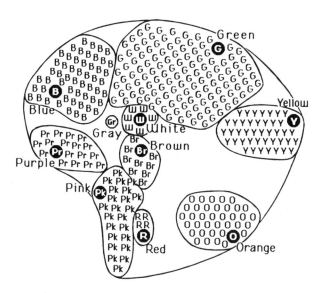

Figure 14.5
Regions of color space for which color names are commonly used, projected (by parallel projection) onto the equatorial disk cutting through the spherical model illustrated in figure 14.1, according to data reported by Boynton and Olson (1987). (Adapted from figure 2 on page 99 of Boynton & Olson, 1987; copyright, John Wiley & Sons, Inc., 1987.)

The rectangular Mercator projection of a globe is equivalent to a cylinder in that the right and left edges of the rectangle correspond to the same meridian on the sphere and, hence, to the same series of colors (here, the reds varying in lightness from darkest red to lightest pink). Thus the focal regions labeled "Red" and "Pink" in figure 14.4 overlap both the left and right ends of the rectangle as displayed in that figure. (As I have already remarked, the surface color purple is not fully represented in the pure spectral colors of monochromatic light such as arise from a prism or in a rainbow. Surfaces that we call purple are surfaces that reflect a mixture of the longest and shortest of the visible wavelengths, that is, a mixture of red and violet.)

Additional, Corroborating Results and Implications

The locations in color space of the universal focal color regions can usefully be displayed in another way—namely, as these regions would project onto a flat plane cutting through that three-dimensional space, for example, the horizontal plane pictured as passing through the equator of the sphere in figure 14.1. Figure 14.5 shows my adaptation of such a plot obtained by Boynton and Olson (1987) on the basis of single-word (monolexemic) color naming of 424 color samples by seven

English-speaking observers. Here again, each region within which colors were given a particular color name is filled in with the initial letter of that color (e.g., with "G"s for "Green"). The point within such a region that, on average, was accepted as the best example of that color, considered the focal color for that region, is indicated by the black circle (with a corresponding white letter, e.g., "G").

The dimensions of this two-dimensional projection of color space are not hue and lightness, as in the Mercator projection of figure 14.4. Instead, the two dimensions here can be considered to be the polar-coordinate dimensions of hue (now represented as a complete circle around the perimeter) and saturation (which is now represented as radial distance out from the unsaturated white and gray near the center to the maximum saturation hues around the perimeter). The focal chromatic colors are not located at the centers of their regions but out toward the maximum saturation perimeter. As noted before, the dimensions of this same projection of color space can alternatively be taken to be the rectangular-coordinate dimensions of red-versus-green (roughly vertical in figure 14.5) and blue-versus-yellow (roughly horizontal).

The disposition of focal color regions obtained by Boynton and Olson (1987) for this projection, though necessarily different, is quite consistent with the disposition of these regions in the Mercator type of projection presented by Berlin and Kay (1969). The representation shown in figure 14.5, however, better accommodates the less saturated and achromatic colors (brown, gray, and white) and—in requiring no break in the pink-red region—more explicitly maintains the integrity of the hue circle (corresponding to the equator in the more schematic figures 14.1 and 14.3). The representation in figure 14.4, on the other hand, more clearly preserves other aspects of color representation—such as that the yellow band of the spectrum appears lighter (or brighter) than the other (red, green, or blue) bands.

The cross-cultural results such as those reported by Berlin and Kay (1969) and by Boynton and his co-workers (especially, Uchikawa & Boynton, 1987, who compared color naming by American and native Japanese observers) provide little support for the Whorfian hypothesis that language structures how we perceive the world. Instead, these results appear to be more consonant with the idea that the innate biology of our perceptual system structures the way we use language.

Physically, the spectrum of solar light seen in a rainbow or refracted by a prism (as in the original investigations by Newton, 1704) is a continuum of wavelengths. Yet we tend to perceive this continuum as divided into a few relatively discrete bands of hue, such as those we call red, orange, yellow, green, blue, and violet. (White, purple, and all unsaturated colors are obtained only by recombining these pure

spectral wavelengths, while black is of course obtained by blocking off all visible wavelengths.)

Eleanor Rosch (formerly Heider) and others, in experimental studies with human observers, have shown, in addition, that the most prototypical (or focal) colors within each region of color space tend to be more rapidly and consistently perceived and remembered than nonfocal colors, which are closer to the boundaries between regions, while discrimination between colors appears to be sharper across the boundaries of these regions than within the same region (Heider, 1971, 1972; Rosch, 1973, 1975; see also Boynton & Olson, 1987, 1990; Mervis & Rosch, 1981; Nagy & Sanchez, 1988; Uchikawa & Boynton, 1987).

Moreover, the tendency toward the perceptual categorization of the hue continuum is not unique to human adults, but has been reported to take essentially the same form in human infants (Bornstein, Kessen, & Weiskopf, 1976) and in other primates (Essock, 1977; Sandell, Gross, & Bornstein, 1979). (In monkeys, incidentally, Zeki [1983] found cortical cells whose responses, like our own color-constant experience of surfaces, were determined by the intrinsic reflectance characteristics of an external surface regardless of the illumination.) There is even evidence that the spectral continuum is also perceptually partitioned by such remote species as pigeons and bees, though apparently into color categories that differ somewhat from those common to humans and monkeys (Kühn, 1927; von Frisch, 1950; Wright & Cumming, 1971). For all of these animals, including humans, visual discrimination between neighboring wavelengths has been reported to be sharpest at the boundaries between the color categories for each species (Graham, Turner, & Hurst, 1973; Jacobs & Gaylord, 1967; Nagy & Sanchez, 1988; Smith, 1971; von Helversen, 1972; Wright, 1972). And, as the evidence obtained by Berlin and Kay (1969) and others has shown in the human case, the boundaries tend to be the same across cultures that have developed on widely separated continents and that have very different languages and sets of color terms. Evidently (as concluded by Uchikawa & Boyton, 1987; and, earlier, by Ratliff, 1976), the way in which humans categorize colors is universally prewired rather than individually acquired.

But we are still left with the question of the source of the particular form of such an innate biology underlying human color categorization. Is this biology merely accidental or has it arisen as an accommodation to some identifiable regularity in the world in which we have evolved? Perhaps we should distinguish two questions: First, why is the continuous space of colors partitioned into discrete categories at all? Second, given that it is partitioned, why is it partitioned in the particular way indicated in figures 14.4 and 14.5?

Possible Adaptive Functions of a Categorical Organization of Colors

In the case of humans, one advantage of an innate structuring of continuous color space into discrete regions, organized around prototypical or focal colors, has already been implicit in the discussion of the linguistic studies by Berlin and Kay and others. Because a discrete structuring makes possible the consistent assignment of words to colors, it facilitates communication between individuals about the colors of objects that may be of biological significance. One may readily identify a person that one is to meet for the first time on the basis of a description of a color that that person will be wearing. But it may be impossible to identify that person on the basis of a description of his or her face. The continuous space of human faces (in addition to being of higher dimensionality) does not seem to be endowed with a consistent categorical structure like that of the continuous space of colors.

Of course, this linguistic advantage of categorical representation of colors cannot be the explanation for the very similar categorical structure that has been demonstrated for the color spaces of other, nonlinguistic species. Still, for the more general purposes of biological signaling within and between species, the categorical representation of colors may have similar advantages, as has been argued by Hardin (1990). The advantages for both of these purposes—for human language and for other types of signaling—can be seen as examples of the general principle of *shareability* enunciated by Freyd (1983, 1990). When cast in evolutionary terms, that principle says that some cognitive structures or functions may arise not because they capture a biologically significant regularity in the physical world but because they facilitate or make possible the sharing of knowledge between conspecifics. Clearly, an innate predisposition toward a consistent partitioning of a biologically significant continuum into discrete categories will facilitate the sharing of knowledge about the things signified by that continuum, whether through changes in the coloration of bodily markings (as in some fish—Fernald, 1984) or through human language (Berlin & Kay, 1969; Kay & McDaniel, 1978; Lenneberg & Roberts, 1956; Miller & Johnson-Laird, 1976).

A categorical structuring can also facilitate communication within an individual—for example, from one information-processing module to another within the same individual's brain (as Freyd has suggested, personal communication, June 1990), or from one occasion to another, across time (Heider, 1972; Rosch, 1975). Certainly, to remember the color of a particular object after a single exposure may be important if that object was, say, a newly encountered predator from which one barely escaped. A clear example of the advantage of perceptual categorization has been reported in the auditory domain, where individuals differ markedly in their abilities to recognize

the absolute pitch of a tone (independent of its relation to some other tone). Individuals with this ability of so-called *absolute pitch* are much more accurate in identifying whether a long-delayed second tone is or is not a repetition of an earlier tone (Bachem, 1954).

Possible Sources of the Particular Categorical Organization of Human Colors

Even if we agree that the organization of color space into categories and prototypes can serve adaptive functions, we are still left with the question of why this space is organized in the particular categorical way that it is, rather than in some other categorical way. Consideration of this question necessarily becomes still more speculative. The organization of color space that (along with its presumably genetically entrenched physiological basis) appears ubiquitous in humans and other primates may eventually be found to stem from any mixture of at least three sources: (a) The organization could be a largely accidental or arbitrary solution (out of countless other, equally satisfactory organizations) to the problem of providing a discrete basis for intraspecific signaling, language, or shareability; (b) the organization could reflect something about the natural groupings of the surface reflectance distributions of objects (into ripe versus unripe edible fruits, predators versus prey, and so on) that have long had particular biological significance for our ancestors and those of other primates (cf. Shepard, 1987b); or (c) in line with my conjecture as to the source of the three-dimensionality of color space itself, this organization could reflect something about the ways in which terrestrial lighting has most typically varied during evolutionary history.

To my knowledge, the systematic survey of the spectral reflectance distributions of a large sample of significant surfaces in the natural environment needed to support the second alternative has yet to be undertaken. In the meantime, I find some support for the last alternative in what already appears to be a nonaccidental correspondence between the most entrenched of the human color categories and the generally accepted opponent process dimensions of human color vision, which (as I have noted) seem to correspond to the natural dimensions of terrestrial lighting.

On one hand, the six focal colors that we call white, black, red, green, yellow, and blue (also termed "landmark colors" by Miller & Johnson-Laird, 1976) are highest in the hierarchy of basic color categories according to Berlin and Kay (1969), as I indicated in figure 14.4 by encircling the corresponding English terms with three or more lines. On the other hand, these are just the six colors that are usually taken to define the ends of the three light-dark, red-green, and yellow-blue dimensions in opponent process theories. Moreover, I have suggested that just these dimensions may be best suited to compensate for the most common variations of terrestrial

illumination. (Even the universally lighter appearance of focal yellow may have an ecological basis—possibly in the yellow central tendency of the direct light form an overhead sun after the shorter wavelength blues and violets have been partially filtered out by atmospheric scattering.)

The secondary focal colors, such as those that we call orange, purple, pink, brown, and gray, may be distinguished (when, in a given culture, they are distinguished) in order to fill in the main gaps in color space between the primary focal colors defined by the underlying opponent processes. Boynton has reviewed evidence that people will describe these secondary focal colors as mixtures of other more primary colors, but will not describe the primary focal colors as mixtures of any other colors (Boynton, 1988, p. 91). Thus, orange, purple, and pink will be described as containing red mixed with yellow, blue, and white, respectively, while a prototypical red itself is never described as containing any discernible contribution of a neighboring color such as orange or purple.

In any case, if categorical structuring of colors serves an adaptive function, there need be no powerful selective advantage of one structuring in order for it to prevail over others. A slight predisposition toward one organization, arising perhaps from a quite different, noncategorical source might bias the selection toward that organization over other, otherwise comparably useful categorical oranizations. The source that I have been suggesting might exert such an influence is the natural variation of terrestrial illumination, for which we must compensate in order to achieve color constancy. Alternatively, of course, the largely unexplored possibility remains that the intrinsic colors of objects that have been of biological significance for our ancestors may have tended to cluster around the focal colors identified by Berlin and Kay—perhaps, red for ripe fruit (e.g., berries, apples, tomatoes, etc.), green for trees and other vegetation, and blue for water and sky. In the absence of a systematic survey of the spectral reflectance distributions of a large sample of significant surfaces in the natural environment, however, the dimensions of variation of natural illumination may provide for the most parsimonious explanation for the most salient features of the universal color categories of humans.

Concluding Remarks

The Search for a Nonarbitrary Basis for Psychological Principles

One can distinguish three ways in which we try to establish and to achieve understanding of a psychological phenomenon. Although any combination of these ways can be pursued, simultaneously or in any order, they may tend to become dominant

in three successive stages of scientific investigation. The first such stage focuses on the empirical establishment of the phenomenon itself, through behavioral, psychophysical, or linguistic investigations (whether using laboratory experiments or field observations). The second stage shifts focus to the elucidation of the physiological mechanisms that may underlie that established phenomenon, through neurophysiological investigations (whether by electrophysiological recording of concomitant brain activity or by simulation of proposed connectionist models on a computer). The third stage, when indeed it is embarked upon, shifts focus, again, to the problems that the external world poses for an individual. In this stage, we try to understand both the neurophysiological mechanisms and the cognitive and behavioral functions that those mechanisms mediate not as arbitrary design features of a particular species, but as accommodations to pervasive and enduring properties of the world.

In our understanding of the human representation of colors, over three centuries of inspired empirical investigation has established many of the basic phenomena of human color vision. For present purposes, these phenomena have included the constancy, the three-dimensionality, the hue-circularity, and the categorical structure of colors. Beginning later, physiological investigations, which I have not attempted to review, have begun to pin down the neuronal mechanisms underlying a few of these phenomena (see, for example, De Valois, 1973; De Valois & De Valois, 1975; Foster, 1984; Lennie, 1984; Livingstone & Hubel, 1984; Zeki, 1983). The regularities in the world that may determine the nature of these physiological mechanisms, as well as of the perceptual-cognitive phenomena that they mediate, remain largely unexplored. Beyond the long-standing recognition of the problem of color constancy and the model recently proposed for its solution by Maloney and Wandell (1986), I have offered little more than some tentative suggestions about possibly fruitful directions for further exploration.

I began this chapter with the claim that natural selection should lead to the emergence not only of perceptual, behavioral, and cognitive mechanisms that are adapted to the specific circumstances faced by particular species, genders, and domains, but also of mechanisms that are adapted to the general circumstances faced by all so-called higher organisms. Color vision offers a less obvious case for supporting such a claim than the phenomena that I have usually used for this purpose, namely, those of spatial representation (e.g., Shepard, 1984) and of generalization (e.g., Shepard, 1987b). Color pertains to a single sensory modality (vision), whereas space and generalization are not modality specific. Moreover, the properties in the world that might determine the organization of colors are less obvious than those that might determine the representation of space. For example, whereas the three-dimensionality

of perceptual space derives directly from the fundamental three-dimensionality of physical space, the three-dimensionality of color space does not so directly or obviously derive from a three-dimensionality in the world. The case for a nonarbitrary basis for the structure of colors, to the extent that it can be made, has the advantage, however, of suggesting that psychological constraints may correspond to regularities in the world even when the correspondence is not initially obvious.

Possible Universal Pressures Toward the Organization of Colors

I conclude with a brief consideration of the sense, if any, in which a tendency toward the properties of color representation I have been considering may be general—or even universal. Throughout, I have spoken of the possibility of selective pressures to which highly visual *terrestrial* animals may be subject in the *terrestrial* environment. I used the qualification "terrestrial" because conditions of illumination in other, for example, aquatic environments can be quite different. Owing to the already noted selective absorption by water of the longer wavelengths, with increasing depth in a marine environment, the available solar light, in addition to being progressively reduced in overall intensity, becomes progressively restricted in spectral range to the shorter wavelengths. This blue shift and compression in range of available wavelengths is known to be matched by a corresponding blue shift and compression in the range of spectral sensitivity of deeper dwelling marine animals (Lythgoe, 1979).

It does seem to me, however, that the wavelength dependencies of the variable height of a sun, presence of atmospheric aerosols, and direct versus indirect illumination might apply quite generally on the surfaces of planets capable of supporting the evolution of highly visual organisms. Such a planet is presumably likely (a) to circle a long-lived star that emits a stable, broad range of wavelengths, (b) to undergo regular rotation about its own axis (owing to the conservation of angular momentum), and (c) to possess an atmosphere that differentially filters the wavelengths of direct and scattered light depending on the (rotationally determined) angle at which the light enters the atmosphere and the size distribution of atmospheric particles. Moreover, the arguments for categorical representation of colors based on memorability and shareability do not depend on particular features of the terrestrial environment. In short, just as there may be universal selective pressures toward mechanisms for the representation of three-dimensional space and for an exponential law of generalization (Shepard, 1987a), there may be quite general selective pressures toward mechanisms for the representation of the surface characteristics of objects in a low-dimensional (perhaps even a three dimensional) color space, with a circular component of hue, and a categorical structure.

Possibly, behavioral and cognitive theorists should aspire to a wider scope for their science. An evolutionary theory of mind need not confine itself to the particular minds of the more or less accidental collection of species we find on planet Earth. There may be quite general or even universal principles that characterize planetary environments capable of supporting the origin and evolution of increasingly complex forms of life. If so, there may be corresponding general or even universal principles of mind that by virtue of their mesh with the principles of these environments, are favored by a process of natural selection wherever it may be taking place.

Acknowledgments

Preparation of this chapter was supported by National Science Foundation Grant No. BNS 85-11685. The chapter has benefited from helpful comments on earlier drafts by a number of colleagues, including Robert Boynton, Leda Cosmides, Jennifer Freyd, Geoffrey Miller, John Tooby, and Brian Wandell.

References

Alpern, M. (1974). What is it that confines in a world without color? *Investigative Opthamology, 13*, 648–674.

Bachem, A. (1954). Time factors in relative and absolute pitch determination. *Journal of the Acoustical Society of America, 26*, 751–753.

Barlow, H. B. (1982). What causes trichromacy? A theoretical analysis using comb-filtered spectra. *Vision Research, 22*, 635–643.

Berlin, B., & Kay, P. (1969). *Basic color terms: Their universality and evolution.* Berkeley. CA: University of California Press.

Blough, D. S. (1985). Discrimination of letters and random dot patterns by pigeons and humans. *Journal of Experimental Psychology: Animal Behavior Processes, 11*, 261–280.

Blumenthal, L. M. (1953). *Theory and applications of distance geometry.* Oxford: Clarendon Press.

Born, M., & Wolf, E. (1970). *Principles of optics.* Oxford: Pergamon Press.

Bornstein, M. H., Kessen, W., & Weiskopf, S. (1976). Color vision and hue categorization in young human infants. *Journal of Experimental Psychology: Human Perception and Performance, 2*, 115–129.

Bowmaker, J. K. (1977). The visual pigments, oil droplets and spectral sensitivities of the pigeon. *Vision Research, 17*, 1129–1138.

Bowmaker, J. K., & Knowles, A. (1977). The visual pigments and oil droplets of the chicken retina. *Vision Research, 17*, 755–764.

Boynton, R. M. (1988). Color vision. *Annual Review of Psychology, 39*, 69–100.

Boynton, R. M., & Gordon, J. (1965). Bezold-Brücke hue shift measured by color-naming technique. *Journal of the Optical Society of America, 55*, 78–86.

Boynton, R. M., & Olson, C. X. (1987). Locating basic colors in the OSA space. *Color research and application, 12*, 94–105.

Boynton, R. M., & Olson, C. X. (1990). Salience of chromatic basic color terms confirmed by three measures. *Vision Research, 30*, 1311–1318.

Brainard, D. H., & Wandell, B. A. (1986). Analysis of the retinex theory of color vision. *Journal of the Optical Society of America A, 3*, 1651–1661.

Brill, M. H. (1978). A device for performing illuminant-invariant assessment of chromatic relations. *Journal of Theoretical Biology, 71*, 473–478.

Brill, M. H., & West, G. (1981). Contributions to the theory of invariance of color under the conditions of varying illuminance, *Journal of Mathematical Biology, 11*, 337–350.

Buchsbaum, G. (1980). A spatial processor model for object color perception. *Journal of the Franklin Institution, 310*, 1–26.

Buchsbaum, G., & Gottschalk, A. (1984). Chromaticity coordinates of frequency-limited functions. *Journal of the Optical Society of America, 67*, 885–887.

Carlton, E. H., & Shepard, R. N. (1990). Psychologically simple motions as geodesic paths: I. Asymmetric objects. II. Symmetric objects. *Journal of Mathematical Psychology. 34*, 127–188, 189–228.

Christ, R. E. (1975). Review and analysis of color coding research for visual displays. *Human Factors, 17*, 542–570.

Cohen, J. (1964). Dependency of the spectral reflectance curves of the Munsell Color Chips. *Psychonomic Science, 1*, 369–370.

Condit, H. R., & Grum, F. (1964). Spectral energy distribution of daylight. *Journal of the Optical Society of America, 54*, 937–943.

Cosmides, L. (1989). The logic of social exchange: Has natural selection shaped how humans reason? Studies with the Wason selection task. *Cognition, 31*, 187–276.

Das, S. R., & Sastri, V. D. P. (1965). Spectral distribution and color of tropical daylight. *Journal of the Optical Society of America, 55*, 319.

Daumer, K. (1956). Reizmetrische Untersuchungen des Farbensehens der Bienen. *Zeitschrift für vergleichende Physiologie, 38*, 413–478.

De Valois, R. L. (1973). Central mechanisms of color vision. In R. Jung (Ed.), *Handbook of sensory physiology* (Vol. 7/3A, pp. 209–253). Berlin: Springer Verlag.

De Valois, R. L., & De Valois, K. K. (1975). Neural coding of color. In E. C. Carterette & M. P. Friedman (Eds.), *Handbook of perception* (Vol. 5, pp. 117–166). New York: Academic Press [Chapter 4, this volume].

Dixon, E. R. (1978). Spectral distribution of Australian daylight. *Journal of the Optical Society of America, 68*, 437–450.

Essock, S. M. (1977). Color perception and color classification. In D. M. Rumbaugh (Ed.), *Language learning by a chimpanzee: The LANA project* (pp. 207–224). New York: Academic Press.

Fernald, R. D. (1984). Vision and behavior in an African cichlid fish. *American Scientist, 72*, 58–65.

Foster, D. H. (1984). Colour vision. *Comtemporary Physiology, 25*, 477–497.

Freyd, J. J. (1983). Shareability: The social psychology of epistemology. *Cognitive Science, 7*, 191–210.

Freyd, J. J. (1990). Natural selection of shareability? *Behavioral and Brain Sciences, 13*, 732–734.

Gibson, J. J. (1950). *The perception of the visual world*. Boston. MA: Houghton-Mifflin.

Gibson, J. J. (1966). *The senses considered as perceptual systems*. Boston, MA: Houghton-Mifflin.

Gibson, J. J. (1979). *The ecological approach to visual perception*. Boston, MA: Houghton-Mifflin.

Graham, E. V., Turner, M. E., & Hurst, D. C. (1973). Derivation of wavelength discrimination from color naming. *Journal of the Optical Society of America, 63*, 109–111.

Hamilton, W. F., & Coleman, T. E. (1933). Trichromatic vision in the pigeon, all illustrated by the spectral discrimination curve. *Journal of Comparative Physiology, 15*, 183–191.

Hardin, C. L. (1990). Why color? *Proceedings of the SPIE/SPSE symposium on electronic imaging: Science and technology*, 293–300.

Heider, E. R. (1971). Focal color areas and the development of color names. *Developmental Psychology, 4*, 447–455.

Heider, E. R. (1972). Universals in color naming and memory. *Journal of Experimental Psychology, 93*, 10–20.

Helmholtz, H. von (1856–1866). *Treatise on physiological optics* (Vol. 2). (J. P. C. Southall, Trans., from the third German edition). New York: Dover, 1962.

Helson, H. (1938). Fundamental problems in color vision. I. The principle governing changes in hue saturation and lightness of non-selective samples in chromatic illumination. *Journal of Experimental Psychology, 23*, 439–476.

Hering, E. (1878/1964). *Zur Lehre vom Lichtsinne*. Berlin. (Republished in English translation as *Outlines of a theory of the light sense*. Cambridge, MA: Harvard University Press).

Hume, D. (1739/1896). A treatise of human nature. (Reprinted from the original 1739 edition. L. A. Selby-Bigge, Ed.) Oxford: Clarendon Press.

Hurvich, L. M., & Jameson, D. (1957). An opponent-process theory of color vision. *Psychological Review, 64*, 384–404.

Jacobs, G. (1981). *Comparative color vision*. New York: Academic Press.

Jacobs, G. H., & Gaylord, H. A. (1967). Effects of chromatic adaptation on color naming. *Vision Research, 7*, 645–653.

Judd, D. B. (1940). Hue, saturation and lightness of surface colors with chromatic illumination. *Journal of Experimental Psychology, 23*, 439–476.

Judd, D. B., MacAdam, D. L., & Wyszecki, G. (1964). Spectral distribution of typical daylight as a function of correlated color temperature. *Journal of the Optical Society of America, 54*, 1031–1040.

Kay, P., & McDaniel, C. K. (1978). The linguistic significance of the meanings of basic color terms, *Language, 54*, 610–646 [Chapter 17, this volume].

Krinov, E. L. (1947). *Spectral reflectance properties of natural formations* (Tech. Rep. No. TT-439). Ottawa, Canada: National Research Council of Canada.

Kruskal, J. B. (1964). Multidimensional scaling by optimizing goodness of fit to a nonmetric hypothesis. *Psychometrika, 29*, 1–27.

Kühn, A. (1927). Über den Farbensinn der Bienen. *Zeitschrift für vergleichende Physiologie, 5*, 762–800.

Land, E. H. (1964). The retinex. *American Scientist, 52*, 247–264.

Land, E. H. (1978, January-February). Our "polar partnership" with the world around us. *Harvard Magazine*, 23–26.

Land, E. H. (1986). Recent advances in retinex theory and some implications for cortical computations: Color vision and the natural image. *Proceedings of the National Academy of Sciences, 80*, 5163–5169.

LeGrand, Y. (1964). Colorimétrie de l'Abeille *Apis mellifera*. *Vision Research, 4*, 59–62.

Lenneberg, E. H., & Roberts, J. M. (1956). The language of experience: A study in methodology. *International Journal of American Linguistics*, Memoir 13.

Lennie, P. (1984). Recent developments in the physiology of color vision. *Trends in Neuroscience, 7*, 243–248.

Livingstone, M. S., & Hubel, D. H. (1984). Anatomy and physiology of a color system in the primate visual cortex. *Journal of neuroscience, 4*, 309–356.

Lythgoe, J. N. (1979). *The ecology of vision*. New York and London: Oxford University Press.

Maloney, L. T. (1986). Evaluation of linear models of surface spectral reflectance with small numbers of parameters. *Journal of the Optical Society of America A, 3*, 1673–1683.

Maloney, L. T., & Wandell, B. A. (1986). Color constancy: A method for recovering surface spectral reflectance. *Jounal of the Optical Society of America A*, *3*, 29–33.

Marr, D. (1982). *Vision*. San Francisco: W. H. Freeman.

McFarland, W. N., & Munz, F. W. (1975a). The photic environment of clear tropical seas during the day. *Vision Research*, *15*, 1063–1070.

McFarland, W. N., & Munz, F. W. (1975b). The evolution of photopic visual pigments in fishes. *Vision Research*, *15*, 1071–1080.

Mervis, C. B. & Rosch, E. (1981). Categorization of natural objects. *Annual Review of Psychology*, *32*, 89–115.

Miller, G. A. (1956). The magical number seven, plus or minus two: Some limits on our capacity for processing information. *Psychological Review*, *63*, 81–97.

Miller, G. A., & Johnson-Laird, P. N. (1976). *Language and perception*. Cambridge, MA: Harvard University Press.

Nagy, A., & Sanchez, R. (1988, November). *Color difference required for parallel visual search*. Paper presented at the Annual Meeting of the Optical Society of America, Santa Clara, CA.

Nassau, K. (1983). *The physics and chemistry of color: The fifteen causes of color*. New York: Wiley.

Nathans, J., Thomas, D., & Hogness, D. S. (1986). Molecular genetics of human color vision: The genes encoding blue, green and red pigments. *Science*, *232*, 193–202.

Newton, I. (1740). *Opticks* (Book 3). London: Printed for S. Smith & B. Walford.

Pavlov, I. P. (1927). *Conditioned reflexes* (G. V. Anrep, Trans.). London: Oxford University Press.

Pavlov, I. P. (1928). Lectures on conditioned reflexes (W. H. Ganntt, Trans.). New York: International Press.

Ratliff, F. (1976). On the psychophysiological bases of universal color names. *Proceedings of the American Philosophy Society*, *120*, 311–330.

Rosch, E. (1973). Natural categories. *Cognitive Psychology*, *4*, 328–350.

Rosch, E. (1975). The natural mental codes for color categories. *Journal of Experimental Psychology: Human Perception and Performance*, *1*, 303–322.

Sälström, P. (1973). *Colour and physics: Some remarks concerning the physical aspects of human color vision* (Report No. 73-09). Stockholm, Sweden: Institute of Physics, University of Stockholm.

Sandell, J. H., Gross, C. G., & Bornstein, M. N. (1979). Color categories in Macaques. *Journal of Comparative and Physiological Psychology*, *93*, 626–635.

Sapir, E. (1916). Time perspective in aboriginal American culture. A study in method. In D. Mandelbaum (Ed.), *Selected writings of Edward Sapir in language, culture, and personality*. Berkeley, CA: University of California Press, 1949.

Sastri, U. D. P., & Das, S. R. (1966). Spectral distribution and colour of north sky at Delhi. *Journal of the Optical Society of America*, *56*, 829.

Sastri, U. D. P., & Das, S. R., (1968). Typical spectral distributions and colour for tropical daylight. *Journal of the Optical Society of America*, *58*, 391.

Shepard, R. N. (1962). The analysis of proximities: Multidimensional scaling with an unknown distance function (Parts 1 and 2). *Psychometrica*, *27*, 125–240, 219–246.

Shepard, R. N. (1964). Attention and the metric structure of the stimulus space. *Journal of Mathematical Psychology*, *1*, 54–87.

Shepard, R. N. (1965). Approximation to uniform gradients of generalization by monotone transformations of scale. In D. I. Mostofsky (Ed.), *Stimulus generalization* (pp. 94–110). Stanford, CA: Stanford University Press.

Shepard, R. N. (1975). Form, formation, and transformation of internal representations. In R. Solso (Ed.), *Information processing and cognition: The Loyola Symposium* (pp. 87–122). Hillsdale, NJ: Lawrence Erlbaum Associates.

Shepard, R. N. (1980). Multidimensional scaling, tree-fitting, and clustering. *Science, 210*, 390–398.

Shepard, R. N. (1981). Psychophysical complementarity. In M. Kubovy & J. Pomerantz (Eds.), *Perceptual organization* (pp. 279–341). Hillsdale, NJ: Lawrence Erlbaum Associates.

Shepard, R. N. (1984). Ecological constraints on internal representation: Resonant kinematics of perceiving, imagining, thinking and dreaming. *Psychological Review, 91*, 417–447.

Shepard, R. N. (1987a). Evolution of a mesh between principles of the mind and regularities of the world. In J. Dupré (Ed.), *The latest on the best: Essays on evolution and optimality* (pp. 251–275). Cambridge, MA: MIT Press/Bradford Books.

Shepard, R. N. (1987b). Toward a universal law of generalization for psychological science. *Science, 237*, 1317–1323.

Shepard, R. N. (1988). The role of transformations in spatial cognition. In J. Stiles-Davis, M. Kritchevsky, & U. Bellugi (Eds.), *Spatial cognition: Brain bases and development* (pp. 81–110). Hillsdale, NJ: Lawrence Erlbaum Associates.

Shepard, R. N. (1989). Internal representation of universal regularities: A challenge for connectionism. In L. Nadel, L. A. Cooper, P. Culicover, & R. M. Harnish (Eds.), *Neural connections, mental computation* (pp. 103–104). Cambridge, MA: MIT Press/Bradford Books.

Shepard, R. N. (1990). A possible evolutionary basis for trichromacy. *Proceedings of the SPIE/SPSE symposium on electronic imaging: Science and technology*, 301–309.

Shepard, R. N. (1991). Integrality versus separability of stimulus dimensions: From an early convergence of evidence to a proposed theoretical basis. In G. R. Lockhead & J. R. Pomerantz (Eds.), *Perception of structure* (pp. 53–71). Washington, DC: American Psychological Association.

Shepard, R. N. (1992). What in the world determines the structure of color space? (Commentary on Thompson, Palacios, & Varela). *Behavioral and Brain Sciences, 15*, 50–51.

Shepard, R. N. & Carroll, J. D. (1966). Parametric representation of nonlinear data structures. In P. R. Krishnaiah (Ed.), *Multivariate analysis* (pp. 561–592). New York: Academic Press.

Shepard, R. N., & Chang, J.-J. (1963). Stimulus generalization in the learning of classifications. *Journal of Experimental Psychology, 65*, 94–102.

Shepard, R. N., & Cooper, L. A. (1982). *Mental images and their transformations*. Cambridge. MA: MIT Press/Bradford Books.

Shepard, R. N., & Cooper, L. A. (1992). Representation of colors in the blind, color blind, and normally sighted. *Psychological Science, 3* (in press).

Smith, D. P., (1971). Derivation of wavelength discrimination from colour-naming data. *Vision Research, 11*, 739–742.

Sperling, G. (1960). The information available in brief visual presentations. *Psychological Monographs, 74* (11, Whole No. 498).

Stiles, W. S., Wyszecki, G., & Ohta, N. (1977). Counting metameric object-color stimuli using frequency-limited spectral reflectance functions. *Journal of the Optical Society of America, 67*, 779–784.

Tversky, A., & Kahneman, D. (1974). Judgment under uncertainty: Heuristics and biases. *Science, 185*, 1124–1131.

Uchikawa, K., & Boynton, R. M. (1987). Categorical color perception of Japanese observers: Comparison with that of Americans. *Vision Research, 27*, 1825–1833.

von Frisch, K. (1950). *Bees: Their vision, chemical senses, and language*. Ithaca, NY: Cornell Univeristy Press.

von Helverson, O. (1972). Zur spektralen Unterschiedsempfindlichkeit der Honigbiene. *Journal of Comparative Physiology, 80*, 439–472.

Wason, P. C., & Johnson-Laird, P. N. (1972). *Psychology of reasoning: Structure and content*. London: Batsford.

West, G., & Brill, M. H. (1982). Necessary and sufficient conditions for Von Kries chromatic adaptation to give color constancy. *Journal of Mathematical Biology, 15*, 249–258.

Whorf, B. L. (1956). *Language, thought, and reality*. New York: Wiley.

Winch, G. T., Boshoff, M. C., Kok, C. J., & du Toit, A. G. (1966). Spectroradiometric and colorimetric characteristics of daylight in the southern hemisphere: Pretoria, South Africa. *Journal of the Optical Society of America, 56*, 456–464.

Woodworth, R. S., & Sells, S. B. (1935). An atmosphere effect in formal syllogistic reasoning. *Journal of Experimental Psychology, 18*, 451–460.

Worthy, J. A. (1985). Limitations of color constancy. *Journal of the Optical Society of America A, 2*, 1014–1026.

Wright, A. A. (1972). Psychometric and psychophysical hue discrimination functions for the pigeon. *Vision Research, 12*, 1447–1464.

Wright, A. A., & Cumming, W. W. (1971). Color-naming functions for the pigeon. *Journal of the Experimental Analysis of Behavior, 15*, 7–17.

Yilmaz, H. (1962). Color vision and a new approach to color perception. In E. E. Bernard & M. R. Kare (Eds.) *Biological prototypes and synthetic systems* (pp. 126–141). New York, Plenum.

Young, T. (1807). On physical optics. In *A course of lectures on natural philosophy and the mechanical arts* (Vol. 1). London: Printed for Taylor and Welton, 1845.

Zeki, S. (1983). Colour pathways and hierarchies in the cerebral cortex: The responses of wavelength-selective and colour-coded cells in monkey visual cortex to changes in wavelength composition. *Neuroscience, 9*, 767–781.

15 Visual Pigments and the Acquisition of Visual Information

J. N. Lythgoe and J. C. Partridge

Introduction

Ultimately we would like to understand how the human visual system is adapted to the complex visual scene that surrounds us, but it may be easier to make a beginning by studying visual environments that are simpler. Such environments are to be found underwater where the wavelength-selective absorption of daylight means that animals live in a world where the ambient light is dim and restricted to a narrow region of the spectrum (Dartnall, 1975; Lythgoe, 1979, 1988). Fish living in these dark and homochromatic conditions may have only one receptor class, the rods, but those living in slightly shallower water often have one or two classes of cone in addition to the rods, whereas near the surface they may have three or four classes of cone in addition to the rods (Loew & Lythgoe, 1978; Levine & MacNichol, 1979). At present we do not have enough information about the depths and ambient light levels where particular classes of cone are lost because there is insufficient light for them to be useful. The behavior and ecology of the animal are also important. Diurnal animals are likely to have more classes of cone than those that are nocturnal or live underground or in turbid conditions (Levine & MacNichol, 1979).

Rhodopsins, the visual pigments, are part of a larger class of G-protein–linked molecules which also include muscarinic and adrenergic receptors. All members of the class have seven helical transmembrane segments and, once activated, appear to have similar effector mechanisms which open or close ion gates in the plasma membrane. However, there are significant variations within each type of the class. Adrenergic and muscarinic receptors are divided into subtypes on the basis of their pharmacological action, whereas rhodopsins are classified into subtypes by their absorption spectra and whether the chromophore group is retinal, dehydroretinal, 3-hydroxyretinal (Kirschfeld & Vogt, 1986) or 4-hydroxyretinal (Matsui et al. 1988), and perhaps there are others. So far only retinal and dehydroretinal have been found in vertebrates.

Genes have been identified and sequenced for several different opsin molecules, including the human and bovine rod pigment and the blue, green and red cone pigments and four *Drosophila* pigments (Hargrave et al. 1983; Nathans et al. 1986; Zuker et al. 1987). So far all the opsin genes that have been found are also expressed, but it is possible that genes could be present but not expressed, or only expressed at particular stages of an animal's life. The 'deep-sea' opsin of the eel (Carlisle & Denton, 1959; Beatty, 1984) and the blue pigment of the pollack (Shand et al. 1988) may be examples of this.

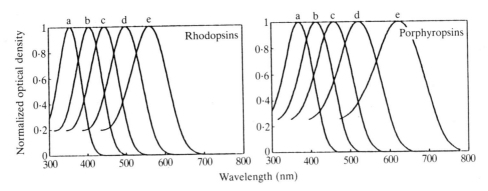

Figure 15.1
Absorbance spectra of five rhodopsins compared with their porphyropsin analogues. At longer wavelengths the porphyropsin absorbance spectra become broader and more red-sensitive than their rhodopsin analogues. The templates are based on Knowles & Dartnall (1977) and transformed by Mansfield's method (MacNichol, 1986). The analogue pairs are amongst those listed by Whitmore (1988).

An opsin becomes a light-sensitive visual pigment when a chromophore group in the 11-*cis* configuration is inserted into it. If the chromophore group is retinal, the visual pigment is a rhodopsin, if the chromophore is dehydroretinal, the visual pigment is a porphyropsin. Rhodopsins and prophyropsins differ in both the wavelength of maximum absorption and the breadth of their spectral absorbance curve. The difference is small for blue-sensitive pigments, but increases progressively at longer wavelengths (Dartnall & Lythgoe, 1965; Whitmore, 1988). Thus a rhodopsin of λ_{max} 565 nm becomes a porphyropsin of λ_{max} 630 nm with a correspondingly broader spectral absorption curve (figure 15.1). There appear to be no visual pigments that absorb at longer wavelengths than this but, nevertheless, a freshwater fish with a 630 nm porphyropsin can see substantially further into the near infrared than can humans with the rhodopsin analogue which has a λ_{max} at 565 nm.

Environmental Light and Visual Pigments

Penetration of Light into Natural Water

There are striking differences in the spectral distribution of natural water according to the amount of chlorophyll and the dissolved products of natural decay that it contains (figure 15.2). Pure water is blue partly because of the selective absorption of water molecules, and partly because of Rayleigh scatter, which is greater at short than at long wavelengths. The salts dissolved in sea water have almost no effect on

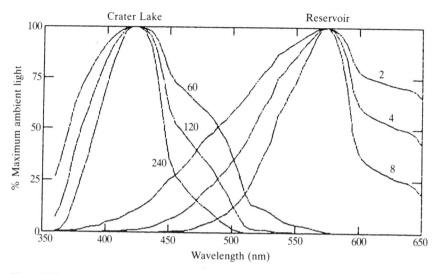

Figure 15.2
The spectral distribution of downwelling daylight at optically equivalent depths in very clear water containing little chlorophyll or dissolved organic matter (Crater Lake, Oregon) and fresh water containing significant amounts of chlorophyll and dissolved organic matter (San Vincente reservoir, California). The numbers are depths in metres. Values are calculated from the spectral attenuation coefficient of downwelling light measured by Tyler & Smith (1970) and do not take into account the spectral distribution of daylight, which is variable but will have little effect on the shape of the spectral distribution curves at these depths. Notice the reduction in the bandwidth of available light as the depth increases. At 60 m in Crater Lake and 2 m in the reservoir, surface light intensity is reduced by a minimum of 60%; at 120 m in Crater Lake and 4 m in the reservoir, surface light is reduced by 85%; at 240 m in Crater Lake and 8 m in the reservoir, surface light is reduced by 98%.

its colour and pure fresh water is the same blue as ocean water. In fact, fresh water very rarely looks blue because it contains enough nutrients to support a rich crop of chlorophyll-containing phytoplankton. It is also coloured by the yellow and brown products of vegetable decay that originate from phytoplankton and from run-off from the land (Jerlov, 1976; Baker & Smith, 1982). Compared with most fresh waters and inshore water, the open ocean and the clear blue seas of the Mediterranean are poor in nutrients and remain the blue colour of pure water. Inshore waters such as those that surround the coasts of the North Atlantic vary from blue-green to yellow-green according to the amount of phytoplankton and dissolved organic matter. Fresh water is often green or yellow-green, but in places where it has filtered through forest litter or peat it is stained brown or reddish brown in colour and it is red and near infrared light that penetrates furthest (Spence et al. 1971; Muntz & Mouat, 1984).

Deep-Sea Animals

It is something of a paradox that we should know the most about the visual pig-
ments of those most inaccessible of animals—the deep-sea fishes. At high sun angles
visually useful light may penetrate the clearest ocean waters to a depth approaching
1000 m (Dartnall, 1975) but, where there is an overcast sky at night, the maximum
depth of vision may only be a few metres below the surface. An alternative source of
light is the bioluminescence produced by fishes and invertebrates. Like the ambient
daylight at mesopelagic depths, bioluminescence also tends to be blue or blue-green in
colour (Widder et al. 1983; Herring, 1983). These colours may be used partly because
they penetrate furthest through the water, and partly because they are the most useful
for camouflage. The visual pigments of 89 species of deep-sea fish have been inves-
tigated (Partridge et al. 1988, 1989) and there is no doubt that most of them have
pure rod retinas containing rhodopsins that absorb most strongly in the 470–490 nm
blue region of the spectrum (figure 15.3) (Crescitelli et al. 1985; Fernandez, 1978;
Denton & Warren, 1957; Munz, 1958; Partridge, 1989; Partridge et al. 1988, 1989).

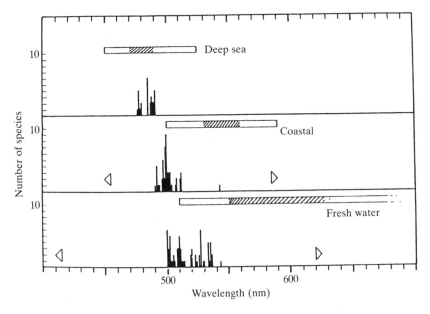

Figure 15.3
The relationship between the visual pigments in the rod outer segments of fishes and the spectral waveband
available for vision in different aquatic environments. The hatched areas of the horizontal bars represent
the absorption maxima of visual pigments which would give greatest sensitivity to fishes living in those
waters.

The scales of many pelagic fishes contain guanine crystals that are orientated in such a way that the curved flank of the fish acts as a vertical mirror (Denton & Nicol, 1965). Beneath the immediate surface waters, the light penetrating into the oceans is symmetrical about the vertical axis, and a vertical mirror viewed from most directions will reflect light of the same colour and intensity as the light against which it is seen. This 'mirror camouflage' does not work for the vertically upward or downward directions of view. Camouflage against downward-searching predators such as sea birds simply needs dark pigmentation along the dorsal surfaces. Camouflage against upward-searching predators is more difficult since the silhouette is always going to be darker than the bright downwelling daylight. The solution adopted by many vertebrates and invertebrates is to arrange for a bank of downwardly directed photophores giving light that exactly matches the downwelling daylight (Warner et al. 1979). Fishes that have well-developed ventral photophores and silvery flanks for spacelight camouflage are likely to live where there is residual daylight. Fishes living deeper than 1000 m or those that only venture into shallower water at night tend to have dark bodies and fewer and less-developed photophores. Bioluminescence is present at all depths, but it appears to be more frequent at depths less than about 1000 m (Marshall, 1979).

All the fishes with counterlighting and mirror camouflage that have been examined have one type of retinal rod containing a single rhodopsin. However, a significant percentage of the deep-living darker-coloured species have two classes of rod containing different visual pigments (Partridge et al. 1988, 1989). It is as though the presence of homochromatic blue daylight in the shallowest quarter of the ocean demands that photophores should emit blue light and that photoreceptors should also be most sensitive to the blue daylight and the blue light from the photophores. Deeper than this, where there is no daylight, a more versatile visual system using more than one class of photoreceptor is allowed, perhaps tuned to distinguish between different bioluminescent sources by the shape of the spectral radiance curves.

There are two related families of fish whose members fall into the dark-coloured category that are worthy of notice. Members of the Malacosteidae and Melanostomiidae have large red and green photophores situated just below the eye. It is now firmly established that there are two classes of rod in their retinas. In *Pachystomias microdon* the two classes have λ_{max} values near 513 and 539 nm. In *Malacosteus niger* the λ_{max} are near 521 and 540 nm (Bowmaker et al. 1988; Partridge et al. 1989; Partridge, 1989). In both cases the short-wave rod contains mainly rhodopsin and the long-wave rod mainly porphyropsin. There are slight differences in the λ_{max} of the two classes obtained by different workers, but this may be largely due to the fact

that the rhodopsin rods contain traces of porphyropsin and the porphyropsin rods contain traces of rhodopsin. The difference between a rhodopsin and a porphyropsin is that rhodopsins have 11-*cis* retinal as the chromophore group and porphyropsin have 3-dehydroretinal. It is likely that the opsin in the two classes of rod is the same, and the difference lies solely in the chromophore group. Some other dark-coloured deep-sea fishes, such as *Bathylagus bericoides,* also have two classes of rod but these, judging by the shape of their spectral absorption curves, contain different rhodopsins and there are no porphyropsins (Partridge et al. 1988). Differently coloured photophores have not been reported from these species and at present we do not know why they should have two types of rod whereas other species have only one.

Fishes Living at Intermediate Depths

There are few systematic data about the visual pigments in fishes living at depths less than about 200 m in blue oceanic water and we must turn our attention to green coastal water and green or brown fresh water where more data are available (Loew & Lythgoe, 1978; Levine & MacNichol, 1979; Lythgoe, 1988). As a *very rough* guide, visually intermediate depths in coastal water might mean something between 10 m and 50 m in some coastal waters and between 5 and 20 m in fresh water. We owe the most systematic study on the relationship between depth and visual pigments in rods and cones to Levine & MacNichol (1979). They found that fishes that live in tropical fresh water, near and on the bottom, and particularly those that are nocturnal or have a well-developed olfactory apparatus, tend to possess only two classes of cones. One of these cone classes typically contains a porphyropsin of 600–640 nm λ_{max} which would be most sensitive to the long-wavelength light that penetrates deepest into the type of water where they live. Fishes living at intermediate depths in the green coastal waters of the English Channel also have two cone pigments, but these have rhodopsins and are most sensitive to the green ambient light that prevails in these waters (figure 15.4).

Terrestrial Animals and Fishes Living in Shallow Water

Fishes that spend at least some of the time in well-lit shallow water are exposed to daylight that is not very different in spectral distribution from that experienced by terrestrial animals. It is interesting that fishes living in these very shallow waters lack the long-wave–sensitive porphyropsins and this includes freshwater fishes which one might expect to have them (figure 15.5). The lack of red-sensitive pigments cannot be explained by any shortage of red light, although the relative amount is less than at greater depths in fresh water. Muntz & Mouat (1984) have noted that the seasonal changes in the ratio of rhodopsin to porphyropsin in rudd and trout follow this

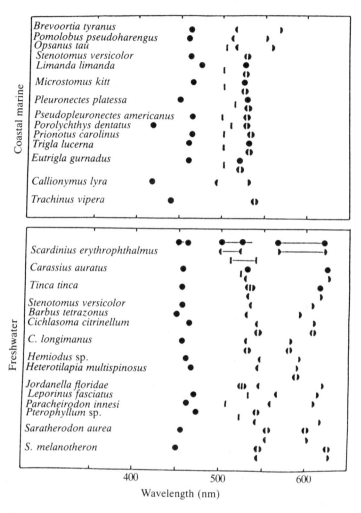

Figure 15.4

The visual pigments present in the rods and cones of various species of fish that live at moderate depths in coastal water and fresh water. Long-wave-sensitive visual pigments (mostly porphyropsins) are rare in fish from coastal water, but frequent in fish from fresh water, which is most transparent at longer wavelengths. Filled circles, λ_{max} of visual pigments in single cones; half circles, λ_{max} of visual pigments in one member of twin or paired cones; vertical bars, λ_{max} of the visual pigments in the rods.

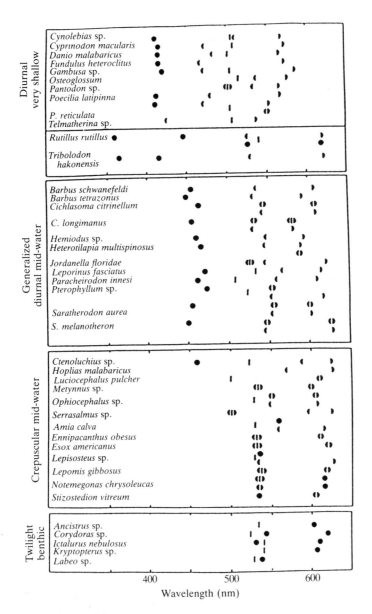

Figure 15.5
The relationship between visual pigments and the depth that the fish lives at in fresh waters. Note that the spectral range of visual pigments is reduced as the depth increases and the spectral bandwidth of incident light available for vision becomes narrower. Symbols as for figure 15.4.

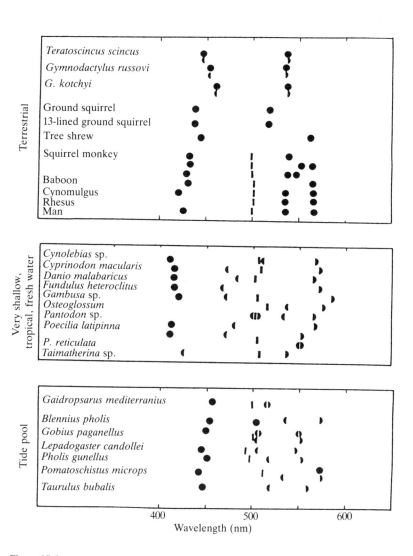

Figure 15.6
Comparison between the visual pigments of terrestrial animals and those living in very shallow fresh water and very shallow coastal water. Note that they are all located in approximately the same region of the spectrum. Symbols as for figure 15.4.

trend, since in summer the fish tend to feed near the surface and have high percentages of rhodopsin, whereas in winter they move to deeper water and their retina contains a higher percentage of porphyropsin. In figure 15.6, the visual pigments of shallow marine and freshwater species are compared with those of terrestrial species. Taking the groups as a whole, there is an overall similarity between them, although there are several differences in detail. Some of these differences may be due to limitation in the gene pool of particular phylogenetic lines. However, we need many more data than we have at present to prove the absence of particular visual pigments and there is little actual evidence to suggest that certain groups of animals are genetically incapable of producing particular visual pigments.

Information from Rods and Cones

So far we have been concerned with the sensitivity of the photoreceptors, but what actually matters to an animal is the amount of useful information it can extract from the retinal image. Photoreceptors are photon counters and it is the number of photons that are absorbed that modulates the strength of the neural message originating from the photoreceptors. However, the actual number of photons that arrive at the photoreceptor can only be predicted as a statistical probability and, even at the light levels prevailing at sunset, the number of photons available limits thresholds for the perception of contrast, detail and movement (Barlow, 1964; Land, 1981). A further problem is likely to be spurious signals generated by 'spontaneous' thermal isomerizations of the visual pigment chromophore (Barlow, 1988; Aho et al. 1988). There are some 10^9 rhodopsin molecules in a (frog) rod (Rodieck, 1973) and if the isomerization of one rhodopsin molecule by a photon of light is sufficient to initiate a signal, it follows that almost all the remaining molecules must not isomerize spontaneously if spurious signals are not to mask the light signal with physiological noise. It is possible that the reason why rods tend to contain rhodopsins of λ_{max} between 470 and 510 nm is because it is those that are least likely to have spontaneous isomerizations. However, there is little or no evidence on the point.

Most visual tasks involve detecting the differences between elements of an image either in space or in time. The larger the change, the more likely it is to be detected at low light levels or when there is a high level of physiological noise. Where two radiances are to be distinguished, it makes sense for the photoreceptors to gather most photons at wavelengths where the two radiances are the most different, always providing that there are enough photons to make statistically reliable judgements. The relationship between the size of a contrast ($\Delta I / I$) to be detected and the level of illumination required to make judgements with varying degrees of confidence has

been discussed by Land (1981). In many situations the greatest contrasts occur in regions of the spectrum where radiances are small, and the λ_{max} of the best visual pigment to detect them is likely to be a compromise between the need to maximize contrast, the need to sample as many photons as possible and the need to employ a noise-free photoreceptor. At high levels of illumination the limits to contrast perception may be set by physiological noise generated by the neural circuitry of retina and brain. However, visual noise, whether of environmental or physiological origin, is likely to be an important factor in setting thresholds and delimiting the spectral band that is useful for vision.

Vision in the Ultraviolet and Infrared

There is no doubt that many animals can see at shorter wavelengths than we can, others can see into the near infrared and some freshwater fish can see in both the ultraviolet and the infrared. The long-wavelength limit for vision is likely to be set by the absorption of the most long-wavelength–sensitive visual pigment which appears to be a porphyropsin with a λ_{max} of about 630 nm (Lythgoe, 1988). This will allow useful sensitivity to light longer than 740 nm, where the absorption of a 630 nm porphyropsin falls to about 10% of its maximum value. Ultraviolet vision is well established by the use of electrophysiological techniques in insects, birds and shallow-living fishes. In fishes, visual pigments that have their λ_{max} in the 350–400 nm region of the spectrum have been measured directly by microspectrophotometry and they are probably sensitive to light of wavelengths as short as 280 nm, where absorption by aromatic amino acids effectively puts a limit to short-wave vision. There is strong evidence that ultraviolet sensitivity in some insects is promoted by the attachment of a sensitizing pigment to the opsin molecule. In the higher flies such as *Musca*, *Calliphora* and *Drosophila*, the short-wave–sensitive pigment has a 3-hydroxyretinal chromophore and a λ_{max} of 420 nm. However, it has attached to it a molecule of 3-hydroxyretinol which sensitizes it to ultraviolet light, the conjugated pigment having a strong peak at 420 nm. In the simuliid flies the pigment is a rhodopsin and the sensitizing pigment is retinol (Kirschfeld & Vogt, 1986; Kirschfeld et al. 1988). We humans are only prevented from seeing ultraviolet light by the absorption of the pre-retinal media, especially the lens (Wyszecki & Stiles, 1967).

Because we humans are limited in our spectral range we have to rely on other evidence, sometimes supported by photography and video, to give us an idea how much visual information we miss in our normal lives. Photographic colour film is available which allows us to visualize the visual scene in the near infrared at wavelengths below about 1000 nm, where it is to be expected that many fresh-water fish can see

quite well. The film shows the very strong reflectance of foliage at these long wave-lengths, but has so far not shown any extra information. Perhaps fresh-water fishes are sensitive to these wavelengths because they penetrate furthest through water stained brown by dissolved organic matter. It has been suggested recently that the deep-sea crustacean *Rimicaris exoculata*, which congregates around the very hot (350°C) volcanic vents to feed, can use the rhodopsin (λ_{max} 500 nm) contained in special organs in their cephalothorax to detect the black-body radiation from the hot water (van Dover et al. 1989; Pelli & Chamberlain, 1989). These authors suggest that the water is just sufficiently hot to give enough light at 600 nm to isomerize rhodopsin molecules at a just detectable level. Not taken into account, however, is the significant absorption of 600 nm light by even very clear waters, or the problems of distinguishing infrared radiation from visible blue-green light from bioluminescent animals to which the rhodopsin is very sensitive.

Using an ultraviolet-pass filter in conjunction with a standard camera lens and monochrome film, it is possible to visualize patterns that are only visible in the ultraviolet. This approach has been particularly useful in seeing 'pollen guide' pat-terns on flowers (Lythgoe, 1979) and, in one example, patterns on the flanks of a fish (Harosi & Hashimoto, 1983). Using monochrome photography it is often difficult to decide which objects are dark because they are in shade and which are dark because they absorb ultraviolet light. By substituting an ultraviolet-sensitive tube for the blue-sensitive tube in a colour video camera, it has been possible to overcome the difficulty of ambiguity due to shading. Despite difficulties due to incorporating an ultraviolet channel into an optical system for which it is not designed, it is evident that there is other visual information in the ultraviolet (Loew & Lythgoe, 1985). Leaves reflect different amounts of ultraviolet light according to species and age, and some that are exposed to high levels of ultraviolet light appear to have ultraviolet-absorbing pigments which would be visible to an animal with ultraviolet receptors. In general, any object that owes its colour to scattering is likely to reflect ultraviolet light strongly. Clouds and blue sky both fall into this category, as do the white feathers of birds, snow and many light-coloured rocks. Iridescent interference colours often do not reflect ultraviolet light, even when they appear deep blue in colour. There is really no way of telling by eye whether an object reflects or absorbs ultraviolet light and the reality is often counterintuitive. For example, most violet and blue flowers are ultraviolet-absorbers, whereas red poppies reflect very strongly in the ultraviolet.

It is likely that the shapes, patterns and colours of flowers have co-evolved with the visual system of their pollinators. The presence of 'pollen guides' in flowers is quoted as an example of this co-evolution. Sometimes these pollen guides are visible

to humans and take the form of marking the area where the nectar and pollen are located. Sometimes, however, the pollen guides are only revealed by ultraviolet video or photography.

Birds, like insects, are exposed to ultraviolet light and it is not surprising that they too have ultraviolet receptors. Fishes living at shallow and moderate depths also possess ultraviolet receptors and one can only suppose that useful amounts of ultraviolet light penetrate through the water. Many fishes feed very close to the water surface, or even at the surface itself, and may only need to see their prey from a distance of a few centimetres. It may be that objects like small plankters suspended very near the surface reflect the ultraviolet light that has travelled the very short distance from the surface, whereas light from the background spacelight which has travelled further through the water is poor in ultraviolet light (Lythgoe, 1988). Conversely, Bowmaker & Kunz (1987) suggest that the plankters may be net absorbers of ultraviolet light, whereas the background is likely to be bright because it scatters this short-wavelength light.

Particles of molecular size scatter short-wavelength light more than long-wavelength light and this is the reason why clear sky is blue and part of the reason why optically pure water is blue. Scattered light is also plane-polarized with the plane of maximum polarization at right-angles to the light ray. For this reason sky-light and underwater spacelight are plane-polarized. Many animals are able to use the plane of polarization for navigation (Waterman, 1981). In bees it is the ultraviolet receptors that are used to detect the plane of polarized light. However, in the more nocturnal cricket *Gryllus bimaculatus*, which has receptors maximally sensitive at 332 nm, 445 nm and 515 nm, it is the blue-sensitive 445 nm receptors that are used to scan the sky above and are the polarization detectors (Zufall et al. 1989). Differential sensitivity to the plane of polarized light is not necessarily confined to one photoreceptor class: the ultraviolet cones in the goldfish are most sensitive to light when the e-vector is vertical, whereas the red- and green-sensitive cones are most sensitive when it is horizontal (Hawryshyn & McFarland, 1987). The blue-sensitive cones in the goldfish show no differential sensitivity to polarized light.

Colour Vision Variation Within a Species

Some lower vertebrates have the ability to alter their visual pigments at different stages of their life history (Beatty, 1984; Shand et al. 1988). As a general rule, it appears that colour vision polymorphism is the result of having different opsins in the visual pigment, whereas most seasonal or developmental changes in visual pigment through life are the result of substituting one chromophore group for another.

It is often possible to recognize environmental reasons why particular visual pigments should appear at different stages of life but, so far, there have been few convincing proposals why different animals sharing the same environment should be polymorphic for visual pigments. It can only be supposed that there is some specialization for particular visual tasks. It should be said, however, that no one has firmly proposed a set of visual tasks that a human deuteranope or protanope can do better than someone who has 'normal' colour vision (Dartnall et al. 1983).

Chromophore Substitution

As was mentioned earlier, the substitution of dehydroretinal for retinal as the chromophore group in the visual pigment molecule results in a shift in spectral absorbance to longer wavelengths. The effect is negligible at short wavelengths but is as much as 60 nm at long wavelengths (Dartnall & Lythgoe, 1965; Whitmore, 1988). This is significant when it is considered that only 40 nm separates our own longwave-sensitive rhodopsins. Fresh-water animals, including crustaceans (Suzuki & Eguchi, 1987) that live more than a few centimetres below the surface, tend to have porphyropsins because of the long-wave bias in the environmental light (Lythgoe, 1979). Most other animals have rhodopsins. Many animals that move from fresh water onto the land or migrate between the oceans and fresh water show chromophore substitution (Beatty, 1984). Thus tadpoles, of both frogs and toads, have mainly porphyropsins, whereas the adults have rhodopsins. Migrating salmon and trout have rhodopsins when living in the sea, which they substitute for porphyropsins when they move up the rivers to breed. Freshwater eels living their adolescent lives have porphyropsins but, in anticipation of their sexual migration to the sea, substitute rhodopsin for porphyropsin (Carlisle & Denton, 1959).

Opsin Changes

Eels appear to take one further step beyond the substitution of chromophore groups for, in reaching their breeding grounds in the tropical west Atlantic, they experience the same homochromatic blue light as deep-sea fishes, and adopt a 'deep-sea' blue-sensitive pigment with similar spectral absorption characteristics. Until recently the eel was the only animal known to substitute or change rhodopsins, but Shand et al. (1988) have shown that the pollack *Pollachius pollachius*, which is a marine coastal fish of northwest Europe, appears to change the rhodopsin in the blue-sensitive class of cone from a λ_{max} of about 420 nm to one of about 460 nm when they have grown to 50–70 mm standard length (figure 15.7). The other cone pigments do not change. The change occurs at about the time when the juvenile pollack changes from a diet of small plankters, usually caught near the surface, to one of small fish, usually cap-

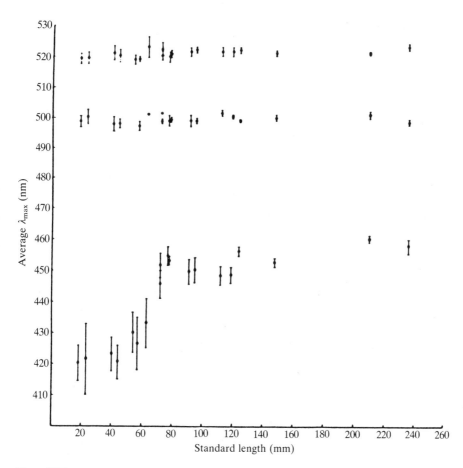

Figure 15.7
The visual pigments in the cones of the pollack during its transition from a plankton eater in shallow water to a predator on small fish in generally deeper water. The change in λ_{max} of the blue-sensitive pigment coincides with the change in lifestyle. The standard deviation and the means of the data are plotted.

tured in rather deeper water. The trout also shows a change in the short-wave–
sensitive cones. Up to the age of 2 years the trout has a class of ultraviolet-sensitive
cones that are lost as it grows older and changes from a shallow feeder on plankton to
more predatory feeder on fish in somewhat deeper water (Bowmaker & Kunz, 1987).

Opsin Polymorphism

From our human perspective it is the norm for each individual to retain the same
colour vision mechanism through life, and for each individual to have the same
mechanism as his neighbour. However, it is now becoming clear that many animals
change photopigments according to season, age or lifestyle, whereas others are poly-
morphic for visual pigments. Anomalous red-green colour vision in human males
appears to be the result of a type of visual pigment polymorphism that is more
strongly established in non-human primates, particularly the New World monkeys
(Bowmaker et al. 1983, 1985; Dartnall et al. 1983).

Cone polymorphism has also been described in a fish, the guppy (*Poecilia retic-
ulata*) (Archer et al. 1987; Archer, 1988). These, in common with other very shallow-
living fishes, have a pure rhodopsin retina and are only slightly more sensitive to
long-wave light than are primates. Guppies appear to have a class of ultraviolet-
sensitive cones, a blue-sensitive cone at 410 nm and another at 465 nm, a rod at
503 nm, and the polymorphic group of cones of λ_{max} 533, 548 and 572 nm. Analysis
of the shape of the spectral absorption curves suggests that the 548 nm cone prob-
ably contains a mixture of the 533 nm and 572 nm rhodopsins. Phenotypes have
been identified that have all three polymorphic cones, the 572 nm cone alone, the
533 nm and the 548 nm cone, and the 533 nm and the 572 nm cone. Archer (1988)
failed to find the 533 nm cone class on its own, but more recent work suggests that
this class is also present. Unlike in the primates, there is no evidence of cone poly-
morphism being sex-linked, despite the fact that guppies show strong sex differences
in both size and coloration. The females are always brown, whereas the males are
smaller and have striking patterns which vary from fish to fish.

Visual Pigments and the Discrimination of Natural Objects on Land

In the past we have considered that the ordinary terrestrial scene is much too com-
plicated to analyse why different animals have the visual pigments that they do.
Instead we have concentrated on the underwater visual scene, where the wavelength-
selective absorption by water limits the light available for vision to a relatively nar-
row waveband. Recently, however, we have begun to question whether many visual
scenes on land are really so complicated that they defeat analysis. Animals living in

environments where vegetation is plentiful experience a world that is predominantly green and brown. In such an environment many important visual tasks are likely to involve distinguishing between objects of very similar colour, such as finding cryptically coloured insects which is, for example, an important visual task for foraging squirrel monkeys. By contrast, colours used in display are very different in spectral radiance from their background, and almost any set of visual pigments that absorb in the same general region of the spectrum will serve to distinguish them.

A single photoreceptor can give information about the amplitude (brightness) of a radiance, but two photoreceptors of different spectral absorbance are required to give any information about the shape of a spectral radiance curve; i.e. about colour. The signals from two different photoreceptors can be combined additively $V1 + V2$ to give unambiguous information about the amplitude of the radiance; or one of them can inhibit the other $V1 - V2$ to give information about the shape of the spectral reflectance curve which is ambiguously combined with its amplitude. The brightness element can be stripped from $V1 - V2$ by dividing it by $V1 + V2$ and there is good neurophysiological evidence for the presence of $V1 + V2$ and $V1 - V2$ channels in vertebrates (Ingling & Martinez, 1983; Derrington et al. 1984). The comparison between the two channels to give unambiguous information about colour, as distinct from brightness, apparently occurs at a high level in the brain (Livingstone & Hubel, 1988).

We have chosen to express the chromaticity (C) of a single object as:

$$C = (V1 - V2)/(V1 + V2) \tag{1}$$

When the spectral radiances of similarly coloured objects are measured, the spread in the values of C will be greater for objects that differ more in colour. Objects are likely to differ more at some wavelengths than at others, and visual pigments that collect most photons at wavelengths where the objects are most different are likely to give the greatest variations in C. We set ourselves the task of finding out which pairs of visual pigments give the greatest range of values of C for different classes of naturally occurring objects. The range in C, for each pair of visual pigments, was measured conventionally as the standard deviation of the values of C for the chosen class of objects.

All the samples were collected in summer (August) from natural woodland near Bristol, England. The collections were (a) mature healthy green leaves, (b) fallen leaves and (c) items of forest litter, such as rotten twigs, brown fungi and rotten wood, but not including fallen leaves or anything that was in any way tinged green with chlorophyll. The specimens were taken into the laboratory and their spectral reflectance measured with a scanning spectroradiometer and the data acquired

by computer. We made the simplifying assumption that they would be viewed by photon-white light that was sufficiently bright to avoid problems with stochastic variation of photon flux. The spectral absorptions of the visual pigments in the individual photoreceptors were calculated by assuming an optical density of 0.05 and Dartnall's 'nomogram' spectral absorption curve for rhodopsin, transformed through the spectrum using the Mansfield transform (MacNichol, 1986). The values of C were computed for each object for every combination of 26 rhodopsins (λ_{max} range 350–600 nm at 10 nm steps in λ_{max}). Finally, the standard deviations of the values of C for each of the possible pairs of visual pigments 'viewing' the different collections was computed and the results are displayed in the contoured 'varygrams' shown in figure 15.8.

The higher the standard deviations for C, the greater the number of objects that can be distinguished on the basis of chromaticity. It is clear that the best pair of visual pigments for distinguishing green leaves is not the same as that which is best for distinguishing between items of brown forest litter. However, in all the cases that we considered, the best pair includes a blue-sensitive rhodopsin with λ_{max} in the 420–450 nm range. For green leaves the best long-wave pigment is in the 510–520 nm range and for forest litter the best long-wave pigment is 570 nm or longer. So far, the longest known rhodopsin λ_{max} is 572 nm. For mammals the most red-sensitive rhodopsin has a λ_{max} at about 565 nm.

In their present form these calculations do not consider trichromatic vision, and they do not take into account statistical uncertainty due to low numbers of photons in dim light, a consideration which is likely to be most important at short wavelengths. Nevertheless, it is interesting to compare the pigment pairs that actually occur in some known dichromats (Mollon et al. 1984; Jacobs & Neitz, 1986; Jacobs et al. 1985; Blakeslee et al. 1988) with the 'best' pigment pairs as computed here. For example, tree shrews and the squirrel monkeys that lack the green pigment would be best at distinguishing between twigs, dead leaves and rotten wood, whereas those squirrel monkeys that lack the red pigment would be best at distinguishing between different items of green foliage. It is also interesting that two species of frog, *Rana pipiens* and *R. temporaria*, have two classes of rod: one with a λ_{max} at about 432 nm, and another with a λ_{max} varying between 500 and 510 nm (Bowmaker et al. 1975). If the signals from the two rod types were compared in the neural network to give a form of colour vision, they would be well-adapted for distinguishing between different shades of green. The importance of a blue-sensitive cone in colour discrimination was not something we had anticipated, but it is interesting that the molecular structures of the four (human) rhodopsins give some reason for believing that the blue-sensitive rhodopsin separated from 500 nm rhodopsin in ancient evolutionary

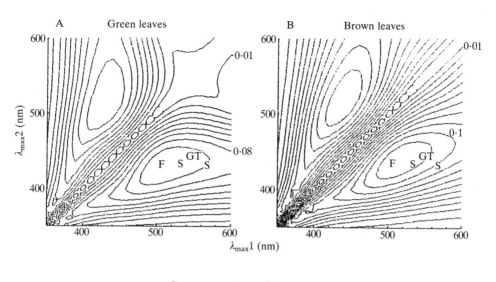

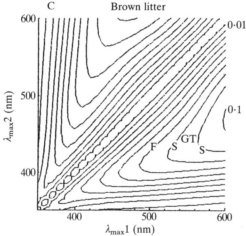

Figure 15.8

'Varygrams' showing the amount of variation in the value of C, a measure of chromaticity, for a retina containing different pairs of rhodopsins. The rhodopsins are 'looking at' (A) various green leaves, (B) fallen dead deciduous leaves and (C) items of brown forest litter. The contours represent the standard deviation of the values of C, the higher the value, the more different chromaticities can be distinguished. The letters represent the rhodopsins known to be present in the two types of cone of various dichromatic animals. G, grey squirrel; T, tree shrew; S, two dichromatic phenotypes of the squirrel monkey; F, the rhodopsins in the two types of rod in the adult frog.

time, but that the separation of the green- and red-sensitive pigments was a comparatively recent evolutionary event (Nathans et al. 1986).

References

Aho, A.-C., Donner, K., Hydén, C., Larsen, L. O. & Reuter, T. (1988). Low retinal noise in animals with low body temperature allows high visual sensitivity. *Nature, Lond.* **334**, 348–350.

Archer, S. N. (1988). Microspectrophotometric study of visual pigment polymorphism in the guppy. PhD thesis, University of Bristol.

Archer, S. N., Endler, J. A., Lythgoe, J. N. & Partridge, J. C. (1987). Visual pigment polymorphism in the guppy, *Poecilia reticulata. Vision Res.* **27**, 1243–1252.

Baker, K. S. & Smith, R. C. (1982). Bio-optical classification and model of natural waters. II. *Limnol, Oceanogr.* **27**, 500–509.

Barlow, H. B. (1964). The physical limits of visual discrimination. In *Photophysiology*, 2 (ed. A. C. Giese), pp. 163–202. New York: Academic Press.

Barlow, H. B. (1988). Thermal limits of seeing. *Nature, Lond.* **334**, 296–297.

Beatty, D. D. (1984). Visual pigments and the labile scotopic visual system of fish. *Vision Res.* **24**, 1563–1573.

Blakeslee, B., Jacobs, G. H. & Neitz, J. (1988). Spectral mechanisms in the tree squirrel retina. *J. comp. Physiol. A* **162**, 773–780.

Bowmaker, J. K., Dartnall, H. J. A. & Herring, P. J. (1988). Longwave sensitive visual pigments in some deep-sea fishes: segregation of "paired" rhodopsins and porphyropsins. *J. comp. Physiol. A.* **163**, 685–698.

Bowmaker, J. K., Jacobs, G. H., Spiegelhalter, D. J. & Mollon, J. D. (1985). Two types of trichromatic squirrel monkey share a pigment in the red-green spectral region. *Vision Res.* **25**, 1937–1946.

Bowmaker, J. K. & Kunz, Y. W. (1987). Ultraviolet receptors, tetrachromatic colour vision and retinal mosaics in the Brown Trout (*Salmo trutta*): age dependent changes. *Vision Res.* **27**, 2101–2108.

Bowmaker, J. K., Loew, E. R. & Liebman, P. A. (1975). Variation in the λ_{max} of rhodopsin from individual frogs. *Vision Res.* **15**, 997–1003.

Bowmaker, J. K., Mollon, J. D. & Jacobs, G. H. (1983). Microspectrophotometric results for old and new world primates. In *Colour Vision* (ed. J. D. Mollon & L. T. Sharpe), pp. 56–68. London, New York, San Francisco, Sao Paulo, Sydney, Tokyo, Toronto: Academic Press.

Carlisle, D. B. & Denton, E. J. (1959). On the metamorphosis of the visual pigments of *Anguilla anguilla* L. *J. mar. biol. Ass. U.K.* **38**, 97–102.

Crescitelli, F., McFall-Ngai, M. & Horwitz, J. (1985). The visual pigment sensitivity hypothesis: further evidence from fishes of varying habitats. *J. comp. Physiol. A* **157**, 323–333.

Dartnall, H. J. A. (1975). Assessing the fitness of visual pigments for their photic environments. In *Vision in Fishes* (ed. M. A. Ali), pp. 543–563. New York, London: Plenum Press.

Dartnall, H. J. A., Bowmaker, J. K. & Mollon, J. D. (1983). Human visual pigments: microspectrophotometric results from the eyes of seven persons. *Proc. R. Soc. B* **220**, 115–130.

Dartnall, H. J. A. & Lythgoe, J. N. (1965). The spectral clustering of visual pigments. *Vision Res.* **5**, 81–100.

Denton, E. J. & Nicol, J. A. C. (1965). Studies on reflexion of light from silvery surfaces of fishes, with special reference to the bleak, *Alburnus alburnus. J. mar. biol. Ass. U.K.* **45**, 683–703.

Denton, E. J. & Warren, F. J. (1957). The photosensitive pigments in the retinae of deep-sea fish. *J. mar. biol. Ass. U.K.* **36**, 615–662.

Derrinton, A. M., Krauskopf, J. & Lennie, P. (1984). Chromatic mechanisms in lateral geniculate nucleus of macaque. *J. Physiol., Lond.* **357**, 241–265.

Fernandez, H. R. C. (1978). Visual pigments of bioluminescent and nonbioluminescent deep-sea fishes. *Vision Res.* **19**, 589–592.

Hargrave, P. A., McDowell, J. H., Curtis, D. R., Wang, J. K., Juszczak, E., Fong, S. L., Rao, J. K. M. & Argos, P. (1983). The structure of bovine rhodopsin. *Biophys. Struct. Mech.* **9**, 235–244.

Harosi, F. I. & Hashimoto, Y. (1983). Ultraviolet visual pigment in a vertebrate: a tetrachromatic cone system in the dace. *Science* **222**, 1021–1023.

Hawryshyn, C. W. & McFarland, W. N. (1987). Cone photoreceptor mechanisms and the detection of polarized light in fish. *J. comp. Physiol. A* **160**, 459–465.

Herring, P. J. (1983). The spectral characterisitics of luminous marine organisms. *Proc. R. Soc. B* **220**, 183–217.

Ingling, C. R. & Martinez, E. (1983). The spatiochromatic signal of the r-g channel. In *Colour Vision* (ed. J. N. Mollon & L. T. Sharpe), pp. 433–434. London: Academic Press.

Jacobs, G. H. & Neitz, J. (1986). Spectral mechanisms and color vision in the tree shrew (*Tupaia belangerei*). *Vision Res.* **36**, 291–298.

Jacobs, G. H., Neitz, J. & Crognale, M. (1985). Spectral sensitivity of ground squirrel cones measured with ERG flicker photometry. *J. comp. Physiol. A* **156**, 503–509.

Jerlov, N. G. (1976). *Marine Optics.* Amsterdam: Elsevier.

Kirschfeld, K., Feiler, R. & Vogt, K. (1988). Evidence for a sensitizing pigment in the ocellar photoreceptors of the fly (Musca, Calliphora). *J. comp. Physiol. A* **163**, 421–424.

Kirschfeld, K. & Vogt, K. (1986). Does retinol serve a sensitizing function in insect photoreceptors? *Vision Res.* **26**, 1775–0000.

Knowles, A. & Dartnall, H. J. A. (1977). The photobiology of vision. In *The Eye*, vol. 2B, (ed. H. Davison), pp. 540–545. New York: Academic Press.

Land, M. F. (1981). Optics and vision in invertebrates. In *Handbook of Sensory Physiology*, vol. VII/6B (ed. H. Autrum), pp. 470–591. Berlin, Heidelberg, London, New York: Springer Verlag.

Levine, J. S. & MacNichol, E. F. (1979). Visual pigments in teleost fishes: effects of habitat, microhabitat and behavior on visual system evolution. *Sensory Processes* **3**, 95–130.

Livingstone, M. & Hubel, D. (1988). Segregation of form, movement, and perception. *Science* **240**, 740–749.

Loew, E. R. & Lythgoe, J. N. (1978). The ecology of cone pigments in teleost fish. *Vision Res.* **18**, 715–722.

Loew, E. R. & Lythgoe, J. N. (1985). The ecology of colour vision. *Endeavour* **14**, 170–174.

Lythgoe, J. N. (1979). *Ecology of Vision.* Oxford: Oxford University Press.

Lythgoe, J. N. (1988). Light and vision in aquatic environments. In *Sensory Biology of Aquatic Animals* (ed. J. Atema, R. R. Fay, A. N. Popper & W. N. Tavolga), pp. 57–82. New York, Berlin, Heidelberg, London, Paris, Tokyo: Springer Verlag.

MacNichol, E. F., Jr (1986). A unifying presentation of visual pigment spectra. *Vision Res.* **26**, 1543–1556.

Marshall, N. B. (1979). *Developments in Deep-Sea Biology.* Poole: Blandford Press.

Matsui, S., Seidou, M., Uchiyama, I., Sekiya, N., Hiraki, K., Yoshihara, K. & Kito, Y. (1988). 4-Hydroxyretinal, a new visual pigment chromophore found in the bioluminescent squid, *Watasenia scintillans. Biochim. biophys. Acta* **966**, 370–374.

Mollon, J. D., Bowmaker, J. K. & Jacobs, G. H. (1984). Variations in colour vision in a New World primate can be explained by polymorphism of retinal pigments. *Proc. R. Soc. B* **222**, 373–399.

Muniz, W. R. A. & Mouat, G. S. V. (1984). Annual variation in the visual pigments of brown trout inhabiting lochs providing different light environments. *Vision Res.* **24**, 1575–1580.

Munz, F. W. (1958). Photosensitive pigments from the retinae of certain deep-sea fishes. *J. Physiol., Lond.* **140**, 220–235.

Nathans, J., Thomas, D. & Hogness, D. S. (1986). Molecular genetics of human color vision: the genes encoding blue, green and red pigments. *Science* **232**, 193–202.

Partridge, J. C. (1989). Visual pigments of deep-sea fishes: ecophysiology and molecular biology. *Prog. underwater Sci.* **14**, 17–31.

Partridge, J. C., Archer, S. N. & Lythgoe, J. N. (1988). Visual pigments in the individual rods of deep-sea fishes. *J. comp. Physiol. A* **162**, 543–550.

Partridge, J. C., Shand, J., Archer, S. N., Lythgoe, J. N., van Groningen-Luyben, W. A. H. M. (1989). Interspecific variation in the visual pigments of deep-sea fishes. *J. comp. Physiol. A* **164**, 513–529.

Pelli, D. G. & Chamberlain, S. C. (1989). Visibility of 350°C black-body radiation by the shrimp *Rimicaris exoculata* and man. *Nature, Lond.* **337**, 460–461.

Rodieck, R. W. (1973). *The Vertebrate Retina*, San Francisco: W. H. Freeman & Co.

Shand, J., Partridge, J. C., Archer, S. N., Potts, G. W. & Lythgoe, J. N. (1988). Spectral absorbance changes in the violet/blue sensitive cones of the juvenile pollack, *Pollachius pollachius. J. comp. physiol. A* **163**, 699–703.

Spence, D. H. N., Campbell, R. M. & Chrystal, J. (1971). Spectral intensity in some Scottish freshwater lochs. *Freshwater Biol.* **1**, 321–337.

Suzuki, T. & Eguchi, E. (1987). A survey of 3-dehydroretinal as a visual pigment chromophore in various species of crayfish and other freshwater crustacea. *Experientia* **43**, 1111–1113.

Thorington, R. W., Jr (1968). Observation of squirrel monkeys in a Columbian forest. In *The Squirrel Monkey* (ed. L. A. Rosenblum & R. W. Cooper), pp. 69–85. New York: Academic Press.

Tyler, J. E. & Smith, R. C. (1970). *Measurements of Spectral Irradiance Underwater*, New York, London, Paris: Gordon & Breach.

van Dover, C. L., Szuts, E. Z., Chamberlain, S. C. & Cann, J. R. (1989). A novel eye in "eyeless" shrimp from hydrothermal vents of the mid-Atlantic ridge. *Nature, Lond.* **337**, 458–460.

Warner, J. A., Latz, M. I. & Case, J. F. (1979). Cryptic bioluminescence in a midwater shrimp. *Science* **203**, 1109–1110.

Waterman, T. H. (1981). Polarization sensitivity. In *Handbook of Sensory Physiology*, vol. VII/6B (ed. H. Autrum), pp. 281–469. Heidelberg, Berlin, New York: Springer Verlag.

Whitmore, A. V. (1988). The visual pigments and action spectra of five types of cone cell in the retina of the rudd *Scardinius erythrophthalmus*. PhD thesis, University of London.

Widder, E. A., Latz, M. I. & Case, J. F. (1983). Marine bioluminescence spectra measured with an optical multichannel detection system. *Biol. Bull. mar. biol. Lab., Woods Hole* **165**, 791–810.

Wyszecki, G. & Stiles, W. S. (1967). *Color Science*. New York: Wiley & Sons.

Zufall, F., Schmitt, M. & Menzel, R. (1987). Spectral and polarized light sensitivity of photoreceptors in the compound eye of the cricket (*Gryllus bimaculatus*). *J. comp. Physiol. A* **164**, 597–608.

Zuker, C. S., Montell, C., Jones, K., Laverty, T. & Rubin, G. M. (1987). A rhodopsin gene expressed in photoreceptor cell R7 of the *Drosophila* eye: homologies with other signal transducing molecules. *J. Neurosci.* **7**, 1550–1557.

16 "Tho' She Kneel'd in That Place Where They Grew...": The Uses and Origins of Primate Colour Vision

J. D. Mollon

Introduction

In his *Uncommon Observations About Vitiated Sight*, a collection of case reports published in 1688, Robert Boyle reproduces his notes on a gentlewoman whom he had examined some years earlier (figure 16.1). During an unidentified illness, apparently treated by fierce vesication, this unhappy maid had transiently gone blind. Visual function had gradually returned, and Boyle satisfied himself that she could read from a book and had good acuity.

... having pointed with my Finger at a part of the Margent, near which there was the part of a very little Speck, that might almost be covered with the point of a Pin; she not only readily enough found it out, but shewed me at some distance off another Speck, that was yet more Minute

But what was most singular and strange for Boyle was that she was left with a permanent loss of colour vision: '... she can distinguish some Colours, as Black and White, but is not able to distinguish others, especially Red and Green ...'.

Boyle's early case of acquired achromatopsia, and similar cases described in modern times (e.g. Meadows, 1974; Damasio et al. 1980; Mollon et al. 1980), bear on [...] the question of whether there are submodalities within each of the major sensory modalities: if colour vision can be disproportionately impaired, while processing of spatial detail remains relatively intact, then we must suspect that there is some independence between the analysis of colour and the analyses of other attributes of the retinal image. The issue is less new than we might suppose: as early as 1869, in discussing the recovery of spatial vision before chromatic vision in a patient recovering from optic neuritis, J. J. Chisholm asked explicitly 'whether there are special nerve fibres, for the recognition of special colours, independent of those used in the clear definition of objects'.

But a second interest of Boyle's gentlewoman lies in the practical expression of her disability.

... that when she had a mind to gather Violets, tho' she kneeled in that Place where they grew, she was not able to distinguish them by the Colour from the neighbouring Grass, but only by the shape, or by feeling them.

Her disability reminds us that we can best understand primate colour vision, and its evolution, by considering the price of not enjoying colour vision: what are the advantages that we should then forego?

SOME

UNCOMMON

OBSERVATIONS

ABOUT

VITIATED

SIGHT.

LONDON:
Printed for *J. Taylor*, at the Ship in
St. *Paul's* Church-Yard, 1688.

ces, that I now wifh had not been omitted.

The Gentlewoman I faw to day, feems to be about 18 or twenty years old, and is of a fine Complexion, accompanied with good Features. Looking into her Eyes, which are Gray, I could not difcern any thing that was unufual or amifs ; tho' her Eye-lids were fomwhat Red, whether from Heat, or which feemed more likely, from her precedent Weeping. During the very little time that the Company allowed me to fpeak with her, the Queftions I propos'd to her were anfwered to this Effect.

That about five years ago, having been upon a certain Occafion immodefately tormented with Blifters, applied to her Neck and other Parts, fhe was quit deprived of her fight.

That

look'd attentively upon it, but told me, that to her it did not feem Red, but of another Colour, which one would guefs by her Defcription to be a Dark or Dirty one : and the Tufts of Silk that were finely Colour'd, fhe took in her Hand, and told me they feem'd to be a Lightcolour, but could not tell me which; only fhe compar'd it to the Colour of the Silken Stuff of the Lac'd Peticoat of a Lady that brought her to me ; and indeed the Blews were very much alike. And when I ask'd her, whether in the Evenings, when fhe went abroad to walk in the Fields, which fhe much delighted to do, the Meadows did not appear to her Cloathed in Green? fhe told me they did not, but feem'd to be of an odd Darkifh Colour ; and added, that when fhe had a mind to gather Violets, tho' fhe kneel'd in that Place where they grew, fhe was not able to diftinguifh them by the Colour from the neighbouring Grafs, but only by the

the Shape, or by feeling them. And the Lady that was with her, took thence occafion to tell me, that when fhe looks upon a Turky Carpet, fhe cannot diftinguifh the Colours, unlefs of thofe parts that are White or Black. I ask'd the Lady whether fhe were not troubled with Female Obftructions? To which fhe Anfwer'd me, fhe was not now, but that formerly fhe had been much fubject to them, having been obftinately troubled with the Greenficknefs.

Figure 16.1
Title page and excerpts from Robert Boyle's *Vitiated Sight* of 1688. (Note: the original pagination is in error.)

The Advantages of Colour Vision

Detection of Targets Against Dappled Backgrounds

In the current literature it is commonly suggested that colour vision serves particularly to detect edges between 'equiluminant' surfaces, surfaces of the same luminance but different chromaticity. Such a view was systematically expressed, for example, by Gouras & Eggers (1983). But, in fact, it is rare in the natural world for one surface to lie in front of another in such a way that both have the same reflectance, both lie at the same angle to the incident illumination, and the nearer throws no shadow on the farther.

And if Nature finds it hard to generate equiluminant edges, so does Art: in the late nineteenth century, when the first 'pseudoisochromatic' plates were constructed for detecting colour-deficient observers, attempts were made to print targets of one colour on fields of different colour in such a way that dichromats could not detect them. The enterprise was not long pursued, since it was hardly possible for the printer so exactly to match figure and field in lightness and texture, and so completely to eliminate edge artefacts, as to deceive the average dichromat. But in the early pseudoisochromatic plates of Stilling (1883), like the later ones of Ishihara, the problem was neatly sidestepped by two ploys: first, the target was formed from discrete patches, embedded in a background array of similar patches; and second, the lightnesses of the individual patches were varied randomly rather than being equated (see color plate 13).

Such pseudoisochromatic plates, which have proved so successful an artifice for detecting colour-deficient observers, nicely show us the tests that defeat the colour-deficient in the natural world. The colour-deficient observer is not often confronted by a homogeneous target of one chromaticity that lies on an equiluminant surface of different chromaticity. Rather, his difficulty arises when the background is dappled and brindled, when, that is, luminosity is varying randomly. Such a variation in luminosity can arise because the illuminant is interrupted by foliage; or it can arise because the background consists of component surfaces that lie at varying angles to the illuminant or (as in the case of new and old leaves) that themselves vary in reflectance. Boyle's gentlewoman is poor at spotting violets among grass: she cannot use lightness to solve the task, and is forced to use shape, but under conditions such that the presence of similar, masking, contours slows down a search on the basis of shape. In the early reports of colour blindness, a recurrent theme is difficulty in searching for natural targets against foliage, vegetation or other visually busy backgrounds. The celebrated shoemaker Harris, described by Huddart in the *Philosophical Transactions* for 1777, had noticed as a child that other children could detect cherries on a tree at a greater distance than he could.

Large objects he could see as well as other persons; and even the smaller ones if they were not enveloped in other things, as in the case of cherries among the leaves.

Similarly, the observer described by Nicholl (1818) reports:

... the fruit on trees when red, I cannot distinguish from the leaves, unless when I am near it, and then from the difference of shape rather than colour.

The protanope of Colquhoun (1829) had been perverse enough to become an orchardist after colour blindness had stymied his earlier career as a weaver.

He cannot discern, even in a loaded bush, the existence of red gooseberries [sic] among the leaves, until he has almost approached so near as to be able to take hold of the branch. Rosy apples on a tree, which may be discovered by ordinary eyes, at a distance of from thirty to forty yards at least, are lost to his sense, until he has come within ten or twenty yards of the tree, when he can trace out the fruit by its form ...

The colour-deficient brassfounder of Edinburgh, described by Combe (1824), was a keen shot, but could not 'discover game upon the ground, from the faintness of his perception of colours'.

... last year, when a large covey of partridges rose within ten or twelve yards of him, the back ground being a field of Swedish turnips, he could not perceive a single bird.

Such complaints are familiar in the early literature on daltonism, although few authors recapture the insight of Huddart's telling phrase '... *if they were not enveloped in other things*, as ... *cherries among the leaves.*' But, however commonplace the complaint might seem, we should listen to it. It tells us the disability of the daltonic observer; and the complement of his disability must be the advantage of the normal trichromat. *A primary advantage of colour vision is that it allows us to detect targets against dappled or variegated backgrounds, where lightness is varying randomly.*

Perceptual Segregation by Colour

The pseudoisochromatic plates of Stilling or of Ishihara show us a second way in which colour assists our perception: the shared hue of different elements in a visual array may serve as a basis for perceptual segregation and so allow the patient to identify a figure which is made up from discrete patches that vary in lightness.

Segregation of the visual field into elements that belong together is an important preliminary to the actual recognition of objects. This segregation corresponds to the process that the Gestalt psychologists called 'figure-ground differentiation' or 'perceptual organization'. Gestalt writers recognized that many features of the visual

image—brightness, colour, local form, local texture, binocular disparity, direction of movement—can each serve as a basis for perceptual organization (Wertheimer, 1923; Koffka, 1935). Barlow (1981) used the term 'linking features' to describe stimulus attributes that can sustain perceptual segregation.

Livingstone & Hubel (1988) make the remarkable claim that 'only luminance contrast, and not color differences, is used to link parts together'. This claim should be understood exclusively in terms of the particular matter with which they are concerned, the incoherence of the visual field when edges are defined only by chromatic differences: under such conditions of 'equiluminance', it becomes difficult, for example, to relate different parts of colinear edges, and we lose the coordination that would otherwise impose a uniform interpretation on apparent movements in different parts of the field. But perceptual failures of this kind may have a special explanation: under the unusual conditions of equiluminance the long-wave receptors of the retina are signalling spatial and temporal transients of opposite, contradictory, sign from those signalled by the middle-wave receptors (see Mollon, 1980, 1989). The very existence of pseudoisochromatic plates shows that Livingstone & Hubel's statement cannot be generally true: normal observers can perfectly well use colour to link different elements in the visual field and extract a figure. Notice, in the case of the Stilling or Ishihara plates (plate 13), that this is done under conditions where lightness is varying randomly—conditions that are very much more common in the natural world than are conditions where lightness remains constant across the field.

When we recognize a digit in the Ishihara plates, the contours of individual patches are detected by their luminance contrast, but the digit is discovered only by colour. The cortex must be able to collect together patches of similar chromaticity while yet preserving the local signs—the spatial addresses—that belong with these patches; and must be able to deliver this subset of spatial addresses as the input to a form-recognition system. We do not know in detail how this is done, although it is plausible to suppose (with Barlow, 1981) that the correlation of patches of similar chromaticity is achieved in the prestriate region in which colour is emphasized (Zeki, 1978)—V4 in the rhesus monkey and perhaps the region of the lingual and fusiform gyri in man (Meadows, 1974); and it is also plausible to suppose that the set of spatial addresses is ultimately delivered to a common form-recognition system, which is located in the inferotemporal lobe and is able to accept similar sets of spatial addresses defined by other linking features such as movement, texture, depth and orientation. But whatever cortical machinery collects common chromaticities while preserving spatial addresses, the important point for our present purpose is that such machinery must evolve before an animal can use colour for the particular purpose of perceptual segregation.

Is there any price to be paid for the advantage of being able to segregate the field on the basis of colour? Here again the Ishihara plates point to the answer. There exist plates (e.g. plates 18–21 of the 10th edition) where a digit is readily visible to the dichromat, on the basis of differences in the short-wave component, but is masked for many normals, owing to a stronger, rival, organization suggested by red-green variations. Morgan et al. (1989) prepared a visual display in which one quadrant of the array differed from the rest in the size or orientation of texture elements; they found that the textural difference could be masked for normals if a random variation in colour was introduced, but that dichromats performed as well as they did in a monochrome condition. A fundamental limitation of the visual system is that it cannot concurrently entertain different perceptual organizations; and this, in itself, suggests that figural organizations based on colour, texture, orientation and other attributes are delivered to a common pattern-recognition system.

Identification by Colour

Finally, colour may serve to identify, that is (a) it may help us assign an already-segregated object to a given category or (b) it may indicate what lies beneath a given surface.

Colour may be one of the cues that monkeys use to identify the species of particular trees or particular plants. Certainly, it must be one of the cues that catarrhine (Old World) monkeys use to identify conspecifics, the sex of conspecifics, and the sexual state of conspecifics. In many members of the genus *Cercopithecus*, the slate blue scrotum of the male contrasts with surrounding yellow fur; and often this contrast is echoed in facial markings, most notably in the moustached guenon (*Cercopithecus cephus*) whose vivid blue face is surrounded by a yellow ruff. Such colourings in *Cercopithecus* are often accompanied by species-specific 'flagging' movements and may serve to maintain species isolation in habitats where several species of guenon overlap (Kingdon, 1980, 1988). Other striking examples of the use of colour as sexual signals are offered by the bright red ischial callosities of the female baboon (*Papio papio*) and the blue, violet and scarlet patterns of the genitalia and muzzle of the male mandrill.

Colour offers a means to discover remotely the structure underlying a surface (Katz, 1935). In the case of fructivorous primates, one of the most important functions of trichromatic colour vision must be to judge the state of ripeness of fruit from the external appearance (Gautier-Hion, 1988). Similarly, variations in the colour of ground-covering vegetation can reveal at a distance the presence of water. In this category of the use of colour, we might also include judgements of complexion: human observers have a finely developed (though little studied) capacity to use skin

colour to estimate the health, or emotional state, of conspecifics, and this ability may have biological advantage in the selection of sexual partners or in the care of infants.

In so far as an animal uses colour to identity—in so far as it uses colour vision to recognize permanent attributes of an object or to make absolute judgements about the spectral reflectances of surfaces—we should expect it to exhibit colour constancy: it ought to be able to recognize the spectral reflectance of a surface independently of the spectral composition of the illuminant (see e.g. Katz, 1935; Land, 1983). Of the three uses of colour vision distinguished here, only the third necessarily requires colour constancy; but the distinction between the three functions is not absolute and there will be many cases, for example, where an animal is searching a complex array not merely for a salient stimulus but for a stimulus of a particular spectral reflectance.

For an alternative approach to the uses of colour vision, the discussion by Jacobs (1981) is recommended.

Trichromacy and Its Evolution

The Photoreceptors

In man, the three classes of retinal cone exhibit overlapping spectral sensitivities, with peak sensitivities lying close to 420, 530 and 560 nm (plate 14). Estimates of these sensitivities have now been obtained by psychophysics (Boynton, 1979), by microspectrophotometry of the outer segments of individual cones (Dartnall et al. 1983), and by electrophysiological measurements of isolated receptors that have been sucked into micropipettes (Schnapf et al. 1987); and the different estimates agree to a first approximation. Notice the asymmetry of the spectral positions of the receptors: there is an interval of 100 nm between the short-wave and middle-wave receptors, but an interval of only 30 nm between the middle-wave and long-wave receptors.

The response of any individual receptor obeys the Principle of Univariance: its electrical response varies only with the rate at which photons are captured by the outer segment, and all that changes with wavelength is the probability that any given photon will be absorbed. Thus, if the visual system is to learn about wavelength, independently of radiance, it must not only have receptors with different sensitivities but also have the neural machinery to measure the relative rates of photon capture in different classes of receptor (Rushton, 1972).

Textbooks often represent the three types of human cone as equal elements in a trichromatic scheme, as if they evolved all at once and for a single purpose. All the evidence suggests, however, that they evolved at different times and for different

reasons; and our own colour vision seems to depend on two, relatively independent, subsystems—a phylogenetically recent subsystem overlaid on a much more ancient subsystem (Mollon & Jordan, 1989).

The Primordial Subsystem of Mammalian Colour Vision

For the main business of vision, for the detection of contours, movement and flicker, most mammals depend on a single class of cone, which has its peak sensitivity near the peak of the solar spectrum, in the range 510–570 nm (Jacobs, 1981). A long time ago, a few short-wave (violet-sensitive) cones were sparsely sprinkled amongst the matrix of middle-wave cones. These short-wave cones, with their wavelength of peak sensitivity well removed from that of the middle-wave cones, provided mammals with a basic, dichromatic, system of colour vision: by comparing the quantum catch of the short-wave cones with that of the middle-wave cones, the visual system is able to estimate the sign and the slope of the change in spectral flux from one end of the spectrum to another. If the spectral distribution of the light reaching us from an object is itself considered as a waveform (Barlow, 1982), then this primordial colour-vision system seems designed to extract the lowest Fourier component of the waveform (Mollon et al. 1989). Subjectively, it is this primordial subsystem that divides our colour sensations into warm, cool and neutral (McDougall, 1901). And it is this subsystem that survives in the common forms of human dichromacy.

The antiquity of the primordial subsystem is suggested by the molecular genetic results of Nathans et al. (1986b), who have sequenced the genes that code for the protein moieties of the four human photopigments. The amino-acid sequence for the short-wave cone pigment is as different from those for the long- and middle-wave pigments as it is from the sequence for the human rod pigment, rhodopsin: in a pairwise comparison, the short-wave pigment shares 42% of its amino acids with rhodopsin, 43% with the long-wave cone pigment and 44% with the middle-wave cone pigment. Nathans and his colleagues use the difference in sequence between bovine and human rhodopsin to estimate the rate at which photopigments diverge, and they conclude that the short-wave pigment diverged from the middle-wave cone pigment (or perhaps indeed from an ancestral rod pigment) more than 500 million years ago.

The Primordial Subsystem Considered as a Purely Chromatic Channel It would be tempting to say that the short-wave cones have been given to us only for colour vision, and that the pathway which carries their signals is the nearest we come to a channel that conveys purely chromatic information. There is certainly good reason why the short-wave cones should not be used for the discrimination of spatial detail: the short-wave component of the retinal image is almost always degraded,

since bluish, non-directional skylight dilutes the shadows of the natural world and since the eye itself is subject to chromatic aberration and usually chooses to focus optimally for yellow light. The short-wave cones were therefore added sparingly to the retinal matrix, and they remain rare: they constitute only a few per cent of all cones in every primate species where cones have been identified directly by microspectrophotometry (e.g. Bowmaker et al. 1987; Hárosi, 1982; Dartnall et al. 1983; Mollon et al. 1984). At a post-receptoral level, little sensitivity to spatial contrast is exhibited by those neurones that draw signals from the short-wave cones (Derrington et al. 1984): such cells are *chromatically* opponent but tend not to draw their opposed inputs from clearly distinct, spatially antagonistic, regions in the way that is usual for other cells in the retina and lateral geniculate nucleus.

It would, in fact, be careless to say that the information provided by the short-wave cones is *purely* chromatic. Their signals must carry with them enough of a local sign that the chromatic information can be associated with the corresponding object. And the local signs are adequate to support perceptual segregation (see above), as is demonstrated by those specialized pseudoisochromatic plates that bear figures visible to the normal trichromat but invisible to tritanopes (the rare type of dichromats who lack the short-wave cones): examples of such plates are those of Willmer (see Stiles, 1952) and of Farnsworth (see Kalmus, 1955). Moreover, if the short-wave cone signals are isolated by presenting a violet target on an intense long-wave adapting field, then the contours formed directly by short-wave signals can support the perception of gratings of low spatial frequency (e.g. Brindley, 1954); such gratings can give an orientationally selective adaptation (Stromeyer et al. 1980) and can provide an input to a motion-detecting mechanism that also draws inputs from the long-wave cones (Stromeyer & Lee, 1987). M. A. Webster, K. K. De Valois and E. Switkes (in preparation) isolated the short-wave system by forming an equiluminant low-frequency grating of two colours that are confused by a tritanope; they found that the discrimination of orientation and spatial frequency was as good as it was for an equiluminant grating that was visible by virtue of variations in the ratio of the signals of the long-wave and middle-wave cones.

Nevertheless, in the natural world, the short-wave cones must play little role in the detection of sharp edges and the discrimination of spatial detail. Using a checkerboard pattern, Stiles (1949) first demonstrated the low values that are obtained for foveal acuity when vision depends only on the signals of the short-wave cones. And later measurements of spatial contrast sensitivity suggest that the short-wave receptors cannot sustain a resolution of much greater than 10 cycles per degree (for references, see Mollon, 1982, Table 1); the maximal sensitivity for vision with these cones lies close to 1 cycle per degree. Tansley & Boynton (1976) required subjects to adjust

the relative luminances of two hemifields of different chromaticity until the edge
between them was minimally distinct; the subject then rated the salience of the resid-
ual edge on an eight-point scale. When the two half-fields differed only in the degree
to which they excited the short-wave cones, when, that is, they lay on the same tritan
confusion line in colour space, observers gave a rating of zero to the distinctness of
the border between the two fields: the fields 'melted' into one another. And the rated
distinctness of other (non-tritan) borders could be predicted simply by how much the
two half-fields differed in the ratio with which they excited the long- and middle-
wave cones (see also Thoma & Scheibner, 1980). In her classical description of 'hard'
and 'soft' colours, Liebmann (1927) described how a blue figure perceptually merged
(*verschwimmt*) with an equiluminant green ground; and in retrospect we may suspect
that these two colours were ones that came close to lying along the same tritan con-
fusion line. In the most recent literature on equiluminance the Liebmann effect has
sometimes been cited, but often no distinction is made between the modest effects
obtained when long- and middle-wave cones are modulated and the much more
spectacular weakening of contours and of figural organization when the target and
field differ only along a tritan confusion line, i.e. when they differ only in the degree
to which they excite the primordial subsystem of colour vision.

The Morphological Basis of the Primordial Subsystem There are growing hints that
the primordial subsystem of colour vision has a morphologically distinct basis in the
primate visual system (indicated in blue in plate 15). Thus Mariani (1984) has de-
scribed a special type of bipolar cell, which resembles the common 'invaginating
midget' bipolar but which makes contact with two well-separated cone pedicles; he
suggests that these bipolars are exclusively in contact with short-wave cones. Using
micropipettes filled with the dye Procion Yellow. De Monasterio (1979) made intra-
cellular recordings from (and stained) three ganglion cells that showed a maximal
sensitivity for 440-nm increments in the presence of a long-wave field: the cell bodies
of these short-wave ganglion cells were clearly larger than those of the standard
midget ganglion cell that draws opposed inputs from the long- and middle-wave
receptors. [Rodieck (1988) has drawn attention to a discrepancy, however: the axons
of Mariani's 'blue cone' bipolars end in the proximal part of the inner plexiform
layer, whereas the dendrites of De Monasterio's short-wave ganglion cells make
contacts in the distal part of the inner plexiform layer.] In the lateral geniculate
nucleus, the cells that draw excitatory inputs from the short-wave cones appear to be
found predominantly in the parvocellular layers 3 and 4 (Schiller & Malpeli, 1978;
Michael, 1988). The primordial subsystem may remain distinct as far as area 17 of
the primate cortex: Ts'o & Gilbert (1988) have examined the properties of individual

cells in the so-called 'cytochrome oxidase blobs' of layers 2 and 3 (Livingstone & Hubel, 1984; see Fig. 4) and report that cells within a given blob exhibited the same type of colour opponency, 'blue-yellow' or 'red-green', the latter type being three times as common as the former. It is likely that Ts'o & Gilbert's 'blue-yellow' cells correspond to what I am here calling the primordial subsystem; but it must be said that the cells were classified only by their responses to coloured lights, and the presence of short-wave inputs needs to be confirmed by the use of selective adaptation (e.g. Gouras, 1974) or of tritanopic substitution (Derrington et al. 1984). Since the maximum ratio of middle- to long-wave cone sensitivity occurs near 460 nm (see, for example, Boynton & Kambe, 1980), it is possible for the spectral cross-over point of a cell (the wavelength where an excitatory response replaces inhibition) to lie at short wavelengths even though the cell draws its opposed inputs from the middle- and long-wave cones.

The Primordial Subsystem: Conclusions Man and the Old World primates thus share with many mammals an ancient colour-vision channel, which depends on comparing the quantum catch of the short-wave cones with the quantum catch of a much more numerous class of cones, which have their peak sensitivity in the middle of the visible spectrum and which subserve the other functions of photopic vision. There may be a distinct morphological basis for this channel in the primate visual pathway, although the short-wave cones, and the cells that carry their signals, are always in the minority. It would be foolish to say that this primordial subsystem is a purely chromatic channel, since the several uses of colour vision (see above) themselves *require* that the chromatic signals carry with them a local sign; and the signals of this subsystem can sustain a number of spatial discriminations, provided only that the stimuli are of low spatial frequency. But the primordial colour channel has little role in the detection of edges and spatial detail.

The Second Subsystem of Colour Vision

As far as is known at present, the Old World primates are the only mammals that share our own form of colour vision (Jacobs, 1981; Jacobs & Neitz, 1986), although the New World monkeys have found their private route to trichromacy (see below). The recent ancestors of the Old World primates acquired a second subsystem of colour vision, overlaid on the first; and the two subsystems remain relatively independent: physiologically independent at early stages of the visual system and psychophysically independent in detection and discrimination (Mollon & Jordan, 1989). The second subsystem depends on a comparison of the rates at which quanta are caught by the long- and middle-wave cones (plate 14); and this subsystem appears to have arisen through the duplication of a gene that coded for the photopigment of an

ancestral middle-wave cone. (By 'middle-wave' is meant here only that the peak sensitivity lay in the range 510–570 nm, a range that includes the present 'long-wave' cone.) The recent differentiation of the long- and middle-wave photopigments has long been suspected (see e.g. Ladd-Franklin, 1892) on account of the distribution of trichromacy among the mammals (Jacobs, 1981) and the fact that hereditary disorders of colour vision chiefly affect the long- and middle-wave receptors (Pokorny et al. 1979). But convincing evidence has recently come from the molecular genetic results of Nathans and his collaborators (Nathans et al. 1986b), who have shown that the inferred amino-acid sequences of the middle- and long-wave human pigments are 96% identical. Moreover, the two genes remain juxtaposed in a tandem array on the q-arm of the X-chromosome (Vollrath et al. 1988). The juxtaposition and the extreme homology of these genes render them vulnerable to misalignment when the X-chromosomes come together at meiosis; and Nathans and his collaborators suppose that the high incidence of human colour deficiency arises from the unequal crossing-over that can follow such misalignments (Nathans et al. 1986a).

Co-Evolution of Fruit and of Primate Trichromacy? Interspecific variations occur in the photopigments of salmonid fish that have been isolated in land-locked glacial lakes for only a short evolutionary period (Bridges & Yoshikami, 1970; Bridges & Delisle, 1974), and it has become customary to suppose that opsins (the protein moieties of the photopigments) can evolve very rapidly. Moreover, Nathans et al. (1986a) have suggested how, in man, hybrid genes could readily be formed that coded for pigments with different spectral sensitivities (see above). The very consistency of the photopigments of catarrhine monkeys thus becomes a matter for remark. The monkeys so far examined—macaques (Bowmaker et al. 1978; Hárosi, 1982; Schnapf et al. 1987), baboons (Bowmaker et al. 1983), patas monkeys, talapoins, guenons (J. K. Bowmaker, S. Astell & J. D. Mollon, unpublished observations)—vary widely in their habitat, their size and their bodily colourings; yet they all exhibit a middle-wave pigment with a peak sensitivity close to 535 nm and a long-wave pigment with a peak sensitivity close to 565 nm. What this set of monkeys do have in common is that a substantial part of their diet consists of fruit; the proportion varies for different species, but is as high as 85% in the case of the moustached guenon *Cercopithecus cephus* (Sourd & Gautier-Hion, 1986; Gautier-Hion, 1988).

Polyak (1957) explicitly proposed that the trichromatic colour sense of primates co-evolved with coloured fruits, such as mangoes, bananas, papaya, and the fruits of the citrus family. And recent ecological studies lend fresh credence to this view. Gautier-Hion et al. (1985) have examined the relationships between frugivors and fruits in a tropical rain forest, and it becomes clear that it is not enough to describe

an animal as fruit-eating. There exists a category of fruit that is disproportionately taken by monkeys: such fruits are orange or yellow in colour, weigh between 5 and 50 g, and are either dehiscent with arillate seeds or are succulent and fleshy. In contrast, the fruits predominantly taken by birds are red or purple, and are smaller, while the fruits taken by ruminants, squirrels and rodents are dull-coloured (green or brown) and have a dry fibrous flesh.

Thus, there exist fruits that appear to be specialized for attracting monkeys. The monkey serves the fruiting tree by dispersing the seed in one of two ways. When the seed is large and the soft flesh is free from the seed, the latter is often spat out; this usually happens at some distance from the parent tree, because the monkeys fill their cheek-pouches and move to another place to eat the contents. When the seeds are small, they are usually swallowed and are excreted intact. Thus, the monkey is a disperser for the tree, rather than a predator (Gautier-Hion et al. 1985). To find orange and yellow fruits amongst foliage, the monkey needs trichromatic colour vision; without it, the monkey would be at the very disadvantage emphasized in the early accounts of human colour blindness (see above).

It would be instructive to know whether the leaf-eating catarrhine monkeys differ from the frugivors, but nothing is yet known about their colour vision.

The Second Subsystem and the Parvocellular Pathway At the early stages of the visual system, there does not appear to be a channel devoted exclusively to carrying the second type of chromatic information, the information obtained by comparing the quantum catches of long- and middle-wave cones; rather the second subsystem is parasitic upon an existing channel that carries information about spatial detail. The substrate of this channel is the Pβ cell of the primate retina (Perry & Cowey, 1981) and the predominant type of unit in the parvocellular layers of the lateral geniculate nucleus (represented in red in plate 15). The receptive fields of such cells are divided into antagonistic centre and surround regions and, thus, the cells are very sensitive to spatial contrast. In the case of the Old World primates, the centre input to such cells is drawn from one class of cone (often, perhaps, from one individual cone), whereas the surround is drawn either from a different class of cone, or promiscuously from middle- and long-wave cones (Lennie et al. 1989). Thus the response of any individual cell is ambiguous: as Ingling & Martinez (1983) have emphasised, the cell will be colour-specific at low spatial frequencies but will respond to all wavelengths at higher spatial frequencies.

Shapley & Perry (1986) have argued that the primary function of the parvocellular system is colour vision, and that the analysis of spatial contrast depends predominantly on the magnocellular pathway. Arguments against this position are given by Mollon & Jordan (1989).

The Polymorphism of Colour Vision in Platyrrhine Primates

Until recently the New World monkeys were held to be protanopes, and to represent an earlier stage of our own colour vision. We now know that platyrrhine colour vision is *sui generis* and is characterized by striking within-species variability (Jacobs, 1983). In a double-blind study that combined behavioural testing and micro-spectrophotometry (Mollon et al. 1984; Bowmaker et al. 1987), six phenotypes were identified in the squirrel monkey (*Saimiri sciureus*): all males and some females were dichromats, combining a short-wave pigment with one of three possible pigments in the red-green spectral region (figure 16.2), whereas other females were trichromatic,

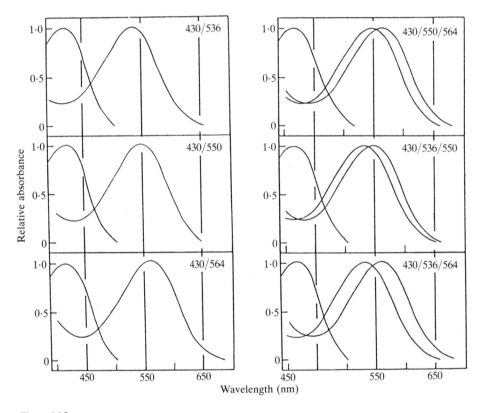

Figure 16.2
The photopigments of six types of squirrel monkey (*Saimiri sciureus*). Each panel shows the absorbance spectra of the photopigments found microspectrophotometrically in a given phenotype. To the left are shown the three possible combinations of pigments that occur in dichromat phenotypes, that is, all males and some females. To the right are shown the combinations that occur in the three possible trichromatic phenotypes, which are always female.

combining a short-wave pigment with two pigments in the red-green region. These findings have been explained by a genetic model (Mollon et al. 1984) that makes the following assumptions. (i) The squirrel monkey has only a single genetic locus for a pigment in the red-green spectral region. (ii) There are at least three alleles that can occur at this locus, the three alleles corresponding to three slightly different versions of the opsin of the photopigment. (iii) The locus is on the X-chromosome. (iv) In those females that are heterozygous at this locus, only one of the two alleles is expressed in any given cone cell, owing to the phenomenon of Lyonization or X-chromosome inactivation.

By this account, at least three photopigments are potentially available to the squirrel monkey in the red-green region. Male monkeys, it is supposed, can draw only one pigment from the set, since they have only one X-chromosome; so males are obligatory dichromats. Females may draw either one or two pigments from the set; if they inherit the same allele from both parents, they will be dichromatic, but if they inherit two different alleles, they will be trichromatic. We must make the explicit assumption that the visual system of the heterozygous female is suufficiently plastic to exploit the presence of distinct subsets of signals from the two types of cone with peak sensitivities in the red-green region. And it may be the heterozygous female that leads her troop in the daily search for ripe fruit.

Acknowledgments

I am grateful to Dr M. Webster and Mr J. Reffin for comments on the text and to Gabriele Jordan for the design of plate 14.

References

Barlow, H. B. (1981). Critical limiting factors in the design of the eye and visual cortex. *Proc. R. Soc. B* **212**, 1–34.

Barlow, H. B. (1982). What causes trichromacy? A theoretical analysis using comb-filtered spectra. *Vision Res.* **22**, 635–643.

Bowmaker, J. K., Dartnall, H. J. A., Lythgoe, J. N. & Mollon, J. D. (1978). The visual pigments of rods and cones in the rhesus monkey, *Macaca mulatta. J. Physiol., Lond.* **272**, 329–348.

Bowmaker, J. K., Jacobs, G. H. & Mollon, J. D. (1987). Polymorphism of photopigments in the squirrel monkey: a sixth phenotype. *Proc. R. Soc. B* **231**, 383–390.

Bowmaker, J. K., Mollon, J. D. & Jacobs, G. H. (1983). Microspectrophotometric results for Old and New World primates. In *Colour Vision: Physiology and Psychophysics* (ed. J. D. Mollon & L. T. Sharpe), pp. 57–68. London: Academic Press.

Boyle, R. (1688). *Some Uncommon Observations About Vitiated Sight.* London: J. Taylor.

Boynton, R. M. (1979). *Human Color Vision.* New York: Holt, Rinehart & Winston.

Boynton, R. M. & Kambe, N. (1980). Chromatic difference steps of moderate size measured along theoretically critical axes. *Color Res. Applic.* **5**, 12–23.

Bridges, C. D. B. & Delisle, C. E. (1974). Evolution of visual pigments. *Expl Eye Res.* **18**, 323–332.

Bridges, C. D. B. & Yoshikami, S. (1970). Distribution and evolution of visual pigment in salmonid fishes. *Vision Res.* **10**, 609–626.

Brindley, G. S. (1954). The summation areas of human colour-receptive mechanisms at increment threshold. *J. Physiol., Lond.* **124**, 400–408.

Chisholm, J. J. (1869). Colour blindness, an effect of neuritis. *Ophthalmic Hosp. Rep.*, April 214–215.

Colquhoun, H. (1829). An Account of Two Cases of Insensibility of the Eye to certain of the Rays of Colour. *Glasgow Medical Journal* **2**, 12–21.

Coombe, G. (1824). Case of Deficiency in the Power of Perceiving and Distinguishing Colours, accompanied with a small development of the Organ, in Mr. James Milne, Brassfounder in Edinburgh. *Transactions of the Phrenological Society*, pp. 222–234.

Damasio, A., Yamada, T., Damasio, H., Corbett, J. & McKee, J. (1980). Central achromatopsia: Behavioral, anatomic and physiologic aspects. *Neurology* **30**, 1064–1071.

Dartnall, H. J. A., Bowmaker, J. K. & Mollon, J. D. (1983). Human visual pigments: microspectrophotometric results from the eyes of seven persons. *Proc. R. Soc. B* **220**, 115–130.

De Monasterio, F. M. (1979). Asymmetry of on- and off-pathways of blue-sensitive cones of the retina of macaques. *Brain Res.* **166**, 39–84.

Derrington, A. M., Krauskopf, J. & Lennie, P. (1984). Chromatic mechanisms in lateral geniculate nucleus of macaque. *J. Physiol., Lond.* **357**, 241–265.

Gautier-Hion, A. (1988). The diet and dietary habits of forest guenons. In *A Primate Radiation: Evolutionary Biology of the African Guenons* (ed. A. Gautier-Hion, F. Bourlière, J.-P. Gautier & J. Kingdon), pp. 257–283. Cambridge: Cambridge University Press.

Gautier-Hion, A., Duplantier, J.-M., Quris, R., Feer, F., Sourd, C., Decoux, J.-P., Dubost, G., Emmons, L., Erard, C., Hecketsweiler, P., Moungazi, A., Roussilhon, C. & Thiollay, J.-M. (1985). Fruit characteristics as a basis of fruit choice and seed dispersal in a tropical forest vertebrate community. *Oecologia* **65**, 324–337.

Gouras, P. (1974). Opponent-colour cells in different layers of foveal striate cortex. *J. Physiol., Lond.* **238**, 582–602.

Gouras, P. & Eggers, H. (1983). Responses of primate retinal ganglion cells to moving spectral contrast. *Vision Res.* **23**, 1175–1182.

Hárosi, F. I. (1982). Recent results from single-cell microspectrophotometry: cone pigments in frog, fish and monkey. *Color Res. Appl.* **7**, 135–141.

Huddart, J. (1777). An account of Persons who could not distinguish Colours. *Phil. Trans. R. Soc* **67**, 260–265.

Ingling, C. R. & Martinez, E. (1983). The spatiochromatic signal of the r-g channel. In *Colour Vision: Physiology and Psychophysics* (ed. J. D. Mollon, & L. T. Sharpe), pp. 433–444. London: Academic Press.

Jacobs, G. H. (1981). *Comparative Color Vision.* New York: Academic Press.

Jacobs, G. H. (1983). Within-species variations in visual capacity among squirrel monkeys (*Saimiri sciureus*). *Vision Res.* **23**, 1267–1277.

Jacobs, G. H. & Neitz, J. (1986). Spectral mechanisms and color vision in the tree shrew (*Tupaia belangeri*). *Vision Res.* **26**, 291–298.

Kalmus, H. (1955). The familial distribution of congenital tritanopia, with some remarks on some similar conditions. *Annals hum. Genet.* **20**, 39–56.

Katz, D. (1935). *The World of Colour.* London: Kegan Paul, Trench, Trubner & Co.

Kingdon, J. S. (1980). The role of visual signals and face patterns in African forest monkeys (guenons) of the genus *Cercopithecus. Trans. zool. Soc. Lond.* **35**, 425–475.

KingJon, J. S. (1988). What are face patterns and do they contribute to reproductive isolation in guenons? In *A Primate Radiation: Evolutionary Biology of the African Guenons* (ed. A. Gautier-Hion, F. Bourlière, J.-P. Gautier, & J. Kingdon), pp. 227–245. Cambridge: Cambridge University Press.

Koffka, K. (1935). *Principles of Gestalt Psychology.* London: Kegan Paul, Trench, Trubner & Co.

Ladd-Franklin, C. (1982). A new theory of light sensation. In *International Congress of Psychology, 2nd Congress, London, 1892.* Kraus Reprint, 1974.

Land, E. (1983). Recent advances in retinex theory and some implications for cortical computations: Color vision and the natural image. *Proc. natn. Acad. Sci. U.S.A.* **80**, 5163–5169.

Lennie, P., Haake, P. W. & Williams, D. R. (1989). Chromatic opponency through random connections to cones. *Investig. Ophthalmol. vis. Sci.*, **30** (Suppl.), 322.

Liebmann, S. (1927). Ueber das Verhalten farbiger Formen bei Helligkeitsgleichheit von Figur und Grund. *Psychol. Forschung.* **9**, 300–353.

Livingstone, M. & Hubel, D. (1984). Anatomy and physiology of a color system in the primate visual cortex. *J. Neurosci.* **4**, 309–356.

Livingstone, M. & Hubel, D. (1988). Segregation of form, color, movement, and depth: anatomy, physiology, and perception. *Science* **240**, 740–749.

McDougall, W. (1901) Some new observations in support of Thomas Young's theory of light and colour-vision (II). *Mind* **10**, 210–245.

Mariani, A. P. (1984). Bipolar cells in monkey retina selective for the cones likely to be blue-sensitive. *Nature, Lond.* **308**, 184–186.

Meadows, J. C. (1974). Disturbed perception of colours associated with localized cerebral lesions. *Brain* **97**, 615–632.

Michael, C. R. (1988). Retinal afferent aborization patterns, dendritic field orientations, and the segregation of function in the lateral geniculate nucleus of the monkey. *Proc. natn. Acad. Sci. U.S.A.* **85**, 4914–4918.

Mollon, J. D. (1980). Post-receptoral processes in colour vison. *Nature, Lond.* **283**, 623–624.

Mollon, J. D. (1982). A taxonomy of tritanopias. In *Colour Vision Deficiencies,* VI (ed. G. Verriest) (*Documenta Ophthalmologica Proceedings Series* 33), pp. 87–101. The Hague: Dr W. Junk.

Mollon, J. D. (1989). On the nature of models of colour vision. *Die Farbe.*

Mollon, J. D., Bowmaker, J. K. & Jacobs, G. H. (1984). Variations of colour vision in a New World primate can be explained by polymorphism of retinal photopigments. *Proc. R. Soc. B* **222**, 373–399.

Mollon, J. D., Estevez, O. & Cavonius, C. R. (1989). The two subsystems of colour vision and their rôles in wavelength discrimination. In *Vision: Coding and Efficiency* (ed. C. B. Blakemore). Cambridge: Cambridge University Press.

Mollon, J. D. & Jordan, G. (1989). Eine evolutionaere Interpretation menschlichen Farbensehens. *Die Farbe.*

Mollon, J. D., Newcombe, F., Polden, P. G. & Ratcliff, G. (1980). On the presence of three cone mechanisms in a case of total achromatopsia. In *Colour Vision Deficiencies,* V (ed. G. Verriest), pp. 130–135. Bristol: Adam Hilger.

Morgan, M. J., Mollon, J. D. & Adam, A. (1989). Dichromats break colour-camouflage of textural boundaries. *Investig. Ophthalmol. vis. Sci.* **30** (Suppl.), 220.

Nathans, J., Piantanida, T. P., Eddy, R. L., Shows, T. B. & Hogness, D. S. (1986a). Molecular genetics of inherited variation in human color vision. *Science* **232**, 203–210.

Nathans, J., Thomas, D. & Hogness, D. S. (1986b). Molecular genetics of human color vision: the genes encoding blue, green and red pigments. *Science* **232**, 193–202.

Nicholl, W. (1818). Account of a case of defective power to distinguish colours. *Medico-Chirurgical Trans.* **9**, 359–363.

Perry, V. H. & Cowey, A. (1981). The morphological correlates of X- and Y-like retinal ganglion cells in the retina of monkeys. *Expl Brain Res.* **43**, 226–228.

Pokorny, J., Smith, V. C., Verriest, G. & Pinckers, A. J. L. G. (eds) (1979). *Congenital and Acquired Color Vision Defects.* New York: Grune & Stratton.

Polyak, S. (1957). *The Vertebrate Visual System.* Chicago: Chicago University Press.

Rodieck, R. W. (1988). The primate retina. In *Comparative Primate Biology* (ed. H. D. Stecklis & J. Erwin), pp. 203–278. New York: Alan R. Liss Inc.

Rushton, W. A. H. (1972). Pigments and cones in colour vision. *J. Physiol., Lond.* **220**, 1P–31P.

Schiller, P. H. & Malpelli, J. G. (1978). Functional specificity of lateral geniculate nucleus laminae of the rhesus monkey. *J. Neurophysiol.* **41**, 788–797.

Schnapf, J. L., Kraft, T. W. & Baylor, D. A. (1987). Spectral sensitivity of human cone receptors. *Nature, Lond.* **325**, 439–441.

Shapley, R. & Perry, V. H. (1986). Cat and monkey retinal ganglion cells and their visual functional roles. *Trends Neurosci.* **9**, 229–235.

Sourd, C. & Gautier-Hion, A. (1986). Fruit selection by a forest guenon. *J. Animal Ecol.* **55**, 235–244.

Stiles, W. S. (1949). Increment thresholds and the mechanisms of colour vision. *Documenta Ophthalmologica* **3**, 138–163.

Stiles, W. S. (1952). Colour vision: a retrospect. *Endeavour* **11**, 33–40.

Stilling, J. (1883). *Pseudo-isochromatishe Tafeln fuer die Pruefung des Farbensinnes.* Kassel, Berlin: Theodor Fischer.

Stromeyer, C. S., Kronauer, R. E., Madsen, J. C. & Cohen, M. A. (1980). Spatial adaptation of short-wavelength pathways in humans. *Science* **207**, 555–557.

Stromeyer, C. S. & Lee, J. (1987). Motion and short-wave cone signals: influx to luminance mechanisms. *Investig. Opthalmol. vis. Sci.* **28** (Suppl.), 232.

Tansley, B. W. & Boynton, R. M. (1976). A line, not a space, represents visual distinctness of borders formed by different colors. *Science* **191**, 954–957.

Thoma, W. & Scheibner, H. (1980). Die spektrale tritanopische Saettigungsfunktion beschreibt die spektrale Distinktibilitaet. *Farbe Design* **17**, 49–52.

Ts'o, Y. & Gilbert, C. D. (1988). The organization of chromatic and spatial interactions in the primate striate cortex. *J. Neurosci.* **8**, 1712–1727.

Vollrath, D., Nathans, J. & Davies, R. W. (1988). Tandem array of human visual pigment genes at Xq28. *Science* **240**, 1669–1672.

Wertheimer, M. (1923). Untersuchungen zur Lehre von der Gestalt. *Pyschol. Forschung.* **4**, 301–350.

Zeki, S. M. (1978). Uniformity and diversity of structure and function in rhesus monkey prestriate visual cortex. *J. Physiol., Lond.* **277**, 273–290.

VIII COLOR CONCEPTS AND NAMES

17 The Linguistic Significance of the Meanings of Basic Color Terms

Paul Kay and Chad K. McDaniel

1 Introduction

Recent empirical research into the meanings of words for color provides evidence that contradicts two widely-held beliefs in linguistics and the philosophy of language. This paper presents a summary of this evidence, uses it as a basis to construct a general model of basic color-term semantics, and explores the implications of this model for general semantic theory.

The first belief against which we will present evidence is familiar to most linguists as the Sapir-Whorf hypothesis. There are various so-called strong and weak forms of this hypothesis (Fishman 1960); in all forms, the basic notion is that each language imposes on the individual's 'kaleidoscopic flux of impressions' its own idiosyncratic semantic structure. This doctrine emphasizes the relativity of semantic structures, and minimizes the role of linguistic universals. The lexical categorization of color has often been presented as a paradigmatic instance of this arbitrary, language-specific imposition of semantic structure. Thus, in his widely-used introductory textbook, Gleason claimed (1961: 4), 'There is a continuous gradation of color from one end of the spectrum to the other. Yet an American describing it will list the hues as red, orange, yellow, green, blue, purple—or something of the kind. There is nothing inherent either in the spectrum or the human perception of it which would compel its division in this way.'

Studying 20 languages experimentally and investigating the literature on color-term semantics for 78 additional languages, Berlin & Kay 1969 (hereafter B & K) presented evidence indicating that, contrary to the claims of Gleason and others, all languages share a universal system of basic color categorization. B & K argued that there are universal basic color categories, and that the basic color-term inventories of most languages expand through time by lexicalizing these categories in a highly constrained, universal order. In addition, McDaniel has argued (1972, 1974, ms) that these universals are inherent in the human perception of color. The color perception of all peoples is the result of a common set of neurophysiological processes, and McDaniel suggests that these pan-human neurophysiological processes are the basis of the universal patterns in the meanings of basic color terms.

We argue, then, in direct opposition to Gleason and other relativists, that the human perception of color offers an explanation of why English speakers segment the visual spectrum as they do—and why, furthermore, speakers of other languages exhibit the limited and systematic set of alternative segmentations of the color space that they do. Working with a biologically based understanding of basic color-term

semantics, we can show the natural relations that exist between the numerous color categories encoded in highly differentiated color terminologies, such as English, and the fewer categories encoded in languages with less differentiated and therefore superficially simpler terminologies. Thus, in extension of the arguments advanced by B & K, we present the lexical categorization of color as a paradigmatic example, not of the relativity of semantic structures, but of the existence of biologically based semantic universals.

A second widespread belief in linguistics and the philosophy of language, challenged by the data reviewed here, is the doctrine that there exist ultimate semantic primes which are DISCRETE entities. These units are called semantic 'features' by both European and American structuralist schools, and 'markers' or 'distinguishers' by Katz (1964, 1966) and those generative linguists who follow him. Although there are, of course, major differences between structuralist and standard generative theories as to how semantic primes are combined into the meanings of words or larger linguistic units, until recently there was nearly universal agreement that all semantic primes are discrete, i.e. non-continuous, entities. When we say that semantic primes have been considered to be discrete entities, we mean that they have been viewed as properties that are predicable of things in an all-or-none fashion. This tacit premise is directly reflected in the common plus/minus notation of semantic features. When [+round] or [−human] is written, it indicates that roundness and humanity are being taken as properties which are simply predicable or not predicable of something being talked about. These properties are not treated in the discrete-feature theory as predicable of something TO A DEGREE.[1]

In discussions of the discrete-feature theory, as in discussions of semantic relativity, the domain of color is often used as a paradigm example. In Katz's theory, one of the major relationships that may exist between discrete semantic features is that of antonymy. For Katz (1966: 195 ff.), two linguistic expressions are antonymous just if they have readings that are identical except that, where one reading has a semantic feature from a (previously specified) antonym set, the other reading has a different feature from that same set. Katz (1964: 532) exemplifies antonymous lexical items as follows:

There are many special antonymy relations between words and expressions. One example is the relation of "sex-antonymy". A pair of lexical items is SEX-ANTONYMOUS just in case they have identical paths except that where one has the semantic marker (*Male*) the other has the semantic marker (*Female*). Some instances are: *woman and man; bride and groom; aunt and uncle; cow and bull*. The majority of antonymous lexical items are not sets of pairs but sets of *n*-tuples. For example, there are the species-antonymous lexical items, one example of a species-antonymous *n*-tuple being: *child, cub, puppy, kitten, cygnet*, and so on. Moreover, there

are *n*-tuples of lexical items that are distinguisher-wise antonymous, e.g., the *n*-tuple of simple color adjectives (*blue, yellow, green, red, orange*). These form an antonymous *n*-tuple because the path associated with each is identical except for the distinguisher which differentiates that color adjective from the others.

Katz here proposes that *yellow, green,* and *blue* each has assigned to it in the semantic component of the grammar a discrete feature, called a distinguisher, which distinguishes it from each of the others and from the remaining color terms. The inadequacy of such a treatment is apparent when one considers compound color terms such as *yellow-green* or *blue-green*. These terms are not self-contradictory, as one might deduce from Katz's treatment, and their meanings are relatively transparent: something which is 'blue-green' is blue to some degree and green to some degree. This and related observations developed below show that the meanings of basic color terms can not be accurately represented with discrete semantic features. We propose instead that color categories, like the neurophysiological processes that underlie them, are continuous functions; and that a non-discrete formalism, in this instance fuzzy set theory, provides the most concise and adequate description of the semantics of basic color terms.

Preliminary to this analysis and further discussion of the general linguistic significance of basic color-term semantics, it is necessary to review some of the anthropological and psychological research from which our understanding of color categorization has developed. In §2, the major findings of B & K regarding semantic and developmental universals in basic color-term vocabularies are summarized. This section also discusses certain inadequacies in the original analysis that can now be corrected. In §3, we offer a brief summary of current theory and research regarding the neurophysiological bases of color perception as they are relevant to understanding McDaniel's psychophysiological re-interpretation and explanation of B & K. Our current analysis is presented in §§4–5, where the work of B & K and of McDaniel is integrated with new data from recent field studies of basic color-term systems. This integration leads to a reformulation of B & K's universals of color categorization and color-category development. In this reformulation, fuzzy set theory is used to model the structure of individual color categories and to explicate the relations which develop between the various universal color categories which appear as basic color vocabularies expand.

2 Anthropological Research into Basic Color-Term Semantics

B & K's experimental and library research into the systems of color categorization in 98 languages, representing a wide range of major language stocks, focused on the

categorization as represented by the basic color terms of each language. Basic color terms were defined as those (a) which are monolexemic (unlike *reddish-blue*); (b) whose signification is not included in that of any other term (unlike *crimson* and *vermilion*, both of which are kinds of *red*); (c) whose application is not restricted to a narrow class of objects (unlike *blond* and *roan*); and (d) which are relatively salient as evidenced in frequent and general use (unlike *puce* and *mauve*).[2]

The experimental portion of B & K's research, dealing with twenty languages, began with the elicitation, in the absence of any particular colored stimuli, of the basic color terms in each informant's language. After an informant's basic color-term inventory had been determined in the elicitation interview, the informant was asked to perform two tasks that involved matching these basic color terms to color chips in a standardized stimulus array.[3] The informant's first task was to pick out the color chips which he felt were the best examples of each of the basic color terms in his language. The second task was to indicate the boundaries of each color category, i.e. to indicate ALL the chips in the array whose color might be denoted by a given color term.

Informants selected best examples with far greater ease, speed, and reliability than they determined boundaries. B & K found that these judgments of best example, indicating what they called the focus of each color category, were more useful than the judgments of boundaries in describing and comparing the meanings of basic color terms in the languages studied experimentally. As expressed in the original report, the basic experimental findings were that 'color categorization is not random and the foci of basic color terms are similar in all languages' (10). A total of eleven foci were identified, located in the color space where English speakers locate the best examples of black, white, red, orange, yellow, brown, green, blue, purple, pink, and grey. These foci were interpreted as the primary designata of a set of universal semantic categories.

Using these results as a guide to interpretation, B & K considered published data from 78 additional languages, and determined that there is a temporal order in which languages encode these universal categories. They concluded as follows (3–4):

Although different languages encode in their vocabularies different numbers of basic color categories, a total universal inventory of exactly eleven basic color categories exists from which the eleven or fewer basic color terms of any given language are always drawn ... If a language encodes fewer than eleven basic color categories, then there are strict limitations on which categories it may encode. The distributional restrictions of color terms across languages are:

1. All languages contain terms for white and black.
2. If a language contains three terms, then it contains a term for red.

Table 17.1
The twenty-two actually occurring types of basic color lexicon

Type	No. of basic color terms	white	black	red	green	yellow	blue	brown	pink	purple	orange	grey
		Perceptual categories encoded in the basic color terms										
1	2	+	+	−	−	−	−	−	−	−	−	−
2	3	+	+	+	−	−	−	−	−	−	−	−
3	4	+	+	+	+	−	−	−	−	−	−	−
4	4	+	+	+	−	+	−	−	−	−	−	−
5	5	+	+	+	+	+	−	−	−	−	−	−
6	6	+	+	+	+	+	+	−	−	−	−	−
7	7	+	+	+	+	+	+	+	−	−	−	−
8	8	+	+	+	+	+	+	+	+	−	−	−
9	8	+	+	+	+	+	+	+	−	+	−	−
10	8	+	+	+	+	+	+	+	−	−	+	−
11	8	+	+	+	+	+	+	+	−	−	−	+
12	9	+	+	+	+	+	+	+	+	+	−	−
13	9	+	+	+	+	+	+	+	+	−	+	−
14	9	+	+	+	+	+	+	+	+	−	−	+
15	9	+	+	+	+	+	+	+	−	+	+	−
16	9	+	+	+	+	+	+	+	−	+	−	+
17	9	+	+	+	+	+	+	+	−	−	+	+
18	10	+	+	+	+	+	+	+	+	+	+	−
19	10	+	+	+	+	+	+	+	+	+	−	+
20	10	+	+	+	+	+	+	+	+	−	+	+
21	10	+	+	+	+	+	+	+	−	+	+	+
22	11	+	+	+	+	+	+	+	+	+	+	+

Note: Only these twenty-two out of the logically possible 2,048 combinations of the eleven basic color categories are found.

3. If a language contains four terms, then it contains a term for either green or yellow (but not both).

4. If a language contains five terms, then it contains terms for both green and yellow.

5. If a language contains six terms, then it contains a term for blue.

6. If a language contains seven terms, then it contains a term for brown.

7. If a language contains eight or more terms, then it contains a term for purple, pink, orange, grey, or some combination of these.

These distributional facts are summarized in [table 17.1], in which each row corresponds to an actually occurring type of basic color lexicon. The pattern displayed by the actual distribution is a tight one; of the 2,048 (that is, 2^{11}) possible combinations of the eleven basic color terms, just twenty-two, about 1 per cent, are found to occur in fact. Moreover, the twenty-two types which do occur are not unrelated but may be summarized by (or generated from) a rather

$$\begin{bmatrix} \text{white} \\ \text{black} \end{bmatrix} < [\text{red}] < \begin{bmatrix} \text{green} \\ \text{yellow} \end{bmatrix} < [\text{blue}] < [\text{brown}] < \begin{bmatrix} \text{purple} \\ \text{pink} \\ \text{orange} \\ \text{grey} \end{bmatrix}$$

Figure 17.1

simple rule [figure 17.1] where, for distinct color categories (a, b), the expression $a < b$ signifies that a is present in every language in which b is present and also in some language in which b is not present. [Figure 17.1] is thus a partial order on the set of basic color categories, the six bracketed sets being a series of six equivalence classes of this order ... [Figure 17.1] represents not only a distributional statement for contemporary languages but also the chronological order of the lexical encoding of basic color categories in each language. The chronological order is in turn interpreted as a sequence of evolutionary stages.

This distribution of color categories in the ethnographic present must reflect a sequence through which each language has to pass as it changes its number of basic color terms. If this were not the case, we would be forced to assume that languages existed in the past which did not conform to the observed distribution; e.g., a language with words for black, white, and blue, but none for red, green, or yellow. This would imply that the pattern displayed by the current synchronic sample of 98 languages is fortuitous with respect to languages in general. This is an unlikely conjecture for which no evidence exists. Moreover, considerable direct evidence has been adduced supporting the hypothesized sequence of temporal development in basic color-term systems (B & K, 36–41; Berlin & Berlin 1975, Dougherty 1975, Kuschel & Monberg 1974).

To continue our quotation from B & K (4–5):

The logical, partial ordering of [figure 17.1] thus corresponds, according to our hypothesis to a temporal-evolutionary ordering, as in [figure 17.2], where the arrow may be read 'is encoded before'.... In sum, our two major findings indicate that the referents for the basic color terms of all languages appear to be drawn from a set of eleven universal perceptual categories, and these categories become encoded in the history of a given language in a partially fixed order.

Although subsequent research has substantiated B & K's basic findings, their 1969 report contained some errors of fact and a theoretical equivocation. The latter involved the conflicting treatments of category foci and category boundaries in the explanation of the successive stages of basic color-term development. B & K interpreted the developmental sequence primarily as the successive encoding of new foci. Stage 1 (i.e. two-term) systems were described as consisting of the categories BLACK and WHITE, where these categories included (on the one hand) black and all darker

$$\begin{bmatrix} \text{white} \\ \text{black} \end{bmatrix} \rightarrow \text{[red]} \begin{array}{c} \nearrow \text{[green]} \rightarrow \text{[yellow]} \searrow \\ \searrow \text{[yellow]} \rightarrow \text{[green]} \nearrow \end{array} \text{[blue]} \rightarrow \text{[brown]} \rightarrow \begin{bmatrix} \text{purple} \\ \text{pink} \\ \text{orange} \\ \text{grey} \end{bmatrix}$$

Figure 17.2

hues, and (on the other) white and all the lighter hues, with the foci of the categories being at pure black and pure white respectively. At Stage II, the warm hues were described as being accorded their own separate basic color term, RED, which focused at red. Thus the development at Stage II was thought essentially to consist of adding, to the categories focused at black and white, a category focused at red. But an equivocation enters at this point with respect to the meanings of the labels BLACK and WHITE. In Stage I, these labels referred to categories, focused at black and white, whose extensions (considered together) take in all other colors. At Stage II, though, the extensions of BLACK and WHITE have retracted, so that the warm colors are not included in either of them, but instead are included in the extension of the new term RED, focused at red. Thus BLACK and WHITE mean one thing at Stage I, and something else at Stage II.

The same equivocation occurs with respect to all B & K's category labels BLACK, WHITE, RED, and GREEN. These labels were used sometimes to refer to a category having a particular focus, and at other times to a category having a particular extension. Moreover, the extensions referred to were not constant across occasions of use of the category label. These equivocations are eliminated in our present analysis of basic color-term semantics, where the non-discrete formalism of fuzzy set theory is shown to provide a unitary mechanism for describing the relationships between color-category foci, extensions, and boundaries.

Studies appearing after 1969, testing B & K's hypotheses, produced empirical results which highlighted the equivocation just noted and revealed certain factual errors in the original report. Heider 1972a,b studied the Stage I system of the Dugum Dani in detail. She found that the Dani's two color categories, *mola* and *mili*, were better labeled 'white-warm' and 'dark-cool', rather than simply WHITE and BLACK (as B & K had suggested for all Stage I systems), since *mola* contains not only white but all the warm colors (reds, oranges, yellows, pinks, and red-purples), while *mili* contains black and all the cool colors (blues and greens). Diagramatically, the situation may be represented as in figure 17.3.

Significantly, Heider also found that the foci of these white-warm and dark-cool categories were variable across informants. *Mola* and *mili* were not always focused

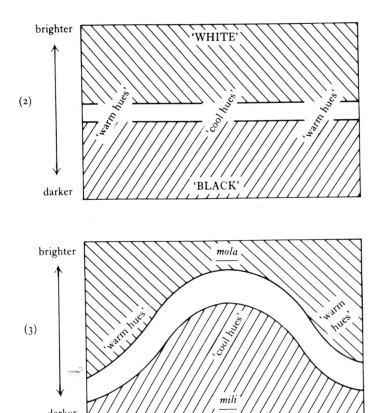

Figure 17.3
Source: Kay (1975a:259).

at only white and black. For example, 69% of her informants focused the white-warm category *mola* at English focal red. B & K's original analysis assumed that all basic color categories have a single focus. Other recent empirical studies of early-stage basic color-term systems, where monolingual informants were tested in their native environments, have corroborated Heider's finding that a language may have multiply-focused basic color terms.[4]

This and related factual emendations to B & K show that their treatment of the basic color-term encoding sequence as the simple successive encoding of single foci cannot be maintained. The re-interpretation of the encoding sequence presented here follows McDaniel 1974, MS, in treating the successive stages of basic color-term development as the progressive differentiation of color categories rather than as the

successive encoding of foci. This re-interpretation, as our general analysis, involves a model of basic color-category formation that utilizes findings from recent researches into the neurophysiological bases of color perception. These findings are reviewed in §3.

3 The Neurophysiological Bases of Color Perception

Research conducted in the past two decades has significantly increased our knowledge of the physiological processes which underlie the human perception of color. This research is concerned, for the most part, with discovering how differences in the wavelengths of light reaching the eye are transformed into response differences in the visual nervous system. It has been known for some time that color perception begins, neurophysiologically, at the retina, with the stimulation of color-sensitive cells called cones. There are three types of cone, and each type is distinguished by its own unique pattern of wavelength-dependent response. The light of each wavelength distinguishes itself neurally at the retinal level by evoking a unique set of neural responses from this three-cone system. Each distinct color is associated with a unique pattern of responses among the three types of cones.

The neural processing and coding of color continues, however, beyond this retinal level. Many recent studies of the visual processes have been concerned with the neural representation of color at some remove from the retina, in the neural pathways between the eye and brain. These studies, which have used microelectrodes to monitor single neurons, indicate that, by the time wavelength-governed neural impulses reach higher points in the visual pathway, the tripartite response of the retina's three-cone system is transformed into a set of opponent neural responses.

Two properties distinguish a cell as an opponent response cell. First, an opponent response cell has a spontaneous rate of firing—a basal response rate that it maintains without external stimulation. Second, the cell shows an increased rate of firing in the presence of lights whose dominant wavelengths are from certain regions of the visual spectrum, while lights from the complementary spectral regions will decrease its rate of firing below its basal rate. The opposing effects of complementary regions of the visual spectrum on these cells gives rise to the term 'opponent response.'

Cells with opponent response characteristics have been identified by R. De Valois and his co-workers in the lateral geniculate nucleus (LGN) of the macaque (*Macaca irus*), an Old World monkey with a visual system similar to man's (De Valois et al. 1966, De Valois & Jacobs 1968). These scholars discovered four types of opponent cell. The mean response patterns that distinguish these four types are shown in figure 17.4, where horizontal dotted lines indicate the mean spontaneous firing rates of the

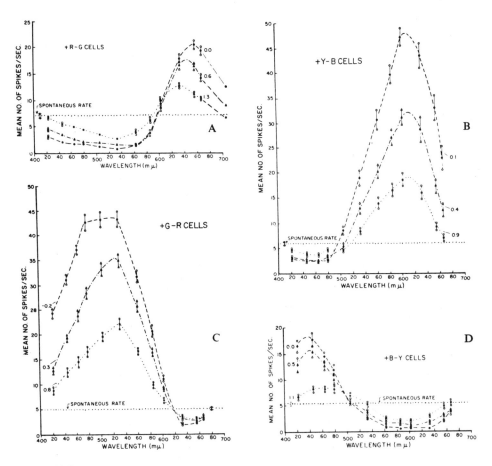

Figure 17.4
Source: De Valois et al. 1966:972–73; figures 9-12. Note: Horizontal dotted lines indicate mean basal response rate for each cell type.

cell, and the curvilinear dotted, dashed, and dotted-and-dashed lines indicate the observed response rates of the cell to lights of varying wavelengths at three different levels of brightness. The +R −G and +G −R cells shown in figure 17.4A and C have responses opposed between the red (far long) and green (near short) regions of the spectrum. These cell types differ fundamentally only in the directions of the response deviations that represent the opposition between the red and green regions of the spectrum. The +Y −B and +B −Y cells illustrated in figures 17.4B and D have responses opposed between the yellow (near long) and the blue (far short) regions of the spectrum. These two types again differ primarily only in the response modes (increased vs. decreased firing) in which this opposition is expressed.

In their analysis of the translation of these response patterns into perceptual effects, De Valois et al. (976) argue, with respect to the cell types that are opposed between the same regions of the spectrum, that 'it seems reasonable to say the excitation in one type [e.g.] (+R −G) carries the same information as inhibition in the other [e.g.] (−R +G).' Following this argument, they sum the absolute values of the red, yellow, green and blue deviations of the +R −G, −R +G, +Y −B, and −Y +B opponent cells into unitary red, yellow, green, and blue response effects. They then take these response distributions as the neural bases of color discriminations at the perceptual level.

Figure 17.5 presents these response distributions for human observers as estimated by Wooten 1970 from human psychophysical data. The direction of deviation above or below the X-axis signifies in this figure the chromatic value (i.e. red, yellow, green, and blue) of the deviations in the combined RG and YB opponent systems (not the actual direction of response rate changes from a basal rate as in figure 17.4). The plus and minus values are used here simply to represent the opposition of red with green and of yellow with blue in their respective opponent systems. The absolute magnitudes of the red, yellow, green, and blue deviations represent the strengths of the response states at different wavelengths (regardless of whether the

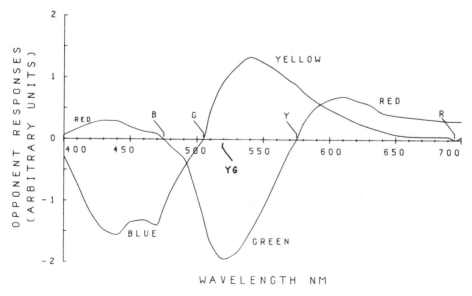

Figure 17.5
Note: Values are taken from Wooten 1970, who estimated them using methods outlined in Jameson & Hurvich 1968.

neural representation of that response at some lower level is through inhibition or excitation).

In sum, the work of De Valois and his colleagues indicates that, while color is coded at the retinal level in the differential distributions of responses from the three types of cone, this code is transformed beyond the retina into one of opposed red and green and opposed yellow and blue neural response states distributed by wavelength as shown in figure 17.6, below. It is the relative strengths of these states, then, that directly determine perceived hue. (In addition to the opponent cells just discussed, De Valois et al. also found in the macaque LGN two additional types of cells, both of which are non-opponent; i.e., they lack the characteristic of opposed response to complementary spectral regions that distinguishes opponent cells. The role of these cells in the definition of the fundamental categories black and white is discussed in §4.2, below. For the moment, however, we continue to restrict our discussion to the four hue response states basic to color perception.)

The above findings are particularly significant in the support they provide for an analysis of the phenomenal quality of color perception presented by Hering 1920, who argued that any color appears subjectively either as a pure, unique instance of one of four fundamental hues—red, yellow, green, and blue—or as a mixture of these primaries. All colors other than unique red, unique yellow, unique blue, or unique green, Hering claimed, could be seen (on introspection) to consist of the simultaneous perception of two of the primaries. His treatment regarded oranges, e.g., not as unitary percepts, but as having recognizable red and yellow components. Purples are composed of red and blue, while yellow-green (chartreuse) and blue-green (turquoise) show their true composite character in their descriptive names.[5]

While claiming red, yellow, green, and blue to be the only four fundamental hue sensations, Hering also noted certain antagonistic relations between red and green, and a corresponding antagonism between yellow and blue. He observed that green and blue may be perceived simultaneously (in what we call *greenish-blues* or *bluish-greens*) and similarly that red and yellow may be perceived simultaneously (in what we call, among other things, *orange*). Contrastingly, he pointed out, there is no such thing as a simultaneous perception of green and red, nor of blue and yellow. Perceptually, there are no yellowish-blues or bluish-yellows. From these and other observations, Hering suggested that the four primary hues are in fact two opposing hue pairs, red-green and yellow-blue, whose opposition indicates that these hue sensations are the product of antagonistic neural processes (as yet undiscovered in Hering's time).

The correspondence between the phenomenal analysis which Hering presented and the neurophysiological findings of De Valois and his associates is striking. Hering's observation of the phenomenal opposition of red to green and of blue to

yellow anticipated De Valois' discovery of single cells which have opposing responses to these regions of the spectrum. Clearly, the R, G, Y, and B outputs of the opponent processes are the four fundamental hues described by Hering. The relative magnitude of the deviations in the RG and YB systems then indicate the relative strength of each fundamental hue in the total color sensation associated with light of a given wavelength. The phenomenal appearance of light of any given wavelength is thus the result of (1) the response state (R or G, Y or B) of each opponent system, and (2) the relative strengths of the responses in each state. Thus in figure 17.5, which shows Wooten's estimates of the human opponent process functions, light of 520 nm is shown to produce a yellow response in the YB system. It also produces a green response in the RG system, and this is of greater magnitude than the yellow response. The result is that light of 520 nm is seen as predominantly green with a 'veil' of yellow, i.e. as yellowish-green. The appearance of the entire visible spectrum can be accounted for in this manner, by evaluating at each wavelength the states and relative strengths of the two opponent response functions shown in figure 17.5.

The articulation of De Valois' findings with Hering's observations indicates that a particular structure is inherent in the human perception of color, a structure which is not deducible from the physical properties of light alone. The opponent process analysis identifies and describes four specific categories of neural response: the R (**red**), G (**green**), Y (**yellow**), and B (**blue**) response states.[6] As is shown below, the semantics of basic color terms in all languages directly reflect the existence of these pan-human neural response categories. Furthermore, when the universal basic color categories are treated non-discretely as fuzzy sets, their structure and formation from these prior perceptual categories can be given a precise representation.

4 Color Categories as Fuzzy Sets

4.1 *Fuzzy Set Membership and Universals of Color-Category Structure*

Fuzzy set theory has developed from several relatively straightforward modifications of the concepts of standard set theory.[7] The basic differences between the two stem from the fact that membership in standard set theory is categorically defined (an element simply IS or ISN'T a member of a given set), while degrees of membership are recognized in fuzzy set theory.

Consider the classes denoted by the words *Congressman* and *gourmet*. The former seems to denote a set in the accepted sense; in particular, someone is either a Congressman or he is not—the Congress does not admit of degrees of membership. This is the only sort of set countenanced by standard set theories. However, *gourmet* (like

many other words) seems to denote something very like a set, except that individuals appear to have different degrees of membership. Charles may be more of a gourmet than Harry, and less of a gourmet than Anne. Zadeh 1965, 1971 has constructed the notion of fuzzy set to formalize this sort of intuition.

A fuzzy set A is defined by a characteristic function f_A which assigns, to every individual x in the domain under consideration, a number $f_A(x)$ between 0 and 1 inclusively, which is the degree of membership of x in A.[8] For example, letting f_G symbolize the characteristic function of the fuzzy set 'gourmet,' perhaps $f_G(Harry)$ = .4, $f_G(Charles)$ = .7, and $f_G(Anne)$ = .9. If so, the inequalities given above in words are satisfied: $f_G(Charles) > f_G(Harry)$, and $f_G(Charles) < f_G(Anne)$.

That color-category membership is a matter of degree in English is apparent from even casual consideration of some of the ways that color is talked about. We can speak of something as (a) *a good red*, (b) *an off red*, (c) *the best example of red*, (d) *sort of red*, (e) *slightly red*, (f) *yellowish-red*, (g) *blue-green*, (h) *light pink*, or (i) *dark blue*. All these constructions indicate the degree to which the color referred to approximates an ideal example of the root color term. A *good red* has a high degree of similarity to some norm for red. Something that is either *sort of red* or *slightly red* is, in a lesser degree, an approximation to this norm. Lakoff has presented a general treatment of hedges like those found in (a)–(e), where such expressions are analysed as modifying or qualifying the degree to which something is a member of a particular category. In (a)–(e), a color is denoted (1) by reference to some basic color category, and (2) by the use of a hedge which indicates how much the color actually named deviates from the norm for this basic category.

Constructions (f)–(i) also indicate degree of approximation to a norm, but they indicate the direction of variation from the norm as well. A *yellowish-red* fails to be a *good example of red* by virtue of having some degree of yellow. *Blue-greens* are neither *good blues* nor *good greens*; and they differ from *good greens*, e.g., by being blue to a significant degree. While (f)–(g) indicate variation in hue from a norm, constructions such as (h)–(i) indicate variation in brightness and/or saturation from a norm. *Light pinks* are pinks which are to some degree lighter or whiter than the pink norm. *Dark blues* are black to a greater degree than blues that are just blue. A phrase such as *slightly purplish blue* combines specification of both degree and direction of deviation from a norm, to denote a sensation that is only marginally a member of the class of purple things, but is a nearly perfect member of the class of blue things.[9]

Constructions of these sorts are found in all languages, showing that all speaker-hearers recognize and talk about degrees of color-category membership. Since color categorization is in general a matter of degree, color categories are best regarded as fuzzy sets. The members of the fuzzy set corresponding to each basic color category

are chosen from the set of all possible color percepts. The degree to which each percept is a member of a particular category is specified as a value between zero and unity; each category is thus characterized by the function that assigns, to each color percept, a degree of membership in that category.

Adopting this framework, it can be seen that when B & K asked informants to pick *the best X* or *the best example of X*, they were in effect asking informants to indicate which colors had the highest degree of membership in the category *X*. It was in these judgments of focal colors that B & K found universal agreement. The regions in the color space where these universal basic color-category foci are found can thus be understood as regions where universal basic color-category membership functions reach their maxima, i.e. unity.

Similarly, the non-focal colors included in the extension of any given basic color term are colors with positive but non-maximal degrees of category membership. B & K's study and subsequent ones show that, in these non-focal regions, the basic color categories intergrade. Colors are found here which are members of more than one basic category. In English, this overlap of basic color-category memberships is obvious for colors such as *yellow-green, reddish-purple* etc.

It is the existence of these colors with positive degrees of membership in more than one of the basic color categories that produced the variability in boundary judgments reported by B & K. They collected boundary data by simply asking informants to indicate 'all' the colors included in each basic color term. This instruction required subjects to judge class membership categorically. Informants were not allowed to indicate degrees of membership, only 'membership'. An English-speaking informant asked to indicate 'all the reds' could reasonably pick out all the stimuli which are red to a greater degree than they are any other color—thereby excluding, e.g., red-oranges. Or the informant could indicate all the stimuli with even a trace of red, since an expression including *red* or *reddish* would be appropriate to a precise description of any of these stimuli. This ambiguity in the elicitation frame for category boundaries left each informant free to determine what degree of membership he felt was sufficient to permit inclusion of a color in a category. Wide variation in boundary judgments resulted.

McDaniel 1972 has attempted to take this ambiguity in the B & K data into account—arguing that, if absolute universal boundaries exist (as do universal foci), then all the boundary judgments that B & K collected for each category should fall between its focus and some specifiable absolute bounds for it. Examining the extensions of each color term across all B & K's informants for all languages, McDaniel has shown that (1) each universal category has well-defined limits in the color space beyond which the category is never extended, and (2) these absolute boundaries are

the foci of the adjacent fundamental color categories. In the fuzzy set framework, these universal boundaries are points in the color space beyond which membership values for a given category are always zero. Once individual variations in boundary placement, as found by B & K, are attributed to individual differences in the selection of criteria for categorical category inclusion, it can be seen that the universal basic color categories have, in addition to universal foci, universal absolute boundaries.

In sum, each basic color category can be regarded as a fuzzy set where the elements in each set are chosen from the set of all color percepts. The degree to which each percept is a member of a particular basic category is specified as a value between zero and unity. Each category is thus distinguished by the set of color percepts which are assigned some positive degree of membership in it. The general structure of these categories, as shown in their pattern of membership assignments, is such that, as one moves through the perceptual color space from the focus of a category toward its boundaries, there is a continuous and gradual decline from unity to zero in the membership values of successive color percepts. In addition, the locations of the basic category foci and their absolute boundaries are universally fixed in the color space.

This formulation of basic color categories as fuzzy sets makes clear the inadequacies of the model of color categorization embodied in the 'focus' and 'boundary' language of earlier works. To talk simply of foci and boundaries entails (or at least invites the inference) that color categories admit of only three degrees of membership: focal member, non-focal member, and non-member. In this respect the focus/boundary model is but a minor variation of the two-degrees-of-membership, discrete-feature model questioned above. The arguments that can be made against that model also apply to the three-degrees-of-membership model implicit in the language of 'focus' and 'boundary'. The data discussed above and below indicate that color categories need to be modeled with continuously graded degrees of membership, not a small finite number such as two or three.

The formalism of fuzzy set theory is a natural device for expressing the continuity of basic color-category membership, allowing accurate description of the full range of memberships admitted. The special status formerly sought for foci and boundaries is nevertheless preserved in the fuzzy set representation, as these become characteristic points (maxima and minima) of the fuzzy membership functions that represent the basic categories. The result is a more accurate description of basic color categories. In addition, when basic color categories are given this non-discrete characterization, the membership functions that then represent the semantic structures of these categories can be derived directly from the neural response functions (discussed in §3, above) that make up the physiological code for color.

4.2 *Fundamental Neural Responses, Fuzzy Identity, and the Primary Basic Color Categories*

Fuzzy set representations of the universal basic color categories red, yellow, green, and blue can be developed directly from neural response functions inherent in the neural code for color. This code consists in the wavelength-dependent behaviors of the opponent neural states **red, yellow, green,** and **blue** (see §3). As shown in figure 17.5, at a given wavelength, at least one and usually two of these states are evoked. Consider, e.g., point YG in figure 17.5, which represents a (yellowish-green) light of 520 nm. At this wavelength, neither **red** nor **blue** is evoked. The absolute value of the **green** response is 1.8, and the absolute value of the **yellow** response is 0.9. These simultaneously evoked states compete in perceptual effect, and the net effect at this wavelength is the perception of a color zero per cent **red**, zero per cent **blue**, 67% **green** $\left(\dfrac{1.8}{1.8+.9}\right)$, and 33% **yellow** $\left(\dfrac{.9}{1.8+.9}\right)$. From computations such as this, we can calculate for each response state its proportional contribution to the total chromatic response at each wavelength. The results of these calculations are represented by the four curves in figure 17.6, which indicate for each wavelength THE PROPORTION OF THE TOTAL CHROMATIC RESPONSE CONTRIBUTED BY EACH OPPONENT STATE. (These proportion-of-total-chromatic-response functions are a standard means of expressing perceived color quality in the vision literature, where they are referred to as 'hue coefficients'.)

Each of the four functions shown in figure 17.6 has the mathematical properties of a fuzzy set. Every individual in the domain, i.e. light of each wavelength, is assigned a number between zero and unity, inclusively, by each function. These net neural response curves are thus formally the graphs of four fuzzy sets, and substantively the graphs of the four fundamental neural response categories f_{red}, f_{yellow}, f_{green}, and f_{blue}.

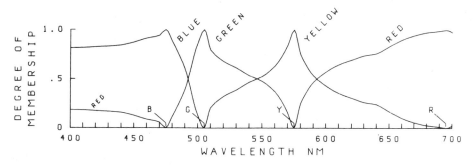

Figure 17.6

It is these four neural response categories that are encoded as the universal semantic categories f_{red}, f_{yellow}, f_{green}, f_{blue}. The latter fuzzy categories are the designata of the English words *red*, *yellow*, *green*, and *blue*, and of the words that are exact translations of these in languages of Stages V, VI, and VII. After presenting the evidence for this claim, we will argue further that the semantic categories corresponding to all the basic color terms occurring in the world's languages are either (a) one of these four fundamental response categories; (b) one of two additional fundamental response categories, f_{black}, and f_{white}, to be introduced below; (c) fuzzy unions among these six fuzzy categories; or (d) simple functions of fuzzy intersections among these six fuzzy neural response categories.

The evidence for the identity of the fundamental neural response categories f_{red}, f_{yellow}, f_{green}, and f_{blue} with the semantic categories f_{red}, f_{yellow}, f_{green}, and f_{blue} begins with the observation just made that the neural response categories and the semantic categories are both manifestly non-discrete and naturally representable as fuzzy sets.

Second, each of the neural response categories has a single point of maximal membership, as do the membership functions characterizing the corresponding semantic categories.

Third, the particular wavelengths at which the neural response functions reach their maxima—in opponent process terms, their unique hue points—coincide with the wavelengths at which the semantic categories reach their maxima, i.e. have their foci (McDaniel 1972). The points where f_{red}, f_{yellow}, f_{green}, and f_{blue} reach maximum (points R, Y, G, and B in figures 17.5 and 17.6) are referred to as unique hue point: at these points, one of the opponent channels is at its basal response rate and makes no chromatic contribution, so that the net chromatic response is determined exclusively (and uniquely) by the response state of the other channel. In a replication of B & K's original experiment, McDaniel has shown experimentally that wavelength measures of these unique hue points correspond to wavelength measures of focal yellows, greens, and blues chosen by English-speaking subjects.[10] The wavelengths at which these unique hue/focal points occur are 695 nm for f_{red} and f_{red},[11] 575 nm for f_{yellow} and f_{yellow}, 510 nm for f_{green} and f_{green}, and 475 nm for f_{blue} and f_{blue}.

A fourth item of evidence for the identity of these neural and semantic categories is that both show a gradual decline in membership values as one considers wavelengths at increasing distances, in either direction, from their membership maxima.

Finally, for each pair of matched neural response and semantic categories, the declining membership values become zero at the same points in the color space (see §4.1, above). Membership values for both the neural and the semantic categories

decline continuously, though remaining positive, as one moves away from the unique hue point/focus of each category, until the unique point/focus of an adjoining category is reached. At these points membership values become zero, and they remain zero across the remainder of the spectrum. For example, both the neural response category f_{green} (as psychophysically determined) and the semantic category f_{green} (as inferred from B & K, and from other semantic investigations) have positive values in the interval between 575 nm (unique yellow) and 480 nm (unique blue), but zero values elsewhere.

In sum, the distinctive properties of the semantic categories red, yellow, green, and blue as discovered in semantic investigations correspond precisely to the properties of fuzzy response functions derivable from the opponent process model of the neural mechanisms that underlie color vision. Each of these semantic categories thus bears the identity relation to one of the four fuzzy fundamental neural response categories. We have termed these identity-based semantic categories PRIMARY basic color categories.

The analysis of the full roster of universal semantic color categories to be presented below requires two further fundamental neural response categories, f_{black} and f_{white}. The existence, at some neural level of response, of categories corresponding to the sensations of black and white is supported not only by the evidence presented here but also by a wide range of psychophysical evidence. At the neurophysiological level, De Valois et al. found that the LGN of the macaque has two further types of cells beyond those playing a role in the opponent processes. Both of these were non-opponent, in the sense that each cell was either excited or inhibited relative to its basal rate by light of every wavelength. These were called excitatory non-opponent cells and inhibitory non-opponent cells, respectively. By further experimentation and analysis that we will not report here, De Valois et al. concluded that 'the non-opponent excitatory cells carry luminosity information' (974), while the opponent cells do NOT carry luminosity information (975). (For technical reasons, the investigators were unable to make a comparable test on the non-opponent inhibitory cells.) De Valois et al. concluded: 'The brightness of a light is almost certainly encoded in the firing rate of the non-opponent cells; we have presented an analysis only of the non-opponent excitatory cells, but non-opponent inhibitors appear to give comparable information (this is clearly so for the squirrel monkey as shown by Jacobs [1964]).' That is, at the level of the LGN, besides the two opponent-process systems of cells that determine the four fundamental hue sensations, we also find a separate channel, consisting of brightness-sensitive and darkness-sensitive cells that inform us regarding the whiteness or blackness of a stimulus. On this basis we posit the two additional fundamental neural response color categories f_{black} and f_{white}.

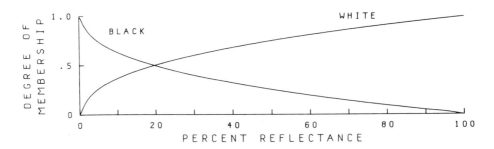

Figure 17.7
Source: Newhall et al. 1943.

Membership functions for f_{black} and f_{white} are given in figure 17.7. As we have just suggested, the neural categories f_{black} and f_{white} do not have the opponent characteristic. They may be perceived in the same part of the visual field at the same time, unlike the opponent pairs red-green and yellow-blue. This is indicated in figure 17.7 by the fact that both curves have positive values throughout the domain. When black and white are perceived together, the resulting sensation is, of course, grey, the lightness (darkness) of the grey reflecting the proportional contribution of the f_{white} (f_{black}) response. In figure 17.7, degree of membership in f_{white} is taken as the Munsell value (brightness) divided by ten, and degree of membership in f_{black} as unity minus this quantity. (The Munsell value scale runs from one to ten.) The abscissa represents the proportion of incident light that a surface reflects.

The membership functions of f_{black} and f_{white} are identical to those of the semantic categories f_{black} and f_{white} encoded by Stage V systems along with the four fundamental chromatic categories. Black and white are of course brightness categories, in contrast to the chromatics we have been considering up to now. Introduction of the brightness dimension requires a brief discussion of the fact that the dimensions of hue and brightness interact, and that both interact with the dimension of saturation (to be discussed below) in determining perceptual color categories. These interactions are illustrated in the representation of the full color space of figure 17.8. In this standard schematization of the color space, the dimensions of hue and brightness are orthogonal. The black/white (brightness) dimension is a polar axis marking the achromatic core of the color space, a line of greys that varies from black to white. Around this central axis the continuous dimension of hue circles in perpendicular planes. A color's distance out from the central axis toward the surface in a particular brightness-defined hue plane determines its chromatic purity or saturation. Chromatic purity is a measure of a color's vividness or chromaticity, an indication of how free a hue is from dilution by achromatic blacks, greys, or whites. Chromatic purity,

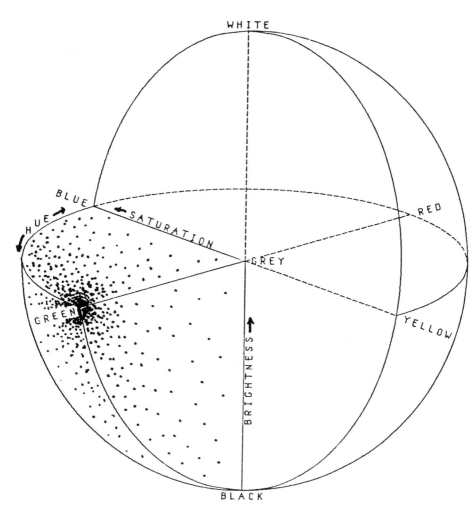

Figure 17.8
Note: Density of stippling indicates degree of membership in green.

i.e. saturation, is thus a function of the relative strengths of the chromatic (opponent) and achromatic (non-opponent) neural responses. (Figure 17.8 represents a cut-away view of the color sphere, with the upper blue-green quadrant removed, as well as both upper and lower green-yellow quadrants.)

Because hue, brightness, and saturation are all dimensions along which the neural responses that code color vary, complete membership specifications for the fundamental neural responses categories (and hence the semantic categories defined in terms of them) would require that membership in each of these categories be expressed as a function of all three dimensions. Figure 17.8 illustrates this situation for the category f_{green}. Membership in f_{green} declines, as was shown in figure 17.6, with movement away from focal green on the hue circuit. Membership in f_{green} also declines with movement from focal green toward the achromatic axis, since the greens along this path are becoming progressively less saturated. Perceived hue remains constant, but chromaticness decreases. This decline in green membership is matched by a corresponding increase in the membership of some achromatic category.

As the spheroidal shape of the color space indicates, the maximal saturation that green can have decreases, as greens darker and lighter than focal green are considered. Thus membership in f_{green} is also a function of brightness. In defining the fundamental chromatic categories, formal description of these three-dimensional membership functions is possible, but the arguments of this paper are not affected thereby; and exposition is facilitated if (as in the beginning of this section and in figure 17.6) brightness and saturation are tacitly held constant.

4.3 Fuzzy Unions, Composite Categories, and Early Stage Basic Color-Term Systems

In standard set theory, the union of two sets A, B is the set that contains everything that is in A, or in B, or in both. Thus, if the set of people eligible for cheap tickets is the union of the set of registered students and the set of people under twelve years old, people who are either registered students or under twelve or both are eligible. The union of the fuzzy sets A, B, which we will denote as 'A OR B' is defined by a function which assigns to each individual x the larger of the two values $f_A(x)$, $f_B(x)$. In symbols, we define the union of two fuzzy sets A, B by this equation:

(1) $f_{A \text{ OR } B} = \text{Max}[f_A, f_B]$

Let us suppose that we are interested in forming the union of the fuzzy sets 'competent basketball player', B, and 'competent landscape painter', P. (Perhaps we are

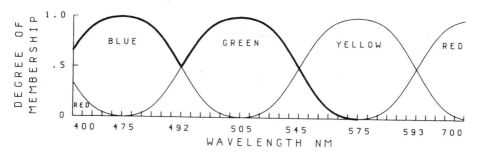

Figure 17.9
Note: Heavy line indicates $f_{green\ OR\ blue}$.

composing a guest list for a potentate whose principal avocations are basketball and landscape painting.) Let us further suppose that Kareem Abdul-Jabbar has a degree of membership of .99 in B and .02 in P; while Joe Furge, who has played semi-pro basketball and sold a few watercolors, has degrees of membership in these fuzzy sets of .5 and .6, respectively. Intuitively, our potentate will be more interested in meeting Abdul-Jabbar than in meeting Furge; and so we are glad to note that our definition of (B OR P) gives a higher degree of membership to Abdul-Jabbar (.99) than to Furge (.6), despite the fact that the sum and product of Furge's degrees of membership both exceed those of Abdul-Jabbar. In standard set theory, an individual is in the union of two sets if it is in either set; in fuzzy set theory, an individual is in the union of two sets to the greatest degree that it is in either set (not to the degree that it is in both, whatever that might mean).

All basic color-term systems prior to Stage V have at least one term that encodes a fuzzy union of two or more of the six fundamental neural response categories. A category formed by such a union will be referred to as COMPOSITE, in the sense of being composed of all the colors that have any degree of positive membership in any of the fundamental response categories from which it is formed. The composite category found most often is GRUE, equivalent to the fuzzy union $f_{green\ OR\ blue}$; cf. figure 17.9. Gatschet 1879 described a grue category as characteristic of many American Indian languages; and the recent world surveys by B & K and by Bornstein 1973a,b have shown that many of the world's languages have a basic color term that means grue.

The heavy line in figure 17.9 represents the membership values that result from evaluating $f_{green\ OR\ blue}$. (The wavelength scale in figure 17.9 has been transformed from the uniform scale of figure 17.6, to normalize the membership functions of the fundamental response categories.) An interesting feature of this membership function

is that a blue-green–appearing stimulus of, say, 492 nm is assigned a lower degree of membership in grue than a stimulus near either the blue or green focal points, 475 nm and 510 nm, respectively. This corresponds to the claim that, in languages that encode grue, the colors intermediate between focal blue and focal green are relatively poorer members of grue than either focal blue or focal green, even though these intermediate colors are nearer the mathematical center of the category. This somewhat counter-intuitive prediction, a direct product of the treatment of grue as a fuzzy union, is supported by evidence on the distribution of grue focal choices from anthropological field studies (Kay 1975a). In the experimental studies that have been conducted subsequent to B & K's work, it has been frequently observed (as B & K found for Tzeltal) that early stage categories, including grue, are often multiply-focused. In these studies, focal grue selections have often proved to be bimodal, being chosen from both the focal blue and focal green regions. But grue has never been found to be focused in the intermediate blue-green region. The absence of focal choices from this intermediate region is strong evidence that these colors have lower grue membership values, and that grue has the membership structure stipulated by the fuzzy union analysis.

Fifty-seven composite categories can be formed by taking all possible unions of two or more of the six fundamental neural response categories; but only three in addition to grue (cool) have actually been observed as basic color categories. These observed composites are 'warm' (red OR yellow), 'light-warm, (white OR red OR yellow), and 'dark-cool' (black OR green OR blue) (Kay 1975a; McDaniel 1974, MS). Only Stage I systems, like that of the Dani, are made up entirely of composite categories. At Stage I, all the fundamental neural response categories are joined into the two composite categories light-warm and dark-cool. Systems at Stages II, III, and IV contain both primary and composite categories. The transitions between these stages take place through the partial or total decomposition of composite categories, with the separate encoding of the primary categories of which they were composed. Grue is the last of the composite categories that languages lose; hence its frequency. The transition to Stage V, where all basic color categories are primary, occurs when grue is replaced by its component primaries blue and green.

Beyond Stage V, the development of basic color-term vocabularies follows a different pattern. Stage transitions no longer occur through the addition of primary categories and the loss of composites. Instead, basic color-term lexicons expand by the addition of terms that refer to regions of the color space where the fundamental neural response categories overlap. These later, 'derived' categories—brown, orange, pink, purple, and grey—are related to the fuzzy intersections of the fundamental response categories.

4.4 Fuzzy Intersection, Derived Categories, and Later Stage Basic Color-Term Systems

In standard set theory, the intersection of two sets A, B is the set that contains just those individuals that are members of A and also members of B. The intersection of fuzzy sets A, B—denoted here as 'A AND B'—is defined by a function that assigns to each individual x the smaller of the two values $f_A(x)$, $f_B(x)$. In symbols, the intersection of the fuzzy sets A, B is defined by this equation:

(2) $f_{A \text{ AND } B} = Min[f_A, f_B]$

If the category corresponding to the fuzzy set 'green AND yellow' is called *chartreuse* (as it is by some speakers of English), then *chartreuse* encodes a category whose membership function has the values indicated by the heavy line in figure 17.10 (or perhaps some monotone function thereof, a point to which we return below). Colors below 505 nm and above 575 nm have zero degree of membership in this category. As one advances to the right from unique green (505 nm) and to the left from unique yellow (575 nm), one initially finds quite poor examples of chartreuse; but as one continues from either end, the stimuli exemplify chartreuse increasingly well, with membership values reaching a maximum somewhere around 545 nm.

Chartreuse is a non-basic color term in English; yet the category it encodes shares an important property with the basic color categories that are added in the later stages of basic color-term development, i.e. brown, orange, pink, purple and grey. Like chartreuse, these later-stage basic color categories have membership functions whose positive (non-zero) ranges are restricted to regions of the color space where two of the fundamental response states co-occur, i.e. to regions where two adjacent fundamental response categories overlap. Brown is found in the region where **yellow** and **black** overlap, pink where **red** and **white** overlap, purple where **red** and **blue** overlap, orange where **red** and **yellow** overlap, and grey where **black** and **white**

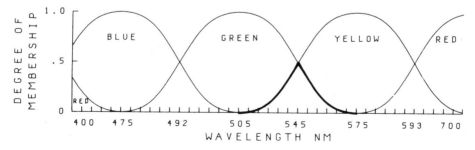

Figure 17.10
Note: Heavy line indicates $f_{\text{green AND yellow}}$.

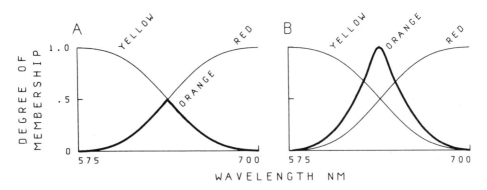

Figure 17.11
Note: B is the preferred formulation for reasons given in the text.

overlap. Thus, as with chartreuse, the regions over which later stage basic categories have positive values are regions where fuzzy intersections of certain fundamental response categories are positive.

Fuzzy intersections can thus be used to specify the regions where later-stage basic color categories have positive membership values; but the actual membership values which these categories have in these regions are not precisely the values that the simple fuzzy intersections yield. Consider orange: in figure 17.11A, this category is modeled as identical to the fuzzy set $f_{\text{yellow AND red}}$. This model makes two claims that are contradicted by both casual and experimental observations. First, the model claims that there are no really good examples of orange. The maximum of the membership function for orange, when modeled this way, is well below the maxima for the previously encoded primary categories yellow and red; in fact it is precisely 0.5. This contradicts experimental evidence that subjects are essentially as confident about assigning good examples of orange to orange as they are about assigning good examples of red to red, or good examples of any other primary category to that category. Many subjects declare that for them orange is just as fundamental a category— just as distinctive a color sensation—as any of the six primaries (Sternheim & Boynton 1966). Second, this model implies, not only that there are no really good examples of orange in comparison to the primaries, but also that there is no hue sensation with a higher degree of membership in orange than in either red or yellow. Every hue point under the left half of the orange membership function in figure 17.11A has a higher degree of membership in yellow than in orange, and every point under the right half has a higher degree of membership in red than in orange. As is shown by subjects' confidence about the existence of good oranges, there is

unquestionably a range of hues that speakers of English more readily label *orange* than either *yellow* or *red* in both experimental and natural contexts.

These observations require that we abandon the simple fuzzy intersection model of orange, illustrated in figure 17.11A, in favor of a model which allows some colors to have a higher degree of membership in orange than in either yellow or red, and which also has a membership function whose maximum is unity. Since orange encodes the simultaneous occurrence of yellow and red, the best examples of orange (i.e. the colors with the highest degrees of membership in orange) will be those that are most nearly equal in their yellowness and redness. In other words, as the absolute difference between a color's degree of yellowness and degree of redness decreases, its orangeness approaches unity. The fuzzy set 'orange' is therefore defined, over the region of the spectrum where $f_{\text{red AND yellow}} > 0$, by

$$(3) \quad f_{\text{orange}}(x) = 1 - |f_{\text{yellow}}(x) - f_{\text{red}}(x)|$$

The membership function for orange that this equation yields is shown by the heavy line in figure 17.11B. This function reaches its maximum of unity at the point where the functions f_{yellow} and f_{red} intersect. Also, at the yellow and red unique hue points, the value of the absolute difference term is unity; hence the degree of membership is zero, as desired, at these boundary points. Equations of the same general form can be constructed to derive membership functions for all of the later-stage categories. The basic categories whose membership functions are formed in this fashion are thus referred to as DERIVED basic color categories.

While Equation 3 is not the simple fuzzy intersection $f_{\text{yellow AND red}}$, it can be rewritten in a form that relates f_{orange} directly to the fuzzy intersection $f_{\text{yellow AND red}}$. It will be recalled that each of the four fundamental chromatic response categories reflects the PROPORTION of total chromatic response resulting from the particular response state at each wavelength. Consequently, at each wavelength, the sum of the four fuzzy set functions f_{red}, f_{yellow}, f_{green}, and f_{blue} is unity. Furthermore, within the interval in which orange is defined, the functions f_{blue} and f_{green} both have the value zero; hence, in this interval, the functions f_{red} and f_{yellow} sum to unity. Recalling that Equation 2 defines $f_{\text{red AND yellow}}$ as the minimum of the functions f_{red} and f_{yellow}, it follows that, in this interval, (a) the smaller of the two functions f_{red}, f_{yellow} will always be equivalent to $f_{\text{red AND yellow}}$; and (b) the larger of the two will always be equivalent to $1 - f_{\text{red AND yellow}}$. Thus Equation 3 may be rewritten

$$(3') \quad f_{\text{orange}}(x) = 1 - (1 - f_{\text{red AND yellow}}(x) - f_{\text{red AND yellow}}(x))$$
$$= 1 - 1 + 2f_{\text{red AND yellow}}(x)$$

$$(4) \quad f_{\text{orange}}(x) = 2f_{\text{red AND yellow}}(x)$$

That is, membership in a derived category such as orange, though not equivalent to the fuzzy intersection of the membership functions of its two constituent categories, is equivalent to twice this intersection.[12]

While Equations 3–4 assign the same membership function to orange, they may represent two distinct cognitive processes in the formation of derived categories. Assuming that the fuzzy set operations referred to in these equations correspond in some way to actual neural and cognitive events, 3 and 4 make different claims about the cognitive processes available for derived color-category formation. Equation 4 suggests that the only operations needed for the formation of a derived category are fuzzy intersection and scalar multiplication. Equation 3, however, suggests the existence of three entirely different cognitive operations. Membership in orange, according to 3, is determined by taking (a) the complement of, (b) the absolute value of, (c) the difference between two functions representing membership in fundamental response categories. Making a choice between 3 and 4 can thus have general cognitive implications. For example, if 3 is taken as the proper representation of orange, this encourages consideration of the role which complement operations play in fuzzy domains. Accepting 4 provides no such motive. In addition, the simple fact that there may be processually distinctive cognitive paths by which the same semantic structure can be formed suggests that semantic processes and semantic structures may sometimes be independent. For example, one might be able to examine experimentally the hypothesis that different individuals—or a given individual under varying conditions—would process the semantic category orange in ways that sometimes suggested 3, and sometimes 4.

There is indirect evidence indicating that these and the other equations used in this paper to relate semantic to neural structures are in fact representative of real neural and cognitive events, albeit at a grosser level. Taking the equations presented in this paper as models of actual cognitive processes, using either 3 or 4 as a model of the cognitive process which underlies derived categories would be to assert that these categories have more complex cognitive bases than do the primary categories based on the identity relation. A likely observable effect of this greater cognitive complexity would be an increase in the time needed by subjects to determine derived category memberships, over the time needed to determine primary category memberships. Heider found just this effect in a study of English focal color naming, even though the 'focal' colors used in the study were probably not optimal for a proper test of this hypothesis. Her finding was that the 'primary focal colors black, white, blue, green, yellow, red were named significantly more rapidly than the non-primary focal colors pink, brown, orange, purple; $t(22) = 2.86$, $p < .01$ (for correlated measures)' (1972b: 15).[13]

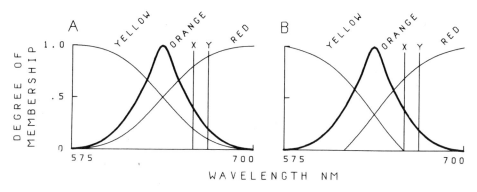

Figure 17.12
Note: Formulation A, in which there is no change in the primary categories, is preferred for reasons given in the text.

Apart from the details of their formal (or cognitive) representation, another question raised by the emergence of derived categories in post–Stage V systems is the possible effect of the emergence of these categories on the primary categories from which they are derived. It was noted above that the encoding of a primary category is accompanied by decomposition of some previously existing composite category. What might seem a comparable effect of the encoding of a derived category would be contraction of the membership functions of the primary categories from which it is derived. This possibility is illustrated for orange, yellow, and red in figure 17.12B. There are data, however, which indicate that the non-contracted membership functions for yellow and red shown in figure 17.12A are retained by yellow and red even after orange is encoded. In an experiment conducted by Sternheim & Boynton, subjects were asked to name ten long-wavelength (530–620 nm) stimuli under a variety of naming conditions. One condition allowed subjects to use the names *yellow*, *red*, and *orange*. In this condition, the yellow and red naming-functions were like the retracted functions shown in figure 17.12B. A second condition required that subjects use only the terms *yellow* and *red*, although a null response was accepted if a subject felt that neither *yellow* nor *red* was appropriate. In this condition, the naming functions for yellow and red expanded to approximate the non-contracted functions shown in figure 17.12A. These results suggest that, as derived categories are encoded, the underlying membership functions of the primary categories remain unchanged, while competition between the memberships which colors have in the old primary categories and the newly encoded derived categories alters surface naming behavior in many (but not all) contexts.

Our intuitions about the use of primary basic color terms in comparative constructions also support the model of orange, yellow, and red depicted in figure 17.12A. An English speaker discussing the two oranges denoted by x and y in figures 17.12A and 17.12B might distinguish them by saying that y is redder than x, since in both figures $f_{red}(y) > f_{red}(x)$. By the model represented in figure 17.12A, the speaker could as well say that x is yellower than y, since $f_{yellow}(x) > f_{yellow}(y)$. However, if f_{yellow} is contracted, as in figure 17.12B, then $f_{yellow}(x) = f_{yellow}(y) = 0$, and our speaker won't be able to use relative yellowness to distinguish x and y. Thus, by the model in figure 17.12B, there is a region of the spectrum where a speaker can describe a first orange as redder than a second, but not the second as yellower than the first. An experiment might show this to be the case; but our intuition is that any orange that is redder than another is also less yellow, and therefore the second will always be describable as yellower than the first. This intuition is taken as further argument in support of the analysis of derived categories shown in figures 17.11B and 17.12A.

While a simple intersection model of orange and the other derived basic categories has been rejected, it may be that simple intersection is the appropriate model for secondary color categories corresponding to non-basic terms such as *chartreuse*. Like derived categories, these categories are psychophysically mixtures of the fundamental response categories. Treating *chartreuse*, for example, as $f_{yellow\ AND\ green}$ would locate $f_{chartreuse}$ in the appropriate region of the color space with an intuitively acceptable membership function. In addition, this formal move would entail the empirical claim that, for speakers with *chartreuse* in their active vocabulary, any stimulus which they would judge as chartreuse would be judged as an equally good or better representative of yellow or of green. This speculation is not immediately rejected by introspection; however, we know of no systematic data that support it. If some subjects were found to react to appropriate stimuli with the labels *chartreuse*, *yellow*, and *green* in the manner just suggested, while others were found to use *chartreuse* in the way they generally use labels for basic (derived) categories such as orange, this could be taken as evidence for the assertion that *chartreuse* has achieved basic color-term status for the latter group, but not the former. Fuzzy set-theoretic representations of color categories might thus prove useful in yet another way, this time in their ability to aid in the sometimes difficult task of distinguishing basic and non-basic categories. (Several controlled field studies have shown orderly variation among speakers in a given community with regard to the number of basic color categories they have; see Kay 1975 for a summary.)

The use of characteristics of color-category membership functions to distinguish between basic and non-basic categories suggests a natural way to enrich the notion

of basicness itself. The basicness of a color category could be taken as the degree to which its membership function approximates a characteristic (prototypic) membership function of one of the three types of basic category described above. We are not aware of any extant empirical evidence bearing on this speculation.

4.5 Summary of the Fuzzy Set Formulation for Basic Color Categories

Basic color terms are universally associated with a small set of non-discrete though well-defined semantic categories. The formalism of fuzzy set theory provides a natural framework for the description of these universal and non-discrete categories. It also allows a formal set-theoretic characterization of the relations which these fuzzy categories bear to neural categories inherent in the perception of color.

All basic color categories are formed from the human visual system's six fundamental response categories by one of three fuzzy-logical operations: identity, fuzzy union, or fuzzy intersection, sometimes along with one or more non-fuzzy operations. Identity with the six fundamental response functions is the basis of the primary basic color categories black, white, red, yellow, green, and blue. Fuzzy unions of fundamental response categories are the basis of the four composite basic-color categories light-warm, dark-cool, warm, and cool (grue). Fuzzy intersections of fundamental response categories are the basis of at least five derived basic color categories—brown, pink, purple, orange, and grey.[14] Thus where B & K described eleven universal basic color categories of a single logical type, there are in fact at least fifteen basic color categories of three types (McDaniel 1974, MS), distinguished by the relations which their semantic structures bear to the visual system's fundamental neural response categories for color. Table 17.2 is a summary listing of these categories, showing the three types of fuzzy set operations that relate them to the fundamental neural response categories.

The basic color categories formed by each fuzzy logical operation share a number of semantic properties. The fuzzy membership functions of the six primary basic categories, being based on identity with the fundamental response categories, share all the properties common to the fundamental categories. Each category has a single membership maximum, i.e. a single focus, at a physiologically defined unique hue point. Membership in these categories declines continuously as colors perceptually more distant from these maxima are considered, reaching zero at the unique hue points adjacent to the focal unique hue points. These characteristics of primary basic color-category membership functions are illustrated in figures 17.6 and 17.7.

In contrast, composite categories, based on fuzzy union, have multiple membership maxima (foci); and colors increasingly distant from a focus do not necessarily have lower degrees of membership. The unique hue points of the two or three

Table 17.2

Neural response categories	Semantic categories based on identity	
f_{black}	f_{black}	= black
f_{white}	f_{white}	= white
f_{red}	f_{red}	= red
f_{yellow}	f_{yellow}	= yellow
f_{green}	f_{green}	= green
f_{blue}	f_{blue}	= blue
	Semantic categories based on fuzzy union	
$f_{black\ OR\ green\ OR\ blue}$	$f_{black\ OR\ green\ OR\ blue}$	= dark-cool
$f_{white\ OR\ red\ OR\ yellow}$	$f_{white\ OR\ red\ OR\ yellow}$	= light-warm
$f_{red\ OR\ yellow}$	$f_{red\ OR\ yellow}$	= warm
$f_{green\ OR\ blue}$	$f_{green\ OR\ blue}$	= cool; grue
	Semantic categories based on fuzzy intersection	
$f_{black + yellow}$	$f_{black + yellow}$	= brown
$f_{red + blue}$	$f_{red + blue}$	= purple
$f_{red + white}$	$f_{red + white}$	= pink
$f_{red + yellow}$	$f_{red + yellow}$	= orange
$f_{white + black}$	$f_{white + black}$	= grey

fundamental response categories encompassed by a composite category are the (multiple) foci of the category. Membership in the category does decline to zero for colors between one of the focal unique hue points and a non-included unique hue point. For the colors between unique hue points that define foci, membership values decline away from each focus, but do not reach zero. Instead, a positive minimal membership value is reached somewhere between the two foci. Figure 17.9 shows a membership function with these characteristics.

Derived category formation from modified fuzzy intersections produced membership functions with structural characteristics analogous to those of the primary basic color categories. As with the primaries, derived category membership functions reach maxima at single points in the color space, declining continuously from these foci to zero at the unique hue points adjacent to them. But while the primary and derived categories share these structural characteristics, they differ significantly in their patterns of neural association. In particular, while the foci of the primary (and composite) categories are associated with physiological unique hue points, the foci of the derived categories are not. Derived category foci are associated with points in the color space perceptually equidistant between the two unique hue points that define the category's boundaries. Simple fuzzy intersections yield functions that assign the correct colors positive degrees of membership in the derived categories, but a scalar multiplication of these functions is necessary to produce the actual membership

values appropriate for these categories. Figures 17.11B and 17.12A illustrate a membership function of this type.

In general, formulating basic color categories as fuzzy sets, rather than in terms either of discrete features or of foci and boundaries, allows us to construct models of these categories more in accord with our empirical knowledge of their semantic structure. It also provides descriptions of basic color categories that can be derived directly from the neural response patterns that underlie the perception of color. As discussed below, the fuzzy set formalism also allows a succinct formal restatement of B & K's model of basic color-term evolution.

5 The Evolution of Basic Color Categories

5.1 Composite, Primary, and Derived Basic Color Categories and Their Relations to the Processes and Pattern of Basic Color-Term Evolution

As noted in the discussions above, primary, composite, and derived basic color categories differ not only in their characteristic semantic structures, and in the relations they bear to the fundamental neural response categories, but also in the stages of basic color-term development with which they are associated. Composite categories are found only prior to Stage V. No primary categories exist at Stage I, and only at Stage V and beyond are all the primaries encoded. The derived categories begin appearing only after Stage V. Figure 17.13 illustrates these relations, recasting the original B & K evolutionary sequence in terms of the fuzzy set-theoretic basic color categories described above.[15]

Figure 17.13 embodies a re-interpretation of the evolutionary sequence that views the development of the basic color-term lexicon not as the successive encoding of foci, but as the successive differentiation of previously existing basic color categories (McDaniel 1974, MS). Beginning at Stage I with the composite categories light-warm and dark-cool (as illustrated by Dani *mola* and *mili*; Heider 1972a), Stages II–V in the evolutionary sequence involve the decomposition of composites into their constituent primaries. First the white component of the light-warm category is lexically distinguished, producing the white, warm, dark-cool configuration of Stage II systems. The Bellonese color system described by Kuschel & Monberg is of this type. Next, either dark-cool is decomposed into black and cool, or warm is split into its red and yellow constituents. The first alternative results in a Stage IIIa configuration, as described for Aguaruna by Berlin & Berlin and for West Futunese by Dougherty 1974, 1975. The second leads to a stage IIIb system, as Hage & Harkes describe for Binumarien. Whichever of these decompositions is not accomplished at Stage III

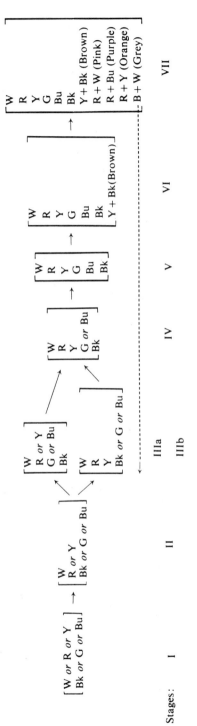

$$
\begin{bmatrix} W \text{ or } R \text{ or } Y \\ Bk \text{ or } G \text{ or } Bu \end{bmatrix} \rightarrow \begin{bmatrix} W \\ R \text{ or } Y \\ Bk \text{ or } G \text{ or } Bu \end{bmatrix} \nearrow \begin{bmatrix} W \\ R \text{ or } Y \\ G \text{ or } Bu \\ Bk \end{bmatrix}
$$

$$
\begin{bmatrix} W \\ R \\ Y \\ Bk \text{ or } G \text{ or } Bu \end{bmatrix} \nearrow \begin{bmatrix} W \\ R \\ Y \\ G \text{ or } Bu \\ Bk \end{bmatrix} \rightarrow \begin{bmatrix} W \\ R \\ Y \\ G \\ Bu \\ Bk \end{bmatrix} \rightarrow \begin{bmatrix} W \\ R \\ Y \\ G \\ Bu \\ Bk \\ Y + Bk \text{ (Brown)} \end{bmatrix} \rightarrow \begin{bmatrix} W \\ R \\ Y \\ G \\ Bu \\ Bk \\ Y + Bk \text{ (Brown)} \\ R + W \text{ (Pink)} \\ R + Bu \text{ (Purple)} \\ R + Y \text{ (Orange)} \\ B + W \text{ (Grey)} \end{bmatrix}
$$

Stages: I II IIIa IV V VI VII
 IIIb

Figure 17.13

is achieved in the transition to Stage IV, producing a system that lexicalizes the primaries black, white, red, and yellow, as well as the most enduring of the composites, grue (cool). Such Stage IV systems have been experimentally observed among more acculturated speakers of Aguaruna (Berlin & Berlin) and Futunese (Dougherty 1975), and among the Mam (Harkness); from the investigation of general ethnographic and linguistic sources, Stage IV systems appear to include the majority of New World languages (Bornstein 1973a,b; Hays et al. 1972). Stage V is achieved with the differentiation of cool into its green and blue primary constituents, completing the decomposition of the composites. Mam Spanish (Harkness) is an example of such a system.

At Stage VI and beyond, differentiation proceeds through the encoding of intersections of the primaries. At Stage VI, brown encodes the intersection of yellow and black. Stage VII extends the privilege of name to white + red (pink), red + yellow (orange), red + blue (purple), and usually to black + white (grey).[16] This view of the later-stage, derived categories suggests that if no language investigated so far has more than eleven basic color terms, with the possible exception of Russian (see B & K, 35–36), this is more an accident of the present moment in world history than a theoretical inevitability. Russian *goluboy* 'light blue' (white + blue) is a potential instance of a twelfth basic color term; it is surely a basic term for some Russian speakers, though probably not for all.[17] There is no certainty that *goluboy* will not, at some point in the future, achieve basic term status for all speakers of Russian. Similarly, it is possible that several now non-basic color terms in English, used to name intersections of fundamental response categories, will become basic in the future, e.g. *aqua/turquoise* (green + blue), *maroon/burgundy* (black + red), and *chartreuse/lime* (yellow + green). Some of these may already be basic terms for some speakers. The process that characterizes derived category formation has not been logically exhausted by any known language; so there is no apparent reason to believe that the process will not continue, extending basic color-term lexicons beyond their present eleven terms.

5.2 *Fuzzy Partitions: A Formal Characterization of the Encoding Sequence*

In formalizing the discussion of the evolutionary sequence, it is desirable to extend fuzzy set theory in a minor way by developing the concept of fuzzy partition. In standard set theory, a collection of sets partitions a set S just if (a) each set in the collection is a subset of S, (b) everything in S is a member of one of these subsets, and (c) nothing in S belongs to more than one of these subsets.[18] Such subsets are often called the cells or blocks of the partition.

There is an intuitive use of the word 'partition' in which it is obvious that every color terminology 'partitions' the universe of color percepts, and in which the transition from stage to stage in the evolutionary sequence (until Stage V is reached) involves moving from a coarser to a finer partition. This intuitive usage can be explicated as follows. We note first that each color category is a fuzzy subset of (is fuzzily contained in) the set of all color percepts. This follow from the fact that, for each individual in the domain, its degree of membership in the fuzzy set 'color percept' (which is unity) is greater than or equal to its degree of membership in any given color term.[19] Hence any color category is formally a fuzzy subset of the set of color percepts. Thus, in speaking of fuzzy partitions, we can directly take over condition (a) of standard set theory that the cells of the partition be subsets of the set being partitioned. Condition (b), the exhaustiveness condition, can also be directly taken over into the definition of fuzzy partition, if we translate 'belongs to' as 'having a non-zero degree of membership in.[20]

While conditions (a) and (b) can be taken over from standard set theory, condition (c) must be modified, since distinct but adjacent basic categories have considerable overlap. As shown above (see figure 17.6), every green above 505 nm (unique green) is also to some positive degree yellow, and every green below 505 nm is to some degree blue. Thus all greens except the unique green at 505 nm are to some degree also yellow or blue. These are not suppositions of the formalism, but facts for which the formalism must account.

These facts can be dealt with by replacing the mutual exclusion condition (c) of standard set theory by a statement to the effect that each cell of a fuzzy partition has at least one member that belongs to no other cell. Thus, given a fuzzy set S and a collection of fuzzy sets $F = \{F_1, F_2, \ldots, F_n\}$,

(5) F is a fuzzy partition of S just if

(i) each F_i in F is a subset of S;
(ii) each x in S has a degree of membership greater than zero in at least one F_i in F; and
(iii) Each F_i in F contains at least one member x_i such that the degree of membership of x_i in every other member F_j of F ($F_j \neq F_i$) is zero.

From this definition of fuzzy partition, it follows that the set of fundamental response categories (**black**, **white**, **red**, **yellow**, **green**, and **blue**) is a partition of the universe of color percepts. Since every color category is a subset of the set of color percepts, condition (i) is satisfied. As evidence for the satisfaction of (ii), we note the fact that subjects given labels for black, white, red, yellow, green, and blue can successfully classify any color stimulus (Hering; Sternheim & Boynton). The evidence

that condition (iii) is met is that, for each of these categories, color stimuli exist that are classifiable in that category and not in any of the other five.

Having shown that the fundamental response categories are a partition of the universe of color percepts, we can show that every basic color-term lexicon is a partition, or contains a partition, of the universe of color percepts. To see how this is so, we consider in turn Stage V systems, systems later than Stage V, and finally systems prior to Stage V.

Stage V systems consist of just the six primary color categories whose identity with the six fundamental response categories makes them ipso facto a partition of the set of color percepts.

Systems later than Stage V contain all the Stage V primary categories. If we assume, as argued in section §4.4, that the membership functions of the primary categories do not contract with the encoding of derived categories, these systems therefore contain a partition of the color space.

Systems earlier than Stage V are made up of primary and composite categories that together exhaust the list of fundamental response categories. It is easy to show that, if we start with a set F of subsets of a set S, where F is a fuzzy partition of S, and create a new set of subsets of S by taking fuzzy unions of the members of F in such a way that every member of F occurs in exactly one of the unions, then the resulting collection of subsets of S is also a fuzzy partition of S.[21] Since the early-stage systems can be viewed as formed from the fundamental response category partition in just this manner, basic color category Stages I–IV also constitute fuzzy partitions of the domain of color percepts. Thus, at any stage, the basic color categories comprise or contain a set of categories that partitions the entire color space. From this it follows that, at every stage, basic color-term vocabularies provide terms for all colors.

Given the fuzzy partition perspective, Stages I–V can be seen as a continuous refinement of partitions of the color domain—where 'refinement of a partition' refers to the creation of a new partition which classifies separately everything classified separately in the old partition, and in addition classifies separately at least two individuals classified the same in the old partition. The addition of derived basic color categories subsequent to Stage V does not in this sense refine the partition, since the derived categories do not satisfy condition (iii) of the fuzzy partition. This follows from the argument made above that primary basic categories do not contract with the emergence of derived categories, and the resulting fact that no color sensation belongs to a derived category if it does not also belong to a primary category. In fact, every stimulus in a derived category belongs to both of the categories from which it is derived. That derived categories do not refine the partition of the color space, in

the sense given above, supports the observation that derived categories are fundamentally less important than primary categories. Derived categories are thus gratuitous in two senses: (a) any color sensation can be referred to without using any of them, and (b) no color sensation can be referred to exclusively by any one of them.[22]

In this context, it may be asked whether derived categories should be considered basic color categories at all. In defining 'basic color term', B & K had tacitly in mind a standard set-theory model when they wrote: 'A basic color term's significance is not included in that of any other color term' (p. 6). We can ask whether a basic but non-primary category like orange satisfies the translation of this criterion into fuzzy set theory. The answer is that it does. Orange, e.g., is not fuzzily contained in either red or yellow (or any other color category). A fuzzy set, say that defined by $f_{red}(x)$, contains another, say that defined by $f_{orange}(x)$, just in case $f_{red}(x)$ exceeds $f_{orange}(x)$ for any x. But, as derived orange has been defined (Equations 3–4), this holds neither for red and orange nor for yellow and orange (see figures 17.11B and 17.12A). Thus the notion that non-primary, derived categories are nonetheless basic color categories survives the translation into the fuzzy set model.

6 Conclusions

We have reviewed evidence that the semantics of color display substantial linguistic universals; and that these semantic universals, which explain a considerable range of both synchronic and diachronic linguistic fact, are based on pan-human neurophysiological processes in the perception of color. We interpret these findings as placing strict limits on the applicability of the Sapir-Whorf hypothesis and related hypotheses of extreme linguistic/cultural relativity.

We have found further that the facts of color semantics are modeled felicitously in fuzzy set theory, and are not readily modeled in the traditional theory of discretely contrasting semantic features. This finding casts doubt on the general usefulness of the feature model, and suggests that more powerful formalisms, employing a range of structures much broader than the restricted Boolean algebra implicit in the discrete semantic-feature approach, are probably necessary to provide realistic accounts of the meanings of words (Fillmore 1975, Kay 1975b, Lakoff 1972).

Acknowledgments

We have benefited greatly regarding the matters discussed here from the ideas of John Atkins, Brent Berlin, Janet Dougherty, Craig Molgaard, Sue Thompson, Bill Wooten, and an anonymous reader for *Language* named George Lakoff.

Notes

1. For recent challenges to this view, see Lakoff 1972, Fillmore 1975, Kay 1975b.

2. For further discussion of the concept 'basic color term', see B & K (p. 5 ff.) and Kay 1975a.

3. The stimulus array consisted of 329 Munsell color chips, including (a) 320 chromatic chips representing a uniform sampling of the colors on the outer skin of the perceptual color solid, where the most highly saturated colors of every hue and brightness are found; and (b) nine neutral, achromatic chips ranging from black through grey to white. For the reader unfamiliar with the color-solid model of the psychological color space, the important point here is that the stimulus array represents a reasonable sampling of the estimated seven million distinguishable colors. For further discussion of the stimuli, see B & K (5; 160, fn. 3; 162, fn. 12).

Collier 1973 and Collier et al. 1976 have examined the possibility that restricting the selection of chromatic chips to the maximally saturated chips at each hue and brightness level may have biased B & K's results; but it was found that no such bias exists.

4. The studies encompass one Jivaroan language, one Mayan, one Papuan, one Eskimoan and three Austronesian (Berlin & Berlin 1972, Harkness 1973, Hage & Hawkes MS, Heinrich 1972, Dougherty 1974, 1975, Heider 1972a,b, and Kuschel & Monberg 1974). These data have been critical in the development of our new understanding of the encoding sequence. The results of these studies, as regards the substance of the encoding sequence, are summarized in Berlin & Berlin 1975, Dougherty 1975, Kay 1975a, and McDaniel 1974, MS.

5. A number of recent studies have noted that a relation exists between the B & K semantic results, on the one hand, and, on the other, either (a) the results of the micro-electrode studies of De Valois and his co-workers, (b) the abstract opponent-process model of Hering, (c) other material in the physiological and psycho-physical vision literature, or (d) some combination of these. None of these studies traces in detail the line of argument developed here and, in any case, limitations of space preclude any attempt to summarize their contents. These studies include Bornstein 1973a,b, 1975; Cairo (MS); Faris 1974; Miller & Johnson-Laird (1976: 342–55); Ratliff 1976; Sahlins 1976; Stephenson 1973a,b; 1976; Witkowski & Brown 1977; and Zollinger 1972, 1973, 1976.

6. The words **red, yellow, green**, and **blue** in boldface refer to response states of LGN cells in an organism that need not have color words at all. That is, they label neural responses which are shared by macaques, humans, and probably all higher primates. As such they have no NECESSARY relation to the corresponding English words or their meanings; but we will see that, empirically, there is a strict relation between these response states and the meanings of color words. Later, when we have established the identity of certain universal semantic categories with neural response categories, it will not always be necessary or desirable to maintain a distinction in notation.

7. This and subsequent sections present, for the convenience of the non-mathematical reader, a non-rigorous description of the basic elements of fuzzy set theory. The mathematical reader is referred to Zadeh 1965, 1971.

8. Actually, the range of the function may be expressed more generally, but we need not be concerned with such mathematical niceties here.

9. Rosch (1973, MS) has also extended, into semantic domains other than color, the notion that semantic categories can be defined in terms of approximation to prototypes.

10. McDaniel did not investigate the relation of unique to focal red because of limitations in the equipment available to him (see fn. 10). There is no reason to suspect, however, that a test of that relation would have yielded a result different from that found for yellow, green, and blue.

11. This is an oversimplification: actually, the purest sensation of red occurs with presentation to the visual system of no monochromatic light, but rather of a mixture of mostly long-wavelength and a little short-wavelength light (Dimmick & Hubbard 1939). That is, the subjectively purest red is in physical terms a kind of 'purple', a mixture of lights of long and short wavelengths. (McDaniel could not study red in his experiment, because only one source of single wavelength light was available.) This complication does not vitiate the present argument, because the phenomenon in question equally affects the neural response

category f_{red} and the semantic category f_{red}. We may thus, without loss of generality, treat unique red as if it corresponded to a single wavelength near the long end of the visual spectrum.

12. We are indebted to John R. Atkins for pointing out to us the equivalence of Equations 3 and 4.

13. The absolute order of reaction times was not in exact agreement with the hypothesis. Whereas orange, purple, pink, and brown should have had the four longest response latencies, the actual rank order of latencies was (from shortest to longest) black, yellow, white, PURPLE, blue, red, pink, brown, GREEN, orange (Heider 1972b: 15). But there are at least two difficulties with Heider's methodology which suggest caution in interpreting these results. First, she determined 'focal' colors by taking the 'geometric centers' of the areas enclosing all the focal choices in the B & K data (p. 9; Heider 1972b: 12). Unfortunately, focal greens in B & K were over-extended toward blue because Vietnamese *xanh* 'grue', which has a near-unique blue focus, was misclassified as green. Thus the 'focal' green which Heider used, Munsell 7.5G 5/10, is rather distant in both hue and saturation from the 10GY and 2.5G, Munsell colors typically chosen as focal greens. This particular difficulty might help explain the especially low position of green in the response latency rankings.

Second, and more important, B & K obtained their focal color judgments, which Heider used to select her stimulus materials, under a standard illuminant A, while Heider conducted her tests with daylight fluorescent illumination. The difficulty here is that object colors can shift radically with changes in illuminant conditions. Thus Heider's relatively well-defined illuminant A focals may have been poor approximations to the focal colors when viewed under her daylight fluorescent illuminant conditions. A less than ideally constituted set of stimuli for the given experimental conditions may therefore be partly responsible for the somewhat equivocal nature of these results.

14. The formulation we have given for orange generalizes directly to purple, whose two constituent primary categories are both hue categories. The same may be true for grey, both of whose constituent primaries are achromatic. The algebraic formulation given in Equation 3 may perhaps generalize also to the categories pink and brown, each of which is based on one hue constituent and one achromatic constituent; but the special relations obtaining between the primary hues that permit the derivation of 4 from 3 do not apply in the case of pink and brown. Henceforth, we will use the symbol '+' to denote whatever function, known or unknown, relates two primary categories to produce a derived category. Thus we will write '$f_{orange} = f_{red+yellow}$', '$f_{pink} = f_{red+white}$', etc. The symbol '+' so used does not denote a single, well-defined fuzzy operation.

15. The empirical facts relevant to the restatement of the encoding sequence represented in figure 17.13 are presented in the works cited in note 4, above.

16. The dotted arrow in figure 17.13 indicates that grey may occur (albeit infrequently) 'as a wild card at various points in the sequence' (B & K, 45). Whereas B & K originally guessed that grey might occur, 'say at any point after Stage IV', more recent information shows that it may occur at any stage from IIIa onward, or possibly even earlier (Barry Alpher p.c.; MacLaury MS). For further discussion, see Kay (1975a: 261).

17. Cf. Daly MS. Other Slavic languages have monolexemic terms for 'light blue', but these appear to be basic terms for very few speakers, if any.

18. For example, the cells of a jail normally provide a partition of the set of prisoners, since every prisoner is assigned to a cell, and no prisoner is assigned to more than one cell.

19. The set of color percepts is, of course, a standard set and it therefore a fuzzy set, since every standard set is also a fuzzy set—in particular, the special case of a fuzzy set in which all values of the characteristic function are either zero or unity.

A fuzzy set A is contained in (is a subset of) a fuzzy set B if, for all x in the domain of discourse, $f_B(x) \geqslant f_A(x)$.

20. Zadeh cautions: 'the notion of "belonging" [membership], which plays a fundamental role in the case of ordinary sets, does not have the same role in the case of fuzzy sets. Thus, it is not meaningful to speak of a point x "belonging" to a fuzzy set A except in the trivial sense of $f_A(x)$ being positive' (1965: 342). We will henceforth use 'belong' in just this sense, since with respect to color the notion is not trivial. Zadeh appears to have in mind applications in which few, if any, individuals in the relevant domain will have zero membership in any of the fuzzy sets under discussion. Such is not the case in color. For example, no

color percept belongs both to red and to green. The same holds for blue and yellow. In discussing color percepts and categories, it is often of interest to know if a given percept belongs (to ANY POSITIVE degree) to a certain category. Similarly, it is often of interest to know whether two categories have members in common, like green and yellow, or are disjoint, like green and red.

21. We want to prove that if (a) S is a fuzzy set, (b) F is a fuzzy partition of S, and (c) F′ is a set whose members are unions of the cells of F, then F′ is a fuzzy partition of S. Obviously the members of F′ are subsets of S; e.g., grue is a subset of the set of color percepts. So condition (i) is satisfied. With respect to condition (ii), for each x in S, x belongs to whatever member of F′ contains F_i as a subset; e.g., if some x in S belongs to green, then it belongs to grue. So condition (ii) is satisfied. With respect to condition (iii), each member of F′ contains a subset F_i which is guaranteed to have a member with the desired property, by virtue of the fact that F satisfies condition (iii); e.g., grue contains green as a subset, and the unique hue point of green has the desired property. Thus condition (iii) is satisfied, and the proof is complete.

22. As noted, the way we have defined fuzzy partition excludes derived categories from being possible cells of a partition, because they do not meet the mutual exclusion condition (iii). Fuzzy partition may be alternatively defined with a weakened mutual exclusion condition which is met by derived color categories as well as by the primaries.

Recall that, in the original statement of fuzzy mutual exclusion (iii), a collection of fuzzy sets meets this condition just if, for each fuzzy set, there is an individual that has positive membership in this set and zero degree of membership in each other set in the collection. This may be weakened by defining a collection of fuzzy sets as mutually exclusive just if, for each fuzzy set, there is an individual that has a higher degree of membership in this set than in any other set in the collection. In figure (i) below, fuzzy sets A, B, C partition the domain of individuals, represented by the abscissa; but in figures (ii) and (iii) there is no partition.

An alternate definition of fuzzy mutual exclusion and fuzzy partition.

Note that none of the situations depicted in these figures conforms to the definition of fuzzy mutual exclusion (and hence fuzzy partition) given in condition 5iii, since no set has a member with zero membership in each of the other sets. In particular, B has no such member. If this weakened version of fuzzy mutual exclusion and fuzzy partition is adopted, then addition of derived categories after Stage V does further refine the partition of the color domain. This formulation would appear to characterize the systems of those individuals for whom derived categories such as brown, pink, orange, and grey are on a perceptual/conceptual par with the primaries. Note that, in the alternate definition of fuzzy partition, categories such as crimson (cf. B) and chartreuse (cf. C) still do not participate in a refinement of the partition.

References

Berlin, B., and E. A. Berlin. 1975. Aguaruna color categories. American Ethnologist 2.61–87.

——, and P. Kay. 1969. Basic color terms: their universality and evolution. Berkeley & Los Angeles: University of California Press.

Bornstein, M. H. 1973a. Color vision and color naming: a psychophysiological hypothesis of cultural difference. Psychological Bulletin 80.257–85.

——. 1973b. The psychophysiological component of cultural difference in color naming and illusion susceptibility. Behavior Science Notes 8.41–101.

——. 1975. The influence of visual perception on culture. American Anthropologist 77.774–98.

Cairo, J. E., II. MS. Spectral color terms: a physiological theory. State University of New York, Binghamton.

Collier, G. A. 1973. Review of Berlin & Kay 1969. Lg. 49.245–8.

——, et al. 1976. Further evidence for universal color categories. Lg. 52.884–90

Daly, T. MS. Color Terms in the Slavic languages. University of California, Berkeley.

De Valois, R. L.; I. Abramov; and G. H. Jacobs. 1966. Analysis of response patterns of LGN cells. Journal of the Optical Society of America 56.966–77.

——, and G. H. Jacobs. 1968. Primate color vision. Science 162.533–40.

Dimmick, F. L., and M. R. Hubbard. 1939. The spectral location of psychologically unique yellow, green and blue. American Journal of Psychology 52.242–54.

Dougherty, J. W. D. 1974. Color categorization in West Futuna: variation and change. Paper presented to American Anthropological Association, Mexico, D.F.

——. 1975. A universalist analysis of variation and change in color semantics. Berkeley: University of California dissertation.

Faris, J. 1974. A theory of color conception. Paper presented to American Anthropological Association, Mexico, D.F.

Fillmore, C. J. 1975. An alternative to checklist theories of meaning. Proceedings, 1st Annual Meeting, Berkeley Linguistics Society, 123–31.

Fishman, J. A. 1960. A systematization of the Whorfian hypothesis. Behavioral Science 5.323–39.

Gatschet, A. S. 1879. Adjectives of color in Indian languages. American Naturalist 13.475–85.

Gleason, H. A. 1961. An introduction to descriptive linguistics. New York: Holt, Rinehart & Winston.

Hage, P., and K. Hawkes. MS. Binumarien color terms. Salt Lake City: University of Uath.

Harkness, Sara. 1973. Universal aspects of learning color codes: a study in two cultures. Ethos 1.175–200.

Hays, D. G., et al. 1972. Color term salience. American Anthropologist 74.1107–21.

Heider, E. R. [=E. H. Rosch.] 1972a. Probabilities, sampling, and ethnographic method: The case of Dani colour names. Man (n.s.) 7.448–66.

——. 1972b. Universals in color naming and memory. Journal of Experimental Psychology 93.10–20.

Heinrich, A. C. 1972. A non-European system of color classification. Anthropological Linguistics 14.220–27.

Hering, Ewald. 1920. Grundzüge der Lehre vom Lichtsinn. Berlin: Springer. [English version: Outlines of a theory of the light sense. Translated by L. M. Hurvich & D. Jameson. Cambridge, MA: Harvard University Press, 1964.]

Jacobs, G. H. 1964. Single cells in squirrel monkey lateral geniculate nucleus with broad sensitivity. Vision Research 4.221–33.

Jameson, D., and L. M. Hurvich. 1968. Opponent-response functions related to measured cone photopigments. Journal of the Optical Society of America 58.429–30.

Katz, J. J. 1964. Analyticity and contradiction in natural language. The structure of languages, ed. by J. A. Fodor & J. J. Katz, 519–43. Englewood Cliffs, N.J.: Prentice-Hall.

——. 1966. The philosophy of language. New York: Harper & Row.

Kay, P. 1975a. Synchronic variability and diachronic change in basic color terms. Language in Society 4.257–70.

——. 1975b. Tahitian words for race and class. (Language Behavior Research Laboratory, Working paper 40.) Berkeley: University of California.

Kuschel, R., and T. Monberg. 1974. 'We don't talk much about colour here': a study of colour semantics on Bellona Island. Man (n.s.) 9.213–42.

Lakoff, G. 1972. Hedges: a study in meaning criteria and the logic of fuzzy concepts. Papers from the 8th Regional Meeting, Chicago Linguistics Society, 183–228.

McDaniel, C. K. 1972. Hue perception and hue naming. A.B. honors thesis, Harvard College.

——. 1974. Basic color terms: their neurophysiological bases. Paper presented to the American Anthropological Association, Mexico, D.F.

——. MS. Universals in color terms semantics and their neuropsychological sources.

MacLaury, R. MS. Reconstructions of the evolution of some basic color term lexicons. University of California, Berkeley.

Miller, G. A., and P. Johnson-Laird. 1976. Language and perception. Cambridge, MA: Harvard University Press.

Newhall, S. M.: D. Nickerson; and D. B. Judd. 1943. Final report of the Optical Society of America Subcommittee on the Spacing of the Munsell Colors. Journal of the Optical Society of America 33.385–418.

Ratliff F. 1976. On the psychophysiological bases of universal color terms. Proceedings of the American Philosophical Society 120.311–30.

Rosch, E. H. [=E. R. Heider.] 1973. On the internal structures of perceptual and semantic categories. Cognitive development and the acquisition of language, ed. by T. E. Moore, 111–44. New York: Academic Press.

——. MS. Human categorization. To appear in Advances in cross-cultural psychology, I, ed. by N. Warren. London: Academic Press.

Sahlins, M. 1976. Colors and cultures. Semiotica 16.1–22.

Stephenson, P. H. 1973a. Color: its apprehension and symbolic use in language and culture. M.A. thesis, University of Calgary.

——. 1973b. The evolution of color vision in the primates. Journal of Human Evolution 3.379–86.

——. 1976. A strophe on structural analysis and neurology: color salience and the organization of the tricolor traffic signal. Paper presented to the Canadian Ethnological Society Meetings, Victoria, B.C.

Sternheim, C. D., and R. M. Boynyon. 1966. Uniqueness of perceived hues investigated with a continuous judgemental technique. Journal of Experimental Psychology 72.770–76.

Witkowski, S. R., and C. H. Brown. 1977. An explanation of color nomenclature universals. American Anthropologist 79.50–57.

Wooten, B. R. 1970. The effects of simultaneous and successive chromatic contrast on spectral hue. Doctoral dissertation, Brown University.

Zadeh, L. A. 1965. Fuzzy sets. Information and Control 8.338–53.

——. 1971. Quantitative fuzzy semantics. Information Sciences 3.159–76.

Zollinger, H. 1972. Human color vision as an interdisciplinary research problem. Platte 40.1–7.

——. 1973. Zusammenhänge zwischen Farbennennung und Biologie des Farbensehens beim Menschen. Vierteljahrschrift der Naturforschenden Gesellschaft 118.227–55.

——. 1976. A linguistic approach to the cognition of color vision in man. Folia Linguistica 9.265–93.

Glossary

Achromatic (color) A neutral color such as black, white, or gray. (See **Chromatic.**)

Achromatic response function (see **Chromatic response function**)

Achromatopsia (see **Central achromatopsia**)

Additive mixture A mixture in which the light from each of the components reaches the eye in an unmodified state. Lights superimposed on a projection screen are an example of an additive mixture. (See **Subtractive mixture.**)

Agraphia An impairment in the ability to write.

Alexia An impairment in the ability to comprehend written words or to read aloud.

Anomaloscope An instrument used for detecting anomalies of color vision. The test subject adjusts the ratio of two **monochromatic** lights to form a match with a third monochromatic light. The most common form of this procedure involves a *Rayleigh match*: a match between a mixture of monochromatic green and red lights, and a monochromatic yellow light. Normal subjects will choose a matching ratio of red to green light that falls within a fairly narrow range of values. Subjects with anomalous color vision (see **Anomalous trichromacy**) will choose a ratio of red to green that falls outside this range, and red-green dichromats (see **Dichromacy**) will accept any ratio of red to green as forming a match.

Anomalous trichromacy Condition of having three functioning **cone** types where one or more of the cones has abnormal **spectral sensitivity**. Anomalous trichromats, like normal subjects, require three **primaries** for color matching but will accept matches that normal subjects will reject.

Area 17 (see **Primary visual cortex**)

Assimilation A perceptual phenomenon in which the color of an area is perceived as closer to the color of the surround than it would if viewed in isolation. Assimilation occurs with stimuli with fine spatial structure; for example, a thin stripe of color between two black bars will look darker than it would between two white bars. Also known as the *von Bezold spreading effect.*

Basic color term A color word (a) that is monolexemic (unlike "reddish yellow"); (b) whose extension is not included in that of any other color term (unlike "scarlet," whose extension is included in "red"); (c) whose application is not restricted to a narrow class of objects (unlike "roan"); and (d) that is psychologically salient (unlike "puce"). A basic color term names a *basic color category.*

Bezold-Brücke hue shift A shift in apparent color of a stimulus toward yellow or blue with increasing **intensity**. If a pair of long-wavelength lights differing only in intensity are compared, the higher-intensity stimulus will look more yellow and less red than the lower-intensity light. For shorter wavelengths higher-intensity lights look more blue and less green than lower-intensity lights. There are three *invariant points* in the spectrum: **monochromatic** lights whose color appearance does not change with intensity. (See **Invariant hue.**)

Binary hue A hue that is perceptually mixed, as orange appears to be a mixture of red and yellow. All binary hues are mixtures of two of the **unique hues.**

Bipolar cells Retinal *interneurons* (neurons that communicate only with other neurons in the same part of the central nervous system) that connect the **photoreceptors** with the **ganglion cells.**

Blobs Regions of **primary visual cortex** that contain a relatively high proportion of neurons that respond more strongly to some wavelengths than to others (wavelength-selective cells) and a relatively low proportion of orientation-selective cells. They receive their main input from the **parvocellular** system. Some layers of the primary visual cortex form a mosaic of blobs when stained for the mitochondrial enzyme cytochrome oxidase. The regions between the blobs (*interblobs*) contain fewer wavelength-selective cells and many orientation-selective cells. The blobs are thought to be an important part of the pathway underlying color vision.

Brightness Attribute of a visual sensation according to which an area appears to emit more or less light. (CIE 45-25-210.) The perceived amount of light coming from an area. "Brightness" is often restricted to apply only to lights and "lightness" is used for the corresponding dimension of the colors of surfaces. One of the three standard elements of color appearance (the other two are **hue** and **saturation**). Its colorimetric equivalent is **luminance**.

Calcarine cortex (See **Primary visual cortex**)

Central achromatopsia A defect of color vision due to damage to the brain, typically to areas of the **visual cortex**. Central achromatopsia is distinct from the more common forms of color defect which are the result of **photoreceptor** loss or abnormality.

Chroma Attribute of a visual sensation which permits a judgment to be made of the amounts of pure chromatic color present, irrespective of the amount of achromatic color. (CIE 45-25-235.) For colors of the same **hue** and **brightness**, chroma and **saturation** are equivalent. Chroma will increase with brightness, however, even if saturation is held constant. Chroma is used instead of saturation in the **Munsell color system**.

Chromatic (color) A **hue**. All colors other than the neutral colors white, black, and the pure grays, are chromatic. The word "color" in ordinary language is often used to refer exclusively to chromatic colors, for example, color versus black-and-white television.

Chromatic response function A function from the wavelength of a stimulus to an aspect of its perceived color. For example, the yellow-blue process of **opponent-process theory** is characterized by a function from the wavelength of the stimulus to the amount of perceived yellow or blue. The red-green process and the black-white process are similarly characterized (the latter by an *achromatic* response function).

Chromaticity coordinates Coordinates that specify position in a **chromaticity diagram**. The chromaticity coordinates of a stimulus are derived from its **tristimulus values** by taking the ratio of the first two tristimulus values to the sum of all three; that is, $x = X/X + Y + Z$, $y = Y/X + Y + Z$, where x and y are the chromaticity coordinates and X, Y, and Z the tristimulus values.

Chromaticity diagram A diagram that represents the unit plane (the plane defined by the equation $X + Y + Z = 1$) in a tristimulus space. The location of a stimulus with a particular set of **tristimulus values** on a chromaticity diagram represents its direction from the origin of the space ignoring its distance. A chromaticity diagram is often used as a convenient approximation to a constant **brightness** plane in the tristimulus space.

Chromaticity Location in a **chromaticity diagram**. Chromaticity is often used as a convenient approximation to *chromaticness*, which is the **hue** and **saturation** of a color ignoring **brightness**. The points within a closed, roughly triangular, curve (the *color triangle*) on a chromaticity diagram correspond to all realizable chromaticities.

Chromophore The light-absorbing part of a **photopigment**. The photopigments contained in **photoreceptors** consist of two components: an **opsin** bound to a chromophore. The chromophore in human (and all mammalian) photopigments is **retinal** (a form of vitamin A). Upon absorbing a photon, retinal changes its conformation which results in its separation from the opsin group. This chemical change initiates the visual response. The differences in **spectral sensitivity** among the photopigments found in the different types of human photoreceptors are due to differences in their opsins.

CIE Commission Internationale de l'Éclairage. An international organization that recommends standards and procedures for light and lighting, including **colorimetry**.

CIE illuminant C or **illuminant C** A standard illuminant that is an approximation to average daylight. Like all illuminants, illuminant C is specified by its **spectral power distribution**.

CIE standard observer A set of **tristimulus values** for **spectral lights** that is designed to allow a standard and objective way of describing the color-matching properties of different lights. Although very few people will accept all the color matches of the standard observer, lights that are matches for the standard observer

will be near matches for most people with normal color vision. Since the matching properties of stimuli vary with size and other features of the viewing conditions, there is more than one standard observer.

Color anomia An inability to name colors despite intact color vision as demonstrated by nonverbal tests.

Color constancy Stability in the perceived color of a surface across changes in illumination and the consequent changes in the light reaching the eye.

Color space A system for ordering colors that respects the relationships of similarity among them. There are variety of different color spaces, but they are all three-dimensional.

Color temperature The temperature of the perfect black body radiator whose **chromaticity** is closest to that of the light under consideration. A useful measure of the quality of a light with a particular **spectral power distribution** when used as an illuminant. Color temperature is most useful when applied to illuminants with broad and smoothly changing spectral power distributions.

Colorimetry The science of measuring color and color appearance. Classical colorimetry deals primarily with color matches rather than with color appearance as such. The main focus of colorimetry has been the development of methods for predicting perceptual matches on the basis of physical measurements.

Complementary colors Two color stimuli that can be additively mixed to produce an achromatic color. (See **Additive mixture**.)

Cone One of the two main classes of **photoreceptor** found in the vertebrate eye. Cones produce usable outputs only at relatively high light levels and provide the main inputs for color vision. There are three types of cones in the human eye, each type having a different **spectral sensitivity**.

Confusion line A line on a **chromaticity diagram** representing colors that are not discriminable by a subject with a particular defect of color vision. The protan confusion line represents colors that are indistinguishable by a protanope (see **Protanopia**), and similarly for the other varieties of color blindness.

Depolarization A decrease in the potential difference across the cell membrane of a neuron. Most neurons depolarize in response to stimulation. (See **Hyperpolarization**.)

Deuteranopia One of the two varieties of red-green color blindness (also known as *green-dichromacy*). Deuteranopia results from the loss of function of the **M-cones**. Deuteranopes, in contrast to protanopes (see **Protanopia**), display essentially normal visual sensitivity throughout the spectrum.

Dichoptic matching A matching experiment in which stimuli are presented separately to the two eyes. The match is thus between a stimulus seen using one eye and a stimulus seen using the other eye.

Dichromacy Condition of possessing two independent channels for conveying color information. Color matching for dichromats requires only two **primaries**. Most "color-blind" humans are dichromats and have lost the function of one of the **cone** types and consequently one of the **opponent processes**. Dichromats are not strictly color blind in the sense that their vision is sensitive to a single chromatic dimension as well as to **brightness**.

dLGN (see **Dorsal lateral geniculate nucleus**)

Dominant wavelength (of a stimulus) The wavelength of the **monochromatic** light that when mixed with a specified achromatic light in suitable proportion yields a match to the stimulus. (The purples cannot be produced by such mixtures; the dominant wavelength of a purple is defined as the "complementary" wavelength λ, where λ is the dominant wavelength of the purple's **complementary color**.) Since there is no unique best choice of achromatic light, the dominant wavelength of a stimulus is relative to the choice of a particular achromatic light. **CIE illuminant C** is a popular and convenient choice of achromatic reference. The colorimetric equivalent of **hue**.

Dorsal lateral geniculate nucleus (dLGN) An area of the **thalamus** that serves as an important relay station for visual information on its way to the **visual cortex**. The dLGN (or LGN) is the primary target for outputs from **retinal ganglion cells** and receives its main input from them. Its main output is to **primary visual cortex** via the **optic radiations**.

Double opponent cell A neuron that exhibits opposite spectral opponency in the center and surround of its **receptive field** (see **Spectrally opponent**). For example, a double opponent cell might be stimulated by the **L-cones** and inhibited by the **M-cones** in the center of its receptive field, and vice versa in the surround. Double opponent cells respond best to stimuli with contrasting colors and are not found in the visual pathway prior to **primary visual cortex**.

Electron volt The amount of energy required to move an electron across a potential difference of one volt. A common unit of energy in physics.

Equiluminant Equal in **luminance**. Two lights may be equally bright although chromatically different (which implies they have different **spectral power distributions**). One consequence of the possession of color vision is the ability to discriminate some equiluminant stimuli.

Extrastriate cortex Those areas of **visual cortex** lying outside **primary visual cortex**.

Farnsworth-Munsell 100-hue test A standard test for deficiencies of color vision in which the subject is asked to arrange a set of 100 colored chips in a circle. Subjects with normal color vision will arrange the chips in a specific order with very few deviations. Subjects with abnormal color vision will deviate from the normal arrangement in ways that provide information about the nature of their defect.

Fluorescence The absorption of light at one wavelength and its reemission at a longer wavelength. Fluorescence plays an important role in the perceived color of many objects: the unnatural brightness of Day-Glo paints is due to fluorescence.

Focal color A paradigm example of a member of a basic color category. (See **Basic color term**.)

Fovea The central area of the **retina**. The fovea contains the densest concentration of **photoreceptors** (**cones** only) and displays other adaptations for high-resolution vision.

Ganglion cells The output cells of the **retina**. They indirectly receive their inputs from the **photoreceptors** and send their outputs to the brain. There are several varieties of ganglion cells which differ in which photoreceptor types they draw their inputs from, the spatial organization of their inputs, and other factors. The axons of the ganglion cells form the *optic nerve*.

Grassmann's laws Laws governing the results of additive color matching experiments (see **Additive mixture**). Grassmann's laws assert the existence of exactly three dimensions of variation in perceived color, for example, **hue**, **brightness**, and **saturation**. They also imply the linear additivity of color matches, a fact of importance to **colorimetry**. Thus if stimulus *a* matches stimulus *b*, and stimulus *c* matches stimulus *d*, then the additive mixture of *a* and *c* will match the mixture of *b* and *d* irrespective of the stimuli's spectral composition.

Grating (chromatic and achromatic) A stimulus pattern consisting of alternating stripes. The stripes can differ in color (chromatic grating) or only in **brightness** (achromatic grating).

Helson-Judd effect The tendency of lighter **achromatic** surfaces to take on the **hue** of the illuminant under which they are viewed, and of darker achromatic surfaces to take on the complementary hue.

Hemianopia The loss of visual capacity in one half of the visual field, typically due to damage to **primary visual cortex**. (Strictly speaking, this type of visual field defect is a *homonymous* hemianopia.) Because each half of the visual field is represented by the contralateral side of the brain, damage to one side of the brain will result in the loss of visual capacity in the opposite side of the visual field.

Horizontal cells Neurons found in the **retina** that make widespread synaptic contacts with other **retinal** neurons and that are thought to play a role in generating the **receptive field** properties of other retinal neurons, including **ganglion cells**.

Hue Attribute of visual sensation which has given rise to color names such as: blue, green, yellow, red, purple, etc. (CIE 45-25-215.) Hue differences depend primarily on variations in the wavelength of light reaching the eye. One of the three standard elements of color appearance (the other two are **brightness** and **saturation**). Its colorimetric equivalent is **dominant wavelength**.

Hue coefficient The ratio between either the red, green, yellow, or blue response to the total chromatic response. For example, a stimulus that is seen as a balanced purple—equally bluish and reddish—has a hue coefficient of .5 for both red and blue, whereas unique yellow has a coefficient of 1.0 for yellow and zero for the others. (See **Opponent-process theory**, **Unique hue**.)

Hyperpolarization An increase in the potential difference across the cell membrane of a neuron. **Retinal photoreceptors** differ from most other neurons in hyperpolarizing in response to stimuli. (See **Depolarization**.)

Illuminant point (of an illuminant) The illuminant's location on a **chromaticity diagram**.

Intensity The power of a light, often weighted by the **spectral sensitivity** of the eye. Since the eye is much more sensitive to light of some wavelengths than it is to others, two **monochromatic** lights can have equal power, while one appears dim and the other appears bright. Visual scientists often use a system of units (*photometric units*) that scale the physical power (given in *radiometric units*) to the sensitivity of the eye at each wavelength.

Interblobs (see **Blobs**)

Invariant hue The perceived hues of **monochromatic** lights that do not change with **intensity**. There are three invariant hues: blue, green, and yellow. (See **Bezold-Brücke hue shift**.)

Ishihara test A test for color blindness using a set of **pseudoisochromatic plates**.

Isoluminant (see **Equiluminant**)

Isomerization The change in conformation upon absorption of a photon that the **chromophores** in **photopigments** undergo.

L-cone One of three **cone** types that contribute to human color vision. The L-cones have their peak **spectral sensitivity** at a longer wavelength than the other two cone types, the **M-cones** and **S-cones**.

L-M cell A **spectrally opponent** type of **ganglion** cell that is excited by inputs from **L-cones** and inhibited by inputs from **M-cones**. These cells (together with **M-L cells**) are of interest because of their possible connection with the red-green opponent channel. (See **Opponent-process theory**.)

Lateral geniculate nucleus (LGN) (see **Dorsal lateral geniculate nucleus**)

Lightness (see **Brightness**)

Luminance The **intensity** (power weighted by the overall **spectral sensitivity** of the eye) per unit area of a light source.

Luminosity (see **Luminance**)

M-cone One of the three cone types that contribute to human color vision. The peak **spectral sensitivity** of the M-cones is between the peak sensitivity of the other two cone types, the **L-cones** and **S-cones**.

M-L cell A **spectrally opponent** type of **ganglion** cell that is excited by inputs from **M-cones** and inhibited by inputs from **L-cones**. These cells (together with **L-M cells**) are of interest because of their possible connection with the red-green opponent channel (see **opponent-process theory**).

Magnocellular pathway One of the two main neural pathways from the **retina** to the **primary visual cortex** (the other is the **parvocellular pathway**). The magnocellular pathway is not thought to play an important role in color vision.

Metameric match A color match between physically different stimuli, that is, a match between stimuli with different **reflectances** or **spectral power distributions**. Such stimuli that match (for an observer and a viewing condition) are *metamers* (with respect to that observer and that viewing condition).

Microspectrophotometry A technique for obtaining measurements of the spectral absorption of a single **photoreceptor** cell. It is especially useful as a means for investigating nonhuman color vision without behavioral tests.

Midget bipolar cell **Bipolar cells** that are thought to feed the **Pβ ganglion cells** which are the origin of the **parvocellular pathway**.

Monochromacy The condition of possessing only a single channel for conveying information about color. Monochromats are strictly color blind and perceive only variations in **brightness**.

Monochromatic Consisting of a single wavelength or narrow range of wavelengths. (See **Spectral light**.)

MRI Magnetic resonance imaging. A noninvasive technique for imaging soft tissues including the brain. MRI has been mostly used for detecting and localizing damage to the brain, but recently versions of the technique have been developed that allow imaging of local differences in brain activity.

Munsell color system A widely used system for describing the color appearance of samples. The Munsell system uses matching against a set of samples and interpolation between them to arrive at a designator for the appearance of a given test sample. Color appearance in the Munsell system is characterized using a special notation; for example, 2.5 YR 5/10. 2.5 YR is the **hue**, 5/ the *value* (=**lightness**), and /10 the **chroma**.

Nanometer One billionth (10^{-9}) of a meter. The most common unit used for characterizing the wavelength of light in visual science. ($1nm = 1m\mu$).

Neutral point All dichromats will accept a match between some **spectral light** and a white light. The wavelength of this spectral light is the neutral point for that dichromat (see **Dichromacy**). No trichromatic subject, including anomalous trichromats (see **Anomalous trichromacy**), will accept a match between a white light and any spectral light.

Opponent-process theory The theory that color appearances are the result of a recoding of **photoreceptor** outputs into three processes or channels, two opponent chromatic channels (yellow-blue and red-green), and one achromatic channel (white-black). The new channels are created by taking sums and differences of the outputs of the three **cone** types. The two opponent chromatic channels can take on positive, negative, or zero values. When (for example) the yellow-blue channel is positive (negative), the result is an appearance of yellow (blue). Thus the incompatibility of yellow and blue is explained by the fact that the yellow-blue channel never simultaneously has positive and negative values. The theory predicts (correctly) that the blue of a stimulus may be canceled by adding to it a stimulus that produces an appearance of yellow.

Opsin The protein component of a **photopigment**. Different opsins give rise to photopigments with different spectral absorption characteristics and consequently account for the differences in **spectral sensitivity** of the various **photoreceptor** types. (See **Chromophore**.)

Optic nerve (see **Ganglion cells**)

Optic radiations The bundles of axons projecting from the **lateral geniculate nucleus** to **primary visual cortex**.

Pα cells Ganglion cells, found in the primate **retina**, that are thought to be the origin of the **magnocellular pathway**. Also referred to as *M cells, parasol cells*, or *A cells*. They are analogous to the well-studied ganglion cells of the cat retina known as *Y cells* or α *cells*.

Parvocellular pathway One of the two main pathways from the **retina** to **primary visual cortex** (the other is the **magnocellular pathway**). The parvocellular stream primarily carries information about **luminance** contrast at high spatial resolution, but is also the main carrier of information about stimulus wavelength.

Pβ cells Ganglion cells, found in the primate **retina**, that are thought to be the origin of the **parvocellular pathway**. Also referred to as *P cells, midget cells*, or *B cells*. They are analogous to the well-studied ganglion cells of the cat retina known as *X cells* or β *cells*.

Photophore Light-emitting (bioluminescent) organ.

Photopic vision Vision under relatively high light levels when the visual response is primarily controlled by the **cones**.

Photopigment Pigments in **photoreceptors** that change their conformation when they absorb a photon. The change in conformation of the photopigments in response to light is the first step in the process that leads to the photoreceptor producing a neural output. Different photopigments have different probabilities of absorbing a photon of a given wavelength, and it is these differences that give rise to the different **spectral sensitivity** characteristics of different types of photoreceptors.

Photoreceptor A light-sensitive neuron. Photoreceptors interact with light which produces changes in their electrical properties which are communicated to other neurons. They constitute the first stage in the physiological process which underlies vision. The human **retina**, like the retina of most vertebrates, contains two basic classes of photoreceptors, **rods** and **cones**.

Polarization The spatial orientation of the electromagnetic waves that make up a beam of light. Light in which the spatial orientation of the waves is not random is said to be polarized. Although most light sources, such as the sun, emit essentially unpolarized waves, many physical processes such as scattering in the atmosphere and reflection off glossy surfaces impose a preferred polarization on light.

Polymorphism A trait of an organism that is found in more than one form in a population, or the existence of different forms of a gene in a population. For example, the human population contains both red-green dichromats (see **Dichromacy**) and normal trichromats (see **Trichromacy**), and human color vision is thus polymorphic.

Porphyropsin Photopigment utilizing 3,4-dehydroretinal instead of **retinal** as its **chromophore**. This substitution has the effect of shifting peak absorption to longer wavelengths.

Positron emission tomography (PET) A method for imaging cerebral blood flow and, indirectly, brain activity, making use of tracers that emit positrons. The tracer is introduced into the subject's blood and then its concentration is measured using the emitted positrons. Since local cerebral blood flow appears to be correlated with neuronal activity PET scans can be used to monitor local brain activity.

Power Energy per unit time. (See **Intensity**.)

Prestriate cortex (see **Extrastriate cortex**)

Primary A member of a minimal set of stimuli (usually lights), mixtures of the elements of which are capable of matching all colors. For normal human beings three primaries are sufficient to provide a perceptual match. There are indefinitely many sets of three primaries, mixtures of which are capable of matching all colors. For colorimetric purposes the concept of a primary has been extended to include

"imaginary" primaries—ones that are not physically realizable. Thus the **CIE standard observer** makes use of imaginary primaries. The results of mixing imaginary primaries are derived from data using real lights.

Primary visual cortex An area of the occipital lobe that performs the first stage of cortical visual processing. It receives inputs from the **retina** via the **dLGN** and sends outputs to other areas of the **visual cortex**. Also referred to as *V1*, *striate cortex*, *calcarine cortex*, and *area 17*.

Prosopagnosia An impairment in the ability visually to recognize individual faces.

Protanopia One of the two varieties of red-green color blindness (also known as *red-dichromacy*). Protanopia is thought to result from the loss of function of the **L-cones**. Protanopes display a marked loss of sensitivity to light at the long wavelength end of the spectrum. (See **Deuteranopia**.)

Protein moiety (see **Opsin**)

Pseudoisochromatic plates Common tests for color blindness that use patterns of colored dots. A normal subject will see a certain figure in the pattern, whereas a color-blind person will see a different figure or no figure at all.

Purity (of a stimulus) The purity of a color stimulus, relative to a specified **achromatic** light, is the ratio of the distance between the **chromaticity** of the achromatic light (achromatic point) and the chromaticity of the color stimulus (stimulus point), and the distance between the achromatic point, passing through the stimulus point, to the edge of the region in the **chromaticity diagram** representing all realizable chromaticities. Since there is no unique best choice of achromatic light, the purity of a stimulus is relative to the choice of a particular achromatic light. **CIE illuminant C** is a popular and convenient choice of achromatic reference. The colorimetric equivalent of **saturation**.

Quantum catch The number of photons absorbed by the **photopigment** molecules of a **photoreceptor**. The rate of quantum catch in a photoreceptor determines its output.

Rayleigh scattering Scattering of light off small uniform particles. Rayleigh scattering is inversely proportional to the fourth power of the wavelength, and in consequence short-wavelength light is much more strongly scattered than long-wavelength light. Sunsets appear red because direct sunlight is depleted of short wavelengths on passage through the atmosphere, and the sky appears blue because the scattered light is correspondingly enriched in short wavelengths.

Receptive field (of a neuron) The region of the visual field in which stimuli will affect the neuron's level of activity.

Reflectance (of a surface) The proportion of incident light the surface reflects. (See **Spectral reflectance**.)

Retina The inside layer of the back of the eye that contains the **photoreceptors** and associated neurons. The earliest stages of visual processing take place in the neurons of the retina.

Retinal (1) In or having to do with the **retina**; (2) The **chromophore** contained in human **photopigments**.

Rhodopsin The **rod photopigment**.

Rod One of the two main classes of **photoreceptor** found in the vertebrate eye. Rods are very sensitive to light but fail to produce a usable signal at high light levels. They mediate night vision and have little effect on color vision in daylight.

S-cone One of the three **cone** types that contribute to human color vision. The peak **spectral sensitivity** of the S-cones is at a shorter wavelength than that of the other two cone types, the **L-cones** and **M-cones**.

Saturation Attribute of a visual sensation which permits a judgment to be made of the proportion of pure chromatic color in the total sensation. (CIE 45-25-225.) Pink and red differ in saturation, with red being the more saturated. The **spectral colors** are all maximally saturated examples of their hues and differ

in this respect from pastels, which are desaturated. One of the three standard elements of color appearance (the other two are **hue** and **brightness**). Its colorimetric equivalent is **purity**.

Scotopic vision Vision under relatively low light levels when the visual response is primarily controlled by the **rods**.

Simultaneous contrast The phenomenon in which the perceived color of an area of a scene tends to take on a **hue** opposite to that of the surrounding area. Thus a gray square on a red background will take on a greenish tint.

Snellen acuity Visual acuity as measured by the ability to discriminate high-contrast shapes. The familiar Snellen eye chart, containing rows of letters each smaller than the one above, provides one way of measuring Snellen acuity.

Spatial contrast A difference in some visible property between one area of a scene and adjacent areas. For example, black letters on a white background display high spatial contrast.

Spatial frequency A measure of how rapidly a property changes in space. A commonly used form of visual stimulus consists of vertical bars where the lightness varies according to a sinusoidal function. In this simple case the spatial frequency of the stimulus is just the frequency of the function used to generate the pattern. In general, stimuli with fine sharp-edged detail have high spatial frequency.

Spatially opponent (neuron) A neuron that is excited (or inhibited) by stimuli in the center of its **receptive field** and inhibited (or excited) by stimuli in the periphery of its receptive field.

Spectral color The color of a **monochromatic** or nearly monochromatic light, that is, a color to be found in the **spectrum**.

Spectral light A **monochromatic** or nearly monochromatic light.

Spectral power distribution (of a light) At each wavelength in the **visible spectrum**, the power of the light at that wavelength as a proportion of its total power over the visible spectrum. (Strictly speaking, this is the *relative* spectral power distribution.)

Spectral reflectance (of a surface) At each wavelength in the **visible spectrum**, the proportion of incident light the surface reflects at that wavelength.

Spectral sensitivity (of a photoreceptor) The sensitivity of a **photoreceptor** at each wavelength in the **visible spectrum**. For a given wavelength, this is equal to the ratio of the photoreceptor response at that wavelength to its response at its most sensitive wavelength. Different photoreceptor types have different spectral sensitivities.

Spectrally opponent (neurons) Neurons that are excited by one **cone** type and inhibited by another.

Spectrum or **visible spectrum** Band of electromagnetic radiation ranging from wavelengths of approximately 400 to approximately 700 **nanometers**, corresponding to the sensitivity of the human eye. Sensitivity does not drop to zero at the standard endpoints of the visible spectrum, but is so low that light outside these limits rarely has a significant effect on visual response. Many nonhuman animals respond significantly to light outside this range, especially to light of shorter wavelengths.

Striate cortex (see **Primary visual cortex**)

Subtractive mixture A color mixture in which the light from each component is modified by the others. Since pigments modify light by absorbing a portion of the incident light, each pigment will modify the light from the others, and thus pigment mixtures are subtractive mixtures. (See **Additive mixture**.)

Successive contrast The influence of perceived color at a time on perceived color at a later time. Afterimages are produced by successive contrast.

Surface spectral reflectance (see **Spectral reflectance**)

Thalamus A midbrain structure that plays a major role in relaying information from the various sensory receptors to other brain areas.

Trichromacy Condition of possessing three independent channels for conveying color information. A single set of three appropriately chosen **primaries** is sufficient to match the color appearance of any stimulus for a trichromat. Normal human color vision is trichromatic—derived from the three different **cone** types—but some other organisms, for example, pigeons, have *tetrachromatic* color vision: they require sets of four primaries to produce complete color matches. Other organisms and some color-deficient humans are dichromats (see **Dichromacy**): they require only sets of two primaries to produce complete color matches.

Tristimulus colorimetry A set of techniques for predicting color matches by equating a given stimulus with the amounts of three specified **primaries** that would be required to match it. The amounts of three primaries that would be required to match the stimulus are the **tristimulus values** of that stimulus for that set of primaries. Any stimuli with the same tristimulus values will match perceptually. Tristimulus colorimetry is useful because once the tristimulus values for **spectral lights** are determined empirically, it is possible to compute the tristimulus values of any mixture of spectral lights. Whether two different mixtures of spectral lights will match or not can thus be determined without anyone actually looking at the stimuli. *Tristimulus colorimeters* are used to determine the tristimulus values of a stimulus with respect to a standard set of primaries.

Tristimulus values (see **Tristimulus colorimetry**)

Tritanopia Yellow-blue color blindness. Tritanopia is thought to result from the loss of function of the **S-cones**. Tritanopia is much less common than either **protanopia** or **deuteranopia**.

Unilateral dichromat A person with normal color vision in one eye and some form of **dichromacy** in the other. Unilateral dichromats are very rare.

Unique hue A **hue** that is perceptually unmixed, containing no other chromatic component. The four unique hues (red, green, yellow, and blue) are thought to be basic components out of which all other (**binary**) hues are composed. According to **opponent-process theory**, an appearance of a unique hue is produced when one of the two chromatic opponent channels is in balance and the other is either positive or negative.

Univariance, principle of The fact that the effect on a **photopigment** of absorbing a photon is independent of its wavelength. Thus the response of a **photoreceptor** is determined solely by the number of photons absorbed and is not sensitive to the wavelengths of those photons. This has the important consequence that there is no information in the response of a single photoreceptor about the wavelength of the light which affects it. A single photoreceptor with a single photopigment is incapable of distinguishing between an intense light at a wavelength to which it is relatively insensitive, and a weak light at a wavelength to which it is relatively sensitive. **Chromatic** vision thus requires multiple photoreceptor types.

V1 (see **Primary visual cortex**)

Value (see **Munsell color system**)

Visible spectrum (see **Spectrum**)

Visual cortex Those cortical areas primarily concerned with the processing of visual information. The visual areas of the cortex are primarily located in the occipital lobe: the rear, lower part of the cortex.

Von Bezold spreading (see **Assimilation**)

Wavelength discrimination function The function from wavelength to the smallest discriminable difference in wavelength. Human wavelength discrimination varies substantially across the **spectrum** and, although performance varies considerably with testing conditions, the resulting curve is typically quite complex. The wavelength discrimination function is an important source of information about the contributions of the different **cone** types to color vision.

Weber's law The thesis that, in a given sensory modality, the ratio between the minimum perceptible change in a physical magnitude and the absolute value of that magnitude is a constant. For example, Weber's law predicts that the minimum detectable **intensity** difference between two lights will increase as the **brightness** of the lights increases. This is approximately true for high levels of brightness.

Suggestions for Further Reading

Physics

For a book-length treatment of the themes of chapter 1, see:

Nassau, K. 1980. *The Physics and Chemistry of Color: The Fifteen Causes of Color.* New York: Wiley.

Color Measurement

Chapter 2 provides an overview of only the most basic elements of colorimetry. A relatively accessible introduction to more advanced topics is the text from which chapter 2 is a selection:

MacAdam, D. L. 1985. *Color Measurement: Theme and Variations.* New York: Springer-Verlag.

The standard handbook of colorimetry, full of useful information but best taken in small doses, is:

Wyszecki, G., and W. S. Stiles. 1982. *Color Science: Concepts and Methods, Quantitative Data and Formulas*, ed. 2. New York: Wiley.

Another classic, containing useful explanatory material and some indications of the practical applications of colorimetric methods, is:

Judd, D. B., and G. Wyszecki. 1975. *Color in Business, Science, and Industry*, ed. 3. New York: Wiley.

Physiology and Psychophysics

There are a large number of textbooks on color vision, most of which provide suitable introductions to the subject for the outsider. Two especially useful ones (both unfortunately out of print) are:

Boynton, R. M. 1979. *Human Color Vision.* New York: Holt, Rinehart & Winston.

Hurvich, L. M. 1981. *Color Vision.* Sunderland, MA: Sinauer Associates.

Boynton is the more difficult of the two but also the more detailed. Both are written from the point of view of opponent-process theory and focus primarily on the psychophysics, with Boynton providing more discussion of physiological issues. Chapter 3 of this volume is a selection from Hurvich.

A recent textbook on vision, containing an extensive discussion of color vision and pointers to the recent literature, is:

Wandell, B. A. 1995. *Foundations of Vision.* Sunderland, MA: Sinauer Associates.

Most neurobiology texts contain discussions of the neurobiology of color vision. Two recent examples are:

Gouras P. 1991. Color vision. In *Principles of Neural Science*, ed. 3, ed. E. R. Kandel, J. H. Schwartz, and T. M. Jessel. New York: Elsevier.

Zrenner, E., I. Abramov, M. Akita, A. Cowey, M. Livingstone, and A. Valberg. 1990. Color perception: retina to cortex. In *Visual Perception: The Neurophysiological Foundations*, ed. L. Spillman and J. S. Werner. New York: Academic Press.

The classic paper on opponent-process theory is:

Hurvich, L. M., and D. Jameson. 1957. An opponent process theory of color vision. *Psychological Review* 64, 384–404.

The concept of luminance is an important one in many areas of visual science. It is supposed to be the formal counterpart of the intuitive notion of visual effectiveness, but there are reasons for doubting the existence of a single measure of the latter for all visual tasks. For a review of some of these complexities, see:

Lennie, P., J. Pokorny, and V. C. Smith. 1993. Luminance. *Journal of the Optical Society of America A* 10, 1283–93.

A major obstacle to straightforward attempts to link the properties of peripheral (noncortical) visual neurons with the psychophysics of color vision has been that all known peripheral neurons confound wavelength and luminance information in their responses. A model that attempts to solve this difficulty is presented in:

De Valois, R. L., and K. K. De Valois. 1993. A multi-stage color model. *Vision Research* 33, 1053–65.

For a somewhat sceptical review of the De Valois' model and others that address the same problem, see:

Kingdom, F. A., and K. T. Mullen. 1995. Separating colour and luminance information in the visual system. *Spatial Vision* 9, 191–219.

Cortical mechanisms supporting color vision have been the object of a great deal of research. A major topic of interest has been the degree of functional specialization in the various pathways and cortical areas, in particular the existence and nature of cortical areas specialized for color. Zeki provides a controversial but accessible case for the claim that area V4 is a color center in the cortex:

Zeki, S. 1990. Colour vision and functional specialisation in the visual cortex. *Discussions in Neuroscience* 6, 8–64.

A discussion of some of the evidence against this hypothesis, and a case for a different location for the putative color center is in:

Heywood, C. A., D. Gaffan, and A. Cowey. 1995. Cerebral achromatopsia in monkeys. *European Journal of Neuroscience* 7, 1064–73.

A sceptical review of the claims of functional specialization in various cortical areas is:

Schiller, P. H. 1996. On the specificity of neurons and visual areas. *Behavioural Brain Research* 76, 21–35.

A less controversial issue has been the claim that the blobs of area V1 and the thin stripes of area V2 are specialized for processing color information. Livingstone and Hubel have attempted to connect the physiological evidence for discrete channels with the results of various psychophysical tests that point to the same conclusion:

Livingstone, M. S., and D. H. Hubel. 1987. Psychophysical evidence for separate channels for the perception of form, color, movement, and depth. *Journal of Neuroscience* 7, 3416–68.

A review of the physiological evidence for separate channels for form and color is:

Yoshioka, T., and B. M. Dow. 1996. Color, orientation and cytochrome oxidase reactivity in areas V1, V2 and V4 of macaque monkey visual cortex. *Behavioural Brain Research* 76, 71–88.

Color Constancy

The literature on color constancy is large and growing rapidly. A useful resource is a special section of the *Journal of the Optical Society of America* devoted to computational theories of color vision:

Krauskopf, J. (ed.) 1986. *Computational approaches to color vision*. Feature section of *Journal of the Optical Society of America A* 3, 1648–757.

For a version of Land's retinex theory (earlier than the one presented in chapter 5 of this volume) see:

Land, E. H. 1977. The retinex theory of color vision. *Scientific American* 237 (June), 108–28.

The extent of human color constancy and even its proper definition are still the subject of controversy. Two different techniques for assessing color constancy, and two correspondingly different answers to the question of how much perceived color varies with illumination, are in the following two papers:

Bramwell, D. I., and A. C. Hurlbert. 1996. Measurements of colour constancy by using a forced-choice matching technique. *Perception* 25, 229–41.

Arend, L. E. 1993. How much does illuminant color affect unattributed colors? *Journal of the Optical Society of America A* 10, 2134–47.

There are a variety of different computational approaches to color vision. The following papers present a few current examples:

Brainard, D. H., and B. A. Wandell. 1992. Asymmetric color matching: how color appearance depends on the illuminant. *Journal of the Optical Society of America A* 9, 1433–48.

Courtney, S. M., L. H. Finkel, and G. Buchsbaum. 1995. A multistage neural network for color constancy and color induction. *IEEE Transactions on Neural Networks* 6, 972–85.

Finlayson, G. D., M. S. Drew, and B. V. Funt. 1994. Color constancy: generalized diagonal transforms suffice. *Journal of the Optical Society of America A* 11, 3011–9.

Color Defects and Genetics

For discussion of other cases of unilateral dichromacy and its relevance to color appearance in color-blind observers see:

Judd, D. B. 1948. Color perceptions of deuteranopic and protanopic observers. *Journal of Research of the National Bureau of Standards* 41, 247–71.

Macleod, D. I. A., and P. Lennie. 1976. Red-green blindness confined to one eye. *Vision Research* 16, 691–702.

Ohba, N. and T. Tanino. 1976. Unilateral colour vision defect resembling tritanopia. *Modern Problems in Opthamology* 17, 331–5.

An interesting discussion of whether there are visual tasks that are better performed by color-blind than by normal persons can be found in:

Morgan, M. J., A. Adam, and J. D. Mollon. 1992. Dichromates detect color-camouflaged objects that are not detected by trichomates. *Proceedings of the Royal Society B* 248, 291–5.

The following papers all deal with the isolation of the genes for the human cone photopigments, and the direct measurement of the cone photopigment absorption spectra, which have been made possible by advances in genetics:

Merbs, S. L., and J. Nathans. 1992. Absorption-spectra of human cone pigments. *Nature* 356, 433–5.

Merbs, S. L., and J. Nathans. 1992. Absorption-spectra of the hybrid pigments responsible for anomalous color-vision. *Science* 258, 464–6.

Nathans, J., S. L. Merbs, C-H. Sung, C. J. Weitz, and Y. Wang. 1992. Molecular genetics of human visual pigments. *Annual Review of Genetics* 26, 403–24.

An interesting application of advances in the genetics of color vision can be found in:

Neitz, J., M. Neitz, and G. H. Jacobs. 1993. More than three different cone pigments among people with normal color vision. *Vision Research* 33, 117–22.

Central Defects of Color Vision and Naming

The most extensive review of the somewhat small number of cases of central achromatopsia is:

Zeki, S. 1990. A century of cerebral achromatopsia. *Brain* 113, 1727–77.

A book whose primary goal is the understanding of cognitive mechanisms involving color in normal people, but which contains extensive discussion of deficit cases, is:

Davidoff, J. 1991. *Cognition Through Color*. Cambridge, MA: MIT Press.

The following papers provide further case descriptions of central achromatopsia, including some of its more puzzling aspects, and attempt, to varying degrees, thereby to elucidate normal processing of color information:

Barbur, J. L., A. J. Harlow, and G. T. Plant. 1994. Insights into the different exploits of colour in the visual cortex. *Proceedings of the Royal Society of London B* 258, 327–34.

Cowey, A., and C. A. Heywood. 1995. There's more to colour than meets the eye. *Behavioural Brain Research* 71, 89–100.

DeRenzi, E., and H. Spinnler. 1967. Impaired performance on color tasks in patients with hemispheric damage. *Cortex* 3, 194–217.

Heywood, C. A., A. Cowey, and F. Newcombe. 1991. Chromatic discrimination in a cortically colour blind observer. *European Journal of Neuroscience* 3, 802–12.

Kennard, C., M. Lawden, A. B. Morland, and K. H. Ruddock. 1995. Colour identification and colour constancy are impaired in a patient with incomplete achromatopsia associated with prestriate cortical lesions. *Proceedings of the Royal Society of London B* 260, 169–75.

Milner, A. D., and C. A. Heywood. 1989. A disorder of lightness discrimination in a case of visual form agnosia. *Cortex* 25, 489–94.

Troscianko, T., J. Davidoff, and G. Humphreys. 1996. Human color discrimination based on a non-parvocellular pathway. *Current Biology* 6, 200–10.

Another classic description of color anomia is:

Kinsbourne, M., and E. K. Warrington. 1964. Observations on colour agnosia. *Journal of Neurology, Neurosurgery and Psychiatry* 27, 296–9.

Comparative Color Vision and Evolution

A very helpful book that describes some of the techniques used in the comparative study of color vision, as well as supplying a survey of vertebrate color vision, is:

Jacobs, G. H. 1981. *Comparative Color Vision.* New York: Academic Press.

A more up-to-date survey of mammalian color vision is:

Jacobs, G. H. 1993. The distribution and nature of colour vision among the mammals. *Biological Review* 68, 413–71.

For a review of primate color vision that illustrates how recent advances in genetics help answer questions in comparative color vision, see:

Jacobs, G. H. 1996. Primate photopigments and primate color vision. *Proceedings of the National Academy of Sciences USA* 93, 577–81.

A case study that addresses the interesting question of the existence of color constancy in nonprimates is:

Dorr, S. and C. Neumeyer. 1996. The goldfish—a colour-constant animal. *Perception* 25, 243–50.

Many invertebrates also possess color vision. For a discussion of one well-studied species, see:

Backhaus, W. 1992. Color vision in honeybees. *Neuroscience & Biobehavioral Reviews* 16, 1–12.

A survey of invertebrate color vision is:

Menzel, R. 1979. Spectral sensitivity and color vision in invertebrates. In *Handbook of Sensory Physiology vol. VII/6A,* ed. H. Autrum. New York: Springer-Verlag.

A well-known alternative to Shepard's explanation of primate trichromacy can be found in:

Barlow, H. B. 1982. What causes trichromacy? A theoretical analysis using comb-filtered spectra. *Vision Research* 22, 635–43.

An interesting review article that is highly critical of the assumptions behind analyses like those of Shepard and Barlow, and which attempts to connect the comparative study of color vision to broader philosophical and theoretical concerns, is:

Thompson, E., A. Palacios, and F. J. Varela. 1992. Ways of coloring: comparative color vision as a case study for cognitive science. *Behavioral and Brain Sciences* 15, 1–74.

The following papers address questions about the way in which different species' color vision is adapted to their visual environment and their ecology.

Chittka, L., and R. Menzel. 1992. The evolutionary adaptation of flower colours and the insect pollinators' colour vision. *Journal of Comparative Physiology A* 171, 171–81.

Goldsmith, T. H. 1990. Optimization, constraint, and history in the evolution of eyes. *Quarterly Review of Biology* 65, 281–322.

Goldsmith, T. H. 1994. Ultraviolet receptors and color vision: evolutionary implications and a dissonance of paradigms. *Vision Research* 34, 1479–87.

Color Concepts and Names

The classic reference for basic color terms is:

Berlin, B., and P. Kay. 1969. *Basic Color Terms: Their Universality and Evolution.* Berkeley: University of California Press.

A later paper that attempts to extend the model presented in chapter 17 to account for some anomalies is:

Kay, P., B. Berlin, and W. Merrifield. 1991. Biocultural implications of systems of color naming. *Journal of Linguistic Anthropology* 1, 12–25.

Some of the data that have been taken as supporting the essential correctness of the Berlin and Kay approach to basic color terms is in the following:

Bornstein, M. H. 1985. On the development of color naming in young children: data and theory. *Brain and Language* 26, 72–93.

Boynton, R. M. and C. X. Olson. 1990. Salience of chromatic basic color terms confirmed by three measures. *Vision Research* 30, 1311–7.

Rosch, E. H. 1973. Natural categories. *Cognitive Psychology* 4, 328–50.

Sternheim, C. E., and R. M. Boynton. 1966. Uniqueness of perceived hues investigated with a continuous judgmental technique. *Journal of Experimental Psychology* 72, 770–6.

Uchikawa, K., and R. M. Boynton. 1987. Categorical color perception of Japanese observers: comparison with that of Americans. *Vision Research* 27, 1825–33.

Werner, J. S., and B. R. Wooten. 1979. Opponent chromatic mechanisms: relation to photopigments and hue naming. *Journal of the Optical Society of America* 69, 422–34.

An interesting attempt to make good on Kay and McDaniels' appeal to neurophysiology in supporting their model can be found in:

Yoshioka, T., B. M. Dow, and R. G. Vautin. 1996. Neuronal mechanisms of color categorization in areas V1, V2 and V4 of macaque monkey visual cortex. *Behavioural Brain Research* 76, 51–70.

Finally, for a very critical and controversial review of this area, see:

Saunders, B. A. C., and J. van Brakel. 1997. Are there nontrivial constraints on colour categorization? *Behavioral and Brain Sciences*, forthcoming.

Contributors

Mathew Alpern[†]

Alan Cowey
Department of Experimental Psychology
Oxford University

Antonio R. Damasio
Department of Neurology
University of Iowa College of Medicine

Karen K. De Valois
Department of Vision Science and
Department of Psychology
University of California, Berkeley

Russell L. De Valois
Department of Psychology and
Department of Vision Science
University of California, Berkeley

Michael Fusillo
Lincoln, M.A.

Norman Geschwind[†]

C. H. Graham[†]

Charles A. Heywood
Department of Psychology
University of Durham, UK

Yun Hsia[†]

Leo M. Hurvich
Department of Psychology
University of Pennsylvania

Dorothea Jameson
Department of Psychology
University of Pennsylvania

Paul Kay
Department of Anthropology
University of California, Berkeley

Kenji Kitahara
Department of Ophthalmology
The Jikei University School of Medicine

David H. Krantz
Department of Psychology
Columbia University

Edwin H. Land[†]

J. N. Lythgoe[†]

D. L. MacAdam
Optics
University of Rochester

Chad K. McDaniel
Academic Information Technology
Services
University of Maryland, College Park

John D. Mollon
Department of Experimental Psychology
University of Cambridge

Kurt Nassau
Lebanon, N.J.

Jeremy Nathans
Department of Molecular Biology
and Genetics and Department of
Neuroscience
Johns Hopkins University School of
Medicine

Freda Newcombe
Russell Cairns Head Injury Unit
Radcliffe Infirmary, Oxford, UK

Julian C. Partridge
School of Biological Sciences
University of Bristol, UK

Joel Pokorny
Department of Opthalmology and
Visual Science and Department of
Psychology
University of Chicago

Matthew Rizzo
Department of Neurology
University of Iowa College of Medicine

Roger N. Shepard
Department of Psychology
Stanford University

Vivianne C. Smith
Department of Psychology
University of Chicago

Brian A. Wandell
Department of Psychology
Stanford University

[†] Deceased

Index

Achromatic response function, 74–79
Achromatic light, 184–185
Achromatopsia
 atypical (*see* Monochromacy)
 central (cerebral), xxiii, 117, 277ff., 291ff., 379
 typical (*see* Monochromacy)
Adaptation
 chromatic, 181–184, 319
 light, 174, 180–181
 postreceptoral, 190–191, 241–242
 von Kries, 181–184, 193
Additive mixture, 40
Afterimages. *See* Contrast, successive
Albedo, 179
Alexia, 261, 271, 273
Animal color vision, xxv-xxvi, 93, 333–336, 357ff.
 See also Color vision
 in fish, 155–156, 357–358, 360–366
 in primates, xxvi, 158, 379ff.
Anomaloscope, 202, 251, 280
Anomalous trichromacy, 201, 217–18, 251, 280
Area 17. *See* Primary visual cortex
Area 18. *See* V2
Assimilation, 131, 188–189

Basic color term, xxvii, 314, 340–348, 401ff.
Berlin, B., 340–343
Bezold-Brücke hue shift, 87–90
Binary hues. *See* Unique hues
Bipolar cells, xvii, 100, 101, 128
Black-body radiation, 8–9
Blobs (cytochrome oxidase), 158, 291–292, 305–306, 389
Boyle, R., 379
Brightness, xiii, 78, 91n3

Calcarine cortex. *See* Primary visual cortex
Chromaticity, 51
Chromaticity confusions, 206–209, 277, 287–288
Chromaticity coordinates, 51
Chromaticity diagram, 52
Chromatic response function, xvii, 69–74
Chromophore (visual pigment), 357–358, 370
CIE illuminant C, xiii, 41
CIE standard observer, xiv, 43–47
CIE *x, y* chromaticity diagram. *See* Chromaticity diagram
Color, ecological significance of, 381–385
Color anomia, xxiv, 117, 261ff., 288
Colorant, 33
Color blindness *See also* Achromatopsia; Monochromacy; Dichromacy
 acquired, 224–225
 inherited, 219–223, 252ff.
 unilateral, xxii, 223–224, 231ff.

Color constancy, xviii, 135–136, 143ff., 161ff., 177ff, 286–287, 311–312, 318–325, 327–329, 332, 385
Colorimeter, 43
Colorimetry, xii–xiv, 33ff.
Color naming, 59, 124–126, 232–233, 238–240, 283, 288, 339–348, 427
Color space, 122–124, 277–278, 287, 312, 418–419
Color temperature, 8–9, 185
Color vision. *See also* Animal color vision
 categorical, 344–348
 evolution of, xxvi, 311ff., 379ff.
 intraspecific variation in, 369–372, 392–393
Complementary color, 40
Complementary stimuli, 84–85
Complementary wavelength, 55, 84–85
Computational color vision, 143ff., 161ff., 177–178, 192–195, 318–325
Cone-monochromacy. *See* Monochromacy
Cones. *See* Photoreceptors
Confusion line. *See* Chromaticity confusions
Constant hue contours, 88
Contrast
 simultaneous, xviii, 130–136, 180, 186–188, 319
 successive, 125–129
Cortical color processing, 110–114, 152–154, 156–158, 191–192, 286–287, 291–293, 305–307, 388–389

Dalton, J., 250
Daylight, spectral power distribution of
 aquatic, 358–359
 terrestrial, 4, 40–41, 164–166, 311–312, 323, 329–333, 337–338
Deuteranomaly. *See* Anomalous trichromacy
Deuteranopia, xxi, 98–99, 201ff., 280. *See also* Dichromacy
De Valois, R. L. 407–411, 417
Dichoptic matching, 233–238
Dichromacy, xxi, 98, 201ff., 231ff., 250–251, 280, 333, 381–382. *See also* Deuteranopia; Protanopia; Tritanopia
Diffraction, 26–28
dLGN. *See* Dorsal lateral geniculate nucleus
Dominant wavelength, 53–60
Dorsal lateral geniculate nucleus, xxiii. *See also* LGN cells
Double opponent cells, 156, 191

Equiluminance, xxv, 381, 383

Fluorescence, 11, 13, 18–19
Focal color, 339–348, 402, 413
Fuzzy sets, xxvii-xxviii, 411–414